THE YEAR CHINA DISCOVERED AMERICA

GAVIN MENZIES

NEW YORK . LONDON . TORONTO . SYDNEY . NEW DELHI . AUCKLAND

HARPER PERENNIAL

This book was originally published in Great Britain in 2002 by Transworld Publishers.

A hardcover edition of this book was published in 2003 by William Morrow, an imprint of HarperCollins Publishers.

P.S. is a trademark of HarperCollins Publishers.

1421. Copyright © 2002 by Gavin Menzies. All rights reserved. Printed in the United States of America. No part of this book may be used or reproduced in any manner whatsoever without written permission except in the case of brief quotations embodied in critical articles and reviews. For information address HarperCollins Publishers, 10 East 53rd Street, New York, NY 10022.

HarperCollins books may be purchased for educational, business, or sales promotional use. For information please write: Special Markets Department, HarperCollins Publishers, 10 East 53rd Street, New York, NY 10022.

First Harper Perennial edition published 2004, reissued 2008.

Library of Congress Cataloging-in-Publication Data is available.

ISBN 978-0-06-156489-5

10 11 12 RRD 10 9 8 7

This book is dedicated to my beloved wife Marcella, who has travelled with me on the journeys related in this book and through life.

CONTENTS

LIST C	DF MAPS AND DIAGRAMS	9
LIST C	OF PLATES	11
CHIN	ese nomenclature	14
ACKN	NOWLEDGEMENTS	15
INTRO	DUCTION	27
	승규는 말 것 같아요. 이렇게 가지 않는 것 같아.	
Ι	Imperial China	
1		43
2	A THUNDERBOLT STRIKES	73
3		87
II	The Guiding Stars	
4	ROUNDING THE CAPE	109
5	THE NEW WORLD	143
		1+5
III	The Voyage of Hong Bao	
	VOYAGE TO ANTARCTICA AND	
0	AUSTRALIA	
	A G STRALIA	167
\mathbb{N}	The Voyage of Zhou Man	
	AUSTRALIA	195
8	THE BARRIER REEF AND THE SPICE	
	ISLANDS	215
9		235
10	COLONIES IN CENTRAL AMERICA	255

V	The Voyage of Zhou Wen	
	SATAN'S ISLAND	279
12	THE TREASURE FLEET RUNS AGROUND	305
13	SETTLEMENT IN NORTH AMERICA	321
14	EXPEDITION TO THE NORTH POLE	341
	The Voyage of Yang Qing SOLVING THE RIDDLE	361
VII	Portugal Inherits the Crown	
	Portugal Inherits the Crown WHERE THE EARTH END	381
16	e e	381 401
16 17	WHERE THE EARTH END	
16 17 18	WHERE THE EARTH END COLONIZING THE NEW WORLD ON THE SHOULDERS OF GIANTS	401 419
16 17 18	WHERE THE EARTH END COLONIZING THE NEW WORLD ON THE SHOULDERS OF GIANTS GUE: THE CHINESE LEGACY	401

APPENDICES

1 CHINESE CIRCUMNAVIGATION OF	
THE WORLD 1421-3: Synopsis of Evidence	493
2 THE DETERMINATION OF LONGITUDE	597
NOTES	609
INDEX	631

LIST OF MAPS AND DIAGRAMS

1	Voyages of the Treasure Fleets, 1421–3	24
2	East Asia, c. 1421	40
3	The voyage to Sofala	119
4	The circulatory winds and currents in the South Atlantic Ocean	126
5	i) The Kangnido map showing Africa	
	ii) The Kangnido map corrected for longitude	
	iii) Modern Africa	129
6	The journey to the Cape Verde Islands	132
7	The journey to Tierra del Fuego	147
8	The Piri Reis map compared to modern Patagonia, showing the	
	Straits of Magellan	149
9	The Falkland Islands on the Piri Reis, compared to a modern	
	map	154
10	The journey to Antarctica	177
11	Locating the Southern Cross	180
12	Hong Bao's journey to Australia	186
13	Zhou Man's journey to Australia	201
14	Evidence of the visit of the Chinese treasure fleet to Australia	205
15	Auckland and Campbell Islands, as shown on the Jean Rotz map	207
16	The journey around New Zealand	211
17	The routes of Hong Bao and Zhou Man around Australia	213
18	Hong Bao's journey home and Zhou Man's journey through the	
	Spice Islands	231
19	The San Francisco Bay area, showing the winds blowing into the	
	Sacramento River	243
20	Evidence of the visit of the Chinese treasure fleet to the Americas	274
21	Zhou Wen's journey through the Caribbean	283
22	Guadeloupe shown on the Pizzigano map,	
	compared with a modern map	291
23	Puerto Rico shown on the Pizzigano map,	
	compared with a modern map	296
24	The bays and inlets of Puerto Rico, depicted on the Pizzigano	
	map	298

25	The Cantino map showing the Caribbean and Florida,		
	compared with a modern map	302	2
26	Locations of unidentified wrecks on the route to Bimini	308	8
27	The junks' approach to Bimini and the Bimini Road	31.	3
28	Zhou Wen's journey up the east coast of Florida	324	4
29	The journey to Rhode Island	320	6
30	The locations of standing stones in Massachusetts	338	8
31	The voyage to the Azores and Cape Verde Islands	344	4
32	The journey around Greenland	340	6
33	Greenland shown on the Vinland map, compared to a		
	modern map	348	8
34	Chinese bases across the Pacific Ocean	45	1

Diagrams

	0	
1	Solar eclipse	371
2	Lunar eclipse	372
3	The progression of a lunar eclipse across the Earth's surface	373

LIST OF PLATES

Ming Emperor Ch'êng-tsu (Zhu Di), anonymous painting on silk, Ming period. National Palace Museum, Taipei.

The Gate of Heavenly Purity, the Forbidden City, Beijing, early 15th century. Werner Forman Archive; the Hall of Harvest Prayer, the Temple of Heaven, early 15th century. Getty Images/Image Bank; the Great Wall near Beijing. Getty Images/Telegraph Colour Library; general view of the Forbidden City from Coal Hill Park, Getty Images/Tony Stone.

Taoist ceramic shrine from Longquan, Zhejiang province, 1406. British Museum; quilin, the Spirit Way. Jane Taylor/Sonia Halliday Photographs; military dignitary, the Spirit Way, Ming tombs, near Beijing. Jane Taylor/ Sonia Halliday Photographs; civil dignitary, the Spirit Way. Christine Pemberton/Hutchison Picture Library; kneeling elephant, the Spirit Way. Jane Taylor/Sonia Halliday Photographs.

Blue and white porcelain dish with melon decoration, Ming, Yongle (Zhu Di) period (1403–24), Jingdezhen, Jiangxi province. British Museum; blue and white porcelain flask with lychee decoration, Ming, Yongle (Zhu Di) period (1403–24), Jingdezhen, Jiangxi province. British Museum; jade recumbent dog, 14th or 15th century. Royal Ontario Museum, Toronto; mallet-shaped lacquer vase, probably early 15th century. *Christie's Images*; woven silk textile with climbing boys motif, 13th to 15th century. *The Textile Gallery, London*.

The Tribute Giraffe with Attendant by Shen Tu (1357–1434), ink and watercolour on silk. Philadelphia Museum of Art. Given by John T. Dorrance.

Fra Mauro's map, 1459, Biblioteca Nazionale Marciana, Venice. Foto Toso.

Kangnido map by Ch'uan Chin and Li Hui. 1402. Ryukoku University Library; the Cape of Good Hope on a stormy day. © Nik Wheeler/Corbis.

Galle stele. Dominic Sansoni; straits of Malacca, Malaysia. Chris Caldicott; Chinese fishing nets at Cochin, Kerala, India. Ancient Art & Architecture Collection; coast of Zanzibar. Chris Caldicott; the fort at Kilwa, Tanzania. Werner Forman Archive; pillar tomb at Kunduchi, Tanzania. Werner Forman Archive.

The Piri Reis map, 1513. Topkapi Museum, Istanbul.

View of the South Orkney Islands, Antarctica. John Noble/Wilderness Photographic Library; a tabular iceberg, South Ocean, Antarctica. John Noble/Wilderness Photographic Library.

Fourteenth-century blue and white porcelain bowl with a phoenix and a quilin cavorting between lotus scrolls, recovered from the Pandanan wreck, Palawan, Philippines. Courtesy of the National Museum of the Philippines.

The Jean Rotz map, 1542. British Library, Department of Maps.

Lacquer chest by Dámaso Ayala Jiménez, 1997, from the collection of Fomento Cultural Banamex, A.C.; *Rosa laevigata*. © *Dr Koonlin Tan*; bronze cannon; Chinese bronze mirror; coin of Zhu Di (1403–24); two Central American grinding stones. All recovered from the Pandanan wreck, Palawan, Philippines. Courtesy of the National Museum of the Philippines.

The Waldseemüller map, 1507. Library of Congress, Washington, D.C.

The Pizzigano chart, 1424. James Ford Bell Library, University of Minnesota, Minneapolis.

Guadeloupe: La Souffrière, Basse Terre, and Les Saintes from the sea. Both courtesy Gérard Lafleur.

The Vinland map. Beinecke Rare Book and Manuscript Library, New Haven; diver above the Bimini Road. *Lynne Sladky/Associated Press*; underwater view of the Bimini Road. *Wade Pemberton*; pyramid, Guímar, Tenerife, Canary Islands. *Courtesy Casa Chacona Museum*.

Cantino world chart, 1502. Biblioteca Estense, Modena.

Sixteenth-century engraved view of Calicut. Ancient Art & Architecture Collection; detail of a 14th-century Catalan atlas, Bibliothèque Nationale, Paris; Christopher Columbus by Ridolfo Ghirlandaio (1483–1561), Museo Navale di Pegli, Genoa. Photo Scala; Vasco da Gama, from a Portuguese manuscript, c. 1558, the Pierpont Morgan Library, New York. Photo Pierpont Morgan Library/Art Resource/Scala; contemporary anonymous portrait of Ferdinand Magellan. Photo Scala; Captain James Cook, Sir Joseph Banks, Lord Sandwich and two others by John Hamilton Mortimer, c. 1771, National Library of Australia, Canberra. © Bridgeman Art Library; A View of the Endeavour's' Watering Place in the Bay of Good Success, 1769, British Library. © Bridgeman Art Library.

Henry the Navigator, from *The Monument to the Discoveries*, Belèm, Lisbon. © *Dave G. Houser/Corbis*

The line illustrations appearing on the opening pages of the chapters are taken from *The Illustrated Record of Strange Countries (I Yü Thu Chih)*, c. 1420, and are reproduced by courtesy of the Cambridge University Library.

Sources of other line illustrations are as follows: 152: Bridgeman Art Library; 204: from Science and Civilisation in China, Joseph Needham, 1971, Cambridge University Press; 287: from Nova typis transacta navigatio by Honorius Philoponus, 1621; 329: The Newport Historical Society (P2278); 367: Mark Horton/Debbie Fulford, from Shanga, the archaeology of a Muslim trading community on the coast of East Africa by Mark Horton, 1996, British Institute in East Africa; 404: Heritage-Images/© the British Library; 436: the British Library, Department of Manuscripts.

The illustration on page 51, the maps on pages 24 and 25 were drawn by Neil Gower; the remaining maps were compiled by Jerry Fowler and Julia Lloyd.

CHINESE NOMENCLATURE

MOST NAMES ARE RENDERED IN PINYIN, WHICH IS NOW standard in China – for example, Mao Zedong is the modern spelling, not Mao Tse-tung. For simplicity, however, I have retained the older form of romanization known as Wade-Giles for names that have long been familiar to Western readers. The Wu Pei Chi, for instance, is more readily recognized than the Wu Bei Zhi. I have also kept the more established spellings of Cantonese place names, writing of Hong Kong and Canton rather than Xianggang and Guangdong. Inscriptions on navigational charts have been left in the older form, as have academic texts in the bibliography.

ACKNOWLEDGEMENTS

A BRIEF OUTLINE OF SOME OF THE MORE IMPORTANT MAPS, documents and other pieces of evidence I have used to form the conclusions presented in this book has been included in the Appendices, and the primary and secondary sources I have used are cited in the Bibliography. However, this is a book for the general reader, not the academic; three-quarters of the evidence has had to be omitted for lack of space. For that reason much of the detail of my proofs and calculations and a large amount of other supporting material have been placed on the internet at www.1421.tv. In addition, I am happy to answer any specific queries and to make my research notes available to any bona fide researcher. Contact should be made in writing, via my publisher in the first instance.

Although my name appears on the cover, this book is a collective endeavour and would not have been possible without the dedicated efforts of many more people than I can possibly name in the limited space available. My sincere thanks to all those who have helped me with advice, guidance and support, and to those who have been inadvertently omitted my sincere apologies – corrections will follow in the next edition.

I am indebted first to those in the Royal Navy who educated me in seamanship, cartography and astro-navigation. The discoveries on which the book is based could never have come about without that knowledge. I visited over nine hundred museums in the course of my researches, but must single out the wonderful collections of the British Museum, the Shaanxi Historical Museum in Xian, China, and Lima's Museum of History. I am also grateful to the Biblioteca Marciana and the Museo Correr in Venice; Barcelona's Museu Marítim; the Fornsals Museum, Visby, on the island of Gottland; the National Maritime Museum, Greenwich; the Smithsonian Institution; the James Cook Museum in northern Australia; the Waikato Museum of Art and History, Auckland, New Zealand; the Tillamook County Pioneer Museum, Oregon; the Natural History Museum of North California; the Zihuantanejo Museum, Michoacán, Mexico; the National Museum of Australia; and the Warrnambool Art Gallery.

In England, my sincere thanks go to the British Library, particularly the staff of the Map Library and Humanities I, with its matchless collection and superb service. The School of Oriental and African Studies, the School of Slavonic Studies, and the School of Islamic Studies of the University of London; the Royal Asiatic Society; the Public Record Office; the Hakluyt Society; the Science Museum and the Natural History Museum; the Bodleian Library, Oxford; the Cambridge University Library and the Eastern Art Library, Oxford, have also been very helpful.

All the distinguished experts I asked to read and comment on my draft have generously given of their time. I am grateful for their help but must stress that responsibility for the opinions expressed in this book and for any errors and omissions rests with me alone. First and foremost, my thanks go to Professor Carol Urness, curator of the James Ford Bell Library at the University of Minnesota, Minneapolis; and also to Dr Joseph McDermott, Faculty of Oriental Studies, University of Cambridge; Professor John E. Wills Jr, Professor of History at the University of Southern California; Professor G. R. Hawting, Professor of Medieval and Islamic History at the School of Oriental and African Studies, London; Dr Konrad Hirschler; John Julius Norwich; Dr Taylor Terlecki of the Faculty of Medieval and Modern Languages and Literature, University of Oxford; Dr Ilenya Schiavon of the Venice State Archive; Dr Marjorie Grice-Hutchinson; Professor Sir John Elliott, Regius Professor of Modern History, University of Oxford; and Admiral Sir John Woodward GBE KCB.

Among other individuals, I must mention Dr Linda Clark at the History of Parliament Offices; Professor Mike Baillie

ACKNOWLEDGEMENTS

of the Palaeoecology Centre of the School of Archaeology and Palaeoecology, Queen's University, Belfast; Dr Robert Massey of the Royal Observatory, Greenwich; Ms Helen Stafford and Professor Philip Woodworth of the Proudman Oceanographic Laboratory, Birkenhead; Bob Headland of the Scott Polar Research Institute, Cambridge; Shane Winser of the Royal Geographical Society (with the Institute of British Geographers); Brian Thynne of the Caird Library of the National Maritime Museum, Greenwich; Dr Piero Falchetta, librarian of the Biblioteca Marciana, Venice; Chris Stringer of London's Natural History Museum; Professor Bryan Sykes, Professor of Human Genetics at the University of Oxford; Vice-Admiral Sir Ian McIntosh KBE CB DSO DSC; Dr Fernanda Allen; and Ron Hughes.

My thanks also go to Dr Johan de Zoete, curator of the Museum Enschede, Haarlem; Dr Muhammad Waley, curator of the Persian and Turkish Collection at the British Museum; Stuart Stirling; Professor Timothy Laughton, Department of Art History, University of Essex; Professor Sue Povey, a human geneticist at the Department of Biology, University College, London; the late Dr Josie Hicks; Professor Christie G. Turner II, Regent's Professor of Anthropology, Arizona State University; Professor John Oliver, Department of Astronomy, University of Florida; Marshall Payn; Alan Stimson, formerly Keeper of Navigation, Royal Observatory, Greenwich; and Dr K. Tan.

Professor João Camilo dos Santos of the Portuguese Embassy, London; the curator of the Torre do Tombo in Lisbon; Daphne Horne, curator of the Gympie Historical Society Museum, Queensland; Brett Green; Vanessa Collingridge; Michael Fitzgerald, curator of the Tepapa Museum, Tongarewa; Catherine Mercer, librarian at the Waikato Museum; Robin J. Watt; and Professor Roderich Ptak of Munich University have all been very helpful to me too, and my thanks must also go to Steven Hallett of Xanadu Productions; Professor Yingsheng Liu, Nanjing; Dr Eusebio Dizon, Director of Underwater Research, Museum of Manila, Philippines; Madam Wenlan Peng, formerly Head of

ACKNOWLEDGEMENTS

English Language Broadcasting for Central China Television; Captain Richard Channon; Commander Mike Tuohy; Christine Handte, the captain of the sailing junk *RV Heraclitus*; the curator of the Macao Maritime Museum; Dr Wang Tao of the School of Oriental and African Studies; Miss Viviana Wong; Professor Kenneth Hsu; Dr John Furry; David Stewart and the Reed and St Louis families; Robert Metcalf; Commodore Bill Swinley, former Chief of the Bahamas Armed Forces; Monsieur Gérard Lafleur; David Borden; Kirsten and Professor Paul Seaver; Professor George Maul, Florida Institute of Technology; Professor Maude Phipps; and Dr K.K. Tan.

I am indebted to the following Chinese experts. For reconstructing junks of Zheng He's fleet, Rear Admiral and Professor Zheng Ming, Professor Yuan-Ou (president of the Chinese Marine History Researchers Association) and Associate Professor Kong Ling-Ren: for ancient Chinese maps, Professor Zhu Jianqu; for Ming foreign policy as it related to Zheng He's expeditions, Professors Shi Ping, Chen Xiansi, Zhu Yafei, Chao Zhong Chang, Chen Qimao and Vice-Admiral Liu Ta Tsai; for Sino-African relations, Professor Zheng Yi-Jun; for Sino-Sri Lankan relations, Dr Tao Jingyi; for Sino-Malaccan relations, Professor Liao Dake; for Sino-Thai relations, Professor Li Dao Gang; for Sino-Indian relations, Professors Zhu Wei and Cheng Bei Bei; for Nanjing's garrison, Professor Xu Yuhu; for provisioning Zheng He's fleet and the role of Taicang, Shouping Huang (director of the Zheng He Memorial Hall of Liu He), Huiming Cheng (secretary of the Taicang Municipal Committee of the Communist Party) and Yao Ming Sun (vice-secretary); for Zheng He's treatment of foreign envoys, Professors Yang Zhao, Yang Suming, Yang Hong Wei and Zhou Zhiya; for the aims of Zheng He's voyages, Professors Chen Xiansi, Du Xiujuan and Yan Xiamei; for Chinese colonies in south-east Asia, Professors Su Haitao, Zhaojijun Duxiujuan, Luo Mi, Zhengyong Tao and Liu Kun; for the Chinese 'Discovery of America', Professors Zhu Jianqiu, Luo Zong Zhen and Liu Manchum; for medical support for Zheng He's fleet, Professor

Gong Jinhan; and for astronavigation, Professor Zhang Guo Ying.

After the American edition was published in January 2003, the following (in no particular order) very kindly provided new evidence: Adela Lee, Professor Fayuan Gao, Admiral Zheng Ming, Lt Lee Juntao, Katherine Zhou, Al Cornett, Albert Yuen, Fran Chunge, Ma Yinghui, Alice Mong, Alphonse Vinh, Elizabeth Flower Miller, Bob Hassell, Brett Green, Bruce Tickell Taylor, Dr Edgardo Caceres, Joel Fressa, Anthony Moya, A. Armstrong, Duncan Craig, Bruno and Chiara Condi, Dr Catherine Skinner, David and Cedric Bell, J. D. Van Horn, Edwin Davey, E. O. Jeago, Charlie and Dottie Marshner, Charlotte Rees, Chung Chee Kit, Greg Jefferies, Bill Ward, Vaughan Cullen, David Crockett, David Borden, Ger Nijman, David Sims, Larry D. Clark, Commodore Bill Swinley, Charles Huegy, Guy Dru Drury, Hector Williams, B. Morelan, Ken Holmes, Howard Smith, Jerry Warsing, Jim Mullins, Shaun Griffin, Paul Yia, Romeo Hristov, Joan Butcher, John Braine Hartnell, Barbara and John McEwan, R. V. Remsen, A. D. Palmer, Steve Haynes, Steve Elkins, John Robinson, Dr John Marr, Kerson Huang, Jake Smothers, Thad Daly, Margo Donovan, Key Sun, Linden Chubin, Mark Zhang, Ms Fan, Mike Armstrong, Jean Elder, Martin Tai, Mary Doerflein, Tony Brooks, R. Wertz, Meg Stocker, Dean Dey, Miranda Mraekts, Scott McClean, Gary Jennings, Michael Osinski, Ambassador Nicolas Platt, Paolo Costa, Peter Robinson, Howard Smith, Sandy Lydon, Durdock Riley, R. Dick Reed, Rene Kollmyer, Professor Bryan Sykes, William Goggins, Richard F. Chauvet, Robert A. Hefner III, Katrina Van Tassel, Gerald Thompson, Robin J. Watt, Philip Mulholland, Greg Autry, Rodney Gordon, Bernard Chang, Holly Midgley, Professor Gary Tee, Roger L. Olesen, Sun Shuyun, Jonathan F. Ormes, Christopher Spedding, Professor Gabriel Novick and colleagues, T. Lang, Dr Gregory Chambers, Dr Winston Peters, Tan Ta Sen, Dr Wang Tao, Dr Shong, L.A.R. Clark, Brent Kennedy, Jack Pizzey, Judge William Hupy, Bruce Trinque, Marti Brodel, William McVicar, D. D. Jevans, Baxter Smith, B. S. Cullins, Professor Yao Jide, Professor Yingsheng Liu, Ken Welch,

W. Feickert, Dutch Meteorological Institute KNMR, Delft Technical University, C. G. Hunt, F. Hochstetter, E. Alan Aubin, Bill Ward, Norm Fuller, A. D. Fletcher, E. N. R. Fletcher, John Grubber, Jeff McCabe, Terry Glavin, Paul Wagner, G. Berteig, Dom Mollick, Ken Holmes, Susan Crockford, Steve Hayes, Jim Tanner, John Ting, F. Lizuka, Dr Theodore Bainbridge, Barbara Vibert, R. Wertz, R. Banzo, B. Remsen, Clay Ranger, Mrazert, Dr Annabel Arends, Zerallos Palmer, Craig Hill Handy, Dr Felipe Vilchis and colleagues, Valary Porter, Glenn R. Whitley, Xiao-Qing Li, Armando Rozari, Stevie Tan, Tan Ing Soon, Regina Faresin, H. C. Hartman, Willard S. Bacon, Richard Zimmerman, National Park Service (United States Department of the Interior), Edwin H. Spencer, Ralph McGeeham, Alan McGillivray III, Peter Sommer, Anthony Fletcher, Tom Bender, Patrick Donohue, Jo Ann Alkamraikhi, Greg Coelho, T. Michael Stanley, Capt. Roddy Innes, Mathias Hartmann, Robert Gariup, Frank Wells, Professor Liu Kan, Professor Quin, David Knight, Rodney Gordon, Professor Edward Bryant, Drs Greg and Laura Little, Michael Ferrero, Cheuk Kwan, Siew Hong Wong, Francis Pickett, An Ping, Ric Baez, Frank Fitch, William Vigil, Alan Moks, J. Peter Thurmond, Heindri Bailey, Lynda Nutter, David Borden, Rewi Kemp, Professor John Oliver, Enrique Garcia Barthe, Charles N. Rudkin, Lindsay Peet, John Weyrich, Tony Abramson, Brian Darcey, Ian McDonald, Aytac Tekin, Steven Lutz, Anthony Fletcher, Greg Jeffer, Annette Brown, Jessica Hanson-Hall, Lindsey Sayvin, Philip Hahl, Vanessa Collingridge, Merle O'Doherty, John and Erica Parker, Darril Fosty, T. Michael Stanley, Dom Kropfer, Robert Chase, Kurt Cox, Tom Felion, Lanton Roberts, Andy Asp, Susie Brumfitt, Andrew D. Basiago, P. J. Evans, Raphael Banzo, Bob Ward, Sydney Stout, Philip Bramble, Bob Shipp, Dom Raab, Orlando J. Martinez, Carlos Quirino, Celia Heil, Jack Andrews, Ciro Matuck, Joy Mertz, Ray Howgego, Adam Dunn, Don Hughes, David Sims, Jim Jackson, Alan Armstrong, Ronald Monroe, Ginni MacRobert, Jack Nixon, Lennart Siltberg, Roy Sandor, Shizhang Ling, Errol Kirk, Steve Mumme, Nico Boon,

Professor David Price, Robert N. Heath, Dr M. E. Phipps, Dr K. K. Tan, Tin Lam and colleagues at Netism Solutions, Dr Alan Leibowitz, B. S. McElney, Perry Debell and Dr John S. Marr.

I must also express my gratitude to Voyages Jules Verne, which provides wonderful tours with extremely knowledgeable guides; Anthony Simonds-Gooding; Wendi and Mike Watson and their team; Steven Williams and Sophie Ransom of Midas Public Relations; Jack Pizzey; Pearson Broadband and Paladin Invision and their teams. I'm also grateful to Dr Joseph McDermott, Elizabeth Hay, Dr Hubert Lal, Dr Taylor Terlecki, Dr Marjorie Grice-Hutchinson, Ian Hudson, Amy Crocker, my wife Marcella Menzies and our elder daughter, Vanessa Gilodi-Johnson, all of whom have provided translations from a variety of foreign languages.

Luigi Bonomi of Sheil Land Associates has been a wonderful literary agent, and at my publishers, Transworld, my heartfelt thanks go to Larry Finlay, Sally Gaminara, publishing director of Bantam Press, Simon Thorogood, Deborah Adams, Julia Lloyd, Alison Martin, Rebecca Winfield, Helen Edwards, Sheila Lee, Neil Hanson, Garry Prior, John Blake, Ed Christie and their teams. I'm also grateful to Gillian Bromley, Daniel Balado, Elizabeth Dobson, Joanne Hill and Sarah Ereira for their work on the text.

Finally, my appreciation to those who have stood by me and the book for fourteen long years. My special thanks to Frank Hopkins, an old friend and an Oxford history scholar, and to Laura Tatham – no writer could have had a more skilful, loyal and dedicated assistant. Last of all, Marcella, my wife, has provided enduring love and support and the finances to pay for my researches. I and this book owe everything to her.

> Gavin Menzies London May 2003

The countries beyond the horizon and at the ends of the earth have all become subjects and to the most western of the western or the most northern of the northern countries, however far away they may be.

- part of an inscription on a memorial stone erected by Admiral Zheng He at Ch'ang Lo on the banks of the Yangtze estuary in 1431

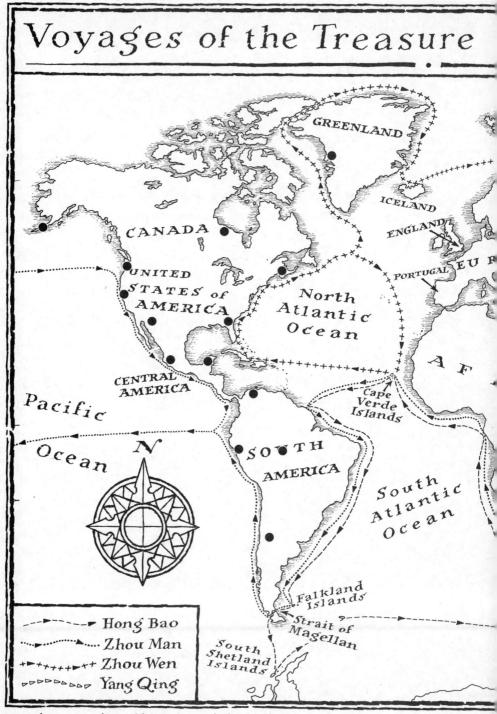

settlements where Chinese people live today

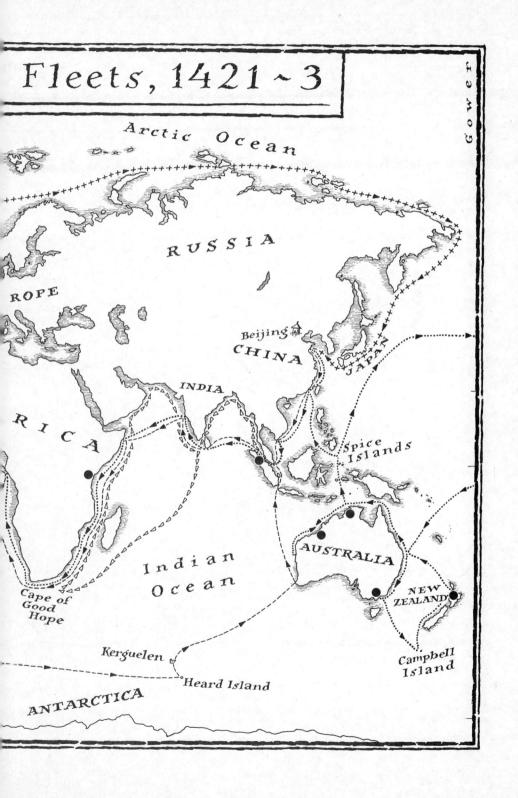

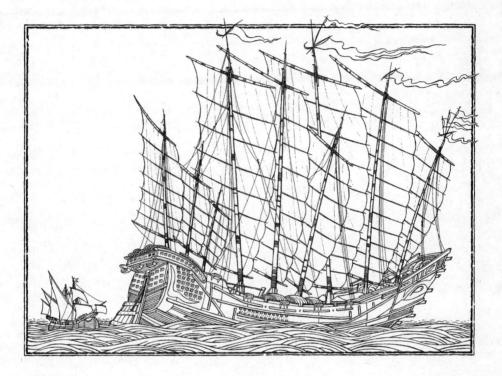

VER TEN YEARS AGO I STUMBLED UPON AN INCREDIBLE discovery, a clue hidden in an ancient map which, though it did not lead to buried treasure, suggested that the history of the world as it has been known and handed down for centuries would have to be radically revised.

I was pursuing an interest that had become a consuming passion for me: medieval history, and in particular the maps and charts of early explorers. I loved to examine these old charts, tracing contours, coastlines, the shifting shapes of shoals and sandbars, the menace of rocks and reefs. I followed the ebb and flow of tides, the pull of unseen currents and the track of prevailing winds, peeling back the layers of meaning contained within the charts.

The wintry plains of Minnesota started me on my research. It was not necessarily the first place you would think of to discover a document with such profound implications, but the James Ford Bell Library at the University of Minnesota has a remarkable collection of early maps and charts, and one in particular had attracted my attention. It had been in the collection of Sir Thomas Phillips, a wealthy British collector born in the late eighteenth century, but its existence had remained virtually unknown until the collection was rediscovered half a century ago.

The chart was dated 1424 and signed by a Venetian cartographer by the name of Zuane Pizzigano. It showed Europe and parts of Africa, and as I compared it with a modern map, I realized that the cartographer had drawn the coastlines of Europe accurately. It was an extraordinary cartographic achievement for that era, but not one of earth-shattering significance in itself. However, my eye was then drawn to the most curious feature of the map. The cartographer had also drawn a group of four islands far out in the western Atlantic. The names he gave them – Satanazes, Antilia, Saya and Ymana – did not correspond to any modern place-names and there are no large islands in the

area where he had positioned them. That could have been a simple error in calculating longitude, for Europeans did not master that difficult art until well into the eighteenth century, but my first, troubling thought was that the islands were imaginary and had existed only in the mind of the man who drew the chart.

I looked again. The two biggest islands were painted in bold colours, Antilia in dark blue, Satanazes in pillar-box red. The rest of the chart was uncoloured, and it seemed certain that Pizzigano wished to emphasize that these were important, recently discovered islands. All the names marked on the chart appeared to be in medieval Portuguese. Antilia – anti 'on the opposite side of' and *ilha* 'island' – meant an island on the opposite side of the Atlantic to Portugal; other than that, there was nothing in the name to help me identify it. Satanazes, 'Satan's or Devil's Island', was a very distinctive name. A greater number of towns were marked on the largest island, Antilia, indicating that it was better known. Satanazes had only five names, and featured the enigmatic words con and ymana.

My interest was now thoroughly aroused. What were these islands? Did they really exist? The date of the map, its provenance and authenticity were unimpeachable, yet if it was genuine, it marked lands in places where, according to the accepted history, no Europeans had ventured for another seven decades. After several months of examining charts and documents in map rooms and archives, I became convinced that Antilia and Satanazes were actually the Caribbean islands of Puerto Rico and Guadeloupe. There were far too many points of similarity between them for it to be a coincidence, but that meant that somebody had accurately surveyed the islands some seventy years before Columbus reached the Caribbean. This seemed an incredible revelation – Columbus had not discovered the New World, yet his voyage had always been regarded as an absolutely defining moment. It marked the point when, led by the

Portuguese, Europeans had begun to embark on the great voyages of discovery, the long, restless expansion over the face of the globe that was to characterize the next five hundred years.

I needed further evidence to support my discovery and I sought the help of an expert in medieval Portuguese, Professor João Camilo dos Santos, who was then at the Portuguese Embassy in London. He examined the Pizzigano chart and corrected my translation of con/ymana to 'volcano erupts there'. The words had been placed in the southern part of Satanazes, just where there are three volcanoes on Guadeloupe today. Did they erupt before 1424? In high excitement I rang the Smithsonian Institution in Washington DC. The volcanoes had erupted twice between 1400 and 1440 but had otherwise been dormant during the previous hundred years and the succeeding two and a half centuries. Moreover, there were no other volcanic eruptions in the Caribbean at that time. I felt I was home and dry; I believed I had found solid evidence that someone had reached the Caribbean and established a secret colony there sixty-eight years before Columbus.

Professor Camilo dos Santos gave me an introduction to the curator of the State Archives in the Torre do Tombo in Lisbon, and on a beautiful early autumn afternoon I began further research there, hoping for corroboration of my hunch about Portuguese landings in the Caribbean. To my astonishment, I came across something entirely different: far from the Portuguese having discovered those Caribbean islands, they were completely unknown to them at the time Pizzigano was drawing his chart. They were, however, shown on another, slightly later chart – drawn by some other, unknown cartographer – that had not come into Portuguese hands until 1428. In addition, I found a command issued by the Portuguese prince Henry the Navigator to his sea-captains in 1431, ordering them to go and find the islands of Antilia shown on the 1428 chart; had the Portuguese discovered them, Henry's edict would

31

scarcely have been necessary. But if the Portuguese had not discovered and surveyed Antilia and Satanazes, who on earth had? Who had provided Pizzigano and the other cartographers with their information?

I began more research, tracing the rise and fall of medieval civilizations that had long since crumbled into dust. In turn, I eliminated virtually every navy in the world that could feasibly have undertaken such an ambitious voyage in the early decades of the fifteenth century. Venice, the oldest and most powerful naval power in Europe, was in disarray. The old Doge was ill, his powers waning, and his successor was waiting in the wings, determined that Venice should abandon its maritime tradition and become a land power. Northern European powers barely had the ships to cross the English Channel, let alone explore new worlds. The Egyptian rulers were mired in civil wars – there were no fewer than five sultans in 1421 alone. The Islamic world was also disintegrating: the Portuguese had invaded its North African heartlands and the once-mighty Asian empire of the Mongol emperor Tamerlane was in pieces.

Who else could have explored the Caribbean? I decided to see if there were other charts like the 1424 map, showing continents that had been surveyed before the European voyages of discovery. The deeper I dug, the more bombshells I uncovered. I was astonished to find that Patagonia and the Andes had been mapped a century before the first European sighted them, and Antarctica had been accurately drawn some four centuries before Europeans reached the continent. The east coast of Africa was shown on another chart, with longitudes that were perfectly correct – something Europeans did not manage to achieve for another three centuries. Australia appeared on another map, three centuries before Cook, and other charts showed the Caribbean, Greenland, the Arctic and the Pacific and Atlantic coasts of both North and South America long before Europeans arrived.

To have drawn maps of the entire world with such accuracy, these explorers, whoever they were, must have circumnavigated the globe. They must have been skilled in astro-navigation and must have found a method of determining longitude to draw maps with negligible longitude errors. To cover the enormous distances involved, they must have been able to sail the oceans for months at a time and that would have meant desalinating seawater. As I was later to discover, they also prospected and mined for metals, and they were skilled horticulturalists, transplanting animals and plants right across the globe. In short, they had changed the face of the medieval world. I seemed to be looking at a series of the most incredible journeys in the history of mankind, but one that had been completely expunged from human memory, the majority of records destroyed, the achievements ignored and finally forgotten.

These revelations were both astounding and horrifying. If I was to pursue them I would be challenging some of the most basic assumptions about the history of the exploration of the world. Every schoolchild knows the names of the great European explorers and navigators whose exploits have resounded down the ages. Bartolomeu Dias (c. 1450-1500) left Portugal in 1487 and became the first man to round the Cape of Good Hope, the southern tip of Africa. He was driven to the south of the Cape by a storm and when he found no land he turned north, rounding the Cape and making landfall on the east coast of Africa. Vasco da Gama (c. 1469-1525) followed in Dias's wake ten years later. He sailed up the east coast of Africa and crossed the Indian Ocean to India, opening up the first sea route for the spice trade. On 12 October 1492, Christopher Columbus (1451–1506) sighted land in the modern Bahamas. He has gone down in history as the first European to glimpse the New World, though Columbus himself never appreciated this, believing that he had actually reached Asia. He made three further voyages, discovering many of the Caribbean islands and the mainland of

Central America. Ferdinand Magellan (c. 1480–1521) followed Columbus and is credited with the discovery of the strait between the Atlantic and the Pacific that bears his name to this day. His ship continued west to complete the first circumnavigation of the world, though Magellan did not survive to see the expedition's triumphant return to Spain, having been killed in the Philippines on 27 April 1521.

All these men owed a huge debt to the great figure of Henry the Navigator (1394–1460), the Portuguese prince whose base in south-west Portugal became an academy for explorers, cartographers, shipwrights and instrument makers. There, the design of European ships was revolutionized, navigational instruments and techniques developed and improved, and impetus given to the great voyages of exploration and colonization.

As I ended my researches in the Torre do Tombo, a mood of utter confusion engulfed me. I spent a misty evening sitting in a bar on Lisbon's waterfront, looking out at Henry the Navigator's statue. His enigmatic smile was one I now understood. We both shared a secret: he had followed others to the New World. The more I brooded, the more intrigued I became. Who were these master mariners who had discovered and charted these new lands and oceans without leaving any trace of having done so, other than these enigmatic maps?

The identity of the master hand was revealed in a curious way. The coasts of Patagonia, the Andes mountains, the Antarctic mainland and the South Shetland Islands had all been drawn with remarkable accuracy on one chart. The distances covered, from Ecuador in the north to the Antarctic peninsula in the south, were immense; a huge fleet must have been required. There was only one nation at that time with the material resources, the scientific knowledge, the ships and the seafaring experience to mount such an epic voyage of discovery. That

nation was China, but the thought of searching for incontestable proof that a Chinese fleet had explored the world long before the Europeans filled me with dread. An attempt to uncover the details of any event from nearly six centuries ago would have been daunting enough, but this one was made even more difficult by one massive, perhaps insurmountable, obstacle. In the mid-fifteenth century almost every Chinese map and document of the period was deliberately destroyed by officials of the Chinese court, following an abrupt reversal of its foreign policy. Far from embracing the outside world, after these momentous discoveries China turned in on itself. Anything commemorating its expansionist past was expunged from the record.

If I was to piece together the remarkable story of the Chinese voyages of discovery, I would have to look elsewhere for proof, but I feared almost to begin. It seemed arrogance bordering on hubris to believe that a retired submarine captain could reveal a story many great minds had failed to unearth, but though I was a mere amateur compared to the distinguished academics in the field, I started with one crucial advantage. In 1953, when I joined the Royal Navy at the age of fifteen, Britain was still a world power with great fleets and bases to support them strung right across the globe. During my seventeen years in the Navy I sailed the world in the wake of the great European explorers. Between 1968 and 1970, for example, I was in command of HMS *Rorqual* and took her from China to Australasia, the Pacific and the Americas.

The coasts, cliffs and mountains early explorers had viewed from their quarterdecks were those I saw through a submarine periscope, with roughly the same perspective. I quickly learned that what is seen from sea level is not necessarily what is actually there. In those days satellite navigation was unknown; we had to find our way by the stars. I saw the same stars those great European explorers had seen and calculated my position by measuring the height and direction of the sun, just as they had

35

attempted to do. The mariner's guiding stars in the southern hemisphere are Canopus and the Southern Cross. These stars played a vital role in the extraordinary story I was to uncover, and without the experience of astro-navigation I had gained in the Navy, this book would never have been written and the discoveries I made might have remained unrecognized for many more years.

A layman, no matter how distinguished in other fields, looks at a map or a chart and sees only a series of outlines that may or may not be the misshapen representations of familiar lands. An experienced navigator looking at the same map can deduce far more: where the cartographer who had first charted it had sailed, in what direction, how fast or slow, how near to or far from the land he had been, the state of his knowledge of latitude and longitude, even whether it was night or day. Given sufficient knowledge of the lands and oceans depicted on the chart, a navigator can also explain why what the chart shows as islands could be mountain peaks, why what was then an extensive body of land might now be shoals, reefs and islands, and hence why some lands might have been depicted with curiously distended forms.

I had seen the maps, dating from the fifteenth and early sixteenth centuries, that show parts of the world then unknown to European explorers. There are inaccuracies – some of the lands depicted are unrecognizable, or misshapen, or in locations where no land exists – and because the picture they offer of the world contradicts the accepted history of exploration they have long been dismissed as fables, forgeries or, at best, puzzling anomalies. But I found myself returning to those early maps and charts again and again, and as I studied them and evaluated them, a new picture of the medieval world began to emerge.

My research confirmed that several Chinese fleets had indeed made voyages of exploration in the early years of the fifteenth century. The last and greatest of them all – four fleets combining

INTRODUCTION

in one vast armada – set sail in early 1421. The last surviving ships returned to China in the summer and autumn of 1423. There was no extant record of where they had voyaged in the intervening years, but the maps showed that they had not merely rounded the Cape of Good Hope and traversed the Atlantic to chart the islands I had seen on the Pizzigano map of 1424, they had then gone on to explore Antarctica and the Arctic, North and South America, and had crossed the Pacific to Australia. They had solved the problems of calculating latitude and longitude and had mapped the earth and the heavens with equal accuracy.

I was educated by a Chinese amah for the first five years of my life - I remember to this day my sorrow at our parting - and I had made a number of visits to China over the years, but despite my interest in that great country, my knowledge of its history was by no means deep. Before I could follow the incredible course of these Chinese voyages of discovery, I would first have to immerse myself in the unfamiliar world of medieval China. That was a voyage of discovery in itself, and my ignorance of those remarkable people was shared, I suspect, by many in the West. The more I learned, the more I was awe-struck by the glory of that ancient, learned and incredibly sophisticated civilization. Their science and technology and their knowledge of the world around them were so far in advance of our own in that era that it was to be three, four and in some cases five centuries before European know-how matched that of the medieval Chinese.

Having learned something of that great civilization, I spent years travelling the globe on the track of the Chinese voyages of exploration. I researched in archives, museums and libraries, visited ancient monuments, castles, palaces and the major seaports of the late Middle Ages, explored rocky headlands, coral reefs, lonely beaches and remote islands. Everywhere I went I

INTRODUCTION

discovered more and more evidence to support the thesis. It turned out that a tiny handful of Chinese documents and sailing directions had escaped the wholesale destruction of records, and there were several first-person accounts: two by Chinese historians, another by a European merchant, and others by the first European explorers to follow in the Chinese wake, who discovered evidence and artefacts left by their predecessors.

There was also a wealth of physical evidence: Chinese porcelain, silk, votive offerings, artefacts, carved stones left by the Chinese admirals as monuments to their achievements, the wrecks of Chinese junks on the coasts of Africa, America, Australia and New Zealand, and the flora and fauna transplanted far from their places of origin and thriving when the first Europeans appeared. Everything I found was confirmation of the accuracy of the maps that had first captured my imagination. The remarkable information that those maps contain is, and always has been, there for all to see, but it has eluded many eminent historians of China, not for want of any diligence on their part but simply because of their lack of knowledge of astronavigation and the world's oceans. If I have found information that escaped them, it is only because I knew how to interpret the extraordinary maps and charts that reveal the course and the extent of the voyages of the great Chinese fleets between 1421 and 1423.

Columbus, da Gama, Magellan and Cook were later to make the same 'discoveries' but they all knew they were following in the footsteps of others, for they were carrying copies of the Chinese maps with them when they set off on their own journeys into the 'unknown'. To misuse a famous quotation: if they could see further than others, it was because they were standing on the shoulders of giants.

l Imperial China

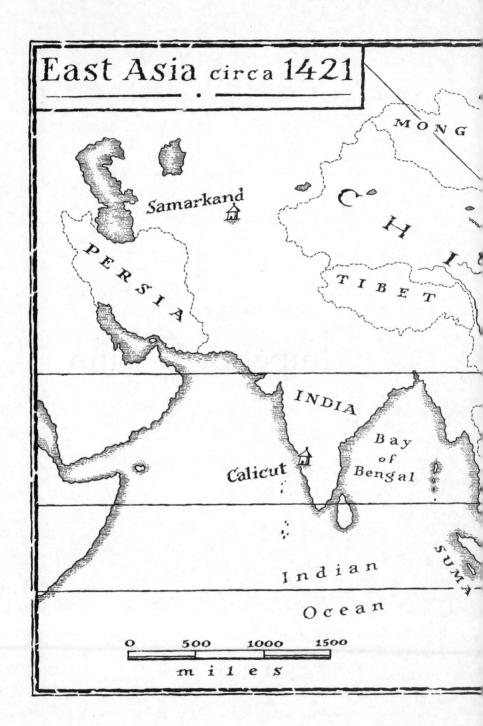

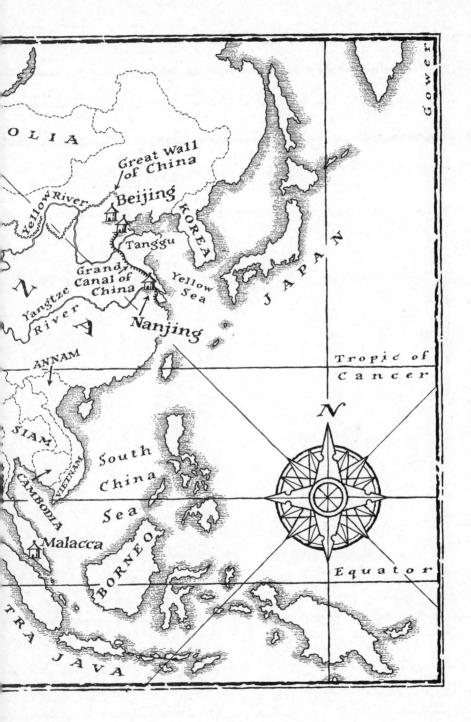

THE

1

EMPEROR'S

GRAND

PLAN

N 2 FEBRUARY 1421, CHINA DWARFED EVERY NATION ON earth. On that Chinese New Year's Day, kings and envoys from the length and breadth of Asia, Arabia, Africa and the Indian Ocean assembled amid the splendours of Beijing to pay homage to the Emperor Zhu Di, the Son of Heaven. A fleet of leviathan ships, navigating the oceans with pinpoint accuracy, had brought the rulers and their envoys to pay tribute to the emperor and bear witness to the inauguration of his majestic and mysterious walled capital, the Forbidden City. No fewer than twenty-eight heads of state were present, but the Holy Roman Emperor, the Emperor of Byzantium, the Doge of Venice and the kings of England, France, Castille and Portugal were not among them. They had not been invited, for such backward states, lacking trade goods or any worthwhile scientific knowledge, ranked low on the Chinese emperor's scale of priorities.

Zhu Di was the fourth son of Zhu Yuanzhang, who had risen to become the first Ming emperor despite his lowly birth as the son of a hired labourer from one of the poorest parts of China.¹ In 1352, eight years before Zhu Di's birth, a terrible flood had struck parts of China. The Yellow River had burst its banks, submerging vast areas of farmland, washing away villages and leaving famine and disease in its wake. The country was still in the throes of a terrible epidemic. The Mongols had ruled China since its conquest in 1279 by the great Kublai Khan, grandson of the greatest warlord of them all, Genghis Khan. But in 1352, plagued by famine and disease and desperately poor as a result of the depredations of their Mongol overlords, the peasants around Guangzhou on the Pearl River delta rose in revolt. Zhu Yuanzhang joined the rebels and rapidly emerged as their leader, rallying soldiers and farmers to his cause. During the next three years the revolt spread throughout China. Over decades of peace, the once ferocious Mongol warriors, the scourge of all Asia, had grown idle and complacent. Riven by internal dissension, they proved no match for the army raised by Zhu Di's father. In 1356, his forces captured Nanjing and cut off corn supplies to the Mongols' northern capital, Ta-tu (Beijing).

Zhu Di was eight years old when his father's army entered Ta-tu itself, in 1368. The last Mongol Emperor of China, Toghon Temur, fled the country, retreating north to the steppe, the Mongol heartland. Zhu Yuanzhang pronounced a new dynasty, the Ming, and proclaimed himself the first emperor, taking the dynastic title Hong Wu.² Zhu Di joined the Chinese cavalry and proved himself a brave and skilful officer. At the age of twentyone he was sent to join the campaign against the Mongol forces still occupying the mountainous south-western province of Yunnan, bordering modern Tibet and Laos, and in 1382 he was ordered to destroy Kunming, to the south of the Cloud Mountains, the remaining Mongol stronghold in the province. After the city was taken, the Chinese butchered the adult defenders and castrated those prisoners who had not reached puberty. Thousands of young Mongol boys had their penises and testicles severed. Many perished of shock and disease; the surviving eunuchs were conscripted into the imperial armies or kept as servants or retainers.

Eunuchs served as 'palace menials, harem watch dogs and spies'³ for rulers throughout the ancient world, in Rome, Greece, North Africa and much of Asia, and they had played an important role throughout Chinese history.⁴ Surprisingly, they were intensely loyal to the emperors who had authorized their mutilation. There had been eunuchs at the imperial court since at least the eighth century BC and as many as seventy thousand were employed in and around the capital. Only sexless males were permitted to act as personal servants to the emperor and to guard the women of his family and the quarters occupied by his concubines in the 'Great Within', inside the palace doors. Emperors retained thousands of concubines both as a symbol of their power and to ensure a number of male heirs at a time of high infant mortality; guaranteeing the continuity of the dynasty and the worship of ancestors was a vital part of Chinese cultural rites. Non-eunuchs, even relatives of the emperor and his consorts, were barred from the vicinity of the women's quarters on pain of death. The absence of potent males ensured that any children born to the concubines had been sired by the emperor alone.

Eunuchs also helped to preserve the aura of sanctity and secrecy that surrounded the imperial throne. While the gods granted a 'Mandate of Heaven' to legitimize the emperor's rule, they could rescind it if he proved guilty of human failings, misgovernment or misconduct. It was forbidden to look upon the emperor: even senior officials kept their eyes downcast in the imperial presence, and when he passed through the streets, screens were erected to shield him from public gaze. Only the 'effeminate, cringing eunuchs', slavishly dependent upon the emperor for their very lives, were considered cowed enough to be silent witnesses to his private foibles and weaknesses.⁵

Ma He, one of the boys castrated at Kunming, was billeted in the household of Zhu Di, where his name was changed to Zheng He. Many of the Mongols whom Zhu Di and his father expelled had adopted the Muslim faith. Zheng He was a devout Muslim besides being a formidable soldier, and he became Zhu Di's closest adviser. He was a powerful figure, towering above Zhu Di; some accounts say he was over two metres tall and weighed over a hundred kilograms, with 'a stride like a tiger's'.⁶ When Zhu Di was elevated to Prince of Yen – a region centred on Beijing – and given the new and more important responsibility of guarding China's northern provinces, Zheng He went with him. Zhu Di based himself in the former Mongol capital, Ta-tu, and renamed it Beijing. By 1387, after over thirty years of fighting, the last vestiges of Mongol rule had been purged from China. Zhu Di's father, the ageing and increasingly paranoid Emperor Hong

IMPERIAL CHINA

Wu, systematically purged his military command, eliminating anyone who might offer even the most remote challenge to his authority. Many senior commanders committed suicide rather than bring dishonour and disgrace to their families and their ancestors by being dismissed or executed, but nonetheless, tens of thousands of civil and military officers were put to the sword.

After the death of his first-born son, Hong Wu had chosen his grandson, Zhu Yunwen – Zhu Di's nephew – to succeed him. He distrusted Zhu Di, wrongly believing he was a Mongol. Hong Wu had married a princess but had not been told she was already pregnant (with Zhu Di). When the old emperor died six years later in 1398, Zhu Yunwen duly continued his policy of eliminating potential rivals. In the summer of the following year, assassins were sent north to kill Zhu Di. To escape execution, he abandoned his fine house and for several months became a vagrant on the streets of Beijing, sleeping in gutters at night and wandering the streets by day. He feigned madness, growing filthy and unkempt, unrecognizable as a prince of the imperial line, and the execution squad passed by this apparently harmless vagrant. Then Zhu Di turned on his pursuers. Aided by his loyal eunuch bodyguard, headed by Zheng He, Zhu Di gathered his forces in secret to strike against his would-be killers. He assembled eight hundred men in a park in Beijing, having previously filled it with honking geese to muffle the clanking of their armour and weapons. Taken by surprise, the assassins were themselves butchered. The victorious Zhu Di at once began to raise and train an army.

When he received the news of his men's failure, Zhu Yunwen immediately despatched an army of half a million men to crush Zhu Di, but the seasons were turning, and his troops were sent north from Nanjing wearing only their summer uniforms and straw sandals. Many men froze as the pitiless winter advanced. Zhu Di's army was on manoeuvres outside Beijing when the demoralized troops of Zhu Yunwen began their advance on the city. They were routed in a battle in which even the women of Beijing took part, hurling pots down on their attackers from the city walls.

In 1402, Zhu Di marched south to Nanjing at the head of a great army. The imperial capital was a divided city. The mandarins, the educated elite in Nanjing, loathed the court eunuchs. Their antipathy was deep-seated and almost as old as imperial China itself. As his personal attendants, the eunuchs had the emperor's ear; like the courtiers of European rulers, they grew wealthy through their imperial connections. But while the eunuchs held sway in the 'Great Within', mandarins alone were entitled to hold office in the 'Great Without' beyond the palace walls.

Men became mandarins and holders of exalted official positions only after years of intensive study and examinations based exclusively upon the teaching of Confucius (551–479 BC),

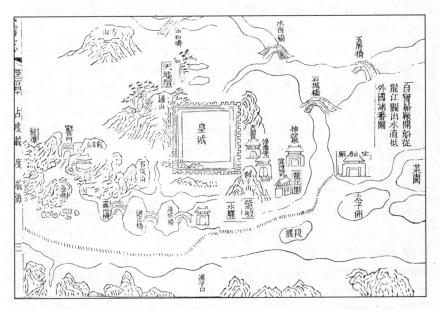

A plan of imperial Nanjing from the *Wu Pei Chi (Wu Bei Zhi)*. This seventeenth-century treatise on armaments drew on illustrations from earlier manuals; the shipyards are on the right across the bridge.

the 'Great Sage' who had expressed his own disapproval of eunuchs holding positions of power. Eunuchs received no Confucian education and relied solely upon the emperor for advancement. Mandarins were steeped in Confucian ethics and a code of moral values intended to maintain order and hierarchy in society by eliminating the opportunity for people to disturb the tao (interaction of natural forces). It determined everyone's life, their rank, their rites and the position allocated to them in the social hierarchy. The Confucian definition of good government required that 'a prince be a prince ... the subject a subject, the father a father, the son a son'.7 Orderly, well-mannered continuity was at the heart of Confucianism and of mandarin government, and the mandarins saw rural farmers, not foreigners or merchants, as the backbone of society. The farmers represented stability, whereas merchants and foreigners continually upset the tao.

The mandarins surrounding Zhu Yunwen had succeeded in marginalizing the court eunuchs, stripping them of much of the power and influence they had previously possessed, and when Zhu Di's army appeared before the walls of Nanjing, the eunuchs threw open the city gates to them. Zhu Di seized the Dragon Throne⁸ and pronounced himself emperor, taking the dynastic title Yong Le. Zhu Yunwen was never found. It was believed he had escaped, dressed as a monk. Zheng He remained at the new emperor's side, one of a group of eunuchs who formed an inner circle within Zhu Di's staff. They had personal knowledge of and gained influence in affairs of state, saw the emperor frequently and became familiar with his moods and wishes. As they were permitted to enter the concubines' quarters, they also became conversant with the intrigues among the two thousand women sequestered there.

The eunuchs were once more a political force. In recognition of his service to the emperor, the most powerful figure of all was the Grand Eunuch, Zheng He. He had earned the nickname San

THE EMPEROR'S GRAND PLAN

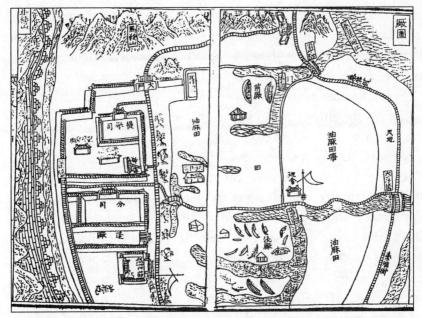

A plan of the Longjiang shipyards from the *Lung Chiang Chiang Chih*, a history of the yards at the time of Zheng He, published in 1553. The administrative offices are on the left, the slipways and docks on the right.

Bao, 'Three Treasures', which referred to the three raisons d'être of a Buddhist: Buddha, doctrine and meditation. Zheng He had placed his severed penis in a temple. The casket containing his pao – 'manhood treasures' – would accompany him to the next world, where once again he could become a whole man. But in this earthly life, he was sworn to serve and do the bidding of his patron and ruler, the third Ming emperor, Zhu Di.

Within twelve months, despite never having been to sea, Zheng He had been appointed Commander-in-Chief of one of the largest fleets ever built. One of Zhu Di's first orders had been to double the size of the Longjiang shipyards, near Nanjing. Already the principal shipyards in China, they were now vastly expanded, covering several square miles on the banks of the Yangtze beyond the eastern gate of Nanjing. Seven vast drydocks were built, connected by a series of locks to the river, and each one could be subdivided to permit three ships to be built simultaneously. They remain there to this day.⁹Zhu Di's aim was to create what even Kublai Khan had failed to achieve: a maritime empire spanning the oceans.

Prior to the ninth century, ships voyaging beyond coastal waters were almost always foreign-owned, but from the ninth century onwards China developed its own ocean-going fleet. The Song and Yuan (Mongol) dynasties had maintained large fleets, sent emissaries overseas and built a substantial foreign trade, gradually wresting control of the spice trade from the Arabs who had once dominated it. Zhu Di now embarked on an incredible expansion of the Chinese fleet. In addition to the warships and the merchant fleet he had inherited, Zhu Di commissioned 1,681 new ships, among them many gigantic nine-masted 'treasure ships', named after the huge value and quantity of goods they could carry in their vast holds. Tens of thousands of carpenters, sailmakers and shipwrights from the southern provinces around the shipyards were put to work to build them. In addition to 250 treasure ships, the fleet contained more than 3,500 other vessels. There were 1,350 patrol ships and the same number of combat vessels based at guard stations or island bases, 400 larger warships and another 400 freighters for transporting grain, water and horses for the fleet. The emperor's ships were to sail the oceans of the world and chart them, impressing and intimidating foreign rulers, bringing the entire world into China's 'tribute system'. Rulers paid tribute to China in return for trading privileges and protection against their enemies, but China always gave its trading partners a greater value of goods - silks and porcelain at discounted prices, often funded by soft loans - than was received from them. They were thus in perpetual debt to China. These ships were also tasked with hunting down the fugitive Zhu Yunwen: 'There are some who say he is abroad. The emperor ordered Zheng He to seek out traces of him.'10 All should know who was the rightful

occupant of the Dragon Throne: the Emperor on Horseback, Son of Heaven – Zhu Di.

As soon as he had claimed the imperial throne, Zhu Di decided to relocate the capital to his former stronghold of Beijing. The ageing Tamerlane, the last of the great nomadic leaders, had decided to seize his last and greatest prize of all, China, and Zhu Di resolved to meet the threat head on. Tamerlane (the anglicized form of the Persian Timur-i-Lang, or 'Timur the Lame', a nickname he received as a result of arrow wounds sustained in battle) had proved a worthy successor to his forebears Genghis Khan and Kublai Khan. 'He loved bold and valiant soldiers, by whose aid he opened the locks of terror, tore men to pieces like lions and overturned mountains.'11 From his capital Samarkand, straddling the Silk Road, the great trading route through central Asia, Tamerlane had waged relentless campaigns across Asia, conquering northern India, Persia and Syria, and defeating the Ottomans at Ankara in 1402. Now his gaze had turned eastwards, his aim to destroy the Chinese armies, overthrow Zhu Di and restore China to Mongol rule.

To counter this potent threat, the new emperor took with him to Beijing his court, guarded by a million-strong army, but his vision for the new imperial capital encompassed far more than its being a defensive stronghold to thwart Tamerlane. Kublai Khan had built Ta-tu to a traditional Chinese design and diverted rivers to encircle the city. Zhu Di incorporated the basic elements of Kublai Khan's capital, but he demolished the royal enclosure and replaced it with a classic imperial complex, the Forbidden City, with far more perfect proportions than its former design. The walled capital surrounding it was to be built on an awesome scale: fifteen hundred times the area of walled London at that time and housing fifty times the population.

Yet building the world's greatest city to dazzle his people and intimidate his enemies and all the rulers of the world was only one part of Zhu Di's master plan. He would also repair the Great Wall, built by the first Chinese emperor, Qin Shi Huangdi, during the Qin dynasty (221–206 BC). Qin Shi Huangdi had united the warring provinces of China and was the first man to rule the entire country. The wall was erected at ruinous expense to protect China's northern frontiers from attack, but over the following 1,600 years it had been allowed to crumble into disrepair. Zhu Di began a programme of rebuilding and strengthening, adding watchtowers and turrets along the wall's existing 5,000 kilometres and extending it by a further 1,400. It ran from the Pacific as far west as the Heavenly Mountains in central Asia.

Still Zhu Di's aims were higher. He despatched expeditions to China's eastern neighbours and along the Silk Road across central Asia to recreate the trading empire China had possessed in the golden age of the Tang dynasty over five centuries earlier. All this in addition to his fleet-expansion programme.

Zhu Di intended to achieve all these stupendous goals within two decades. Running through all his policies was his determination that the Chinese should once again believe in themselves and their illustrious history. The Mongols had been expelled, China was Chinese again. Zhu Di was always concerned by the fact that he was not his father's designated heir, and he constantly sought to demonstrate that the gods had bestowed legitimacy on his ascent to the Dragon Throne. Hence the first buildings he commissioned were those of the great ceremonial complex, the Temple of Heaven, at the centre of the new city. It was to be not only the stage for the annual ceremonies the emperor, the Son of Heaven, was required to perform, but the very heart of the new Chinese empire. A new observatory, in turn, would be at the epicentre of Beijing. Zhu Di took a personal interest in astronomy, and in the means by which he could build on the wonderful legacy he had inherited in this field. Chinese astronomers had well over two thousand years' experience of recording events in the night sky. They had noted the

appearance of a new star in 1300 BC, had charted every arrival of Halley's comet since 240 BC, and by 1054 were describing the remnants of the supernova explosion known as the Crab Nebula, with its rapidly spinning neutron star, or pulsar, at its centre.

During eighty-nine years of rule over China, the Mongol emperors had neglected this priceless inheritance; in the first year of his reign, Zhu Di restored the nightly practice of recording the stars. His astronomers charted no fewer than 1,400 of them as they traversed the sky, and they were able to predict both solar and lunar eclipses with considerable accuracy. Zhu Di also set up a committee of distinguished astronomers to 'compare and correct the drawings of the guiding stars'12 and eventually persuaded the Shogun of Japan, the King of Korea, and Prince Ulugh Begh, grandson of Tamerlane, to do the same. The emperor's interest in astronomy was practical, not theoretical. He was determined that his astronomers should perfect new methods of using these guiding stars, enabling his admirals to navigate accurately at sea and correctly locate the new territories they would find on their journeys of discovery. His aim was to ensure that Beijing's great observatory was the reference point from which the entire world would be explored and charted, and all new discoveries located - in short, the centre of the known universe.

The relocation of the capital from Nanjing to Beijing was by far the most complex and far-reaching project undertaken during the Ming dynasty. The move started in 1404, when ten thousand households were forcibly moved north to increase Beijing's population. A vast army of workers was also required to accomplish Zhu Di's vision and hundreds of thousands of Chinese labourers were force-marched to the north; some 335 army divisions were re-deployed to guard them, even though the threat from Tamerlane's Mongol hordes had quickly evaporated. The great warlord had left Samarkand at the head of a vast army in January 1405, his aim to march eastwards through the

55

mountains, set up encampments near the Chinese border, and await the first sign of the approach of spring before striking deep into China, catching the emperor's forces unprepared. Sick and old, Tamerlane was too weak to march and was carried in a litter – a couch carried by bearers – but even so, the privations of the journey over such bleak terrain in the depths of winter were too much for him. He died on 18 February without even sighting the Chinese frontier. His army broke up into rival factions and dispersed.

Zhu Di's plans for Beijing remained unaltered by the news of Tamerlane's death, but feeding the first construction workers soon began to prove difficult. The growing season in the north was short; millet could be grown, but not rice, and wheat and barley produced poor yields. There was nowhere near enough grain to feed the tidal waves of workers continuing to arrive. Zhu Di delegated his third son, Zhu Gaozhi, to assume military command of Beijing, and tax rebates were granted to anyone who could grow grain around the city. When this measure failed to produce enough to feed the growing armies of workmen, the emperor decided that the Grand Canal must be repaired and enlarged to carry shipments of grain northwards.

Begun in 486 BC under the Wu dynasty, the canal was one of the wonders of the ancient world. From AD 584 onwards it was extended and the individual sections linked together to form a system stretching for 1,800 kilometres – to this day the longest man-made waterway in the world. However, it was built at a horrific human cost: it is estimated that half of the six million labour force perished at their work. The financial stresses and domestic upheavals caused by the building of the canal were also one of the principal causes of the rapid collapse of the short-lived Sui dynasty (AD 589–618).

The Grand Canal was the main artery of commerce between north and south China, but its capacity was no longer equal to the demands being placed upon it. The work to enlarge it was

THE EMPEROR'S GRAND PLAN

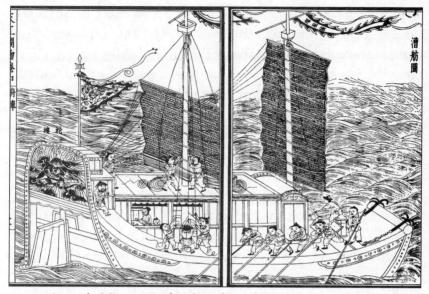

An early Ming grain freighter from the *Thien Kung Kai Wu* (*Tian Gong Kai Wu*), 'The Exploitation of the Works of Nature', 1637.

carried out in two stages. In 1411, dredging and reconstruction of the northern section began to clear 130 miles of channel, and thirty-six new locks were built, for Beijing was over a hundred feet higher than the Yellow River. Three hundred thousand labourers were employed on the task. The southern section from the Yellow River to the Yangtze was opened in 1415. The completed canal stretched from Beijing in the north to Hangzhou on the coast, south of Shanghai. Grain was transported in close to ten thousand flat-bottomed barges, and shipments rose from 2.8 million piculs (approximately 170 million kilograms) in 1416 to five million (300 million kilograms) by the following year.

The insatiable demand for grain to feed the workforce in Beijing led to shortages and famine elsewhere in China, and the timber required for Zhu Di's great schemes stripped the forests of hardwood. Quite apart from the timber needed to build the Forbidden City, each treasure ship in the emperor's huge fleet consumed the wood of three hundred acres of prime teak forest. The imperial navy was supported by a new fleet of auxiliary store ships, and hundreds of smaller merchant ships were also built to trade between Chinese, Indian and African ports. Yet more hardwood was used in the construction of the thousands of grain barges plying the Grand Canal. Hundreds of thousands, if not millions, of acres of forest were felled. Annam (the northern part of modern Vietnam) and Vietnam were also denuded of trees, sparking off the first of a series of uprisings against Chinese rule.

Zhu Di also faced domestic problems. The scale and cost of his grandiose schemes provoked increasingly ferocious opposition from the mandarins, and even an emperor could not undertake a massive project like the building of the Forbidden City without their co-operation. The mandarins were responsible for raising the tax revenues to fund Zhu Di's projects, and, as with officials of any court in any country, there were a thousand ways for them to delay or hinder schemes they did not favour. Zhu Di continued to pursue his dreams with a customary mixture of guile and ruthlessness, even going so far as to exploit the arrival of a 'qilin' – in reality a common giraffe obtained by Admiral Zheng He on one of the epic expeditions that began in 1405, when his fleet visited East Africa – to bamboozle and outmanoeuvre his opponents.

The qilin was an important animal in Chinese mythology, said to have the body of a musk deer, the tail of an ox, the forehead of a wolf, the hoofs of a horse, and a fleshy horn like a unicorn. In legend, a qilin had appeared before a young woman, Yen Tschen-tsaii, in the sixth century BC. It dropped a piece of jade into her hand on which was engraved a message: she would bear a son, 'a king without a throne'.¹³ The son she bore was Confucius, whose philosophy of system and order was to dominate Chinese thought for over two millennia.

The 'qilin' was presented to Zhu Di by Zheng He on 16 November 1416. Proclaiming its arrival as a sign of heavenly approval for his rule, Zhu Di immediately convened a council to confirm once and for all the merits of transferring the capital from Nanjing to Beijing. The court poet wrote a eulogy to the emperor and, astounded by the appearance of the celestial animal, the mandarins duly obliged him.

The whole of China was now mobilized to achieve the completion of the imperial design. Gangs were sent to fell yet more teak in the forests of the Chinese provinces of Jiangxi, Shanxi and Sichuan, and in Annam and Vietnam. Kilns were built to manufacture enormous quantities of bricks. A workforce of artisans, soldiers and labourers was recruited from all over the Chinese empire. In all, one million men were employed directly on constructing the Forbidden City, three and a half million indirectly. A further one million soldiers stood guard over them.

Once barges could carry food along the Grand Canal to this multitude of workmen, the rate of progress on the Forbidden City accelerated. Improvements were made to the moats, walls and bridges of the former Ta-tu and a start was made on the emperor's residence, the western palace in the Forbidden City. In March 1417, the emperor left Nanjing for the last time, and by the end of that year most of the palace buildings had been completed. In 1420, sections of the southern city wall that had fallen into disrepair under the Mongols were restored, and later that year the Temple of Heaven was completed. Sufficient buildings had also been erected to enable the court permanently to move north, and on Chinese New Year's Day, 2 February 1421, the magnificent new capital was inaugurated. To emphasize the importance of the occasion, the envoys of all visiting heads of state were required to bow and kow-tow - prostrate themselves and press their foreheads to the ground - at Zhu Di's feet. China's absolute dominance was further highlighted by the humiliation imposed on two of the most powerful men in the world: the son and grandson of the mighty Tamerlane. Their first attempt at kow-towing before Zhu Di was deemed

unsatisfactory and one of Zhu Di's eunuchs, Haji Maulana, made them repeat it. Their second attempt was also inadequate. Only after their third prostration at his feet did the emperor pronounce himself satisfied.

This array of foreign heads of state kow-towing before the emperor was the culmination of fifteen years' assiduous diplomacy. Chinese foreign policy was quite different from that of the Europeans who followed them to the Indian Ocean many years later. The Chinese preferred to pursue their aims by trade, influence and bribery rather than by open conflict and direct colonization. Zhu Di's policy was to despatch huge armadas every few years throughout the known world, bearing gifts and trade goods; the massive treasure ships carrying a huge array of guns and a travelling army of soldiers were also a potent reminder of his imperial might: China alone had the necessary firepower to protect friendly countries from invasion and quash insurrections against their rulers. The treasure ships returned to China with all manner of exotic items: 'dragon saliva [ambergris], incense and golden amber' and 'lions, gold spotted leopards and camel-birds [ostriches] which are six or seven feet tall' from Africa; gold cloth from Calicut in south-west India. studded with pearls and precious stones; elephants, parrots, sandalwood, peacocks, hardwood, incense, tin and cardamom from Siam (modern Thailand).

Those rulers who accepted the emperor's overlordship were rewarded with titles, protection and trade missions. In south-east Asia, Malacca was rewarded for its loyalty by being promoted as a trading port at the expense of Java and Sumatra; the emperor even personally composed a poem for the Malaccan sultan, and can be said to have been the founder of Malaysia. The subservient Siamese were also extended trading privileges to the detriment of the truculent Cambodians. Korea was especially important to China: Zhu Di lost no time in despatching an envoy to the King of Korea, Yi Pang-Won, granting him an honorary Chinese title. The Koreans needed Chinese medicine, books and astronomical instruments, and in return they agreed to set up an observatory to co-operate with Zhu Di in charting the world. They traded leopards, seals, gold, silver and horses – one thousand of them in 1403, ten thousand the next year. Despite some reluctance, they also found it expedient to comply with Chinese requests to fill Zhu Di's harem with virgins. Many Korean ships were to join the Chinese fleets when they left to sail the world.

As soon as he had expelled the last Mongols from China in 1382, Zhu Di had despatched his eunuch Isiha to the perennially troublesome region of Manchuria in the far north-east, and in 1413 the Jurchen people of Manchuria responded by sending a prestigious mission to Beijing, where its members were showered with titles, gifts and trading rights. Japan was also assiduously courted. The third Ashikaga Shogun Yoshimitsu was a Sinophile; he lost no time in kow-towing as 'your subject, the King of Japan'.¹⁴ His reward was a string of special ports opened to promote trade with Japan, at Ningbo, Quanzhou and Guangdong (Canton). Like Korea, Japan also set up an observatory to aid Zhu Di's astronomical research, and Japanese ships also joined the globetrotting Chinese convoys.

Having pacified Manchuria and brought Korea and Japan into the Chinese tribute system, Zhu Di next turned his attention to Tibet. Another court eunuch, Hau-Xian, led a mission to court the famous holy man the Karmapa, leader of one of the four sects of Tibetan Buddhism, and bring him to China. When he arrived, a procession of Buddhist monks met him outside the city and Zhu Di bestowed upon him the title 'Divine Son of India Below the Sky and Upon the Earth, Inventor of the Alphabet, Incarnated Buddha, Maintainer of the Kingdom's Prosperity, Source of Rhetoric'. The emperor then presented the Karmapa with a square black hat bearing a diamond-studded emblem. It has been worn by successive incarnations of the Karmapa ever since.

Joining China's tribute system also gave rulers and their envoys the opportunity to visit the capital of the oldest and finest civilization in the world. The traditional imperial capital of Nanjing had received dignitaries from around the world, and now the new capital of Beijing began to welcome the latest arrivals. Although the emperor's main concern was to awe all countries into becoming tribute-bearing states, great efforts were also made to learn about their history, geography, manners and customs. Beijing was to be not only the world's greatest city but its intellectual capital, with encyclopedias and libraries covering every subject known to man. In December 1404, Zhu Di had appointed two long-time advisers, Yao Guang Xiao and Lui Chi'ih, assisted by 2,180 scholars, to take charge of a project, the Yong-le-Dadian, to preserve all known literature and knowledge. It was the largest scholarly enterprise ever undertaken. The result, a massive encyclopedia of four thousand volumes containing some fifty million characters, was completed just before the Forbidden City was inaugurated.

In parallel with this great endeavour, Zhu Di ordered the opinions of 120 philosophers and sages of the Song dynasty to be collated and stored in the Forbidden City together with the complete commentaries of thinkers from the eleventh to the thirteenth centuries. In addition to this wealth of academic knowledge, hundreds of printed novels could be bought from Beijing market stalls. There was nothing remotely comparable anywhere in the world. Printing was unknown in Europe -Gutenberg did not complete his printed Bible for another thirty years - and though Europe was on the eve of the Renaissance that was to transform its culture and scientific knowledge, it lagged far behind China. The library of Henry V (1387-1422) comprised six handwritten books, three of which were on loan to him from a nunnery, and the Florentine Francesco Datini, the wealthiest European merchant of the same era, possessed twelve books, eight of which were on religious subjects.

The voyage to the intellectual paradise of Beijing also offered foreign potentates and envoys many earthly delights. Carried in sumptuous comfort aboard the leviathan ships, they consumed the finest foods and wines, and pleasured themselves with the concubines whose only role was to please these foreign dignitaries. The formal inauguration of the Forbidden City was followed by a sumptuous banquet. Its scale and opulence emphasized China's position at the summit of the civilized world. In comparison, Europe was backward, crude and barbaric. Henry V's marriage to Catherine of Valois took place in London just three weeks after the inauguration of the Forbidden City. Twenty-six thousand guests were entertained in Beijing, where they ate a ten-course banquet served on dishes of the finest porcelain; a mere six hundred guests attended Henry's nuptials and they were served stockfish (salted cod) on rounds of stale bread that acted as plates. Catherine de Valois wore neither knickers nor stockings at her wedding; Zhu Di's favourite concubine was clad in the finest silks and her jewellery included cornelians from Persia, rubies from Sri Lanka, Indian diamonds and jade from Kotan (in Chinese Turkestan). Her perfume contained ambergris from the Pacific, myrrh from Arabia and sandalwood from the Spice Islands. China's army numbered one million men, armed with guns; Henry V could put five thousand men in the field, armed only with longbows, swords and pikes. The fleet that would carry Zhu Di's guests home numbered over a hundred ships with a complement of thirty thousand men; when Henry went to war against France in June of that year, he ferried his army across the Channel in four fishing boats, carrying a hundred men on each crossing and sailing only in daylight hours.

For a further month after the inauguration of the Forbidden City, the rulers and envoys in Beijing were provided with lavish imperial hospitality – the finest foods and wines, the most splendid entertainments and the most beautiful concubines,

63

skilled in the arts of love. Finally, on 3 March 1421, a great ceremony was mounted to commemorate the departure of the envoys for their native lands. A vast honour guard was assembled: 'First came commanders of ten thousands, next commanders of thousands, all numbering about one hundred thousand men ... Behind them stood troops in serried ranks, two hundred thousand strong ... The whole body ... stood so silent it seemed there was not a breathing soul there.'15 At noon precisely, cymbals clashed, elephants lowered their trunks, and clouds of smoke wafted from incense-holders in the shape of tortoises and cranes. The emperor appeared, striding through the smoke to present the departing ambassadors with their farewell gifts - crates of blue and white porcelain, rolls of silk, bundles of cotton cloth and bamboo cases of jade. His great fleets stood ready to carry them back to Hormuz, Aden, La'Sa and Dhofar in Arabia; to Mogadishu, Brava, Malindi and Mombasa in Africa; to Sri Lanka, Calicut, Cochin and Cambay in India; to Japan, Vietnam, Java, Sumatra, Malacca and Borneo in southeast Asia, and elsewhere.

Admiral Zheng He, dressed in his formal uniform – a long red robe and a tall black hat – presented the emperor with his compliments and reported that an armada comprising four of the emperor's great fleets was ready to set sail; the fifth, commanded by Grand Eunuch Yang Qing, had put to sea the previous month. The return of the envoys to their homelands was only the first part of this armada's overall mission. It was then to 'proceed all the way to the end of the earth to collect tribute from the barbarians beyond the seas ... to attract all under heaven to be civilised in Confucian harmony'.¹⁶ Zheng He's reward for his lifelong, devoted service to his emperor had been the command of five¹⁷ previous treasure fleets tasked with promoting Chinese trade and influence in Asia, India, Africa and the Middle East. Now he was to lead one of the largest armadas the world had ever seen. Zhu Di had also rewarded other eunuchs for their part in helping him to liberate China. Many of the army commanders in the war against the Mongols were now admirals and captains of his treasure fleets. Zheng He had become a master of delegation. By the fourth voyage fleets were sailing separately. On this great sixth voyage loyal eunuchs would command separate fleets. Zheng He would lead them to the Indian Ocean then return home confident that they would handle their fleets as he had taught them.

The envoys' parting gifts were packed into their carriages, the emperor made a short speech, and then, after kow-towing one last time, the envoys embarked and the procession moved off. Servants ran behind the carriages as they rumbled down to the Grand Canal a mile to the east of the city. There, a fleet of barges decked with silk awnings awaited them. Teams of horses, ten to twelve for each barge, stood on the banks, bamboo poles tied to their harnesses. When the envoys were aboard, whips cracked and the sturdy animals began to drag the barges on their slow journey down to the coast.

Two days and thirty-six locks later, they arrived at Tanggu (near the modern city of Tianjin) on the Yellow Sea. The sight that greeted the envoys at Tanggu was one that must have lingered long in their minds. More than one hundred huge junks rode at anchor, towering above the watchers on the quayside the ships were taller by far than the thatched houses lining the bay. Surrounding them was a fleet of smaller merchant ships. Each capital ship was about 480 feet in length (444 chi, the standard Chinese unit of measurement, equivalent to about 12.5 inches or 32 centimetres) and 180 feet across - big enough to swallow fifty fishing boats. On the prow, glaring serpents' eyes served to frighten away evil spirits. Pennants streamed from the tips of a forest of a thousand masts; below them great sails of red silk, light but immensely strong, were furled on each ship's nine masts. 'When their sails are spread, they are like great clouds in the sky.'18

IMPERIAL CHINA

The armada was composed very much like a Second World War convoy. At the centre were the great leviathan flagships, surrounded by a host of merchant junks, most 90 feet long and 30 feet wide. Around the perimeters were squadrons of fast, manoeuvrable warships. As the voyage progressed, trading ships of several other nations, especially Japan, Korea, Burma, Vietnam and India, joined the convoy, taking advantage of the protection afforded by the warships and the opportunities offered as the magnificent armada, almost a trading country in its own right, swept over the oceans. By the time it reached Calicut, it comprised more than eight hundred vessels whose combined population exceeded that of any city between China and India. Each treasure ship had sixteen internal watertight compartments, any two of which could be flooded without sinking the ship. Some internal compartments could also be partially flooded to act as tanks for the trained sea-otters used in fishing, or for use by divers entering and leaving the sea. The otters, held on long cords, were employed to herd shoals of fish into nets, a method still practised in parts of China, Malaysia and Bengal today. The admiral's sea cabin was above the stern of his flagship. Below were sixty staterooms for foreign ambassadors, envoys and their entourages. Their concubines were housed in adjacent cabins and most had balconies overlooking the sea. Chinese ambassadors, one for each country to be visited, were housed in less grand but nonetheless spacious apartments. Each ambassador had ten assistants as chefs de protocol and a further fifty-two eunuchs served as secretaries. The crewmen's quarters were on the lower decks.

In 1407, Zheng He had established a language school in Nanjing, the Ssu-i-Quan (Si Yi Guan), to train interpreters, and sixteen of its finest graduates travelled with the fleets, enabling the admirals to communicate with rulers from India to Africa in Arabic, Persian, Swahili, Hindi, Tamil and many other languages. Zhu Di and Zheng He also actively sought out

foreign navigators and cartographers; the diaries of one of them, an Indonesian by the name of Master Bentun, have survived. Religious tolerance was one of Zhu Di's great virtues, and the junks also habitually carried Islamic, Hindu and Buddhist savants to provide advice and guidance. Buddhism, with its teachings of universal compassion and tolerance, had been the religion of the majority of the Chinese people for centuries. Buddhism in no way conflicted with Confucianism, which could be said to be a code of civic values rather than a religion. On this sixth and final voyage of the treasure fleets which would last until 1423, the Buddhist monk Sheng Hui and the religious leaders Ha San and Pu He Ri were aboard.¹⁹ After the inauguration of the Forbidden City and the dedication of the awesome encyclopedia the Yong-le-Dadian, thousands of scholars found themselves without an obvious role. It would have been natural for Zhu Di to send them overseas on the great voyages of exploration. Through interpreters, Chinese mathematicians, astronomers, navigators, engineers and architects would have been able to converse with and learn from their counterparts throughout the Indian Ocean. Once the ambassadors and their entourages had disembarked, the vast ships with their labyrinths of cabins would have been well suited to use as laboratories for scientific experiments. Metallurgists could prospect for minerals in the countries the Chinese visited, physicians could search out new healing plants, medicines and treatments that might help to combat plagues and epidemics, and botanists could propagate valuable food plants. Chinese agricultural scientists and farmers had millennia of experience of developing and propagating hybrids.

The native Chinese flora is perhaps the richest in the world: 'In wealth of its endemic species and in the extent of the genus and species potential of its cultivated plants, China is conspicuous among other centres of origin of plant forms. Moreover the species are usually represented by enormous numbers of botanical varieties and hereditary forms.'²⁰ In Europe, a long

67

IMPERIAL CHINA

The betel-nut tree from the *Chêng Lei Pên Tshao* (*Cheng Lei Ben Cao*), 'Classified Pharmaceutical Natural History', 1468. Above is the whole palm, below the fruit. The description to the left of the drawings states that it grows in the South Seas.

period of economic and agricultural decline followed the fall of the Roman Empire. The plant forms known to the Western world from Theophrastus to the German fathers of botany show that European knowledge had slumped, but there was no corresponding 'dark age' in Chinese scientific history. Botanical knowledge, and the number of plant species recorded by the Chinese, grew steadily as the centuries passed. The contrast between the voyages of discovery of the Chinese and those of the Europeans cannot be overestimated. The only interest of the Spanish and Portuguese was in gathering sustenance, gold and spices, while warding off attacks from the natives. The great Chinese fleets undertook scientific expeditions the Europeans could not even begin to equal in scale or scope until Captain Cook set sail three and a half centuries later.

As the admirals and envoys embarked, and the armada was readied for sea, the water around the great ships was still black with smaller craft shuttling from ship to shore. For days the port had been in turmoil as cartloads of vegetables and dried fish and hundreds of tons of water were hauled aboard to provision this armada of thirty thousand men for their voyage. Even at this late hour, barges were still bringing final supplies of fresh water and rice. The great armada's ships could remain at sea for over three months and cover at least 4,500 miles without making landfall to replenish food or water, for separate grain ships and water tankers sailed with them. The grain ships also carried an array of flora the Chinese intended to plant in foreign lands, some as further benefits of the tribute system and others to provide food for the Chinese colonies that would be created in new lands. Dogs were also taken aboard as pets, others to be bred for food and to hunt rats, and there were coops of Asiatic chickens as valuable presents for foreign dignitaries. The larger ships even kept sties of Chinese pigs. Separate horse-ships carried the mounts for the cavalry.

The staggering size of the individual ships, not to mention the

armada itself, can best be understood by comparison with other navies of the same era. In 1421, the next most powerful fleet afloat was that of Venice. The Venetians possessed around three hundred galleys - fast, light, thin-skinned ships built with softwood planking, rowed by oarsmen and only suitable for island-hopping in the calm of a Mediterranean summer. The biggest Venetian galleys were some 150 feet long and 20 feet wide and carried at best 50 tons of cargo. In comparison, Zhu Di's treasure ships were ocean-going monsters built of teak. The rudder of one of these great ships stood 36 feet high - almost as long as the whole of the flagship the Niña in which Columbus was later to set sail for the New World. Each treasure ship could carry more than two thousand tons of cargo and reach Malacca in five weeks, Hormuz in the Persian Gulf in twelve. They were capable of sailing the wildest oceans of the world, in voyages lasting years at a time. That so many ships were lost on the Chinese voyages of discovery testifies not to any lack of strength in their construction but rather to the perilous, uncharted waters they explored and the hurricanes and tsunami they encountered along rocky coasts and razor-sharp coral reefs to the ice-strewn oceans of the far north and far south. Venetian galleys were protected by archers; Chinese ships were armed with gunpowder weapons, brass and iron cannon, mortars, flaming arrows and exploding shells that sprayed excrement over their adversaries. In every single respect - construction, cargo capacity, damage control, armament, range, communications, the ability to navigate in the trackless ocean and to repair and maintain their ships at sea for months on end - the Chinese were centuries ahead of Europe. Admiral Zheng He would have had no difficulty in destroying any fleet that crossed his path. A battle between this Chinese armada and the other navies of the world combined would have resembled one between a pack of sharks and a shoal of sprats.

By the end of the middle watch – four in the morning – the

last provisions had been lashed down and the armada weighed anchor. A prayer was said to Ma Tsu, Taoist goddess of the sea, and then, as their red silk sails slowly filled, the ships, resembling great houses, gathered way before the winds of the north-east monsoon. As they sailed out across the Yellow Sea, the last flickering lights of Tanggu faded into the darkness while the sailors clustered at the rails, straining for a last sight of their homeland. In the long months they would spend travelling the oceans, their only remaining links to the land would be memories, keepsakes and the scented roses many brought with them, growing them in pots and even sharing their water rations with them. The majority of those seamen at the rails would never see China again. Many would die, many others would be shipwrecked or left behind to set up colonies on foreign shores. Those who eventually returned after two and a half years at sea would find their country convulsed and transformed beyond all recognition.

2

THUNDERBOLT

STRIKES

N THE NIGHT OF 9 MAY 1421, TWO MONTHS AFTER Zheng He's armada had set sail, a violent storm broke over the Forbidden City.

On this night by chance a conflagration started ... lightning struck the top of the palace that had been newly constructed by the Emperor. The fire that started in that building enveloped it in such a manner that it seemed as if 100,000 torches provided with oil and wicks had been lit up therein ... so much so that the whole city was set ablaze with the light of that conflagration and the fire spreading ... it burnt down the Ladies' Apartments behind the Hall of Audience ... about 250 quarters were consumed to ashes, burning a large number of men and women. It continued burning like that until it was day and in spite of all efforts, the fire could not be brought under control until it was afternoon prayer time.¹

Balls of fire appeared to travel down the Imperial Way itself, along the very axis of the Forbidden City, destroying what we now call the Hall of Great Harmony, the Hall of Central Harmony and the Hall of Preserving Harmony – the magnificent palaces where Zhu Di had received leaders of the world three months earlier. The emperor's throne was burned to cinders. 'In his anguish he repaired to the temple and prayed with great importunity, saying, "The God of Heaven is angry with me, and, therefore, has burnt my palace; although I have done no evil act. I have neither offended my father, nor mother, nor have I acted tyrannically."'²

The shock killed the emperor's favourite concubine. Zhu Di was so distraught that he was unable to make proper arrangements for her burial in the imperial mausoleum.

He fell ill owing to his anguish and on account of this it could not be ascertained as to in what manner the dead personage was buried... The private horses of the deceased lady were let loose to

IMPERIAL CHINA

graze freely... on the mountain where the sepulchre was situated. They had also posted about that sepulchre a number of maidens and eunuchs ... leaving for them provisions to last five years so that after that period when their food got exhausted, they might likewise die there.³

Chinese emperors believed they ruled with the mandate of heaven. The manner in which the lightning struck and the severity of the fire that followed could hardly have been more ominous for Zhu Di. An event of this terrible nature could only signal the gods' demand for a change of emperor. Zhu Di temporarily handed power to his son, Zhu Gaozhi. 'The illness of the Emperor having increased, his son used to come and sit in the audience hall.'⁴ Struggling to comprehend the nature of the calamity that had befallen him, the emperor then issued an edict to his people:

My heart is full of trepidation, I do not know how to handle it. It seems that there has been some laxness in the rituals of honouring heaven and serving the spirits. Perhaps there has been some transgression of the ancestral law or some perversion of government affairs. Perhaps mean men hold rank while good men flee and hide themselves, and the good and evil are not distinguished. Perhaps punishments and jailings have been excessive and unjustly applied to the innocent, and the straight and the crooked not discriminated ... Is this what brought about [the fire]? Harshness to the people below and above, going against heaven. I cannot find the reason in my confusion ... If our actions have in fact been improper, you should lay these out one by one, hiding nothing, so that we may try to reform ourselves and regain the favour of heaven.⁵

The edict unleashed a predictable storm of criticism from the mandarins. Most of it was targeted on Zhu Di's grandiose plans and projects, notably the Forbidden City that the gods had destroyed. Vast areas had been denuded of trees to build the enormous halls, tens of thousands of artisans had laboured for years on the fabulous rooms, huge sums had been invested in marble and jade, the Grand Canal had been rebuilt using a million teaspoons to ferry grain, and the treasury drained to such an extent that peasants had even been reduced to eating grass. And all this toil, suffering and sacrifice had led only to a carpet of ashes and cinders. The fires also coincided with a terrible epidemic of some unknown disease that had been raging in the south for two years. More than 174,000 people had died in the province of Fujian alone and their bodies lay rotting in the fields, for there was no-one to bury them. The epidemic seemed yet another sign of the gods' anger.

The mandarin Minister of Revenue, Xia Yuanji, who had managed to find the funds for the Forbidden City and for Zheng He's great armada, bravely stepped forward to accept personal responsibility for the catastrophe, but to no avail. Frantic efforts were made to pacify the people. Twenty-six high-ranking mandarin court officials were sent on 'calming and soothing' missions⁶ and, in an attempt to save his throne, Zhu Di issued a series of ill-conceived decrees. A halt was placed on future voyages of the treasure fleets and foreign travel was prohibited.

Zhu Di had been plagued by other indignities and misfortunes. He had suffered a series of strokes during the previous four years and was being treated with an elixir containing arsenic and mercury that was probably poisoning him. Shortly before the great fire, he had also been thrown from his charger, Tamerlane's former steed and a present from one of the Mongol conqueror's sons, King Shah Rukh of Persia. Zhu Di was so furious that he was determined to put Shah Rukh's ambassador to death.

Thereafter the Qazi, coming forward, said to the ambassadors: 'Dismount and when the Emperor arrives prostrate yourselves on the ground!' They did so.

IMPERIAL CHINA

When the Emperor came near he asked them to mount again. The ambassadors mounted and proceeded along with him. The Emperor began to make complaint saying to Shadi Khwaja: 'I mounted for chase one of the horses which you brought me, and it being extremely old and feeble fell down throwing me off. Ever since that day my hand is giving me pain and has become black and blue. It is only by applying gold a good deal that the pain has abated a little.'⁷

A mandarin replied on behalf of the Persians:

The ambassadors are in no way to blame, for if their sovereign had sent good horses or bad as presents, those persons had no choice in the matter . . . Moreover, even if your Majesty has the envoys cut in pieces it shall make no difference to their sovereign. On the other hand . . . the whole world would say that the Emperor of China had acted contrary to all convention by imprisoning the envoys.⁸

Slurs on Zhu Di's manhood were even more humiliating. He had fathered no children after 1404, and had probably been impotent since the Empress Xiu's death in 1407. Two imperial concubines had been found trying to assuage their sexual frustration by attempting intercourse with one of the eunuchs who guarded them. In the subsequent witch hunt, 2,800 concubines and eunuchs were alleged to have been involved in treasonable activity; Zhu Di personally executed many of them, but before they died a number of Korean concubines flung insults at him, taunting him for his impotence: 'You have lost your yang power and that is why your concubines resorted to a relationship with a young eunuch.'9

Apparently abandoned by heaven, the humiliated, ill and distraught old emperor also faced mounting political problems. The construction of the Forbidden City, the Grand Canal, the fleet of treasure ships and the repair of hundreds of miles of the Great Wall had placed enormous strains on China's economy, and the felling of the vast hardwood forests had provoked rebellions in Annam and Vietnam. The first rebellion, in 1407, was led by Le Qui Ly, a former minister of the Vietnamese court who usurped the throne and introduced reforms that won him wide support. Taxation was simplified, ports were opened to foreigners and trade boomed. Restrictions were placed on the acquisition of land by the wealthy at the expense of peasants, a system of health care was introduced, and the army and civil service were reorganized; ability was henceforth to be the key word. His ultimate aim was to end his country's subjugation by China. Vietnam would no longer be a colony, but a proud and united sovereign nation. Zhu Di had sent an army southwards to crush the rebellion, depose Le Qui Ly and begin the systematic obliteration of Vietnamese national identity. Native literature was burnt and works of art destroyed. Chinese classics became required reading in schools and Chinese dress and hairstyle were imposed on Vietnamese women. Local religious rites were outlawed and private fortunes confiscated, while the pillage of the forests continued.

Another uprising began in 1418, this time led by an aristocratic landowner, Le L'oi, the founder of the dynasty that was to rule Vietnam for 360 years. Although twice defeated by the Chinese armies, each time he managed to escape to the jungle and continue the war. Despite a massive commitment of combat troops, the Chinese could neither find Le L'oi nor suppress his guerrilla army.

Insurrection spread throughout Annam and Vietnam; the entire coastal region south of the Red River delta (near modern Hanoi) was in revolt. Enormous numbers of Chinese troops were now tied down in the jungle at vast cost to the treasury and Chinese pride. The rebellion was a serious political and military problem, but it was one that a fit, powerful emperor such as Zhu Di in his prime would have solved with ruthless efficiency.

79

Weighed down by his domestic troubles, he failed to suppress the revolt; Le L'oi then inflicted on the Chinese armies the first serious defeat the Ming dynasty had ever experienced. It was another shattering blow to the morale of the Chinese and their emperor, and though Le L'oi did not secure his country's formal independence until 1428, Zhu Di had effectively abandoned Vietnam by July 1421.

The demoralized old emperor had also lost control of his cabinet, and of China itself. There had always been an inherent contradiction at the heart of Zhu Di's government: it was effectively two separate administrations – a mandarin cabinet in charge of finance, economics, home affairs and law and order, and the eunuchs, who led the armed forces and executed Zhu Di's foreign policy. At the peak of his powers, Zhu Di had tolerated his mandarin critics, allowing them to influence his favourite son and successor, Zhu Gaozhi. Deep down the mandarins loathed Zhu Di's grandiose plans, his foreign policy, and the bleak northern location of the Forbidden City. They seized the opportunity offered by his illness and waning powers and looked to the crown prince, Zhu Gaozhi, to reverse his father's policies.

A diplomatic crisis accelerated the disintegration of Zhu Di's government. Sensing the emperor's weakness after the fire in the Forbidden City, the Mongol leader Arughtai refused to pay the tribute demanded by China. Zhu Di saw a heaven-sent opportunity to reassert his authority; the emperor himself would lead an army to bring Arughtai to heel. As a young man, Zhu Di had relied on the speed of his cavalry to outwit and outmanoeuvre the Mongol army. Now, he and his eunuch generals assembled an enormous, ponderous force of almost a million men and 340,000 horses and mules and plodded northwards into the steppe. Some 177,500 carts were needed just to transport the grain to feed this vast army. The mandarin Minister of Revenue, Xia Yuanji, the financial genius who had raised the funds for the Forbidden City, for widening the Grand Canal, for the fleet of grain barges and for Zheng He's armada, baldly stated he could not find the money for this latest imperial adventure. The Minister of Justice, Wu Zhong, also objected. Zhu Di had both ministers arrested. Fang Bin, Minister of War, then committed suicide. By the end of that terrible year, Zhu Di had lost his most able, loyal and long-serving ministers and his cabinet had disintegrated.

As his ministers had feared, Zhu Di's expedition was a fiasco. Arughtai simply disappeared into the vastness of the steppe. On 12 August 1424, while still pursuing Arughtai, Zhu Di, a broken man, died at the age of sixty-four. Some of the army's pots and pans were melted down to make a coffin to carry him back to the burnt remains of the Forbidden City in Beijing, where his body lay in state for one hundred days.

Zhu Di's funeral had the same epic quality as his life. The procession was led by the old emperor's honour guard. Ten thousand soldiers and officials surrounded the cortège as it slowly zigzagged on its two-day march to the magnificent imperial mausoleum at Chang Ling in the foothills north-west of Beijing. There, in hazy autumn sunshine, they marched down an avenue lined with stone animals to lay the emperor's body in his magnificent tomb. Animals were sacrificed to his ancestral gods and then his cloak of imperial yellow and military decorations were laid beside him. Sixteen concubines were buried alive with Zhu Di. The complex was sealed as the cries of the doomed women marked the end of the mortal life of one of the greatest visionaries and gamblers in history.

On 7 September 1424, Zhu Di's son, Zhu Gaozhi, ascended the throne. That very day he issued an edict:

All voyages of the treasure ships are to be stopped. All ships moored at Taicang [a Yangtze port] are ordered back to Nanjing and all goods on the ships are to be turned over to the Department of Internal Affairs and stored. If there are any foreign envoys wishing to return home, they will be provided with a small escort. Those officials who are currently abroad on business are ordered back to the capital immediately ... and all those who have been called to go on future voyages are ordered back to their homes.

The building and repair of all treasure ships is to be stopped immediately. Harvesting *tieli mu* [hardwood for shipbuilding] is to be conducted in the same way as it was in the time of the Hongwu Emperor [Zhu Di's father]. [Additional harvesting] is to be stopped. All official procurement for expeditions abroad (with the exception of items already delivered at official depots), the making of copper coins, buying of musk, raw copper and raw silk must also be stopped ... All those employed in purchasing should return to the capital.¹⁰

Zhu Gaozhi also ordered the immediate release of those senior officials who had been imprisoned by his father, including the former finance minister, the mandarin Xia Yuanji. Xia took immediate steps to control inflation, forbidding the mining of gold and silver and stabilizing the amount of non-paper currency in circulation (paper money had been invented by the Chinese in AD 806, centuries before it came into use in Europe). Such was the value of pepper that it had been used as a means of payment by the Chinese. Now, all the pepper in the imperial warehouses was given away, the purchase of all luxury goods banned, the budget deficit slashed and all expenditure on the treasure fleets curtailed. China's territory produced all goods in abundance, so why buy useless trifles from abroad?¹¹

The young emperor, fat, studious and religious, had shown no interest in military affairs and had hardly ever accompanied his father on his military expeditions, preferring to remain surrounded by his mandarin advisers. His priorities were in strict accordance with their Confucian values; 'Relieving people's poverty ought to be handled as though one were rescuing them from fire or saving them from drowning. One cannot hesitate.¹² He saw no need to listen to the eunuchs who, in aiding and abetting his father's expansionary schemes, had brought China to the brink of disaster.

As two of the battered treasure fleets limped home in October 1423 after two and a half years at sea. Zheng He's men had no idea of the dramatic events unfolding at home and must have been expecting a heroes' welcome. Their voyages had been a remarkable success. They had reached countless unknown lands and immeasurably furthered their knowledge of navigation, but instead of plaudits, the returning admirals were spurned by those who now ruled China. Only Zheng He was spared from humiliation; perhaps his prestige was too great to strip him of his rank. The old admiral was pensioned off as an imperial harbour master in Nanjing, but was allowed to keep his sumptuous palace there and to continue building his mosque.

Zhu Gaozhi died in 1425 after only a year as emperor, and was succeeded by his son, Zhu Zhanji, who intensified his father's policies. Social harmony returned, but China had reverted to rule by traditional rural gentry. As long as the irrigation systems were maintained, the farmers were well fed and famine averted, there was little requirement for economic or political change, or the exercise of China's inventive genius. The country's institutions remained as if preserved in amber. Merchants wielded little political power, bankers and soldiers virtually none, and revenue from foreign trade dropped to less than 1 per cent of government income. Zhu Zhanji did allow Admiral Zheng He his swansong - one final voyage to Mecca - but with Zhu Zhanji's death in 1435, complete xenophobia set in. All voyages of the treasure fleets were halted and the first of a stream of imperial edicts banned overseas trade and travel. Any merchant attempting to engage in foreign trade was to be tried as a pirate and executed. For a time, even learning a foreign language or teaching Chinese to foreigners was prohibited.

83

The embargo on overseas trade was rigidly maintained throughout the next hundred years, and the Qing dynasty that succeeded the last of the Ming emperors in 1644 went even further. To prevent any foreign trade or contact, a strip of land along the southern coast 700 miles long and 30 miles wide was devastated and burnt, and the population moved inland. Not only were the shipyards put out of commission, the plans for building the great treasure ships and the accounts of Zheng He's voyages were deliberately destroyed. The mandarin Liu Daxia, a senior official at the Ministry of War, seized the records from the archives. He declared that 'the expeditions of San Bao (Zheng He) to the Western ocean wasted myriads of money and grain, and moreover the people who met their deaths may be counted in the myriads'. The goods the fleets had brought home - 'betel, bamboo staves, grape-wine, pomegranates and ostrich eggs and such like things' - were useless, and all the records of these expeditions - 'deceitful exaggerations of bizarre things far removed from the testimony of people's eyes and ears' - should therefore be burned. Liu then blandly reported to the Minister of War that the logs and records of Zheng He's expeditions had been 'lost'.13 Not only was the priceless legacy of the greatest maritime expeditions of all time gone for ever, foreign lands were to be banished from the minds of the Chinese people. Only piracy and smuggling would be left to connect the fallen colossus with the outside world. The colonies established in Africa. Australia, New Zealand and North and South America were abandoned and left to their fate.

By late 1421, China's history was set for centuries to come. The legacy of Zhu Di, Zheng He and their great treasure fleets would be all but obliterated. What oceans they had sailed, what lands they had seen, what discoveries they had made, what settlements they had created were no longer of interest to the Chinese hierarchy. The ships that had made those voyages were left to rot and were never replaced. The logs and records were destroyed and the memory of them expunged so completely over the succeeding decades that they might never have existed. As China turned its back on its glorious maritime and scientific heritage and retreated into a long, self-imposed isolation from the outside world, other nations took up the torch. But all their explorers, colonizers and discoverers voyaged in the long shadows cast by Zhu Di's fleets.

THE FLEETS

S E, T

SAIL

NAWARE OF THE UPHEAVAL THAT WAS ABOUT TO OVERtake China, the great armada sailed majestically south across the Yellow Sea, beginning a journey that would take them to the ends of the earth. Early on the first morning of the voyage, 5 March 1421, the helmsmen kept the Pole Star, Polaris, dead astern while the navigators measured the star's altitude with their sextants. After taking their first readings, the navigators held their course due south for exactly twenty-four hours, then took another measurement of Polaris. By sailing due south, at the end of their first day at sea not only were they able to determine their change in latitude – their distance south of the North Pole – but could also adjust their compasses for magnetic variation, measure their speed and the distance covered, and calibrate their logs.

The methods of navigation employed by Zhu Di's admirals are revealed by one of the few documents of the era to have survived, the *Wu Pei Chi*. These Chinese sailing instructions, essentially a manual of the arts of seamanship and naval warfare, somehow escaped the purges of the mandarins.¹ There were instructions, inscribed on a long, thin strip of paper, for each regular voyage they made, giving detailed directions including star positions, latitudes, bearings and the physical description of islands, prominent headlands, bays and inlets that would be clearly visible along the route. By studying these sailing directions, it is possible to deduce not only the course the Chinese had steered but the accuracy of their navigation and their ability to set a course by the stars. It is an invaluable document.

The Pole Star was of great importance to the Chinese, both symbolically and for navigation. It was the fundamental basis of Chinese astronomy, for the celestial pole was regarded as the heavenly equivalent of the position of the emperor on earth. As mandarins, courtiers and servants circled around the emperor, so the other stars rotated around the Pole Star; as the clothes of the servants and their proximity to the emperor signified their

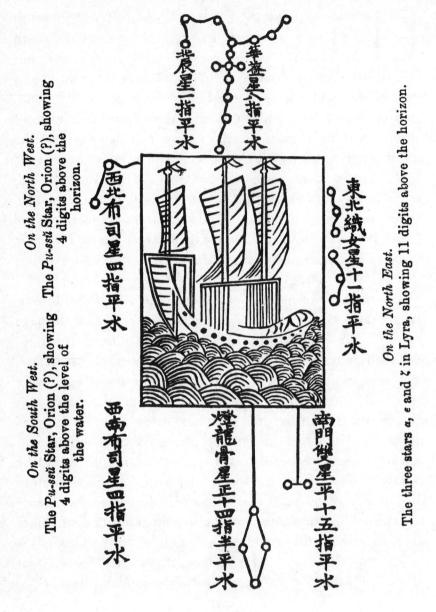

On the South.

Navigational diagram used by Zheng He for the Sri Lanka–Sumatra run and reproduced in the *Wu Pei Chi*, 1628.

IMPERIAL CHINA

importance, so did the brightness, colour and positioning of the stars that were 'tied' to the Pole Star. 'There is high Confucian authority. The master says, "He who exercises government by means of his virtue may be compared to the Pole Star which keeps its place while all the stars turn around it."²

Western methods of astronomy embodied the principles first enunciated by Greek astronomers such as Aristotle and Ptolemy, basing latitude on the equator. In Chinese astronomy, latitude was determined not by the distance north of the equator but by the distance from the North Pole, which was determined by the altitude of the Pole Star, Polaris. A bright and easily identifiable star, Polaris sits directly above the North Pole, billions of miles out in space. When viewed from the North Pole it is directly above the observer at 90° altitude or 90° latitude; at the equator it sits on the horizon at 0° altitude or 0° latitude. Measuring its height above the horizon (altitude) enables the navigator to calculate his latitude. Moreover, since Polaris is due north it enables magnetic variation – the difference between due north and the magnetic north of a compass – to be determined and adjustments made.

By 1421, the Chinese had well over six centuries' experience of ocean navigation, basing their calculations on both the Pole Star and the stars circling the pole at high altitudes which never rise and never set. In effect, once the Chinese had determined the absolute position of Polaris in the celestial sphere, they 'tied' other stars in the northern hemisphere to it. When viewing one star or constellation, they knew exactly where the others were in relation to it, even when they had not yet risen in the night sky. They were thus in a position to know a star's exact location, even when invisible below the horizon, by observing the meridian passage – the highest point of their track across the night sky viewed from any particular point – of the circumpolar stars to which it was 'tied'. However, the Chinese had not yet mastered using the sun to obtain latitude,³ something the Portuguese first

achieved in 1474 and which enabled them to measure latitude in the southern as well as the northern hemisphere. The Chinese could not determine their latitude south of the equator, where Polaris was invisible. It was a problem that had to be solved. A star or stars in the southern hemisphere that could fulfil the function of Polaris in the northern had to be identified before Zhu Di's dream of charting the whole world could be realized.

By the seventh century, the Chinese could accurately determine the course to steer, for they had discovered the compass. They knew that the magnetic properties of lodestone could be transferred by induction to iron, and that this magnetized iron could be floated on oil, allowing it to swivel freely, one end pointing always to the earth's magnetic south. In 1421 the Chinese could steer to within two degrees of their chosen course using reliable magnetic compasses. They could also measure the distance travelled using hour-glasses of sand. A day was divided into ten parts, each hour-glass equalling 2.4 hours, the length of one watch for the seamen on duty.

The calculation of longitude, however, remained a problem they had not fully resolved at the start of this sixth voyage. Changes in longitude depend on four things: the course steered, the speed of the ship, the time that has elapsed and the distance north or south of the equator. By recording the number of watches, the speed through the water and the compass course, the navigator could estimate his change in longitude. But there was one great disadvantage to the Chinese method of navigation: if the body of water over which the ship was sailing was itself moving - for example, when a current was moving with or against the ship - the mariner had no way of measuring his change of longitude. This could only be achieved by measuring absolute time, something Europeans were not to achieve for another three and a half centuries, when John Harrison finally perfected a clock that could keep precise time at sea. At the start of the sixth voyage, this defect caused huge errors in Chinese

calculations of longitude. Polaris navigation enabled them to calculate latitude and make landfalls north of the equator with astonishing accuracy, but a method of calculating longitude with anything approaching the same accuracy was not perfected until near the end of their voyages.

With centuries of experience in building ships to sail stormtossed oceans, the Chinese marine engineers had evolved a robust frame built in sections. Each section was contained by watertight bulkheads at either end, resembling the internal partitions of a bamboo, and the watertight sections were bolted together with brass pins weighing several kilograms. Three layers of hardwood were nailed to a teak frame, then the planks were caulked (made waterproof) with coir (coconut fibre) and sealed with a mixture of boiled tung oil and lime. This hard, waterproof lacquer had been used to seal Chinese ocean-going ships since the seventh century, but so much tung oil was required to build Zheng He's treasure fleets that acres of land along the Yangtze banks were acquired to plant orchards of tung trees.

Marine engineers at the Longjiang shipyards designed their ships to survive the fiercest storms on the open ocean. Reinforced bows enabled the vessel to smash through the waves, and at either side of the bow were channels leading to internal compartments. As the square bow pitched in heavy seas, water was funnelled in; as the bow surfaced above the waves, the water drained out, modifying the pitching motion. A teak keel bound together by iron hoops ran the length of the ship, and specially cut, large rectangular stones – or composite stone and mud balls – were packed around it for ballast. Additional keels that could be raised and lowered were fitted at either side for more stability. In a storm, semi-submersible sea anchors could also be thrown overboard to reduce rolling. Even in the roughest weather and sea conditions, pitching and rolling were greatly reduced by these ingenious modifications.

IMPERIAL CHINA

The giant ships could survive typhoons and the sectional construction reduced the risk of sinking through a collision with a reef or an iceberg. They were designed to remain afloat even if two compartments were flooded after being punctured by coral or ice. To increase cargo capacity, the hulls of the junks were very wide compared with their length and they were flat-bottomed. Their sails were balanced lugs, four-sided sails hanging from a yardarm set at an oblique angle – the characteristic sail of China. They were stiffened by a series of bamboo battens, so the design was extremely efficient when sailing before the wind. It also allowed the sails to be reefed, or lowered, quickly in an emergency.

The most reliable ships in the world in the fourteenth and early fifteenth century, and by far the biggest, were these Chinese junks. Ibn Battuta, the Moroccan traveller and writer who journeyed through Asia in the fourteenth century, wrote that the trade of the whole world between the Malabar coast of India and China was carried in Chinese ships. Centuries later, in 1848, a junk built to the designs of that era was sailed from China via New York to London by a party of British naval officers. They sailed before the wind all the way and the junk handled beautifully. But magnificent though these ships were, they had been designed to operate primarily between China and Africa, sailing before the monsoon winds (which changed direction twice yearly), as they had for centuries. Although a lug-sail is also quite efficient when sailing into the wind, the combination of the hull shape and sail design meant that the Chinese monsters were crab-like and inefficient when attempting to do so. They had to wear rather than tack, and for all practical purposes were constrained to sail before the wind - a severe limitation when outside the monsoon belt of the Indian Ocean and South China Sea. It was to be one of the crucial clues when it came to tracking the course of the Chinese fleets during the great voyages of 1421 to 1423.

The eunuch captains and admirals of these great treasure ships were men of awesome ability but, like the European explorers who followed them, they often drew their crews from the lowest levels of society. Most were criminals, sent to sea in lieu of imprisonment or internal exile, and in some respects life as a crewman was far better than a prison sentence. They were provided with a uniform – a knee-length white robe – food and wine, and were well cared for when at sea. The admiral's staff included 180 medical officers, and every ship and company of soldiers had a medical officer for every 150 men. There was a varied and plentiful diet on the treasure ships, but the perils of voyaging through uncharted waters meant that life expectancy was short: only one in ten returned from the great voyages of exploration and discovery. But those who had survived the earlier voyages of the treasure fleets had been well rewarded. They were often freed and given endowments or pensions.

Like all sailors, the Chinese were superstitious. Each of Zheng He's ships had a small cabin dedicated to Ma Tsu, the mariners' deity, and prayers were said to her every evening before supper. When the crew went ashore in foreign lands, they carried round bronze mirrors to ward off evil spirits; on the reverse was the eight-spoked Taoist wheel.

The elite of the crew were the navigators and 'compass-men', operating from an enclosed small bridge and living and dining separately from the rest of the men. The junks also carried artisans and craftsmen of every description, capable of performing any task. Caulkers, sailmakers, anchor- and pump-repairers, scaffolders, carpenters and tung oil painters would keep the ships in good repair on their long voyage into the distant oceans. Their work in the Forbidden City complete, stone-carvers and stone masons were also embarked to leave permanent legacies of the fleets' voyages across the world. There was even a historian, Ma Huan, to document the voyage. His diaries, *The Overall Survey of the Ocean Shores*, were published in 1433, after Zheng He's final voyage.

IMPERIAL CHINA

The staple foods - soya beans, wheat, millet and rice - were carried in separate grain ships, enabling a fleet to stay at sea for several months without replenishing supplies, but if the grain ships sank, the whole fleet was in desperate trouble. Soya beans, grown in tubs all year round, were used in several ways. Soaked in water, they sprouted 'yellow curls' from the green bean. The sprouting process increased the content of ascorbic acid, riboflavin and nicotinic acid, the basis of vitamin C, and protected the crew from the deficiency disease scurvy. The Chinese knew well the dangers of scurvy and the remedies to prevent it. Enough citrus fruit - limes, lemons, oranges, pomelos and coconuts - was taken aboard to give every man protection against the disease for three months. Pomelos - a grapefruit-like fruit, also known as a shaddock - had been particularly valued ever since the Warring States period from the fifth to second centuries BC. 'The candid and ingenious prince should know the State of Chu must necessarily gain wealth from its groves of orange and pomelo trees.'4

Some of the rice was brown, not polished, and the husks contained vitamin B1. As a result, beri-beri – a disease causing degeneration of the nervous system – was rare among the crew. Fresh vegetables mainly comprised cabbages, turnips and bamboo shoots. When they ran out, the sprouting soya beans were particularly valuable. Soya beans also produced 'milk'. When boiled, it became curd, or tofu, rich in vitamin D, while fermentation of soya produced soy sauce. Tofu and vegetables were flavoured with a sauce made from fermented fish, soy, dried herbs and spices, or glutamate made by chewing wheat flour. The grains were chewed, spat out into a container and left to ferment. The method is still used in South America today. Noodles, pasta and dumplings were also made from wheat flour. Sugar cane was used to sweeten dried fruit and was also chewed raw by the crew.

Fruits and vegetables were preserved in ingenious ways. Fruit

The third Ming emperor, Zhu Di, under whom exploration flourished.

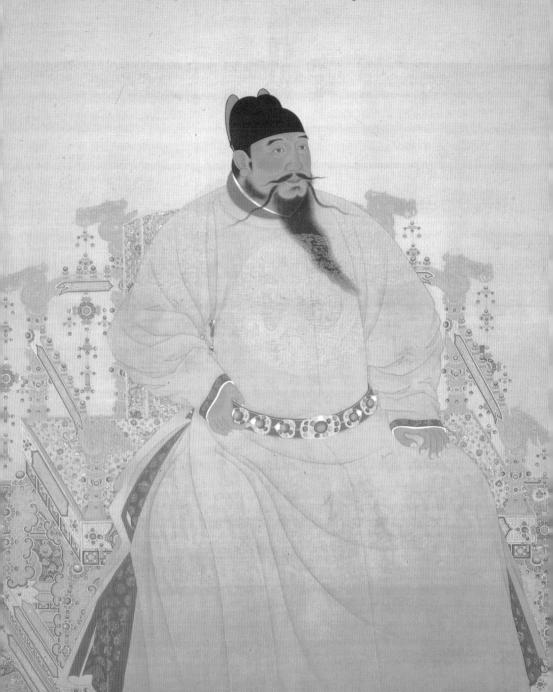

From 1406 to 1420 Zhu Di presided over the building of the Forbidden City with the Imperial Palace (*below* and *bottom*) as its centre. The Temple of Heaven was its place of ritual; it encompasses the Hall of Prayer for Good Harvests (*opposite left*) where the emperor came to pray at the new year. When the capital moved north, the renovation of the Great Wall (*opposite right*) became a priority.

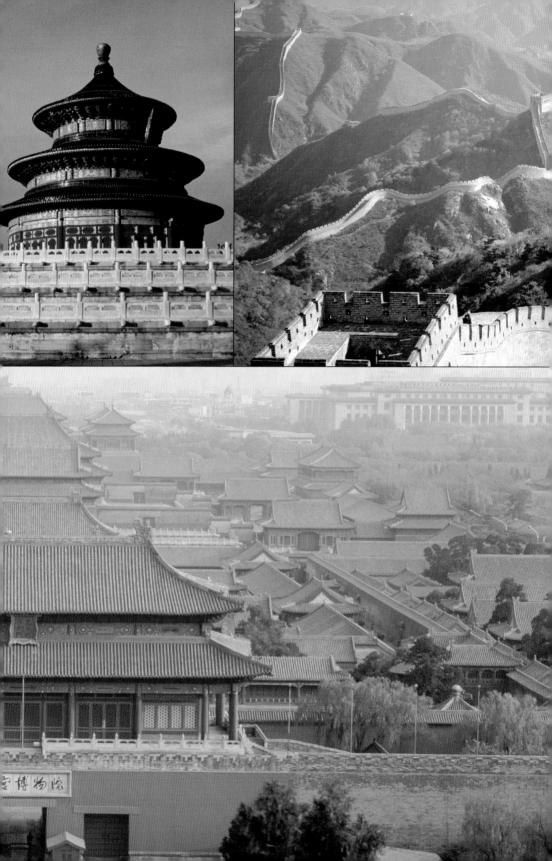

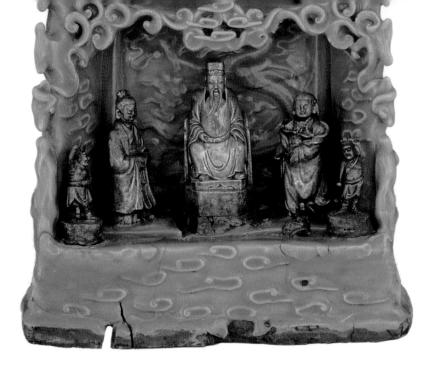

The Ming court in life and death: the emperor sits ensconced at the bottom level of a Taoist shrine (*above*) between a civil and a military adviser and flanked by two guardian figures.

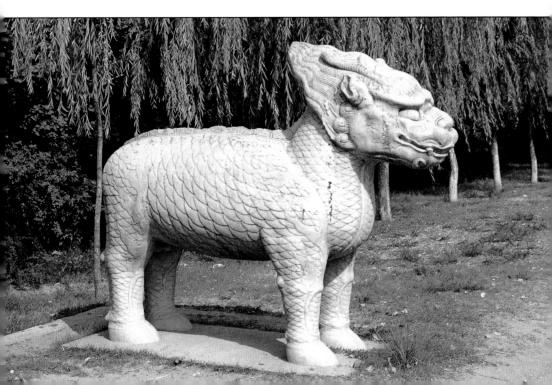

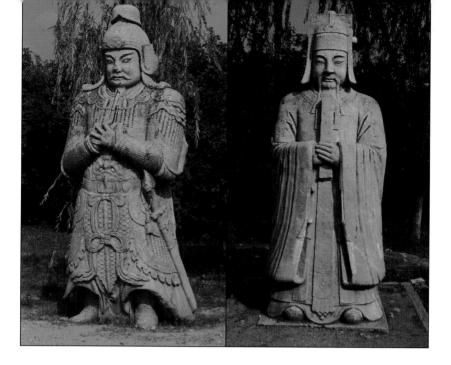

The Spirit Way leading to the Ming tombs in Beijing is lined by stone warriors (*above left*) and high officials, here a Grand Secretary (*above right*), as well as powerful beasts – exotic elephants (*below*) and the mythical quilin (*opposite*, *below*).

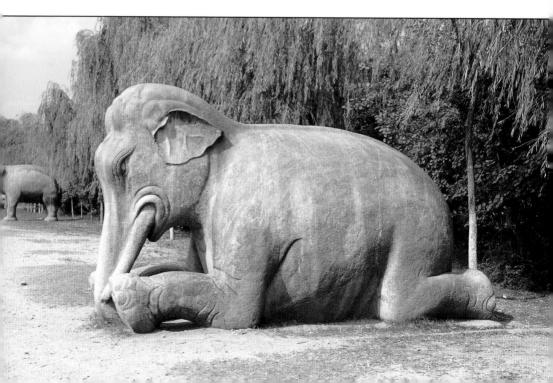

The treasure ships took with them not only the much-prized blue and white porcelain (*above* and *top*), but also jade (*middle*), lacquer (*right*) and luxurious silk textiles (*opposite*).

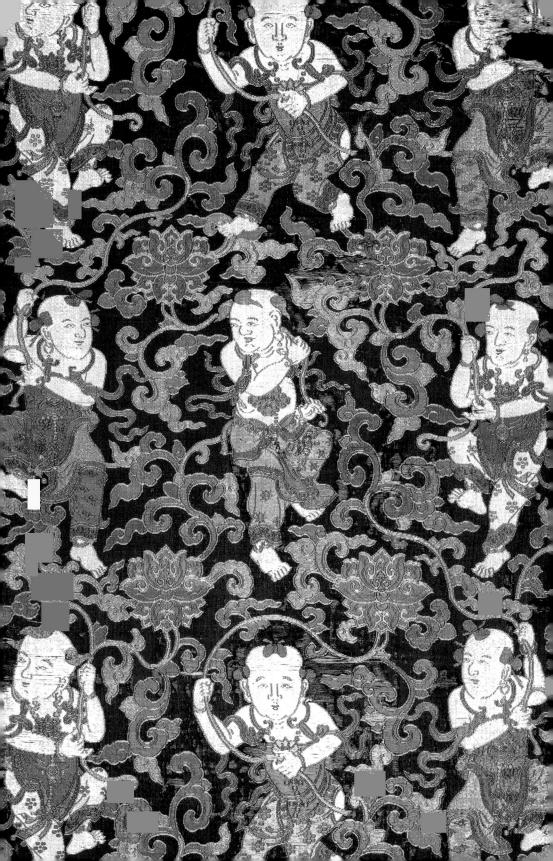

A giraffe, with its attendant, sent from Africa to the Ming imperial court as tribute.

報

雜

水梁十二年翁次甲

音徑下詞承

原於,肥以受治

下與

鴉

致熊蘇

was dried or caramelized, pears, bamboo shoots and grapes were buried in sand, and vegetables were salted, pickled and marinated in vinegar and sugar.⁵ Meat was limited, for the most part comprising Chinese pigs, dogs bred for the purpose and frogs kept in tubs. Chickens were kept for divination and were never eaten on board, but fresh, salted, dried and fermented fish were plentiful. They were caught by the trained otters, working in pairs to herd shoals into the nets, and by an array of hooks and nets. The crew drank green oolong and red tea, carried in both leaf and cake form, and rice wine (*jiu*) was hugely popular. 'In the sixth month [August] we gather wild plums and berries; in the seventh we boil marrows and beans; in the eighth we dry the dates; in the tenth we take the rice to make with it the spring wine so that we may be granted long life.'⁶

Wine was also distilled into liqueurs, brandy and vinegar. The junks required huge quantities of fresh water for crew and horses and replenished their tanks whenever an opportunity arose, but they also knew how to distil it from sea-water, using paraffin wax or seal blubber for fuel. Their capacity to desalinate sea-water and the fresh vegetables they carried gave them the ability to cross the broadest oceans. The overall diet was infinitely more varied and nutritious than that provided for Magellan the best part of a century later – 'We ate only old biscuits turned to powder, all full of worms and stinking of the urine the rats had made on it.'⁷ On the junks, rats were hunted by the sailors' little ship-dogs. Arsenic was used to kill bugs and insects and to promote the growth of plants.

The concubines for the treasure fleets were recruited from the floating brothels of Canton.⁸ They belonged to an ethnic group called the 'Tanka', descendants of people who had emigrated from the remote interior of China to the coast to engage in pearl fishing. They spoke a peculiar dialect and differed from Chinese women by refusing to have their feet bound. They were prohibited from going ashore at any ports of call and from marrying

97

Chinese men. They attended the sumptuous banquets aboard the treasure ships and were taught how to hold their drink; they consumed huge amounts. They were well educated and, as well as satisfying the sexual demands of the ambassadors and envoys, were expected to play cards and chess, to act in plays and to sing and dance. Most of them were Buddhists, a creed they adopted because of its teaching of universal love, compassion and equality of all beings, man and woman, emperor or prostitute.

Concubines were not viewed with contempt because of their profession; they were regarded as a long-established, legitimate and necessary part of society. Indeed, sex was viewed as a sanctified act. 'Of all the ten thousand things created by heaven, man is the most precious. Of all things that make man prosper, none can be compared to sexual intercourse. It is modelled after heaven.'⁹ All men were free to have concubines, and 'class or fortune mean nothing in the selection as the only standard of preference is physical beauty'.¹⁰ The Chinese invariably invited rulers back to Beijing, and foreign envoys could dwell in heaven from the time they left their home country until they returned, often a year or more later. Little wonder that they accepted invitations to Beijing with such alacrity.

Sex aids and aphrodisiacs were available to concubines and their guests. The most popular aphrodisiac was a pair of red lizards caught while copulating and drowned alive in a jar of wine. The wine was left for a year before being sold. There were also 'the genitals of a lewd animal, the beaver, with the drug so obtained to anoint the penis', and 'bald chicken potion'¹¹ was very popular. The name derived from a prefect of Shu who started drinking the elixir when he was seventy. His wife was so exhausted by his subsequent virility that 'she could neither sit nor lie down', and insisted that her husband throw the potion away. A cockerel then ate it, jumped on a hen and 'continued copulating several days without interruption, pecking the hen's head until it was completely bald'.¹² The 'classic' concubine's bed was decorated with symbolic fruit. Bedspreads were embroidered with patterns of blossoming plum branches – the plum denoted sexual pleasure and fulfilment. The peach represented women's genitalia, and pomegranates represented the vulva. When envoys boarded treasure ships they frequently gave pomegranates as gifts. By day, concubines wore pantaloons, wide trousers; they usually made love wearing the *mo xiong*, a red brassière and silk stockings. Envoys and concubines were expected to wash their private parts before and after intercourse. A male contraceptive, a condom called *yin jia*, was available, and agar-agar jelly acted as a lubricant and mild disinfectant; venereal disease in the era of the treasure ships was rare, though it was to spread like wildfire in the late Ming period.

For the courtesan, the voyages offered an opportunity to attain the ultimate aim: to be freed to join a man who loved her. An envoy would request that a particular favoured concubine be disembarked with him at his home port, and she would remain with him as the fleet sailed on. Aboard she was respected and protected. If she failed to attain her dream and became too old to attract men, she was given the job of instructing the younger women in dancing and singing. By the time the foreign envoys left the treasure ships, some of the courtesans would undoubtedly have been pregnant. What happened to their children will become an interesting part of our story as more and more DNA analysis results come in. The concubines also assumed other duties - cooking, weaving and sewing silk, making hemp ropes and looking after the tubs of beans and coops of chickens. The eunuchs clearly had no use for the concubines and crewmen would have been executed for even approaching their quarters.

As the armada continued south on the first stage of the great voyage, the power to drive its huge ships was provided by the massive energy of the monsoon winds. Monsoons had always determined sailing patterns from China through the Indian Ocean to India and Africa. Ports such as Malacca (modern Melaka in Malaysia) developed where goods could be stored between the monsoons, the south-west in July and the north-east starting in January. Chinese ships took advantage of the northeast monsoon to sail before the wind to India, returning home on the next monsoon. The south-west monsoon reaches India in July, several weeks before it breaks over the coast of China. Ships from India sailing before the north-east monsoon winds arrived in Malacca before the junks from China had even set sail, and had unloaded and sailed for home by the time the junks arrived in Malacca.

According to Ma Huan, Zheng He's fleet arrived in Malacca six weeks after leaving Beijing. First established by the Chinese as a port where spices from the Moluccas - the Spice Islands (the modern Maluku Islands of Indonesia) - could be collected, Malacca soon expanded into a distribution centre for Chinese porcelain and Indian textiles, and grew to become one of the principal hubs of Indian Ocean trade. Halfway between India and China and 120 miles up the west coast of Malaysia from modern Singapore, Malacca lies on a strait through which sailing vessels must pass and has a sheltered location protected from storms by a ring of islands. There were rich tin mines in the surrounding area, a freshwater river bisected the town and the abundant water and teak from the surrounding forests made Malacca an ideal port. The trade in spices remained of paramount importance, offering merchants and traders the chance to amass vast fortunes. The attempt to exploit and control this vastly lucrative spice trade was later to be one of the principal engines driving the European voyages of discovery.

The Chinese set up a series of trading ports such as Malacca and Calicut on the south-west coast of India throughout southeast Asia and around the Indian Ocean. They were used as forward bases by Zheng He's fleets, providing fresh provisions,

THE FLEETS SET SAIL

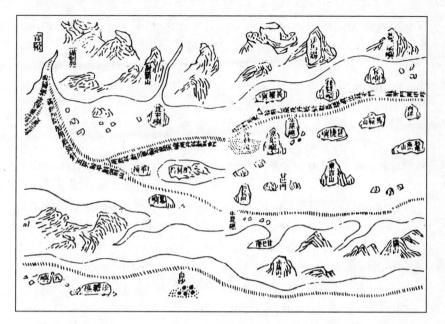

Chart of the Straits of Malacca from the Mao Kun map in the *Wu Pei Chi*. Malacca is in the top left-hand corner and Sumatra runs along the bottom.

water and wood all the way from China to East Africa. They were an essential prerequisite for Zhu Di's plan to bring the entire world into China's tribute system. In 1421, trade throughout the Indian Ocean was dominated by the Chinese and Arabs from Egypt and the Gulf States; relations between them were friendly. Like the rest of the known world, the Arabs craved Chinese porcelain and silk, and Chinese junks were almost always welcomed in Arab ports.

A report came from Mecca, the honoured, that a number of junks had come from China to the sea ports of India and two of them had anchored in the port of Aden, but their goods, chinaware, silk, musk and the like, were not disposed of there because of the disorders of the State of Yemen . . . The Sultan wrote to them to let them come to Jeddah and to show them honour.¹³

IMPERIAL CHINA

Chinese and Arabs met in equal numbers at the great Indian port of Calicut. Hormuz in the Persian Gulf and Malindi, Kilwa and Zanzibar in East Africa were Arab ports used extensively by the Chinese, but Malacca was virtually a Chinese colony and epitomized the Chinese forward base.

Formerly this place [Malacca] was not designated a 'country' ... There was no king of the country; it was controlled only by a chief. This territory was subordinate to the jurisdiction of Hsien Lo [Thailand]; it paid an annual tribute of forty Liang of gold [approx. 48 troy ounces]; if it were not [to pay] then Hsien Lo would send men to attack it.

In the seventh year of the Yung Lo [1409] the Emperor ordered the principal envoy the grand eunuch Cheng Ho [Zheng He] and others to assume command and to take the imperial edicts and to bestow upon the chief two strong seals, a hat, a girdle and a robe ... Thereafter Hsien Lo did not dare to invade it (Ma Huan, 1424).¹⁴

In effect, this was the birth of Malaysia.

The diaries of Ma Huan also give a vivid picture of south-east Asia – the crocodiles that inhabit the mangrove swamps, rubber being tapped, the tin mines and coconut plantations.

The coconut has ten different uses. The young tree has a syrup, very sweet and good to drink; it can be made into wine by fermentation. The old coconut has flesh, from which they express oil, and make sugar, and make a food stuff for eating. From the fibre which envelops the outside they make ropes for shipbuilding. The shell of the coconut makes bowls and cups; it is also good for burning to ash for the delicate operation of inlaying gold or silver. The trees are good for building houses, and the leaves are good for roofing houses.¹⁵

THE FLEETS SET SAIL

Ma Huan also described the procedures followed by the Chinese fleets when in port:

When Malacca is visited by Chinese merchant vessels, [the inhabitants] erect a barrier [for the collection of duties]. There are four gates in the city wall, each furnished with watch and drum towers. At night men with hand bells patrol the precincts. Inside the walls, a second small enclosure of palisades has been built where godowns [warehouses] have been constructed for the storage of specie and provisions. When the government ships [Zheng He's fleet] were returning homewards, they visited this place in order both to repair their vessels and to load local products. Here they waited for a favourable wind from the south and in the middle of the fifth month [June] they put to sea on their return voyage.¹⁶

As well as trade, the Chinese were also greatly intrigued by the erotic Thai and Malaccan women. 'The mental capacity of the wives far exceeds that of their husbands. Should it happen that one of their wives is on terms of great intimacy with one of our countrymen, and allows him to feast and carouse with her, her husband looks calmly on and is not angry, but simply remarks: "My wife is beautiful and the Chinaman is delighted with her." '¹⁷ Malaccan men went to considerable lengths to give pleasure to their women. Chinese-made tin or hollow gold beads assisted them, a custom still practised in some parts of south-east Asia today.

When a man has attained his twentieth year, they take the skin which surrounds the penis (*membrum virile*), and with a fine knife shaped like an onion they open it up and insert a dozen tin beads inside the skin . . . [The beads] look like a cluster of grapes. The King and the great chiefs or the rich people use hollow beads of gold in which is placed a grain of sand. After these have been

IMPERIAL CHINA

inserted, when they walk there is a tinkling sound which is considered beautiful. Men who have no beads inserted [in the manner described] are people of the lower class.¹⁸

All manner of peoples visited Malacca – Thais, Bengalis, Gujaratis, Parsees, Arabs and many others conversed in eightyfour languages – and all returned home with Chinese goods. Boats that brought spices from the Spice Islands of Ternate and Tidore in the Moluccas returned with Chinese porcelain. Arab dhows sailed north-west for India, the Gulf, Egypt and Venice laden with silk, supplemented with batiks and tin from Malacca and Java. After the Chinese junks had unloaded their silk and porcelain, they refilled their holds with spice, Indian gems and Venetian glass.

[The Chinese] go about the country, scales in hand, buying up all the pepper they find, and after weighing a small amount so that they can judge approximately the quantity, they offer the payment for it in a lump sum, depending on the need for money of those who are selling it, and in this way they amass such a quantity they can fill the ships from China when they arrive, selling fifty thousand caixas' [a Portuguese trading currency] worth, which has cost them no more than twelve thousand.¹⁹

Throughout the archipelago and the whole of south-east Asia, trade was focused on Malacca and dominated by the Chinese. China consumed a hundred times more spice than distant Europe, and the Chinese merchants not only controlled commodity and currency markets but property prices too, even amusement and gambling. For ten months on end there was a Chinese fair where merchants gambled. 'As their merchandise is sold, they occupy less room and rent fewer houses. As sales fall, the gaming increases'.²⁰ Malacca was used as a forward base on each of Admiral Zheng He's voyages, and the importance he

THE FLEETS SET SAIL

attached to the port is demonstrated by the temple he established there. It still stands in the road that bears his name, a few yards east of the Malacca River. According to legend, his flagship was once holed on a reef but its triple hull and watertight compartments enabled him to reach Malacca without sinking.

Zheng He's expeditions had become progressively more adventurous. His first, between 1405 and 1407, had sailed in sixty-two treasure ships manned by 27,800 men. En route for Malacca, they visited Cambodia and Java, then sailed on the next south-west monsoon for Sri Lanka and Calicut on the west coast of India. An incident on this voyage cemented a belief among the sailors that Zheng He's fleet was under divine protection. In the midst of a storm so ferocious that the sailors were praying to Ma Tsu to save them from death, a 'divine light' – presumably St Elmo's Fire, a luminous electrical discharge sometimes seen during a storm at sea – appeared at the tips of the masts of Zheng He's flagship. 'As soon as this miraculous light appeared, the danger was appeased.²¹

By the time of the third expedition, 1409 to 1411, Zheng He had established a settled programme. The fleet used Malacca as its forward base and there divided into squadrons that sailed on independently to separate destinations. The next great fleet set sail from China in 1413. One squadron departed from Malacca for Bengal, the Maldives and Africa; another sailed for the Arabian Sea and up the Persian Gulf to Hormuz. The fleets of the following expedition, 1417 to 1419, visited every major trading port in Africa, Arabia, India and Asia, then brought back the rulers and ambassadors travelling to Beijing for the inauguration of the Forbidden City. They were to spend almost two years enjoying the lavish hospitality of the emperor before the inauguration of his capital. Now, another fleet led by Admiral Yang Qing had been sent on ahead of the main armada. After returning rulers and ambassadors to the Gulf states, his daunting task was to solve the problem of determining longitude.

The rest of Zheng He's armada was embarked on the greatest voyage of them all. After provisioning in Malacca, they sailed northwards for five days before anchoring off Semudera (modern Sumatra) at the entrance to the Indian Ocean. There, the admiral divided his armada into four fleets. Each carried an army equipped with gunpowder weapons. Three of these great fleets were placed under the command of Grand Eunuch Hong Bao, Eunuch Zhou Man and Admiral Zhou Wen.²² The fourth, by far the smallest fleet, remained under Zheng He's direct command. He was the emperor's right-hand man and could not be spared for the entire duration of the voyage. He would return envoys to south-east Asia and then sail for home, arriving in November 1421.

We know from an account by the widely travelled Portuguese poet Camões (1524-1580) that by the time the Chinese fleets reached Calicut so many foreign merchant ships had joined the convoy that it comprised over eight hundred sail. Assuming that Zheng He would have taken only a handful of ships with him for a brief and relatively easy passage home, it is safe to estimate that each of the remaining Chinese fleets numbered nearly two hundred ships - the largest armada the world had ever known. Zheng He delegated powers of life and death to his admirals, and command was further delegated within each fleet: two brigadiers and ninety-three captains commanded regiments, and 104 lieutenants and 103 sub-lieutenants reported to them. The first task of the fleets was to return the rulers, ambassadors and envoys to their home ports in India, Arabia and East Africa. They were then to rendezvous off the southern coast of Africa and set sail into uncharted waters to fulfil Zhu Di's vision. They knew exactly what was expected of them. They would proceed all the way to the end of the earth to collect tribute from the barbarians beyond the seas or they would die in the attempt.

II The Guiding Stars

ROUNDING

4

THE

CAPE

IN ORDER TO TRACE THE STORY TO THIS POINT, I HAD HAD TO learn the history of medieval China almost from scratch; my previous knowledge of Chinese history and culture had been modest at best. However, as I began to trace the voyages of the great treasure fleets in the 'missing years' from 1421 to 1423, I was entering familiar territory, making use of knowledge and skills I had acquired over many years' experience as a navigator and commanding officer on the high seas. During that sixth voyage, the fleets of Hong Bao, Zhou Man, Zhou Wen and Yang Oing sailed the oceans for as many as five years, but the mandarin official at the Ministry of War, Liu Daxia, had ordered the destruction of all written records and there was virtually no evidence to show where they had sailed or what discoveries they had made. But where before I had been plodding in the footsteps of academics and historians far more knowledgeable and gifted than myself, I could now use my skills to decipher the fragmentary evidence offered by ancient maps and charts, and those few documents and artefacts to have survived.

Two of these artefacts were carved stones. Old, virtually ignored by the new regime in China and perhaps fearing that he might never return, Admiral Zheng He erected two carved stones in palaces of the Celestial Spouse, a Taoist goddess, before he set sail on his final voyage in late 1431. The first was in Chiang-su, Fujian province, and the second at Liu-Chia-Chang. Only rediscovered in 1930, the stones commemorate the crowning achievements of his life, the great voyages of the treasure fleets. Their inscriptions are the key to unlocking the riddle of the sixth voyage.

Inscription at Chiang-su

From the time when we, Cheng Ho [Zheng He] and his companions at the beginning of the Yung Lo Period [or Yong Le – Zhu Di, 1403], received the imperial commission as envoys to the barbarians, up until now seven voyages have taken place and each

THE GUIDING STARS

time we have commanded several tens of thousands of government soldiers and more than a hundred oceangoing vessels. Starting from T'ai Ts'ang and taking the sea, we have by way of the countries of Chan-Ch'eng (Champa), Hsien-Lo (Siam), Kua-Wa (Java), K'o Chih (Cochin) and Ku-Li (Calicut) reached Hu-Lu-Mo-Ssu [Hormuz, in the Gulf] and other countries of the western regions, more than three thousand countries in all.² *Inscription at Liu-Chia-Chang*

We have traversed more than 100,000 *li* of immense water spaces and have beheld in the ocean huge waves like mountains rising sky-high [tsunami], and we have set eyes on barbarian regions far away, hidden in a blue transparency of light vapours, while our sails, loftily unfurled like clouds, day and night continued their course, rapid like that of a star, traversing those savage waves.³

The original English translation of Zheng He's Chiang-su inscription had been made by that great scholar of medieval China J.J.L. Duyvendak in the 1930s. In his article 'The True Dates of the Chinese Maritime Expeditions in the Early Fifteenth Century', the translation of a key phrase in the inscription was given as 'three thousand countries'. He and later scholars⁴ thought that such a claim was so wildly implausible that the stone mason who carved the inscription must have made a mistake. On these grounds, the translation was amended to read 'thirty countries'. This was then repeated by subsequent writers and historians, and it was only when I consulted Duyvendak's text that I realized the original translation could have been correct; there was no logical reason why the mason who carved the inscription should have made such a gross error. But could such an extraordinary claim really be true? Had Zheng He's fleets reached three thousand countries? If so, the history of the exploration of the globe would have to be rewritten.

In attempting to reconstruct the voyages the fleets had made,

ROUNDING THE CAPE

I first had to put myself into the shoes of the Chinese admirals. There was no better way of doing that than by sailing in their wake, as I had done as a young officer in the British Royal Navy aboard HMS Newfoundland. Our captain was a very brave and distinguished submariner, now Vice-Admiral Sir Arthur Hezlet KBE CB DSO and bar DSC. Newfoundland left Singapore in February 1959, passed through the Malacca Straits into the Indian Ocean and then turned westwards for Africa. We visited the Seychelles in the Indian Ocean before continuing west, making landfall on the East African coast at Mombasa. From there we went on to call at Zanzibar and Dar es Salaam before arriving at Lourenço Marques. We then sailed on down the east coast of Africa, visiting East London and Port Elizabeth before rounding the Cape, calling in at Cape Town, and sailing up the west coast round the 'bulge' of Africa to Sierra Leone, through the Cape Verde Islands and back home to England.

That journey gave me an invaluable insight into the winds, currents and navigational problems the Chinese admirals had encountered. Without that experience I could never have followed the elusive trail of evidence across the globe that revealed the incredible journeys made by the great Chinese treasure fleets. If I was able to state with confidence the course a Chinese fleet had taken, it was because the surviving maps and charts and my own knowledge of the winds, currents and sea conditions they faced told me the route as surely as if there had been a written record of it.

After parting company with Zheng He, the three Chinese fleets sailed for Calicut, the capital of Kerala in southern India and by far the most important port in the Indian Ocean. The Chinese had been trading with Calicut since the Tang dynasty (AD 618–907). It was not only an important Chinese forward base but a great trading port, holding a huge stockpile of Indian cotton and textiles (calico), and the foremost centre for the trade in pepper. Its rulers, the Zamorins - Hindu kings - had built up an extensive network of trading relations throughout the Indian Ocean, East Africa and south-east Asia. Nearly all the celebrated travellers and explorers of the Middle Ages, such as Marco Polo (1254-1324), Ibn Battuta (1304-1368) and Abdul Razak (active 1349-1387), travelled to Calicut. In Zhu Di's reign, the Chinese explicitly recognized Calicut, which they called Ku-Li, as the leading emporium of the Indian Ocean, describing it as 'the most important harbour in the western ocean' and 'the meeting port of all foreign merchants'.5 Chinese sailing directions for the Indian Ocean specified distances to and from Calicut and gave courses to steer between Calicut, Malacca, northern India, the Gulf and Africa. For their part, Calicut's rulers venerated China; between 1405 and 1419 they sent a series of diplomatic missions to Nanjing and Beijing, and a delegation attended the inauguration of the Forbidden City and presented Zhu Di with valuable horses.

The official historian Ma Huan described the Chinese voyage from China via Malacca to Calicut in great detail: no fewer than nine pages of his account were devoted to the city. He gave an enthralling account of life in a medieval Indian city through Chinese eyes, noting the religious practices of the Zamorin king in contrast to those of his Muslim subjects, and bringing to life the habits of the people, their festivals, music and dancing, clothing and food: 'The King of the country and the people of the country all refrain from eating the flesh of the ox. The great chiefs are Muslim people, they all refrain from eating the flesh of the pig.'6 Ma Huan went on to describe local crime and punishment, in particular how the guilt or innocence of a person was determined in a 'trial by ordeal' in which the accused's fingers were held in boiling ghee, or clarified butter, before being wrapped in cotton. He also detailed the way in which goods from the treasure fleets were sold, and the form of contract used:

ROUNDING THE CAPE

If a treasure ship goes there, it is left entirely to the two men to superintend the buying and selling: the King sends a Chief and a Chei-Ti [a port customs official] to examine the account books in the official bureau; a broker comes and joins them [and] a high officer who commands the ships discusses the choice of a certain date for fixing prices. When the day arrives, they first of all take the silk embroideries and the open-work silks ... when the price has been fixed, they write out an agreement ...

The Chief and the Chei-Ti with his excellency the Eunuch all join hands together and the broker then says: 'In such and such a moon on such and such a day, we have all joined hands and sealed our agreement with a hand clasp. Whether [the price] be dear or cheap, we will never repudiate or change it.'⁷

By an extraordinary coincidence, at the very time the treasure fleets were in the city in 1421, a young Venetian, Niccolò da Conti (c. 1395-1469), also arrived. A well-connected trader, da Conti had left Venice in 1414 for Alexandria. The Islamic rulers in Egypt, the Mamluk sultans from the steppes of Asia, did not then permit Christians to travel south of Cairo for they were determined that the Indian Ocean should remain an Islamic lake. While in Egypt, da Conti had learned Arabic, married a Muslim woman and converted to Islam. Now travelling as a Muslim merchant, he journeyed to the Euphrates delta (in modern Iraq) and on to India, arriving by late 1420. He made for Calicut, because at the time it was a centre for Nestorian Christians - a cult of followers of St Thomas, also known as 'The Holy Apostolic Catholic Assyrian Church of the East', that had thrived in Syria in the sixth century and still exists in parts of western Asia - who were allowed to worship there by the tolerant Zamorins.

Years later, as penance for da Conti's renunciation of Christianity, Pope Eugenius IV made him relate the story of his journeys to the papal secretary Poggio Bracciolini, who had them published.⁸ Da Conti described Calicut as 'eight miles in circumference, a noble emporium for all India, abounding in pepper, lac [a kind of insect gum used in making lacquer] and ginger'. There can be no doubt that da Conti was in Calicut when the Chinese fleets passed through, nor that he had at the very least boarded a junk, for he later described them in conversation with his friend, the Castilian Pedro Tafur: 'Ships [junks] like great houses and not fashioned at all like ours. They have ten or twelve sails and great cisterns of water within ... the lower part is constructed with triple planks. But some ships are built in compartments, so that should one part be shattered, the other part remaining entire, they may accomplish the voyage." The description could only refer to warships of Zheng He's fleet; Chinese merchantmen did not have that type of construction, or that number of sails. I felt certain that da Conti also met Ma Huan in Calicut, for he described scenes almost identical to those Ma Huan recounted, as I discovered when comparing their two accounts. It was as if two different witnesses were describing the same things: the land surrounding Calicut, the trial by ordeal,

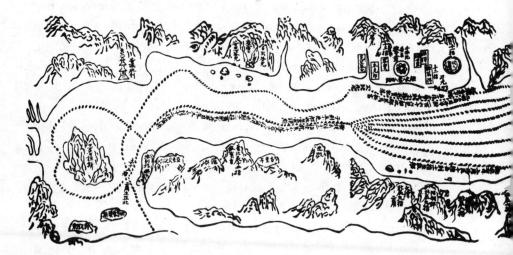

Chart of the Arabian Sea from the Mao Kun map in the *Wu Pei Chi*. At the top is the west coast of India and at the bottom the coast of Arabia.

capons and partridges kept in coops, the price and quality of ginger and pepper. Only in writing about sex did their emphases differ: da Conti described how women's orgasms were heightened by the beads inserted in boys' penises; the more fastidious Ma Huan mentioned only the tinkling noise the beads made.

Having travelled through India and the Far East on many occasions over several decades, I can vouchsafe for the accuracy of da Conti's descriptions – durians (a luscious but curious fruit) smelling of cheese in Malaysia, the musk of civet cats on the Malabar coast, the sweet smell of the scent used by Goanese women. He describes African ostriches and hippopotami, the rubies of Sri Lanka, Hindu women practising suttee (selfimmolation on their husbands' funeral pyres), vegetarian Brahmins (the priestly caste of Hindu India), the dusty smell of cinnamon. Da Conti's descriptions of his subsequent travels in Chinese junks were to prove a vital link in solving the riddle of where the Chinese fleets had gone in the 'lost' years, for, as Ma Huan's account makes clear, with his role as official chronicler

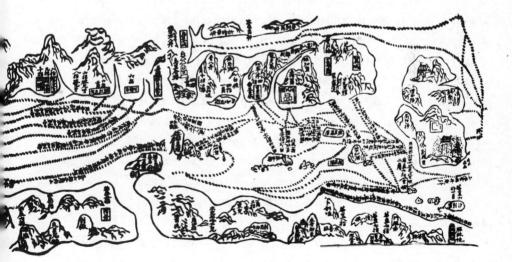

apparently over, he left the treasure fleets at Calicut. His departure meant that one useful source of information had dried up, and I had to look for other sources to replace him. The importance of da Conti to the story of the Chinese voyages became increasingly clear. Someone must have brought back copies of maps showing the discoveries made by the Chinese fleets, for how else could this information have reached Europe and become incorporated in the charts that were later to guide the Portuguese explorers? If it turned out that da Conti had also conversed with the Chinese on their return journey, he would be a prime candidate. Those charts were now proving equally vital to me as I endeavoured to trace the routes the Chinese fleets had followed.

The first task of the Chinese admirals after leaving Calicut was to return ambassadors to the coastal states of East Africa. Their passage plan was marked on the Chinese Mao Kun chart compiled after the sixth voyage. The Mao Kun forms part of the much larger Wu Pei Chi. That part of the Mao Kun that has survived - no-one knows how large it originally was - is in strip form, 21 feet long and plastered with hundreds of names of ports and prominent coastal features, and the courses to steer and distances between them. It is 'believed to have been compiled in about 1422 from a mass of information brought back by Zheng He's fleet or collected for their use'.¹⁰ Only a part of it has been translated to date, and as I write, scholars of medieval Chinese are working on the remainder. The translations of the Mao Kun and the Wu Pei Chi, and other documents of the period, will almost certainly produce further evidence of the great Chinese voyages. The quest to find further records was formally inaugurated at a conference in Nanjing on 18 October 2002.11

The treasure fleets sailed from Calicut on the tail end of the north-east monsoon into the Indian Ocean, altering course to the south-west to make landings in Africa to return the ambassadors to their home ports – the route we followed over

ROUNDING THE CAPE

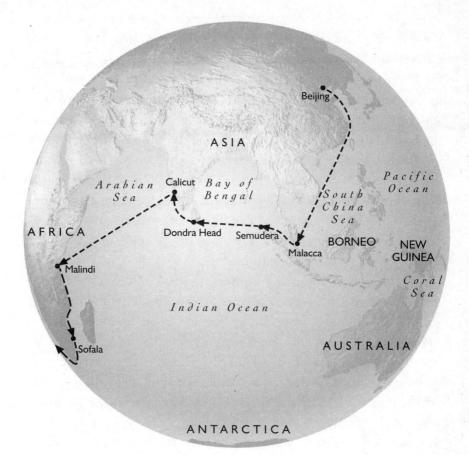

The voyage to Sofala.

half a millennium later in HMS *Newfoundland*. It would have been uneconomical for all the fleets to have gone to each African state, so they would almost certainly have divided, with one returning ambassadors to Mogadishu (in modern Somalia) in the north, another to Zanzibar in the middle of the east coast, and a third to Kilwa (in modern Tanzania) further south. After all the ambassadors had been returned to their home countries, the Mao Kun indicates that the fleets rendezvoused off Sofala (near Maputo in modern Mozambique). Finding the rendezvous must have posed a major problem, for during a voyage from India to southern Africa, Polaris, the Chinese guiding star, would have sunk closer and closer to the horizon and become invisible at 3°40'N, north of Mogadishu in Somalia. Until they found another guiding star in the southern hemisphere to fulfil the same purpose as Polaris in the north, they were sailing into the unknown. They could use the Southern Cross for direction, for they knew that its leading stars, Crucis Alpha and Crucis Gamma, pointed to the South Pole, but as yet they had no star they could use to determine latitude. To locate one, they would have to sail far into the icy waters of the deep south. This was to be one of the most important aims of the expedition.

Allowing for sailing a hundred nautical miles (115 statute miles) in a day (the average speed recorded in the surviving records of Chinese voyages in the Indian Ocean) and for remaining a maximum of one week in each port to re-provision (it usually took two to four days), all three fleets had probably completed the return of the envoys and ambassadors to their home ports by July 1421. By the time they had arrived at the rendezvous off Sofala, the admirals had already sailed some ten thousand miles since leaving China four months earlier. Some would not return for five years, but they did leave signposts of where they had sailed. The Chinese were rightly proud of their great voyages, and whenever they landed they usually carved stones in commemoration, like those erected by Zheng He in China. There are other similar stones near Cochin and Calicut in India, and near Galle in Sri Lanka. Some of the masons and stone-carvers who had worked on the Forbidden City had been brought with the fleets for precisely this purpose. The discovery of such stones was to prove one of the crucial links in the chain of evidence I was assembling. From the inscriptions on the carved stone erected by Zheng He in the Palace of the Celestial Spouse at Liu-Chia-Chang, I knew they had sailed forty thousand miles on their sixth voyage – almost twice around the globe.¹² The *Wu Pei Chi* and the Mao Kun covered only the Chinese routes across the Indian and Southern Oceans. Without Chinese records to help me, how could I find out how far they had sailed, what new oceans they had traversed and what new lands they had discovered?

My first recourse was to turn to the other great seafarers of the fifteenth century, the Arabs. My initial instinct has always been to look first for evidence in maps. The British Library holds copies of the great collection of early Arab maps assembled by Prince Youssuf Kamal, a wealthy Egyptian. These maps showed that the Arabs had certainly visited the east coast of Africa, and made regular voyages from the Gulf to collect slaves. However, dependent upon the prevailing winds, they had not ventured beyond the monsoon belt that spans the Indian Ocean but stops short of southern Africa. They set off from the Gulf on the north-east monsoon, sailed down to Zanzibar or sometimes further south to Kilwa and Sofala, then returned on the next south-west monsoon to the Gulf, laden with their tragic cargoes of slaves. I could not trace a single Arab chart that accurately depicted the east coast of Africa south of Sofala.

I knew of, but at that stage had never seen, a planisphere – a map of the world – showing the Indian Ocean and southern Africa. It was drawn in 1459 by Fra Mauro, a cartographer based on the island of San Michele in the Venetian Lagoon but working for Dom Pedro of Portugal, Henry the Navigator's brother and another leading light in the first wave of European journeys of exploration, who was then compiling a map of the world. I wondered if Fra Mauro's map, now held by the Biblioteca Nazionale Marciana, could throw some light on the Chinese voyages.

When I flew to Venice, the curator, Dr Piero Falchetta, took me into his office and proudly showed me Fra Mauro's map, a grandiose undertaking: the first map of the entire world to be

THE GUIDING STARS

drawn since the days of the Roman Empire. It was to be the first, vital clue to the course taken by the Chinese fleets. Dr Falchetta pointed out that Fra Mauro had correctly drawn the Cape of Good Hope (which he had called Cap de Diab) with its easily identifiable triangular shape, and had done so thirty years before Bartolomeu Dias rounded the Cape. That this was no mistake was emphasized by Fra Mauro himself, for he had appended notes stating that a ship or junk had rounded the Cape:

Around the year 1420, a ship or junk [coming] from India on a non-stop crossing of the Indian Ocean past 'the Isles of Men and Women' was driven beyond Cap de Diab [Cape of Good Hope] and through the Isole Verde and obscured islands [or darkness] towards the west and south-west for 40 days, found nothing but sea and sky. In their estimation, they ran for 2,000 miles and fortune deserted them. They made their return to the said Cap de Diab in 70 days.¹³

Near the note, Fra Mauro had drawn a picture of a Chinese junk. It had the highly unusual broad, square bow, like a modern tank landing-craft, typical of Zheng He's junks, and was shown much bigger than his depiction of European caravels. Another inscription, placed in the middle of the Indian Ocean, read: 'The ships or junks that navigate these seas carry four masts or more, some of which can be raised or lowered, and have 40 to 60 cabins for the merchants.'¹⁴ A further note described the huge eggs the crew found when replenishing at Cap de Diab and the giant size of the birds that laid them. That description could only have applied to ostriches.

Fra Mauro's planisphere of 1459 showed the Cape of Good Hope correctly drawn, had an accurate depiction of Zheng He's junks and described birds unique to southern Africa several decades before the first Europeans, Dias and da Gama, got to the Cape. The immediate and obvious question was, how did Fra Mauro get his information? How did he know the shape of a junk, and that the Cape was triangular? I found a partial answer in another fifteenth-century document describing the Portuguese conquest of Guinea: 'Fra Mauro has himself spoken with "a trustworthy person" who said that he had sailed from India past Sofala to Garbin, a place located in the middle of the west coast of Africa.'¹⁵ There was no other clue to help identify the location of Garbin; the name does not correspond to that of any modern place. It is a bastardized version of the Arabic Al Gharb, meaning 'a place in the West'. The identity of the 'trustworthy person' would vitally affect the provenance and credibility of the notes on Fra Mauro's planisphere.

I was convinced that the person could only have been Niccolò da Conti. He was in Calicut when the Chinese junks berthed to offload passengers and cargo and take on supplies on their way across the Indian Ocean. The notes on Fra Mauro's map alluding to the voyage of the junk refer to 'the Isles of Men and Women', a peculiar name also used by da Conti in the account related to the papal secretary Poggio Bracciolini. Da Conti (c. 1395–1469) was a contemporary of Fra Mauro (c. 1385-1459), both came from Venice, and both were engaged in exploration or documenting exploration. Fra Mauro was working for the Portuguese government, and as well as publishing da Conti's stories, Poggio Bracciolini was also the intermediary between the Pope, Fra Mauro and the Portuguese government. There are no records of other Venetian merchants in India at the time, let alone in Calicut, when the Chinese passed through. It would be extraordinary if Fra Mauro's 'trustworthy person' were not da Conti.¹⁶

This was the crucial link in the chain connecting the maps drawn by the Chinese cartographers during the great voyages of exploration by the treasure fleets to the later Portuguese discoveries based on the mysterious maps they were soon to obtain. Chinese knowledge and Chinese maps passed from da Conti to Fra Mauro, and from him to Dom Pedro of Portugal and Prince Henry the Navigator. The Papal Secretary, Poggio Bracciolini, was, as we shall see, a key intermediary.

If Fra Mauro's description did come courtesy of da Conti's travels aboard a Chinese junk, it came from a reliable and accurate eyewitness, as I had already discovered. In those circumstances it seemed sensible to examine Fra Mauro/da Conti's claim that a ship or junk had indeed rounded the Cape of Good Hope and then sailed into the South Atlantic. If so, it was a towering achievement, for Pedro Álvares Cabral (1467–1520) and Bartolomeu Dias (c. 1450–1500), the first Europeans to round the Cape and venture into the Indian Ocean, did not do so until 1488. To have drawn the Cape so accurately Fra Mauro must have had a copy of a chart showing the exact shape and location of the southern tip of Africa. Da Conti could have brought him such a map, obtained during his voyages aboard the Chinese fleet.

As I know from my own naval career, rounding the Cape remains an emotional experience for sailors today. As the clouds peel off the strange flat mountain tops of the fabled Cape, another ocean and another world – the exotic East – beckons. To the Chinese in 1421, coming from the opposite direction, it must have seemed that at last they had reached the brink of the unknown – not even the great admirals of the Tang dynasty had sailed this far. As they saw the lengthening waves and deepening troughs, they must have prayed that their ships would prove equal to the colossal challenges the vast and stormy Atlantic Ocean would surely bring.

I now had to discover where the mysterious ship described by Fra Mauro had sailed after rounding the Cape, and look for further independent evidence that it was a junk of one of the Chinese fleets. I started from the treasure fleets' last recorded position, shown on the Mao Kun chart of 1422 as off Sofala, sailing southwards at 6.25 knots, a good speed explained by the Aghulas current that sweeps southwards along the east coast of South Africa down to the tip. At that speed, the Chinese would have rounded the Cape of Good Hope in approximately three weeks, by August 1421.

As they have for millennia, winds and currents in the South Atlantic circle anti-clockwise in a huge oval loop from the Cape of Good Hope in the south to the 'bulge' of Africa in the north. At the Cape, the mariner meets the Benguela current that carries him due north up the west coast of Africa. After some three thousand miles, the current starts to hook first to the north-west, then westwards to South America. Off the coast of South America the current continues its anti-clockwise movement, running southwards off Brazil and Patagonia down the east coast as far as Cape Horn before sweeping to the east, back to South Africa. If a sailing ship, carrying sufficient supplies and robust enough to withstand the 'Roaring Forties' - powerful winds that circle the globe for hundreds of miles north and south of the latitude that gives them their name - were to hoist its sails off South Africa and sail before the wind and current, then several months later, having crossed thousands of miles of ocean in this great anti-clockwise loop, it would return more or less to where it started. An illustration of this is provided by the epic voyage of a very brave and distinguished submarine captain, now Vice-Admiral Sir Ian McIntosh KBE CB DSO DSC, once captain of the submarine squadron in which I served. He wrote to me:

In March 1941 I was a Sub Lieutenant in a merchant ship taking passage to Alexandria. She was sunk by gun-fire by an armed commerce raider some 500 to 600 miles west of Freetown at about 08°N 30°W. The 28-foot standard wooden lifeboat, 'authorised' capacity 56, finally had 82 souls on board.

Even when I had repaired the shrapnel holes in the hull and the boat was reasonably dry I could not get her to sail closer than 5 or 6 points to the wind, a brisk NE Trade. This would never have

THE GUIDING STARS

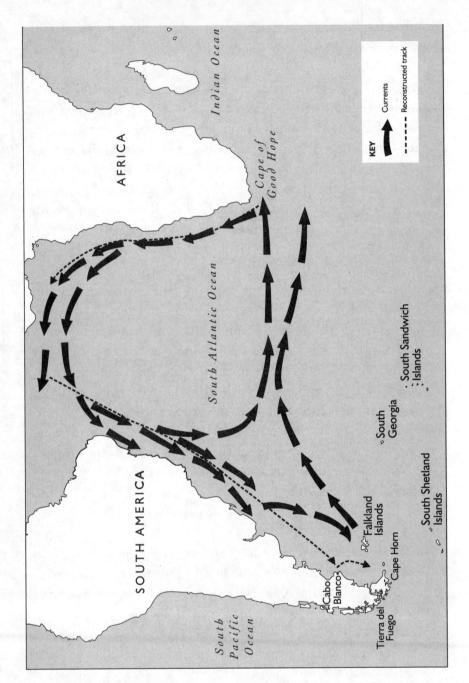

The circulatory winds and currents in the South Atlantic Ocean.

ROUNDING THE CAPE

allowed us to reach Africa, and to run before the wind to Brazil some 1,600 miles distant by the route chosen seemed preferable.

The plan was to steer due west until reaching 33° West then alter course to SW. This made full use of the NE Trades and gave us only a few days of shifting winds (and some most welcome rain) in the Doldrums before picking up light SE Trade winds. We made the [South American] coast on the 22nd day, ran NW along the coast looking for a suitable landing, which we found on the afternoon of the 23rd day.

I had estimated a maximum of 28 days for rationing purposes knowing that the equatorial currents were helping us but I had no idea at our latitude and time of the year whether they were a quarter knot or more than 1 knot, so I disregarded it in my noon DR [Dead Reckoning] positions.¹⁷

It is entirely feasible that the treasure fleets did reach the Cape of Good Hope where they would have been swept by the wind and current around the Cape and up the west coast of Africa to the 'Garbin' described by Fra Mauro. What I now urgently needed was independent evidence that this had happened. I pondered this question for months. Then I had a stroke of luck. John E. Wills Jr, Professor of History at the University of Southern California, and Dr Joseph McDermott, Professor of Chinese at Cambridge University, England, suggested to me that although the charts and records of the treasure fleets in China had been destroyed, there might be copies in Japan, for Japanese scholars were particularly interested in the early Ming era.

Subsequent research revealed that Ryukoku University in Kyoto held a copy of a Chinese/Korean chart known colloquially as the Kangnido. The Korean ambassador had presented Zhu Di with this extraordinary world map in 1403 after his inauguration as emperor. The original map, however, has been lost, and the Ryukoku version of the Kangnido was extensively modified after 1420. It is nearly square and strikingly large, measuring 1.7 by 1.6 metres. Painted on silk, it remains in excellent condition, its colours little faded by the passing centuries. It is 'nicely organized and well worth admiration. One can indeed know the world without going out of the door.'¹⁸

The Kangnido gave a grandiose panoramic view of the world as seen in the early fifteenth century, and was compiled from many different sources. Names for Europe were in Persian Arabic, central Asia came from the Mongols, China and southeast Asia from old Chinese maps. Europe was covered in names as far north as Germany (named Alumangia). Spain was depicted, as were the straits of Gibraltar leading into the Mediterranean and the North African coast with the Atlas mountains. Europe, Africa, Asia, Korea and China were in their correct positions relative to one another, though Korea, perhaps for reasons connected with national pride and its traditional rivalry with Japan, was shown vastly larger than it should be and Japan much smaller. Nonetheless, it was an extraordinary piece of mapmaking.

For the moment, the part of the Kangnido that interested me most was Africa. So accurately does the Kangnido depict the coasts of East, South and West Africa that there cannot be a shred of doubt that it was charted by someone who had sailed round the Cape. Europeans did not reach South Africa for another sixty years; Arab navigators on the west coast never sailed south of Agadir in modern Morocco, eight thousand kilometres away, and the Mongols never reached Africa at all. The accuracy of the Kangnido told me that Mauro/da Conti's description made absolute sense. A Chinese navigator could indeed have reached 'Garbin' and then drawn the Kangnido. Still I had no precise location for Garbin save that, from the shape of the coastline shown on the Kangnido, it appeared to be near the Bay of Biafra, off western Nigeria. It was a problem I would have to address later. For now, I felt justified in assuming that the 'junk' referred to by Fra Mauro and drawn on his planisphere was from

ROUNDING THE CAPE

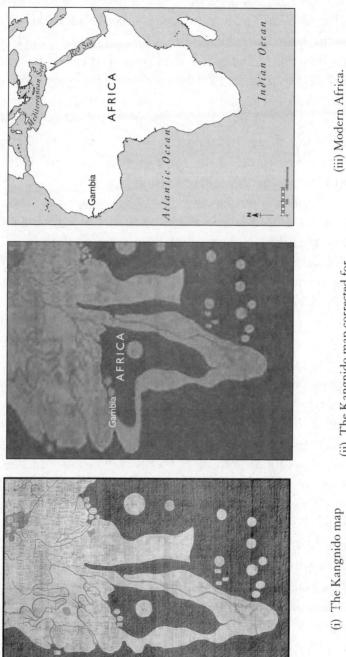

(ii) The Kangnido map corrected for longitude.

showingAfrica.

the treasure fleets, for Chinese merchant ships did not sail beyond Kilwa in East Africa. The Kangnido was much less accurate when it came to the 'bulge' of Africa north of the Bay of Biafra, so I next turned my attention to that part of the voyage. If they had managed to survey the coast of southern Africa with such accuracy, why was the bulge of West Africa not shown on the Kangnido chart?

By the time the Chinese fleets reached the Bay of Biafra, they had sailed some three thousand miles north from the Cape. I assumed that they rounded the Cape on their outward journey some time in August. At their average speed of 4.8 knots it would have taken about twenty days to sail from the Cape to 'Garbin'. They would have reached it in late August or early September 1421, the end of summer and towards the end of the rainy season. As I well know from my own time at sea in the South Atlantic, there is an extraordinary natural phenomenon in this part of Africa. Starting in the Bay of Biafra, the south equatorial current runs first to the north past São Tomé e Príncipe Island (where the bulge starts) then hooks westwards to flow due west along the south coast of the bulge, past Nigeria, Ghana and the Ivory and Gold Coasts until it peters out a thousand miles out into the Atlantic around 21°W. This massive body of cold water flows westwards with considerable speed the whole year round; a minor change occurs in summer when it extends further north to reach 5°N, a similar latitude to Monrovia in modern Liberia.

This current would have had two important implications for the Chinese: they would have been carried due west for some 1,800 miles, but they would not have known that this had happened. At this stage of their voyage the Chinese could only measure longitude by estimating their speed through the water, and if the great body of water was itself moving, either against them or with them, there was no way that they could determine their position with any accuracy, any more than a man walking up an escalator can judge the distance he has travelled by the number of paces he has taken. With mounting excitement, I realized that the charts drawn after they had entered the south equatorial current had to be adjusted to take account of this discrepancy, and the land they showed moved by up to 1,800 miles further to the west. I went back to my copy of the Kangnido and adjusted the land north of the Bay of Biafra to allow for this longitudinal error. The result was startling: the familiar outline of Africa became immediately recognizable. It appeared that the Chinese had been carried by the wind and current to the 'bulge' of Africa forty years before the first Europeans set eyes on it.

The south equatorial current gave them a 'free ride' westwards until the current petered out a thousand miles into the Atlantic. By then, they were in the south-east trade belt and being blown towards the coast of Senegal. In the wet season, running from April to October, the Sénégal current off this coast of West Africa reverses its normal direction and runs northwards along the coast at a rate of 0.6 to 1 knot. Yet again the junks would have had a free ride, this time to the north for around five hundred miles until the current itself petered out off Dakar, the modern capital of Senegal. By then they were in the belt of the north-east trade winds, blowing them south-west to the Cape Verde Islands. These lonely islands, then unknown to Europeans, were to play a vital part in unravelling the mystery of the Chinese voyages.

I checked and rechecked my calculations. By late September the junks that left the Cape of Good Hope in August would have found themselves approaching the Cape Verde Islands from the north-east. The design of the ships and the prevailing winds and currents would have prevented these flat-bottomed, broad-beamed monsters from sailing south at any point. It was now clear that Fra Mauro's account was entirely possible and that the Cape Verde Islands could have been the 'Isole Verde' reached by the ship or junk from India, forty days after leaving the Cape of Good Hope; they even had the same name. At 4.8 knots, the speed the treasure fleets averaged over all six great voyages, this would have taken

THE GUIDING STARS

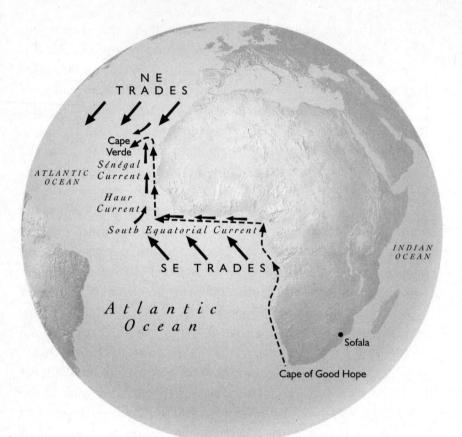

The journey to the Cape Verde Islands.

forty days. Vasco da Gama took thirty-three days to make the same passage in the closing years of the century.

To have been called the 'Isole Verde', the islands Niccolò da Conti described to Fra Mauro must have been strikingly green. I knew the Cape Verde Islands well, having sailed through them in HMS *Newfoundland*. They are divided into two groups, and the windward (*balaventos*) are significantly wetter than the leeward (*sotaventos*). Of the windward islands, the biggest, highest, wettest and greenest is Santo Antão. It is an island of savage grandeur, awesome and eye-catching from the sea, particularly to a mariner seeking fresh water. The Chinese admirals would have been approaching from the north-east on the trade winds, and from that direction they would have sighted Santo Antão first. On the north coast of Santo Antão, clearly visible from miles out as you approach from the north-east, there is a dramatic volcano. Streams pour down its sides and rush through lush valleys to the sea around what is now the small settlement of Janela. That strip of coast would have been an obvious and immediate place for the Chinese fleets to anchor and obtain water. If the Chinese had indeed landed there, I was confident that a legacy of their visit should exist.

The Cape Verde Islands were uninhabited when the first European, Cà da Mosto (1432-88), a Venetian explorer in the service of Henry the Navigator, arrived in 1456, so I could not expect to find goods that the Chinese had traded for food, such as the blue and white plates that were their currency on the south-east coast of Africa. On the Cape Verde Islands the Chinese could have obtained any amount of food and water for nothing. The seas teemed with swordfish, sole, shark, octopus, crayfish and tiny sweet mussels, the island was lush with fruit, and flocks of tame birds could be picked up by hand, for they had never learned to be wary of humans, as Cà da Mosto's crew found to their joy thirty-five years later. Nonetheless, there should have been other mementoes. A carved stone similar to the one erected by Zheng He on the estuary of the Yangtze stands at Galle, near Dondra Head in southern Sri Lanka. Inscribed in Chinese, Tamil and Persian, it extols the virtues of Hinduism (the local religion), Buddhism (Emperor Zhu Di's faith) and Islam (the religion of most Indian rulers in the early fiftcenth century). There are other similar stones near Cochin and Calicut. I wondered if a carved stone might have been erected here.

The Chinese were always careful to respect local sensibilities;

the language school in Nanjing, the Ssu-i-Quan, was, after all, set up by Zheng He specifically to train interpreters, and the fleets on this sixth voyage carried interpreters fluent in seventeen different Indian and African languages. It was highly probable that they had also left a stone on one of the Cape Verde Islands, carved with inscriptions in a language they thought people from the surrounding areas would understand. Such stones were always sited in prominent places where they would readily be discovered by others – what would be the point of erecting a monument to your achievements and then hiding it where it would never be found? If such a stone existed, the first Europeans should have found it when they reached Santo Antão thirty-five years later.

I referred to the journals describing Antonio da Noli, Cà da Mosto and Diego Alfonso's first voyages to the islands, and discovered that they had indeed found a large, free-standing stone near the coast at Janela. The stone still stands there today, in a dramatic setting framed by encircling mountains, beside the Ribeira de Penedo. Until a century ago, a clear, rushing stream tumbled down the side of the volcano, but now the stream has dried up and the stone is surrounded by agave plants. The stone, called locally Pedra do Letreiro (Stone of Letters), is of red sandstone, some three metres high and covered with inscriptions from top to bottom. The later carvings are in medieval Portuguese, commemorating the death of a mariner, Antonio of Fez, but underneath them I could see more calligraphy, unfortunately obscured by moss and lichen. The stone was so badly weatherworn and defaced by recent graffiti that it was very difficult to decipher the underlying calligraphy. A series of experts had tried first a Frenchman, M. Chevalier, in 1934, then several learned Portuguese and Cape Verde historians over the past twenty years. They could tell me what the calligraphy was not - it was not Arabic, Judaic, Berber, Tifnaq, Aramaic, Phoenician, Latin, or any other European language - but they could not tell me what it was.

ROUNDING THE CAPE

After receiving the necessary approval from the Cape Verde authorities, some of the lichen was removed. This revealed two pieces of calligraphy. I hoped that, helped by computer enhancement, I would at least be able to determine the language, but the calligraphy was quite extraordinary, unlike anything I had ever seen in my travels anywhere in the world. It appeared to have two characteristics: whorls like interlocking ram's horns, and a number of concentric circles.

My first thought was that it could be medieval Chinese, either the Zhu Qi Shan script or 'Flowinghand'. I sent photographs to experts at the Forest of Steles in Xian, China. Once the Temple of Confucius, it is now a museum and library holding a huge collection of steles, or engraved stone tablets, a timeless memorial to the Chinese written language. It was neither script. Could it be Tamil, similar to the writing on the stone the Chinese erected in southern Sri Lanka? It does resemble Tamil, but not closely enough. Nor is it Swahili, the lingua franca of the east coast of Africa. I then wondered if it could be another Indian language, perhaps one of the thirteen shown on today's high-denomination Indian banknotes. Could the Bank of India help? I faxed them a photo of a small section of one of the pieces of calligraphy.

'It looks like Malayalam,' they replied.

It was a language I had never even heard of. I faxed again.

'Where was this language spoken?'

'It was the language of Kerala.'

'Was it in use in the fifteenth century?'

'Yes, it had been in common use since the ninth century.'

Once I'd put down the phone, I punched the air in my excitement. In 1421, Kerala's capital was Calicut, the great port of India from which the Chinese had sailed. Once again, Fra Mauro and Niccolò da Conti seem to have been correct: a ship or junk from India appeared to have reached the Cape Verde Islands before the Portuguese arrived.

I next trawled through the learned experts' research¹⁹ to see

whether they had come across another, similar stone while they were attempting to decipher the writing at Janela. They had, but not in the Cape Verde Islands. The other stone was sited at the Matadi Falls in the Congo. My first impression was that this was a wild goose chase. Why should a ship voyaging from India have visited a waterfall in Africa? But closer examination revealed the Matadi Falls to be at the upper navigable limit of the Congo River, where a mariner may anchor in beautiful surroundings and obtain clean, fresh water. A succession of ships had done just that down the centuries, from the Portuguese in 1485 to the Chinese today. The river pours over a series of cataracts before reaching the falls. The carved stone stands sentinel above a dark pool near the foot of the falls, where in days gone by fishermen would sit motionless while prostitutes patrolled the banks awaiting the arrival of the crews of foreign ships sailing upstream to water and gather provisions.

I had to retrace my route back to the coast of Africa to investigate this discovery. Like its Janela counterpart, the Matadi Falls stone has calligraphy beneath medieval Portuguese. The Portuguese writing once again commemorated a deceased comrade, here the navigator Álvares. There is less underlying material than at Janela, but experts confirmed that it was the same calligraphy, that once again it looked like Malayalam. Its identity appeared to have been solved, although the concentric circles remained a mystery. It was likely that the Chinese had come here on their journey up the African coast. Not only is the Matadi Falls an ideal place for watering, it is 'in the middle of the west coast of Africa', and fits the description of 'Garbin' given by Fra Mauro. It is a busy port today.

Once again, Fra Mauro and da Conti appeared to have been vindicated: a ship sailing from India 'around the year 1420' seems to have reached Garbin. This does not, of course, guarantee that the ship was Chinese rather than Indian, but Indian ships were sailing with the Chinese fleets. It appeared the Chinese had reached there. The simple and obvious explanation was that the calligraphy carved on the 'Garbin' and Janela stones was inscribed by stonemasons travelling with the Chinese fleet, just as they had carved inscriptions in foreign languages at Dondra Head, Cochin and Calicut.

Despite the wholesale destruction of Chinese records carried out in the fifteenth century, I now had a trail of evidence of the treasure fleets' movements from departure from Tanggu to arrival in the Cape Verde Islands in September 1421. Ma Huan had described the voyage from China via Malacca to Calicut, and the Mao Kun chart of 1422 had then put the armada off Sofala in south-eastern Africa. My evidence for it having rounded the Cape of Good Hope and sailed north up the west coast of Africa was provided by the Kangnido map in Japan, and corroborated by Mauro/da Conti's descriptions. Their accounts, together with the inscribed stones, also showed that 'Garbin' in the middle of the west coast of Africa was the Matadi Falls, and that 'Isole Verde' was Santo Antão in the Cape Verde Islands. The Chinese were sailing before the wind and current all the way. It was precisely the route a ship sailing from India would have been obliged to follow, and at the Chinese average speed of 4.8 knots the latter part of the voyage would have lasted the forty days Fra Mauro had stated.

The great Chinese armada had already voyaged far into the distant and uncharted oceans, but I now had to discover where they had sailed next. The account by Mauro/da Conti described a seventy-day voyage after leaving the Cape Verde Islands, through *le oscuritade*, which can be translated as 'the obscured islands' or 'darkness'. My task was now to identify them. My first line of approach was to search for independent evidence of the next part of the Chinese voyage, for example in another chart that might throw some light on the location of these 'obscured islands'. In that era, Venice was the cartographic capital of Europe. If such a map existed, Venice was the most likely source.

During my researches in Venice I was told of a description by

THE GUIDING STARS

the Portuguese historian Antonio Galvão (died 1557) of a world map the Portuguese dauphin, Dom Pedro, Henry the Navigator's brother, had brought back with him from Venice in 1428 (my italics):

In the yeere 1428, it is written that Dom Peter, the King of Portugal's eldest sonne, was a great traveller. He went into England, France, Almaine [Germany] and from thence into the Holy Land, and to other places; and came home by Italie, taking Rome and Venice in his way: from whence he brought *a map of the world, which had all the parts of the world and earth described. The Streight of Magelan was called in it the dragon's taile: the Cape of Boa Esperança, the forefront of Afrike* and so foorth of other places: by which Map Dom Henry the King's third sonne was much helped and furthered in his Discouveries.²⁰

Here was an unequivocal assertion that by 1428 both the Cape of Good Hope (Boa Esperança) and 'the Streight of Magelan' (separating Argentina from Tierra del Fuego) had been charted on a map. It was an extraordinary claim. How could the Strait of Magellan have appeared on a map – for simplicity, I shall call it the 1428 World Map – nearly a century before Ferdinand Magellan discovered it? To emphasize that this was no mistake, Galvão continued:

It was tolde me by Francis de Sousa Tavares that in the yeere 1528, Dom Fernando, the King's sonne and heire did show him a map which was found in the studie of the Alcobaza [a renowned Cistercian monastery traditionally used as a library by Portuguese kings] which had beene made 120 yeeres before which map did set forth all the navigation of the East Indies with the Cape of Boa Esperança according as our later maps have described it; whereby it appeareth that in ancient time there was as much or more discovered than now there is.²¹ This 1428 World Map was of huge importance to the Portuguese government, for in December 1421 the overland route to China and the Spice Islands – the great Silk Road running from China right across central Asia to the Middle East – had been blocked when the Ottomans surrounded Byzantium. In that same climactic month, on 6 December, the Mamluk Sultan Barsbey seized power in Egypt and nationalized the spice trade. The effect of the two events was to ruin the merchants who had controlled the spice trade, seal Egypt's borders to international trade and sever the sea route through the Bosphorus to the western end of the Silk Road. With the canal linking the Red Sea and the Nile (completed in the tenth century) collapsing and unusable, all land and sea routes to the East were now closed to Christians. A new ocean route to the East had to be found.

I knew from Antonio Galvão's description that the 1428 World Map showed the 'East Indies' (the Indian Ocean and what is now Indonesia) and revealed the ocean routes to the Spice Islands (Ternate and Tidore in eastern Indonesia), Asia and China round the Cape of Good Hope and through the Strait of Magellan. The information it contained was of incalculable commercial value and it was kept for decades under lock and key in the Portuguese treasury in Lisbon. However, the secret eventually leaked out and others became determined to get their hands on this vital map, even though the penalty for stealing it was death.²² Certainly, Christopher Columbus was in possession of a copy in 1492 (see chapter 18).

The 1428 World Map has long been lost, but the information contained on some sections of it has survived, the most important of which is the section showing South America. A Spanish seaman who had sailed to the Americas with Columbus kept that portion of the map together with some notes Columbus had written about it. In 1501, the Ottomans captured the ship in which the seaman was serving; he still had the map in his possession. Neither the seaman nor any other who sailed with

139

THE GUIDING STARS

Columbus could have been the originator of this map because Columbus never sailed south of the equator. The information can only have come from the 1428 map.

Appreciating the extraordinary value of this captured document, the Ottoman Admiral Piri Reis incorporated it into a map known from that day to this as the Piri Reis map of 1513. This beautiful map can be seen today in the Topkapi Serai Museum high above the Bosphorus in Istanbul. It was based on several different maps, pieced together by the admiral from a number of different sources, and parts of it are unreliable, but the southwestern portion based on the map taken from Columbus's seaman is very accurate. The trail I had begun to follow the day I visited the Torre do Tombo in Lisbon and read Antonio Galvão's description of a mysterious map that had come into Portuguese hands in 1428 had now led me to another chart that would prove one of the most valuable keys to unlocking the secrets of the Chinese voyages.

In recreating the Chinese route I remained certain of one thing: because of the hull shape of the Chinese junks, they would have had to sail before the wind. Their route after leaving the Cape Verde Islands was not hard to establish for there, as Admiral McIntosh described so many centuries later, the wind blows relentlessly westwards, towards South America. Moreover, at the Cape Verde Islands 'the north equatorial and south equatorial current converge, forming a broad belt of current setting west. Average rates reach two knots.'²³ The converged currents separate near the Caribbean: the northern part sweeps through the Caribbean to New England where it becomes the Gulf Stream; the southern part turns south-west towards South America.

My study of the old maps and charts, together with the evidence from wrecks and artefacts found around South America and in the Caribbean (to be examined more fully later), led me to conclude that the Chinese fleets had separated with the current. Admiral Zhou Wen sailed north-west through the Caribbean towards North America, while Admirals Hong Bao and Zhou Man took the south-west branch of the equatorial current towards South America. It must have been an emotional parting as the great ships began to drift apart, gathering speed as the wind filled their sails. They were sailing into hazardous, uncharted waters and the admirals and their men would have been well aware that they might never set eyes on their companions again.

The evidence of the Piri Reis map and of the winds and currents seemed conclusive; the Chinese fleet must have sailed in this direction from the Cape Verde islands. Perhaps I would find the answer to the mystery of the 'obscured islands' somewhere off the coast of the Americas. I would return later to track the northward voyage of Zhou Wen's fleet, but for the moment I had to follow the course of Zhou Man and Hong Bao on their southwest track towards the 'New World'.

THE

THE FLEETS OF HONG BAO AND ZHOU MAN WOULD HAVE sighted the coast of what is now Brazil approximately three weeks after leaving the Cape Verde Islands. What a moment that must have been, a sprawling, unknown land filling the horizon before them, the air full of unfamiliar scents and the calls of strange birds. They may well have wondered if this was the land of Fusang, described by their forebears almost a thousand years earlier.

During the Northern and Southern dynasties in the first year of the 'Everlasting Origin' Emperor, AD 499, a Buddhist priest named Hoei-Shin ('Universal Compassion') returned from a land twenty thousand li (eight thousand nautical miles) east of China. He named this continent Fusang after the trees that grew there. The Fusang tree bore fruit like a red pear, and had edible shoots and bark the inhabitants used for clothing and paper. Coupled with his statement that the country had no iron, Hoei-Shin's description suggests that the Fusang was the maguey tree that grows only in Central and South America. It bears red fruit and is also used in the other ways he described. Iron is found in almost every part of the world except for Central America, just as Hoei-Shin indicated. Whether or not Hoei-Shin reached the Americas, the Chinese certainly believed he had, for his report was regularly entered in the yearbooks or annals (official histories) of the Chinese Empire. From there it passed not only to historians but also to poets and writers, and down the centuries innumerable tales were told of Hoei-Shin's exploits and adventures in the land of Fusang.

Fusang is about twenty thousand Chinese miles [eight thousand nautical miles] in an easterly direction from Tahan, and east of the Middle Kingdoms [China]. Many fusang trees grow there, whose leaves resemble the *Dryanda cordifolia*; the sprouts, on the contrary, resemble those of the bamboo tree, and are eaten by the inhabitants of the land. The fruit is like a pear in form but is red. From the

THE GUIDING STARS

bark they prepare a sort of linen which they use for clothing ... The houses are built of wooden beams; fortified and walled places are there unknown ... They have written characters in this land [which the Olmecs did have] and prepare paper from the bark of the Fusang [which the Olmecs did from the maguey tree, which indeed has red fruit like pears].¹

Zheng He and his admirals certainly knew these tales when they set sail, as did the Chinese seamen crowding at the rail for a sight of this new land. Was it a land of no iron? Did it have the famous Fusang trees? No doubt they were nervous, perhaps even frightened, but they must also have been immensely curious. Their landfall must have been around the Orinoco delta, for the Piri Reis map shows that they had surveyed that small part of the coast with great accuracy. My search for the obscured islands Fra Mauro/da Conti had described during the junk's seventy-day voyage after leaving the Cape Verde Islands could now begin in earnest.

Just before the book went to print I was informed that a considerable amount of research had been carried out into the DNA of American Indian peoples of the Amazon and the Orinoco and the diseases that they carried which were otherwise unique to China and South East Asia. Briefly, it concerns a skin disease of the Indians of the Mato Grosso of Brazil; hookworms occurring in the Lengua Indians of Paraguay; roundworm in Peru and Mexico; ancylostoma duodenale in Mexico; and Chinese DNA in the Indian peoples of the Amazon, Brazil and Venezuela. It is conclusive proof of Chinese sea voyages to the Americas before Columbus. For the moment, however, I had to continue with the charts.

After making landfall near the Orinoco, where they would have replenished their water and taken on fresh food, they would then have set sail once more for the south. The winds would have carried them past the Amazon delta down THE NEW WORLD

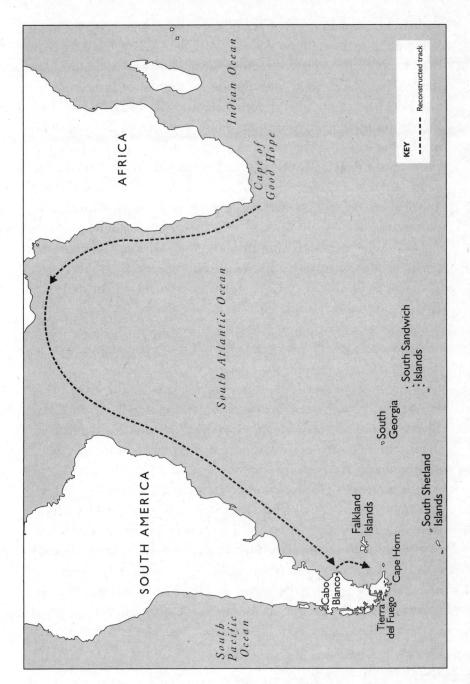

The journey to Tierra del Fuego.

the east coast of Brazil to Cabo Blanco in southern Argentina. I had found an inscription on the southern part of the Piri Reis map stating: 'It is related by the Portuguese Infidel [Columbus] that in this place, night and day are, at their shortest period, of two hours duration, and at their longest phase of 22 hours.'² For the winter daylight to have lasted only two hours, the man who originally drew the chart and made that note must have been in the deep south at a latitude of about 60°S, well to the south of the southern tip of Tierra del Fuego. The map also shows what appears to be ice connecting the tip of South America to Antarctica.

I was able to use the inscription on the Piri Reis map and the position of the ice shown on it to fix the southern tip of South America to approximately 55°S, the northern limit of drift ice. Establishing the latitude of Tierra del Fuego allowed me to make a closer examination of the southern part of the Piri Reis and compare it with a modern chart. This revealed at once that the original cartographer had drawn the east coast of Patagonia with great accuracy. The prominent features of the coastline – headlands, bays, rivers, estuaries and ports – tally from Cabo Blanco in the north to the entrance of the Strait of Magellan in the south. The cartographer of the Piri Reis also drew a number of animals on the land.

It is a bleak, desolate, windswept region, as Darwin recalled: 'Without habitations, without water, without trees, without mountains, they support merely a few dwarf plants . . . The plains of Patagonia are boundless, for the area is scarcely passable, and hence unknown.'³ Columbus could not possibly have been the original cartographer; he never got south of the equator. His knowledge of the region, including his description of the islands in the South Atlantic being in darkness – obscured – for twentytwo hours each day, can only have come from the inscriptions on another chart he had copied.

The first European, Magellan, did not set sail for Patagonia

THE NEW WORLD

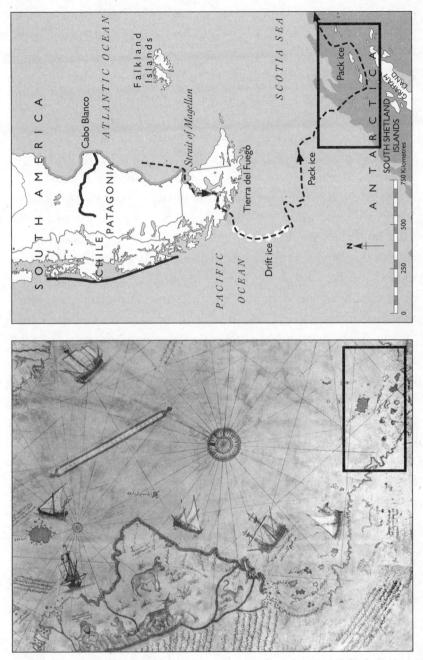

The Piri Reis map compared to modern Patagonia, showing the Strait of Magellan.

until years after the Piri Reis was drawn. So who originally provided the information to enable Patagonia to be drawn on the Piri Reis, and how did he obtain it? Knowing I was looking at Patagonia, a desperate place but nonetheless one that supports animal life, I began to examine the five creatures depicted on the map.

The first, a deer with prominent horns, was superimposed on an area that has now been designated a national park, the Parque Nacional Perito Moreno. This animal is clearly a huemil, an Andean deer, with the head and antlers accurately depicted. There are still huge herds of these deer where the animal is shown on the Piri Reis. The next creature was placed in what is now the Monumento Natural Bosques Petrificados, 150 kilometres south of modern Caleta Olivia. I have spent some time photographing animals in the Andes and instantly recognized the creature as a guanaco. Guanacos are members of the camel family. They have curious, floppy ears which are bent forwards when they are excited or anxious. Andean people decorate guanacos' ears with red tassels in the same way we would plait a horse's mane. From a side view, the bent ears resemble forwardpointing horns. Clearly, the cartographer who copied the original chart mistook the bent ears for horns. Large herds of guanaco are found in the Monumento Natural Bosques Petrificados, just where they are shown on the Piri Reis, and, like the huemils, guanacos are unique to South America. The third animal, a mountain lion, was placed in what is now the Parque Nacional Monte León where, as the name indicates, mountain lions are common. All three animals were shown exactly where I have seen them in Patagonia and were drawn before Europeans arrived.

There is also a drawing of a naked bearded man. At first glance, he appears to have his head in the middle of his body, but on closer examination it seems perfectly possible that he had been drawn in a crouching position, allowing his thick beard to cover his genitals. I surmised that the Turkish cartographer who copied the captured Portuguese chart onto the Piri Reis was almost certainly a Muslim. Muslims are very conservative about exposing their bodies; if the cartographer had indeed been of that faith, he would not have been comfortable depicting naked men. When Magellan arrived in Patagonia long after the original map was drawn, he was surprised to find that despite the cold weather the people did indeed go about naked, keeping themselves warm with fires, even when they were travelling in boats. As a result, he named the land 'Tierra del Fuego' – the land of fire.⁴

That left one last creature to identify, a beast that appeared to have come from fable: a dog-headed man. There were two notes describing the creature: 'In this place there are ... wild beasts of this shape',⁵ and 'These wild beasts attain a length of seven spans ... between their eyes there is a distance of only one span [the distance between the outspread tips of the thumb and the little finger]. Yet it is said they are harmless souls.'6 The Piri Reis map had depicted the other Patagonian animals with remarkable accuracy and placed them precisely where they are found today. I could therefore expect the monster, if it ever really existed, to have lived in the south of the Santa Cruz province of Argentina or in the north part of the Chilean province of Magallanes. Did such monsters ever walk the earth there? London's Natural History Museum could offer no help in identifying the creature, so I contacted natural history museums within a two-hundredmile radius of where the monster was shown and described on the Piri Reis.

My first call, to the Museo de Fauna, Rio Verde in Magellanes province, Chile, was answered in the negative, with barely suppressed mirth. The fourth call, to the nearby Museo de Sitio in Puerto Natales, was much more fruitful.

'I'm looking for a monster twice the size of a human. Were there ever any creatures like that in your area?' 'Yes.'

'Does your museum exhibit one?'

'Yes.'

'What is its name?'

'The mylodon.'

The mylodon is a creature of which I had been wholly ignorant until then, but London's Natural History Museum now provided a wealth of information about it. The monster was a giant sloth weighing around two hundred kilograms, unique to South America. In 1834, Darwin found a skeleton on a beach at Bahía Blanca in Patagonia near to where the creature is shown on the Piri Reis map; from the oil still present in the remnants of attached flesh, he concluded that the creature's demise was 'recent'. He sent the bones to Dr Richard Owen at the Royal College of Surgeons in London, who reconstructed the skeleton. It resembled a giant man with a dog's head, rearing on its

A nineteenth-century engraving of the skeleton of a mylodon.

haunches and using its legs and tail as a tripod while it knocked down small trees. It would strip the branches bare of fruit before lumbering off to demolish the next tree. The animal was said to reach three metres, sometimes even more, in height and slept for most of the time. The native people of Patagonia harnessed these 'harmless souls'⁷ in caves during the winter, taking them out to graze in summer; their meat apparently tasted like bland mutton.

Later I was to find a Chinese book published in 1430 entitled *The Illustrated Record of Strange Countries*. As its title implies, this book records the strange animals the Chinese found on their travels. A dog-headed creature very similar to that drawn on the Piri Reis map is shown, with a note – the only part of the document that has yet been translated – stating that it was found after travelling for two years west of China.

The Chinese must have looked upon such alien creatures with wonder, and at once would have begun efforts to capture some specimens. When encountering strange and exotic animals, it was their custom to take them back to China to present to the emperor for his zoo.⁸ A stream of quilins (giraffes) had returned with Zheng He's captains to astound and delight Zhu Di, and I believe that a number of mylodons were also taken aboard the Chinese junks, two of which did reach China.⁹ I could imagine the Chinese seamen luring these lumbering, dog-headed creatures out of their caves and onto the giant ships, accompanied by tons of leaves for them to eat.

The Piri Reis map was so accurate both in its depictions of physical features and its descriptions of animals unique to South America that it could only be charting Patagonia. For that reason, I was also certain that the mountains drawn on the western side were the Andes. These mountains, running northwards up the Pacific coast, are not visible from the Atlantic; they are hundreds of miles away from the east coast. The original cartographer must have sailed that Pacific coast long before the first THE GUIDING STARS

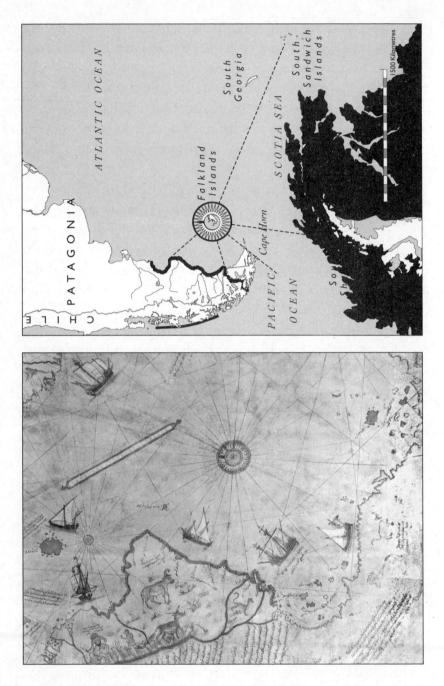

The Falkland Islands on the Piri Reis, compared to a modern map.

Europeans reached South America or the Pacific, and the fleet that carried him can only have passed through the Strait of Magellan or braved the blizzards, incessant gales and mountainous seas of Cape Horn.

Knowing the size of Patagonia, I could accurately determine the scale of the Piri Reis map and fix the latitudes of the land and islands shown on it. Cabo Blanco is at 47°20'S, so the islands shown at the bottom of the Piri Reis must be at 68°43'S – exactly the latitude of the South Shetland Islands. I now knew that the original cartographer had been aboard a ship that had discovered the Antarctic continent and the South Shetland Islands four centuries before the first Europeans reached them. As I was later to discover, these obscure, almost uninhabited islands were of vital importance to the Chinese.

It must have taken thousands of man-hours for the skilled surveyors and navigators to chart such a large area of land and ocean, stretching thousands of miles from Antarctica in the south to the Peruvian Andes in the north. To cover such vast distances, the charting must have been co-ordinated, involving the use of different fleets. Before Europeans reached the South Atlantic, the only nation capable of putting such fleets to sea was China, and the only plausible opportunity was provided by the Chinese treasure fleets during the 'missing' two years of the great voyage of 1421-3. Although I was convinced I was right, I had not yet found any first-hand evidence of a Chinese visit to South America. The clearest evidence would come from the surviving wreck of a treasure ship full of early Ming porcelain. Such wrecks were to play a vital part in establishing the presence of the Chinese treasure fleets elsewhere in the world, but finding such a wreck on the coasts of South America is likely to be a lengthy task. The seas are buffeted by incessant storms and strong tides break up and sweep away wreckage and spilled cargoes. The search is in hand, but it is unlikely to yield shortterm results.

Meanwhile, I needed an interim solution. For example, did the first Europeans to reach South America find plants or animals unique to China when they landed there, or were plants unique to the Americas seen in China when the first Europeans arrived there? If so, had the Chinese junks carried them home with them? Fortunately, a number of distinguished scholars have worked on this problem for many years.¹⁰ I was led to their work as a result of waking at cockcrow on my first morning during a visit to Peru. I had lived in Malaysia and remembered well how the morning call of Asiatic hens – 'kik-kiri-kee' – was markedly different from the 'cock-a-doodle-do' of their European counterparts. As I lay in bed, I recognized the familiar 'kik-kiri-kee' and began to wonder how Asiatic rather than European hens had come to be in Peru.

The domesticated Asiatic cock and hen originated several thousand years ago in the jungles of south-east Asia, in South China, Annam, Vietnam, Cambodia and Malaysia. The strain remains quite distinct from the European hen. When Magellan arrived off Rio (as it is now called), he 'picked up a great store of chickens ... for one fish hook or a knife, they gave me six chickens, fearing even so that they were cheating me'.11 But the chickens Magellan and the Spanish conquistadors found in South America had virtually nothing in common with European 'dunghill fowl'. They were of four principal, wholly different types. The Malay class were tall and thin - the cocks were able to peck food off a dinner table. They had thin heads, more like a turkey's than a chicken's, with a bare throat and a bare strip running down the breast. The Chinese class had stocky, heavy bodies, fluffy feathers, short wings and feathered legs. The cocks had modest tail feathers and very small, short, blunt spurs. They were poor flyers and notably tame. To this day, the silkyfeathered melanotic chicken ('melanotic' denotes the black feathers, skin, flesh and bones of this strange bird) is found throughout Latin America; I have seen them in Amazonian villages. The fourth type of hen was the Asian frizzle fowl, with feathers that curve back towards the body instead of lying flat. Again, there was nothing remotely resembling this bird in the Mediterranean world of 1500, when frizzle fowl were found all over South America. Perhaps the most striking difference was that the Asiatic hens laid blue-shelled eggs whereas those of European hens were white or cream. Blue eggs are still found all the way from Chile to Mexico.

There were two other significant differences. If the Europeans had brought chickens, then the European name would have been adopted by the Indians of South America. This did not happen. The Arawak of northern South America called melanotic chickens *karaka*; the Indian name is *karaknath*. In north-west Mexico, chicken was *tori*; in Japanese it is *nihuatori*, meaning 'yard bird'. The Inca emperors, who were just embarking on a period of imperial expansion in 1421, frequently wore feathers and adopted the names of birds. In their Quechua language, chicken was *hualpa*, and the name Yupánqui (c. 1438–1493) was adopted; Atahualpa was the formal name of the emperor overthrown by Francisco Pizarro. The Incas therefore had a word for chicken at least forty years before the arrival of the conquistadors.

The Chinese practices of divination using eggs or dripping chicken blood on bark paper before burning the paper, and the belief that a melanotic chicken protects the household from evil spirits, were also found in South America. Like the Chinese, the Amerindians used them for sacrifice, divination and healing the sick.

Asiatic chickens were found the length of both the Atlantic and Pacific coasts of the Americas as far north as Rhode Island. These birds cannot fly and must have been brought by ship. The only non-European ships that could travel such vast distances were Chinese. The spread of Asiatic chickens prior to the European conquest closely correlates with the lands shown on

THE GUIDING STARS

The frizzle fowl from Aldrovandi's Ornithologia, 1604.

the Piri Reis map – the Amazon and Orinoco deltas in Venezuela, Brazil, Patagonia, Chile and Peru. Even today, in areas of South America where there has been minimal Spanish (or other European) influence, one still finds chickens which lay pale blue eggs and possess other Asiatic characteristics unknown in European birds.¹² The conclusion is inescapable: Chinese fleets must have brought chickens to South America.

Since the Asiatic chickens are very different from the Mediterranean chickens and most of the traits that reappear in the flocks of the Amerindians are found in Asia, the obvious conclusion would be that the Amerind chickens were first introduced [to South America] from Asia and not from the Mediterranean...¹³

When one considers the total data available on the chicken in America, a conclusion for a Spanish or Portuguese first

THE NEW WORLD

introduction of chickens into America is simply counter to all the evidence. The Mediterraneans, as late as 1600, did not have, and did not even know of, the galaxy of chickens present in Amerind hands ... If a scholarly and scientific approach to the subject is taken, an approach that pays attention to the data instead of the clichés of the past, then the only possible conclusion is that chickens were introduced from across the Pacific, probably repeatedly, long before the Mediterranean discoveries of America.¹⁴

The second line of evidence came from maize, a very unusual plant that originated in the Americas and was unknown in China before Zheng He's voyages. Just as chickens cannot fly, maize is incapable of self-propagation. Wherever it is found, it has been propagated by man. There is considerable evidence that maize was carried to Asia before Columbus landed in America in 1492.15 For example, within his description of the expedition landing at Limasava in the Philippines in 1520, Antonio Pigafetta, Magellan's diarist, noted this: 'The islanders invited the General [Magellan] into their boats in which were their merchandise, viz. cloves, cinnamon, ginger, pepper, nutmegs and maize.'16 There is no possibility that Pigafetta had misidentified the plant. In his notes in the original Italian, maize is translated as miglio against which Pigafetta had written the Caribbean word, maiz. He knew what maize looked like - it had 'ears like Indian corn and is shelled off and called *lada'* – and not only had he spent months with Magellan in South America on his way to Limasava but several seamen aboard had also served with Columbus in the Caribbean.¹⁷ Chinese records state that Zheng He's admirals brought back 'extraordinarily large ears of grain'.18 The Chinese were used to rice with ears the size of barley. The only 'extraordinarily large' ears compared to rice were those of maize. There is a wealth of further evidence, for the Portuguese also found maize in Indonesia, the Philippines and China, and metates - utensils for grinding maize unique to

South America – were found in the hold of a junk, built in 1414, that was recently discovered on the sea-bed at Pandanan in the south-west Philippines where it had sunk in about 1423.

There was now not a scintilla of doubt in my mind that the Chinese fleet had been in South America in 1421 and had surveyed the lands shown on the Piri Reis map a century before Magellan. But they were sailing on this epic voyage to bring the entire world into the Chinese tribute system. Why should they have taken such inordinate trouble to chart this part of inhospitable Patagonia, a land of driving snow and bitter cold occupied only by unsophisticated, naked people with nothing to trade and with little natural wealth save for burberries and fish?

Could the Piri Reis map provide a further clue? At first it seemed only to deepen the mystery, for it showed a series of 'spokes' extending from the Patagonian coast and intersecting in a hub – the centre of a compass-rose – in the wastes of the South Atlantic. These spokes are what navigators call 'portolan lines', used in portolan navigation, also known as triangulation. Comparing the Piri Reis with a modern map, I identified the prominent points on the Patagonian coast from where each portolan line was drawn. The cartographers must have been aboard seven ships that set sail from Puntas Guzmán and Mercedes on the northern coast, Cabos Curioso and San Francisco in the centre and Punta Norte, Cabos Buen Tempo and Espíritu Santo in the south.

Knowing the scale of the Piri Reis map, I could now readily identify the true location of the centre of the compass-rose. The portolan lines intersected in King George's Bay in the West Falkland Islands. At the absolute centre of the compass-rose is Mount Adams (2,917 feet), the most conspicuous mountain in the Falklands. Was either Zhou Man or Hong Bao a secret mountaineer at heart? Is that why the ships were ordered to steer towards a mountain peak? For weeks I was baffled by this conundrum, then suddenly the answer came to me. The Chinese needed a star in the southern hemisphere to replace Polaris in the northern, and in the event they selected two: Canopus for latitude and the Southern Cross for navigation.¹⁹

Canopus, a yellow-white, super giant star, sits in space three hundred light years from Earth towards the South Pole and pumps out more than a thousand times the power of the sun. The combination of its power and distance makes it the second brightest star in the sky, nearly as bright as Venus, and instantly identifiable because of the colour of its light. Like the Southern Cross, Canopus is in the far south but not directly above the South Pole. To use Canopus for latitude, the Chinese had to determine its precise position by sailing to a point directly underneath the star. The Southern Cross points to the South Pole but, unlike Polaris, it is not directly above the Pole. To be able to use the Southern Cross for accurate navigation, the Chinese also had to locate its position in the sky – its height and longitude. Once again, the only way to calculate the precise position of the Southern Cross was to sail to a position directly beneath it.

The Chinese had been attempting to locate the positions of both the Southern Cross and Canopus for centuries:

In the eighth month of the twelfth year of the Khai-Yuan period [in the eighth century AD] [an expedition was sent to the] south seas to observe Lao Jen [Canopus] at high altitudes and all the stars still further south [Southern Cross] which, though large, brilliant and numerous, had never in former times been named and charted. They were all observed to about 20° from the south [Celestial] Pole [viz. 70°S]. This is the region that the astronomers of old considered was always hidden and invisible below the horizon.²⁰

Only when Canopus and the Southern Cross had been located could new lands in the southern hemisphere be accurately placed on charts. When they reached Mount Adams in the West Falklands the Chinese cartographers were nearly underneath Canopus. They were taking such pains to fix their position so that they could calculate their precise latitude: 52°40' South. By cross-referencing Canopus to Polaris they could establish Canopus's height and then use that star to obtain their latitude anywhere in the southern oceans, just as they used Polaris in the northern hemisphere. Given the importance of this location to them, I would expect the Chinese to have erected a carved stone near Mount Adams, and I have asked the governor of the Falklands for his help in organizing a search for it.

Once the latitude of Canopus had been discovered, the fleets of Zhou Man and Hong Bao could have returned independently to China, sailing westwards across the Pacific and eastwards across the southern oceans, along the same line of latitude, directly under Canopus. By doing so, all ships would be conducting surveys from the same latitude. I also came to the conclusion that it would have been logical to survey the world at latitudes where the position of other stars could be precisely determined, for example at 3°40'N, where Polaris disappeared below the horizon. It also seemed logical to expect that other latitudes of particular significance to the Chinese, for example that of their capital city Beijing at 39°53'N, might also have served the same function. As will be seen, my hunches were to prove correct.

The first Chinese 'anchor point' was the Falkland Islands, selected because they are not only underneath Canopus but also almost exactly half the world away (179°) from Beijing. At this stage, although the Chinese could not measure longitude they knew the earth was a sphere. Moreover, by using Polaris they could determine the semi-circumference of that sphere ($180^\circ \times 60$ nautical miles) and thus approximate when they were half the world away from Beijing (days sailed multiplied by average speed). If a fleet sailed westwards from this anchor position in the Falklands and found another island south of Australia at 52°40' South, the cartographers could chart that continent by

triangulation as precisely as they had charted Patagonia. Similarly, a fleet sailing eastwards and finding another island south of Africa at 52°40′ South could chart the Indian Ocean.

I pondered how I could track the onward movements of the Chinese fleets from this anchor position. I already knew the dates on which the fleets under Zhou Man and Hong Bao had eventually returned to China and the number of ambassadors each one had brought with them. I soon realized that by using the charts and maps, and noting the locations from which the ambassadors had been collected, I could make a rational deduction about the course each fleet had followed in the intervening period. It was another significant link in the chain of evidence leading me in the wake of the treasure fleets.

Whereas the fleet under the senior admiral, Yang Qing, had remained in the Indian Ocean throughout the duration of the voyage, and returned to China in September 1422 with seventeen envoys from states in East Africa and India, Zhou Man and Hong Bao did not reach China until the autumn of 1423. Zhou Man brought no ambassadors and Hong Bao only one, from Calicut. From that, I deduced that Admiral Zhou Man's fleet had sailed westwards to chart the Pacific and returned via the Spice Islands. Admiral Hong Bao's fleet had sailed southwards for Antarctica to measure the Southern Cross and then made its way home eastwards via the southern oceans, Malacca and Calicut. I began the search for traces of their voyages, first of all by tracking Hong Bao across the southern oceans.

III The Voyage of Hong Bao

VOYAGE

ТО

ANTARCTICA

AND

AUSTRALIA

6

DMIRAL HONG BAO'S DESIGNATED TASK WAS TO chart the world eastwards from the fixed reference point established at the Falkland Islands – 52°40'S – but by now the rice in his container ships must have been running low and the bean shoots growing in tubs would all have been eaten. Before setting sail eastwards into the unknown waters of the southern oceans, he had to take on fresh supplies of food.

The Falklands offered cabbage, wild celery, penguins, geese and fish, but little other meat and no fruit at all. The only mammal ever discovered on the Falkland Islands was the warrah, an indigenous fox, described by Charles Darwin: 'There is no other instance in any part of the world of so small a mass of broken land, distant from a continent, possessing so large an aboriginal quadruped [the warrah] peculiar to itself... Within a very few years after these islands shall have become regularly settled, in all probability this fox will be classed with the dodo, as an animal which has perished from the face of the earth.'¹

There is something curious about this creature which, as Darwin predicted, was wiped out in the Falklands by the 1870s. Darwin and other naturalists remarked on the warrah's extraordinary tameness. The British biologist Juliet Clutton-Brock has analysed the animal's physical characteristics from specimens in the Natural History Museum in London and concluded that, like the aboriginal dingo, the warrah had once been domesticated. It was a cross between the South American fox and a feral dog brought across the sea to the Falklands before the Europeans arrived. The most plausible explanation of its origins is that the Chinese left some of their dogs on the Falklands (they bred them on the junks for food) which then interbred with the local foxes. A request has been made to the Natural History Museum in London for DNA samples from the now-extinct warrah so that they can be compared to the DNA of Chinese food dogs. Results will be posted on the website.

THE VOYAGE OF HONG BAO

If the Falklands offered a very limited food supply, Patagonia, three hundred nautical miles to the west, resembled an enormous larder, as later explorers were to find to their delight. Enough fish to feed the whole fleet could be netted in a morning; mussels the size of crabs littered the shallow pools. Guanaco. huemil and hares as large as dogs were almost tame; only snarling mountain lions stood between the sailors and limitless meat. Burberries and wild apples rich in vitamin C were also plentiful. Perhaps taking advantage of one of the periods of calm weather frequently found in an Antarctic summer, Admiral Hong Bao returned due west from the Falkland Islands to Patagonia to replenish his supplies. Still underneath Canopus at 52°40'S, he would have found what appeared to be a safe anchorage in a large bay just south of Cape Virgines. Unknown to him, the bay was the entrance to a strait leading to the Pacific. As he entered the bay, a ferocious current running at up to six knots would have dragged his fleet south-westwards through the strait like water down a plughole.

By the next morning the fleet had been sucked halfway through the strait. At last out of the current, they found themselves off the Brunswick Peninsula (the southernmost tip of the South American mainland), clearly identifiable on the Piri Reis map. By now the fleet was south of Canopus, and Hong Bao would have wished to sail north to get underneath his reference point once again, the latitude from which he was to chart the world to the east. The strait becomes narrower and narrower leading into the Canal Geronimo – less than a mile wide and far too narrow for his huge ships to manoeuvre, their turning circle being nearly a mile. As a result, the fleet was forced to reverse its course, and hence the cartographers drew the Canal Geronimo as a river, just as it must have appeared to them.

Back off the Brunswick Peninsula, the fleet took the Canal Magdalena south-westwards for the Pacific, entering the ocean near Isla Aguirre, a small, uninhabited island but one of the few

VOYAGE TO ANTARCTICA AND AUSTRALIA

out of the hundreds lining the coast to have been named, even today. The 'Strait of Magellan' had been discovered and charted by a complete accident: the latitude of the entrance to the strait is also the latitude of Canopus, the Chinese guiding star in the southern hemisphere. But although the Chinese had discovered the strait by chance, that does not diminish their astonishing achievement in piloting their enormous, square-sailed junks through such a narrow strait in the fierce gales and sudden violent snow squalls common in that region, which reduce visibility to a few yards. Magellan would not have known of this strait had the Chinese not charted it. Europeans thus owe a huge debt to the Chinese for pioneering the link between the Atlantic and Pacific Oceans, and opening up the sea route to the Spice Islands.

Not without reason was the remote, inhospitable land on either side of the dreaded strait named 'the uttermost part of the earth' by the earliest European explorers. Despite the nearendless snowstorms, often driven horizontally across the land by the force of the wind, Tierra del Fuego has an enthralling grandeur. I have seen glaciers tumble vertically into the ocean, and ice-bound mountain peaks glistening like diamonds against the pale skies. Today, as for centuries past, navigators dread the violent currents that seem to start and finish without warning or apparent cause, and the westerly gales that spring from nowhere and whip the seas into a boiling cauldron within minutes. Until the nineteenth century, its howling gales and bleak terrain discouraged settlement, leaving the Yahgan natives who inhabited this grim terrain to live in peace, huddling around the fires that led Magellan to name the region Tierra del Fuego. The Yahgan seemed to Darwin 'among the most abject and miserable creatures I ever saw, the difference between them and Europeans being greater than that between wild and domestic animals'.²

The discovery that the Chinese had made the first ever voyage through this daunting region was a tremendous moment for me.

I wondered if Hong Bao had also realized its remarkable importance and significance. I returned to the British Library to see if the diaries of the Portuguese explorer Ferdinand Magellan and Antonio Pigafetta, who sailed with Magellan's fleet, could offer any further verification of this ground-breaking voyage of a century before.

Magellan renounced his own country and set sail on his great voyage of circumnavigation on 20 September 1519 under the colours of Spain. He had a fleet of five ships and a crew of 265 men. Only one ship and eighteen men survived to complete the circumnavigation. Magellan himself was fatally wounded in the Philippines on 27 April 1521 after becoming involved in a dispute between two warring tribes. Pigafetta had this to say about the critical point in their journey:

After going and setting course to the fifty-second degree towards the said Antarctic Pole on the festival of the Eleven Thousand Virgins (19th October), we found by a miracle a Strait [near what] we called the Cape of the Eleven Thousand Virgins [today Cape Virgines]. Which Strait is in length 110 leagues which are 440 miles and in width somewhat less than half a league.³

The fact that they were 'setting course to the fifty-second degree' indicates that Magellan knew that at 52°S he would find the strait that was later to bear his name, linking the Atlantic with the Pacific. His fleet reached the dark and forbidding region on 19 October 1520. By that stage, Magellan and his crew were in a wretched state. Howling gales battered the ships and blizzards obscured both the passage ahead and the rocky islands surrounding them. He had problems finding an anchorage, many of his sailors were dying from scurvy, and he had succeeded in quelling a mutiny only by the brutal expedient of hanging, drawing and quartering the leaders. Now mutiny was again in the air.

VOYAGE TO ANTARCTICA AND AUSTRALIA

'This Strait was a circular place surrounded by mountains ... and to most of those in the ships it seemed there was no way out from it to enter the said Pacific sea.'⁴ Magellan could not persuade his men that it was safe to go onward through the strait, so he ordered his critics to put their reasons in writing for either continuing or returning to Spain. He read their opinions aloud, then, taking a sacred oath on St James whose insignia he wore upon his cloak, he solemnly swore to his men that 'there was another Strait which led out [to the Pacific] saying that he knew it well and had seen it in a marine chart of the King of Portugal, which a great pilot and sailor named Martin of Bohemia [Martin Behain] had made'.⁵

Magellan was telling the truth, though not the whole truth. The existence of the strait leading from the Atlantic to the Pacific was well known both to the King of Spain and Magellan before he set sail. He took with him on the voyage a marine chart that showed the strait and the Pacific Ocean beyond it. The contract he had signed with the king specified the aims of the voyage – to sail westwards for the Spice Islands – and the share of the profits each was to enjoy. Magellan wanted knowledge of the strait to be restricted to himself alone to prevent others from following in his wake and claiming their own share of the riches that awaited him, but the King of Spain was in no position to grant his request, for the Portuguese held the master chart.

Magellan's words, and his ruthless and inspired leadership, persuaded his men to continue, and they completed the passage of the strait that ever afterwards bore his name rather than that of the first man to do so, Hong Bao. In his description of the ships clearing the strait and entering the Pacific, Pigafetta made a vitally significant comment: 'When we had left that Strait, if we had sailed always westwards, we should have gone without finding any island other than the Cape of the Eleven Thousand Virgins ... in 52 degrees of latitude exactly towards the Antarctic Pole.'⁶ Pigafetta's statement contained information that could only have been obtained by someone who had either sailed the world at that latitude or seen a chart showing the Pacific empty of land at 52°S. Magellan turned to the north towards the equator when leaving the strait and so could not have discovered for himself that there was no land at that latitude. He must therefore have seen a chart. Magellan knew that he was not the first to sail through the strait, nor the first to cross the Pacific. Indeed, the first Spanish ships to pass through the strait found wrecked Chinese junks off the coast of Chile.

Once again, Fra Mauro had been correct: a ship from India had rounded the Cape of Good Hope and sailed to the 'obscured islands'. The riddle of the Piri Reis map had also been solved. Patagonia and the 'Strait of Magellan' were indeed drawn long before Magellan set sail, but not by a civilization predating the Pharaohs, as one authority has suggested,⁷ nor by aliens from outer space, as another, rather less academic writer argued,⁸ but by a great Chinese treasure fleet during the 'missing years' of 1421–3.

After passing through the strait, Admiral Hong Bao took his fleet southwards, sailing to the west of the islands of Tierra del Fuego. The cartography of the Piri Reis map clearly shows the route the fleet took: while Patagonia is very accurately charted, the low eastern islands of Tierra del Fuego are not recorded at all, indicating that the Chinese had sailed down the mountainous west coast.

I compared the Piri Reis map with a modern satellite photograph and immediately identified the bays and small islands surrounding the Chinese passage to the south. Further down the coast, Cook Bay is accurately positioned, suggesting that Admiral Hong Bao had anchored there. From this anchorage, he would have seen the magnificent snow-capped mountains of the Cordillera Darwin towering in an arc to the east of him. They appear on the map as separate islands, for from that distance the cartographer could have seen only their snow-capped peaks. I magnified the Piri Reis map to the same scale as a modern chart⁹ and found that all eleven 'islands' shown on the Piri Reis south of Patagonia coincide with mountain peaks on the islands that collectively form western Tierra del Fuego. My detailed work-ings will appear on the website.

The Chinese had already established the position of Canopus in the sky, the nearest and brightest equivalent in the southern hemisphere to Polaris in the northern, but to fix its position relative to the South Pole they had to establish the precise position of the pole itself. Only then would they be able to navigate and chart lands as accurately as they did in the northern hemisphere. Since they already knew from their observations of the night sky that the two leading stars of the Southern Cross, Crucis Gamma and Crucis Alpha, were aligned with the pole, they believed that they only had to sail in the same direction to reach the pole.

The polar regions can be a terrible place for a mariner. In summer there are periods of flat calm, clear skies and limpid blue seas speckled with ice floes, but when the weather breaks massive waves crash over the bows and the wind screams through the sails, driving squalls and flurries of snow and ice that sting the skin like needles. For weeks in midwinter there is unbroken black darkness; even when the sun does begin to reappear it is no more than a brief, dim disc on the northern horizon. Often cloud and freezing mist cloak every outline, leaving the seamen on watch straining their eyes into the murk for the first warning sign of drifting ice floes or a towering iceberg in their track.

However, the prospect of sailing into these frozen regions would have held few terrors for the Chinese, who had eight centuries' experience of navigating in northern polar latitudes behind them and a thousand-year tradition of navigating in ice: the nearest port to Beijing, Tanggu, is ice-bound for three months each year. I found the first anecdotal evidence that the Chinese had indeed attempted to set sail for the South Pole after leaving Cook Bay in an account¹⁰ of the travels of a young nobleman from Bologna, Ludovico de Varthema, in 1506. Ludovico de Varthema was sailing between Borneo and Java where he was told a strange tale. His companions, two Chinese Christians and an East Indian navigator, told him sailors from the other (Chinese) side of Java had sailed by the Southern Cross to regions where it was very cold and the days were only four hours long.¹¹ How could they have known without sailing there?

The Piri Reis map provided further evidence that they had sailed south. Ice is shown running due south of the Strait of Magellan, and to have drawn it the Chinese must have been sailing alongside it. They were heading due south, making straight for the South Pole. The two leading stars of the Southern Cross were overhead,¹² pointing in the direction they had to sail. Some two hundred miles south of Tierra del Fuego,¹³ they met the first drift ice, which had begun to curve to the east, drawn as a C-shaped arc on the Piri Reis map. They attempted to continue southwards around the ice but were unable to do so and were obliged to alter course, first to the east and then to the south-east, all the time trying to find a way to continue towards the pole. After sailing another two hundred miles south,¹⁴ they met pack ice that continued all the way down to the Antarctic peninsula. The ice depicted on the Piri Reis map corresponds with the normal maximum limits of drift and pack ice in midsummer.¹⁵

Admiral Hong Bao was now approaching the Antarctic Circle. At this latitude strange things happen. At the South Pole itself, longitude has no meaning. It becomes a dot; there are no directions other than north. In midsummer (December), the sun is always in the north and it is light all day; in winter, it is permanently dark. The navigational difficulties are exacerbated by magnetic anomalies caused by the South Magnetic Pole, far

VOYAGE TO ANTARCTICA AND AUSTRALIA

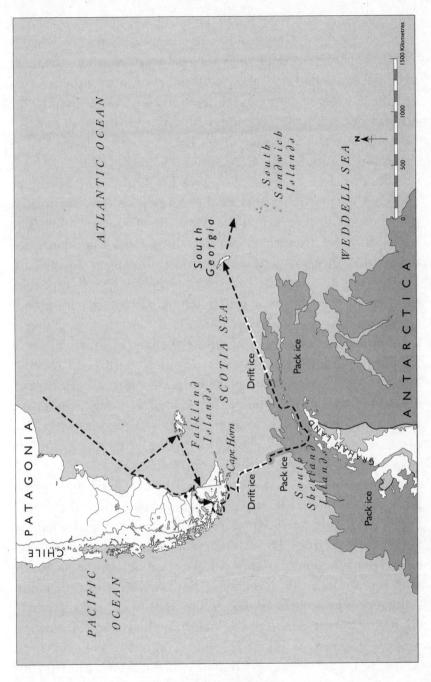

The journey to Antarctica.

THE VOYAGE OF HONG BAO

removed from the true South Pole. This would have played havoc with the Chinese magnetic compasses; the only navigational aids they could then rely on were bearings obtained from the constellation of the leading stars of the Southern Cross and the latitude of Canopus, both of which become circumpolar – never rising and setting and visible in the sky at all times – below 68°S. The intensity of its light and the clarity of the Antarctic air often make Canopus visible in daylight.

The Piri Reis map shows Graham Land, the northernextremity of the Antarctic peninsula, largely ice-free, confirming that the expedition reached the Antarctic in January 1422. The C-shape of the drift ice shown stretching from Cape Horn indicates that they had first met a current flowing from the east. Further south, where the current had more or less disappeared, the chart shows the pack ice stretching east-west before once again curving in a shallower curve to the south-east as it met another, weaker current. The uniform shape of these curves of ice showed that the Chinese were favoured with good weather and sailing into the circumpolar current before a light breeze, insufficient to break up the ice. I estimated that they would have made an average speed of approximately three knots. At that rate the voyage from Cape Horn to the Antarctic peninsula would have taken approximately fourteen days.

A group of islands was shown on the Piri Reis map where none exists in reality. In shape they resembled the South Shetland Islands, and I wondered if they were indeed what the map was depicting. The Chinese could measure latitude precisely from Canopus, but they could not yet determine longitude with similar accuracy, and once again, I had to adjust the longitudinal positions of the islands recorded on the Piri Reis map to allow for the movement of the water in which the Chinese fleet was sailing, just as I had for the Kangnido map of Africa. Allowing for an average current of two-thirds of a knot against them during their passage south, the islands shown on the Piri Reis map would be in fact four hundred miles further west than they were charted – precisely the position of the South Shetlands.

I knew from the Piri Reis map that the Chinese must have approached Antarctica from the north-west, skirting the edge of the ice, and would have made landfall on the south-western edge of the South Shetland Islands. Three of the islands are charted very accurately: Snow Island in the west, horseshoe-shaped Deception Island in the south, and four mountains on Livingstone Island in the north. A note near Deception Island also states: 'Here it is hot'. At first sight this appears a curious comment to make about a snowbound island in the Antarctic, but Deception Island is volcanic and active. Modern cruise ships anchor in the lagoon to allow tourists to bathe in the hot volcanic waters of Benjamin Cove.

Apart from Deception Island, the South Shetlands are an uninhabited wilderness of frost-shattered rock, glaciers and ice-fields, without so much as a blade of grass to be seen. As I knew from my own time in submarines sailing in polar regions, the cold can be so severe that metal objects stick to your fingers. To avoid tearing the flesh, you need to warm the fingers. The only way of doing so is usually to urinate on them, but if you attempt to do this while exposed to the Antarctic winds, you risk a very painful frostbite. The Chinese would have huddled below decks, trying to keep warm among their horses, pigs and dogs, returning to the upper deck for as short a time as possible. Their rice supplies would have had to be carefully covered and insulated to prevent the intense cold causing permanent damage to the grains, and the flooded sections of the holds where they kept their supplies of fish and their trained otters would have had to be emptied to prevent the water expanding as it froze, and forcing apart the seams of the hull. Furthermore, in these terrible conditions, surveying this part of the islands so precisely would have taken some considerable time. Why had the Chinese bothered to do so? I began to wonder if they really had gone

THE VOYAGE OF HONG BAO

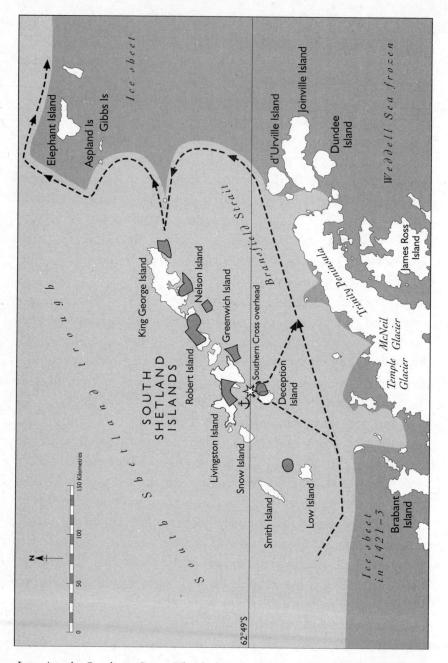

Locating the Southern Cross. The darker shaded portion is what is shown on the Piri Reis; the light areas are what is shown on modern Admiralty charts. there. Then the answer that I should have seen at once suddenly came to me. They had chosen to sail to the Antarctic in order to get underneath Crucis Alpha, the leading star of the Southern Cross.

I could only shake my head in wonder at the skill and sophistication of these Chinese mariners of so many centuries ago. The Chinese astronomers' determination of the positions of Canopus and the Southern Cross in the sky was a pivotal moment in the history of man's knowledge of the globe. Because they knew the circumference of the earth, they could now calculate the true position of the South Pole. By observing the difference between the true bearing shown by the Southern Cross and that shown by their magnetic compasses, they could determine the position of the Magnetic South Pole and therefore make the necessary corrections to their compasses. In 1421-3, the stars of the Southern Cross and Canopus could be observed as far as 28°N the latitude of the Canary Islands - where Polaris was also clearly visible.¹⁶ A cross-reference to check latitudes could be obtained by comparing the latitudes derived from Canopus and Polaris. The Wu Pei Chi confirms that this was indeed a practice of Chinese navigators, whereas the Portuguese did not adopt this method of calculating latitude for another fifty years.

The Chinese could now steer a completely accurate course in the southern as well as the northern hemisphere and determine exact latitudes. Only the problem of longitude remained to be solved. Once true latitudes in the southern hemisphere could be calculated, Chinese charts could be drawn in a readily comprehensible form – not as a table or as a long strip of sailing directions such as the *Wu Pei Chi*, but as a recognizable geometric depiction. A note appended to the Piri Reis map confirms this change: '[This map was] drawn... from about twenty charts and mappae mundi... which shows the countries of Sint, Hint, and Cin [China] geometrically drawn... By reducing all these maps to one scale, this final form was arrived at.'¹⁷

THE VOYAGE OF HONG BAO

To have found a way of accurately charting the whole world in a recognizable form must have been an incredibly exciting, triumphant moment for the Chinese astronomers, navigators and cartographers, just as it was for the Europeans when they made the same discoveries in 1473. The Chinese fleets could now go on to survey the world, using the latitude of Canopus as a baseline. They had accomplished one of the prime tasks their emperor had set them. They could now brave the biting cold of the air to enjoy a hot bath in the lagoon inside Deception Island, gather up penguins for food and cut off blocks of ice for fresh water. This would have been the moment to enjoy a cask of rice wine and feast on some of the pigs, before setting sail once again to explore the Antarctic mainland further south.

As the junks sailed through the strait separating the South Shetlands from the Antarctic peninsula, the islands would still have been visible thirty-five miles away to the north-west, with the mainland twenty miles to the south. At that range they would have seen only mountains, but they located them, with just a very small error. Their charting of mainland Antarctica was equally accurate. I was able to identify sixty-three prominent features of the Antarctic mainland on the Piri Reis map. My detailed working drawings will appear on the website. Only one thing seemed out of place – a strange serpent shown resting on the ice of Elephant Island. But the leopard seal resembles a serpent as it slithers across the ice, and, like serpents, leopard seals have fangs. East of Elephant Island, the Weddell Sea was shown as solid ice, and it is indeed ice-bound throughout the year. It is remarkably accurate cartography.

There was no longer the slightest shred of doubt in my mind. There was no need to summon ancient Egyptians or space aliens to explain how the Piri Reis map could have depicted Antarctica with such accuracy four hundred years before the first Europeans arrived there. The information came from surveyors aboard Admiral Hong Bao's fleet in 1422, who

VOYAGE TO ANTARCTICA AND AUSTRALIA

had been charting the precise position of the Southern Cross.

The Piri Reis map also showed another, smaller compass-rose south-east of the Falklands and north-east of the South Shetlands. The centre of this secondary rose corresponds to Bird Island, the north-west island of South Georgia. As its name implies, Bird Island is populated by millions of sea-birds using it as a launching platform for feeding forays into the plankton- and fish-rich Antarctic Ocean. It is a tiny island, two miles long and nowhere more than half a mile wide, fringed by sheer onethousand-foot cliffs on its north side but with sandy beaches to the south.

The compass-rose showed that Bird Island was used as a pivotal point by the Chinese cartographers. Having established the course and distances the fleet had sailed from the South Shetlands and the Falklands to Bird Island, they could reduce longitude errors by cross-referencing the three. I applied the same scale as I had worked out for measuring Patagonia and discovered that the distance shown on the Piri Reis map from Deception Island in the Antarctic to Bird Island was correct. The only mistake was that both the South Shetlands and South Georgia were shown further east than they should be. Once again, the circumpolar current accounted for the longitudinal error.

After he had reached and charted Bird Island, Admiral Hong Bao would have had no choice but to continue eastwards, sailing beneath Canopus, for around these latitudes, as the name implies, the Roaring Forties would have driven his ships before the wind to the east. These are winds to test the courage of the bravest sailor. They howl over towering seas, great walls of green water capped with foam, hurling spume through the air. Seamen would have worked frozen and soaked to the skin and shouted themselves hoarse in a vain attempt to be heard amid the shrieking of the wind through the rigging, the creaks and groans of timbers as the hull flexed and twisted in a swell like none other on earth, and the roar and hiss of waves breaking over the bows and foaming away through the scuppers. The prow would have dragged itself free of one giant wave only to bury itself immediately in the next. There would have been little respite for the men below decks, their clothes permanently sodden and the pitching and heaving of the ship so severe that sleep would have been all but impossible.

Driven eastwards by the relentless winds, Admiral Hong Bao would not have anchored until he next found land along 52°40'S, enabling him to conduct another detailed cartographic survey, just as he had in South America. But travelling eastwards at this latitude there is no substantial landmass, only a few scattered islands. At last, after a voyage of some five thousand miles across the southern oceans, all the time with the brilliant yellow-white Canopus directly above him, the increasing numbers of sea-birds – albatross, terns, skua and petrels – would have alerted him to the fact that land was nearby, and at last his look-outs would have spotted the volcanic Mawson's Peak on Heard Island silhouetted above a group of smaller islands just fifteen miles to the south. Now he could begin a survey to establish another 'anchor' position for his cartographers.

Heard Island would have seemed a far from inviting prospect to Hong Bao and his men. It is heavily glaciated and much of the coastline is covered by ice cliffs. There are a few isolated patches of tussock grass, moss and lichen, but 80 per cent of the island is permanently ice-bound. However, a group of somewhat less forbidding islands, the Kerguelens – named after the Frenchman Le Comte Yves de Kerguelen-Tremarec, who is credited with discovering them on 12 February 1772 – lies three hundred miles to the north. The driving winds in that region mean that the Kerguelens can most readily be approached by square-rigged ships from the west – from South America, precisely the direction from which Hong Bao's fleet was sailing.

I found some independent evidence¹⁸ that Hong Bao's fleet

VOYAGE TO ANTARCTICA AND AUSTRALIA

had reached the islands: the *Dictionary of Ming Biography* records, 'Some of the ships reached as far as a place called Habuer which may be identified as Kerguelen Island in the Antarctic Ocean.'¹⁹ The island of Habuber is also shown on the Chinese Mao Kun chart, part of the *Wu Pei Chi*, compiled around 1422,²⁰ alongside a note stating that 'storms prevented the fleet sailing further south'. Hong Bao had found more new lands.

Dominated by the six-thousand-foot Mount Ross, the main island of Kerguelen is sufficiently barren to have been described as 'Desolation Island' by Captain Cook. Rain, sleet or snow falls on three hundred days a year and 30 per cent of the island is permanently ice-covered, but the coasts are rich in penguins and elephant seals, and Kerguelen cabbages, very valuable plants for seamen, grow among the tussock grass and moss. A relative of our own cabbage, Kerguelen cabbages are rich in vitamin C and were much harvested and eaten by whalers and sealers in the following centuries to prevent scurvy. Hong Bao's crew would almost certainly have been suffering from scurvy after their marathon voyage across the southern oceans and would have gathered as many cabbages as possible, but Kerguelen's sour and barren soil did not support anywhere near enough of the plants to feed the thousands of men carried by the fleet. The search for fresh supplies would now have been becoming urgent.

The revelation that the Chinese had discovered Ha-bu-er/ Kerguelen Island filled me with excitement, for after leaving the island Hong Bao's ships could have sailed in only one direction. As the Mao Kun says, the Roaring Forties would have prevented them from sailing further south, and they would also have stopped them from going north or retracing their route westwards. Instead, the Chinese junks would have been propelled eastwards before mountainous waves along a sea corridor that led straight to the south-west coast of Australia. I had no doubt that Hong Bao must have reached Australia, so I returned to the British Library to search for a chart of the continent that had been

THE VOYAGE OF HONG BAO

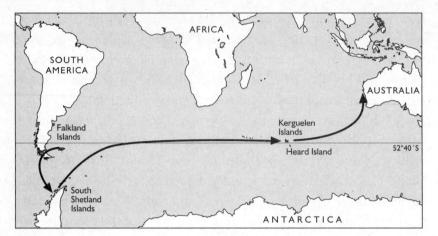

Hong Bao's journey to Australia.

surveyed and drawn before the first Europeans discovered it.

Australia is not depicted on the Piri Reis map, but it is shown on another very early chart, held by the British Library. It was drawn by Jean Rotz, appointed 'Hydrographer to the King' by Henry VIII of England, and was included in the *Boke of Idrography* Rotz presented to the king in 1542, two centuries before Captain Cook 'discovered' Australia. Rotz came from the Dieppe School of Cartography, celebrated throughout Europe for the clarity and accuracy of the maps and charts they produced. He was the leading mapmaker of his day, renowned for the meticulousness with which he depicted new lands. He never invented or fudged; what is shown on his charts is exactly what he had seen on older charts.

It is commonly accepted²¹ that Rotz, and indeed the other Dieppe cartographers of his day, copied much older Portuguese charts. The styles of the Piri Reis and Jean Rotz charts are very similar, and both use Portuguese names to describe the newly discovered lands. The Rotz chart shows Malaysia, Cambodia, Vietnam and China all the way up to modern Hong Kong, and the whole coast is extremely well charted. The Persian Gulf,

VOYAGE TO ANTARCTICA AND AUSTRALIA

India and south-east Asia are also instantly recognizable. The original chart can only have been drawn by someone with intimate knowledge of the coastlines of the Indian Ocean, China and Indochina. That at once ruled out the Portuguese, for although the Rotz chart was made after Magellan's circumnavigation of the world, neither Magellan nor the Portuguese explorers who followed him spent long enough on the Chinese coast to chart it with such compelling accuracy. Their target was the Spice Islands; they were making for the Moluccas far further south. If the original cartographer was not Portuguese, he in turn must have copied an earlier original.

Despite his accurate depiction of the coasts of China, Asia, India and Africa, many historians have failed to identify a vast new landmass Rotz showed south of the equator. It consists of two islands, 'Little Java' south of Sumatra and 'Greater Java', a huge continent stretching away from near the equator towards the South Pole. At its northern end, this continent has a protruding spit resembling Cape York, the northernmost tip of Australia. The north-east part of this southern continent also resembles the north-east Australian coast, but the land shown on the Rotz chart stretches far further to the south-east than Australia actually does.

The theories of Ptolemy – the astronomer, mathematician and geographer who lived in Alexandria in Egypt c. AD 87–150 – had been rediscovered in the late Middle Ages. Ptolemy's belief in the symmetry of the stars and the planets had led him to advance a theory in his book *Geographia* that a substantial southern landmass must exist to 'balance' the continents of Europe and Asia in the northern hemisphere. My first assumption was that when drawing the land in the far south the original cartographer of the Rotz chart had based it not on observation but on Ptolemy's forccast, but this did not square with Rotz's reputation for precision. For the moment I had to set that puzzle aside and concentrate my attention on the south-west coast of 'Greater Java', which was

THE VOYAGE OF HONG BAO

depicted with considerably more accuracy. The shape of the coast accords with Hong Bao's fleet having made a landfall near modern Bunbury, a hundred miles to the south of Perth in Western Australia. The prevailing wind and current would then have driven them up the coast to an anchor point in the estuary of the Swan River that separates modern Perth and Fremantle, shown as a deep indentation on the Rotz chart.

The Kerguelen cabbages they had collected would have been of only modest help in staving off scurvy among the crew of the fleet, but in south-west Australia they would have found plentiful supplies of vitamin C in the berries that abound in the area. Blue fairy penguins and manna crabs were also there for the taking, the quokkas (small wallabies) were slow, timid and easy prey, and the jarrah, marri and karri trees would have provided plenty of hardwood for repairing their junks. Although the Rotz chart also shows the eastern and northern coasts of the Australian continent with great fidelity, the west coast is drawn no further south than Bunbury, where it ends abruptly. The most plausible reason for this curtailment of the survey, I would argue, is that the junk despatched by Admiral Hong Bao to chart the south coast of Australia foundered off Warrnambool in modern Victoria, south-east Australia, where a wreck was indeed discovered 166 years ago that could well have been a ship from Hong Bao's fleet.

In 1836, three men hunting seals sailed into the muddy Hopkins River and continued westwards down the small estuaries and lagoons of that coast. Where the Merri River joins the sea, they came across the wreck of a very old ship known from that day to this as the 'Mahogany Ship' because of the timber used in its construction. Seven years later, Captain Mills, a local harbour master, inspected the wreck on behalf of the government. He was astonished at the hardness of the wood; when he tried to cut a piece, his knife was useless, 'like glancing off iron'.²² European ships were not then built of mahogany – the contemporary name used for any of a variety of reddish-brown hardwood trees – for there were no such trees in Europe, but Chinese ships were built of teak, a reddish-brown hardwood from the forests of Annam. Captain Mills was also baffled by the ship's origins: 'She struck me as a vessel of a model altogether unfamiliar and at variance in some respects with the rules of shipbuilding as far as we know them ... As regards to the nationality of the wreck, I do not profess to be a judge ... I should say the wreck in question is connected with neither [Spanish or Portuguese] build.'²³

Twenty years later, an Australian woman, Mrs Manifold, examined the wreck, one of a further twenty-five people to record their impressions of it. She was impressed by the internal bulkheads, 'stout and strong'.24 I am confident that this is probably a missing ship from Hong Bao's fleet.²⁵ The Aboriginal Yangery tribe, who then lived on the mainland close to the wreck-site of the ship, have a legend that 'yellow men' long ago settled among them.26 Since then many observers have commented on the distinctive colour and facial characteristics of Aborigines who come from this small area of southern Australia. Pending carbon-dating of the material to establish the date of the wreck, at the very least it is arguable that sailors aboard the ship detached by Admiral Hong Bao to chart the south Australian coast were shipwrecked, and that some of the men and their concubines managed to reach the shore and settled among the Aborigines. Professor Wei Chuh-Hsien (Wei Chu Xian) goes further, believing that the men wrecked at Warrnambool rode on horseback up the valleys of the Murray, Darling and Murrambidgee Rivers to what is now Cooktown, leaving traces of their journey along the route.²⁷ Professor Wei's theory seems to be corroborated by Toscanelli's map of 1474 which shows the rivers explored by the Chinese cavalry.

By March 1423, the Chinese fleets had been at sea for two years

THE VOYAGE OF HONG BAO

and had sailed the nethermost reaches of the oceans. Admirals Hong Bao and Zhou Man had accomplished the major part of their mission - locating Canopus and the Southern Cross and going on to chart the southern hemisphere – but one aspect of the voyage had not gone according to plan. After leaving the Indian Ocean, the admirals had expected to greet foreign potentates and present them with fine silks and porcelains, bringing their countries into China's tribute system. Yet the people they had met along the route were unused to trade and appeared to have no kings. The Bantu in South Africa, Aborigines in Australia and naked men in Patagonia had no use for silk or porcelain, and places such as the Antarctic and Cape Verde Islands were uninhabited. Life in the lands the Chinese had discovered was far more primitive than they had expected, and as a consequence the holds of their surviving ships must still have been full of their 'treasure' of porcelain and silks. But as he set sail from the west coast of Australia, Hong Bao would have known that he still had the opportunity to trade his goods before making for home, for the Spice Islands and the great trading port of Malacca were well within his reach.

The Rotz chart depicts western Australia, Sumatra, the Malay Peninsula, Indochina and the west coast of Borneo with considerable accuracy. This suggests that, having sailed northwestwards from Perth, the remainder of the fleet under Hong Bao circumnavigated Sumatra, berthed at Malacca, one of the prime trading ports in the Indian Ocean, and then returned home through the South China Sea, sailing along the west coast of Borneo – the east coast is not charted – and to the west of the Philippines before eventually arriving home on 22 October 1423.

Admiral Hong Bao's fleet had been the first voyagers ever to sail through the Strait of Magellan. They had discovered the Antarctic continent and reached southern Australia over two centuries before Abel Tasman (1603–c. 1659), who discovered the island of Tasmania that bears his name. Taken in isolation,

VOYAGE TO ANTARCTICA AND AUSTRALIA

Hong Bao's voyage would have been more than worthy of modern commemoration. He had made one of the epic journeys in the history of mankind's exploration of the planet and his name deserves to be remembered and celebrated. But that was not the end of the Chinese achievements. As Hong Bao prepared to return home in triumph, another Chinese fleet under Admiral Zhou Man was also sailing along southern latitudes making for Australia from the opposite direction, crossing the Pacific a century before Magellan.

AUSTRALIA

7

THE DESIGNATED TASK OF ZHOU MAN WAS TO SURVEY THE world west of South America; like Admiral Hong Bao, who had sailed eastwards, Zhou Man would have needed 'anchor' reference points at 52°40'S as he crossed the oceans beneath Canopus. But as his fleet entered the Pacific, the squarerigged junks would have met the cold Humboldt current and been swept northwards up the coast of what is now Chile. Magellan, Carteret, Bougainville and countless other explorers following in the wake of the Chinese had the same experience. The depiction of the Andes on the Piri Reis map¹ gives clear evidence that this had also happened to Zhou Man's fleet, but I did not yet know how far north the Chinese had travelled and whether they had reached Peru or met the Incas, one of the great civilizations of pre-Columbian South America.

For once, there was a helpful Chinese document that had escaped destruction by the mandarins. Dr Wang Tao of the School of Oriental and African Studies in London told me of a novel about Zheng He's voyages written in 1597, the Hsi-Yang-Chi (Xi Yang Ji). It became hugely popular in China after its publication, but is now so rare that the copy held by the library of the School of Oriental and African Studies is the only one in the world. Although it was written the best part of two centuries after the voyages it describes, and most of the book is taken up with fanciful adventures, the author did the modern researcher a valuable service by giving a detailed list of the tributes offered to the Chinese fleet by the barbarians they encountered on their voyages. The descriptions differ from the lists of goods given by Ma Huan (who never sailed beyond the Indian Ocean), suggesting that the author must have drawn on a different, now vanished source, but the detail and oddity of the list makes a convincing impression:

One pair of whale's eyes, commonly called bright-eyed pearls. Two bream whiskers. These are lustrous and may be used for

THE VOYAGE OF ZHOU MAN

hairpins or ear-ornaments. The price is very high.

One pair of camels that go to a thousand li [four hundred miles – possibly a reference to the distance the animals could travel without water].

Four boxes of dragon's saliva [ambergris].

Eight boxes of frankincense.

Four pairs of landscape porcelain bowls. In these is a landscape; by pouring water into the bowl, the mountains become blue and the water green.

Four pairs of porcelain bowls with representations of men and things: by pouring water into them there is gradually a picture of men saluting each other.

Four pairs of porcelain bowls with flowers and plants. In these are flowers and plants. By pouring water into them, they appear to move and wave.

Four pairs of porcelain bowls with feathers. In these are feathers, and by pouring water into them, they appear to fly.²

Clearly, these bowls greatly impressed the Chinese, who had prided themselves on making the world's finest and thinnest porcelain. These bowls must have been even finer. They became translucent when filled with water, allowing scenes painted on the undersides to be seen through the porcelain. It was beyond the capacity of any Indian, African or Islamic states of that or any earlier era to produce ceramics of such quality, and Europeans did not discover the technology to produce fine porcelain until the early eighteenth century. The only porcelain of that thinness at the time came from Cholula (in modern Mexico); the Aztec emperor Montezuma II (1480–1520) was eating off Cholula ware when the Spanish conquistadors encountered him. It was literally eggshell-thin, extremely expensive and much sought after, and was exported from Cholula to the Pacific coast and South America.

At the time of the Chinese voyages, Cholula was in its prime,

AUSTRALIA

producing huge quantities of this renowned porcelain and building pyramids more colossal than those of Egypt. Assuming that 'the pair of camels' were llamas (camelids), then everything in the tribute list, including the ambergris (from small whales called cachalots), could have been found in northern Peru. Asiatic hens were found there when the Spanish first landed, and at the very least it is arguable that they could have been left by Zhou Man's fleet after an exchange of gifts with the birdloving Incas. I was later to find overwhelming evidence of pre-Columbian voyages between China and the Americas in Mexico, Guatemala, Colombia, Ecuador and Peru, as will be discussed later.

I returned to the task of tracing the course taken by Zhou Man. After leaving Peru, his fleet would first have been carried by the equatorial current as far north as Ecuador, where the current turns due west and carries mariners across the Pacific, the route along which explorer after explorer was swept in later centuries. Don Luis Arias, a Spanish envoy to South America in the sixteenth century, sent a memorandum to his king describing a South American legend of a Pacific crossing from Chile before the European voyages of discovery, carried out by 'light coloured or white skinned people . . . who wore white woven garments'.³

The course followed by the fleet would have taken it through the Tuamotu archipelago, four thousand miles west of South America. In 1606, Pedro Fernandez de Quirós (1565–1615), a Portuguese explorer working for the Spanish Crown, landed at Hao Atoll in the Tuamotu archipelago.⁴ There he encountered an old lady wearing a gold ring set with an emerald. He offered trade goods for it but she greeted his offer with disdain – it was far too valuable. Neither gold nor emeralds are found within thousands of miles of the Tuamotu archipelago, but it is well documented that such rings were exported during the early Ming dynasty and given as presents by Zhu Di's ambassadors. Stepped pyramids were also found along this south-western route and in Australia, and the first Europeans to reach Fiji found that someone had been mining copper before them – something the locals did not do. Polynesians could have carried artefacts across the Pacific in their canoes, but that does not explain the Chinese hens and artefacts found in the Americas or the sheer volume of goods carried from the Americas to the Pacific. I would suggest that the only logical explanation is that they were carried by the junks of a Chinese treasure fleet and the ships of the traders that accompanied them.

When those legendary voyagers reached the mid-Pacific off Samoa, they found that the south equatorial current split there, just as it does today. The northern part carries on towards the Carolines, New Guinea and the Philippines; the southern part sweeps south-west towards Australia.

There is substantial evidence that Zhou Man's fleet separated at this point. The northern squadron built observation platforms at Kiribati in the Carolines, and another five in New Guinea. They were stepped pyramids with truncated tops like those in China. Rose-pink beads, made by rubbing a spiny oyster against cowrie shells, exactly similar in size and design to those found in the rivers of Mitla in Central America were found in the Caroline Islands last century, together with a fragment of obsidian and a piece of iron resembling a spearhead - all items foreign to the islands. Chinese hens were found in Peru by the first European explorers; maize, indigenous to the Americas, was found by the first Europeans to reach the Philippines; metates - tools used to grind maize - were in the holds of the junk found on the sea-bed in the Philippines in 1993, which was believed to have sunk about 1423. All of this is consistent with the Chinese sailing with the wind up the west coast of South America (shown on the Piri Reis map) and then across the Pacific.

The southern squadron swept on to chart Norfolk Island and, still carried westward by the current, made a landfall on the east coast of Australia just north of where Sydney is sited today. The

AUSTRALIA

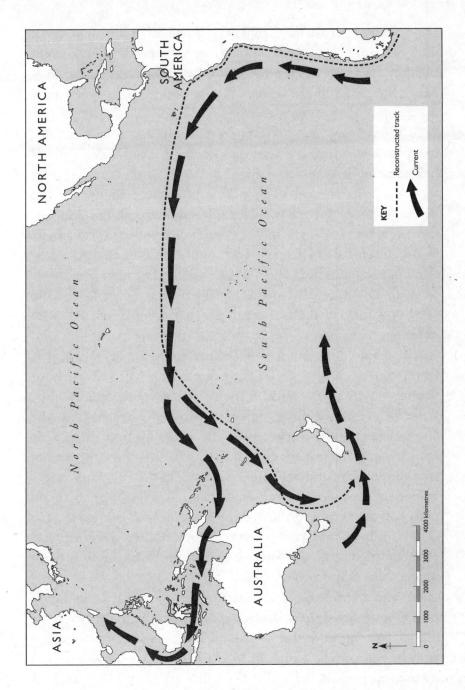

Zhou Man's journey to Australia.

great voyage across the Pacific had covered more than seven thousand miles and taken around three months. The current turns to the south when it meets the Australian coast, and Zhou Man's fleet would have been carried with it towards the latitude of Canopus, their reference point.

Admiral Hong Bao's voyage to Australia has been described in chapter 6. Admiral Zhou Man knew of Australia's existence before he landed there, for since Sui dynasty times (AD 589-618) the Chinese had known of a great landmass peopled by men who threw boomerangs, one hundred days' sailing south of Asia.⁵ In the Shan-Hai Jing ('Classic of Mountains and Seas'), Chinese historians of that era described an animal with the head of a deer that hopped on its hind legs and had a second head in the middle of its body - the baby in the pouch. By the time Marco Polo reached China in the thirteenth century, Chinese charts were showing two Javas - the island we know today as Java and 'Greater Java', the source of the trepangs, or sea slugs, the Chinese ate with such relish. They remained a lucrative catch for fishing vessels and are still a highly prized delicacy in China. After his visit to China, Marco Polo called Greater Java 'the largest island in the world', and even before his time there were kangaroos in the imperial zoo in Beijing. Kangaroos, of course, are unique to Australia. Further evidence of the Chinese voyages to Australia could be seen at Taiwan University: a map on porcelain dated to 1447 showed the coastline of New Guinea, the east coast of Australia as far south as Victoria, and the north-east coast of Tasmania. Unfortunately, at the time of writing it appears this map has been lost.

It seemed probable that cartographers aboard Zhou Man's fleet had surveyed these lands and provided the information for the charts, but since the records of his voyage were destroyed after he returned to China in 1423 I had to look abroad to find corroborative evidence of his landfall in Australia. My analysis started from the assumption that this great southern continent

AUSTRALIA

was already well known to the Chinese, but was surveyed in more detail during their 1421–3 voyage. If so, I expected the cartography to be of a very high standard, with the latitudes and the alignment of the land correct, but possibly with substantial errors in longitude.

The great landmass shown on the Jean Rotz chart (pp. 151-2) could be Australia, but with some longitudinal errors and some distortion of the land in the south-east of the continent. I began my investigation by examining the eastern coast of the continent from just south of Byron Bay in New South Wales down to Flinders Island off the south-eastern tip of Australia. A close examination of this part of the Rotz chart in comparison to a modern map showed that it depicted eastern Australia to a great degree of accuracy from Nelson Bay⁶ down to the southern tip of Tasmania.⁷ I could readily identify Port Stephens, Broken Bay and Botany Bay with their correct latitudes.

If Zhou Man's fleet had reached south-east Australia after crossing the Pacific, there should be evidence of that landfall in the area depicted with most precision on the Rotz chart. As soon as I started a search of the coastline south of Newcastle, I found a mine of information. In the 1840s, a ruined fortress was found by Benjamin Boyd, one of the earliest European settlers, at Bittangabee Bay near Eden in the far south of New South Wales. He noted a large, fully mature old tree with its roots growing under the stones of the complex. Bittangabee's substantial ruins comprise a square platform surrounded by large rocks that had once formed a sturdy, defensive perimeter wall. Foundations and parts of the walls of a blockhouse formed by large stones bound with mortar lie inside the perimeter wall. It must have taken a large labour force to bring the stones to the site and then dress and erect them. There is no evidence anywhere in Australia of Aborigines constructing such fortifications, and the age of the tree and the position of its roots show that construction can only have been carried out long before the British first

203

arrived. More stone buildings erected before Europeans reached Australia can be found south of Sydney; a group of twenty, like a small village, are set beside the coast, and there are well-built paths leading from a reservoir to a fifteen-metre stone wharf beside the sea. Similar stone dwellings are found at Newcastle.

Further indications that visitors had landed in Australia were found in ancient Aboriginal rock carvings depicting a foreign ship similar to a junk on the Hawkesbury River north of Sydney. There are similar carvings further up the coast at Cape York, Gympie, and in Arnhem Land. This does not, of course, guarantee that the foreigners were Chinese – they might have arrived on an unknown Portuguese voyage – but rock carvings near the Hawkesbury River show people wearing long robes, which narrows the choice to Asian or Chinese people. Furthermore, an Aboriginal tradition from the Tweed River area tells of strange visitors attempting to mine metals in the Mount Warning area, south-west of Brisbane, many generations before the British did so.

The most compelling evidence for the date of these foreign

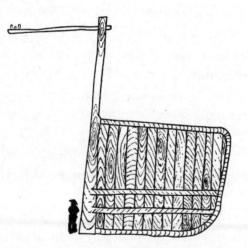

Reconstruction of the rudder of a treasure ship with a figure to the left for scale.

AUSTRALIA

visits came from shipwrecks, especially one found near Byron Bay in northern New South Wales. Two wooden pegs were unearthed, provisionally carbon-dated to the mid-fifteenth century but with a potential error of plus or minus fifty years. Before sand-mining destroyed the wreck, local people had described part of the hull and three masts protruding from the sand. In 1965, sand-miners unearthed a huge wooden rudder from this site; some said it was 40 feet (12.2 metres) high. If this description was even remotely accurate, it eliminates the possibility of an unknown Portuguese or Dutch voyage, for their caravels weren't much bigger than that rudder. It can only have come from an enormous ship several hundred feet long - the rudders of treasure ships were 36 feet high. The wreckage of another ancient ship was found at Wollongong on the coast south of Sydney, and two more were found in swampland near Perth. An ancient Chinese stone head depicting a goddess has also been found at Ulladulla,8 south of Wollongong, and a

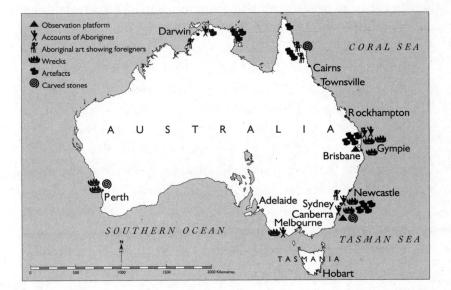

Evidence of the visit of the Chinese treasure fleet to Australia.

THE VOYAGE OF ZHOU MAN

similar votive offering was unearthed on the Nepean River.

The 'mahogany ship' at Warrnambool, the similarities of the three wrecks at Perth and Wollongong, the age of the wooden pin and the size of the huge rudder in Byron Bay point to a Chinese origin. Only the Chinese built ships that could house a rudder the size of that found in Byron Bay, and only they could afford to lose so many ships in one area. The addition of the findings from the wrecks to the Aboriginal legends and carvings depicting foreigners in robes arriving by ship, the groups of stone buildings and the votive offerings produces powerful if not yet conclusive evidence that a large Chinese fleet visited south-east Australia in the fifteenth century.

South of Bittangabee Bay, the original cartographer of the Rotz chart drew the southern curved part of Tasmania, but the chart also shows what appears to be a great landmass running first eastwards then southwards. This has always baffled professional cartographers, but when I compared the Jean Rotz and Piri Reis charts at the same latitude I saw at once that what appears to be land south of Tasmania is in fact ice. It is drawn in identical fashion to the ice shown on the Piri Reis map, and the line drawn on the Rotz chart corresponds to the northern limit of pack ice to the south of Tasmania in midwinter (June) in 1421–3.

At a stroke this would have solved the mystery of the apparent landmass to the south and south-east of Australia were it not for two rivers shown on the Rotz chart flowing eastwards out of the ice. These two 'rivers' are shown well south of New Zealand; there are none there, of course. There appeared to be nothing but ocean at those latitudes, but when I examined a large-scale map I discovered two small islands of which I had previously been ignorant, Auckland Island and Campbell Island, at a similar latitude to Tierra del Fuego. Both have identical long thin bays lying east–west, precisely as drawn on the Rotz chart, and at the same latitude.

The two islands were shown at the edge of the normal limit of

AUSTRALIA

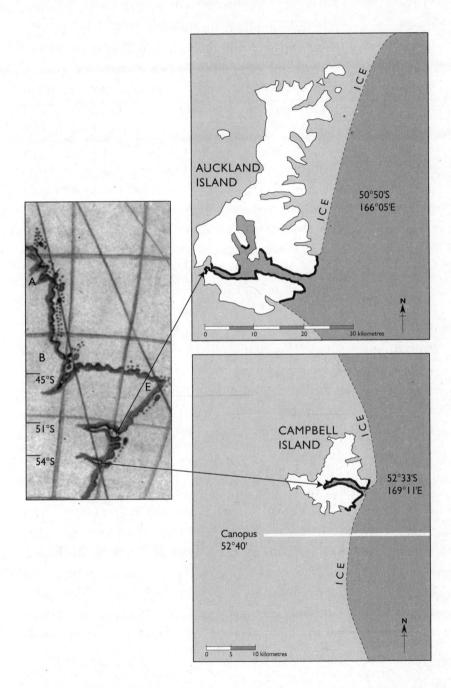

Auckland and Campbell Islands, as shown on the Jean Rotz map.

THE VOYAGE OF ZHOU MAN

the pack ice that links them in midwinter. This explains the apparent anomaly on the Rotz chart. The Chinese could not possibly have known that they were islands rather than part of an ice-bound landmass because continuous ice lay between them and stretched away north to Tasmania; once again, they had drawn precisely what they saw. They were sailing to Campbell Island to fix the position of Canopus $-52^{\circ}40'S$, precisely the latitude of the southernmost tip of the island. They had their reference position, and they could now start a detailed survey of this part of the world.

I found further indications that Zhou Man's fleet had reached Campbell Island in the accounts of the early Europeans who explored the island, discovered by Frederick Hasseburg, the captain of a sealing ship, in 1810. In Camp Cove, they found the wreck of an old wooden ship and a tree stunted by the endless winds, but recognizable as a mature Norfolk Island pine, a tree unique to Norfolk Island. It was the Chinese custom to collect saplings, seeds and pine-cones on their voyages, planting them as shrines at places where they made landfall and burying votive offerings in the roots. The Norfolk Island pine on Campbell Island could well have been brought there by one of Zhou Man's junks.

The fleet had now surveyed and charted eastern Australia from Nelson Bay down to Campbell Island in the far south, but they were faced with real difficulties when it came to setting course back to Australia. Unknown to them, the Antarctic drift current was pushing them to the east, towards the South Island of New Zealand. I have many happy memories of that beautiful land after taking my submarine there at Christmas in 1969. The South Island is a place of rugged grandeur, spectacular mountains and crystalline lakes, a land where the Antarctic winds scour the skies clean. However, the Tasman Sea is a nightmare for navigators. The skies are frequently clouded and the currents are irregular. They can reverse their direction without warning.

AUSTRALIA

The Chinese would have had to claw their way back against the current; as they did so, at least two of the great treasure ships were lost. The wreck of an old wooden ship was found two centuries ago at Dusky Sound in Fjordland at the south-west tip of New Zealand's South Island. It was said to be very old and of Chinese build and 'to have been there before Cook', according to the local people.9 A Sydney packet visited Dusky Sound in 1831 and two sailors from the crew 'saw a strange animal perching at the edge of the bush and nibbling the foliage. It stood on its hind legs, the lower part of its body curving to a thick pointed tail, and when they took note of the height it reached against the trees allowing a metre and a half for the tail, they estimated it stood nearly nine metres in height. The men were to windward of the animal and were able to watch it feeding for some time before it spotted them. They watched it pull down a heavy branch with comparative ease, turn it over and tilt it up to reach the leaves it wanted.'10 The animal described corresponds in size, posture and eating habits with the mylodons the Chinese could have taken aboard in Patagonia. Perhaps a pair escaped from the wreck, survived and bred in similar conditions to their home territory in Patagonia - the latitudes are the same. Sea-otters, which are not indigenous to New Zealand but, of course, were kept in the Chinese junks to herd fish, have been seen swimming in the fiords of South Island.

Further north, on the west coast of the North Island of New Zealand, the deck and sides of part of a large and very old ship were exposed in 1875 after a violent storm. The wreck was found near the mouth of the Torei Palma River at Whaingaroa; it is known as the Ruapuke Ship after the beach of that name. The wreck was said to have diagonal planking, and its internal bulkheads were bolted together by large brass pins, each weighing 6.3 kilograms. There has, though, been some dispute about the wood from which the wreck was built. Those who originally found it said that it was teak, but in May 2002 pieces of European

209

oak were found in the area, leading certain experts to conclude that a European ship was wrecked there.

However, a huge stone carved in what local experts say is Tamil calligraphy stands at the point where the river empties into a little harbour. In shape, size and location this stone corresponds with those set up by the Chinese mariners in the Yangtze estuary, at Dondra Head, at Cochin on the Malabar coast of India, at Janela in the Cape Verde Islands and by the Matadi Falls in the Congo delta. In addition to the calligraphy, the Ruapuke stone has the same patterns of concentric circles as the stone at Janela. I had already found a number of carved stones at sites visited by the Chinese fleets, so my next step was an obvious one. Sure enough, a search on the internet soon revealed several more on the route from the Cape Verde Islands down to Patagonia, at Santa Catarina, Coral Island, Campeche and Arrorado Island on the east coast of South America. Each is also sited beside a watering place and overlooks the sea, and the concentric circles inscribed on them match those at Ruapuke. But this could still have been a coincidence; after all, pyramids were built in Central and South America as well as in Egypt. The proof would be more conclusive if I could find similar carved stones in China. Another long search produced three more, at Wong Chuk Ha, Chang Zhou and Po Ti in Hong Kong. Again, these stones had similar markings to the ones I had already found. I now believed that the concentric circles were a 'signature' agreed upon before the armada set sail, denoting where each fleet had landed and watered.

Perhaps the most controversial piece of evidence unearthed in New Zealand is the celebrated bell found near the wreck on Ruapuke beach, named the 'Colenso Bell' after Bishop Colenso who discovered it being used as a kettle by the Maoris. It looks like a smaller version of Zheng He's bell cast after the sixth voyage, and the lip of the bell is inscribed in Tamil calligraphy similar to that carved on the stone near the wreck. It has been

AUSTRALIA

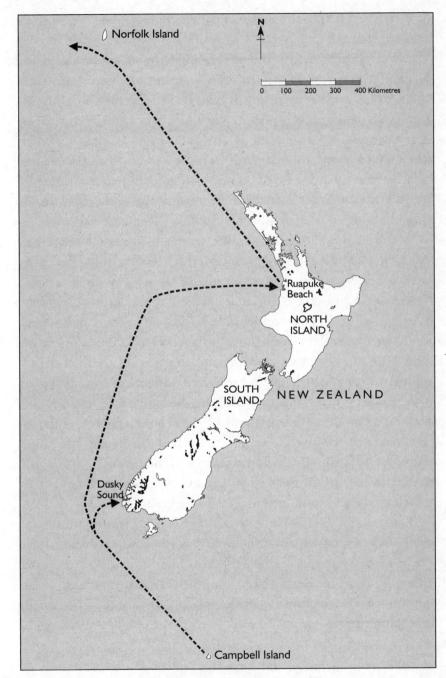

The journey around New Zealand.

translated as 'Bell of the ship Mohaideen Baksh'. The inscription suggests that the owner was a Muslim Tamil, probably from one of the well-known ship-owning families based on the port of Naga Pattinam on the eastern coast of Tamil Nadu in south-east India.¹¹This is evidence of an Indian not a Chinese ship, but, as the Pandanan wreck found in the Philippines (see chapter 10) demonstrates, it was common for local ship-owners to sail with Zheng He's fleets for they not only provided protection from pirates, they also afforded valuable opportunities to trade. It seems most unlikely that a Tamil ship would have travelled from India to South America and then to New Zealand on its own.

Within a mile of the Ruapuke wreck is a large fallen tree. When it was blown over in a gale, a duck, beautifully carved in dark green serpentine, was revealed nestling among its roots. The duck could well have been a Chinese votive offering. A similar offering, a lion, was found in East Africa, and others have been found in Queensland and the Northern Territory of Australia. This type of shrine is typical of, and unique to, the culture of southern China. Although they are clear evidence of Chinese visits to Australia, I accept that on their own the votive offerings are not proof of a landing by a treasure fleet; they could have been carried by Chinese merchants. However, the collective evidence – the ship, the votive offering, the bell, the stone and the carving – leads me to the conclusion that the ship at Ruapuke was almost certainly the wreck of a Tamil junk attached to the Chinese fleet.

The final piece of evidence is another votive offering found on the banks of a tributary of the Waikato River some thirty miles north of the Ruapuke wreck. The find was made in the late 1800s by Elsdon Best, the distinguished historian and then curator of the Dominion Museum in Hamilton. The small oriental figurine was

found under singular and interesting circumstances at Mauku near Auckland. The lands around the place of discovery have been

AUSTRALIA

uninhabited since the arrival of Europeans until twenty years ago, and since then merely occupied by farm employees; nor have these lands ever been ploughed. In pre-European times, however, natives occupied the place, as shown by the remains of old settlements ... The figurine is undoubtedly Oriental in design and workmanship ... having the grotesque aspect so common in Oriental designs, some form of turban-like head dress is depicted, also a loose cloak or wide-sleeved garment ... Altogether, this snub-nosed Tartar-looking figure represents an interesting discovery when the conditions of that discovery are noted.¹²

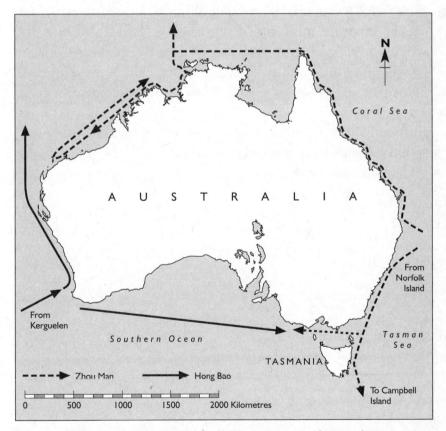

The routes of Hong Bao and Zhou Man around Australia.

The Chinese fleets were losing ships with almost every landfall, a rate of attrition that continued throughout their voyages across the world, for of the 107 treasure ships that left China in 1421, a mere handful survived to return home in 1423. As the mandarins complained, 'Myriads were lost.' Those huge losses increase the likelihood that the wrecks at Ruapuke and elsewhere on the Chinese route were ships from the treasure fleets.

If the ship at Ruapuke is a wrecked treasure ship, then tales of the shipwrecked crew must exist in local legends, just as they do in Central America and southern Australia near wreck-sites. When I investigated, I found that Maoris living near Ruapuke had just such a legend.¹³ The strangers who settled among them were called 'Patupaiarehe', or pale-skinned, almost supernatural people. Another meaning of the word is 'fairies'. They wore white woven garments and also differed from the Maoris in having no tattoos and by carrying their children in their arms. Some married Maori women. I believe this local legend is true, and that the first non-Maori settlers in New Zealand were not Europeans, but Chinese. Subsequent DNA analysis (see postscript) has only strengthened my belief.

THE

BARRIER

REEF

AND THE

SPICE

ISLANDS

NCE BACK IN THE TASMAN SEA, ZHOU MAN'S SURVIVING ships entered a counter-clockwise, circular current that at last propelled them back to the Australian coast. The shape of the south-east Australian coast, coupled with the location of Campbell Island on the Jean Rotz chart and the wrecks in the south-west and north-west of New Zealand, are all consistent with the junks being swept before the winds and currents from the Australian coast down to Campbell Island and then in a loop with the wind back to New Zealand. Continuing before the wind would have caused them to make their second landfall on the Australian coast just north of Brisbane. Assuming an average speed of 4.8 knots, reduced to 3.8 by the current and storms, the journey down to Campbell Island and back again would have taken at least ten weeks.

The coast around Brisbane is shown on the Rotz chart with incredible precision, and that chart was not the only one of Australia to be drawn by cartographers of the Dieppe School, all of them drawn centuries before Europeans reached Australia. The Dauphin chart of 1536 and those of Desliens (1551) and Desceliers (1553) gave an almost identical depiction of the continent. Two decades ago, one of the Dieppe maps was exhibited. Visitors were stunned: 'Look at Brisbane. Look, there's Stradbroke Island, Moreton Island, the Pine River, the Heads and Fraser Island. There's the lagoon at Surfers' Paradise.'1 The accuracy with which the eastern Australia coast had been drawn left me equally dumbstruck. To have surveyed it with such precision, the Chinese fleet must have spent some time on the east coast of Australia in what is now New South Wales and Queensland, and one obvious reason for that is the mineral wealth of the region.

Perhaps the most commercially valuable scientists carried by the great treasure fleets were mining engineers. At that time, China and India together accounted for almost half the world's entire wealth² and Indian engineers led the world in mining

technology. They had opened up gold and iron fields in East Africa, stimulating a flow of raw materials eastwards across the Indian Ocean. Indian engineers and metallurgists sailed with the treasure fleets, but China also had centuries of experience in geology, mineral extraction and processing. As is claimed in Chinese records of a much earlier period,³ the treasure fleets would have mined ores and carried gemstones and refined metals back to China in their holds, but the Chinese would also have set up longer-term settlements to exploit the mineral riches they discovered on their voyages.

Chinese scientists had classified minerals into groups by the first century AD.⁴ Those early Chinese scientists could distinguish between different chlorides, sulphides and nitrates, and knew how to exploit them. They used mercuric sulphide (cinnabar) for red inks and paints; steatite was added to paper as a filler; and skins were first dried with saltpetre (potassium nitrate), then treated with ammonium chloride, and finally dyed with ferrous sulphate.

They were equally skilled in geological prospecting, capable of detecting minerals and metals by magnetic surveys or by measuring shock waves caused by explosive detonations, even by the lie of the land. They also knew that the ores and minerals they sought were often geologically linked with others. Greenstones always occurred in the neighbourhood of copper ores. They even had a rhyme for such associations: 'When there is cinnabar above, gold will be found below; when there is magnetite above, copper and gold will be found below.'5 Similarly, iron was associated with haematite on the surface, and both sulphur and iron pyrites signified alum. Chinese chemists had also deduced that certain plants thrived on particular minerals, to the extent that they changed colour and taste when growing near them. Cybule onions signified silver; shallots, gold; ginger, copper and tin. Western scientists did not establish until the eighteenth century what the Chinese had known for centuries, that some plants can indeed signal the presence of gold and other metals.⁶

The Rotz chart of Australia and the wealth of wrecks and Chinese artefacts found in and around that country show that, by luck or design, the great Chinese fleets had discovered the location of some of the most varied and rich mineral seams in the world. They had done so accompanied by horse-ships. The Chinese took inordinate care in the selection of their horses. Their favourites were the famous 'blood ponies' of Tajikistan, so named because they supposedly sweated blood (the red markings on the skin were actually caused by a skin parasite). Blood ponies were bred in the high, rolling valleys of China's Tian Shan -'Heavenly Mountains' - where they galloped through the walnut forests that cloak the slopes. They were incredibly swift, but also hardy and strong enough to make their way through dense snow and survive the worst weather. Zhu Di imported millions during his reign, placing such a strain on the imperial treasury that a special 'Tea for Horses' bureau was established to barter tea for the animals, thus avoiding further payments in silver.

Thousands of horses for the Chinese cavalry were carried on the horse-ships accompanying the treasure fleets. They were fed on mashed boiled rice, necessitating three gallons of water per horse per day. There is evidence that the Chinese took them ashore. Horses were then unknown in Australia, but they are beautifully depicted in drawings on the Vallard chart of the Dieppe School, although not, it must be said, on the Rotz chart. There was good pasturage for them around Sydney, from where an easy trail led up the Nepean and Hawkesbury valleys into the interior. A huge range of minerals including gold, silver, gemstones, coal and iron can be found within two hundred kilometres of Sydney. Further up the coast at Newcastle, also clearly identifiable on the Rotz chart, there was an equally spectacular array of riches. Within a week's ride from the coast were diamonds, sapphires and a wealth of other minerals.

Like their modern counterparts, the Chinese and Indian geologists with Zhou Man's fleet must have felt they had arrived in a mineral paradise. Many of Australia's minerals were of direct use to the fleet. Combining copper and zinc gave them brass; saltpetre mixed with sulphur and charcoal made gunpowder. Arsenic was a poison and insect repellent, yet also accelerated the growth of silkworms. White paint made of lead and copper prevented wood decay along the hull line. Kaolin was available for ceramics, while oxides of cobalt, copper and lead served for colours and glazes. Alum was particularly useful for making hides supple, for making drinking water potable and for its astringent properties. Asbestos has been used for fire protection since the sixth century BC: 'When King Mu of the Zhou dynasty made an expedition to the western people ... fireproof cloth was cleaned by being thrown into a fire ... when taken out and shaken it became as white as snow.'7 Local Aboriginal legends mention foreign people coming to these parts and mining materials while 'dressed in stone clothes'.8

There is further evidence in the accounts of Franciscan missionaries to China in the sixteenth century, who spoke of Chinese expeditions to Australia recorded on copper scrolls (dating from the sixth century onwards) together with maps of the continent.⁹ These early Chinese records, which have since disappeared, described voyages carried out by gigantic fleets of massive junks (sixty to a hundred ships), each carrying several hundred men, with the aim of gathering minerals.

The wrecks on the coast and the stone buildings ashore, Aboriginal rock carvings and paintings depicting foreigners in their long robes, and the carved votive offerings are all signs of a Chinese presence in the mining areas of New South Wales. A beautiful carved stone head of the goddess MaTsu, the protector of mariners at sea, was recovered from the beach front at Milton, New South Wales, in 1983. It is now in the Kedumba Nature Museum in Katoomba. Each of Zheng He's ships had a small

220

cabin dedicated to her. However, the most direct and persuasive evidence of the Chinese visits to Australia comes from Gympie, a mining area further up the coast, two hours' drive north of Brisbane. In 1422, a creek connected Gympie to Tin Can Bay and the Pacific; according to ancient Aboriginal tradition, a race of 'culture heroes' sailed up this creek and into Gympie's harbour in ships 'shaped like birds'. They later returned to their ships carrying rocks.¹⁰

While ashore, these mysterious people built truncated pyramids, one of which was discovered by a local researcher, Rex Gilroy, in 1975 and subsequently photographed. Now sadly vandalized, the pyramid was built of granite blocks and stood a hundred feet high, with the stepped construction typical of the other pyramids I had seen in South America and right across the Pacific. Mr Gilroy describes local people uncovering pre-European opencut copper, tin and gold mines, and he personally found an ancient pipe similar to those used to pour mercury to separate gold from ore. Half a mile from the Gympie pyramid, near an ancient opencast gold mine, were hearths that contained nodules of melted metal. Until 1920, Gympie remained Queensland's largest and richest goldfield. Many other artefacts have been found in the area. Two beautifully carved votive offerings are of particular interest: one is of the Hindu god Ganesh, the elephant god, carved in beige granite; the other is of Hanuman, the Hindu monkey god, this time made of conglomerate ironstone. Ganesh and Hanuman are two of the most important deities of Hindu worshippers in southern India, whence the fleet sailed and where they embarked Hindu priests, mining engineers and geologists.

Two equally fascinating carved animals can still be seen in the Gold Museum at Gympie today. The 'Gympie ape', dug up in 1966, is a monster with a head much larger than a human's. Its snout has been broken off, but a photograph of the second animal (it has now disappeared) shows the snout, nose and

221

mouth¹¹ of a beast closely resembling a mylodon. Whether through intent or happenstance, animals were collected and carried from one continent to another – giraffes, ostriches and rhinoceros from Africa to China, Asiatic chickens to South America, Chinese ship dogs left in South America and on islands across the Pacific to New Zealand, kangaroos from Australia to China and otters from China to New Zealand. A number of mylodons might well have been captured and taken aboard the Chinese ships in Patagonia; one pair might have escaped in New Zealand and another pair landed in China. Perhaps Chinese sculptors wished to immortalize these strange creatures before the memory of them faded. A century later the arrival of exotic species brought back from the New World was to create a similar sensation in the courts of Europe.

The purpose of the Gympie pyramid has baffled Australian observers, but its size, height and shape are typical of Ming dynasty observation platforms, and it would have been wholly logical for the Chinese to build observatories to determine precisely the location of the phenomenal riches they had discovered, so that future fleets could return to the same place.

When Zhou Man's fleet resumed its voyage, it sailed north up the Great Barrier Reef, again shown with amazing accuracy on the Rotz chart. The reef itself and the islands inside and outside it have the correct latitudes and can be clearly identified for more than a thousand miles. However, when they returned to Australia after their voyage to Campbell Island to locate Canopus, their calculations of longitude (as shown on the Rotz map) are twenty degrees in error. Why should they have believed they were 1,800 miles further west than they really were? The answer, of course, was that they had been in the Antarctic drift current during their ten weeks in the southern oceans. The body of water in which they had sailed was itself moving eastwards, and Admiral Zhou Man as yet had no means of measuring longitude accurately.

I realized that the coastline of Australia on the Rotz chart north of where Zhou Man's fleet returned had to be adjusted to the east by 1,800 miles. As soon as I did this, the result was electrifying. Australia was laid out before me. The cartographer had done a remarkable job and had made only one mistake – longitude, which he had had no means of measuring. He had drawn the eastern Australian coast and the Great Barrier Reef with phenomenal accuracy 247 years before Captain Cook was to do so. When I further corrected the southern coast of New South Wales and Tasmania by removing the ice, I had an instantly identifiable map of Australia.

Cook was awestruck by the size and shape of the Great Barrier Reef, a type of structure 'scarcely known in Europe. It is a wall of coral rock rising almost perpendicular out of the unfathomable Ocean.'12 For a mariner, any voyage near razorsharp coral reefs is a nerve-racking prospect, particularly at night or in low visibility when the only warning is the noise of breaking surf. If your ship hits coral, it punctures the hull and it is difficult to get off the reef without tearing the vessel to bits. I knew the dangers only too well from my own experience of taking my submarine HMS Rorqual inside the Barrier Reef, and that was with accurate charts at my disposal. A voyage through uncharted reefs is a constant waking nightmare. At night one sees not a single light ashore, by day nothing but an unbroken belt of greygreen jungle, as if man had never penetrated this beautiful but forbidding region. The Barrier Reef stretches for more than 1,500 miles from Hickson Bay, south of Brisbane, up to Cape York in the north. Captain Cook narrowly escaped death after striking it, and like me, he had a chart to help him. It is inconceivable that Zhou Man's fleet could have made the passage through those uncharted waters without suffering severe damage or loss of ships. To have got through it at all was an incredible feat.

The Rotz chart shows the Great Barrier Reef, the islands between the reef and the coast, and yet more islands in the ocean beyond the reef. In many places, once inside the reef it is not possible to leave it. I remember very well how my submarine was hemmed in by the reef, and the relief I felt as I escaped from the straitjacket where the reef ends off Brisbane. The wealth of detail on the Rotz chart indicates that several Chinese ships must have been charting the coast, reef and islands. They would have been more or less in line abreast as they sailed north, some inside the reef and others in the ocean outside it. I estimate that there must have been at least six, probably ten or more ships to have gathered such a mass of information.

The Barrier Reef itself, the coastline and the islands both inside and outside are particularly accurately charted around what is now Cooktown, indicating that the Chinese had spent some time surveying there. Captain Cook later used some of the maps of the Dieppe School to get to Cooktown, where he beached his ship, HMS *Endeavour*, after it hit a reef that was also shown on the earlier charts. The detail and precision of this part of the Rotz chart suggests that the Chinese might well have been forced to make a similar halt for repairs.

The Barrier Reef ends abruptly north of the Cape York Peninsula. The nightmare was over, and those Chinese junks that had survived the hazardous passage – and there must have been several casualties – could at last set course to the north-west for China. What an incredible sense of relief the eunuch captains and navigators of the surviving Chinese ships must have felt as they rounded the northern tip of Australia and sailed on past Cape York and the islands to the west. Here, the junks entered the Torres Strait, separating Australia from New Guinea, where the current flows from the east, sweeping the mariner westwards across the Gulf of Carpentaria. The Gulf is shown on the Rotz chart narrower than it should be; once again, the Chinese underestimated their change in longitude as the body of Europe and Africa from Fra Mauro's planisphere of 1459: south is at the top. The surface is a glittering pattern of text and schematic walled medieval towns, but the map itself is informed by real geography, the result of up-todate knowledge gleaned from contemporary explorers.

A detail of Africa and Asia from the Kangnido world map of 1402 (*opposite*) by Ch'uan Chin and Li Hui, the most advanced of its day. The Cape of Good Hope is delineated with extraordinary accuracy.

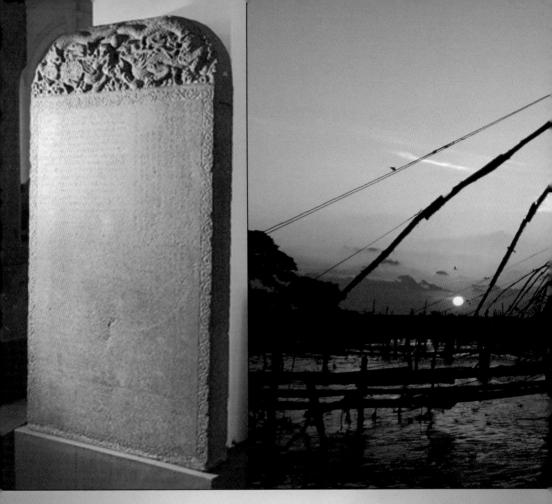

Chinese supremacy in the Indian Ocean: the Galle stele (*above left*), inscribed in four languages, testifies to Zheng He's attempts at diplomacy with the diverse inhabitants of Sri Lanka. By the time Zheng He set sail, the Chinese had well-established routes along the Malabar coast (*below*), where Chinese fishing nets are still used (*above*), and across the ocean to East African trading forts such as Kilwa (*opposite, below*), where Ming porcelain is incorporated into the mosque, just as in these pillar-tombs further up the coast at Kunduchi (*opposite, inset*).

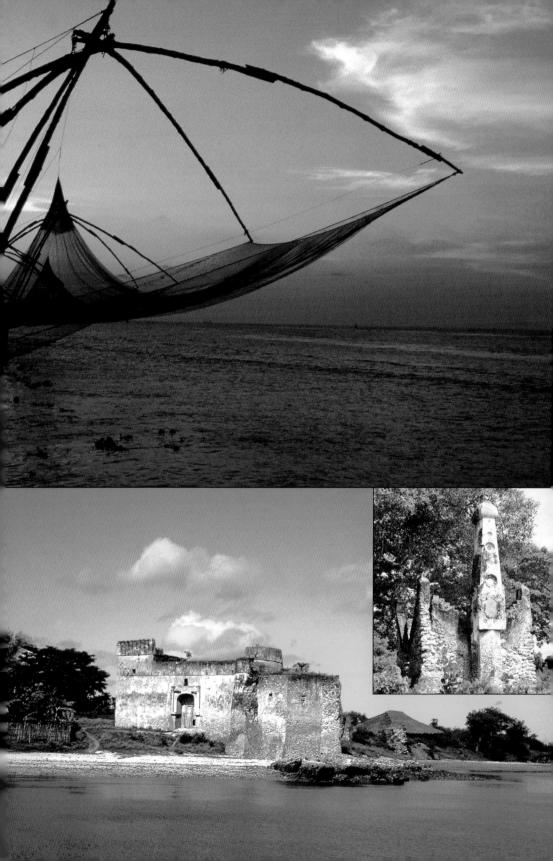

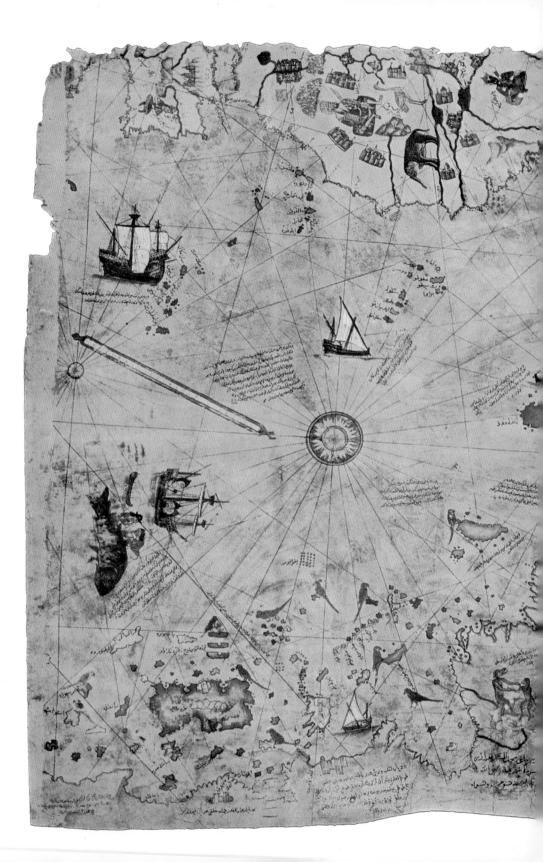

The Piri Reis map of 1513, oriented with north to the left, so that South America is at the bottom of the page and Africa and Europe at the top.

3218

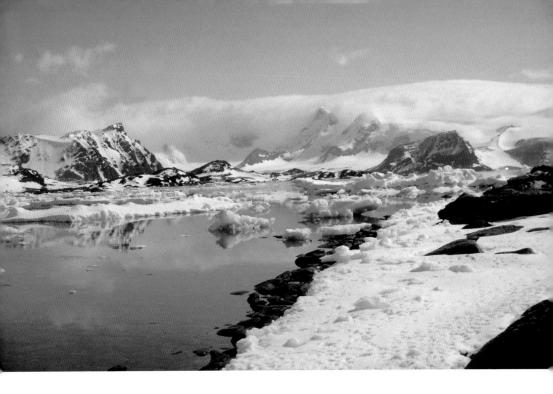

The inhospitable shores of Antarctica (*above*): it is easy to see how giant icebergs (*below*) could be mistaken for islands.

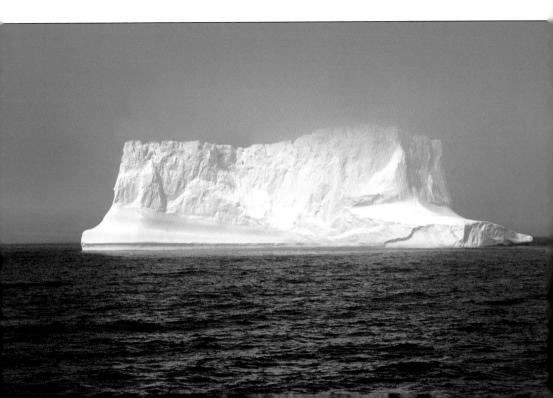

water in which they were sailing moved westwards across northern Australia.¹³ (After publication of the hardback, it was pointed out to me that Zheng He's charts show the Barrier Reef and northern Australia.)

In the folio of charts he presented to Henry VIII of England, Jean Rotz included another map of this part of Australia drawn in greater detail and to a much larger scale. He drew the island of Lesser Java – the Chinese knew it as Little Java – separated from Greater Java by a narrow channel, though some of his contemporaries in the Dieppe School showed it as a river. It was a simple matter to determine who was right. I compared it with a modern map at the same latitude and saw at once that the channel Rotz had drawn was the Victoria River in the west and the Roper River in the east. Lesser Java on the Rotz chart is Arnhem Land, part of the mainland of Australia. The shape of north-east Australia was now instantly recognizable.

A number of descriptions in medieval Portuguese were written on Rotz's more detailed chart. The names are easy to translate and all of them correspond to what is found there today. Canal de Sonda - 'narrow sea ford' in medieval Portuguese - is marked where the long, narrow Apsley Strait bisects Melville and Bathurst Islands. Aguada dillim - 'waterway leading to inland sea' - corresponds to the Dundas Strait that does indeed lead into the Van Diemen Gulf. Agarsim - translated as 'yes indeed water is here' - is inscribed beside the Yellow Water Billabong in the Kakadu National Park, designated by the United Nations as 'wet lands of international importance'. Nungrania means 'no farmland' - there is none there - and lingrania means 'lime trees', which still grow there today. The Gove Peninsula, the eastern tip of Arnhem Land, is finjava, or 'the end of Java'. Only one inscription had me baffled - chumbão, or 'lead'.

The west coast of Arnhem Land is drawn with great fidelity. Rotz showed the main coastal features at their correct latitudes right up to 10°S, beyond the northern tip of Australia, and drew a mass of fishing stakes straddling Trepang Bay – as its name implies, the centre of sea-slug fishing. The first Chinese map of Australia was drawn by fishermen centuries before Europeans reached the continent, and Chinese boats still fish this part of the coast today for the much-prized trepang. All this remarkably precise information predates the arrival of the first Europeans by over two centuries. The chart also shows details of the interior – the Finniss River wending westwards, and trees recognizable as eucalyptus and blackwood pines, both common in Arnhem Land. A tall rock is also depicted on the chart by what is now the Nourlangie Anbanbang Billabong in the Kakadu National Park. The original cartographer must have seen the rock to have drawn it so accurately.

As I studied the modern map of Arnhem Land, I realized I had found the answer to the mystery of the word *chumbão*. Lead is still mined in substantial quantities at the huge Jabiru Ranger Mines. It is the natural derivative of uranium 235 as it breaks down through the process of nuclear decay. Uranium is, of course, highly radioactive, and lethal to touch or ingest. The Jabiru Ranger Mines contain one of the world's largest deposits of uranium 235. Not realizing the danger they were placing themselves in, the Chinese must have been digging uranium out of the ground alongside the lead ore they sought. This may help to account for the appalling loss of life among Zhou Man's fleet, for only a tenth of the original nine thousand men remained alive when it finally reached home in October 1423.

To discover the lead, the Chinese had to penetrate well into the interior of the country. At that time, as now, Aborigines had made Arnhem Land their spiritual home. They were skilful artists, painting beautiful frescoes in caves, and I hoped to find evidence of the Chinese visit depicted in their cave art. George Grey, later the governor of South Australia, led an expedition to Arnhem Land in 1838. When they entered a group of caves

THE BARRIER REEF AND THE SPICE ISLANDS

twenty miles upstream from where the Glenelg River pours into Colliers Bay, they saw a group of paintings prominent among which was 'the figure of a man, 10ft 6in in height, clothed from the chin downwards in a red garment which reached to his wrists and ankles'.¹⁴ Captain Grey's description accords with the picture drawn by the native Mexican tribes at Jucutácato (see chapter 10) of the Chinese arriving in their red robes reaching to their ankles. Grey's find also accords with Aboriginal lore, which records that long before the Europeans a honey-coloured people settled north-east Arnhem Land. The men wore long robes and the women pantaloons. They went far inland for freshwater prawns, sandalwood and tortoiseshell, grew rice and lived in stone houses, unlike the Aborigines whose dwellings were of wood. The women wove silk dyed with local herbs.

Adze anchors with the curved fluke (the piece that holds the anchor in the mud) set at right angles to the stock of the anchor – a Chinese design – have been discovered on the coastline of north-east Arnhem Land, and substantial quantities of broken Chinese ceramics dating from the Han dynasty (202 BC–AD 220) to the early Ming (1368–1644) have been found at Port Bradshaw on the eastern shore of the Gulf of Carpentaria and on the nearby mainland, just where the currents and the reefs would make it likely that wrecks would be found.

Even with horses, the Chinese would have needed several months to carry out the detailed survey of the coast and interior lands depicted on the Rotz chart. For this they would have needed a base in a protected anchorage with fresh water. I expected to locate it on the most accurately charted part of the coast. The Beagle Gulf off the north-west part of Arnhem Land is very well drawn, and Darwin, at the south-western end of the gulf, has a splendidly protected anchorage. Today, a hotel, the Banyan View Lodge, stands on Doctor's Gully, shaded by a magnificent banyan tree. The stream running through Doctor's Gully is now paved over, but in those days fresh water would have been available from it. The lodge is a popular haunt of backpackers drinking lager, oblivious of the history that surrounds them.

Late in the nineteenth century, a figure of a Taoist immortal, Shu Lao, was found buried beneath that banyan tree. It is now in the Chinese collection of the Technological Museum in Sydney. Although very valuable, it had been deliberately wedged deep down in the roots. Dated by one expert as early Ming (late fourteenth century),¹⁵ the figure sits upon a deer and in its right hand carries a peach, the symbol of longevity. It is made from very fine pinite and is beautifully carved and polished. Shu Lao is one of the Triad of Gods of long life in the Taoist pantheon; unlike Buddhism and Confucianism, Taoism is a religion peculiar to China and was never disseminated overseas.

Moreover, the banyan is foreign to Australia and must have been imported. This one was already several hundred years old when the statue was discovered over a century ago. In southern China and Burma, shrines were often built in cavities between the spreading roots of large trees such as banyans which are holy trees to Theravada Buddhists. The shrine at Darwin was almost certainly built by a Chinese centuries ago, and in structure and location it resembles the one at Ruapuke in New Zealand. It is theoretically possible that the shrines were created by the crews of Chinese boats fishing for trepang, but the possibility is very small indeed. No fishing boat would carry such a valuable statue - it would be worth a lifetime's wages to the crew; it is far more likely that it belonged to a wealthy Chinese captain or admiral from a great ship. By far the most plausible explanation is that Zhou Man's fleet used Darwin as its base and created a shrine in which the figure was placed in thanks for having survived a long voyage.

I am strongly inclined to believe that the Venetian Niccolò da Conti was telling the truth when he informed the Papal Secretary, Poggio Bracciolini, that he had landed in Greater Java

THE BARRIER REEF AND THE SPICE ISLANDS

on a Chinese junk and had spent nine months there with his wife. Perhaps she was one of the women in pantaloons.

When Europeans eventually arrived, they were not sailing blindly into a great unknown. The Dauphin chart, one of the other charts from the Dieppe School and almost identical to the Rotz chart, came into the possession of Edmund Harley, Earl of Oxford and First Lord of the Admiralty, in the mideighteenth century and became known as the Harleian. It was later acquired by Joseph Banks, the young scientist who sailed in the *Endeavour* with Captain Cook. At the time Captain Cook sailed, the British government therefore had access to both the Harleian and Rotz charts, since the latter was at that stage owned by the Admiralty. Cook's orders from the Admiralty were to search down to 40°S – the latitude of South Australia shown on both charts – where they 'had good reason'¹⁶ to suppose the southern continent existed. They certainly did – they already had two charts showing such a continent at 40°S.

As they left Australia, like Hong Bao's fleet before them Zhou Man's ships were still laden with porcelain and silk, but the fabled Spice Islands lay between Australia and home, and spice was then an extremely valuable commodity in China. Even when the fleet had been reduced to a few ships, their holds could still carry thousands of tons of ceramics, and by sailing for the Spice Islands Zhou Man would at last have an opportunity to exchange them for goods of real value, such as nutmeg, pepper and cloves.

If the Rotz chart was based on an earlier map drawn by cartographers aboard Zhou Man's fleet, it should show the Spice Islands. It does. The importance of Ambon, then the collecting centre for the two Spice Islands of Ternate and Tidore – so tiny one can walk around them in a couple of days – is emphasized by its being coloured red. In the Middle Ages, Ternate and Tidore were the hub of the spice trade, far and away the most productive islands. They were legendary, and had been fought over for centuries, for virtually all spices could be obtained there in huge quantities. To this day, the distinctive scent of cloves is detectable far out at sea, long before the islands themselves are sighted.

Further north, at a latitude of 10°N, the Rotz chart shows the channel between the Philippine islands of Mindanao in the south and Leyte in the north, but Rotz drew only the south coast of Leyte, leading to the obvious conclusion that the cartographer was in a ship passing down the middle of the channel. Using a similar common-sense approach, I could determine the angle from which the Spice Islands and the other islands between Australia and the Philippines were drawn, and hence deduce the route taken by Zhou Man's fleet through the islands. Along the way, now sailing in calm and sunny seas, Zhou Man would have had many opportunities not only to obtain spices but to barter his porcelain for batiks, artefacts, fresh water, fruit and meat.

There would once have been plentiful examples of the silks and porcelain Zhou Man's fleet had exchanged for spices and supplies, but would any traces remain today? How could I find such evidence after an interval of nearly six hundred years? I wondered if Magellan had also sailed this way on his circumnavigation of the world. If so, his account might throw some light on the question. When I went to the British Library and consulted a copy of the detailed map of Magellan's route produced after his death, I was staggered to discover that his course from the Pacific through the Philippines and down to the Spice Islands, a distance of well over a thousand miles, was identical but in the opposite direction to the track of Zhou Man's fleet I had just reconstructed. It was as if the two were using the same passage drawn on the same chart. The chances of this being a coincidence are microscopic. I surmise that Magellan's chart showed Zhou Man's route.

THE BARRIER REEF AND THE SPICE ISLANDS

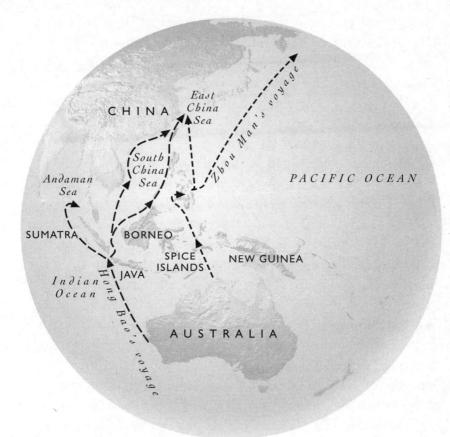

Hong Bao's journey home and Zhou Man's journey through the Spice Islands.

As well as Pigafetta's description of Magellan's voyage, I found that the British Library also held an account by the Genoese pilot who sailed with Magellan. He described Magellan's landfall in the Philippines and how he found a strait leading from the Pacific to the Spice Islands – the same strait between Mindanao and Leyte shown on the Rotz chart. Magellan passed through this strait and anchored at the first island, Limasava, where the king greeted him. Pigafetta described the king and queen wearing Chinese silk and eating off Chinese porcelain that had been buried for fifty years to increase its value. Their houses had silk curtains and porcelain ornaments, and their trading currency was Chinese coins with square centres. The same story was repeated on island after island visited by Magellan's ships en route to the Spice Islands. Zhou Man must have emptied his holds of porcelain as he went along, a century before Magellan.

Pigafetta also recounted Magellan's meeting with the King of Limasava. Magellan showed him 'the marine chart and the compass of his ship telling him how he had found the Strait to come hither and how many moons [months] he had spent in coming; also, he had not seen any land, in which the King marvelled' (my italics). Magellan showed the king a chart depicting the strait and the empty Pacific. There was also a letter from Sebastian Alvarez, the King of Spain's factor (a merchant buying and selling on commission), to his king: 'From Cape Frío until the Islands of the Moloccas throughout this navigation there are no lands laid down in the maps they [Magellan's expedition] carry with them.'17 Taken together, these accounts can mean only one thing. When Magellan sailed, he had with him a chart that not only showed the Strait of Magellan but also the Pacific at 52° South and an empty ocean from there to the Spice Islands on the equator. Someone must have sailed through the Strait of Magellan and across the Pacific before Magellan to make that chart. Who else but the Chinese, 'the yellow men wearing long robes'?¹⁸

Fortunately, the evidence from Magellan's visit to the Philippines was further confirmation of a Chinese voyage between 1421 and 1423. Chinese porcelain, silk and coinage of Zhu Di's reign, seen by Magellan in the Philippines, might have been the result of Chinese trade before Zhou Man's voyage, but Magellan noted substantial quantities on island after island. Clearly, huge amounts must have been exchanged, and that in turn must have resulted in Zhou Man taking aboard a vast quantity of traded goods, principally the greatly valued pepper. If

THE BARRIER REEF AND THE SPICE ISLANDS

so, that pepper would appear in the records of the Chinese stockpiles of the spice soon after he returned to China in October 1423.

I searched among copies of the few Chinese records that exist and found that my deductions were absolutely correct. By 1424 there were such massive stocks of pepper in the imperial warehouses that on his accession that year Emperor Zhu Gaozhi ordered much of it to be given away: 'To each banner bearer, housekeeper, soldier and guardsman one catty [half a kilo] of pepper ... to each first degree literary graduate and licentiate, district police chief, prison warder, astronomer and physician, one catty ... to each resident of the city and the environs of Beijing, each Buddhist or Taoist priest, artisan, musician, professional cook ... one catty.'19 The population of Beijing in 1423 certainly exceeded one million and the soldiers of the imperial army and their dependants accounted for another six hundred thousand people. The weight of pepper distributed is likely to have been more than 1,500 tons. When Magellan's ship returned home, he had less than twenty-six tons of usable pepper aboard. It was sold at ten thousand times the price he had paid for it in the Spice Islands, sufficient to generate a profit for the entire voyage. Contrary to the claims of the Chinese mandarins, the voyages of the treasure ships brought substantial tangible rewards, for the pepper added to Chinese stockpiles late in 1423 was of colossal value on the international market.

Pigafetta's account of Magellan's voyage yielded still more evidence that Zhou Man's fleet had sailed from the Americas to the Spice Islands and the Philippines. Pigafetta described maize growing in the Philippines and Magellan's crew loading it. Maize is not only unique to the Americas but a crop that can only be propagated by man. Furthermore, some of the surviving Chinese records state that Zheng He's fleets brought back maize from their voyages. Not only had junks brought porcelain, silk and currency from China and carried pepper back there, they had also brought maize from South America to the Philippines.²⁰

THE

9

FIRST

COLONY

IN THE

AMERICAS

LTHOUGH HE WAS NOW LITTLE MORE THAN A thousand miles from the Chinese mainland, Zhou Man's remarkable voyage was still far from over. I next had to track his fleet as it sailed onwards from the Philippines to reach the coast of yet another new land. After leaving the Spice Islands with his rich cargo, the most direct route home for his fleet would have been to continue north, sailing west of Mindoro in the Philippines. From there, the prevailing summer wind would have blown him north towards China. Yet the manner in which the islands were drawn on the Rotz chart suggests that Zhou Man had chosen to alter course to the east, passing south of Leyte and re-entering the Pacific.¹ Assuming that he had left Darwin at the beginning of the south-west monsoon, in late April, he would have entered the Pacific by early June. I knew that Zhou Man had arrived in Nanjing on 8 October 1423, carrying no foreign envoys. What had he been doing and where had he sailed in the four months he had been in the Pacific?

The north Pacific is a vast circulatory system, with winds constantly blowing in a clockwise oval direction. In June, the prevailing wind off Leyte is to the north. As Admiral Zhou Man's fleet entered the Pacific, the Kuroshio or Japanese current would also have carried them northwards before starting a clockwise sweep towards the coast of North America. In fact, had Zhou Man simply unfurled his sails off Leyte, the winds and currents would have carried him to the Pacific coast of modern Canada. The California current would then have taken over, sweeping the fleet southwards down the western seaboard of the United States to Panama. From there, the north equatorial current would carry a square-rigged ship back across the Pacific towards the Philippines. The whole round trip, before the wind and current all the way, would have been about sixteen thousand nautical miles. At an average of 4.8 knots, the voyage would have taken some four months, matching the date of Zhou Man's return to Nanjing in October. My surmise, for reasons which will become apparent later, was that squadrons of ships from the main fleet were detached to establish colonies along the Pacific coast from California down to Ecuador.

I began the search for corroboration that Zhou Man's fleet had indeed reached the Pacific coast of North America. The first European to explore that coast was Hernando de Alarcón in 1540. Having sought fame and fortune in New Spain, he left Acapulco on 9 May of that year in command of a fleet supporting the conquistador Coronado's expedition to New Mexico. Alarcón first charted the peninsula of Baja California, and then California itself. I knew that he was the first European to chart it, for neither Columbus nor any of the other early explorers reached any part of the west coast of North America, so any map of the Pacific coast predating Alarcón's voyage would be powerful evidence that he was not the first to reach it.

Such evidence does exist in the form of the Waldseemüller world map, published in 1507, the first to chart latitude and longitude with precision. Originally owned by Johannes Schöner (1477-1547), a Nuremberg astronomer and geographer, it had long been thought lost and was only rediscovered in 1901 in the castle of Wolfegg in southern Germany. It remained there in relative obscurity until 2001, when in a blaze of publicity the US Library of Congress acquired it from Prince Johannes Waldburg-Wolfegg for ten million dollars. The man who drew the map, Martin Waldseemüller (c. 1470-1518), was German-born and one of the foremost cosmographers - combining the study of geography and astronomy - of his era. The globe and wall maps he made in 1507 are the first ever to call the continent 'America'; for some unknown reason this was not included on the 1516 map. The 1516 map, Carta Marina - A Portuguese Navigational Seachart of the Known Earth and Oceans, was 'the first and only printed version of the world charts previously known only to Spanish and Portuguese explorers and their patrons'.2 The east coast of North America is clearly charted, with several place names.

THE FIRST COLONY IN THE AMERICAS

The Caribbean and Florida, shown on the Waldseemüller map, were also depicted on two earlier charts, the Cantino (1502) in the Biblioteca Estense, Modena, Italy - a map which would play a significant role in my researches elsewhere in the world (see chapter 11) - and the Caverio map (1505) in the James Ford Bell Library at the University of Minnesota, Minneapolis. They too showed lands drawn before the first Europeans had reached them, but those maps cannot have been the original source of the Waldseemüller. The Great Bahama Bank is drawn identically on all three maps, but the Caverio map shows the Yucatán Peninsula in Mexico, which was not depicted on the earlier Cantino. Hence the Caverio cannot have been a copy of the Cantino, any more than the Waldseemüller is a copy of them, for the latest of the three, the Waldseemüller, shows the Pacific coast of North America and the Cantino and Caverio do not. All three maps have different original features, and all must have been copied from an even earlier map.

The Pacific coast of America is strikingly drawn on the Waldseemüller chart and the latitudes correspond to those of Vancouver Island in Canada right down to Ecuador in the south. This is completely consistent with a cartographer aboard a ship sailing down the Pacific coast, but not charting the coast in great detail. Oregon is clearly identifiable, and several very old wrecks have been discovered there on the beach at Neahkahnie. One was of teak with a pulley for hoisting sails made of calophyllum, a wood unique to south-east Asia. The wood has yet to be carbon-dated, but if it proves to be from the early fifteenth century it will provide strong circumstantial evidence that one of Zhou Man's junks was wrecked off Neahkahnie Beach. Some examiners of the wreckage there claim to have found paraffin wax, which was used by Zheng He's fleet to desalinate sea-water for the horses.

Even without finds from wrecked junks, the Pacific coasts of Central and South America are full of evidence of Chinese

voyages. The Asiatic chickens found from Chile to California were described in chapter 5, and many other flora and fauna were carried across the globe by the Chinese fleets. On my first visit to California many years ago, I remember coming across a bank of beautiful camellia roses (Rosa laevigata). It was a still summer's evening and their lovely fragrance filled the air around me. In 1803, European settlers found a beautiful fragrant rose growing wild; they named it the Cherokee Rose. Yet it was indigenous to south-east China and had been illustrated in a twelfth-century Chinese pharmacopoeia. 'When and by what means it reached America is one of the unsolved problems of plant introductions,'3 but it was a common practice for sailors aboard Zheng He's junks to keep pots of roses, their scent an enduring reminder of home. The Chinese also took plants and seeds home with them. Amaranth, a native North American grain with a high protein content, was brought from America to Asia in the early fifteenth century, as of course was maize brought to the Philippines and seen there by Magellan. Coconuts, native to the South Pacific, were found by the first Europeans on the Pacific coasts of Costa Rica, Panama and Ecuador and on Cocos Island west of Costa Rica. The carriers of grain from the Americas to Asia, of roses and chickens from China to the Americas, and coconuts from the South Pacific to Ecuador can only have been the Chinese.

San Francisco and Los Angeles are clearly depicted at the correct latitudes on the Waldseemüller chart, and I was certain that Zhou Man must have sailed down that coast. Crossing such an enormous expanse of ocean after two years at sea must have left some of his junks in bad condition and in urgent need of repair. Even the best-built ships could not remain at sea for such long periods without suffering at least some damage from storms and the pounding of the waves. At the very least they would have required running repairs and careening – scraping the barnacles from their hulls – and the most badly damaged might well have

THE FIRST COLONY IN THE AMERICAS

been cannibalized to repair the others. If so, the remains of these wrecked ships should have been found off the coast of California, just as other wrecks had been in Australia and other parts of the globe.

My enquiries into strange wrecks on the coast of California drew a blank, but I did discover that museums there held substantial quantities of Ming blue and white ceramics. The accepted wisdom is that these items were brought to California in the holds of Spanish galleons, but a number of medieval Chinese anchors have been found off the California coast, and these are unlikely to have been brought by Spanish ships. I began to question seriously the provenance of the Ming porcelain; had it really been brought by the Spanish? Medieval Chinese porcelain can be dated by its cobalt content: the greater the amount of iron in the cobalt, the deeper blue the glaze. The dark cobalt of the Mongol era came from Persia, also ruled by the Mongols, but Zhu Di's father sealed the Chinese borders after he drove out the Mongols in 1368 and Persian cobalt was no longer available. However, Zhu Di reopened the frontiers and restored trade along the Silk Road through Asia allowing Persian cobalt to be imported once more. The period when Chinese pale blue porcelain was produced and used in Ming China is thus limited, and the colour of the porcelain held by Californian museums would indicate whether or not it was made during this period in China's history.

I was certain that a great treasure fleet had discovered the Pacific coasts of North and South America, but my researches failed to uncover conclusive evidence such as the wreck of a Chinese junk. In the hope that others might have found traces I had missed, I decided to 'go public' on the issue in a lecture at the Royal Geographical Society in London in March 2002. It was broadcast around the world; within forty-eight hours reports began to come in from California, drawing my attention to the wreck of a medieval Chinese junk buried under a sandbank in

241

the Sacramento River off the north-east corner of San Francisco Bay. My first reaction was to discount the reports – the site was more than a hundred miles from open sea and the discovery seemed too good to be true – but over the next few days more e-mails describing the same junk continued to arrive. As soon as I had carried out some preliminary research, I discovered that the prevailing north-easterly winds on this coast could have blown a junk straight across the bay and into the Sacramento River. Six centuries ago the river was broader and deeper than today, for deforestation and mining have caused the water level to fall. It was indeed possible, if not probable, that a junk entering San Francisco Bay would have been driven by the winds into the Sacramento River. The tide would also have carried the ship upstream as far as Sacramento.

Dr John Furry of the Natural History Museum of Northern California first became aware of the junk twenty years ago when he read an account of the strange armour that once had been found in its hold (the wreck was then evidently less deeply buried in sand and silt than it is now). The armour was of an unusual metal (native Americans did not know how to forge metal) and curiously silver-grey in colour. It was shown to a local expert who is said to have identified it as of medieval Chinese origin. Dr Furry's attempts to pursue the story met a brick wall – the expert had died in the intervening years, and the armour had been lent to a local school and was now lost – but he was sufficiently intrigued to begin investigating the wreck-site.

The site was covered with a 40-foot layer of the accumulated sand and silt of centuries, so Dr Furry began by taking magnetometer readings of the area. These showed a strong magnetic anomaly outlining a buried object 85 feet long and 30 feet wide, very similar in size and shape to the trading junks that accompanied Zheng He's fleets. Core samples were then extracted from the site. The fragments of wood brought up were carbon-dated to 1410, indicating that the junk was built in that

THE FIRST COLONY IN THE AMERICAS

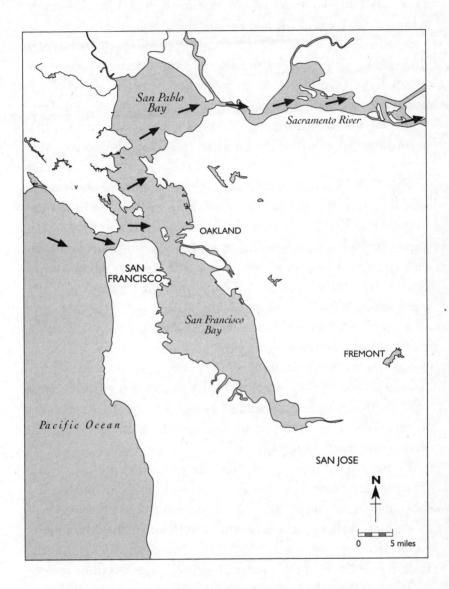

The San Francisco Bay area, showing the winds blowing into the Sacramento River.

year, 'a period that included a maritime highpoint for the ancient Chinese',⁴ as local newspapers laconically reported.

The evidence from the carbon-dating encouraged Dr Furry to drill again with more sophisticated equipment. This yielded much larger samples including further pieces of wood and a compacted 80lb mass of millions of black seeds. He sent fragments of the wood and the seeds to China for analysis, and according to Dr Furry, the Chinese Academy of Forestry have provisionally identified the wood as Keteleria, a conifer native to south-east China but not to North America. In the Middle Ages, the Chinese cultivated Keteleria for ship-building. Dr Furry also told me that Dr Zhang Wenxu, a former professor at the Chinese Agricultural University in Beijing and the leading Chinese expert on ancient seeds, had provisionally identified four different types of seeds in the black mass brought up from the wreck-site. Three were native to both China and North America, but the other was found only in China. Most interesting of all, however, was Dr Furry's further discovery of rice grains and the body of a beetle among the material raised. Rice, indigenous to Africa and China, was unknown in the Americas in the fifteenth century. Further analysis of the rice and the beetle is being carried out as I write, but to date no written reports on the analysis of the wood or the seeds have been received from China.

I now had little doubt that the site contained the wreck of a Chinese junk; it was exactly the evidence I had been looking for. It seemed highly improbable that the crew would have drowned when the junk grounded on the sandbank in the Sacramento River. It was far more likely that they had come ashore onto the lush, fertile lands of the valley. Their first task would have been to rescue as much rice as possible from the holds of the ship. Much would have been needed to meet their short-term food requirements, but they would also have set some aside as seed and planted it in a suitable location – the floodplain of the Sacramento River.

THE FIRST COLONY IN THE AMERICAS

It has long been claimed that rice was introduced to West Africa by Europeans and then to the Americas by the Spanish, but Professor Judith A. Carney of the University of California has argued that this thesis is fundamentally flawed. It is widely accepted that the Chinese made a major contribution to developing agriculture in the rich soils of California, particularly the cultivation of rice in the swamplands of the lower Sacramento. By the 1870s, 75 per cent of the farm labourers in California were of Chinese origin. 'The Chinese actually taught the American farmer how to plant, cultivate and harvest.'5 But were these Chinese working in the fields and plantations of the Sacramento Valley all part of the great nineteenth-century waves of immigration into the United States, or could some have been descendants of settlers left on the banks of the Sacramento by Zhou Man in 1423? I found a clue to this mystery in an unlikely source.

In 1874, Stephen Powers, an official inspector appointed by the government of California who had spent years collecting data on the languages of the tribes of California, published an article claiming that he had found linguistic evidence of a Chinese colony on the Russian River in California, some seventy miles north-west of the Sacramento junk.⁶ Powers also claimed that diseases brought by European settlers had decimated this Chinese colony as well as the other Indian people of California, '[the] remittent fever which desolated the Sacramento valleys in 1833 and reduced these great plains from a condition of remarkable populousness to one of almost utter silence and solitude there was scarcely a human being left alive'.7 Powers' report was badly received by his government employers, and although he courteously and bravely attempted to maintain his position, his official report, published in 1877, is a watered-down version of his claims. Nonetheless, it makes for fascinating reading.

Quite apart from his claim of a Chinese colony based on linguistic evidence, Powers described Chinese settlers as having

intermarried with local Indians over centuries. Their descendants were paler than the people of the coast, and, unlike other Indian tribes, the older generation had magnificent beards while the women 'are as proud of their black hair as the Chinese'. Rather than skins, women wore 'a single garment in the shape of a wool sack, sleeveless and gathered at the neck, more or less white once'. They were 'simple, friendly, peaceable and inoffensive'. After death, 'they generally desire like the Chinese to be buried in the ancestral soil of their tribe'. Again like the Chinese, but unlike other hunter-gatherer tribes of North America, the peoples around the Sacramento and Russian Rivers were sedentary: 'at least four fifths of their diet was derived from the vegetable kingdom ... They knew the qualities of all herbs, shrubs, leaves, having a command of a much greater catalogue of [botanical] names than nine tenths of Americans.' Their ancestors' legacy could also be seen in pottery beautifully formed in classic Chinese shapes, whereas the '[modern] Indian merely picks up a boulder of trap [a dark, igneous rock] or greenstone and beats out a hollow leaving the outside rough'. The ancestors of the Sacramento and Russian River tribes also used 'long, heavy knives of obsidian or jasper' their descendants, Powers found, no longer knew how to make. And while the ancestors had fashioned elegant tobacco pipes from serpentine, their descendants made use of simple wooden ones. They had also 'developed a Chinese inventiveness'8 in devising methods of snaring wildfowl using decoy ducks - a Chinese custom, but one not found among the Indians. Like the Chinese, they ate snails, slugs, lizards and snakes, and built large middens of clam shells. (For DNA corroboration, see Synopsis of Evidence.)

On the eastern side of San Francisco Bay, some seventy miles south of the site of the Sacramento junk, there is a small, stonebuilt village with low walls. In 1904, Dr John Fryer, Professor of Oriental Languages at University College, Berkeley, California, stated, 'This is undoubtedly the work of Mongolians ... The Chinese would naturally wall themselves in, as they do in all their towns in China.⁹ This accords with Powers' succinct description of Chinese people who had created a colony and then intermarried with native Americans.

It certainly seems that Zhou Man's fleet left a settlement in California. Were they the first to cultivate rice in the Americas? And was the wealth of blue and white Ming porcelain found in California really brought by Spanish galleons, as conventional wisdom has it, or was it carried in the holds of the junks of Zhou Man's fleet? The investigation is ongoing, the definitive conclusion yet to be written; meanwhile, I had to press on with my own research, tracking the fleet as it set sail once more from San Francisco Bay.

After emerging from the bay, Zhou Man's fleet would have been carried southwards by the wind and current to Mexico. The Waldseemüller map shows the coast with reasonable accuracy, charted just as one would expect from a ship passing by, but there is a gap at the latitude of the Gulf of Tehuantepec in Guatemala, as if the Pacific and Atlantic Oceans met there, which of course is not the case. This is consistent with the Chinese having sailed into the Gulf, but finding it too shallow to proceed, turning back and then drawing what they could see from the entrance: water stretching away for miles in front of them, marking an apparent opening between North and South America.

I made the assumption that they had sailed beyond the isthmus of Panama, clearly shown on the Waldseemüller, and then been driven back across the Pacific towards China by the winds and current, as one would expect with a square-rigged sailing ship. But on their way down that coast they would have been swept across the Gulf of California and could have made a landfall on the Mexican coast somewhere near Manzanillo in the modern province of Colima. Here a spectacular volcano, the Colima, some 12,700 feet high and clearly visible for miles out to sea, would have attracted them.

247

I decided to make a search for another wreck between Manzanillo and Acapulco, a stretch of coastline only around three hundred miles long and again clearly shown on the Waldseemüller map. I started my search with the accounts of the first Spaniards to reach that coast in the 1520s, Fra Bernardino de Sahagún¹⁰ and Bernal Diaz del Castillo,¹¹ both of whom described the exotic Mayan civilization, still surviving in 1421 but in decline when they arrived. Many of the things de Sahagún and del Castillo described – chickens, lacquer boxes, dye-stuffs, metalwork and jewellery – seemed to have the imprint of China all over them.

As in California, when they arrived in Mexico the conquistadors found Asiatic chickens quite different from the European fowl they had left behind. The Mayan names for the birds, *Kek* or *Ki*, were identical to those used by the Chinese; like the Chinese but unlike the Europeans, Mexicans used chickens for ceremonial purposes such as divination. These were such remarkable similarities that for these reasons alone I felt a visit to that small strip of the Mexican coast was justified.

Before departing, I also investigated whether plants originating in China grew in New Mexico or western Mexico. The Chinese Rose did, but that could have been propagated southwards from California. Other than the rose, I found no plants growing in Mexico that had originated in China, but I did find the opposite; plants indigenous to Central America had found their way across the world before the European voyages of discovery.¹² Sweet potatoes, tomatoes and papayas were found in Easter Island, sweet potatoes in Hawaii, and maize in China and the Philippines. Maize could have come from South or North America, but the other plants had come from a much narrower area, from what we now call Mexico, Guatemala and Nicaragua.

The Mayan civilization the Chinese would have encountered was almost as old as their own. The Maya's predecessors were the Olmecs, the earliest civilization in Central America and possibly the whole of the Americas, whose capital was at La Venta on the Atlantic coast of Mexico. By 1200 BC, the Olmec people had constructed two large artificial plateaux at La Venta and San Lorenzo on which they built religious cities nearly as old as Babylon. These great mounds stretching for miles were the centre of a settlement system that integrated Olmec villages and hamlets into one social, political and economic unit straddling what we now know as southern Mexico.

They set up extensive trade networks with the peoples to the south, importing obsidian, basalt, greenstone and iron ore, and exporting pottery, jaguar pelts, coca and wonderfully expressive sculpture. Examples can be seen to this day in Parque La Venta: mischievous stone monkeys hang from trees; stone dolphins, so lively that one can almost see the water splashing off their bodies, leap between ponds; a man crawls out of the entrance of a tomb carved out of basalt; a distraught mother cradles her dead child in her arms. It is fabulous sculpture, the work of a truly amazing people. But around 300 BC, the Olmecs vanished for reasons that remain unclear. They were followed by the Maya, who created a trading empire spanning Central America. The Mayan epoch was already coming to an end by 1421 and civil war had broken out in Yucatan, but the Chinese would have found a very old and very distinguished civilization.

I saw traces of that great Mayan civilization everywhere as I took a bus from the Atlantic to the Pacific coast of Mexico. The Atlantic coast is littered with mooring posts, each of which seems to have its own sentinel pelican, watching over a sea teeming with fish. Then come mile upon mile of marshes, with flocks of ducks and skeins of geese crossing the sky. Ibises and storks stand motionless in pools and lagoons. This is Mayan country, with a system of agriculture unchanged for centuries. *Milpas* – cultivated fields – sprawl across the jungle, the result of the slash and burn system. In the dry season, around Christmas, farmers cut trees with their machetes. From March until May there is

little rain and the heat becomes oppressive, an ideal time for burning dried wood, leaving a cleared area for cultivation covered with a nutrient-rich bed of ashes.

The first rains come at the end of May, preceded by silent lightning. Now farmers take long thick staffs and poke small holes into the wet earth into which they drop kernels of maize, beans and squash seeds. This marvellous trio has provided the healthy diet on which the peoples of the Americas – Olmec, Maya, Toltec, Inca and Aztec – have sustained themselves for millennia. As the corn grows, the beans wind around the stems and the squashes spread across the ground. By July, the sun is blistering but there is abundant rainfall, and in September it is time for harvest. The Chinese would have found such rich agriculture spread right across the land together with a sophisticated irrigation system and raised fields supporting a far higher density of population than is found in the Mexican countryside today. It rivalled their own.

Beehives are scattered along the fringes of the forest; honey was important to the Maya for sugar, as a basis for wheatfermented alcohol and as a cash crop enabling the farmers to buy shoes and the cotton cloth their wives embroidered in traditional patterns. To this day, their children wear smocks exquisitely embroidered in vivid colours identifying family and village, very similar to those painted in the frescoes of long ago. The traditional Na houses peep out of the rainforest, unchanged for millennia. The foundations, an oval platform of rocks, are bound together by limestone cement. Horizontal beams are lashed to the uprights with rope made from fibres of the agave plant. Smaller bamboos complete the framework and the roofs are of dried fan palms. This traditional construction is still used in hotels and resorts throughout southern Mexico and Guatemala. The Maya still sleep in hammocks, and their everyday greeting remains 'Have a hammock.'

The jungle of Central America provides a rich and varied

THE FIRST COLONY IN THE AMERICAS

diet; man only needs to hunt, fish and gather fruit for two or three days each month, and in the sultry heat he needs few clothes. Building materials, vegetables, medicines, coca, coffee, edible birds and animals of all descriptions surround him. The jungle is never silent; night is punctuated by cries, whistles, screams, muffled roars and croaks. In this rich jungle environment, the Maya built glorious stone cities. Nothing I have seen on this fabulous planet, not even Machu Picchu or the Acropolis, has equalled the Mayan city of Palenque in Chiapas, Mexico, rising out of the white mist of a perfect summer's day. The city was built by the Maya in their glorious golden age (c. AD 325-925) and lay hidden under its cloak of jungle for a thousand years. Constructed on a series of adjacent hills overlooking the plains, it spreads over three and a half square miles. Each hill group comprises a cluster of buildings - pyramids, temples and palaces. Within each group, white stone palaces surround an enchanting central plaza with a backdrop of verdant, bottlegreen jungle. The buildings have been superbly positioned to accentuate the natural features of hill and valley, while a placid river wends through the middle of the site. When the Chinese met the people of Mexico it is highly probable that they would have been shown Palenque, the finest Mayan city.

At the time, Palenque would have appeared to the Chinese as the work of a people whose talent equalled their own. It is the complete Mayan city, suddenly abandoned with its treasures intact. Here there is everything the archaeologist or historian could wish for: the fabulous tomb of a 'pharaoh of the jungle', filled with treasures; palaces of kings and priests covered in hieroglyphics telling the story of the site; observatories, temples, ball courts and, perhaps most important of all, the houses of ordinary people. Every aspect of art is here, from masks, statues, jewellery and ceramics to the humble pots and pans, fishing hooks and spears used by ordinary folk to hunt game.

The extraordinary white pyramid of King Pakal dominates

the site. The Cuban scholar Alberto Ruz Lhuillier spent years digging down a secret stairway into the chamber at the very bottom. In 1952 his team wrenched aside a huge stone and entered a darkened vault.

Out of the dim shadows emerged a vision from a fairytale, a fantastic ethereal sight from another world. It seemed a huge magic grotto, carved out of ice, the walls sparkling and glistening like snow crystals ... the impression, in fact, was that of an abandoned chapel. Across the walls marched stucco figures in low relief. Then my eyes sought the floor. This was almost entirely filled with the great carved stone slab, in perfect condition ... Ours were the first eyes that gazed upon it for more than a thousand years.

In feverish excitement, Alberto Ruz Lhuillier and his team jacked up the huge lid and peered inside.

My first impression was that of a mosaic of green, red and white. Then it resolved itself into details – green jade ornaments, red painted teeth and bones, and a fragment of the mask. I was gazing at the death face of him for whom all this stupendous work – the crypt, the sculpture, the stairway, the great pyramid with its crowning temple – had been built ... This, then, was a sarcophagus, the first ever found in a Mayan pyramid.¹³

The most spectacular of the exotic treasures that accompanied Pakal to the next life was his burial mask of jade, with shell eyes and obsidian irises. It must be one of the finest works of art ever made by man, of incalculable value. The dead king's wrist, neck, fingers and ears were adorned with exquisitely carved jade jewellery. Here were objects to rival or even eclipse the finest products of the Chinese or Japanese craftsmen. The beautifully proportioned pyramid with its simple, smoothly faced stone, the hidden stairway, the interior crypt and the superb mask and jewellery are the work of a people of immense architectural, engineering and artistic talent.

A walk downriver from Pakal's pyramid brought me to a museum filled with Mayan decorative art, mostly symbolic plants and animals – jaguars, serpents with fangs and claws, birds with their feathers and scales, so lifelike they appear to leap out of the display cases. It is an astounding cornucopia of artistic treasure. At last, after years of sailing the storm-tossed oceans, the Chinese had met a civilization nearly as old and as fine as their own. They had found jade jewellery as exquisite as theirs, and Cholula ware even thinner than the best Chinese porcelain, Jingdezhen from Jiangxi province. At long last, they could exchange their silks and blue and white ceramics for wonderful works of art.

COLONIES

IN

CENTRAL

AMERICA

FOUND SOME OF THE STRONGEST SIGNS OF CHINESE influence when I arrived in Uruapan in the mountains of western Mexico. It lies approximately two hundred miles upriver from the Pacific, with the river and the sea to the south and the mountains to the north. The town owes its name to the Spanish monk Fra Juan de San Miguel who was so impressed by the lush vegetation when he arrived in 1533 that he christened the area Uruapan – 'eternal spring'. To this day, it is renowned for its avocados and fruit, and for the beautiful lacquer boxes and trays that delight tourists.

Lacquer, known in Mexico as maque and in China as Ch'i-ch'i, is a highly unusual, complex and time-consuming method of decoration. The lacquer tree occurs in a wild state in China, regarded as the original birthplace of lacquer, and is also cultivated in plantations. The Chinese recognized the protective qualities of seshime, the resin extracted from the branches of the lacquer tree, at least three thousand years ago. They introduced it throughout south-east Asia; the Chinese and Japanese lacquering processes are essentially the same. The oldest known Chinese examples date from the Shang dynasties (c. 1523-1028 BC) when the Middle Kingdoms began using lacquer on household utensils, furniture and art objects, and to preserve historical objects carved on bamboo. To their astonishment, the first Europeans to reach southern California and Mexico found that the process of lacquer decoration was flourishing in the states of Chiapas, Guerrero, Michoacán and as far north as Sinaloa on the Gulf of California.¹ Uruapan is considered to be the centre of the maque art, but how could the people of Pacific Mexico have come to know of it? Was it developed independently, or did the Chinese introduce it?

Lacquer's unique characteristic is its need for a moist and temperate atmosphere in order to dry. Warm dampness converts the sap into a dense mass that hardens as enamel. Density and drying vary with temperature, thickness and humidity. Perfect

conditions are found in the moist, warm Pacific winds of Uruapan. Before applying lacquer in the traditional way, the surface of a box or other object is prepared by filling all the cracks with a mixture of rice flour and seshime. The correct consistency is achieved by mixing it with rice paste, or, in the case of Mexico, with volcanic ash. The box is then sanded down and the first of between ten and a hundred coats of lacquer applied with a very fine brush made of human hair. Each layer has to be completely dry, sanded and polished before the next is applied. Polishing was an art in itself, using a whetstone and deer-horn powder applied with a soft cloth; sixty or seventy coats were common.

This process is virtually identical in China and Mexico, with Chinese technology being adapted to the climate and materials found in Mexico. Preparation of the surface is identical: cracks are filled with a mixture called *nimacarta*, the object is sanded until completely smooth, and as many coats of *nimacarta* as necessary are applied, each one dried, sanded and polished with a whetstone.

Although the process is the same, the ingredients in Mexico do vary. The maque is a semi-liquid paste formed using a mixture of animal and vegetable oils and natural refined clays. The principal animal ingredient is grease extracted from the aje insects (Coccus lacca) bred by the local people around Uruapan. The insects are gathered during the rainy season and dropped alive into boiling water until their bodies release a hard, waxy substance that floats to the surface. When the water cools, the substance is collected, washed and reheated to remove any water. It cools like slabs of butter. The second ingredient, chia vegetable oil, serves to thin the aje mixture. The oil is extracted from the seeds of the sage plant, a native of Mexico. Chia oil has a high glycerine content that quickly absorbs oxygen from the air, forming a hard elastic surface when dried. The third ingredient, finely ground dolomite called teputzuta, a mineral clay, gives body to the maque mixture.

The decorative techniques and colours used in Mexico and China are also remarkably similar, with spectacular reds incised into a deep black background. In both countries, the traditional colour is black obtained from the fine powder of burnt animal bones or burnt corncobs. Decorative *maque* techniques used in today's states of southern Mexico are the same as in China and Japan. The design is carved using the point of a sharp cactus needle inserted in a turkey quill. The soft plume of the feather is used to brush off the excess clay, or *maque*, as it is carved off. The fine incised lines are then filled with contrasting colours, one colour at a time, with plenty of drying, scouring and polishing after each application. The end result, the wonderful decorated plate or box, is so similar in Uruapan and China that it is almost impossible for those who are not experts to differentiate between them.

Theoretically, if very implausibly, this elaborate and timeconsuming process could have evolved simultaneously in China and Mexico, countries thousands of miles apart, but lacquering is not the only congruity when it comes to the artwork of western Mexico and China. Both also have extraordinarily similar and highly unusual methods of obtaining the dyes used in their artwork. Madder red, indigo blue, scarlet and shellfish purple are obscure dye-stuffs producing brilliant colours but requiring complex procedures to extract and fix them. Again, I would argue, too large a coincidence to be probable.

Madder is a red dye derived in China from the roots of shrubs of the Rubiacea family. The dye is prepared by digging up, drying, cleaning and pulverizing the roots, then soaking the mash overnight and steeping it for a short time at about 150° Celsius. The fabric is first mordanted, or fixed, with an aluminium sulphate before being boiled in the dye bath. It is then rinsed in water mixed with wood ash. In Mexico, the roots come from relatives of the Rubiacea – *R. relbunium* and *R. nitidum*, small, sub-tropical shrubs found as far south as Argentina. The New

259

World mordant includes aluminium, oxalic acid and tannin.

The brilliant blue indigo, used for millennia throughout south-east Asia, is the oldest of all the natural dye-stuffs and requires the most complicated technology. The plant must be very carefully cultivated. The fresh cut leaves, whole or ground, have to be steeped in hot water for nine to fourteen hours, during which time the leaves ferment and produce the most unpleasant smell. The resultant liquid is clear, but yarn or cloth soaked in it turns a vivid blue upon oxidization with the air. The process used for dyeing in pre-Columbian Central America was almost identical, save that ash and lime were employed as solubility enhancers.

Vermilion dyes, obtained from tiny insects scraped off oak leaves, were extensively used in south-east Asia. The insects were drowned in a vinegar bath, giving them a reddish brown colour, and when crushed they yielded a dye that was dissolved in alcohol and then fixed with alum or urine. The other red dye that occurred throughout south-east Asia was lac (laccaic acid), obtained from wild or domesticated curmese or lac insects parasitic on various trees. The twigs were broken off, dried in the sun and dropped into a hot soda solution from which the liquid was evaporated and the residue made into cakes. Both Ma Huan and Niccolò da Conti described them on sale in Calicut.²

The New World equivalent made use of another scaled insect, the cochineal, parasitic on cactus plants. The insect envelops itself in a cottony white film, and when crushed produces a spectacular scarlet colour ten times richer than the curmes and lac of Asia. After the Spanish invaded Mesoamerica, they exported cochineal to the Middle East and Asia. As in China, cochineal's colour was associated with royalty. True Mexican cochineal had reached southern Asia before Columbus set sail.³

The final dye was royal (tyrian) purple obtained from marine snails. This was the most celebrated of all colours used in the Old World. It was so expensive that only the wealthy could afford it,

COLONIES IN CENTRAL AMERICA

and purple robes became synonymous with high rank. The rulers of Byzantium were brought up in purple rooms and clothed in purple robes. In the New World, shellfish purple was produced from the region of Michoacán – the province surrounding Uruapan – and as far afield as Ecuador, and was very widely used on the Pacific coast. As early as 1898, this method of extracting shellfish purple was considered a possible indicator of pre-Columbian transoceanic trade.

... in many areas where the step of applying these substances as colorants might have occurred, it didn't, and sophisticated application of them to fiber is so involved that it seems remarkable that it developed at all, not to say multiple times ... thus when we find several of these dye stuffs, together with use of mordants, shared by distant regions, we must consider the possibility of historical contact, and rather intimate, repeated contact at that – especially in light of a host of other shared, and often arbitrary, traits.⁴

It is inconceivable that these dyeing processes could have been accidental, independent discoveries; 'a common source of the two civilisations must therefore be assumed'.⁵

But the links between Mexico and China do not end with natural dyes, lacquerwork, hens and plants. Lake Pátzcuaro, upriver from Uruapan, is surrounded by mountains rich in copper ore. To this day, lakeside towns such as San Christobal sell beautiful copper artefacts to swarms of tourists, and the museums are filled with treasures from the past. In Michoacán, as in China, metals were separated after they had been mined, stored in different warehouses and catalogued according to the quality and type of the metal and whether it was to be used for religious offerings or as tributcs.

The *Florentine Codex* – Fra Bernardino de Sahagún's great book,⁶ completed in 1569, describing pre-Hispanic civilizations in Mexico – illustrates the processing of the metals by blowing

oxygen through them to separate impurities, an advanced process not used in pre-Columbian North America. The metals used by the Michoacáns were copper, gold, silver and metal alloys. They were particularly adept at casting bells, which took up nearly 60 per cent of the metals fabricated. The resonance of a bell is determined by the type of metal alloy used; just as in Asia, the proportions were carefully measured to give the correct resonance. Metal bells using these same alloys were important symbols in the Buddhist religion, and visitors to Thailand, Burma, China and India are still charmed by the sweet notes of such bells through the day, as I know from dreamy afternoons spent in monasteries in Burma and Tibet.

Metal *hachuelas* – burial offerings in the shape of a crescent moon – are also found in abundance in Mexican tombs. *Hachuelas* were often placed in the mouth of the deceased, just as jade marbles were placed in the mouth of the dead in China. The curved, moon-shaped form was an important universal symbol of Lamaist Buddhism. Emperor Zhu Di made significant efforts to encourage Lamaism in China by inviting the Tibetan Karmapa to visit him and bestowing honours upon him. Moonshaped ceremonial knives were used symbolically to sever the attachment with life, and can be found in Buddhist temples and tombs throughout Tibet and China to this day. While the eunuch captains were Muslims, the crews of Zheng He's fleet were almost all Buddhist, attracted by Buddha's teaching of universal compassion to all sentient creatures.

Mirrors also had an important place in the cultures of both Central America and China. In China, a mirror was believed to assist the transition of the soul to other planes, to the abodes of the spirits of gods and the souls of the ancestors. Most Chinese bronze mirrors were round, embodying the Taoist concept of the circle as a universal space. In China and Japan, the reverse side of a mirror was inscribed with symbols of animals and flowers, and with religious reliefs. It became a tradition to carry a

COLONIES IN CENTRAL AMERICA

symbolically decorated, round, bronze mirror as protection from evil spirits. In Michoacán, round metal discs called *rodelas* were used in ceremonies and rituals. Like bells, they were produced in large numbers from gold, silver, copper and alloys, and were decorated on the reverse side with symbols of nature and the universe.

As a result of this research, I was certain that the Chinese had been to Uruapan, had traded hens there, and that they must have stayed for months or possibly years to impart their knowledge of lacquerwork and dye technology to the Mexicans. My tentative conclusion – that squadrons or individual ships had been detached as the fleet passed down the coast in order to set up colonies – seemed more and more plausible. There was corroboration of that in the oral history of the Nayarit, to the north-west of Guadalajara – tales of a pre-Columbian ship from Asia that arrived on the Mexican coast and was cordially received by the chief of the Coras, a prominent Nayarit people. I began to search through the museum collections. It was a long haul with little to show for it at first. Then I came across the *lienzo de Jucutácato* (the linen of Jucutácato), a painting discovered in the nineteenth century in the village of that name.

The *lienzo* comprises around thirty-five squares, thirty of which are about the same size, and each square tells a little story. The first scene shows men disembarking from a ship. Running ahead of them is a dog with a distinctive tail curved in a bow over its back. In shape, size and gait, especially its peculiar tail, it resembles the Chinese shar-pei, a hunting dog originally from Guangzhou, and much prized by poor Cantonese for its extreme devotion to its keeper and his family.⁷ At least one of the men is on horseback, a creature the local people would have found very strange and worthy of note; there were none in the Americas prior to the Spanish conquest. The leader emerging from the bows is dressed in a red tunic (the same garment Zheng He is

wearing on the statue recently found buried in the Fujian Palace – see postscript) and he holds a round mirror. The mirror clearly had symbolic importance for it is repeated no fewer than fourteen times in the other pictures. In some of them the reverse side of the mirror is shown 'marked with eight divisions'; this 'wheel of doctrine' relates to a major event in the life of the Buddha, particularly his preaching and enlightenment. The mirror being carried by the red-robed leader is entirely consistent with a Buddhist religious leader coming ashore to meet local people.

In the centre of the picture, a leader sits while local people lay trays of minerals on the ground at his feet – to my mind an obvious reference to their selling copper to the Chinese. At the bottom is a tree with rays of light emanating from it. It may symbolize the tree of enlightenment under which the Buddha sat. Finally, there are several drawings of a large bird with a drooping tail trailing on the ground. In size and posture, the bird resembles the Asiatic Malay chicken. Taken as a whole, the picture is wholly consistent with Chinese disembarking on horseback and on foot from a great ship, striding ashore with their mirrors to ward off evil spirits, assisted by the tree of enlightenment and the wheel of doctrine. The local people brought them minerals and perhaps in return the Chinese bequeathed their chickens, lacquerwork, dye-stuff and mineral technology.

According to the historian Nicolás León,⁸ the first person to have the *lienzo* analysed and copied, it was painted with black vegetable ink on a coarsely woven cloth and dates to long before the Spaniards arrived in Mexico. He states that it was altered in the sixteenth century by the Spaniards who added buildings and words in an attempt to explain it. These alterations were made with a different type of ink and at a later date.

Was it plausible that the Chinese had reached Jucutácato, even though it lies inland from the coast? The village stands some ten kilometres south of Uruapan where the Cupatitzio River ceases to be navigable. The Cupatitzio empties into a large lake some forty kilometres further south, which in turn is connected to the sea by the Balsas River. Just as at Sacramento, it is entirely possible that a junk could have reached Jucutácato from the sea, to obtain minerals and plants in return for trade goods and technology.

If the Chinese had made such a visit to trade and teach the Maya the secrets of lacquer technology, evidence of their stay should still exist. Professor Needham, one of the great experts on Ming China, visited Mexico in 1947 and described his experiences. 'I was deeply impressed during my stay with the palpable similarities between many features of high Central American civilisations and those of East and Southwest Asia," he wrote, then listed more than thirty cultural parallels. In addition to the metallurgy described earlier, he cited Mayan drums resembling those found in China, tripod pottery, games, computing devices, jade used to demonstrate a panoply of complex beliefs, music (more than half the types of Mayan musical instruments are also found in Burma and Laos), Chinese carrying poles and Chinese neck-rest pillows. With respect to the great professor, I would go even further. From the Pacific coast of Mexico down to central Peru one can be forgiven for thinking one is in China, so similar is the atmosphere, so familiar the bustle, so reminiscent the 'kik-kiri-kee' of the hens in the morning, so alike the people.

To my mind, direct evidence of an early Chinese presence is littered right across the Mayan landscape. Pre-Columbian Chinese bronze figures were found in Peru, and Nazca figurines of the sun god have on their base a Chinese figure for heaven. The museum at Teotihuacan, then an important city, has Chinese medallions, and Chinese jade necklace decorations were found at Chiapa de Corzo in the modern state of Chiapas. Don Ramón Mena, then director of the National Museum of Mexico, described one medallion as 'centuries old . . . carried to America when the Chinese came to this continent'.¹⁰ In the celebrated Cueva Pintada caves on the Mexican peninsula of Baja California, there are paintings of men pierced with arrows and a depiction of the Crab Nebula supernova of 1054 recorded by the Chinese (see chapter 1). In the debris at the foot of the paintings, charred wood has been found and carbon-dated to between 1352 and 1512.

Further evidence of a Chinese stay in Mayan lands comes from Guatemala. The distinguished biologists Carl Johannessen and M. Fogg describe the divination and witchcraft practised by the local people using black-fleshed melanotic chickens.¹¹ They make a compelling case that not only were the chickens brought from China, but the Chinese must have spent a long time indoctrinating the different groups of people.

Seemingly incontrovertible proof of Chinese colonies in Central America also comes from the foothills of the mountains west of the Gulf of Venezuela, an area clearly shown on the Waldseemüller chart. I have seen these mountains from far out to sea, their snow-capped peaks silhouetted against the setting sun – an unforgettable sight. Some of the native tribes living in this remote area have traces of Chinese genes in their blood.

In 1962, Dr Tulio Arends and Dr M.L. Gallengo of the Instituto Venezolano de Investigaciones Científicas, Caracas, reported the findings of their electrophoretic study of the distribution of transferrin phenotypes (the study of the migration of suspended particles in particular protein macro-molecules under the influence of an electric field) in linguistic and ethnological groups of the mature population of the American continent. They identified transferrins (proteins transporting iron in blood) in the Irapa, Paraujano and Macoita people who inhabited the foothills of the Sierra de Perija (9° to 11°N; 72°40' to 73°30'W). These tribes were primitive populations on the verge of extinction. In 58 per cent of these people, the scientists found a slow-moving transferrin indistinguishable from one which to date has been found only in Chinese natives of the province of Kwantung in south-east China.¹² As the report says, 'this finding is additional evidence for the existence of a racial link between South American Indians and Chinese'. A goodly proportion of the crews of Zhou Man's and Hong Bao's fleets would have been born in Kwantung, for then, as now, its ports were among the busiest in China, thronged with boats and the seamen who sailed them. It appears that some of the Kwantung sailors aboard Zhou Man's ships interbred with Venezuelan women.

There is also linguistic evidence of Chinese visits to South America. A sailing ship is *chamban* in Colombia, *sampan* in China; a raft, *balsa* in South America and *palso* in China; a log raft, *jangada* in Brazil, *ziangada* in Tamil. Until the late nineteenth century, villagers in a mountain village of Peru spoke Chinese.¹³ A mountain of evidence – wrecks, blood groups, architecture, painting, customs, linguistics, clothes, technology, artefacts, dye-stuffs, plants and animals transferred between China and South America – points to a pervasive Chinese influence the length of the Pacific coast of Central and South America, and inland. So broad and deep is the influence that one may almost call the continent of that era 'Chinese America'.

There is one further incontrovertible proof that the Chinese reached Mexico. When I commanded HMS *Rorqual*, I took her through the South China Sea and Philippine Islands to Subic Bay. There were many legends about Chinese junks lying on the sea-bed with their treasures intact. I searched for them with my sonar, but alas without success. Then I discovered that on 9 June 1993 a pearl fisher diving off Coral Bay in south-west Pandanan, a small island to the south-west of the Philippines (and marked on the Rotz chart), had found the wreck of a Chinese junk. The wreck was encrusted with barnacles, but much of the hull – of teak – remained intact. Under the supervision of Dr Eusebio Dizon, the head of the underwater archaeology section of the National Museum of the Philippines, the wreck was excavated in the spring of 1995 and 4,722 artefacts brought to the surface.

They provide a vivid illustration of trade between China, southeast Asia and the Americas.

The wood of the hull has been carbon-dated to 1410 - very similar to the date of the wood found at Sacramento, the site of a possible junk. Both are of the same length and beam, approximately 97 feet by 26 feet, and both apparently carried iron woks in their holds - those at Pandanan have been photographed on the sea-bed and those at Sacramento were located by 3D magnetometer readings. Both junks carried exotic as well as ordinary commercial goods. The Pandanan junk had millions of tiny glass beads the size of those used by the Chinese as a sex aid, a practice noticed by both Ma Huan and Niccolò da Conti in south-east Asia (see chapter 3), and extant in the Philippines today. The (unconfirmed) Sacramento junk carried millions of tiny black seeds, some of which have been provisionally analysed as those of a poppy unique to south-east China. If this analysis is confirmed, it is possible the Chinese were trading in drugs. The Pandanan junk also carried metates - pestles for grinding maize - which were then unique to South America, and what appears to be Cholula ware, the eggshell-thin ceramics made in Mexico. The junk had been trading throughout south-east Asia before she sank, for the hold contained porcelain from eight separate countries, including superb ceramics from Vietnam and blue and white Chinese porcelain from the celebrated kilns at Jingdezhen. Complementing these beautiful pieces were ordinary household goods such as clay cooking pots and stoneware storage jars for rice, beans and seeds. There were also three bronze gongs from Dongson (Vietnam) and a peculiar bronze scale balance that may have been the compensating mechanism for a Chinese water clock.

Of the 4,722 items brought up, about a thousand currently remain to be identified. When they have been, it should be possible to reconstruct the junk's route. On the evidence already available, it appears to have returned from Central America with the north equatorial current (the route sailed by Zhou Man's fleet)

COLONIES IN CENTRAL AMERICA

and been wrecked off Pandanan, perhaps in a sudden squall. This would put the date of its demise at about early September 1423, towards the end of the south-west monsoon, a time when there are unpredictable squalls.

Uncovering the evidence of these early-fifteenth-century Chinese voyages of discovery had been immensely stimulating and exciting, but the implications of what I was learning were now beginning to dawn on me. There seemed to be a mass of powerful evidence that the Chinese had not only traded with the Americas but set up colonies from California to Peru (indeed, recent DNA analysis shows conclusively that local peoples in Mexico, Panama, Colombia, Venezuela and Peru share Chinese DNA). They had also explored the world long before the Europeans and appeared to have been well on the way to setting up colonies in East Africa and Australia and across the Pacific as well as in America. If all this was true, history would need to be radically revised, but it seemed extremely presumptuous for a retired Royal Navy submarine captain to be the one initiating this process. Although I was confident in the veracity of the evidence I had assembled, the thought of the potential responses in academic circles was causing me nightmares. I decided it was imperative to find corroborative evidence from the academic world, for, generous though they had been in helping me so far, I could well imagine the reaction of some distinguished professors of history to a radical reinterpretation of the subject they had devoted their lives to studying and teaching.

Although all the Chinese records had allegedly been destroyed, I felt sure that somewhere something like the *Wu Pei Chi* and Ma Huan's diaries must have been missed; the mandarins could not have been so thorough that they had obliterated every description, every letter, every mention of what had been found during the voyages. Surely another private memoir or account must have survived somewhere.

My first approach was to the Zheng He Museum in Nanjing. The museum is situated in the centre of the city in what used to be the private park encircling Zheng He's palace and has been built in early Ming style, surrounded by bamboo groves and carpets of green grass dotted with flowers. The principal exhibit is entitled 'Historical Relics and Material Exhibitions of Zheng He's Expeditions'. The most interesting and important relic is the 36-foot-high rudder post. By the standards of conventional ship engineering, a vessel carrying such a gigantic rudder must have been around four hundred feet long. The only other artefacts of interest I found in the museum were Zheng He's bell, resembling a larger version of that found at Ruapuke Beach, and the highly unusual claw-shaped anchors like those found in Australia.

These findings, though interesting, were inconclusive. I then wrote to professors in the Chinese or Asian Studies departments of the universities of California, world-renowned for their research into medieval China, to the relevant professors at Oxford and Cambridge and to the librarians of the great libraries of England, America and Australia to enquire if their collections included books of the early Ming era unknown to the outside world.

After a wealth of friendly but negative replies, I at last struck lucky. Professor Charles Aylmer, the librarian of the East Asian Collection at Cambridge University in England, informed me of a unique book, I Yü Thu Chih – 'The Illustrated Record of Strange Countries' – a compilation of the people and places known to the Chinese in 1430. The book's cover page is missing so the author is not known for certain, but it is believed to have been written by the Ming prince Ning Xian Wang (Zhu Quan) and printed within a year or so of 1430. It formed part of the magnificent collection donated to the University of Cambridge in the late nineteenth century by Professor Wade, who had spent most of his life in China and was the first professor of Chinese at Cambridge. The Cambridge copy is the only one in existence, anywhere in the world. It has never been translated and only one photocopy has ever been taken, by the Chinese Embassy in London. Professor Aylmer and other learned sinologists are absolutely convinced of the provenance and authenticity of the book.

I hurried to Cambridge. Although the book itself is in very poor shape, Professor Aylmer had arranged for it to be photographed onto a microfiche which showed all ninety-eight pages with remarkable clarity. There are some eight thousand characters in medieval Chinese and 132 illustrations drawn by different artists. Some are quite brilliant, catching the atmosphere with a few strokes of the brush. There are plants, animals and people from practically every continent in the world. It is a most concise and powerful illustration of Chinese knowledge of the world and its creatures in 1430 - hence the title of the book. The Chinese incorporated only what they found strange, and there are therefore very few scenes of China itself. Instead, the illustrations showcase all the principal religions on earth: Muslims in long robes praying to Mecca; the Hindu trinity of Lord Brahma, the creator and supreme being with his four arms, Lord Vishnu, the maintainer and preserver of the universe, and Lord Shiva, its destroyer; there is Ganesh, the elephant god, and a wonderfully lively picture of monkeys dancing around Hanuman, the Indian monkey god; Buddha is depicted in contemplation under the holy tree and praying towards the holy mountain. The artist has drawn Sikhs in their turbans and Venetians in their distinctive hats, long boots and flowing cloaks, but most vivid of all are the animals: a well-fed zebra with its fat, rounded belly; African elephants and lions; Indian peacocks and tigers, all drawn with masterful economy of line. There are pictures of the deer of south-east Asia and the steppe, and the hunters who pursued them with their different weapons - the double-ended bow of the Mongols and the western Asian longbow. There are also drawings of creatures unique to the Americas: llamas, an armadillo plodding across the ground in search of ants, a jaguar with its slack belly, men chewing coca, the naked men of Patagonia, and the dog-headed mylodon, 'which is found two years and nine months' journey west of China'.¹⁴

Two things particularly surprised me. The first was the emphasis placed on people from the far north. There were Eskimos in their fur-lined hoods carrying harpoons, and a wonderful Cossack dancer. At that time, Moscow was the leading principality of Russia but had not yet started to expand eastwards across Asia. The Chinese could conceivably have seen Eskimos in the Aleutian Islands, but not Cossacks. There are no records in that era of any Chinese expeditions overland into Muscovy, but recently undertaken analysis shows that fishermen in northern Norway have Korean DNA, and Aleuts have Chinese DNA. It appears that Korean and Chinese ships did indeed sail along the coast of northern Siberia.

The second curious aspect was how little space was devoted to Australia; I could only assume that was because by 1430 it was no longer considered a 'strange country'. By the fifteenth century there had been many descriptions of fleets of junks, each carrying hundreds of people on voyages from China to Australia. In one, the north coast of 'the great south land of Chui Hiao' was described as lying thirty thousand li – approximately twelve thousand miles – from China and being in the south temperate zone, where seasons are opposed to those in the northern hemisphere.¹⁵ It was inhabited by a race of small (just one metre tall) black people identified by the Australian anthropologist Norman B. Tyndale as Aborigines from the mountains above Cairns in north Queensland.¹⁶

In March 2002, the talk I gave at the Royal Geographical Society in London was broadcast live to Australia. The television station Channel 9 then invited me to take part in a live interview

COLONIES IN CENTRAL AMERICA

in which a number of distinguished Australian professors participated. The fact that Zheng He's fleet had reached Australia came as no surprise to them, and I was subsequently referred to several books that made the same claim. If my theory seemed to be broadly accepted in Australia, did this hold true in China? Dr Wang Tao of the School of Oriental and African Studies, University of London, kindly offered to introduce me to the widow of Professor Wei of Nanjing. Professor Wei's life work was a study of Zheng He's voyages, in particular his fleet's discovery of the Americas. He was about to publish a book entitled *The Chinese Discovery of America* when, sadly, he died. Professor Wei's work is widely known in the academic community in China, though it is yet to be translated into English (or published in China). The revelations in my book caused no particular surprise there either.

I began to wonder why American and European historians had managed to persuade the world for so long that Columbus had discovered America and Cook Australia. Were they ignorant of the Chinese voyages to the Americas before Columbus? I decided to find out. To my amazement, I discovered that there were more than a thousand books providing overwhelming evidence of pre-Columbian Chinese journeys to the Americas. This literature has even been summarized in a two-volume bibliography.¹⁷ As Professor George F. Carter, an expert on hens in the Americas and author of several fascinating books on the subject of early Chinese voyages, remarked, 'Sinologists and Asiatic art historians are normally struck by the overwhelming, all-pervasive evidence of Chinese influence in Amerindian civilization. Seemingly the Americanists are not aware of the Chinese literature suggesting not only discovery but colonization of America.'18 Professor Carter's phrasing is a masterpiece of tact. Perhaps, as he suggests, those academics are not aware of the evidence; perhaps they have chosen to ignore it, presumably because it contradicts the accepted wisdom on which

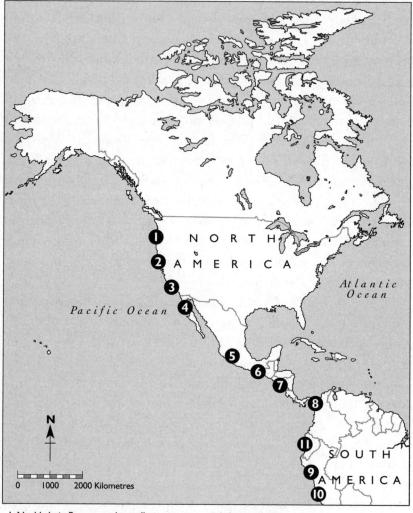

- I Neahkahnie Bay wooden pulley
- 2 Sacramento junk plus Chinese speaking peoples and location of a Chinese village
- 3 Los Angeles Chinese anchor
- 4 Cave art depicting foreigners arriving
- 5 Michoacán artefacts lacquers, dye-stuffs, both with Chinese influence
- 6 Asiatic chickens
- 7 Gulf of Fonseca
- 8 Venezuelan Indians with Chinese DNA
- 9 Peruvian village with Chinese-speaking people
- 10 Peruvian bronzes with Chinese inscriptions
- 11 Ecuador Chinese anchor and fish hooks

Evidence of the visit of the Chinese treasure fleet to the Americas.

not a few careers have been based. Academics with rather more open minds will look again.

The thesis that the Chinese explored virtually the whole world between 1421 and 1423 might be a radical departure from convention when it comes to the dates of the discovery of these 'new worlds' and the identity of those who first explored and charted them, but I was confident that there was solid evidence to support it. My training in astro-navigation had also enabled me to find further proofs that no academic, unless he were an astronomer, could have reached. No matter what heavy artillery was brought to bear, I was confident the thesis could withstand it. Reassured, I turned the spotlight onto Admiral Zhou Wen and his fleet.

The Voyage of Zhou Wen

SATAN'S

11

ISLAND

In OCTOBER 1421, WHEN THE FLEETS OF HONG BAO AND ZHOU Man had sailed south-west from the entrance to the Caribbean towards the coast of South America, they had left the fleet of Admiral Zhou Wen taking a course to the north-west following the northern branch of the equatorial current. I already knew that this fleet must have later reached the Azores, at the latitude of Beijing, for the islands appear on the Kangnido map, drawn before the first Europeans discovered those islands. My task was now to find where Zhou Wen had sailed between those two landfalls.

When Admiral Zhou Wen reached the Cape Verde Islands he had already sailed across a substantial part of the globe and must have known that the mysterious land of Fusang lay to the west of him. By the time of the great cartographer Chu Ssu Pen (1273–1337), the Chinese had made an accurate estimate of the distance from the Pacific to the Atlantic, but how far to the west Zhou Wen thought Fusang lay would depend on how far he considered he had already sailed. The Kangnido shows that, because of the effects of the ocean currents, the Chinese fleets had underestimated their voyage across the 'bulge' of Africa by a couple of thousand miles. As he lay at anchor at Santo Antão in the Cape Verde Islands, Zhou Wen might well have assumed that Fusang lay four thousand rather than two thousand miles to the west of him, but that was still well within his range, without the need for fresh provisions or water en route.

North of the equator, the Atlantic is a vast oval-shaped wind and current system rotating clockwise day in, day out, throughout the year. British Admiralty sailing directions advise mariners on how to make use of these winds and currents: 'From Madeira the best track is to pass just west of, but in sight of, the Cape Verde Archipelago . . . from Cape Verde steer a direct course [for the Caribbean] . . . thereafter . . . the north equatorial current and south equatorial current converge, forming a broad band of current setting west. Average rates reach 2 knots.' From the

Cape Verde Islands they carry the mariner due west to the Caribbean, then north-west towards Florida and north up the American seaboard before taking him clockwise to the east, where the current becomes the Gulf Stream carrying the mariner across the Atlantic to the Azores, a thousand miles west of Portugal. It then hooks southwards, back once again to the Cape Verde Islands. The commander of a ship with sufficient provisions can hoist sail off the Cape Verde Islands and sit back and do nothing. Provided he is not capsized by a storm, a common occurrence in the North Atlantic, he will eventually end up more or less where he started.

The westerly current from the Cape Verde Islands reaches its strongest flow when approaching the Caribbean at the latitude of the island of Dominica. As a result, explorer after explorer down the centuries – Columbus on his second voyage, the Spanish explorers Rodrigo de Bastida and Juan de la Cosa in the early years of the sixteenth century, the French and English fleets during the Napoleonic Wars – has entered the Caribbean through the passage between Dominica and Guadeloupe. I would put the likelihood as high as 80 per cent that if, having replenished with fruit and fresh water, the Chinese had sailed from the Cape Verde Islands in October they would have been entering the Caribbean by early November.

The track of the junks of Admiral Zhou Wen's fleet through the Caribbean should logically have been the same as that of Columbus, for the winds and tides have remained unaltered from that day to this. Whatever the Chinese discovered should have been rediscovered by Columbus seventy years later. By examining Columbus's diaries of his second voyage, I should be able to reconstruct the most likely track. If the Chinese had found any islands or land on their voyage across the North Atlantic, I could expect those discoveries to be recorded on charts drawn after they returned to China in 1423. Just as I had done for South America and Australia, I now began to search for a SATAN'S ISLAND

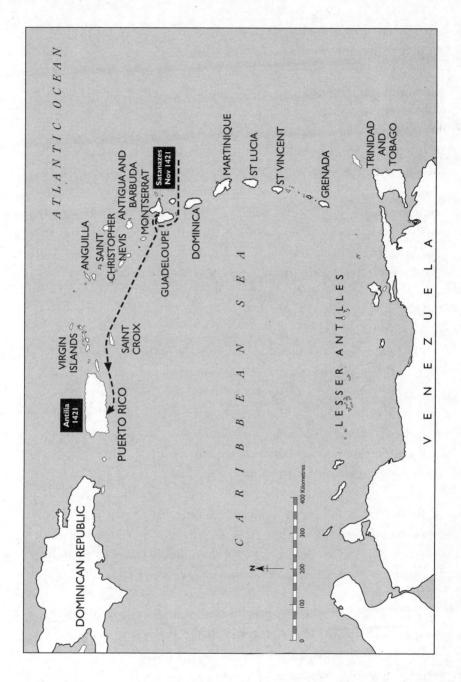

Zhou Wen's journey through the Caribbean.

chart that, like the Piri Reis and Jean Rotz maps, appeared to depict lands Europeans had yet to discover.

In that era, Venice, the base of Fra Mauro, the Venetian cartographer working for the Portuguese government, led the West in mapmaking. As I expected, Venetian and Catalan charts (Catalonia was then part of the Kingdom of Aragon; the Catalans were redoubtable seafarers) drawn before 1423 disclosed nothing new in the western Atlantic, but a chart dated 1424 and signed by the Venetian cartographer Zuane Pizzigano was an entirely different matter. The Pizzigano chart was rediscovered some seventy years ago and in the early 1950s it was sold to the James Ford Bell Library at the University of Minnesota. Its authenticity and provenance have never been questioned and several books have been written about it by distinguished historians.

[The 1424 chart] is a document of capital importance to the history of geography. From the historical point of view, it is undoubtedly one of the most, if not the most, precious jewel yielded by the disclosure of the almost unknown treasures contained in the unique collection of early manuscripts assembled by Sir Thomas Phillips during the first three-quarters of the nineteenth century. The great importance of this chart lies in the fact that it is the first to represent a group of four islands in the western Atlantic, called Saya, Satanazes, Antilia and Ymana ... there are many and good reasons for concluding that the Antilia group of four islands shown for the first time in the 1424 chart should be regarded as the earliest cartographic representation of any American lands.²

This was high praise indeed. I made a close study of the chart (see Introduction). It is markedly different from its contemporaries. It is not centred on the Mediterranean, as earlier charts were, but looks westwards across the Atlantic, where two large islands, Antilia and Satanazes, hitherto unknown to Europeans, are depicted. Two smaller islands are also shown: Saya, a parabolic island to the south of Satanazes, and the box-shaped island of Ymana to the north of Antilia.

Other accounts of the era put the islands '700 large leagues'³ west of the Canaries, which would put them near the Bahamas, but no large islands are located there. Were the islands imaginary? Other chartmakers clearly believed they were genuine, for the group was subsequently represented on at least nineteen fifteenth-century maps and two globes, all of them drawn before Columbus set sail (see chapter 17). But as time went by, successive cartographers relocated the islands further and further to the south-west, until they ended up in the Netherlands Antilles.

The Portuguese names on the chart had made me presume that they were the original cartographers, but the names on the Piri Reis and the Jean Rotz charts were also in Portuguese and they could not possibly have been the discoverers of the Antarctic, Patagonia or Australia. Portuguese records in the Torre do Tombo, the National Archives of Portugal in Lisbon, state unequivocally that Henry the Navigator sent caravels to discover Antilia after he had received a similar but slightly later chart (the 1428 World Map discussed in chapter 4).4 Moreover, in 1424 the Portuguese simply did not have the capacity to survey the islands with such accuracy - for the cartography of Antilia was amazingly good. I concluded that it could only have been the Chinese. However, I needed further proof that this was the case, and I found once again that the best way of tackling this puzzle was to put myself in the cartographers' shoes. When in submarines, we used to spend time in the Barents Sea photographing military installations. Part of our training was in periscope photography and the obscure art of constructing charts from near sea level. At the time I was working from about the same height as the cartographers of the Pizzigano chart, standing on the deck of a medieval ship.

As Zhou Wen's ships approached the Caribbean, they would have had warning some two days out that they would shortly sight land. Clouds, winds, weather and sea-bird types would all change, and finally, a few hours before the islands became visible, the crew would have begun to detect the soft, subtle smell of wet foliage. Because Columbus sailed through the Dominica Passage on a Sunday, he named the island to the south Dominica, the Spanish name for that day of the week; that to the north was named Marie-Galante after his flagship. He first landed at Marie-Galante but found little and pushed on northwards with the current, landing the next day at an island he named Guadeloupe in memory of his visit to a monastery of that name in Extremadura in Spain. Had they known, the monks might have raised objections to his choice of name, for the inhabitants of the island were Carib cannibals. Dr Chanca, a chronicler of Columbus's second voyage, recorded his men striding through the soft sand into the coconut groves where they found 'houses, about 30, built with logs or poles interwoven with branches and huge reeds and thatched ... with palm ... square and cottage like ... For dishes [they use] calabashes [a gourd]... and, oh horrors!, human skulls for drinking vessels.'5 Only women were left in the villages; the native men had fled to the hills in terror at the sight of the sails of Columbus's fleet.

The stench of bodies horrified Columbus's men. 'Limbs of human bodies hung up in houses as if curing for provisions; the head of a youth so recently severed from the body that the blood was yet dripping from it, and parts of his body were roasting before the fire, along with savoury flesh of geese and parrots.'⁶ The natives used arrow-heads made from human bones, and

in their attacks upon the neighbouring islands, these people capture as many of the women as they can, especially those who are young and beautiful, and keep them as concubines... they eat the children which they bear to them ... Such of their male

SATAN'S ISLAND

enemies as they can take alive they bring to their houses to make a feast of them, and those who are killed they devour at once. They say that man's flesh is so good, that there is nothing like it in the world . . . in one of the houses we found the neck of a man undergoing the process of cooking in a pot. When they take any boys prisoners, they dismember [castrate] them and make use of them until they grow up to manhood, and then when they wish to make a feast they kill and eat them, for they say that the flesh of boys and women is good to eat. Three of these boys came fleeing to us, thus mutilated.⁷

Another contemporary writer noted that it was 'their custom to dismember the male children and young slaves, whom they capture and fatten like capons'.⁸

To fifteenth-century eyes, the cannibalism Columbus encountered could easily have been seen as the work of the devil. Could that be the explanation of the name Satanazes – Satan's

Cannibalism in the Caribbean: a fanciful seventeenth-century reconstruction of Columbus's encounter with the Caribs

Island? Was this what the Chinese had found, and was Guadeloupe the Satanazes shown on the Pizzigano chart? If so, like Columbus seventy years later, the Chinese would have approached the island from the south-east on the prevailing wind and current.

I turned my attention to the island of Saya lying to the southeast of Satanazes on the Pizzigano chart. I could vividly picture the scene as the Chinese approached because I spent some time in the Caribbean in command of the submarine HMS *Rorqual* and had visited and photographed many of the islands. In many cases the mountains appear black, surrounded by green jungle. Heavy rainstorms occur without warning, blotting out the islands. Frequently, birds take flight just before the rains arrive, circling in flocks, shrieking with foreboding.

As soon as I consulted a modern map, I saw that Saya on the Pizzigano map corresponded to Les Saintes. It is approximately the same shape and lies in the same position relative to Guadeloupe as Saya to Satanazes. I assumed that Saya was indeed Les Saintes, Satanazes was Guadeloupe and, based on my calculations of their course and speed, that the Chinese had arrived off the islands in November 1421. Given the maximum height of Les Saintes (about a thousand feet) and the height of eye of a seaman on the deck of a Chinese junk, I estimated that they would have seen the island from twenty-five miles away, while still in the Dominica Passage. From that position they should also have seen the plateau island of Marie-Galante ten miles north of them and the mountainous Dominica ten miles to the south, yet neither was recorded on the chart. I made the obvious deduction that they had passed through the passage in darkness with no moon. When I checked the records, I discovered that the new moon occurred on 25 November 1421, so I took it that they had probably approached Les Saintes from the south-east around dawn, possibly on 26 November 1421.

Les Saintes is composed of two large islands, Terre de Basse

and Terre de Haut, and three smaller ones, La Coche and Grand Ilet in the south, and Ilet a Cabrit in the north. The big islands are much higher than the smaller ones and, approached from the south-east, the lower Grand Ilet and La Coche would merge with the taller islands in the background and appear to form a single block of land. The south coast would appear as a single parabolic island, just as it is drawn on the Pizzigano chart. Knowing the height from which they had surveyed it – the deck level of a treasure ship – I could now make an estimate to within two miles of the location from where Saya was charted.

What else would the Chinese have seen from this position? Just what Columbus saw from the same spot seven decades later: 'Dawn reveals a most romantic landscape. A volcanic peak rises to an immense height, and cataracts pouring down its sides appear like water falling out of heaven ... Flights of brightly coloured noisy parrots and other brilliant tropical birds are winging their way from one island to another and the wind of the land is laden with sweet odours.'⁹ The 'volcanic peak' is La Souffrière on Guadeloupe, eighteen miles to the north-west. La Souffrière is well inland, its peak frequently shrouded by clouds and heavy rain, and seven rivers pour down its eastern side, the most spectacular among them the 120-metre Karukera Falls. The Chinese junks would have been at sea for at least three weeks, and I am sure the chance to take on water would not have been spurned. They would have altered course for the cataracts.

I turned to the words *con* and *ymana* marked on Satanazes on the Pizzigano chart. My first attempt to solve the riddle of these names was to recruit an expert at crosswords, who came up with *con* as a shell, conical mountain or volcano – interesting, but not much help. Then Professor João Camilo dos Santos, an expert in medieval Portuguese attached to the Portuguese Embassy in London, translated these words for me as 'a volcano' *(con)* 'erupts there' *(ymana)*. The description was highly significant. Transposing the location of these words on the Pizzigano chart

289

onto the corresponding modern map placed them directly above the volcanoes of La Souffrière, La Citerne and L'Echelle. Had these volcanoes erupted in 1421? The Smithsonian Institution confirmed there were two eruptions of the three volcanoes between 1400 and 1440; the dates, calculated by radio carbondating, cannot be determined more precisely.¹⁰ There were no further eruptions from these volcanoes for another 250 years, and no eruptions of other volcanoes in the Caribbean during the whole of the fifteenth century.¹¹ Since the Pizzigano chart can only have recorded an eruption of the volcanoes on southern Guadeloupe, I had first-hand evidence that a cartographer had been in the Caribbean no later than 1424, sixty-eight years before Columbus.

There are some anomalies in the map, but they are easily explicable when one retraces the route the ships must have taken. As the Chinese junks headed for the waterfalls on Guadeloupe, they would have had to sail closer and closer to Les Saintes, for all the time the current was pushing them westwards. As they passed the north-east tip of Les Saintes, the cartographer drew Baie du Marigot from half a mile away with the morning sun behind him. Because this bay was so close and so well lit, its size was somewhat exaggerated on the Pizzigano chart. As the junks neared land, the cartographer drew two further bays on the north coast of Saya. The third, Passe du Pain du Sucre, was drawn from a distance of seven miles, much further away than the first drawing, and it was now nearly noon (assuming their speed through the water was 4.8 knots) so the sun was in the cartographer's eyes. The combination of the position of the sun and the greater distance resulted in the third bay being drawn smaller than it should have been. To check that my conclusions were accurate, I showed the chart and my navigational workings to a fellow of the Royal Geographical Society, like myself a professional navigator. He was also convinced that Saya is Les Saintes; it is drawn precisely as it would have been

SATAN'S ISLAND

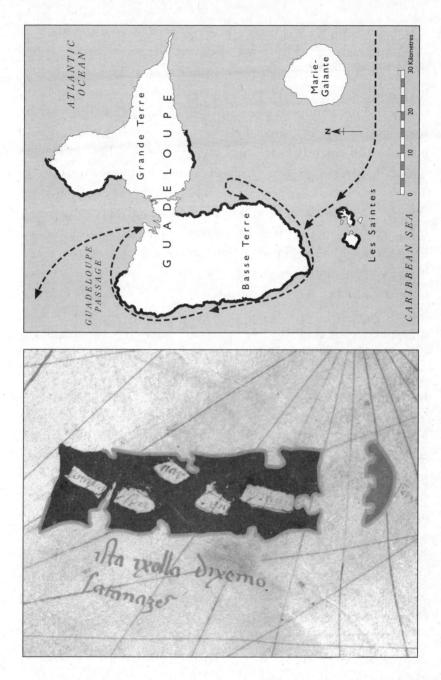

Guadeloupe shown on the Pizzigano map, compared with a modern map.

seen from sea level when approaching from the south-east.

Having calculated the time of day at which the cartographer drew Les Saintes, I was able to estimate with some certainty that by noon the junks had landed in the Baie de Grande Anse on southern Guadeloupe. I could imagine them replenishing their fresh water supplies against a backdrop of white, purple and blue hibiscus and orchids ('the wind of the land is laden with sweet odours'). Cassava, peppers and yuccas were there for the taking. The sea is a kaleidoscope of fish, crabs bask on exposed coral and crayfish are abundant. I could visualize the mariners gambolling in the surf before they feasted, washed their clothes and stocked their ships with fruit. How delightful it must have been to swim in the warm water after being at sea for nearly a month. It used to be my practice when in command of HMS Rorqual to anchor off an inhabited bay and send the sailors ashore in the inflatable dinghies we carried. It always proved a popular excursion - a swim in the sea, followed by rum toddies and roast lobster.

In the eastern Caribbean, an offshore breeze usually springs up as the land cools in the early evening. The Chinese had landed on an exposed Atlantic shore and would have had to find a sheltered anchorage for the night. Two hours' sailing up the east coast would have brought them to a secluded anchorage between two coral islands in the southern part of Baie de Sainte Marie. My assumption was that the Chinese had landed, watered and anchored at precisely the same spot Columbus found seventy years later, and the French and English fleets centuries after that. At first sight that may seem an incredible proposition: why should ships of so many different nations over several centuries all end up at the same spot on a remote Caribbean island thousands of miles from home? They did so because they were all subject to the same natural forces.

The clockwise movement of current and winds drew Zhou Wen's fleet from the Cape Verde Islands to a latitude of 18°N, where the equatorial currents converged to sweep them towards the Dominica Passage. As they entered the Caribbean, they were greeted by the magnificent volcano of La Souffrière in Guadeloupe with its cataracts of 'water falling out of heaven'. After watering on the Atlantic shore they needed to find shelter for the night; their anchorage was the nearest sheltered bay to the waterfalls. What they did not know was that this seeming paradise was 'Satan's Island' - Satanazes - populated by cannibalistic Carib tribesmen. Guadeloupe was the Caribs' principal lair in the Caribbean, and they were skilful hunters of men, even when swimming. I spent a day in the British Library poring over Columbus's journal of his second voyage, which includes a description of a Carib attack on his fleet: 'These Caribs can fight about as well in water as in their canoe ... the Spaniard dies in consequence.' After a Spanish sailor was killed, Columbus retaliated, and one of the Caribs had his belly slit open. His intestines were floating on the sea but, according to the Spanish accounts, the wounded Carib pushed them back inside his stomach with one hand while still firing arrows with the other.12

On that gruesome note, I decided to end my researches for the day, but as I was making my way home that evening, it occurred to me that if the Chinese had landed on the island, they must have been attacked by the Caribs, just as Columbus was. Might there be some record or legacy of that landing? When I went back to the British Library to look again at the account of Columbus's second voyage, I made another extraordinary discovery as I read the following passage:

In one house they find what seems to be an iron pot... but here is a curiosity amongst savages – the stern post of a vessel. This must have drifted across the ocean from some civilized country. Perhaps, it is a part of the wreck of the *Santa María*. Now all stand aghast at the sight of a pile of human bones – probably the remains of many an unnatural repast.¹³

Iron is not found on the Caribbean islands, nor indeed in Central America. The islanders used hollowed-out tree trunks for their boats, and they did not build them with stern posts, a sophisticated design. Stern posts had been in use in China since the first century AD; they did not reach Europe until the fourteenth century. Columbus's *Santa María* was wrecked off the north coast of Haiti, far away to the north-west of Guadeloupe, and the Gulf Stream would have carried flotsam from that wreck in precisely the opposite direction, north-west towards New England. I strongly suspected that the stern post came from a junk and the iron pot was one brought by the Chinese.

The Chinese would have put to sea to escape the Caribs, just as Columbus's fleet did. When safe in open water, three miles offshore, they would have rounded the southern tip of Guadeloupe and sailed before the wind up the west coast where they charted the headland of Vieux Habitants, the Bay of Anse de la Barque and the Bay of Deshaies. By the next evening they would have been sailing into the bay now known as Le Grand cul de sac Marin, and from there the cartographer drew what he could see of Grande Terre, the eastern island of Guadeloupe. It is a low-lying island, rising from fifty metres near the shore to no more than a hundred metres further inland. By this stage it would have been after dusk and Grande Terre would have appeared as no more than a hazy blur. The cartographer probably saw little of it, and never properly charted it. The Chinese then set sail once more before the wind and current, heading north-westwards across the Caribbean, probably making for 39°53'N, the latitude of modern Atlantic City, New Jersey, but also of Beijing, and another obvious reference point for the Chinese fleets to have chosen.

The cartographer had charted Les Saintes as he saw it from sea level, and placed it in the correct position relative to the western island of Guadeloupe, Basse Terre. He had accurately charted the east, south and west coasts of Basse Terre and Le Grand cul de sac Marin, placing the bays and rivers in their correct position, and had described the volcano La Souffrière and its sisters erupting. The chances of finding another island with erupting volcanoes, coupled with the same-shaped islands in the south and the bay in the north, are nil; there cannot be the slightest doubt that Satanazes is Guadeloupe (Basse Terre) and Saya is Les Saintes. Knowing Basse Terre's true size, I could adjust Satanazes' size to true, and as the Pizzigano chart gave Antilia's size and orientation in relation to Satanazes, I could also calculate the true size and orientation of Antilia. The Pizzigano chart also showed the relative positions of and distance between Satanazes and Antilia. To find Antilia, all I had to do was look for an island 135 kilometres long by 50 kilometres wide, aligned east-west, and lying some six hundred kilometres west-northwest of Guadeloupe, once again in the track of the prevailing current and wind

I turned to a modern map to see if I could find a match for Antilia. The map revealed that Puerto Rico was in the correct position, had the true alignment and size, and lay directly on the route along which the wind and current would have swept the junks after they left Basse Terre. I compared the shape of Antilia on the Pizzigano chart with Puerto Rico. It was a very good match. I remember this still as a tremendous breakthrough. Overwhelmed by the importance of what I had discovered, I wandered off into the night in search of a celebratory drink.

I returned to the British Library early the next morning worried that tiredness and elation might have caused me to misread the evidence, but a comparison of a large-scale modernday map of Puerto Rico with Antilia on the Pizzigano chart at once removed any residual uncertainties. There are striking similarities, particularly the overall shape and the bays of Guayanilla, San Juan and Mayaguez. Save for the south-east tip, Antilia and its harbours fitted Puerto Rico like a glove. The standard of the cartography was astounding, way

295

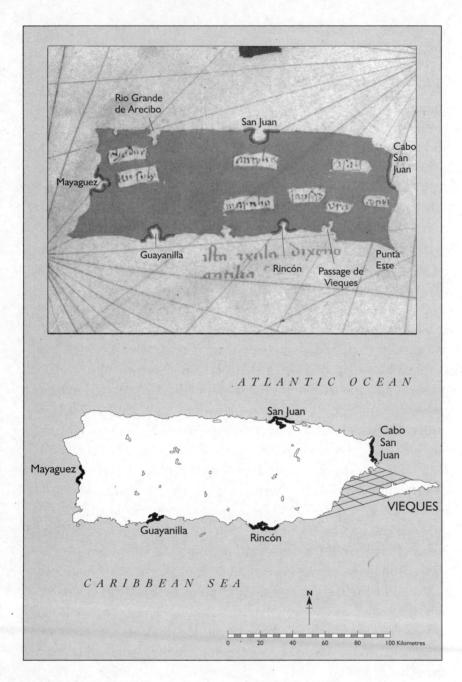

Puerto Rico shown on the Pizzigano map, compared with a modern map.

beyond what the Portuguese could have achieved in 1424.

But the exaggerated south-east tip is easily explained. After leaving Guadeloupe, the winds and currents would have driven the Chinese to the north-west - the same track Columbus later followed - to a point sixty miles east of Puerto Rico. There. they would have sighted the menacing, anvil-shaped volcano El Yunque near the east coast and turned towards it for water. As they had done many times when surveying other islands during their voyages, the Chinese squadron would have been split in two, one sailing north and one south of Puerto Rico to chart both coasts simultaneously. Had they sighted the volcano in the evening, and if they were travelling at their average rate of 4.8 knots, they would have passed south of Vieques Island during the night. In the darkness they could not have seen that Vieques is a separate island, and accordingly drew it as part of the mainland of Antilia.14 The Pizzigano chart is also inscribed with the word ura - hurricane - near the east coast of Puerto Rico, a clear indication that Zhou Wen's fleet had been battered by a hurricane as it sailed away from the island. It would have been prudent of him to run before the storm on as few sails as possible so as to find anchor in a sheltered bay. This is consistent with the astonishingly precise cartography of the harbours on Puerto Rico's south, west and north coasts, drawn before Columbus had even been born.

The storm-damaged Chinese fleet had completed its survey of Puerto Rico, and I could imagine the junks unfurling their great sails at the tail end of the hurricane and setting sail for the north from Puerto Rico towards the latitude of Beijing. If that theory was correct, there should have been evidence of their voyage at that latitude. I was confident that the Chinese had sailed to the North Atlantic, for the stone erected by Zheng He at Liu-Chia-Chang in south China after this epic sixth voyage states 'the countries beyond the horizon and at the ends of the earth have all become subjects and the most western of the western or the

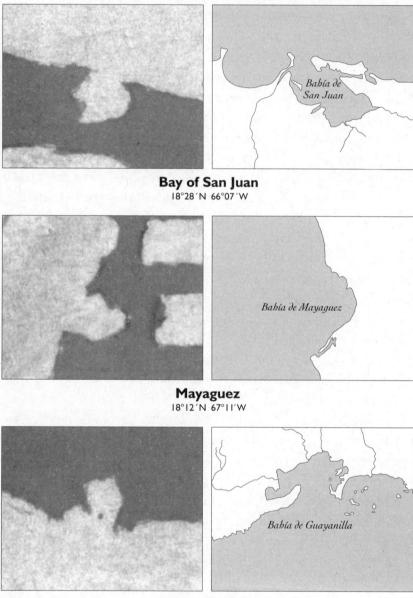

Guayanilla 18°00'N 66°46'W

The bays and inlets of Puerto Rico, depicted with extraordinary precision on the Pizzigano map.

most northern of the northern countries, however far away they may be'.¹⁵ From a Chinese perspective, the most northern of the northern countries and the most western of the western could only be referring to the Atlantic coasts of North America, but as ever, my problem was that the mandarins had destroyed all records of the treasure fleets. Once again, I had to look for clues in maps and charts of the northern hemisphere drawn before the first Europeans reached the Americas. I had to find a counterpart to the Pizzigano chart.

A world map popularly known as the Cantino came to my rescue. I had unearthed this extraordinary chart in the Biblioteca Estense in Modena, Italy, during my investigation into Zhou Man's visit to the Americas. It was drawn by an anonymous Portuguese cartographer and surreptitiously obtained by Alberto Cantino, the agent of the Duke Ercole d'Este of Ferrara. The Cantino's provenance and credibility have never been questioned, and there is firm evidence for dating its acquisition to October 1502. The Chinese fleet had to sail before the wind and current; after leaving Puerto Rico, it would have been blown north-west towards Hispaniola and Cuba, and then through the Caribbean to the coast of Florida. The Cantino indeed reflects this, for it shows Hispaniola, Cuba and many other islands in the Caribbean and off Florida, but though it portrays the coast of Africa and the Indian Ocean and its archipelagos of islands with extraordinary accuracy, at first glance its depiction of the Caribbean appears woefully inadequate. Many of the islands seem to bear little relation to their present sizes and shapes, and I was baffled as to why it was so much in error.

I struggled to make sense of this for some considerable time; then, all at once, the answer came to me. Sea levels in 1421 were lower than they are today. Global warming has caused the south polar ice to melt, causing sea levels to rise slowly but inexorably. The best estimate of the Proudman Oceanic Laboratory of Birkenhead in England is that they have risen over the past

centuries by about one to two millimetres a year. Other reputable oceanographers put the rise a little higher, at an average of four millimetres a year. In the almost six centuries since 1421 it is safe to say that sea levels have risen between just under four and just under eight feet. For simplicity, I assumed that the overall rise had been one fathom, or six feet, roughly the midpoint of the range of estimates.

The British Admiralty charts of the Caribbean¹⁶ enabled me to visualize a completely new picture of the region. In 1421, vast areas that today are submerged would have been either above water or with rocks and reefs showing as breaking water and shoals. The banks and reefs of the Great Bahama Bank, stretching south of Andros Island towards Cuba, would in 1421 have been above water down to the latitude of the Tropic of Cancer, and the numerous sand ridges today marked as 'almost uncovered' on the modern chart¹⁷ would also have been above water. To the Chinese cartographers, everything from Cayo Guajava in the middle of Cuba's north coast as far as the latitude of Miami would have appeared as one large low-lying island, an extension of Cuba.

The prevailing wind and current would have driven the fleet along the north-east coast of Cuba, then due north to the east of Andros, up towards Grand Bahama. (Andros Island is a favourite submarine haunt, for there is a deep-water trench well to the east of the coast along which thousands of tons of nuclear submarine can hurtle at forty miles an hour in order to test its silence at depth and speed. Afterwards we would surface and relax under the palms on Andros beach, drinking Bacardi and Coke.) If the Chinese fleet had made the passage at night, they would never have seen any openings to the west and could only have drawn what appears on the Cantino. When I adjusted the modern chart to show everything to a depth of one fathom, many of the shallow lagoons between the Caribbean islands became dry land, and when I superimposed these adjustments onto the Cantino it was clear the Caribbean had been drawn with incredible accuracy, just as it would have appeared to mariners sailing through it on a following wind six centuries ago. Once again, it was extraordinarily good cartography.

The question I now had to face head on was whether this mapping could have been carried out by Columbus, who had reached the Caribbean in 1492, ten years before the Cantino was acquired. A number of learned professors have slightly different interpretations on the location of his first landfall in the Caribbean, varying between Samana Cay and Cat Island, and on where he first landed on the coast of Cuba. Columbus was a poor cartographer. On his first voyage his calculations of latitude were twenty degrees out - he believed he was somewhere in Nova Scotia - and his longitude was a thousand miles in error. Even if Columbus had a secret, and rather better, cartographer aboard who could have accurately drawn the Caribbean islands shown on the Cantino during all four of Columbus's voyages, that still left hundreds of thousands of square miles of ocean and islands shown on the Cantino that neither Columbus nor any other European explorer reached until twenty years after the chart was drawn. I concluded that the chart could not have been the product of any voyage by Columbus.

Could it have been drawn by an unknown Portuguese or Spanish expedition? One has to look at the overall picture of the lands covered by the Piri Reis and the Cantino together. By 1501, when the source chart was obtained from Columbus's sailor, the maker of the Piri Reis map could accurately depict South America and Antarctica. By the next year, 1502, the Cantino was showing Africa, the Indian Ocean and the Caribbean. To achieve the remarkable precision and wealth of detail of the Cantino and Piri Reis charts would have required at least thirty ships just to survey the Indian Ocean, let alone South America, Antarctica and Africa. Neither Portugal nor Spain could have sent so many huge fleets simultaneously to different quarters of the world.

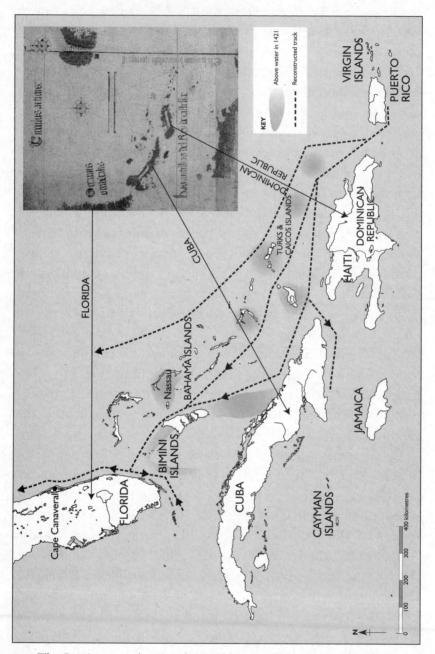

The Cantino map showing the Caribbean and Florida, compared with a modern map.

Only China had the ships, the resources and the expertise to have done so. Cartographers aboard the Chinese treasure fleets had to be the originators of these remarkable charts.

By looking at the Caribbean islands charted on the Cantino, I could reconstruct the passage of the cartographers who had drawn them. To chart the islands, they had to see both coasts, and sailing always before the wind and current, square-rigged sailing ships had no opportunity of turning back for a second pass. To survey both coasts of an island required at least two ships, one either side of it. The way the charts are drawn, coupled with the prevailing winds and currents, leads me to believe that at least five squadrons of ships would have been needed to chart the Caribbean. By my best estimate, at least ten to twenty ships would have had to sail through the Caribbean to collect this mass of information in one pass. Assuming they were within sight of one another, working for ten hours a day, and travelling at an average speed of 4.8 knots, they would have charted fifteen thousand square miles per day and could have obtained the information in four to six weeks.

Many of the islands are very low-lying, and to survey them with the accuracy shown the junks must have been within ten miles of each one, exposing themselves to horrific risks. To cross the Great Bahama Bank from Cuba to the east of Andros Island and inside the Berry Islands (all shown on the Cantino), the ships must have passed, frequently and at night, what the British Admiralty charts call 'numerous sand ridges almost uncovered', and 'numerous rocky heads'. In one small stretch of forty nautical miles,¹⁸ there are literally hundreds of rocks and reefs capable of ripping wooden hulls apart. That short distance must have been achieved at a terrible cost. I cannot conceive how they could have made that passage without losing ships. By the time the junks had crossed the Great Bahama Bank and reached the Berry Islands they would surely have been in desperate trouble, the internal compartments of many ships flooded. The calm, moonlit seas might well have been echoing with the cries of dying seamen.

It was a sombre thought, but it also highlighted the fact that I was closing on my quarry. The charts told me exactly where to look. I had to search for traces of the wrecks of treasure ships within a few miles of the Berry Islands in the Florida Strait.

THE,

TREASURE

FLEET

RUNS

AGROUND

S YOU PASS FROM SHALLOW WATER INTO THE DEEPER waters of the open ocean, the pattern and length of the waves change and they have a different colour and smell. It is a phenomenon familiar to all blue-water sailors, and as his fleet passed the Berry Islands, Admiral Zhou Wen would have known at once that his fleet had entered deep water – the Northwest Providence Channel leading into the Florida Strait. I made the assumption that several of his junks had been damaged in crossing the reefs, and he would have had to find somewhere to beach his fleet before it sank in deep water. The search for a suitable island would have been a matter of desperate urgency, for many of the junks must have been in a critical condition, unable to survive in the open ocean.

My detailed research of the area surrounding the Berry Islands now began in earnest. Large-scale British Admiralty charts¹ and Coffman's treasure atlas² show wrecks strewn along the Chinese track. These wrecks have been classified by Coffman as Spanish galleons, later ships and earlier, unidentified ones. I focused my attention on the latter class of wrecks, and compared them with the Admiralty chart. It was a dramatic moment, for eight unidentified wrecks were disclosed within six hours' or forty miles' sailing from the point where the Chinese would have entered the Florida Strait. Four wrecks³ are shown on the Little Bahama reef and the Florida coast; another four⁴ are due south. When I examined a large-scale chart, it revealed that the track of these four southern wrecks was pointing towards a group of small islands, North and South Bimini, Gun and Ocean Cay, fifteen miles away. The position of the wrecks was consistent with four junks making a desperate but doomed bid to reach the islands; the last wreck is within a mile of North Bimini. All are in shallow water; if the sharks did not get them first, the crew could have swum ashore. I felt sure that there should be evidence of other wrecks - ships that had managed to struggle to land - on Bimini itself.

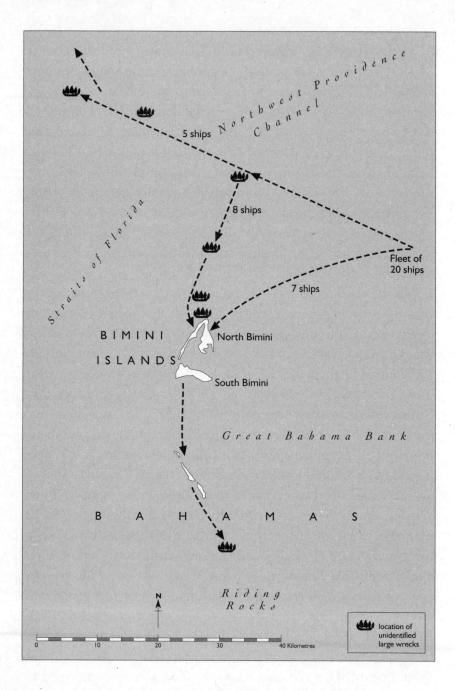

Locations of unidentified wrecks on the route to Bimini.

THE TREASURE FLEET RUNS AGROUND

Before I flew there to begin a detailed search of the island, it seemed sensible to see if the first European to reach Bimini had found anything, such as wrecks or porcelain, left behind by the Chinese. The first European on Bimini was Juan Ponce de León (c. 1460–1521), a Spanish conquistador and governor of Puerto Rico from 1510 to 1511. On 23 February 1512, he was given a commission by the King of Spain:

The King

To the officials of the island of Española upon the agreement which they have made with Juan Ponce de León upon that and the said island of Biminy which he has to go to discover.⁵

The king's eagerness to locate the mystical island of Bimini was based on the legend that its waters conferred perpetual youth on those who drank them: 'There is an island about three hundred and twenty-five leagues from Española in which there is a continual spring of running water of such marvellous virtue that, the water thereof being drunk, perhaps with some diet, maketh old men young again . . . bathing in it, or in the fountain, old men were turned into youths."6 This legend was widespread before Columbus set sail. The waters have subsequently been identified as a foul-smelling sulphurous spring on the east side of North Bimini island. It can be reached via a shallow creek infested with caymans - members of the alligator family. Few kings could have resisted the allure of immortality, however remote the possibility, and such a discovery would have been of incalculable commercial value. There was not a rich man living who would not have exchanged the greater part of his wealth for the promise of eternal youth, as is the case to this day.

The bays to the north and south of Bimini are clearly marked on the Cantino chart, drawn twelve years before Ponce de León set sail. Someone must have been there before him, not only to draw the island that appears on the Cantino but to convey

309

descriptions of its magical spring. Bimini is only a few feet high and can be circumnavigated in a day. It was uninhabited for centuries save for wreckers, who based themselves there for salvage during the hurricane seasons. In the twentieth century, Ernest Hemingway took a liking to the island and drank the night away in local bars while writing *The Old Man and the Sea*. Today, thousands of trippers come by seaplane and yacht from Florida to see Hemingway's haunts, oblivious of the history that surrounds them.

In September 1968, Dr J. Manson Valentine, a zoologist and underwater archaeologist, was swimming off North Bimini. He was in ten feet of water about a thousand yards from the shore when he spotted hundreds of flat rocks, eight to ten feet square, arranged in regular patterns. His discovery, named the 'Bimini Road', comprises two parallel lines of stones on the sand dunes of Bimini Bay running south-west towards the deep ocean. The western section starts at an angle of 160° to the beach and curves round to run directly to the shore. The curved part, some 330 feet long, is composed of large, well-laid stones. The straight, shoreward section is 1,200 feet long by 200 feet wide and has a trench in the middle where there are no slabs. (The website has further details.)

In 1974, an American scientist, Dr David Zink, led an expedition (the first of nine) to survey these mysterious stones. He produced overwhelming evidence that the road was man-made. Small stones are placed underneath large ones, apparently to make the sea-bed level, and the larger of the two structures contains arrow-shaped 'pointers' that can only have been manmade. Parts of the road contain stones cut to the same size and laid in rows, and some small square stones have tongued and grooved joints. They have been submerged over a long span of time, for the edges of some have become rounded by wave action, giving them something of the appearance of huge loaves of bread. Some of them were not of Caribbean origin. The road is clearly visible from the air through the azure water. It runs straight as a die down into the depths, a broad band of beige stone. After Dr Zink's expeditions, Jacques Cousteau surveyed the 'road' in detail for a television programme,⁷ and *National Geographic* has published several features. The 'road' has been surveyed by a number of different experts, and there is almost universal agreement that the structure is man-made.

Dr Zink later reached the bizarre conclusion that the stones of the Bimini road were part of the fallen pillars of a sacred temple built about 28,000 BC by a long-lost civilization, the Atlanteans, who employed aliens from the star cluster Pleiades to build a megalithic temple complex similar to Stonehenge.⁸ Although I disagree with the strange conclusions Dr Zink reached, they do not detract from the value of his basic observations, measurements and surveys, which were meticulous.

As Admiral Zhou Wen's fleet made for Bimini, many of his ships must have been holed below the waterline, with one or more flooded compartments. The captains of the crippled junks desperately needed to beach them before they sank so that they could carry out repairs to the hulls and pump out the sea-water before it reached the rice that was their principal food supply. The standard practice with crippled ships, established over centuries and used extensively during the Second World War, is for damaged ones to be lashed alongside seaworthy ones to keep them afloat and offer all possible assistance. It is likely that some flooded horse and grain ships were tied to capital ships limping towards the shore. One can imagine the relief of the seamen and concubines as they saw the sandy spit of land fringed by palm trees.

As soon as they saw North Bimini, the ships' captains would have made straight for it. Since the water levels in 1421 were approximately one fathom lower than today, and the junks drew an average of two fathoms (twelve feet), depending on the cargo or ballast they were carrying, I calculated that the junks would

have grounded where today there is eighteen feet of water – the depth of the seaward end of the Bimini Road. The inverted 'J' section at that end is in the exact position a junk rounding the Great Bahama Bank and then turning directly towards North Bimini would have beached.

This supposition enabled me to look at the Bimini Road with fresh eyes. As I studied it, I hit upon a possible solution to the mystery of the road's purpose. Could the road have been a slipway made of smooth stone to prevent further damage to the hulls of ships being beached and refloated? The curved section of the road could have acted as a turntable. When one of the treasure ships beached, its keel and rudder would have prevented it from being dragged sideways to the shore. The great ship's stern would have had to be swivelled to face the beach before it could be hauled ashore backwards. When I drew a treasure ship and a grain ship on the same scale as the road, and then rotated their sterns, the treasure ship ended up on the larger stretch of road and the grain ship on the smaller. Both roads had grooves for the ships' keels and rudders, enabling them to be dragged stern first to the beach.

Obtaining stones and rocks of the required size for the Bimini slipway would have been a simple exercise. The junks would have contained thousands of tons of stone ballast. Zhou Wen's fleet carried gunpowder that could be used to blow up rocks, and Chinese stone masons were aboard the ships. They had built thousands of miles of Great Wall between 1403 and 1421 using a wide variety of percussion hammers, drills, awls, saws and sledgehammers. Assuming, for reasons I shall explain later, that fifteen treasure ships had reached Bimini, about six thousand sailors and concubines would have been available as labourers. At first sight, laying the stones on the sea-bed appears problematic, but the Chinese also had more than six centuries' experience of building coffer-dams, watertight enclosures pumped dry using 'Archimedes' screw-pumps to permit work

THE TREASURE FLEET RUNS AGROUND

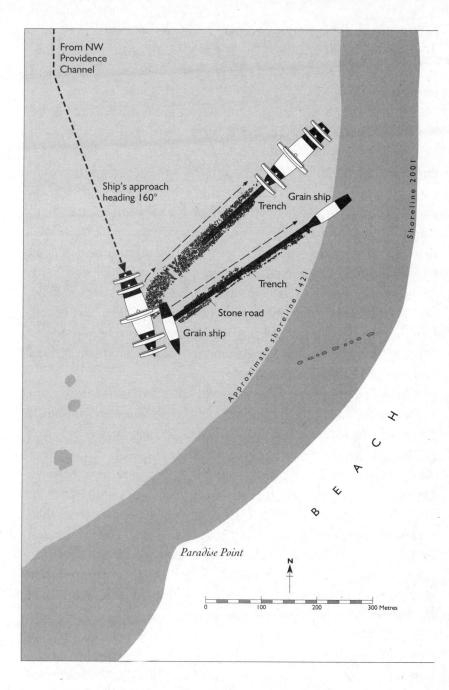

The junks' approach to Bimini and the Bimini Road.

below the waterline. By the early Ming period they even had diving equipment with breathing tubes and face masks.⁹ Laying stonework under water was a problem they were well equipped to overcome.

When the slipway had been completed, each huge ship would have had to be hauled ashore in turn, keeping the rudder and keel in the groove. Again, this appears to be a tremendous engineering challenge, but although the treasure ships displaced thousands of tons, Chinese engineers had developed a wide variety of capstans using wire or hemp ropes in order to haul ships. The capstans had geared ratchet-wheels and differential drives, and were designed to be powered by men or horses. The Chinese would have expected their square-rigged junks with shallow draughts and flat bottoms to run aground occasionally, and it is probable that the crew's training included practising hauling flooded ships ashore for repairs. It was reasonable to suppose that the necessary equipment would have been aboard each ship to enable them to do so.

There remained several unsolved puzzles that did not yet fit my scenario. Many of the big rectangular stones were not made from rock found at Bimini. The bedrock there was softer, and laid in a far more disordered pattern than the 'imported' slabs.¹⁰ The 'cement' which appeared to bond the sections also differed. Dr Zink found one sample to be dominated by aragonite crystals, another by spalling calcite, implying that adjacent stones had different physical properties and hence had been formed in different locations. But why would it be necessary to transport huge stones and those square 'building blocks' to Bimini when there was plenty of usable rock there – unless they were part of the ballast carried by the Chinese junks?

Dr Zink sent a sample to the Brookhaven National Laboratory on Long Island. As it had never been fired in a kiln, they were unable to carbon-date the blocks but the head chemist, Dr Edward V. Sayre, confirmed that some of the smaller square blocks were made with a sandstone-limestone mixture and suggested that they 'might have been created by an ancient technique of mass production'. Moreover, each 'building block' was tongued and grooved to slot into its neighbour, and although they had square sides, they tapered in thickness. There appeared to be no need for the tongue and groove on the sea-bed, for the stones were not joined together with them. The solution could be that the building blocks were tongued and grooved so that they could be joined together around ballast in the bottom of a junk, preventing the large stones from moving in a heavy sea and damaging the hull.

A junk's beam was very wide in comparison to its length, and because it was flat-bottomed, substantial ballast was required. The displacement of the capital ships was around 3,400 tons; according to standard nautical engineering I would expect each of them to have carried between five and six hundred tons of ballast – around thirty tons in each of the eighteen watertight compartments. The slipway is composed of a mixture of local rock, building blocks and large 'imported' stones. Some 450 of the latter are still in place on the slipway, but in recent years dredgers have removed part of it to build a seawall in Miami. I calculated that originally there were about six hundred stones on the slipway, each weighing about ten tons, the equivalent of the ballast carried by a dozen junks.

I could now reconstruct a plausible scenario for what had happened. A junk hit the shore, its hull fractured, and some stones or building blocks spilled out onto the sea-bed – the first part of the 'road'. To increase buoyancy, other large stones might have been lowered through the ruptured hulls using long stones as 'straps' beneath them, held by ropes at either end. The 'support' stones on the sea-bed might have been the straps left when the stone reached the sea-bed.

Although the 'imported' large stones¹¹ are commonplace (save in the Caribbean) throughout the world, they are found in the

Yangtze area and could have been mined and cut to size in the Ming quarries in the eastern suburbs of Nanjing, where the treasure ships were built. The building blocks on the sea-bed are one *chi* (thirty-two centimetres) square, and the sandstonelimestone mixture used to make them was widely available in the Yangtze area.

Once the junks had been hauled onto the beach, the sea-water could be pumped out and the urgent task of drying the rice stores could begin. The Chinese crewmen would have been able to supplement their basic diet with the abundant conches, turtles and gamefish around Bimini. Water could be obtained from the celebrated spring, the bubbling pool of sulphurous water later described to Ponce de León as a fountain of life. But however skilful the Chinese carpenters, some junks would have been damaged beyond repair. They would have been cannibalized, their holds emptied of stores, their hull planking used for the repair of potentially seaworthy junks and for firewood. The remainder of the hulls would have been left as giant wooden skeletons on the beach beyond the slipway. If this had happened, some evidence might remain.

In 1989, Raymond E. Leigh, a land surveyor attached to Dr Zink's expedition, flew across North Bimini and took measurements with infra-red equipment of the north-eastern end of the island, opposite the place where the slipway comes ashore. He discovered four rectangular sand mounds, the largest 500 feet long and 300 feet wide. Their size and shape suggest that they may be the sand-covered hulls of treasure ships, and they are just where I would expect to find the skeletons of junks swept ashore by a hurricane. Another mound was found by Dr Zink on the beach near the slipway. As Chinese warships, the remains of the junks may technically still be the property of the Chinese government. Negotiations are in hand between the Bahamian authorities and myself to resolve the issue of ownership of any artefacts that may be found. When these protracted negotiations are complete, archaeologists may be allowed to excavate the mounds. Their contents may yield detailed knowledge of Zhou Wen's fleet, and perhaps some of the treasure it carried. It could be a priceless discovery in every sense: each junk could carry two thousand tons of cargo, and a single early Ming plate was recently auctioned for £89,500.¹²

I concluded that four junks had sunk just short of North Bimini, another five had been abandoned on East Bimini and the remainder had been repaired and refloated. The lost ships would have carried several thousand sailors and concubines, and Bimini could probably not have supported more than a hundred. A large number would have been taken aboard the surviving junks, but it is inconceivable that room could have been found to carry all of them back to China. Some must have been left on Bimini, others put ashore wherever conditions seemed to offer better hope of survival. As Admiral Zhou Wen's shrunken fleet continued its voyage, its upper decks crowded with crew and passengers from the abandoned junks, many others must have been left to their fate, as happened to sailors from Columbus's ships seventy years later: one of his ships and crew were left behind on Hispaniola. Once the available food on Bimini was exhausted, the abandoned Chinese would have had to attempt the crossing to Cuba, the nearest large island, some 180 miles to the south, or to Florida. Had they managed to do so, some of their descendants should have been alive when Columbus arrived.

In the summer of 1494, on Columbus' second voyage, he anchored his ships off Cuba near a beautiful palm grove to get fresh water and wood.

As the landing party cut wood and filled their water casks, an archer strayed into the forest in search of game, only to return a few minutes later to relate a baffling and frightening experience ... He had come across a band of about thirty well-armed Indians

... three white men were in the company of the natives.

The white men, who wore white tunics which reached to their knees, immediately spotted the intruder . . . one of them stepped towards the hunter and started to speak.¹³

The hunter then fled. Upon hearing his story, Columbus despatched another party who failed to find the men. White men with 'white tunics which reached to their knees' is the description local people in Mexico (Jucutácato) and Australia (Arnhem Land) gave to the strangers landing on their shores. Not without reason did Columbus conclude that the men were people of Mangon (China) and that he had reached the shores of Asia.¹⁴

In isolation, the description of the men in white tunics who greeted Columbus's men could be taken with a pinch of salt, but explorer after explorer in continent after continent reported the same story, all along the Chinese track I had reconstructed from the charts published before the first Europeans reached those continents. In South America, the Spanish envoy, Don Luis Arias, recounted tales in the sixteenth century of light-coloured people who wore white woven garments and crossed the Pacific after leaving what is now Chile. Father Monclaro, a Jesuit priest who accompanied a Portuguese expedition to East Africa in 1569, described the inhabitants of Pate whose claim to be descendants of shipwrecked Chinese sailors was reinforced by their story of the giraffe, the 'quilin' presented to Emperor Zhu Di. Indian sailors reported a Chinese expedition to Antarctica following the Southern Cross constellation. In southern Australia, the Yangery tribe, living beside the wreck of a 'mahogany' ship, claimed that 'yellow men' had settled among them; and in northern Australia the Aborigines said that a honey-coloured people, the men wearing long robes and the women pantaloons, had settled in north-east Arnhem Land. The Maoris made a similar claim, and the French explorer Bougainville reported meeting Chinese people in the Pacific in 1769. It is scarcely credible that all these accounts are imaginary or fabricated.

The Bimini Road has, of course, excited great controversy and interest. All sorts of exotic ideas and theories have been put forward; mine is but the latest. I fully accept that it requires some leaps of the imagination that are not, as yet, backed up by hard evidence. Only when the Bahamian authorities grant permission for the archaeological excavation of the sand mounds on the beach will we be able to determine whether or not my theory is correct. For the time being, frustrating though it was, I had to leave the mounds undisturbed and depart from Bimini, following in the wake of Admiral Zhou Wen as he assembled the remnants of his fleet and sailed northwards.

SETTLEMENT

IN

NORTH

AMERICA

In SOLVING THE IMMEDIATE PROBLEM OF HIS DAMAGED AND destroyed ships, Admiral Zhou Wen had fallen foul of another. Some of his ships were again seaworthy and some of the rice had been salvaged, but he now had to make provision for the crews and concubines from the wrecks that had been left on the beach at Bimini. There would have been several thousand additional sailors and several hundred concubines to be accommodated and fed from a much-reduced food supply. The rulers of many Arabian, African and Indian states had been served by the concubines. Many must have been pregnant when the fleet left India, and some would already have given birth. The only way to cope with the chronic overcrowding in the surviving junks would have been to create settlements ashore where some of the crewmen, concubines and their children at least had a chance of survival. A later voyage would have to return for them.

If such Chinese settlements had been made in North America - and the results of recent tests on the Moskoke people of southeastern United States show that they do have Chinese DNA my problem, as ever, was to locate the physical evidence. Along the Florida coast marked on the Cantino map, the cartographer drew the Florida Keys, Port Sewall, Cape Canaveral and the Savannah estuary. I know Cape Canaveral well. I was operations officer on HMS Resolution when we fired Britain's first Polaris missile there in February 1968. It splashed down 2,800 miles away off South America, just fifteen feet shy of the target buoy the splash as the warhead hit the water temporarily blinded the reading apparatus. As we surfaced back in Florida, we found sea snakes nestling in the conning tower, attracted by the submarine's warmth. The cape itself is a bleak place, renowned for its manatees, the strange sea mammals that gave birth to the legend of the mermaids. Both Cape Canaveral and St Augustine are littered with wrecks, some of them ancient and unidentified, but the fierce current has carried away the timbers to such an extent that identification is very difficult. Nonetheless, the attempt is in hand.

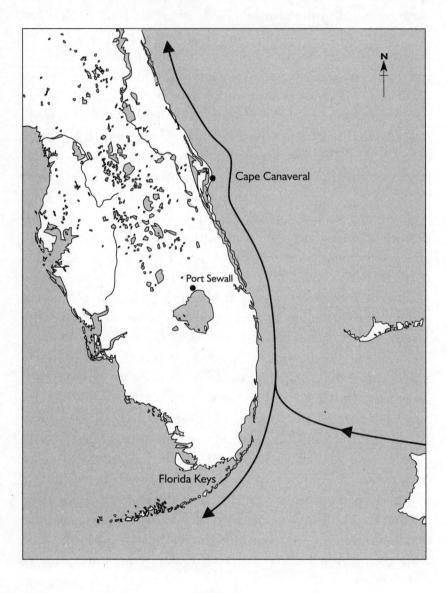

Zhou Wen's journey up the east coast of Florida.

The Cantino ends abruptly at the estuary of the Savannah River, at Point Tybee. This suggested that, having reached this point, the junks had then been carried away from land towards the north-east, exactly the direction in which the prevailing winds and the Gulf Stream run there. These would have carried the junks up to Cape Hatteras in North Carolina. Off Cape Hatteras, the Gulf Stream divides in two, one branch flowing north-east towards the Azores. Those islands appear on the Kangnido, drawn before the first Portuguese reached the islands, and I was certain that the Chinese had reached them. The other, westerly branch of the current off Cape Hatteras flows at first due north, then slowly rotates to the north-east past Philadelphia. At latitude 40°N, the current flows inshore towards Long Island, Rhode Island and Cape Cod.

Once again, this part of the coast is littered with unidentified wrecks, many of them ancient, and a sensible point to begin a detailed search for traces of the Chinese was at the latitude of Beijing – 39°53'N. On the course the junks were taking, they would have reached this point off the coast of modern New Jersey. I have taken my submarine up that coast and can confirm that a huge volume of water flows north-east and the wind and current push ships directly towards Cape Cod. I began the search around Narragansett Bay and Buzzards Bay, and on the Cape Cod peninsula, making sure first of all to consult the accounts of the first Europeans to reach this part of the coast.

The renowned Venetian explorer Giovanni de Verrazzano (c. 1480–c. 1527) arrived there in 1524, twenty-two years after the Cantino was produced. Francis I of France had retained him to explore the North American coast with the aim of finding a seaway to the Pacific and the Spice Islands – 'the happy shores of Cathay'.¹ Verrazzano's voyage was carried out at the same time as the Spanish sent Magellan around South America and the Portuguese despatched a series of expeditions around the Cape of Good Hope. All three countries were in a race to find the most

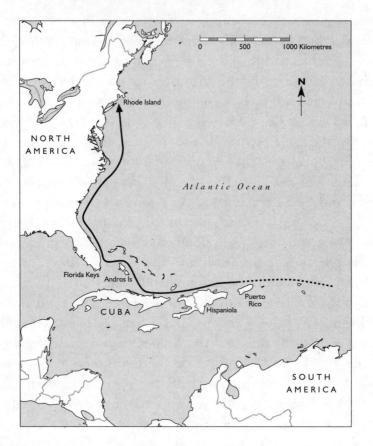

The journey to Rhode Island.

cost-effective and secure means of reaching the Spice Islands of Ternate and Tidore now that the overland route to the East, the Silk Road, had been severed.

In 1524, Verrazzano with his small squadron sailed northwards up the coast from Virginia to the eastern tip of Nova Scotia, describing the pleasant land and its savage people as he went. When at the parallel of Rome, '41 degrees and 2 terstices north', he entered a large bay, corresponding with Narragansett Bay off Rhode Island, where he spent fifteen days. The local people were:

SETTLEMENT IN NORTH AMERICA

the colour of brass, some of them incline more to whiteness: others are of yellow colour, of comely visage, with long and black hair, which they are very careful to trim and deck up; they are black and quick eyed, and of sweet and pleasant countenance . . .

The women are of the like conformity and beauty; very handsome and well favoured, of pleasant countenance and comely to behold; they are as well-mannered and continent as any woman, and of good education ... [women] use other kinds of dressing themselves like unto the women of Egypt and Syria; these are of the elder sort: and when they are married, they wear divers toys [jewellery] according to the usage of the people of the East, as well men as women.²

This is a very significant passage. Verrazzano was comparing elegant people with brass-coloured skin to the much darker and more uncouth people he had met further south. He referred twice to the women's connection with the East and their clothes – dresses rather than the furs and animal skins worn by the people he had encountered previously. Most important of all, Verrazzano was not describing local women married to foreigners, but women resembling those from the East who had somehow ended up in North America. Clearly they were from a different civilization and were not natives of North America, nor of Europe.

Verrazzano's description suggests that the younger girls were not following their grandmothers' traditions; the original customs they had brought were dying out, indicating that they had been there a few generations. The description would indeed have fitted Syrian or Egyptian women just as much as it would Chinese. All of these women would have worn long dresses and jewellery and had their black hair decked up, but Egyptian and Syrian seafarers never reached the Atlantic; in any case, their women were not taken on long voyages. The description would fit the descendants of the Chinese concubines pregnant by Middle Eastern rulers and ambassadors. It could have been they who greeted Verrazzano.

There is another clue in Verrazzano's account of leaving Narragansett Bay: 'In the midst of this entrance [to the harbour] there is a rock of stone produced by nature apt to build any castle or fortress there, for the keeping of the haven ... which we call La Petra Viva [the living rock].'3 Verrazzano's description fits the rock on which the Round Tower still stands, in a park in Newport, Rhode Island, on a promontory overlooking the harbour. The tower is a mystery; visitors muse over whether or not it was built by strange people who arrived before Columbus. To me it is a curiosity, quite unlike any other colonial building in America, placed in isolation, in a commanding position but not a fortress, and out of the wind, so unlikely to be a mill. Historians have furiously debated its origins. One school claims it was a sixteenth-century flour mill, another that it served as a lighthouse and was built around the end of the fourteenth century. Both theories could be correct; an earlier building could have been modified to serve as a flour repository, if not a mill. Historians in the flour-mill camp rely for their evidence on the first Rhode Island governor, Benedict Arnold, a prosperous merchant whose will referred to 'my stone builte tower'.

A detailed survey of the tower by the respected Danish Committee for Research on Norse Activities in North America AD 1000–1500 took place in the early 1990s. The publication in 1992 of the results of investigations and analyses seemed to confirm the flour-mill thesis. The report, prepared by Johannes Hertz of the National Museum in Copenhagen, concluded that Arnold was the builder in 1667, but an American architect, Suzanne O. Carlson, who has made a meticulous examination of the tower, recently challenged these findings.⁴ She argued that closer study of the report revealed the tower could not have been built by Arnold at that date, and she cited four specific pieces of scientific evidence in support of her argument.

SETTLEMENT IN NORTH AMERICA

The Rhode Island Tower.

Firstly, she contended that every seventeenth-century colonial structure in New England was built using English measurements – yards, feet and inches – yet not a single dimension of the Newport Round Tower conforms. Secondly, she claimed that the seventeenth-century trench surrounding the tower, which the flour-mill camp says supports their argument, could only have been built to stabilize an earlier building. Thirdly, she argued that the Danish committee's carbon-dating was based on a new and experimental technique that measured the carbon 14 in carbon dioxide bubbles in the mortar. The actual range of dates measured was between 1410 and 1970, and while the Danish committee attributed it to the late 1600s, the analysis could equally well apply to any date after 1409. Lastly, the tower was built using an unusual type of mortar made from crushed shells, rather than the standard lime mortar habitually used by colonial builders.

However, the details of the tower's construction do not reveal its purpose, which has been described as follows:

The first storey of the tower served as a lighthouse. The larger windows of the first storey were so placed in relation to the fireplace that the light from the fire at night seen through the south window would be a guide to a ship approaching the entrance to Narragansett Bay... fireplace light through the two-foot opening of the west window would guide a ship to the harbour landing at the bottom of Tower Hill ... The ingenious builder of the tower had obviously had considerable experience ... in designing lighthouses.⁵

The Norse were present in Greenland from the end of the tenth to the early fifteenth century. Greenland had no wood, so each summer they set sail to Vinland - North America - to gather wood, returning each autumn. At first sight the narrow windows and rounded arches of the Rhode Island tower appeared Romanesque, and my initial reaction was that it was a lighthouse built by the Norsemen. It could have been; they had penetrated nearly as far south as Newport. However, the Norse had little experience of lighthouse design and are not known to have built one overseas; and in my view the design and position of the windows closely resembled those on the Song dynasty (960-1279) lighthouse that guided Chinese and Arab trading fleets into the port of Zaiton (Quanzhou) in Fujian province in southern China. A number of the crewmen aboard the Chinese fleet would certainly have known Zaiton and its lighthouse, for at the time of the Chinese treasure fleets Zaiton was probably the largest commercial port in the world. Marco Polo described it as 'a great resort of ships and merchandise ... for one spice ship

that goes to Alexandria or elsewhere to pick up pepper for export to Christendom, Zaiton is visited by a hundred. For you must know that it is one of the two ports in the world with the biggest flow of merchandise.⁶

The Zaiton lighthouse is twice the size of the Newport Round Tower and is five storeys high rather than three, but the windows are notably similar, as is the design of the central fireplace. Like Zaiton, too, the tower at Newport was once covered in smooth plaster. There are several other striking resemblances. The Rhode Island tower is a grey shell of stones rising above arches that span eight columns set on an octagonal base, just as at Zaiton. The masonry consists of stones of various shapes held together by a powerful and long-lasting mortar; neither the stones at Newport nor those at Zaiton have moved since the wall was built. Furthermore, the dimensions of the tower show that it conforms to the standard Chinese units of measurement used in the fifteenth century: the external diameter is 2 *chang* 40 *chi* and the internal 1 *chang* 80 *chi* (1 *chang* = 10.167 feet; 1 *chi* = 32 centimetres).

Professor William Penhallow, Professor of Physics and Astronomy at the University of Rhode Island, offered an alternative explanation for the purpose of the Round Tower. He made a study of astronomical alignments and discovered that the seemingly random openings and asymmetrical, splayed windowjambs framed specific astronomical events, notably lunar eclipses and the rising and setting of the sun at its solstices and equinox.⁷ This accords precisely with the design of Ming observatories and observation platforms. The length of the sun's shadow at solstice and equinox at any particular latitude gives the precise time, and viewing a lunar eclipse gave the Chinese the opportunity to observe the leading star on the zenith and so determine the longitude of the Newport Round Tower when they returned to Beijing,⁸ just as they did with observation platforms around the world.

The tower could thus have served two vital purposes. It could have been used to determine the exact location of the settlement set up by the Chinese crewmen and concubines left behind, so that they could be found and rescued on a subsequent voyage of the treasure fleets. It could also have been a lighthouse to guide the rescuers safely into Narragansett Bay. Although now obscured by encroaching woods, the tower was sited in a prominent position and was once a distinctive landmark clearly visible from the sea. Like the Zaiton lighthouse, it was angled so that the light burning from its fire could warn of danger through one set of windows, but also act as a guide through another set to bring mariners to a safe anchorage.

An analysis of the mortar used in the Newport Round Tower would settle the matter once and for all, for Chinese mortar had a very distinctive property – it contained gypsum as a hardening and rice as a bonding agent. It can also be dated; from analysis of the mortar on the Great Wall, it has been possible to determine the different rice and gypsum contents used in the Tang and Ming eras, and therefore when each section of the wall was built. I have asked the authorities at Newport for permission to arrange an analysis, but this has been denied. The first duty of the authorities is of course to preserve the fabric of the monuments in their care, not to make them available for experiments, but I hope they can be persuaded to change their minds. It would then be possible not only to determine the nature of the mortar but also to date it, and early Ming is particularly easy to date.

There is a substantial body of evidence that the Chinese landed at Newport. They had reached Bimini and later the Azores, and a detailed cartographic survey of the coast of Florida had been carried out before the first European reached North America. The route from Bimini to New England and then the Azores is precisely the one a square-rigged sailing ship would have followed, before the wind and current all the way. And the first Europeans to reach New England described – there exist six

SETTLEMENT IN NORTH AMERICA

separate accounts – civilized white- or bronze-skinned women living around Newport who wore clothes of the East and dressed their hair in buns, as Chinese women did.

In view of all this evidence, it is more likely that the tower was erected by the Chinese, who had centuries of experience of lighthouse and observatory building, than by Norsemen, who had virtually no experience of either. The Newport Round Tower faces south, the direction from which the Chinese would have arrived, sailing with wind and current. It would have been useless to Norsemen approaching from Greenland to the north, sailing against the prevailing winds and currents.

I contend that the people Verrazzano met at what is now Newport, Rhode Island, can only have been Chinese men and women, the descendants of sailors and concubines from Zhou Wen's great fleet. Knowing the longitude of the tower, the junks of the next treasure fleet would have been able to sail directly to Newport, and it would have been natural for those stranded there to have built a lighthouse to guide their rescuers safely into harbour, protecting them from the tragedy that had overtaken Zhou Wen's fleet in the Caribbean. If my surmise was correct that Zhou Wen had several thousand men and concubines to land around Narragansett Bay, a substantial amount of evidence should remain in the countryside surrounding the Newport tower. I would expect at least to find stones similar to those the Chinese erected elsewhere on their journey.

I began my search on the internet to see if there were any carved stones in eastern Massachusetts. My search produced immediate and dramatic results. Thirty miles upriver from the tower is the celebrated Dighton Rock. It is a free-standing, easily identifiable rock of a distinctive reddish-brown colour with an exposed face measuring approximately five feet high by eleven feet wide. It stands on the banks of the Taunton River and is covered with ancient carvings, on top of which is a Portuguese cross and graffiti. In that respect, Dighton Rock strongly resembles examples in the Cape Verde Islands and at the Matadi Falls. I felt that another link in the ever-lengthening chain of evidence had fallen into place.

Dighton Rock would have been the logical place for any explorer of the Taunton River to stop to leave a mark. It is the largest rock in the bay on the south side of what is now Perry Point, the northernmost point any large vessel can reach along the Taunton River. Above Perry Point, the river narrows to under two hundred feet and the depth falls to a few feet. It is the reason why the Taunton Yacht Club is located there rather than further north.

The rock was first drawn in 1680 by a local clergyman, Mr Danforth, who also related the legend associated with the rock that had passed into the folklore of the local Indians: 'Then there came a wooden house (and men of another country in it) swimming up the River Asooner [as the River Taunton was then called] who fought the Indians with some mighty success.'⁹ The Chinese themselves described their junks as 'wooden houses', as did other observers such as Niccolò da Conti and Pedro Tafur, a Spanish traveller to whom da Conti related his story (see chapter 4). In 1421, the sea level was some six feet lower than today, and the rock, now covered at high water, would have been above the waterline in all but the highest spring tide. It was certainly respected and deemed old by local native Americans:

This monument was esteemed by the oldest Indians not only very antique but a work of a different nature from any of theirs ... some reckon the figures here to be hieroglyphicall [*sic*] the first figure representing a ship without masts, and a mere wrack [wreck] cast upon the shoals. The second representing an head of land, possibly a cape with a peninsula. Hence a gulf.¹⁰

This description accords with the dreadful experiences a few weeks earlier of Zhou Wen's fleet.

SETTLEMENT IN NORTH AMERICA

After Mr Danforth's drawing of 1680, at least six more were made before 1830. I have received accounts of an artist and another clergyman who visited Dighton Rock after Mr Danforth; they met Mongolian people there and stated that the carving on the rock was Mongolian. However, it was the practice of local boatmen to take tourists to the rock and scrub off the algae to reveal the hieroglyphics underneath, and as time went by fewer and fewer of the hieroglyphics remained legible and the drawings grew more and more extravagant and fanciful, bearing little relation to Mr Danforth's sketch. Whatever message the stone carried can no longer be read, and sadly all I or anyone else can conclude is that the rock was carved in a non-European language by foreign mariners sailing upriver in a ship like a house, that the inscription described a shipwreck and that the Portuguese later found the rock and inscribed a cross upon it.

I next searched the work of local historians for further evidence. Narragansett Bay is open to the North Atlantic and experiences brutal winter weather. Snowstorms lash the coast, and the native Americans who inhabited this bleak region, even the wild animals, sought refuge inland, away from the worst of the weather. It would have been natural for the Chinese also to seek shelter up one of the arms of the bay, and the Taunton River was the most obvious route. It was the native Americans' highway to the interior, and it would have been logical for the Chinese to sail upriver to the highest navigable point, beside Dighton Rock, to escape the sudden squalls that might have caused the ships to drag their anchors and run aground.

In the 1950s, just before a housing development started at Perry Point, a cluster of very old stone buildings was found. They were all the same size, arranged in a cruciform pattern and held together by mortar. Hops and wild rice, not indigenous to the area, grew nearby. No-one at the time thought the matter sufficiently important to attempt to stop the housing development or to arrange an extensive excavation.¹¹ Could this have

335

been a settlement established by the Chinese? Sadly we will never know as all traces of these buildings have been destroyed.

Professor Delabarre, a distinguished North American historian,¹² contended that there were noticeable differences in physiology and colouration between the 'pure blood Wampanoag Indians' living near Dighton Rock and adjacent tribes in Massachusetts. Based upon this, he postulated that while exploring what is now Narragansett Bay, the ship of the Portuguese explorer Miguel Cortreal was wrecked in 1510.¹³ He and his crew were accepted by the Wampanoag and intermarried within the tribe. Professor Delabarre's theory could, of course, also apply to the bronze-skinned people Verrazzano met. The Wampanoag later proved hospitable to the first pilgrims, contrary to experiences elsewhere: male pilgrims were frequently killed by other tribes and women and possessions taken. One can speculate that the Wampanoag might earlier have been fairly treated by shipwrecked Chinese.

I began to search for more corroborative evidence such as other carved stones, without any great hope of finding any. After discovering the Cape Verde stone, I had spent considerable time searching for inscribed rocks around each Chinese landfall and had very rarely found more than one, at most two, in any one area. To my amazement, I discovered no fewer than twelve curious stones in one small area of eastern Massachusetts.¹⁴ The size, position and aspect of these rocks was strikingly similar to those I located on the Cape Verde Islands, at the Matadi Falls on the Congo River and at Ruapuke beach in New Zealand. Many were propped up with round stones at one corner in precisely the same way as the Cape Verde stone. Someone must have pushed the rocks into this odd position, recalling the description given by the Aborigines of foreign visitors to Australia 'pushing the rocks in long lines'.

I decided to plot these stones on a map of eastern Massachusetts and immediately saw that they were either beside the Taunton River in the south, the Merrimack River in the north or around Massachusetts Bay. What appears highly likely is that the people who hauled the huge stones into position had sailed upriver, one 'great house' sailing up the Taunton River, another up the Merrimack.

One of these stones, the 'Shutesbury', appears to have carved upon it a figure of a seated Buddha in the classic position, 'contemplating ageing'. If the carving could be dated to the pre-Columbus period this would be highly significant but unfortunately the museums I have approached so far have been unable to give a final opinion of the date. Curiously, at North Salem, a hundred miles south of Shutesbury, there is an instantly recognizable carving of a horse – pre-Columbus. If the people who raised the stones had used horses the likelihood would be that they came with horse-ships, for the rocks were found in place by the first European settlers and horses died out in North America round 10,000 BC. At this stage all one can say is that it is possible the huge stones were hauled into position by people using horses. The investigations continue and the results will be posted on the 1421 website.

It could be argued that the similarities of site, size, shape and method of support among the twelve large stones found in eastern Massachusetts and those in the Cape Verde Islands, at the Matadi Falls and at Ruapuke beach are coincidental, and that the inscriptions on the Dighton Rock represented shipwrecked mariners other than the Chinese, but I was sure the Chinese fleet had reached the Caribbean, and later the Azores. In between these two landfalls, the winds and currents would have taken them to exactly the place where the rocks have been found. The most plausible explanation is that the rocks were erected by the Chinese and that the women Vcrrazzano met were the descendants of Chinese concubines. I suggest that the first settlers of North America came not with Columbus nor any other European pioneer, but in the junks of Admiral Zhou

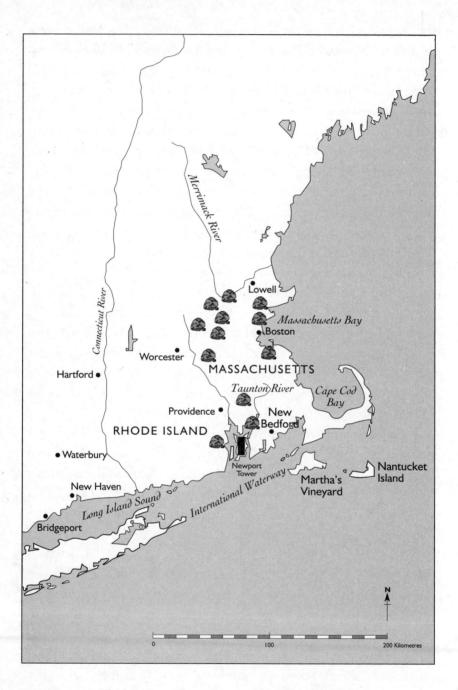

The locations of standing stones in Massachusetts.

Wen's fleet, landing around Christmas 1421, and there is now ample DNA evidence to back up this assertion. Perhaps New England should now be renamed New China.

After establishing the settlements, the junks would have set sail. How desolate the crew and concubines left ashore must have felt, watching the great red sails unfurl and fill with wind, carrying the junks away. Those lining the beach would have strained their eyes until the ships were no larger than specks on the horizon, and as they turned away at last, their hearts must have been full of foreboding. No doubt promises were made that the next great treasure fleet would return for them, bringing fresh supplies and more people and carrying those who so wished back to their homeland. As the years passed, amid the daily struggle to survive - building shelters, catching fish, tilling the soil and foraging inland for food - they must have paused often to cast their eyes out to sea, raking the horizon for the first smudge of red that might signal the arrival of a rescue fleet. But as the years went by, hope must have faded, as must talk of their homeland, constant in the conversation of the old but dimming to a half-remembered tale and then forgotten altogether by succeeding generations. Not one single Chinese ship ever returned to collect them.

EXPEDITION

14

TO THE

NORTH

POLE

DMIRAL ZHOU WEN'S ALREADY DEPLETED FLEET WAS to be further reduced in strength on the next stage of its epic voyage, for the surviving medieval maps suggest that as the Chinese fleet crossed the icy waters of the North Atlantic, it was divided into two squadrons. One set sail even further to the north; the other carried on eastwards and, swept before the winds and currents, it would have been approaching the Azores from the north-west within a month of leaving New England. The Azores chain stretches four hundred miles from north-west to south-east, and the first island the Chinese would have sighted approaching from the Americas is the most north-westerly of the Azores, the small but dramatic island of Corvo on the same latitude as Beijing.

Like Santo Antão in the Cape Verde Islands and Guadeloupe, Corvo is dominated by a huge volcano, the long-extinct Caldeirão, usually capped by a large white cloud. Streams tumble down the sides of the volcano, visible from miles out into the Atlantic. Only five miles long, the island looks verdant green, rising above a sea of the deepest blue, but the living is hard, for there is only a narrow strip of fertile land on the south shore around what is now the capital, Vila Nova, between the foothills of the volcano and the sea. All the houses huddle together as if begrudging even a single lost yard of the precious soil.

Here I began to look for a lighthouse, or a carved stone like the ones I had already located along the routes the Chinese had sailed. If it existed, it would have been placed in a prominent site and would have been noted by the Portuguese when they first discovered the island. The earliest account of the Portuguese arrival in the 1430s has this to say:

On the summit of a mountain on an island they call The Raven [Corvo] ... a statue of a man seated upon a horse; his head is uncovered and he is bald; his left hand rests upon his horse, his right hand points towards the west. The statue is set firmly upon a

stone base carved out of rock. At the bottom are inscriptions in a writing which we could not understand.

This statement is significant on several counts. The people who carved the horse and the writing were clearly not European, and the horseman is not only hatless but bald. Some of the terracotta army guarding the Emperor Quin's tomb were depicted with shaven heads covered by a close-fitting stocking, like a tight hairnet. They do, indeed, look bare-headed and bald. The Corvo horseman is pointing to the west, to New England, the direction from which the Chinese would have arrived. The Azores are easy for a junk to reach from the Americas, but very difficult to

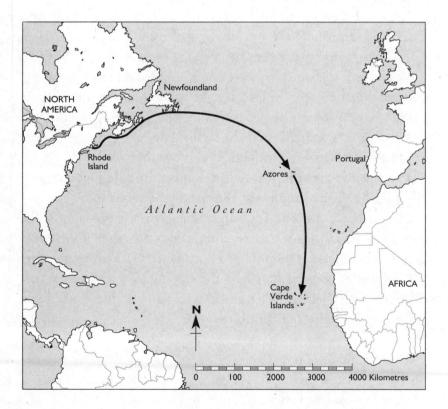

The voyage to the Azores and Cape Verde Islands.

reach from Portugal because from there ships would be sailing into the wind. That is why the Portuguese discovered them long after the Canaries and the Cape Verde Islands, despite the Azores being nearer to Portugal.

For me, the final confirmation that the Corvo horseman was indeed a Chinese statue, perhaps even of 'The Emperor on Horseback' Zhu Di, is that the Azores appear on the Chinese/ Korean Kangnido chart, produced before the Portuguese discovered the islands. They had never appeared on any Arab maps, not even those of the famous historians Al Idrisi (1099–1166) and Ibn Khaldun (1332–1406). If the Azores were not discovered by the Chinese, who could have discovered the islands before the Portuguese, and why should they have informed the cartographer in distant China?

Surprisingly, corroborative evidence that the Chinese may have inhabited the Azores comes from Christopher Columbus, who reported a local story of non-European bodies washed onto the beach at Flores, some twenty miles south of Corvo. This report came before Columbus set sail for the Americas and Ferdinand Columbus indicates that his father believed these bodies, together with 'artistically carved pieces of wood', were evidence of contact between Cathay and the West.²

While one squadron of Admiral Zhou Wen's fleet set sail for home from the Azores via the Indian Ocean, the early maps show that the other squadron had taken a different route. South of the Grand Banks off Newfoundland,³ the Gulf Stream separates. While the main body flows clockwise, carrying ships to the Azores and then via the Canaries to the Cape Verde Islands, a second, smaller part of the stream, the Irminger current, carries on to the east. Due south of Iceland, it veers counter-clockwise, first to the north, then the north-west and then north again, carrying a ship into the Davis Strait separating Greenland from northern Canada. There it becomes the West Greenland current, which flows up the west coast of

345

THE VOYAGE OF ZHOU WEN

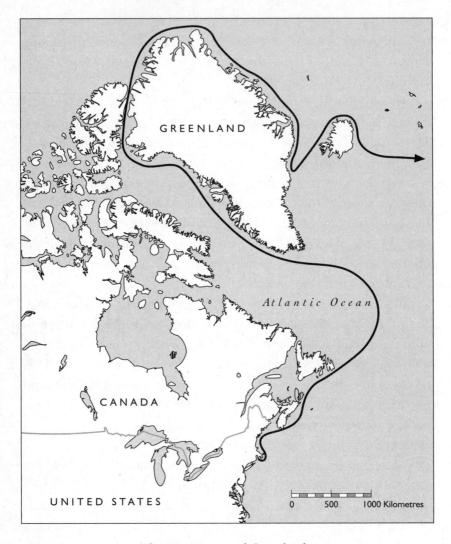

The journey around Greenland.

Greenland, circles around the north coast and then comes back down the east coast as the East Greenland current, leading back into the Atlantic. Any ship circumnavigating Greenland in this way would never have to sail into an opposing wind or current at any stage. I was faced with two questions: why would the Chinese have wanted to circumnavigate such a barren, frozen land, and even if they had good reason to do so, was it actually possible? The answer to the first was easier to find than the second. The symbolic and practical significance of Polaris to the Chinese made fixing the absolute position of the North Pole of great importance. Not without reason had the emperor ordered them to reach 'the most northern of the northern ... countries', and to explore the nethermost parts of the earth – as their compatriots were doing in the far south, locating the South Pole.

I found the first circumstantial evidence that their thrilling gamble might have succeeded in two charts. The first was the Cantino, the remarkable medieval map that had already led me to so many discoveries about the Chinese voyages. The second chart was far more controversial: the Vinland map, dated to between 1420 and 1440. The Vinland map shows Newfoundland, Labrador and the whole of Greenland with great accuracy and in considerable detail. If it is genuine, it is proof that someone – perhaps the Chinese – had penetrated to within 250 miles of the North Pole four centuries before the first recorded European exploration of the High Arctic.

By using information from the Vinland map, I knew I would be opening a Pandora's box of controversy. The map's credibility has been attacked on many grounds. Its extraordinary provenance – it first appeared in 1965 from the back of a small Fiat car owned by a map-dealer – has made it suspect in many expert eyes. There is no shortage of historians who believe its cartography just too good to be true; Greenland is so accurately drawn that it simply must be a modern fake. Walter McCrone of McCrone Associates, a respected Chicago firm expert in chemical analysis, claimed in 1972 that the ink's composition, in particular its anatase content (a form of titanium that first appeared in inks in the 1920s) made impossible the purported date of the map's creation. However, in 1992, Dr Thomas Cahill

THE VOYAGE OF ZHOU WEN

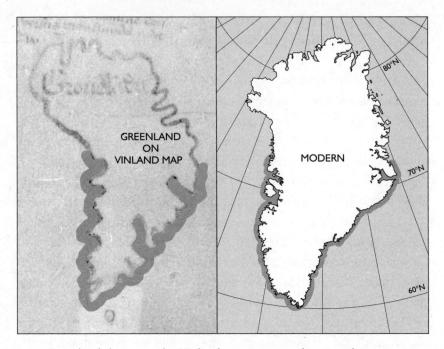

Greenland shown on the Vinland map, compared to a modern map.

of UC Davis found anatase in a variety of medieval manuscripts, reopening the question of the Vinland map's authenticity.

The other grounds for attacking the map's credibility are that the Norsemen who first settled Greenland had no cartographic knowledge, only an oral tradition that substituted for map making, and the map could not conceivably have been drawn from an oral description. Furthermore, it was believed that Greenland could not have been circumnavigated, and that the names on the Vinland map supposedly placed there by Claudius Clavius, an eminent Danish cartographer who is believed to have drawn the map in about 1424, are fairytale names; surely the Norsemen would have told him what they had called places in the north. However, if the original cartographers had been Chinese, Clavius would probably not have been able to translate the names marked on the chart, which might explain why he felt

EXPEDITION TO THE NORTH POLE

the need to invent them. The ink remains the one controversial issue that has not yet been resolved. Several books have been written about it. No less an authority than the then Keeper of Maps of the British Library, Mr R.A. Skelton, considers it genuine; in this he has been supported by several learned professors corroborating Dr Cahill's discovery that anatase was in fact contained in some medieval inks, particularly those used in Alpine monasteries early in the fifteenth century.

Those claiming the Vinland map is a forgery have not remotely satisfied the burden of proof, and it is my belief that it is genuine and that the original cartographers who produced the information on which it was based were aboard several Chinese junks, at least one of which circumnavigated Greenland on a quest to reach the North Pole. To justify that belief, I had to answer the question of whether Greenland really could have been circumnavigated. It is completely impossible today, even in a nuclear-powered icebreaker, for the seas surrounding the far north are frozen solid all year round. However, there is direct evidence that conditions in the early fifteenth century were markedly different from those ruling today.

Contemporary accounts of the wedding of Sigrid Bjornsdottir in 1408, preserved in the state archives in Oslo, paint a very different picture of the land we know as Greenland. Sigrid was a widow; her father and sisters had died and she had inherited the family land, becoming the wealthiest landowner in Greenland. She possessed substantial flocks of sheep and cattle that fed on lush Greenland pastures, a scene quite unrecognizable from today's barren, ice-bound land. The church in which Sigrid was married still stands in bleak and splendid isolation above the dark fjord. We can imagine her that September Sunday as the service ended, hurrying from the church into the dark warmth of her house to begin her wedding celebrations.

Excavations of the floors of the houses in which she, her

THE VOYAGE OF ZHOU WEN

family and her retainers and servants lived show that the climate in Greenland was far warmer before the onset of a miniature Ice Age in the 1430s. The evidence is supplied by a change in the type of flies found during the excavations. Those that inhabit warm houses disappeared and were replaced by flies that can live in cold, empty houses off the rotting flesh of the dead. Evidence of an abrupt change in climate came from the skeleton of an elkhound whose throat had been slit – perhaps a last meal for the dying inhabitants. A valuable hunting dog would only have been slaughtered like this in the most dire circumstances, for without it a family's chances of killing enough game to survive the winter would be drastically reduced. I am now in receipt of expert corroberative evidence that the summers of 1422 to 1428 were exceptionally warm (see postscript).

I found further corroboration that Greenland can periodically be navigated in the accounts of Captain George Nares's voyage to the Arctic in 1875–6.⁴ One of his ships reached 83°20' North, just nineteen miles from the northern tip of Greenland. An officer, Lieutenant Lockwood, marched the nineteen miles to the northernmost tip, Lockwood Island, later named after him. And this at a time when the climate was much colder than in 1422.

It is safe to conclude, therefore, that Greenland was circumnavigable in 1421–2, for the climate of Greenland was far warmer than it is today. In 1421 it would have been a country of green pastures where cattle grazed in the open from Pentecost (fifty days after Easter) to Cross Sunday (the second Sunday in September). The rivers were full of salmon, the coasts rich in walrus.

Additional corroboration that the Chinese did reach Greenland comes from a most curious letter written in 1448 by Pope Nicholas V to the bishops of Skalholt and Holar in Iceland, setting out the background to his desire to appoint a new bishop to Greenland: '[Thirty years ago,] the barbarians came from the nearby coast of the heathens, and attacked the inhabitants of Greenland most cruelly and so devastated the mother country

EXPEDITION TO THE NORTH POLE

and the holy buildings with fire and sword that there remained no more than nine parish churches ... The pitiable inhabitants of both sexes they carried away . . . the greater number have since returned from captivity to their own houses." The Pope referred to 'barbarians' who came from 'the nearby coast of the heathens'. In other letters, he referred to the Inuit tribes of the Canadian Arctic as 'the heathen', so 'the nearby coast' can reasonably be assumed to refer to the Canadian Arctic. Addressing a Christian audience, the Pope distinguished between heathens and barbarians - they were not interchangeable terms. He cannot be referring to Norsemen - Greenland was a Norse colony - nor to any other Christian invader; they might have been heretics in the Pope's eyes, but they would not have been barbarians. In those days, as is commonly accepted, barbarians were people who invaded Europe from the East; the Pope was almost certainly referring to a Mongolian or Chinese invader of Greenland. The Pope would not have been referring to North American Indians as the barbarians, for these people had no 'swords' or 'fire' with which to fight. They used bows and arrows. I believe the only rational view to take is that this letter is describing a Chinese fleet arriving from North America and attacking the local people, perhaps with cannon (Hvalsey, Sigrid Bjornsdottir's home town and the main settlement of Greenland, was within cannon range from the sea). They took them away in their great ships then returned them. But why the Chinese should have acted in this uncharacteristic way is inexplicable. Perhaps they were attacked first.

Assuming that the Chinese did indeed reach the settlement at Hvalsey – and DNA analysis has again shown that the native people around Hvalsey possess Chinese DNA – the Vinland map should show where they had most accurately surveyed the coast, and therefore the sites where further direct evidence of settlements, wrecks and artefacts might be found. Peter Schlederman and Farley Mowat, two well-known authors and explorers, have

351

carried out years of painstaking research in the High Arctic at the extraordinary villages of stone houses centred on the Bache Peninsula of Ellesmere Island, to the west of Greenland on the west shore of the Kane Basin, and made some remarkable discoveries.⁶

The colony on the Bache Peninsula is of particular interest. There are about twenty-five houses and a similar number of beacons on the peninsula, and some of the houses are immense nearly 150 feet (45 metres) long and over 5 metres wide. The houses are so large and the stonework so well constructed that it is unlikely they were built by Inuit peoples. They have other notable characteristics too. Stone beacons resembling small lighthouses were built alongside the houses, and there is one very curious omission: none of the houses has a roof. The Norse settlers of Greenland almost invariably roofed their houses with sod, but there is not a trace of such roofing on any of the houses on the Bache Peninsula. That there are no roofs at all is astounding. The buildings are large enough to have accommodated as many as three thousand people, but without a roof over their heads they would have been lucky to survive a single Arctic night. The ruined walls of the buildings can be seen today. Outside the houses, row upon row of hearths had been constructed, 142 in all, each separated from its neighbour by a stone wall. This multiple arrangement of outdoor hearths is again quite unique; nothing like it has ever been identified among prehistoric sites in the Canadian Arctic.

In trying to solve the mystery of these curious buildings, my first clue came from the local geography. The settlement at Ellesmere Island was built on a spit near a large polynya – a stretch of open water, a curious phenomenon found all the way to the North Pole. As I can vouch from navigating submarines under the ice in this part of the world, polynyas remain ice-free in both summer and winter. The reason for this is still not fully understood, but because they are permanently free of ice, they

A magnificent Ming porcelain bowl, decorated with a phoenix and a quilin, recovered from the Pandanan wreck.

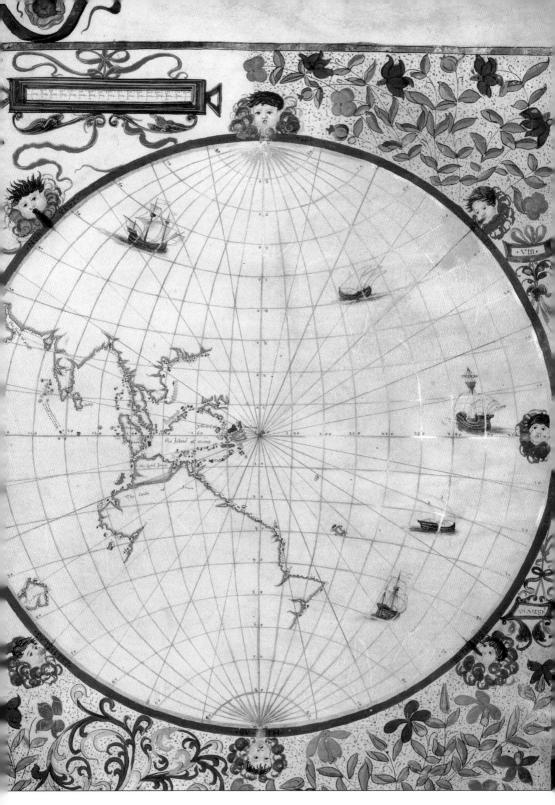

The Jean Rotz world map, 1542.

Chinese influence abroad: a contemporary lacquer chest produced in Mexico (*opposite, main image*); the Cherokee rose (*opposite, inset*) originating in China and found in North America.

Artefacts recovered from the Pandanan wreck, including a bronze ceremonial saluting cannon (*top*), a bronze mirror (*above left*), a coin of Zhu Di's reign (*centre right*) and grinding stones from Central America (*above and right*).

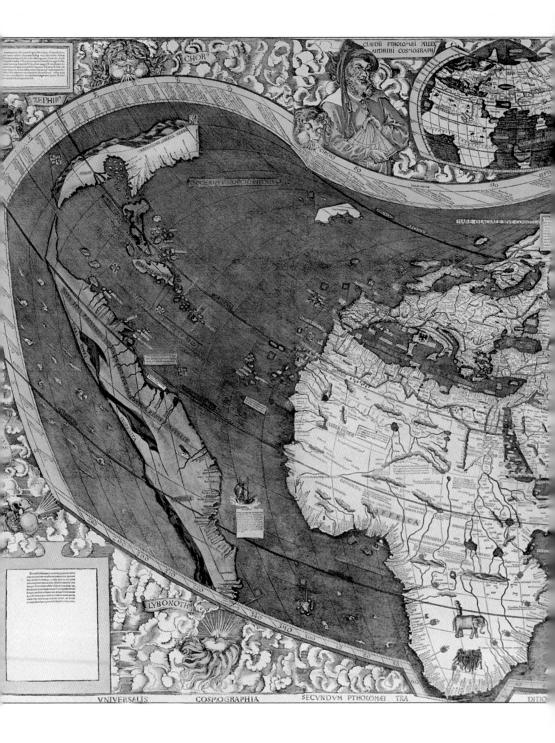

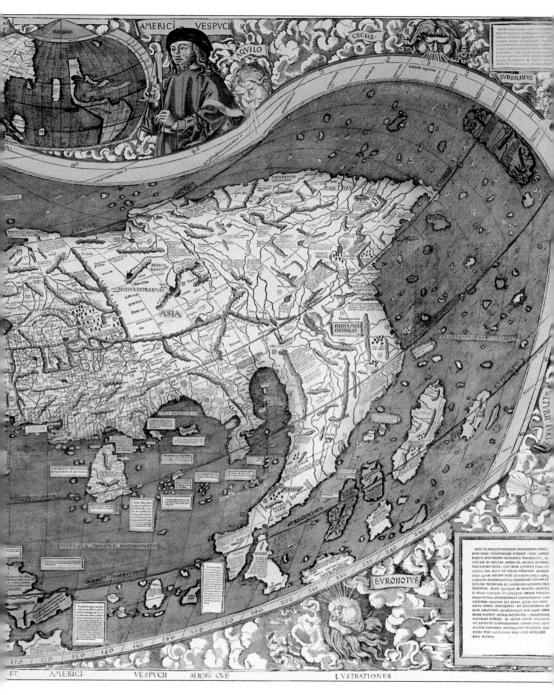

The Waldseemüller map of 1507.

The Pizzigano chart of 1424 and an enlarged detail of Antilia/Puerto Ricc The rectangular, blue island above i Satanazes/Guadeloupe.

The state of the s

CAStein

EXPEDITION TO THE NORTH POLE

are extraordinarily attractive not only to submariners in search of fresh air but as breathing-holes for mammals. There, mammals can also seek their prey. The polynya off the Bache Peninsula is particularly rich in fish and attracts large numbers of walrus. Walrus were very greatly valued in the Middle Ages for their meat, their magnificent ivory tusks and their hides, which could be boiled to make blubber oil for heating and lighting and distilled to make pitch to seal the hulls of ships. That the villagers on the Bache Peninsula in the High Arctic were there for the walrus is confirmed by the superb artefacts of exquisite workmanship that have been found nearby, such as fish hooks made from walrus ivory.

Ellesmere Island also has another very valuable commodity: copper. Evidence of ancient mining and processing of copper has recently come to light on nearby Devon Island;⁷ of course, the Chinese were adept at surveying for, mining and refining metals. Coal originating from Newport, Rhode Island, has also been found in Greenland. Someone must have carried it there.

All of this was reasonably logical, but it begged the question of why the Chinese, with their magnificent ships, should have bothered to build stone houses at all. Why not simply anchor off the polynya to hunt the walrus and prospect for copper? But if one or more of the great ships had been holed by ice and forced to beach, they would then have found themselves on land with thousands of tons of teak near a rich fishing ground that would keep them alive if only they could withstand the cold. In such circumstances they would probably have done what Shackleton was to do centuries later: they built houses of the local material – stone – and roofed them using the timbers of their ships. By my calculations, one three-thousand-ton junk could have roofed all twenty-five houses of the settlement on the Bache peninsula.

I next turned to the stone hearths. If they had been designed for cooking, they would have been inside the houses: sited outside, they must have been built for industrial purposes. The sheer number of them -142 in total - supports this thesis. One explanation would be that the hearths were used to boil blubber, both to make pitch for sealing the wooden roofs of the houses and to provide heating and lighting oil for winter. They could also have been used for desalinating sea-water or melting snow for drinking water, but so many hearths would scarcely have been required for these purposes. I believe that the Chinese were also smelting copper.

Part of the Chinese fleet must have remained at the settlement for some time, but at least one ship must have gone on to circumnavigate Greenland because the northern and eastern coasts of Greenland appear on the Vinland map. The south-western and south-eastern coasts are very accurately drawn with correct latitudes, but the north-west coast has a substantial 'bulge' in the area from Cape York through the Kane Basin to Petermann Fjord and Peary Land. To work out how this might have happened, I studied modern ice maps of the region⁸ and concluded that the bulge shown on the Vinland map is in fact ice protruding into the sea from the huge glaciers of Mylius Erichsen's Land and Kronprins Christian's Land. Superimposing the shape of the glaciers onto a modern map of Greenland reconciles the disparity on the Vinland map.

Excepting this one error, the coastline is well drawn. Once again, it is a staggering cartographic achievement. The cumulative evidence – the Chinese reaching the Caribbean, the currents and winds that could have carried them from there around Greenland, the Pope's letter and the stone village – is suggestive of a Chinese attempt to reach the North Pole. By reaching Greenland they failed only by four hundred nautical miles ... or did they? The most exquisite artefacts – snow geese, polar bears, seals and walruses of sumptuous workmanship carved from walrus ivory – have been found in the High Arctic even further north than Greenland, within 250 miles of the North Pole. They were designed by artists of genius. Could the Inuit have made

EXPEDITION TO THE NORTH POLE

them, or were they the art of a civilization almost as old as time?

After setting sail from Greenland, the currents and prevailing winds would have driven the Chinese fleet on towards Iceland. Confirmation that this was feasible came from Christopher Columbus: 'In the month of February 1477, I sailed 100 leagues [approximately 470 nautical miles] beyond the island of Tile [Iceland], whose southern part is in latitude 73 degrees north ... and at the time when I was there, the sea was not frozen, but there were vast tides, so great that they rose and fell as much as 26 braccia [about 50 feet] twice a day." Professor Mike Baillie of Queen's University, Belfast, a world expert on dendrochronology - the analysis of tree rings to establish dates - has shown that 1477 was indeed an unusually warm year, hence Columbus's claim is perfectly acceptable. Such a voyage would have taken him to the coast of Greenland. Then came the bombshell. Columbus summarized his voyage in his own handwriting in the margins of his copy of Pope Pius II's book History of Remarkable Things that Happened in my Time. He wrote: 'Men have come hither [to Iceland] from Cathay in the Orient.'10

I now had separate testimony from a pope and from Columbus that the Chinese had reached Greenland and Iceland, documentary evidence corroborated by the Vinland map of c. 1424 that shows the south coast of Greenland with stunning precision. In addition, the great expert on Ming China, Professor Needham, says that there exist more than twenty separate Chinese claims that they actually reached the North Pole.¹¹

When they rounded Greenland's North Cape, the Chinese would have been just 180 miles south of the North Pole, for its position in 1422, as determined by Polaris at 90° altitude (*Wu Pei Chi*), was well to the south of where it is today. To reach the pole, the Chinese had only to travel a further 180 miles to the north – less than two days' sailing. Could the Arctic waters have been ice-free over those last 180 miles? A current (2000) temperature

THE VOYAGE OF YANG QING

chart for the Arctic in July shows a tongue of relatively warm water off the North Cape of Greenland – perhaps the last feeble remnant of a branch of the Gulf Stream – extending northwards beyond the North Cape towards the North Pole. It is entirely possible that the Chinese claims are true, that they had indeed reached the North Pole five centuries before Europeans did. Having been in a submarine on patrol near the North Pole using a series of polynyas, I can only marvel at the Chinese achievement. They could now eat the last of the dogs and drain the remaining bottles of rice wine in celebration before at last setting sail for their homeland.

Their route home from these far northern latitudes may solve yet another mystery, for the Waldseemüller map, published in 1507, shows the north coast of Siberia from the White Sea in the west to the Chukchi Peninsula and the Bering Strait in the east. The whole coast, with its rivers and islands, is clearly identifiable. If not the Chinese, who could have surveyed that enormous coastline? How was this chart drawn, showing lands that were not 'officially' discovered by Europeans for another three centuries, unless the Chinese had also travelled there? The first Russian surveys of Siberia did not take place for another two centuries, and the first Russian map did not appear until the nineteenth century.

The only logical explanation, and the DNA evidence backs it up, is that it was surveyed by Zhou Wen's fleet as it made its way back to China through the Bering Strait. As discussed previously, *The Illustrated Record of Strange Countries* features drawings of Cossack dancers and Eskimos hunting. The Eskimos could have been those of the Aleutian Islands, known to the Chinese, but the drawings of Cossacks cannot be explained in this way. There are no records of any Chinese visits to Muscovy in the first half of the fifteenth century. How could the drawings have been made without a visit to the Arctic?

Another Chinese admiral, Zhou Wen, had now completed an

epic voyage of discovery, equalling if not surpassing the extraordinary voyages of Hong Bao and Zhou Man. Yang Qing had also been at sea with a great fleet in the missing years of 1421 to 1423, and I now turned my attention to him. He may not have travelled as far as the others, remaining for the most part in waters already familiar to the Chinese, but his achievements during the voyage he made lose nothing in comparison to the successes of the other great admirals.

SOLVING

THE

RIDDLE

15

HILE HIS PEERS HAD BEEN LOCATING CANOPUS AND the Southern Cross, penetrating the polar regions and discovering new lands and continents across the globe, Grand Eunuch Yang Qing's fleet, having left Beijing a month before the rest, spent the entire voyage in the waters of the Indian Ocean. Nowhere was more familiar to Chinese seamen, for trade with the states of the Indian Ocean, particularly the vastly lucrative spice trade, was the source of much of the Chinese national wealth. Trade was carried on not just with the Spice Islands, the countries of south-east Asia, India and the Arab states of the Gulf, but with ports and states the length of the East African seaboard.

By the early fifteenth century, Arab ports along that coast traded directly with China, exporting gold, ivory and rhino horn. Rulers of East African states habitually travelled aboard the junks of Zheng He's fleets to the Forbidden City. Many were returned to their home states as the fleets made their outward voyages in 1421, and more were collected and taken to China by two of the fleets limping homeward at the end of their remarkable voyages: Yang Qing himself returned from the Indian Ocean in September 1422 bearing the envoys of seventeen states from the East African and Indian coasts, and Hong Bao sailed home in October 1423 with the ambassador of Calicut. Once again, the emperor's foreign policy had succeeded brilliantly. The Indian Ocean had become a Chinese lake.

As most of the Chinese records had been destroyed, I had as usual to look elsewhere for evidence of the route Yang Qing's fleet had taken around the Indian Ocean. I found it in a familiar source: the Cantino map of 1502. My belief that it was based on information obtained from the Chinese voyages of 1421–3 arose from Portuguese historian Antonio Galvão's comment about a map (the 1428 World Map) that 'set forth all the navigation of the East Indies, with the Cape of Boa Esperança' (see chapter 4).¹ In those days, the 'East Indies' meant India, the Indian Ocean,

THE VOYAGE OF YANG QING

Malaysia and Indonesia. It was an unequivocal declaration that the Cape of Good Hope, the Indian Ocean and the East had been set out on a map drawn early in the fifteenth century. Further corroboration that the Portuguese had a map showing the Cape of Good Hope before Dias or da Gama set sail came from the instructions of King João II of Portugal to the explorer Pêro da Covilha (c. 1450–c. 1520) in May 1487, when he sent him on a voyage to search for a sea route to India:

He recommended him very much to enquire whether beyond the Cape of Good Hope it was possible to navigate to India ... Then the King sent two of his trustworthy men who could speak Arabic well and were experienced travellers, Pero de Covilha, a knight of his household, and Alfonso de Paiva ... [the future] King Dom Manuel gave them a chart (*Carta de Marear*) taken from the Map of the World [1428 chart] ... all these showed as well as they could how they would have set about going and finding the countries the spices came from [the Moluccas].²

Significantly, Dias had not 'discovered' the Cape of Good Hope in May 1487, when these instructions were issued.

By the fifteenth century, the Chinese had hundreds of years' experience of navigating the Indian Ocean and the east coast of Africa; they had been visiting Africa since the time of the Tang dynasty (AD 618–907). The chronicles of Ma Huan and Fei Xin, who sailed on five voyages prior to 1421, the detailed sailing directions in the Wu Pei Chi, listing the courses to reach East Africa, and the accounts of medieval travellers recording the wealth of early Ming blue and white porcelain in merchants' palaces along the East African coast as far south as Sofala, all show the extent of Chinese trade and influence.

When serving in HMS *Newfoundland*, I travelled thousands of miles along the East African coast from Kenya to South Africa. In 1958 it was largely unspoilt, lined by the remains of old

SOLVING THE RIDDLE

Arab and Portuguese slave towns and the occasional musty British club, the last remnants of empire. One incident remains vivid in my memory. People on safari in Africa in those days carried guns, not cameras, as their essential equipment. We decided to go on a crocodile shoot in the estuary of the Limpopo, and duly borrowed the ship's motor boat, several rifles and a crate of rum. We arrived in the glassy, greasy estuary under a leaden sky, a scene Kipling would have recognized. There were no crocodiles but plenty of hippos with their ugly snouts and big ears showing above the muddy water. This was sport! We soon discovered two things: hippos' hides are tough (the bullets bounced off) and hippos do not enjoy being peppered with shot. One charged us; I can see the boat now, flying through the air upside down, its propellers whirring away as it passed overhead. Both we and the hippo retired bruised but otherwise undamaged. From then on I found my entertainment in more environmentally sensitive ways, by exploring some of the old Arab and Portuguese trading and slaving towns along the coast.

When the Portuguese first arrived in East Africa, they found that the kings and queens of Zanzibar and Pemba (in modern Tanzania)³ were dressed in fine Chinese silk and lived in stone houses decorated with Chinese porcelain. Further evidence of the Chinese presence in the Indian Ocean comes from the Lamu archipelago or Bajun Islands, five hundred miles north-east of Zanzibar, off the northern coast of modern Kenya. The Bajun capital, Pate, was habitually used by Zheng He's fleets, and when the Portuguese arrived they found 'Bajuni', honey-skinned people with fine features. A Jesuit priest, Father Monclaro, wrote in 1569: '[They produced] very rich silk cloths, from which the Portuguese derive great profit in other Moorish cities where they are not to be had, because they are only manufactured on Pate, and are sent to the others from that place.'⁴ Craftsmen from Pate also specialized in lacquerwork, another craft

365

unknown to medieval Africa, and wove baskets using the same technique as in southern China.

An Italian anthropologist, Signor N. Puccioni, made an expedition to the Juba River in Africa in 1935 and concluded that the Bajuni at Pate were of 'a physical type absolutely different from other people in the region. The skin is rather light, in some lightly olive, and in the men you can spot flowing beards, and the women part their hair in the middle and then braid it into two side braids.'⁵ One of the clans on the island, the Washanga, claimed that their forebears were Chinese sailors wrecked off the island, and their folklore relates that the King of Malindi, the most powerful local potentate, presented two giraffes to the Emperor of China.⁶ This indeed happened in 1416.

Pate has changed little since the fifteenth century, save that for a while after the 1960s the island became a haunt of hippies. The people are Islamic, the men still wear the full-length white robes known as *Khanzus* with *Kofia* caps, and the women are shrouded in black capes known as *Bui Bui*. Dhows still ply the coast, their design unaltered for centuries – a triangular lateen sail and a broad, roughly planed hull sturdy enough to beach on the rocky shores. Most have coconut matting tied to their sides and a wooden 'eye' painted on their bow. Those of the Lamu archipelago are distinctive through having perpendicular bows. Dhows are remarkably fast and particularly good at tacking into the wind. Because of the stinking fish bait they carry, dhows can frequently be smelt before they are seen. I used to surface my submarine alongside to load up with flying fish, which made a very welcome variation from the standard Navy diet.

The remains of the former Arab trading town of Shanga, supposedly named after Shanghai, lie at the eastern edge of Pate Island. Today, the town is almost deserted save for mangrove pole cutters. Two centuries ago, large quantities of Chinese ceramics of the Song (960–1280) to early Ming (1368–1430) era were found there, together with the statuette of a Song lion,

A bronze Song lion statuette found off the Kenya coast.

buried as a votive offering. Even the name for these settlers, Bajuni, may be of Chinese origin: *bjun* is Chinese patois for 'long-robed'. Native people on the East African coast wore loin cloths. Long, silken robes would have been striking and unusual enough for the name to be bestowed upon the settlers.

The Chinese were already sailing those waters and they certainly had the capacity in terms of both ships and scientific knowledge to make an accurate survey of the Indian Ocean. They could measure time accurately, plot the course of the stars in the heavens, and determine accurate latitudes in both hemispheres. But could they also determine longitude? East Africa on the Cantino bears an astonishing likeness to a modern chart; the latitudes of inlets, bays and rivers are correct from the Cape of Good Hope in the south to Djibouti at the mouth of the Red Sea in the north, a straight-line distance of seven thousand kilometres. Even more startling, the longitudes on the Cantino are correct to within thirty nautical miles – a mere thirty seconds of time. How had the cartographers achieved this incredible feat?

To date there is no connection between the Chinese and the calculation of longitude. All we can say is that an accurate

THE VOYAGE OF YANG QING

calculation of longitude had been achieved before 1502 when the Cantino arrived in Italy.

Finding longitude without clocks has a long history. The key is to mark the precise moment when a heavenly event occurs, one which may be seen simultaneously across the globe. One of the oldest and best-tried methods was by observing lunar eclipses and elapsed time. Ptolemy in his *Geographia* in the first century AD records Hipparchos (c. 190–120 BC) advocating this method and giving an example of its use in 330 BC. However, Hipparchos does not explain how local time was to be found, a problem because the sun must be below the horizon during a lunar eclipse.⁷ It is quite possible that a few Europeans knew of Hipparchos' method by 1415, when Ptolemy's *Geographia* was brought to Venice by two Byzantines escaping the Ottomans, who were by then threatening Byzantium. The Arabs certainly knew of Hipparchos' theory.

The observatories the Chinese built and the written records they kept show that they measured the passage of time by the length of the sun's shadow. The most famous observatory, the Zhou Gong Tower fifty miles south-east of Luoyang, still stands. Built seven centuries ago, it is a truncated pyramid with stairways leading from ground level to a 25-foot-square platform. A small building in the centre of the platform houses a thin vertical rod for observation of the stars on the local meridian, and a clepsydra, a large water clock. A gnomon - a 40-foot metal measuring pole - was set in a bed of stones extending for 120 feet to the north of the tower, between two parallel troughs of water. The stones were laid perfectly flat, parallel with the water surface. The Chinese measured the sun's noon shadow cast by the gnomon on to the stones. At the equinox on the equator, the sun rises due east and sets due west. At midday it is directly above the observer and casts no shadow at all. The longest shadows are cast at sunrise and sunset, and the length of the shadows between those points determines the precise time at that particular location.

SOLVING THE RIDDLE

As far back as AD 721, the Chinese had realized that the length of the sun's shadow varies not only with the time of day but with the day of the year and the latitude of the observation points. Using a smaller, standard 8-foot gnomon, they made simultaneous measurements of the lengths of shadows during the summer and winter solstices at several different locations from the latitude of modern Hue in Vietnam due north to Beijing. They calculated that the shadow lengths varied by just over 3.56 inches for every 400 miles of latitude, allowing them to make corrections for their position anywhere on earth on one particular day.

However, the shadow length also varied day by day throughout the year. In one remarkable measurement they calculated that the length of the shadow was 12.3695 feet at the summer solstice and 76.7400 feet at the winter solstice. By extrapolating from the two experiments described above, the Chinese were able to make corrections for each day of the year as well as for different latitudes on the earth's surface. Furthermore, by the length of the noon shadow they could establish which day of the year it was. At this time, Europeans' only means of measuring time was hour-glasses, which could not give them either the date or any more than a rough estimate of time on any particular day.

A third adjustment was necessary to correct for the irregular motion of the earth around the sun, occasioned by the eccentricity of the earth's orbit and the difference between the equator and the ecliptic (the great circle of the celestial sphere representing the sun's apparent path through the sky during a year). This causes differences between absolute time and the apparent time obtained from the sun which reach a maximum positive difference of 14 minutes 30 seconds in February and a maximum negative difference of 16 minutes 30 seconds in November. The Chinese determined this with such accuracy that 'observations made from 1277 to 1280 are valuable for their great precision and prove incontestably the diminution of the obliquity of the ecliptic and the eccentricity of the earth's orbit between then and now'.⁸ In layman's language, the earth's orbit around the sun has changed in the past seven centuries.

The Chinese replicated the Zhou Gong Tower first in Nanjing and then in Beijing after the capital was moved there. Zheng He's treasure fleets went on to build similar observatories around the world. Each was equipped with instruments for amplifying the sun's shadow and measuring its length, recognizing stars in the sky, determining the exact positions of the sun and moon at eclipses, and observing Polaris.⁹ The stone tower at Rhode Island (see chapter 13) may prove to be one such example. Each observation platform thus had everything needed to measure latitude and longitude.

The Chinese had long known that the taller the gnomon and the longer the shadow it cast, the more accurate the measurement of time. However, as it grew longer, the shadow also became fainter and more attenuated. In the early Ming era, the Chinese devised a 'camera obscura' by cutting a tiny hole in the roof of the observation chamber. This resulted in a sharper shadow that was intensified through a type of magnifying glass. The long shadow could then be measured to an accuracy of one hundredth of an inch.

The outstanding precision of this Chinese measurement of time is illustrated by their calculation of the length of lunation – the interval between new moons – which they estimated at 29.530591 days.¹⁰ This figure would produce an error of less than one second in a month. Using these methods, measurements of time could only be taken when the sun was above the horizon. Measurements after dark were made using clepsydras (water clocks) that were calibrated in daylight against a gnomon.¹¹ With their gnomons and clepsydras, the Chinese were able to determine the passage of time, day by day, minute by minute and second by second, both day and night. They could also forecast and make use of the full lunar eclipses that take

SOLVING THE RIDDLE

place somewhere across the globe roughly every six months.

Solar and lunar eclipses occur when the sun, moon and earth are in line with one another and when the moon's orbit around the earth is in the same plane as the earth's orbit around the sun. In a solar eclipse, the moon's shadow blots out the sun over a small portion of the earth and it becomes night for a very short period. The spot of darkness, the umbra, travels across the earth as the moon rotates around the earth, and the earth itself rotates. Observers in different locations see the solar eclipse at different times. In a lunar eclipse, the earth is between sun and moon, and because the earth is so much bigger than the moon, its shadow obscures the moon. The great difference for astronomical observations is that the event may be seen simultaneously by observers across half the earth, whereas in a solar eclipse the event occurs only above a very small part of the earth at any one time. The ability to time a lunar eclipse with absolute precision and the fact that the same event could be seen simultaneously from different parts of the globe were to prove the vital steps in Chinese attempts to find a method of calculating longitude.

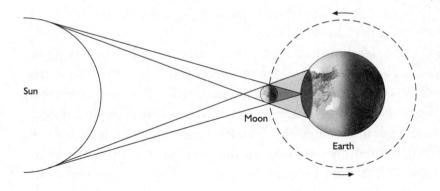

Solar eclipse

THE VOYAGE OF YANG QING

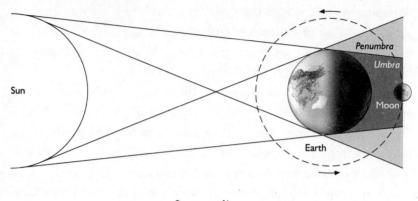

Lunar eclipse

The keys to using a lunar eclipse to determine longitude are, first, that the event is seen across half the world simultaneously, and secondly, while the eclipse is taking place, the earth's rotation makes the stars appear to move across the sky. There are four distinguishable events during an eclipse: U1 – first contact, when the moon enters the dark umbral shadow; U2 – second contact, when the moon has just fully entered the umbra and is totally covered; U3 – third contact, when the moon first starts to emerge; and U4 – fourth contact, when the moon has just fully emerged. The Chinese concentrated on U3 and used it as the basis of their calculations.

After landing in an unknown territory, Chinese navigators and astronomers would have been instructed to observe the lunar eclipse, wait until the moment when the third event (U3) occurred, then determine what star was just crossing the local meridian in the night sky. The local meridian was the imaginary longitudinal line, starting on the horizon directly north of the observer, passing over his head and ending at the horizon due south of him. The known star crossing that line at the time of the third event of the eclipse was the key sighting for the observers in the new territory, and for those back in Beijing.

SOLVING THE RIDDLE

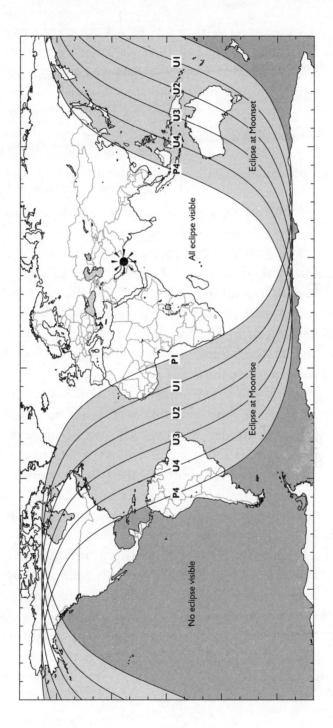

The progression of a lunar eclipse across the Earth's surface.

373

THE VOYAGE OF YANG QING

When the astronomer returned from his voyage, he and his colleagues in Beijing compared their data. Using their timekeeping device, calibrated from the gnomon, they timed the interval between the transits of the star observed in the new territory at the time of the eclipse and the star seen by the astronomers in Beijing at the same moment. The earth rotates 360° in twenty-four hours. If the elapsed time between the two transits was six hours, a quarter of the time it takes the earth to rotate, the difference in longitude between Beijing and the new territory would be a quarter of the total longitude around the world - 90°, one quarter of 360°. Errors could be reduced by timing each of the four events of the eclipse, U1, U2, U3 and U4, then averaging the results. By observing the same event at different locations around the globe and fixing the exact time at which this event took place, the Chinese could then compare their results. By determining the differences in the time when the event took place, as observed from the separate locations, they could then calculate the difference in longitude.

Professor John Oliver, Professor of Astronomy at the University of Florida, put the theory to the test by observing the lunar eclipse of 16 and 17 July 2000. He set up teams of observers across the Pacific from Tahiti to Malacca, near Singapore, choosing the same sites as the Chinese observation platforms (Appendix 4). The average longitudinal errors produced by this method were minuscule: 1.1 degrees in Tahiti, 0.1 degree in New Zealand, 0.1 degree in Melbourne and zero degrees in Singapore. This has startling implications. In Professor Oliver's experiments, there was a six-mile longitudinal error between Singapore and New Zealand, and none between New Zealand and Australia. In all, longitude was calculated across one-third of the world's surface, a distance of some eight thousand miles, with a maximum error anywhere of just sixtysix miles. And Professor Oliver's observers were amateurs; with more training and experience, the errors could have been reduced even further. Using their observation platforms at the same sites, the Chinese would have determined longitude just as accurately as Professor Oliver's team, maybe more so. The brilliance of the method is that, unlike calculations for latitude, neither a sextant nor a clock is required.

Having accurately determined the longitude of Malacca near Singapore, for example, the Chinese fleets could then use Malacca as a base to repeat the process using the observation platforms and gnomons on their other bases around the Indian Ocean: Semudera (Sumatra), the Andamans, Dondra Head (Sri Lanka), Cochin and Calicut on the Malabar coast of India, Malindi and Zanzibar in East Africa, and the Seychelle and Maldive archipelagos, all of which appear on the *Wu Pei Chi*. If a sufficiently large fleet was deployed, there is no reason why longitudes across the whole of the Indian Ocean should not have been established in a single lunar eclipse. Men would have been despatched to different locations in readiness to take readings of the lunar eclipse, all on the same night. They could then return to base to compare measurements.

One can imagine the ships of the great fleet dispersing across the Indian Ocean to take their measurements, the eunuch captains anxious to arrive in good time, the sailors doubtless far more interested in meeting the local women, renowned for their beauty and sexual appetite. They welcomed sailors with open arms, as Marco Polo noted: 'They are all black-skinned and go stark naked, both males and females, except for gay loin cloths: they regard no form of lechery or sensual indulgence as sin. Their marriage customs are such that a man may wed his cousin german or his father's widow or his brother's. And these customs prevail throughout the Indies.'¹² However, the crews would have had to postpone their pleasures until the business of the fleet had been completed and the lunar eclipse timed. The results of this Chinese expertise can be seen in the Cantino map of 1502, where the coast of East Africa is depicted with such accuracy that it

THE VOYAGE OF YANG QING

appears to have been drawn with the aid of satellite navigation. Who else but the Chinese could have drawn this astounding chart two centuries before Europeans had clocks, and four centuries before they knew how to separate the South Pole from the magnetic pole? Was there even the remotest possibility that it could have been an earlier, unknown Portuguese voyage?

The Portuguese had no accurate method of calculating longitude; in 1541, thirty-nine years after the Cantino was drawn, a Portuguese attempt to determine the longitude of Mexico City by the measurement of a solar eclipse put it nearly 1,500 miles too far to the west. Yet the Cantino had longitudes correct to within thirty miles along thousands of miles of coastline. The reason was that the Portuguese were using solar eclipses, the Chinese lunar eclipses. The Portuguese did not have enough ships to determine longitude by trigonometry.

Three expeditions to the Indian Ocean had returned to Portugal before the Cantino was made. Vasco da Gama visited Sofala, Kilwa and Mombasa in 1498–9. At Malindi, he took an Arab pilot who guided him directly to Calicut, therefore he could not have charted the coast north of Malindi. Pedro Álvares Cabral's second expedition set off in 1499 and returned in June 1501. Early in the voyage, his fleet was hit by a terrible storm and four ships were lost. One, commanded by Diego Dias, sailed along the east coast of Madagascar, and from there to Mogadishu. His ship was severely damaged and he lost many men. On his voyage home, Dias stood well out to sea, and the only part of the East African coast he could have charted was between Mogadishu and Berbera. Cabral's broken fleet limped from Sofala to Kilwa, then to Malindi.

Thus none of the three fleets that arrived back in Lisbon before the Cantino was drawn had spent long enough on the East African coast to make such an accurate cartographic survey, and none could have charted the entire coast. Moreover, the Cantino covers about nine million square miles of ocean. It would have taken forty ships at least two years to carry out such a vast survey, an undertaking far beyond Portugal's resources at the time. Indeed, it took sixty years for the Portuguese to survey Africa's west coast. To expect a few battered caravels to have done the same on the east coast while simultaneously charting nine million square miles of ocean and six island archipelagos in the few months they were in the Indian Ocean before 1502 is as realistic as expecting a lone surveyor to map a continent with nothing more than a measuring stick and a horse and cart.

Having ruled out the Portuguese, I wondered if Arab navigators could have been the original cartographers. I made an exhaustive examination of the wonderful collection assembled by the wealthy and dedicated map collector Prince Youssuf Kamal, copies of which are in the Map Library of the British Library, but found not one detailed Arabic chart of the east coast of Africa in that whole monumental collection. The best Arabic medieval maps, such as those of Al Idrisi, bear no comparison in detail or accuracy to the Cantino of 1502.

Admiral Yang Qing journeyed much less far than the other Chinese admirals, yet the task he had been set was as vital and as demanding as those of Hong Bao, Zhou Man and Zhou Wen, and his success matches their towering achievements, for by the end of that voyage his men had perfected a method of determining longitude over three centuries before John Harrison's invention of the chronometer.

Though the Western world is largely silent on the origin of these extraordinary world maps, now correct both for latitude and longitude, the inscription on the stone erected by Zheng He in commemoration of his voyages shows where the credit is due: 'And now as a result of the voyages the distances and courses between the distant lands may be calculated.' It was another towering achievement by the Chinese fleets, one that should have burned like a beacon in the annals of global history. Instead, it was to be snuffed out and forgotten, along with the discovery of the Americas, Australia, Antarctica and the Arctic; Europeans would claim the glory that should have belonged to the great Chinese admirals and their fleets. The Portuguese were to lead this European wave of exploration and colonization. They more than any other nation benefited from the hard-won Chinese knowledge of the oceans and new lands that lay beyond them.

VII Portugal Inherits the Crown

WHERE

THE

EARTH

ENDS

IN JUNE 1421, AT THE SAME TIME AS THE CHINESE FLEET WAS rounding the Cape of Good Hope to head north for the Cape Verde Islands, far out in the Atlantic a little caravel – a small Portuguese sailing ship – lay at anchor in a wooded bay of the uninhabited island of Madeira. The great wave of European expansion and colonization that was to spread across the globe and, for better or worse, change the lives and destinies of billions of people had begun, in the most unobtrusive manner. This first small, hesitant step was taken by the Portuguese on their own initiative, but within three years news of the great Chinese discoveries and charts showing those far-flung lands and seas would be filtering into Portugal. No longer would they be sailing into the unknown.

On that June day in 1421, the Portuguese explorer João Gonçalves Zarco and his family must have felt they had arrived in paradise. A kaleidoscope of fish circled the caravel – black espadas, blue tunny, silver-striped mackerel, red bream and grey mullet – and sea lions were Zarco's only competitors for this bounty of nature. Streams of crystal water tumbled into a small lagoon, rich in langoustines and snails. The air was heavy with the sweet smell of jasmine and alive with the songs of birds that had never learned to fear man. Beyond the vivid banks of orchids, azaleas, begonias and jacarandas lining the Madeiran shore stretched mile upon mile of fennel interspersed with clumps of passion fruit.¹

The same streams, the Ribeira de Santa Luzia and the Ribeira de São João, still tumble into the Atlantic, but in place of the lush fields of green fennel are now the quiet streets of Madeira's capital, Funchal. The statue of its founder dominates the Avenida Zarco. The Santa Catarina chapel, erected by Zarco's wife, stands on another street named after him, and next to it is the statue of Prince Henry the Navigator, the man who had made the expedition possible.

The colonization of Madeira, begun on that June day in 1421,

was a pivotal moment in the history of European exploration. Zarco, a knight in the service of Prince Henry, discovered the island by accident. In December 1418, Zarco and Tristão Vaz Teixeira ('Vaz'), another Portuguese knight who had loyally served Prince Henry, had been ordered to explore the African coast down to Guinea, two thousand miles south of Portugal, but their ship was blown off course and driven before the wind to Porto Santo, an island sixty kilometres north-east of Madeira² then populated by crying seabirds and câmara de lobos (sea lions). One sunset, while on the island, Zarco spied a smudge on the horizon in the direction of the setting sun. They set off a week later and took formal possession of the new land in the name of the King of Portugal, of Prince Henry and the Order of Christ, naming the mountainous, densely forested island 'Ilha da Madeira', the Island of Wood. They returned almost immediately to Portugal where Zarco, Vaz and their companions were received with acclaim. Zarco was knighted and given the title Count of Câmara de Lobos.

Prince Henry warmly endorsed Zarco's plan to colonize the islands and financed two further expeditions, providing Zarco with ships and stores. The island was to be divided in two, with Vaz governor of the northern half and Zarco of the southern. Another of Zarco's shipmates, Bartolomeu Perestrello, was sent to establish a colony on the neighbouring island of Porto Santo. It was an ill-starred choice. Perestrello's children had a pet rabbit, a doe. It gave birth to a litter during the voyage to Porto Santo, and when the colonizers settled on the island the rabbits multiplied so fast without natural predators to control their numbers that the island was soon reduced to a desert.

In contrast, the colonization of Madeira was an enormous success and vividly demonstrated the benefits of overseas exploration. Prince Henry pioneered the introduction of grape vines and sugar cane from Crete, which flourished in the warm, damp climate. The famous Madeira wines made from the grapes were exported throughout Europe, and sugar cane production showed equally spectacular profits. Entrepreneurs flocked to Prince Henry's court to participate in future bonanzas, and Portuguese explorers set sail on ever more adventurous voyages, in the vanguard of an expansion that was to see European nations dominate the world for another five hundred years.

Henry was the third son of King John I of Portugal and his wife, Queen Philippa, daughter of England's John of Gaunt. With English help, John had led an uprising in 1383 and replaced the old Portuguese nobility with a new landed aristocracy, the House of Avis, loyal only to himself. John proved a cautious and pragmatic king, negotiating a defensive treaty with England and exploiting that arrangement to make an uneasy truce with Castile. The existing treaty between the separate Spanish kingdoms of Castile and Aragon left the whole peninsula at peace. John's foreign policy was equally cautious, and he was particularly careful not to antagonize Castile by interfering in its sphere of influence abroad.

It was an era of massive Christian confidence throughout the peninsula. After six centuries, the Moors had finally been driven out of the Algarve, their last stronghold in Portugal. King Sancho I of Portugal had invaded the Algarve in 1189, and by 1249 the whole region, once the westernmost province of the majestic Arab caliphate of Cordoba, was in royal hands, allowing the capital to be moved south from Coimbra to Lisbon. With the *Reconquista* complete, Portugal's soldiers, like their counterparts in Aragon, had nowhere to go but overseas.

John and Philippa were devout Christians, but their court was one of the most enlightened in Europe, a centre for men of scholarship and ability regardless of religion. China remained years ahead of Europe in terms of science, technology and, arguably, culture, but fifteenth-century Portugal was beginning to flower and would quickly grow into the principal European centre for voyages of discovery and exploration. It was an age of

rapid change, and his parents ensured that young Prince Henry received an appropriate education. In 1415, just out of his teens, he was entrusted with the command of the Portuguese attack on Ceuta, an important Arab port on the north coast of Africa overlooking the Strait of Gibraltar. Plans were well advanced when Queen Philippa fell gravely ill. As she lay dying, she gave a sword to Henry with the words, 'I give you, Henry, this ... sword. It is as strong as you are. To you I commend all the lords, knights, squires and those of noble blood.'³ She also insisted that Henry proceed with the attack on Ceuta rather than remain at her bedside.

In past centuries, the Moors had launched three invasions of Spain using troops drawn from Senegal to Arabia, and Islamic rulers still controlled a vast empire. Even for someone as daring and resolute as Henry, an attack on Islam's heartland was a colossal gamble, the first European invasion of Africa since that of the Emperor Justinian eight hundred years earlier. Henry's army was drawn from all over Europe, the Christian forces uniting under the banner of a new crusader prince. The attack on Ceuta was preceded by all manner of ruses to disguise the real plan; Portugal even declared war on Holland as a distraction to mislead the Moors. When the assault on Ceuta began, Henry handled his forces so skilfully that the battle was quickly over.

The capture of Ceuta was the first European victory over the Moors in their own territories, an event of great moral and psychological significance. A despatch rider was sent post haste with news of the victory to the Holy Roman Emperor Sigismund and the royal houses of Europe. Henry's success brought him invitations to take up all manner of commands – from the Pope to head the papal armies, and from Henry V of England to lead a crusade against the infidels – but he declined all offers, preferring to act as his father's representative in Ceuta, from where he set about building a Portuguese empire based on the wealth of the gold trade that stemmed from the capture of the city. The Mediterranean world cried out for gold; Arab camel caravans plodded across the Sahara from Mali through Marrakesh, Fez and Meknes – glorious, immensely prosperous cities – to Ceuta. Capturing Ceuta had given Henry's army a secure harbour on African soil, and the opportunity to intercept bullion shipments and strike at the wealth of the fabled Moroccan cities, in the process depriving the Arabs of the money to lubricate their trading routes. Henry had a stranglehold on one of Islam's prime sources of wealth.

Arabs had enriched Portugal and Spain in many ways, and were skilled at exploiting the trading opportunities presented by their far-flung empire. They brought Syrian engineers to irrigate Portugal's Algarve and improve rice cultivation, and developed the corn lands of the Alentejo, where they also introduced cotton and sugar cane. 'Persian' carpets were woven in Bera and Caleena, Chinese methods of paper manufacture were copied in Játiva, and 'Moroccan' leather and textiles were made in Cordoba where there were thirteen thousand leather workers and weavers. Islamic ships carried the finished products from the Tagus estuary in Portugal to Cairo and North Africa.

At the time of the attack on Ceuta, Portugal was still a medieval land, riddled with superstition. Books described the incredible wealth of lands beyond the seas, the extraordinary challenges that awaited explorers and the strange people and monsters lying in wait to attack them. On the way to India there was 'a sea so hot that it boils like water over a fire, and it is all green; and in that sea serpents breed bigger than crocodiles, having wings wherewith they fly, and so venomous that all people run from them in fear . . . because [the serpent] grew in the boiling sea, no fire can burn it . . . in that sea is a whirlpool, so terrible that men fear to venture'.⁴ India was a land 'of wild beasts that are in the wilderness, blue dragons, serpents and other ravening beasts that eat all they can get. There are many elephants, all white; some are blue and of other colours, quite

Sea monsters from Sebastian Münster's Cosmographia, 1546.

numberless; there are also many unicorns and lions and other hideous beasts.⁵ In those far-off lands, men had heads in the middle of their chests, their eyes were in their shoulders; 'They have two small holes, all round, instead of eyes, and their mouth is flat also without lips.' Women hid snakes in their vaginas 'which stung the husbands on their penises'.⁶ By taking Ceuta, Prince Henry and his countrymen had the opportunity to learn the true facts. In his four years in the city, Henry became familiar with the blinding African sun, the bite of sand in the air when the wind comes off the desert, the hot dusty streets, the soft smell of cloves and the extraordinary clarity of desert nights.

Ceuta was also an important port, attracting a cosmopolitan population, and a home to fine Islamic universities. The Arabs revered scholarship and had carefully stored the masterpieces of Greece and Rome, including the geographical works of Ptolemy. They did not subscribe to myths and superstitions about the world around them. They had been trading from the Atlantic to the Pacific for centuries. The Arab geographer Al Barouwi had charted North and East Africa from the Atlantic to Zanzibar by 1315, and in 1327 another famous Arab traveller, Al Dimisqui, had described the real world of the East peopled by ordinary beings and reached by sea voyages across natural oceans. Although the Arabs had not drawn accurate maps of Africa or the Indian Ocean, they did know the relative positions of Africa, India, China and the Far East as early as 1340, when Hama Allah Moustawfi Qazami drew his mappa mundi based on the work of Ptolemy. The Arabs described the sea route to India in 1342 and produced an encyclopedia of Asia in 1391, giving detailed descriptions of the major towns, cities and mosques.

It must have been a life-changing moment for Prince Henry to learn that Arabs had traded over the whole known world for centuries. He had only to follow in the wake of Arab dhows to discover those same exotic lands. The whole world lay at his feet if he could build an ocean-going fleet, and to do that he had to return to Portugal. By Christmas 1419 he had chosen Sagres in south-west Portugal as his permanent base. There Henry the Navigator built a *forteleza* (fortress) and founded a chapel, a hospital, and the school of navigation that earned him his name and changed the course of world history. A painting in Lisbon's Maritime Museum depicts Henry's court at Sagres, peopled by Catalan sea captains, Jewish cartographers, Arab astronomers, Portuguese knights, men-at-arms, sailmakers, priests, shipwrights, physicians, sailors and court retainers, all of whom lived, prayed, ate and worked together.

There are some parts of the ocean where a mariner knows his position by the smell of the sea. The Grand Banks off Newfoundland is one, the Straits of Malacca another, but most potent of all is the scent of pines off Sagres on a warm summer's night, a smell that for me always brings back memories of voyages to the East, for after Sagres one alters course to the south-east for the Mediterranean and the lands beyond. Even today, Sagres is daunting. It stands some two hundred feet above the Atlantic, jutting out into the ocean, looking out over Cape St Vincent, passing ships no more than a distant blur on the horizon. Below, long rolling breakers smash into the cliffs, their dull boom a constant background to the haunting cries of seabirds. In winter and spring the promontory is lashed by rain; at many other times it is veiled in spray and sea-mist. The lush vegetation of the mainland gives way to stony scrub; neither flowers nor trees grow. A great grey wall, its stones hewn from the cliffs, guards the entrance, and through a dark oak door one can glimpse a row of austere houses and the simple chapel of St Catherine.

To the Portuguese, Sagres was the end of the world, 'where the earth ends and sea begins'.7 Closer inspection reveals that the promontory was an inspired choice as a base. Each winter and spring, the prevailing north-west wind sucks vast quantities of water out of the Atlantic and dumps it onto the mountains of the Sierra Monchique; despite the torrid summer heat - it is further south than most of Spain - the area is sub-tropical in character. A day on horseback takes the rider into foothills where lush, verdant forests are interspersed with cork and oak trees, and white almonds, oleanders, hibiscus, lilies and geraniums thrive on the heat and moisture. Groves of orange and lemon trees, laden with fruit, grow among dark pine forests. Cabbages are planted beneath date palms, and vines are cultivated on trellises among the heather. The edge of the continental shelf is only a few miles offshore from Sagres where the ocean falls steeply to two thousand fathoms, over two miles deep. The seas teem with fish; over a hundred species have been found around Cape St Vincent. Fleets of small boats bring in heavy catches of cod, anchovies and sardines for drying and salting. The cliffs afford shelter, the small harbours safe mooring against the prevailing northerly storms.

Here, in the south-west Algarve, Henry the Navigator had access to everything necessary to build, fit out and provision a fleet – limitless supplies of soft pine for ribs, resinous pine for planking, oak for rudders and keels, gum for caulking, wool and hides to clothe the crews, bamboo and reeds for their beds and baskets. Provisions for a two-month voyage – salt fish, rice, wheat, olives, dates, oranges, lemons and almonds – were in abundant supply. Sailors also need alcohol; as in Henry's day, the

A Portuguese caravel in full lateen rigging.

full, fruity and strong Alentejo wine, made from Periquita grapes, is still fermented in large earthenware jars cast from the heavy red soil.

When Henry arrived at Sagres, Catalan cogs – small cargo vessels – were evolving into good ocean-going ships, but they were still square-rigged. From his experiences at Ceuta, Henry knew that Arab dhows bound for the eastern Mediterranean spent much of their voyage in light, variable winds, and had to be able to sail into the wind. Square-rigged ships, sailing always before the wind, often had no rudder. Dhows had rudders, and the Arabs had refined the lateen (triangular) sail so that two men, hoisting it on a simple block and tackle, could control a large area of canvas. Henry incorporated a stern rudder into the design of his new sailing ship, the caravel, a cross between a Catalan cog and an Arab dhow – the design lives on in the modern ketch – but of all the improvements Henry introduced, none surpasses his brilliant adaptation of the Arabic lateen sail. The later caravels had lateen sails on mizzen and main masts and a square sail on the foremast, and could be converted at sea to be either square- or lateen-rigged. A mariner could sail southwards from Portugal square-rigged before the prevailing wind, then convert to lateen sails to return north into the wind. Although tiny in comparison to Chinese junks, caravels were much more nimble and manoeuvrable.

Henry's next problem was to enable his captains to measure their position on the earth's surface. Determining the correct position of new discoveries and then finding the way home depended upon knowing latitude and steering the correct course, and that in turn depended upon the compass. Arabs had used compasses for centuries, after obtaining the device from the Chinese with whom they regularly swapped nautical knowledge. However, the Chinese knowledge of navigation, astronomy and the means by which latitude and longitude could be calculated, perfected on the last great voyage of the treasure fleets from 1421 to 1423, remained theirs alone. Europeans were still floundering in their wake decades, and in the case of longitude centuries, later.

Henry was a dedicated mathematician, and by the late 1460s, just after Henry's death, his astronomers, assisted by Arabs, had solved the problem of latitude. Arabs had an old civilization and they, too, were dedicated mathematicians. In Henry's era they were far better educated than Europeans and were used to sailing the Mediterranean and Indian Oceans out of sight of land. To this day, many stars in the sky – Betelgeuse, Aldebaran, Mikah – have Arab names, and British Admiralty charts credit Arab navigators in the use of names such as Ras Nungwi and Ras Al Khaimah. Arab navigators knew that the altitude of the meridian passage of the sun – its maximum height in the sky at noon each day – could be measured by lining up the sun with the

WHERE THE EARTH ENDS

A European determining latitude, from Pedro de Medina's *Regimiento de Navigación*, 1563.

horizon. Either wooden or brass instruments would do; one of the simplest and best was designed by Gil Eannes, one of Henry's captains, in the 1460s.

The sun's maximum height varies day by day throughout the year, and the difference between this daily height and the height at its lowest point in midwinter was named the declination of the sun. The Arabs had discovered that the sun's declination, when subtracted from its height at midday, gave the latitude of a place in the northern hemisphere.⁸ In 1473, Regiomontanus, the Viennese astronomer who had attended Henry's court, produced a set of 'ephemerides tables' giving day-by-day declinations of the sun. A captain in the distant oceans now merely had to measure with a quadrant – a rudimentary type of sextant – the altitude of the sun at its meridian passage, then consult the tables to find the sun's declination for that day. By subtracting declination from altitude the mariner knew how many degrees south (and hence how many miles) he was from home. With a caravel and a quadrant, sailing back to Sagres was relatively simple. The mariner

sailed due north, following the Pole Star by night and setting a course opposite to the sun's noon position by day, until he reached the latitude of Sagres, whereupon he altered course to the east, keeping to that same latitude until he could see Cape St Vincent or smell the scent of pines in the air.

By 1420 Henry had designed and built an ocean-going caravel that could remain at sea for weeks at a time and could return home. He knew from the Arabs that the medieval fables of monsters and boiling seas were nonsense, and that the oceans of the world could be crossed to discover new worlds. The last piece of the jigsaw was the production of accurate charts to enable his captains to reach the East. In 1416, Prince (Dom) Pedro, Henry's elder brother, 'seized with the desire to gain enlightenment by travel through the principal countries of Europe and Western Asia',9 had set off on an odyssey to garner every possible piece of information about the world beyond the Mediterranean. King John had invested a substantial sum in Florentine bonds to cover his son's travelling expenses, and the King of Spain had provided him with a retinue of servants. translators and scholars. He travelled through Spain, Palestine, the Holy Land, the Ottoman Empire - 'the Grand Sultan of Babylon' - Rome, the Holy Roman Empire, Hungary, Denmark, England and Venice, and 'at the end of twelve years' travel Dom Pedro returned in 1428 to Portugal'.¹⁰

He had departed the year after Ceuta was taken, a time when the Portuguese were lionized throughout Christian Europe. All had shared in the excitement of Prince Henry's daring gamble to form a bridgehead in Africa, the heartland of Islam, and now Dom Pedro was treated as a conquering hero at whose feet Europe lay. He could go where he wanted, ask what questions he wished and receive all the knowledge his hosts possessed. In England, he had been created a Knight of the Garter; the Doge had personally entertained him in Venice; the King of Spain had showered him with gold; and Emperor Sigismund had given him valuable land in the March of Treviso, a fertile province a few miles north of Venice that had served as his base from 1421 to 1425.¹¹

In many ways, Dom Pedro was the ideal complement to his younger brother. Henry was a practical man of action, Pedro a dreamer and a visionary of immense charm who was appalled by European conflicts and fired his hosts with his ideal of uniting Christians in Africa, India and Cathay (China) by voyages of discovery. His twelve-year odyssey was a brilliant success, and he returned to Portugal in 1428 with 'a map of the world, which had all the parts of the world and earth described'.12 This seemingly incredible map showed the 'Streight of Magelan' and the Cape of Good Hope sixty years before Dias and nearly a hundred years before Magellan set sail (see p. 107). Until it appeared, most European maps of the world had Jerusalem at their centre, their edges patrolled by wild beasts. This new knowledge of the world, hard-won by the Chinese during their great voyages of exploration, was to become the driving force behind the European voyages of discovery.

Dom Pedro, like Henry, had been well educated in an enlightened court, and tutored by Venetian scholars. When the princes were young, the Council of Pisa (1409) had been convened, primarily in an attempt to end the thirty-year 'Great Schism' between the rival popes established in Rome and Avignon. It failed in its aim – the attempt to depose the rivals and install a new pope merely led to there being three popes instead of two – but Portugal sent a major mission to that council, and Dom Pedro and Prince Henry took great interest in its other deliberations. They could not have failed as a result to become acquainted with a revolutionary work, Ptolemy's *Geographia*, long forgotten in Europe but now translated into Latin. It was brought to that council and delivered to the newest pope, Alexander V.

The rediscovery of the Geographia created a sensation in

Europe, for it maintained that the earth was not flat, but a sphere - something the Chinese already knew - and set out the principles of latitude and longitude by which man could determine his own position and that of new discoveries on that sphere. More than anything else, the reintroduction of Ptolemy into the mainstream of European political life revolutionized cartography and exploration. But brilliant as the Geographia was, it contained no maps, only explanations of how to use information to make them. This deficiency was rectified when the Byzantine cartographers Lappacino and Bonnisegni fled the Turks encircling Byzantium, to settle in Venice in 1415. They brought with them a number of maps based upon Ptolemy's Geographia showing Africa and India in their correct positions. At the latest, Dom Pedro would have known of these maps by 1428, when he paid his state visit to Venice, though almost certainly he knew of them by 1424, when Niccolò da Conti returned from his travels.

There are two versions of how da Conti returned to what we now call Italy. One school contends that he had returned from the East by 1424, but he had come in fear of his life, in disguise and under the *nom de guerre* 'Bartholomew of Florence' because he was a renegade who had converted to Islam at a time of intense religious persecution and wished to avoid being burned like John Huss, the Czech protestant reformer who had been executed for heresy only nine years earlier.¹³ The other school claims that Dom Pedro instructed a famed Franciscan friar, Alberto de Sarteano, to bring da Conti back from Cairo, where he was in hiding, on the promise of absolution.¹⁴ Fra Sarteano succeeded, escorting da Conti to Florence, and Dom Pedro then immediately summoned his envoy to Portugal for a complete debrief of his voyage with the Chinese fleet.

Dom Pedro's principal aim in this was to link Portugal with isolated Christian communities in the East supposedly founded by the apostle Saint Thomas, to encircle Islam and to find a new way to Cathay – a route urgently needed, for while Dom Pedro was travelling, the borders of Egypt were sealed by the Mamluk sultans who ruled the country. By the end of 1421, the Ottomans, who were already in possession of Asia Minor, had surrounded Byzantium and taken control of the terminus of the Silk Road across Asia. An impenetrable barrier had been erected across the eastern Mediterranean and the Near East.

Dom Pedro achieved a magnificent intelligence coup by retaining Fra Mauro and Poggio Bracciolini, the Papal Secretary, and by debriefing the 'renegade', Niccolò da Conti. By doing so he obtained the knowledge that da Conti ('Bartholomew of Florence') had acquired in twenty years' sailing the world – from India to the Cape Verde and Falkland Islands, to Australia and China. Dom Pedro now knew that Cathay and the Spice Islands could be reached by sailing westwards.¹⁵

The cartographer Paolo Toscanelli (1397–1482) made the same claim after meeting da Conti and extracting every scrap of usable information from him. He later relayed the material in a letter to Christopher Columbus:

I notice your splendid and lofty desire to sail to the regions of the East [China] by those of the West as is shown by the chart which I send you, which would be better shown in the shape of a round sphere ... not only is the said voyage possible, but it is sure and certain, and of honour and countless gain ...

I have had most fully the good and true information . . . of other merchants who have long trafficked in those parts, men of great authority.¹⁶

Toscanelli sent a map to Columbus showing the westwards route across the Atlantic via Antilia. He also passed on da Conti's information to Behain of Bohemia¹⁷ (1459–1507), who was working for the Portuguese government. Behain then showed the strait leading from the Atlantic to the Pacific on both the globe he produced in 1492 and on his maps, and Magellan

acknowledged that he had seen them in Portugal before he set sail.¹⁸ A number of other accounts describe Magellan examining Toscanelli's charts in the Portuguese treasury. One can only imagine the extraordinary impact these charts, based on the Chinese voyages of 1421 to 1423, must have had on the Europeans, for they traced the boundaries of vast, unknown oceans and of lands such as South America and the Antarctic whose very existence had previously been clouded and uncertain.

Toscanelli's letter to Columbus and the statements of Magellan and his diarist Pigafetta are further evidence that, long before Magellan set sail, the Portuguese knew that the quickest way to China lay westwards through the strait later named after Magellan but first navigated and charted by the Chinese. The information came from Niccolò da Conti, 'the merchant who travelled in those parts'.¹⁹

With the reappearance of Niccolò da Conti, I felt I had almost come full circle. It had been in every sense a long and extraordinary journey since I had first seen a mention of his name and his presence in Calicut at the time Zheng He's treasure fleet passed through the port. It had led me to every corner of the globe, and everywhere I had found traces of the Chinese voyages da Conti had described. Now it was clear that the Portuguese and Spanish had read and heard the same accounts and been inspired to make their own voyages of discovery.

Having learned of the existence of new lands beyond the seas from da Conti in 1424, Dom Pedro carried back to Portugal in 1428 a map of the world showing 'all the parts of the world and earth'²⁰ – Africa, the Caribbean (Antilia), North and South America, the Arctic and Antarctic, India, Australia and China. The information it contained was hugely valuable, and for over a century afterwards the Portuguese went to considerable trouble to prevent any knowledge of it from reaching competing European powers. Coupled with Henry's improvements to navigation and ship design, the world map revolutionized European exploration for all time. Henry knew that if he could fund his expeditions, Portugal could dominate the world. He needed substantial capital, for there was a large retinue to feed and house, a hospital to maintain, a chapel to be endowed and caravels to be built and fitted out for voyages that might last for months.

The Pope had appointed Prince Henry Grand Master of the Order of Christ in 1420, and its Red Cross motif adorned the sails of his caravels. Funded by tax revenues, the order's principal duties were to defend Portugal and to lead crusades against the infidel. Both Niccolò da Conti and Marco Polo had described a series of Christian states extending all across India.²¹ Dom Pedro and Prince Henry now had the knowledge that would enable Portuguese seafarers to reach those Christian communities, and the Order of Christ could fulfil its destiny by linking them.

The order, then, was Henry's prime source of funds, but even its substantial wealth would have been swiftly exhausted without a return on the capital invested in those voyages of discovery. The return was to come first through the colonization of Madeira, an uninhabited island with fertile soil, abundant rainfall and plentiful sunshine. As we have already seen, by June 1421 João Gonçalves Zarco had claimed the island for Portugal and begun the work of planting crops that were to yield huge profits for Portuguese investors and drive the search for new territories to explore, exploit and colonize.

Colonization was carried out methodically, and the governors of Madeira were required to produce monthly reports of progress. Although vast areas of virgin forest were devastated by fires soon after settlers began to arrive, it proved to be a blessing in disguise. By clearing the forest and enriching the soil with potash, the fires merely speeded the growth of an island economy based on the planting of grape vines and sugar cane,

and ever larger quantities of sugar and Madeira wine were produced and exported.

The island provided a vivid illustration of the commercial gains to be won from successful exploration, and as increasing numbers of Portuguese entrepreneurs beat a path to Henry's court, financing voyages of exploration became easier. In the earlier years the strain of fund-raising had taken a heavy toll on the resources of the Order of Christ and on Henry's stamina, but after colonizing Madeira he was financially secure. Portugal could now begin to look further across the oceans to the west. If one small island could yield such wealth, what untold riches might be made from new colonies beyond the seas? Those lands were not unknown to Prince Henry and his sea-captains, for they had the Chinese charts to lead and guide them.

COLONIZING

THE

NEW

WORLD

THE PORTUGUESE LOST LITTLE TIME IN EXTENDING THEIR search for new territories in which colonies could be established westwards across the Atlantic: 'As early as 1431 we see Prince Henry the Navigator send Gonzalo Velho Cabral in search of the islands marked on the map which Dom Pedro, the son of King João I, had brought from Italy in 1428.'¹

As they voyaged further and further, Prince Henry's caravels must have quickly discovered Antilia - Puerto Rico - and established a colony there. Andrea Bianco's 1436 chart describes the Sargasso Sea with the Portuguese name for seaweed, mar de baga - powerful evidence that they had reached the Caribbean, for the Sargasso Sea, a mass of floating seaweed, is unique in the world. It could only have been described by someone who had sailed there: and because of the circular wind and current systems, it can only be easily reached from Europe after passing through the Caribbean. The Portuguese could not have been the creators of the first map showing these lands, for of course it predates their voyages. I could only wonder if those first Portuguese settlers had found traces of the Chinese voyages - a carved stone, fragments of porcelain, utensils or artefacts, or a once neat but long overgrown plantation of rice. Would they have paused to wonder at them, or merely shrugged their shoulders, dismissed them as native curiosities and turned their minds from high-flown thoughts to the gritty reality of winning a living from the soil?

Unlike Guadeloupe, Puerto Rico was populated by peaceable people. If the Portuguese did settle here in 1431, some ten years after the Chinese visit, their descendants should have survived to greet Columbus or later explorers. Columbus's first visit to Puerto Rico in 1493, during his second voyage to the New World, was a fleeting one. He was in a hurry to reach the Spanish garrison of La Navidad and the gold mines in Hispaniola, the next island to the west, and visited a single port in Puerto Rico, remaining only a few days. Nonetheless, Columbus found the port to be a civilized one:

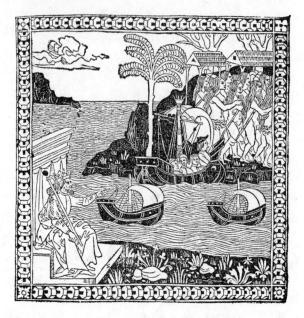

King Ferdinand sending Columbus to the New World. From Giuliano Dati's verse rendition of Columbus's first letter to the King of Spain published in 1493.

The fleet moved on past Saint Ursula and her eleven thousand virgins [the Virgin Islands] till it reached Porto Rico which was the home of most of the captives taking refuge with the Spaniards [refugees taken aboard at Guadeloupe]. On the west end they found a fine harbour abounding in fish. Here was a native village with a public square, a main road, a terrace – all in all quite an artistic home-like place.²

As I dug deeper into Columbus's records, I found another story: 'A storm driven ship landed at the Isle of the Seven Cities [Antilia] in the time of the Infante D Henriques [Henry the Navigator].' The crew were welcomed by the inhabitants, invited in good Portuguese to attend divine service and urged to remain until their ruler showed up.³ Prince Henry, of course,

COLONIZING THE NEW WORLD

had died long before Columbus set sail. The story was corroborated by the sixteenth-century Portuguese historian Antonio Galvão:

So in this year, also 1447, it happened that there came to Portugal a ship through the streight of Gibraltar, and being taken with a great tempest, was forced to run westward more willingly than the men would [wish], and at last they fell upon an island which had seven cities, and the people spake the Portuguese tongue, and they demanded if the Moors did yet trouble Spain... The boatswain of the ship brought home a little of the sand, and sold it unto a goldsmith of Lisbon, out of which they had a good quantity of gold.

Dom Pedro understanding this, being then governor of the realm, caused all the things thus brought home, and made known, to be recorded in the House of Justice.

There be some that think that those islands whereupon the Portugals were thus driven were the Antiles or New Spain, alleging good reasons for their opinion.⁴

It was compelling evidence that the Portuguese did settle Antilia in 1431, and were still there in 1447. The Portuguese regent, Dom Pedro, certainly knew of the island; it had appeared on the 1428 map he had personally brought back to Portugal. I was sure that records of what those visiting caravels found must have existed. It would be absurd to imagine that they had travelled for weeks across the oceans, come across an island of Portuguesespeaking people, then sailed on without making a record of the island and their compatriots' way of life. It was also likely that some of the people who had landed in Puerto Rico in 1431 would have wished to return home by 1447. Some of them were doubtless yearning for their homeland, longing to hear once more the sad, lilting *fado*, and hoping to pass their twilight years in their native land. Those people who did return after the 1447 voyage would also have given the necessary information

to the cartographers to correct the earlier chart.

Zuane Pizzigano, author of the 1424 map showing Antilia, never produced another chart and history does not record his fate - I assumed that he had died by the 1440s - but I returned yet again to the Map Room of the British Library and examined the first charts drawn after 1447. These proved a remarkable source of information. A series of charts followed one another in quick succession between 1448 and 1489.5 In all, I looked at seven pre-Columbian charts, containing seventy-three names and describing features on Antilia and Satanazes. I would have expected these later charts to be updated with further information, but in fact the map drawn in 1463 by Grazioso Benincasa had the same number of cities as the Pizzigano chart. The only change was that all seven cities shown on the earlier chart had been renamed on the later one. The drawing of the island was identical, save for the addition of one more bay on the north coast of Antilia and a more accurate depiction of the south-west and east coasts. I could not understand why the cartographer had renamed all the cities. The mystery deepened with another chart, from 1476, which yielded yet another set of names. Why had they kept changing the names of the cities?

I was convinced that the names must be in medieval Portuguese because the caravels despatched by Prince Henry would hardly have been manned by mercenaries, so I turned to a dictionary for a translation. With the exception of Antilia, not a single name on the later charts appeared to be in medieval Portuguese. They were incomprehensible.⁶ If the islands were indeed populated, why did the seven cities not have Portuguese rather than fairytale names?

I asked the owners of the Pizzigano chart for help. The Royal Geographical Society in London had a copy of a pamphlet⁷ by Professor Carol Urness, the custodian of the chart, describing the efforts of historians over the last fifty years to solve the question of the identity of the islands. It appeared from the pamphlet that the experts were baffled, and it seemed presumptuous of me to expect to succeed where they had failed. I decided to abandon my quest and leave the mystery for others. I headed home from the Royal Geographical Society thoroughly despondent after being frustrated at this last hurdle, unable to get corroborative evidence that the Portuguese had settled in Puerto Rico after the Chinese had discovered the island but before Columbus set sail.

In times of trouble, my habit is to pray to the Virgin and eat bacon sandwiches. Having done so, a thought occurred to me. Sagres, the home base of the caravels, is only a day's sailing from Sanlúcar de Barrameda on the estuary of the Guadalquivir. In 1431, it was a major Castilian port. Had there been any Castilians aboard those caravels, and if so, could the writing be in medieval Castilian? I hurried back to the British Library. I found a Castilian dictionary in six volumes, but only A-D was available. That scarcely mattered, because six of the seven names on Grazioso Benincasa's 1463 chart began with the letter 'A'. Not one appeared in this massive medieval dictionary; the names were not Castilian. Were they from Aragon, then? The people of Aragon spoke Catalan, but once again, not one name appeared in the dictionary of medieval Catalan. I made a final, desperate search in the Basque and Latin dictionaries, to no avail. I was beaten.

I left the reading room and paced around the courtyard outside the library, cudgelling my brains without success. I then went back to the reading room to put away the dictionaries. There were seven of them strewn across my desk. As I closed the medieval *Dizionario Etimologico* my eye was caught by a section on the code employed in medieval times. Y meant 'there is' or 'and'; *a* meant 'towards'; *j* emphasized the letter before or after it; and *an* before a word meant *particular negativa*, 'the opposite of'. To describe black, they would write *anblanco* (the opposite of white). Was this the key I was looking for?

I went back to the charts. Six of the names began with an, 'the

opposite of'. Instead of looking for *ansollj* in the dictionary, I should have been looking for its opposite, *sollj* – and *sollj* meant 'sun'. Feverishly, I worked through the medieval Catalan, Castilian and Portuguese dictionaries, cross-referencing with modern dictionaries. There were now ten of them scattered across the desk. One of the names was indeed Catalan, a few were Castilian, but the great majority were medieval Portuguese. I began to compile an alphabetical list. Sixty-three of the seventy-three names were in medieval Portuguese, four of the remaining ten were Castilian, one was Catalan and five were unaccounted for. I expected the last five to be medieval Venetian – Pizzigano came from Venice – but surprisingly, only one was. Three were in the Veneto language of Treviso. One name, *anthib*, had me beaten.

I checked the names against a modern map of Puerto Rico and within half an hour I had found the solution: the names were not of the seven cities but descriptions of natural and man-made features, and the descriptions on the 1448–89 charts put it beyond argument that Antilia was Puerto Rico. Mountains, rainforests, harbours, rivers and salt-pans were described on Antilia exactly where they are found on Puerto Rico. There were no discrepancies between the charts: the later ones merely amplified the former. Some Castilian names were used on later charts, but they still described the same place. Only two islands in the whole world fit these descriptions: Puerto Rico and Guadeloupe.

Con is marked on the south-east part of the island of Antilia/Puerto Rico – the conical mountain of Pico del Este. To the north, the cartographer has placed ansollj, 'no sun', corresponding precisely to the El Yunque rainforest, deluged with 240 inches of rain a year. Similar tropical downpours – choue, chouedue, cyodue – are shown at the western end of the island at the end of the Cordillera Central. This area has an annual rainfall of a hundred inches, still prodigious by European standards. The draughtsman described marshes (ensa) around present-day Mayaguez, the waterlogged estuary of the Grande Rio de Añasco, but one of the most interesting descriptions was antuub or an tuub, literally 'without drainage tubes', placed on the north coast to the east of Arecibo. Today, the area remains a vast mosquito-ridden swamp called Cienaga Tiburones. The name Tiburones is Castilian, tiberon, or 'drainage', in turn deriving from the Portuguese tubaro. Brilliant red and green Puerto Rican parrots, ansaros, are denoted in the south-west - presumably the Portuguese wore the feathers of these exotic birds in the same way Columbus's sailors later did. The forest of Boquerón where the cartographer drew these parrots remains a bird watcher's paradise today. The lack of arable and fertile land is vividly caught in the descriptions of the cartographers (Puerto Rico to this day has less than 5 per cent arable land): ansessel, 'no grass', appears four times, supplemented by an suolo, 'no arable land'. Redeeming features are found on the narrow coastal plains.

The translation that caused me most difficulty was asal. My dictionary⁸ said that the word is derived from the Latin acinus, meaning 'berry, especially grape, also any berry or the seeds in a berry', but asal is placed on the chart on a mountain slope behind Ponce. Winters in Puerto Rico are too hot for grapes - they need very cold winters to thrive - but asal was written above modernday Yauco, the 'coffee capital' of Puerto Rico, so I wondered if the Portuguese were describing coffee beans. This theory provoked a vigorous debate among the historians advising me. Some pointed out that coffee was indigenous to East Africa and was introduced to the Caribbean by the Spanish, so it could not have been marked on charts made before the Spanish landed. But further research9 revealed that at least nineteen strains of coffee were found in the Caribbean before the Spanish arrived. It grew on mountain slopes, usually between three and four and a half thousand feet, in temperate climates within the tropics where there is no wind but plenty of morning sun. These

conditions are found on the southern slopes of the Cordillera Central behind Ponce, just where *asal* is marked on the charts of Antilia. Could the Chinese have introduced coffee when they arrived in late 1421?

The second translation that provoked a heated debate was *cua cusa* – pumpkin – shown on the coastal plain in the east near Naguabo. Had pumpkins and squashes really grown there? It transpired that they still do. On a visit to Puerto Rico while researching this book, I took photographs of twenty varieties piled in heaps beside the road: long yellow, champion market, hackensack, manu, rocky ford and white Japan musk squashes; yellow, crookneck, orange, white, delicate and golden scalloped melons; and an assortment of cucumbers, gherkins and eggplants.¹⁰ They grow in such variety and profusion and to such a size because of the sunshine, volcanic soil and moderate rainfall particular to the eastern coastal strip of Puerto Rico.

The really fascinating aspect of the translations of these names is that they were shown on charts published before Columbus set sail and they describe plants foreign to Puerto Rico. Coffee was then native to Africa, cucumbers to India, mangoes to south-east Asia. Columbus also found coconuts, native to the Pacific. Not only had someone reached the Caribbean before Columbus and drawn Puerto Rico with incredible accuracy, they had also brought plants there from all over the world. It seems to me that only the great Chinese fleet commanded by Admiral Zhou Wen could have achieved these things.

Marolio was another interesting name, on a chart drawn by Albino Canepa in the 1480s. It was placed in the same position as *marnlio* on the Pizzigano chart; I assumed that the lower edge of the o had become erased. Marolio is medieval Portuguese for 'plants of the Annonaceae family' – star fruit, sweet and sour sops, pawpaws and custard apples. On both charts the cartographer had placed the description just north of modern Ponce in the middle of the south coast. This area remains the centre of the tropical fruit industry of Puerto Rico, rejoicing in plantations of star fruit, sour sops and papaya. Their juice is exported all over the Americas and forms the basis for the rum punches tourists continue to enjoy. These fruits were indigenous to southeast Asia and South America. Once again, I concluded that the Chinese had introduced them to Puerto Rico in 1421.

The cartographers depicted Satanazes (Guadeloupe) in an entirely different light to Puerto Rico. They changed the name from Satan's or Devil's Island to Saluagio (Island of Savages) in later charts.¹¹ Those later charts of Guadeloupe merely amplified what could be seen from the sea -a second volcano (con), Mont Carmichael at 1,414 metres, with a plateau (silla) between it and La Souffrière. The waterfalls flowing down the east side of La Souffrière (Karukeka and Trois Rivières) had the soubriquets duchal and tubo de agua - 'showers from heaven'. Villages and cultivated fields (aralia y sya) are shown on the low land on the west coast of Grande Terre, just where Columbus described them as he sailed past years later. Satanazes is clearly a horrible place, summarized by Albino Canepa as nar i sua, 'nothing but sweltering heat', but the description of the island of Saya (Les Saintes), 'any number of tropical birds', was apt, for the island is still renowned for its kingfishers, hummingbirds and bananaquits - little flying jewels flitting across the turquoise sea that separates the islands.

The most unusual name Zuane Pizzigano had written on Antilia (in the south-east, covering Vieques Island) was *ura*, placed next to *con* on later charts. *Uracano* is Venetian for 'violent explosion', 'eruption' or 'tempest'. By 1421, the volcanoes on the south-east coast of Puerto Rico had long been extinct, and earthquakes were and are more prevalent on the west of the island, near Mayaguez, but hurricanes invariably approach from the east and roar north-westwards from Vieques Island to San Juan. I was sure that this was what the Chinese cartographer had seen when the junks arrived in November, during the

hurricane season that runs from June to the end of November.

All these names, coupled with the physical similarity between the islands on the Pizzigano chart (and others) and what is actually there, put it beyond argument that Antilia is Puerto Rico, Satanazes is Guadeloupe and Saya is Les Saintes. Although it is possible to quibble over the nuances of a few of the medieval Catalan or Castilian translations, continued debate about the identity of the Antilia group of islands is pointless. These names and maps are unequivocal proof that the islands were continuously settled by the Portuguese from before 1447 until 1492, the time of Columbus's first voyage. The plants foreign to Puerto Rico were brought there before Columbus set sail. To my mind, this is proof that the Chinese discovered Puerto Rico.

Although the depiction of the islands was accurate, their location and orientation was not. They were shown in the Atlantic rather than in the Caribbean, more than two thousand miles away from their correct position. The error was gradually corrected by succeeding cartographers. By 1448, the islands were 1,500 miles west of the Canaries (750 miles in error), and by 1474 they had again shifted westwards, just 500 miles in error. The mistake is easily explicable. In 1431, Henry's captains did not have good astrolabes (sextants), nor did they understand declination. Portuguese navigators did not know how to use Polaris until 1451; only after 1473, using declination tables, could they finally determine latitude with accuracy (Toscanelli's 1474 chart places Antilia at the correct latitude). Longitude remained a problem. Columbus put the Americas a thousand miles out for longitude, as well as twenty degrees for latitude. When he returned from his first voyage, he did not know where he had gone, what he had found or where it was. He thought he had reached China.

In the fifteenth century, the Portuguese navigated by compass and measured their speed through the water by throwing logs off the bow. They positioned the islands by dead reckoning, calculating their position by speed through the water multiplied by the number of days travelled. But they did not realize that the great mass of water over which they were sailing was itself moving, taking them away from their dead-reckoning position. Like Columbus, the Portuguese did not know where they had gone. When I made adjustments to allow for the movement of water during their ten-week voyage from Madeira to Guadeloupe,¹² I found that the Portuguese had placed the islands in their correct dead-reckoning position and orientation.

I felt that there were two further questions about the Pizzigano chart still to be answered. The first concerned the size of the islands. In the earlier charts, Antilia was depicted as bigger than Puerto Rico, and Satanazes was also shown larger than Guadeloupe; a mistake caused, I believe, by transposing not only the wrong position of the islands but their scale from the earlier (Chinese) map onto a European one. The other outstanding question was when and where the Pizzigano chart had been made. It seems likely that he was working under the direction of Dom Pedro, whose cartographers were searching for information about new lands in order to create a world map for Prince Henry. I knew that the Holy Roman Emperor had given Dom Pedro substantial estates in the Veneto at Treviso, fifteen miles north of Venice, and this became the Portuguese delegation's base. It struck me that the Portuguese cartographers probably met Niccolò da Conti there in 1424. He, of course, had spent years aboard a junk of the Chinese treasure fleet, the original discoverers of Antilia. The chart was almost certainly made in Treviso, since the majority of the 'non-Portuguese' names on the chart were in the dialect of Veneto rather than Venice. Pizzigano may have been a monk at the great Dominican sanctuary of San Niccolò at Treviso.

The Pizzigano chart depicted Puerto Rico so accurately that whoever collated the information must have been a master of his craft; in that era, that meant the original cartographer can only have been Chinese. The importance of the chart and those that followed is twofold: not only do they provide evidence that the Chinese discovered the Americas seventy years before Columbus, they also show that Puerto Rico had become a permanent Portuguese settlement before 1447. The names on the subsequent charts continually hone the descriptions of the islands long before Columbus reached them. The positions of the islands were also continually corrected, and the charts from 1463 and 1470 contain a wealth of additional information about Antilia, including further bays on the north-west and east coasts, and the slightly exaggerated south-west tip was redrawn with greater accuracy. The island of Ymana, to the north of Puerto Rico, was also better drawn on later charts, its name changed to Rosellia. As European navigators discovered declination and the measurement of latitude, and improved their sextants and their measurement of time, the positions of the islands on the charts were moved to the south-west.¹³

Identifying Antilia and Satanazes enabled me to pinpoint the other 'islands' surrounding them on the medieval charts. Andrea Bianco's chart of 1448, for example, includes the north-east coast of Brazil, and Cristobal Soligo's 1489 chart¹⁴ shows a further seven 'islands' – the tip of Hispaniola in the west, Trinidad, the Virgin Islands, St Vincent, St Lucia, Barbados and the north coast of Venezuela in the south – all before Columbus had even set sail.

I returned to the chart of Puerto Rico and began to search for the probable site of the first settlement. Both the Portuguese and the Chinese must have approached from the south-east on the prevailing winds. The southern and western coasts of Antilia were more accurately drawn on the Pizzigano chart than the northern or eastern coasts, so I concentrated the search there.

The Pizzigano chart has *cyodue*, 'incessant rain', to the west, *ansuly*, 'lack of fertile land', in the south-west and *ura*, 'hurricane', to the east; none of these sounded a particularly

COLONIZING THE NEW WORLD

inviting place to settle. On the other hand, *marolio*, 'luscious tropical fruit', is shown just north of Ponce, and Ponce Bay was drawn with striking accuracy on all the charts, showing a prominent headland, La Guancha, to the east of the bay. For centuries, this headland has provided sheltered anchorage from the easterly winds. The sea abounds in fish and, located as it is in the rain shadow of the mountains, Ponce has by far the best climate in Puerto Rico. When I flew there to take a look on the ground, I could see the purple clouds of an afternoon thunderstorm breaking on the central Cordillera to the north, leaving the town dry. Not without reason was Ponce named 'the pearl of the south'. It is likely the Portuguese made their first settlement here; this is where they would have greeted newcomers on the 1447 voyage and invited them to attend divine service.

The river leading from the harbour into the old town still retains the name Rio Portugués. The brilliant-white cathedral of Our Lady of Guadeloupe stands on its banks, and as I sat in the main square of Ponce one evening, sipping bitter black Puerto Rican coffee at the end of another day spent combing the island for evidence of the Chinese voyages and the early Portuguese colonists, I watched people pouring into the cathedral to attend evening mass. Some men had red hair, the women fine chiselled faces, sharper features and paler skins than in the north. In their looks, their way of life, their *fado* songs and their *ferrapeira* dances, the people of Ponce to this day resemble their Portuguese ancestors from the Algarve. Will the bones of their brave forefathers who set sail from Sagres long ago to found this, the first European colony in the New World, one day be found beneath the cathedral of Our Lady of Guadeloupe?

The Portuguese had taken their first steps into the New World that the Chinese had discovered, but despite the evidence offered by copies of the charts drawn by the Chinese, one obstacle – as much psychological as physical – remained to be overcome

before the Portuguese empire could spread across the globe. The fear of the unknown still dominated the minds of ordinary Portuguese seamen, and a lifetime of myth, legend and superstition could not be erased overnight. Magellan was still struggling to overcome the fears of his crewmen in the early years of the sixteenth century as he tried to coax them through the strait that was to bear his name.

In the summer of 1432, with Madeira, the Azores (discovered by La Salle) and Puerto Rico already colonized, Prince Henry called Gil Eannes, a skilled seaman and loyal retainer, to his court at Sagres. Eannes had been despatched on a mission the previous year to the Canary Islands. Now Henry insisted that, come what may, he must round Cape Bojador on the coast of modern Western Sahara, to the south of Morocco. The cape featured in many lurid seamen's myths about the unknown world. It was a place where vast cataracts crashed into the sea, fierce currents dragged ships to their doom and even the sea-water itself had been turned into 'red slime'.

Eannes followed Prince Henry's commands with understandable caution, standing well out to sea so as to approach the dreaded Cape Bojador from the south and thus avoid the legendary waterfall off the cape, but he found no serpents or giant sea monsters as he made his first landfall a few miles beyond the cape. The land appeared uninhabited; there were even a few flowers on the beach. Eannes plucked a bouquet for Prince Henry: 'My Lord, I thought that I ought to bring some token of the land since I was on it. I gathered these herbs which I here present to your gaze, which we in this country call Roses of Saint Mary.'¹⁵ Returning northwards to Bojador itself, Eannes found the 'eternally rushing water' was but vast shoals of grey mullet, the 'waterfalls tumbling off the earth' were cliffs, rising sheer from the sea, and the 'sea baked into red slime' was water discoloured by the red Sahara sand.

Eannes's achievement in rounding Cape Bojador completely

COLONIZING THE NEW WORLD

changed European man's attitude to seafaring. At a stroke, he had shattered centuries of legend and superstition. If a ship could safely round Cape Bojador, man could sail anywhere. There was no need for irrational fears about falling off the edge of the earth. With the Chinese charts to guide them, there was nowhere the Portuguese sea-captains would not venture, once they had persuaded their men to follow where they led; exploring the limits of the world became merely a matter of time.

on the

SHOULDERS

OF

GIANTS

By 1460, THE YEAR HENRY THE NAVIGATOR DIED, PUERTO RICO was well known and Portuguese exploration of the three groups of islands in the Atlantic – the Azores, the Canaries and the Cape Verde Islands – was complete. The islands were stocked with animals and became bases for explorers making their way between North and South America and Africa. By a fortunate coincidence, all lay in the track of the circulatory wind systems; the Canaries and Cape Verde Islands on the way out to the Americas and the Azores on the way back. Gradually, Europeans reached the lands the Chinese admirals had discovered.

In parallel with his systematic and continual improvements to ocean navigation, Henry the Navigator had relentlessly pushed his captains further and further across the seas. By the time Portuguese ships set sail for the Cape of Good Hope, the measurement of latitude in the northern hemisphere was as accurate as the Chinese calculations had been years earlier.

Bartolomeu Dias (c. 1450–1500) led the way. In 1482, he was captain of one of the ships exploring the Gold Coast and Africa past the 'bulge', and in 1487 he was appointed to the command of a small squadron of three ships that was to attempt to round the southern tip of Africa. Neither Dias nor his masters knew how far south the Cape really stretched – the charting of West Africa by the Chinese fleet had been carried out before they had mastered the calculation of latitude in the southern hemisphere – but they had no doubts that it could be rounded. Dom Pedro's map of 1428 had showed the Cape's triangular shape, and before Dias set sail the Portuguese king gave his emissary, Pêro da Covilha, a map of the world (*Carta de Marear*) showing that the Cape could be rounded to reach India. When Dias duly reached the Cape, he

came in sight of that Great and Famous Cape *concealed for so many centuries*, which when it was seen made known not only itself but

also another new world of countries. Bartolomeu Dias, and those of his company, because of the perils and storms they had endured in doubling it, called it the Stormy Cape, but on their return to the Kingdom, the King Dom João gave it another illustrious name, calling it the Cape of Good Hope [my italics].¹

Dias was followed by Vasco da Gama (c. 1469–1525) who was ordered to continue round the Cape to India and the source of spice. Da Gama was provided with charts showing the Cape, and precise declination tables:

Tables showing the declination of the sun were provided by the Astronomer Royal, Abraham Zacuto Ben Samuel. These ... had been translated from Hebrew into Latin the previous year and printed at Leira under the title *Almanach Perpetuum Celestium Motuum Cujus Radix Est 1473*. Other books, maps and charts were supplied ... amongst these documents almost certainly [were] the log and charts of Dias.²

After rounding the Cape, da Gama proceeded up the east coast of Africa, finding the famous ports of Sofala, Kilwa, Zanzibar, Mombasa and Malindi, developed by Chinese and Indian fleets over the centuries when the Indian Ocean trade was by far the most busy and lucrative in the world. By the late 1400s the Chinese had closed their trading routes with the outside world; nonetheless, the Portuguese explorers found evidence of the earlier Chinese visits in the mass of blue and white porcelain decorating many houses the length of East Africa. When da Gama returned from his second voyage, he knew the way to Malacca and the Spice Islands in the East. The world's spice trade was now within Portugal's grasp. Anyone who opposed them was mown down with grapeshot. In effect, da Gama stole the trade the Indians and Chinese had spent centuries developing. Skilful though he was, like Dias before him, da Gama discovered nothing new. In parallel with da Gama's pursuit of the spice trade in the East, King João of Portugal had sent Pedro Álvares Cabral (1467–1520) to South America, to the lands shown on the 1428 World Map. In 1500, King João's successor, Manuel I, ordered Cabral to take possession of the western parts of the Indies. Like Dias and da Gama, Cabral used the Canaries and then the Cape Verde Islands as his bases before making landfall on the South American coast. At this time, a cluster of explorers reached South America within a year of one another: Vespucci, Pinzón and De Lepe in 1499, and Mendoza the next year. The first three made landfall on the Amazon delta, then sailed northwestwards.

This north-east coast of Brazil, discovered by the Chinese treasure fleets of Zhou Man and Hong Bao, had appeared on many maps drawn before any of those European explorers set sail. Andrea Bianco's map of 1448 referred to Ixola Otinticha Xe Longa a Ponente 1500 mia - 'a genuine island is 1,500 miles west of here [West Africa]' - and Master João de Barros, on the 1500 expedition to the Brazilian coast, confirmed that the land had appeared on earlier maps: 'The lands might the King see represented on the Mappa Mundi which Pêro daz Bisagudo had.'3 Bisagudo was a nickname given to the famous explorer Pero da Cunha who had been sent with a Portuguese map of the world to colonize what is now Ghana in Africa. De Barros said the only real difference between what Cabral's expedition saw in 1500 and what appeared on Bisagudo's earlier 'Mappa Mundi' was that he, de Barros, could now certify Brazil was inhabited. Christopher Columbus also confirmed that Brazil was known to the Portuguese before any of their expeditions set sail for South America. He noted in his diaries that he wished to proceed further south of Trinidad 'to see what was the meaning of King John of Portugal who said there was terra firma to the south'.4

So, Andrea Bianco, Columbus and de Barros all state that a map of Brazil existed before the first European expedition sailed in 1500. The only possible sources of the information on that map, the 1428 World Map, were the cartographers with the Chinese fleets of 1421–3. The port of San Luis is instantly recognizable on the Piri Reis map (derived from the 1428 map) and the latitudes of the Orinoco and Amazon deltas are precisely correct. In addition, there is no shortage of other, permanent traces of the Chinese visit to South America: Asiatic chickens were found in the Orinoco delta by the first European explorers, and Venezuelan Indians and other native peoples have blood groups that are otherwise unique to south-west China.

With the Cape of Good Hope rounded and South America discovered, the exploration of the rest of the world quickly followed. Ferdinand Magellan (c. 1480–1521) was orphaned when he was ten years old and became a page at the Portuguese court, where he was trained in navigation. He was sent to East Africa in 1505, and for the next seven years saw service in the Indian Ocean. He took part in the expedition to establish a Portuguese colony in India, and in 1511 he played a significant part in the conquest of Zheng He's former forward base, Malacca. He returned home in 1512 and sailed with the Portuguese expedition to Morocco, where he was severely wounded. After a disagreement with his commander, he left the army without permission. As a result he was disgraced and was refused a pension.

In disgust, he moved to Spain and in 1518 was appointed captain general of a fleet to explore a westward route to the Spice Islands, across the Pacific. He sailed from the Guadalquivir estuary the next year with five ships and 241 men. Magellan knew of the strait that bears his name before he set sail, for it was shown on a map in the King of Portugal's treasury that Magellan inspected and took with him.⁵ On reaching the Spice Islands, Magellan showed the chart to the local king.⁶ It depicted a way through the Strait of Magellan and across the Pacific; 'From Cape Frio until the Islands of the Maluccas throughout this navigation there are no lands laid down in the maps they [Magellan's expedition] carry with them.⁷

Magellan never claimed to be the first man to have circumnavigated the world; nevertheless, his was still an amazing feat. He was in a tiny ship, a toy compared to the Chinese leviathans, and, unlike the Chinese, the Portuguese had very little experience of long transoceanic voyages and were unaware that certain foods could prevent scurvy. Magellan, Dias, da Gama and Cabral were very skilful navigators and seamen, they were also brave and resolute men with awesome qualities of leadership, but not one of them actually discovered 'new lands'. When they set sail, each one of them had a chart showing where he was going. All their 'discoveries' had been made nearly a century earlier by the Chinese.

Nor did Christopher Columbus 'discover' the Americas. Far from setting sail full of fear that his fleet might fall off the edge of the world, he knew where he was going, as can be seen in excerpts from his logs when he was still in mid-Atlantic:

Wednesday September 19th [1492]

The Admiral did not wish to be delayed by beating to the windward in order to make sure whether there was land in that direction, but he was certain that to the north and to the south there were some islands, as in truth there were ... [he said] 'and there is time enough, for, God willing, on the return voyage, all will be seen'. These are his words.

Wednesday October 24th

[describing how to reach Antilia] I should steer west-south-west to go there . . . and in the spheres which I have seen and in the drawings of mappae mundi it is in this region.

Wednesday November 14th

And he says that he believes that these islands are those without

number which in the mappae mundi are placed at the end of the east.⁸

It is clear from these three entries that Columbus had seen spheres and mappae mundi showing islands in the Atlantic, and that these lay, in Columbus's opinion, to the north and south of his position on 19 September 1492. Puerto Rico (Antilia) appears on the 1424 Pizzigano chart, the coast of New England on the Cantino, Brazil on Andrea Bianco's map of 1448 and many West Indian islands on Cristobal Soligo's chart of 1489 – all drawn before Columbus reached them.

In 1479, Columbus had married Doña Felipa Perestrello, the daughter of the governor of Porto Santo, the small island near Madeira settled by the Portuguese. His forthcoming marriage gave him sufficient confidence to correspond with the celebrated scientist Toscanelli, who replied at once: 'I have received thy letters with the things that thou didst send me and with them I received a great favour. I notice thy splendid and lofty desire to sail to the regions of the east by those of the west [i.e. reach China by sailing westwards], as is shown by the chart which I send you.'⁹ The 'chart' that accompanied Toscanelli's letter to Columbus has been lost, but it can be reconstructed using another letter from Toscanelli to the King of Portugal, enclosing a chart of the Atlantic: 'But from the Island of Antilia known to you to the far famed island of Cipangu there are ten spaces...so there is not a great space to be traversed over unknown waters.'¹⁰

Antilia was indeed very well known to the Portuguese. They had settled there in 1431, and were still there when Columbus set sail in 1492, but his knowledge of the Americas went far further. By his own evidence he knew of the 'Strait of Magellan' in the south and the coast of north-east Brazil.¹¹ He had seen mappae mundi and spheres showing the Atlantic. He also knew well that China and the Spice Islands could be reached by sailing eastwards round the Cape of Good Hope, for Christopher and his brother Bartholomew were both present when Dias reported to the king that he had rounded the Cape at that latitude.¹² Columbus was hell bent on gaining fame and glory by sailing westwards for China and the Spice Islands.

Columbus certainly saw the 1428 master chart of the world. This is corroborated in a number of ways: in notes on the 1513 Piri Reis map which credit Columbus with knowing that there were only two hours of daylight in the far south; in Columbus's letter to the King of Portugal in which he writes about lands in South America, a letter written before the Portuguese explorers had set sail for that continent; and in his notes inscribed on the inside flap of his own copy of Marco Polo's book about his voyage from China to India by sea. In short, Columbus knew that China could be reached by sailing westabout (Toscanelli's letter) or by sailing eastabout. He must have known from the 1428 World Map that the eastabout voyage was the shorter.

In these circumstances, it must have been horrifying for Columbus to realize that the Portuguese were well on their way to rounding the Cape of Good Hope and sailing into the Indian Ocean, whence they could sail with the monsoon winds to China. The Portuguese advances down the African coast must have been a matter of grave concern to him. By 1485, Dias had reached the African coast as far as 13°S. At that stage, not only did Columbus know of the route westwards, but he had sailed to Iceland (in 1477), which country he was told Chinese people had visited.

In 1485, Christopher Columbus left Portugal, where he had been on and off since his marriage. During that time he may well have sailed to Antilia on a secret voyage funded by the Pope, as Señor Ruggero Marino has stated. Marino bases his assumption largely on the inscription on the tomb of Pope Innocent VIII, who died in July 1492, i.e. before Columbus set out on his first 'voyage to the Bahamas'. On the Pope's tomb were the words 'novi orbis suo aevo inventi gloria' – 'the glory of the new world having been found with his gold'.

427

Bartholomew Columbus remained in Portugal as a member of the team improving the Portuguese maps as and when new evidence came in from the voyages of discovery. In 1487–8, Dias pushed on further down the African coast and reached what we call the Cape of Good Hope. In 1473, the Portuguese had discovered how to calculate latitude from the sun's declination, so Dias was able to put the latitude of the Cape of Good Hope at $34^{\circ}22'$ South. Both Bartholomew and Christopher knew this correct latitude (see p. 430).

Columbus's plans for a voyage westwards were now in desperate trouble, for the Portuguese were on the verge of opening up the route to India round the Cape of Good Hope. Unless he acted quickly, his chances of glory were over. At this time, the Catholic monarchs Ferdinand and Isabella had begun their assault on the last Moorish enclave in Spain, south of the Sierra Nevada mountains around Granada. Columbus had no chance of extracting funds from the Portuguese, who were concentrating on the easterly route to China, and knew that his only chance lay with the Catholic monarchs who did not have the 1428 chart and thus did not know that the shorter route lay eastabout. It was therefore in Columbus's interests to persuade Ferdinand and Isabella that the quickest route to China lay westwards. This, in my submission, is the motive for the forgery and theft Christopher and Bartholomew Columbus now perpetrated.

Their timing was extraordinarily fortunate, for in 1492 Granada had fallen and the Catholic monarchs wished to extend the pursuit of the Moors overseas. Columbus's plan to sail westabout for China would fall on receptive ears if he could persuade Ferdinand and Isabella that his plan was realistic and that it offered the chance of reaching the Spice Islands before the Portuguese.

In 1963, Alexander O. Vietor, the map curator at Yale University, reported a gift by an anonymous donor 'in the form of a magnificent painted world map signed by Henricus Martellus approximately six feet by four feet $[180 \times 120 \text{ cm}]$ '. Vietor went on:

It is painted in what seems to be tempera over a base of paper in sheets of different sizes, the whole backed up with a large framed canvas, much in the manner of a painting ... It has graduations of latitude and of longitude in the margins, the first instance of longitudes being shown on the map ... on this map Cipango is placed 90 degrees from the Canaries.¹³

Mr Vietor subsequently corresponded on the matter with Professor Arthur Davies, who at the time held the Reardon Smith Chair of Geography at the University of Exeter (1948–71). Vietor also provided Professor Davies with infrared photographs of the map for close study. This map, which I shall call the 'Yale Martellus', is four times the size of another map Martellus published in 1489. The experts, principally Davies and Vietor, are unanimous that the Yale Martellus was the original and the 1489 Martellus a copy at one-quarter the scale. Ashleigh Skelton has also concluded that the Yale map is genuine, its author Martellus. My belief is that both maps, although genuine, contain forgeries, and the forger was Bartholomew Columbus.

The 1489 Martellus map extends from the Canaries to the east coast of China. Although no meridians or longitude scales are given, estimates based on the measurement of the map show that the distance from Lisbon to the east coast of China eastabout is not less than 230° and probably 240°. Westabout, the coast of China is shown approximately 130° west of Lisbon. This is a colossal exaggeration of the distance eastabout. The Catalan atlas of 1376 had the distance from Portugal to China eastabout at approximately 116°; the Genoese map of 1457 approximately 136°; and the Fra Mauro of 1459 about 120°. The true measurement is 141° from the Canaries to Shanghai, so the 1489 Martellus exaggerates the distance to China from Portugal eastabout by

429

nearly 100°. The Columbus brothers of course knew the true distance eastwards from Lisbon to China because the Portuguese had the 1428 World Map.

The 1489 Martellus map could not have been completed before that year, for it featured complete details of the discoveries of Bartolomeu Dias's voyage of 1487 – when he doubled the Cape of Good Hope and reached the Indian Ocean. He returned to Portugal in December 1488. Within a year, then, full details of this trip, including Dias's rich nomenclature, had appeared on the map Martellus made in Italy, this despite strenuous efforts on the part of the King of Portugal to keep the map secret. The penalty for stealing maps was death. The Portuguese government's policy had been shattered in one fell swoop by someone in a unique position to know all the details.

The second forgery, on both Martellus maps, is that a huge dogleg of fictitious land has been appended to the Malayan peninsula from the equator south to 29° South, thereafter being widened to reach China. So enormous and wide was this peninsula that it seemed to render impossible any voyage between China and India. In short, anyone who had got into the Indian Ocean could not continue to the east. To a third party, such as the Catholic monarchs, who did not have the 1428 map, it showed that eastabout China could not be reached by rounding the Cape of Good Hope.

The third forgery is that Martellus's two maps extend southwards to the latitude of the Cape of Good Hope, which Dias had fixed at 34°22' South, to 45° South. That Bartholomew Columbus was responsible for this addition is beyond doubt, for it was made in his own hand. In the volume of *Imago Mundi* found among the possessions of Christopher Columbus after his death are numerous notes written in the margins or below the printed matter. Number 23 has been identified by Professor Davies, who has spent a lifetime analysing the characteristics of the Columbus brothers' scripts, as being the handwriting of Bartholomew. It reads:

ON THE SHOULDERS OF GIANTS

Note in the year '88 in the month of December arrived in Lisbon Bartholomew Diaz [*sic*], captain of three caravelles which the most serene king of Portugal had sent to try out the land in Guinea. He reported to the same most serene king that he had sailed beyond Yan 600 leagues, namely 450 to the south and 250 to the north, up a promontory which he calls Capa de Buon Esperanza [Cape of Good Hope] which we believe to be in Abyssinia. He says that in this place he found by the astrolabe that he was 45 degrees below the equator and that this place is 3,100 leagues distant from Lisbon. He has described this voyage and plotted it league by league on a marine chart in order to place it under the eyes of the most serene king himself. I was present in all of this.¹⁴

Bartholomew Columbus's claim that Dias had put the Cape of Good Hope at 45° South was blatantly untrue. No-one in Lisbon at the time bar the Columbus brothers knew of this 45° assertion, for Bartholomew made it after he had left Portugal.

To date, no link has been shown between the Columbus brothers and Martellus; it could have been that Martellus was the forger. The link, however, can be deduced in two ways. The first is that Martellus's map contains information only the Portuguese knew (Martellus was Italian), moreover information guarded upon pain of death which had been acquired only months earlier. Someone with access to top-secret Portuguese maps must have provided the information to Martellus. That points the finger at Bartholomew Columbus, or others who were part of that trusted mapmaking circle, which includes Behain of Bohemia, for example.

The direct link between Bartholomew Columbus and the Martellus map, however, comes from the construction of the Yale Martellus. The sheets of paper on which the Yale map is drawn are of different sizes, which excludes the possibility that they were printed map sheets, for they would then have had to be the same size to fit within the map portfolio. In private letters

between Alexander Vietor and Professor Davies, Vietor stated that an X-ray examination had revealed no evidence of printing on the paper sheets and that everything on the Yale map was hand-drawn, lettered and coloured. In short, it came from a tracing. The tracings have been identified by Professor Davies as being in the hand of Bartholomew Columbus. In making this devastating assertion, Professor Davies wrote:

When Columbus left Lisbon in 1485 for Spain, Bartholomew, with his highly trained skills as a cartographer in the Genoese style, stayed on in the map workshop of King John II. He was engaged in building up a large map of the world based on Donnus Nicolaus and on the Portuguese charts. It was, like all important maps at that time, drawn on sheets of parchment which could be joined together almost invisibly, and mounted on linen. This large map, 180cm by 120cm, formed a standard Portuguese world map, continually added to by new discoveries, including those of Cão and Dias. By the beginning of 1489, Columbus faced poverty and failure in Spain: his pension had been ended in 1488 and he no longer had free board and lodging from Medina Seli or the Marquess de Moya. Bartholomew prepared to join him in Spain and help his projects. They needed money, and in particular the vital and continued support of the Bank of St George in Genoa. They got both. Money could be obtained from the sale of maps kept secret in Portugal. Before leaving Lisbon, Bartholomew copied maps of convenient size. The large standard world map he had to copy in some secrecy and, because of its size, he needed eleven sheets of paper, cheaper, thinner and quieter than parchment. These sheets of the Yale Martellus were tracings in the hand of Bartholomew. Early in 1489 he left Lisbon. He went first to Seville to help his brother and there altered the Yale map by substituting another sheet of paper which showed Africa to 45° South rather than its true latitude of 34° 22' South. The Martellus map was rather like a picture with a picture frame. The frame

ON THE SHOULDERS OF GIANTS

ends at 41°S. To get the addition into the picture, it has to burst through the frame down to 45° S.¹⁵

A second lead comes from a legend shown on the east coast of Africa which reads 'Ultima navigatio Portuga A.D., 1489'. On the face of it, seeing the Martellus map extending down to 45°S, this inscription would appear to assert that Dias had proceeded north along the east coast of South Africa to beyond Natal. This he did not do on that voyage. The legend is shown between 33° and 34°S, which exactly accords with where Dias got to – the Rio de Infante, the Great Fish River at 34°S. It appears to be north of Natal only because Africa is shown as extending to 45°S. When Bartholomew altered the prototype map to 45°S, he was unable to remove the legend.

The three forgeries combined appeared to all but rule out the possibility of reaching China eastabout from Portugal. The purpose of the Martellus maps clearly was not to influence the Portuguese, who knew the true situation for they had the 1428 World Map; it was to influence the Catholic sovereigns who were completely in the dark. At that time, one degree of latitude was thought to be fifty nautical miles (ninety kilometres), according to Toscanelli's letter. To reach India round Africa, according to the forged Martellus maps, would involve sailing from 39°N to 45°S, and then north to India, another $45^{\circ} + 15^{\circ} -$ all told, the voyage to India would be some fifteen thousand miles. Moreover, and perhaps this was the decisive factor, ships would have had to sail below 45° South in order to round Africa through seas Dias had already described as the roughest he had encountered anywhere in the world.

In several ways, the forged Martellus maps depicted a monumental eastward journey, whereas by sailing westwards for Antilia to China, Spanish ships could pass through the Strait of Magellan and beat the Portuguese to it. This is the reason, I submit, why the Portuguese concentrated on the eastern route to

433

China and the Spanish tried to reach the same destination via South America. Bartholomew Columbus stole the intellectual property of the Portuguese government. He then forged a chart he and Christopher knew was bogus, and both of them used that chart to extract money and backing under false pretences from the Bank of Genoa and the Catholic monarchs of Spain. Columbus's true legacy to posterity is not the discovery of the Americas, but of the circulatory wind systems of the Atlantic he so brilliantly analysed and exploited on his later voyages. Knowledge of these wind and current patterns proved invaluable in the preparation and execution of the voyages that led to the colonization of the Americas in the following centuries.

Finally, to that brilliant seaman, Captain James Cook, 'the ablest and most renowned navigator this or any country hath ever produced. He possessed all the qualities necessary for his profession and great undertakings.'¹⁶ Cook made the first of his three great voyages in 1768, sailing to the Pacific to observe the transit of Venus. He then continued across the Pacific and 'discovered' New Zealand, finding it a suitable country for settlement 'should this ever be thought an object worthy of the attention of Englishmen'. He explored Australia's east coast, claimed the whole country in the name of the king, and sailed for home via New Guinea and the Cape.

On his second voyage, in 1772, 'to complete the discovery of the southern hemisphere', Cook put in at New Zealand and landed animals and planted vegetables to provide food supplies for future explorers and settlers. He then sailed south to the edge of the Antarctic continent. Cook's mission on his third voyage to the Pacific was to find a northern passage from the Pacific to the Atlantic. He again visited New Zealand and Australia, then sailed for North America, exploring the coast from Oregon northwards. He entered the Bering Strait, could find no ice-free route through and began the journey home. He was killed

in Hawaii on 14 February 1779 after a dispute with the natives.

Cook was a great man, and the greatest navigator of all time, but he discovered neither New Zealand nor Australia. More than two centuries before he embarked on his voyages, a cluster of maps from the Dieppe School showed Australia with remarkable clarity. The Jean Rotz map was in the possession of the British government when Cook set sail, and Joseph Banks, who sailed with Cook, had acquired another of the finest, the Harleian (Dauphin), showing Australia with the same precision as the Rotz map. The Desliens and Desceliers charts from the Dieppe School were also known to the Admiralty. The Endeavour Reef, on which Cook later ran aground, is clearly shown on these earlier maps, together with what later became known as Cooktown Harbour. When Cook had extricated himself from the reef, he sailed directly for Cooktown. 'This harbour will do excellently for our purposes, although it is not as large as I had been told.'17

When Cook returned, claiming to have discovered Australia, the head of the Map Department at the British Admiralty, Commander Dalrymple, wrote a furious protest. Captain James Cook had enormous courage, determination and integrity, but he had not discovered the continent. The Admiralty had maps showing Australia drawn 250 years earlier.

Brave and determined though they were, Columbus, Dias, da Gama, Magellan, Cook and the rest of the European explorers set sail with maps showing the way to their destinations. They owed everything to the first explorers, the Chinese on their epic voyages of 1421–3. How lucky Europe was, and how unfortunate China, that fire had ravaged the Forbidden City on 9 May 1421. Europeans had now rediscovered almost the entire world, known at first hand until then only by the Chinese and Niccolò da Conti. The charts, ships and systems of ocean navigation used by the great European explorers owed much to Henry the Navigator and his brother, Dom Pedro, but more

Cook's ship, the Endeavour, sketched by Sydney Parkinson in June 1770.

to the Chinese emperor, Zhu Di, and his brave and skilful eunuch admirals, Zheng He, Zhou Man, Hong Bao, Zhou Wen and Yang Qing.

The revelation that Vasco da Gama was not the first to sail to India round the Cape of Good Hope, that Christopher Columbus did not discover America, that Magellan was not the first to circumnavigate the world, and that Australia was surveyed three centuries before Captain Cook and Antarctica four centuries before the first European attempt may come as a disappointment, even a shock, to the champions of those brave and skilful explorers, but the Kangnido, Pizzigano, Piri Reis, Jean Rotz, Cantino and Waldseemüller charts are indisputably genuine. They contain information that can only have come from cartographers aboard the pioneering Chinese fleets. Niccolò da Conti was aboard the junks that reached Australia from India; Dom Pedro obtained this information from da Conti himself, and had it incorporated in the map that showed the whole world. Toscanelli persuaded Columbus that China could be reached by sailing west, and Magellan spoke no less than the truth when he told his near mutinous crew that he had seen the 'Strait of Magellan' on a map in the Portuguese treasury before he set sail. Truth, after all, is stranger than fiction.

And what epitaph is there at Sagres to commemorate the lifetime of sacrifice and achievement of Prince Henry the Navigator, the man who began this wave of European exploration that was to conquer the world? Nothing but a rundown sundial where the weeds grow among the stones. Zheng He's tomb on Bull's Head Hill in the west of Jiangsu province is also neglected and weed-choked. These great men must have their reward in heaven.

EPILOGUE: The Chinese Legacy

THE LEGACY OF THOSE GOLDEN YEARS WHEN CHINA'S power and influence extended from Japan to Africa and beyond to encompass the whole world remains. Chinese Buddhist architecture graces the Asian skyline from Malacca to Kobe. Chinese silk of the Ming dynasty is found from Africa to Japan, glorious blue and white ceramics from Australia to Manchuria, and graves in many places across the globe bear witness to Chinese jade jewellery of that era. Even the most blasé traveller to south-east Asia must be struck by the pervasiveness of China's legacy. From Sumatra to Timor to Japan, communities are still united by trade, religion and a written language inherited from China. For four thousand kilometres west to east and an equal distance from north to south, China's imperial footprint remains, the imprint of a colossus.

The depth of Chinese culture is as awesome as its width. Three thousand years ago the Chinese had mastered bronze moulding and casting with simple yet stunning designs. By the Qin dynasty (221–206 BC), pottery was being cast as sublime as anything our planet has seen, epitomized by the graceful horses and fluid soldiers of Emperor Qin's terracotta army. By the Tang dynasty (AD 618–907), at a time when our European ancestors were clothed in rags, rich Chinese were dining off gold plates adorned with phoenixes and dragons and drinking their wine from silver chalices engraved with dancing horses. Fruit was displayed in white jade bowls. Merchants' wives, sheathed in fine embroidered silk, wore subtle Persian scents. Exquisite jade and gold jewellery adorned their ears, throats and wrists.

The Chinese had millennia of experience and expertise in every sphere of human activity. By 305 BC conservation of land and rotation of crops had been the subject of letters to the emperor. Zhu Di's huge ships and incredible expeditions were the culmination of eight hundred years of voyages of discovery – Song dynasty (960–1279) ships had reached Australia. Chinese trade with India was six hundred years old when Admiral

THE CHINESE LEGACY

Zheng He set sail, and even his vast fleet was dwarfed by that of Kublai Khan two centuries earlier. Chinese science and technology were centuries ahead of the rest of the world, their military and civil engineering know-how epitomized by the Great Wall. The stability and protection that wall provided ensured that, of all the great civilizations of antiquity, China alone survived. Its most striking national symbol is a monument to the history, resilience and enduring power of China and its people.

Although much evidence of the Chinese voyages of discovery has been lost or destroyed over the centuries, one very tangible kind is visible everywhere today: the plants and animals the Chinese fleets carried with them to new lands, and those they brought back to China and south-east Asia. China's greatest contribution to civilization may well be the cultivation and propagation of plants.

For centuries it was believed that the global propagation of the world's plants began after Columbus 'discovered' the Americas in 1492, and accelerated when the British founded their great maritime empire after the Battle of Trafalgar. In fact, although the Victorians were certainly great plant collectors, almost all of the important agricultural plants had been spread across the world before Columbus set sail on his first voyage. Europeans not only had charts showing them the way to the New World, they found the most important crops already flourishing when they arrived there. No fewer than twenty-seven important cash crops are known to have been brought to the islands of Hawaii from India, Asia, Indonesia, the Americas and even Africa. The sweet potato, sugar cane, bamboo, coconut palm, arrowroot, yam, banana, turmeric, ginger, kava, breadfruit, mulberry, bottle gourd, hibiscus and candlenut tree were all growing in Hawaii when the first Europeans arrived; none of them is indigenous to the islands.

This pattern was repeated throughout Polynesia and halfway

across the world to Easter Island. There the first Europeans found totora reeds from Lake Titicaca, tomatoes, wild pineapples and sweet potatoes from South America, tobacco from Central and North America, gourds from Africa, papayas from Central America, yams from south-east Asia and coconuts from the South Pacific. The first Europeans to reach the Caribbean also found coconuts; Magellan loaded maize in the Philippines that had originated in Central America; California was graced with Chinese roses; South America had Asiatic chickens. No fewer than ninety-four genera of plants were found to be common only to South America and Australasia;¹ another seventy-four genera, including 108 distinct species, are common only to tropical West Africa and tropical America.

It has been argued that this mass of plants could have been propagated naturally, by seeds carried by ocean current and wind, or by birds. Coconuts will float, and in theory they could have found their own way from the South Pacific across the Indian Ocean, the South Atlantic and the North Atlantic to end up in the Caribbean. Some certainly did float from island to island, and some seeds and spores were undoubtedly carried on the wind, but to suggest that all plants were propagated in this way is preposterous. The argument collapses with maize and sweet potatoes; they do not float, and sweet potatoes are far too heavy for birds to carry from country to country. In the last three decades, a number of distinguished botanists have carried out research into the places of origin of cultivated plants. Improved understanding of the classification of plants has radically altered views on their wild relatives and hence place of origin. An example is the coconut, which early European explorers found on Atlantic and Pacific coasts of Central America.

The coconut (*Cocos nucifera*) was once thought to have originated in the New World because this is where the other species of *Cocos*

THE CHINESE LEGACY

occurred. Now, however, *Cocos* is treated as a monotypic genus whose closest living relative is African. This, together with the fossil records of the coconut and its variability and range of uses in south-east Asia, suggests that the coconut originated in the western Pacific and spread west to east, not east to west, across the ocean.²

An analysis of the plants common to Africa and South America and of those common to South America and Australasia discloses that they were all carried in the direction of the prevailing winds and currents – in short, by ships crewed by men. No Polynesian ships are known to have left the Pacific to enter the South Atlantic ocean, and propagation predates the European voyages of discovery. Only one nation could have transported this array of plants and animals around the globe. The Chinese ships certainly carried plants and seeds and they not only circumnavigated the world but did so in precisely the direction propagation has been found to have occurred, from China through south-east Asia to India, thence to Africa, from there across the South Atlantic to South America, and finally on to Australasia.

Rice was by far the most important Chinese crop, perhaps the most diverse and adaptable crop on our planet. The Chinese developed varieties that could flourish on dry mountain slopes, while others needed to be submerged. Some species took months to ripen, others only two. Some were sensitive to temperature, others to sunlight. Some crossbred species became so tolerant of salt that they could be used to reclaim marshes along the sea shores. Rice is an ideal food crop – it tastes good and, flavoured with soy products, has high nutritious value. It stores well, and is easy and economical to cook. Until the twentieth century, rice produced seven times as many calories per hectare of land as any other grain,³ and China was the most efficient agricultural country in the world.

THE CHINESE LEGACY

The entire way of life of over a billion people revolves around rice, the ideal crop for sustaining the dense populations of Asia, where it has even higher status than bread in Western societies. In China, a man who has lost his job has 'broken his rice bowl'. Marriages and business deals are sealed over cups of sake – rice wine. In the West, we throw confetti as a symbol of rice, to bring good luck at weddings. When Japanese children look at the night sky, rather than the man in the moon, they see a rabbit making rice cakes.

In the Ming era, China exported rice to the Pacific, principally through Makassar (Selat in modern Indonesia). Rice ships accompanied the treasure fleets, and rice was found in the hold of the Sacramento junk.⁴ But the Chinese were also importers of plants, and they showed their inventive genius by utilizing the crops they found in distant lands. The south-east Asian climatic zone, stretching from China to Indonesia, was an important source of crop plants. A case can be made that the domestication of such crucial crops as millet, rice and yams originated in this zone. Later introductions to China included sugar cane, bananas, ginger and some species of citrus fruits, and cotton was imported from India, but perhaps the most spectacular example was the maize brought back by Zheng He's fleets from the Americas.

After rice, maize is the world's most prolific crop; compared to wheat, at least three times as much can be harvested from the same area. Furthermore, it can grow in arid deserts or in humid jungles, at sea level or up to 12,000 feet (3,600 metres). Maize originated in Central America, yet it was loaded in the Philippines by Magellan, the first European to reach there, and surviving Chinese records tell of 'extraordinarily large ears of grain' being carried back by Zheng He's fleets to China. Maize was ideal for China's mountain dwellers for it had deep roots, preventing the plant being washed away by heavy rain, and cultivation on the mountain slopes minimized the danger of frost damage. To the Miao people of southern China, the introduction of maize with its extremely high yield was an enormous benefit. Today, maize, the third most important crop in the world, has spread across Asia and is the staple food in many African countries.

The third group of foods carried by the Chinese were taros, yams and sweet potatoes. Sweet potatoes (Ipomoea batatas) thrive in the hot, moist climate of South America where they originated, and they have subsequently become an important root crop in warm, sub-tropical countries. By the time Captain Cook arrived in New Zealand, sweet potatoes had become the principal food of the Maori. Their name for them, kumara, is almost identical to the name kumar still used in the Lima region of coastal Peru. True yams (the Dioscorea species) originated in Africa and south-east Asia, yet they were growing in Hawaii when the first Europeans landed there. Taros originated in south-east Asia but had also reached Hawaii before the Europeans. They are members of the Arum family (Aracheae) and, like potatoes, are rich in starch. Taros are widely cultivated throughout the Pacific from Tahiti in the south - taro ponds greet the visitor leaving Tahiti's airport - to Hawaii in the north.

It can be said that rice, maize, sweet potatoes, taros and yams, originating in entirely different parts of the world, provided the essential food for those living in the tropics and sub-tropics. Their transportation was of incalculable benefit to mankind, for man now had the capacity to grow and harvest crops in almost every soil and climatic condition.

Apart from its role as the world's leading producer and exporter of silk, China also led the way in other fabrics. First used in the Indus valley several millennia ago, cotton is probably the world's most important cash crop, accounting for 5 per cent of the world's agricultural output. Scientists and scholars were initially baffled by the chromosomal structure of South American cotton, but after a series of painstaking experiments experts have now agreed that one parent of American cotton undoubtedly came from Asia. The wild American cotton the first Europeans found in the Americas had one gene that came from India. Cotton had been brought from India to Canton, where it was cultivated by the eighth century. It was widely grown during the Mongol Yuan dynasty that preceded the Ming, and Ming fleets carried huge amounts of cotton on their voyages.⁵ The King of Cochin was rightly grateful to Emperor Zhu Di: 'How fortunate we are that the teachings of the sages of China have benefited us. For several years now, we have had abundant harvests in our country and our people have had houses to live in, have had the bounty of the sea to eat their fill of, and enough fabrics for clothes.'⁶

Coconut is far and away the most important nut crop in the world. Its native home was in the islands of Indonesia, yet coconuts were found by the first Europeans when they arrived in the Caribbean and on the Pacific coast of Central America, and there are now about 3.5 million hectares of coconut plantations in the Philippines, India, Indonesia, Sri Lanka and the Caribbean. Coconuts grow within the tropics, yet can withstand slight frost. Besides providing delicious meat and coconut milk, oil extracted from the dried white meat has been used for centuries for cooking and frying and in the manufacture of soaps, cosmetics and lubricants. After extracting the oil, dried copra cake can be ground to a meal high in protein, used for cattle and chicken feed. The trunk provides roof beams, and the fibres of the husk (coir) can be used to make ropes. Ming fleets traded coir extensively.

Bananas originated in south-east Asia, but were also found in Hawaii by the early European explorers and have subsequently spread to India, Africa and tropical America. Along with grapes, oranges and apples, bananas are the world's most important fruit crop; their cousins, starchy plantains, are eaten as a vegetable throughout the tropics. Pineapples originated on the hot, steamy Atlantic coast of South America, yet Columbus noted pineapples

447

THE CHINESE LEGACY

on his second voyage to the West Indies in 1493. The evidence of the great voyages by the Chinese treasure fleets is literally growing all around us today.

At the start of my long journey in the tracks of the great fifteenth-century Chinese explorers, I had learned of a monument, a carved stone erected by Zheng He overlooking a bay in the Yangtze estuary in China, and read the inscription incised on its surface. It was almost the only surviving physical evidence on the whole Chinese mainland of that epic sixth voyage of the treasure fleets. Little else had survived the purges of the mandarins. Translated, it read:

The emperor ... has ordered us [Zheng He] and others [Zhou Man, Hong Bao, Zhou Wen and Yang Qing] at the head of several tens of thousands of officers and imperial troops to journey in more than a hundred ships ... to treat distant people with kindness ... We have gone to the western regions ... altogether more than three thousand countries large and small. We have traversed more than a hundred thousand *li* [forty thousand nautical miles] of immense water spaces.

I had puzzled over this inscription as I began the voyage of discovery that was to consume me for years. Now at the conclusion of my journey, I returned, believing that I had found the evidence to overturn the long-accepted history of the Western world. I had found a wealth of evidence that the Chinese fleets commanded by Admirals Zheng He, Yang Qing, Zhou Man, Hong Bao and Zhou Wen on that epic sixth expedition had surveyed every continent in the world. They had sailed through sixty-two island archipelagos comprising more than seventeen thousand islands and charted tens of thousands of miles of coastline. Admiral Zheng He's claim to have visited three thousand countries large and small appeared to be true. The Chinese fleets had voyaged across the Indian Ocean to East Africa, around the Cape of Good Hope to the Cape Verde Islands, through the Caribbean to North America and the Arctic, down to Cape Horn, the Antarctic, Australia, New Zealand and across the Pacific. Throughout the entire hundred thousand *li*, only in the Antarctic would the treasure ships have had to sail into the wind or an opposing current.

Before that great voyage of 1421 to 1423, Zhu Di had already brought all of south-east Asia, including Manchuria, Korea and Japan, into China's tribute system. The eastern end of the Silk Road had been reopened from China as far as Persia (modern Iran). Central Asia was in thrall to China, and the Indian Ocean was dominated by Chinese shipping. The treasure fleets of 1421 to 1423 added to this already vast trading empire. They created permanent colonies along the Pacific coast of North and South America, from California to Peru. Settlements were also initiated in Australia and New Zealand and throughout the Indian Ocean as far as East Africa. Supply bases were established right across the Pacific to link first the Americas with China, and then Australia and New Zealand with China. Vast distances were covered: there were bases from Easter Island to Pitcairn Island, through the Marquesas and the Tuamotu Archipelago, at Tahiti, Sarai in Western Samoa, Tonga, San Christobal in the Solomons, Nan Madol, Yap and Tobi in the Carolines, and Saipan in the Marianas. The remains of stone barracks, quays, houses, reservoirs and observation platforms may be seen on many of these islands to this day. Zheng He's great fleets and their supply trains were to link all these settlements and supply bases.

My claims about the Chinese voyages in the 'missing years' from 1421 to 1423 rest on the authenticity of the Kangnido, Piri Reis, Jean Rotz, Cantino, Waldseemüller and Pizzigano charts. No-one has ever questioned their veracity. The Vinland map has been questioned in the past, but as I have demonstrated (see

449

chapter 14 and postscript), I believe it passes the authenticity test. The Piri Reis, Jean Rotz and Cantino charts depict the whole of the southern hemisphere, covering tens of millions of square miles of ocean, thousands of islands, and tens of thousands of miles of coastline from the Antarctic to the equator. The lands they show can only have been surveyed by fleets that had sailed the southern hemisphere before the European voyages of discovery, and those fleets can only have been Chinese.

There is also a wealth of physical evidence for these great Chinese voyages. The Pandanan junk in the Philippines vividly demonstrates the extent of Chinese trade with the states of the Indian Ocean, the Americas and south-east Asia. Ming porcelain has been found down the East African coast, in the Persian Gulf and Australia, Ming silk as far north as Cairo. The wrecks of treasure ships lie off New Zealand and southern Australia, and there is also a wealth of other evidence of a Chinese presence in those countries. Carved stones were erected across the Indian Ocean, in the Cape Verde Islands, New Zealand and South America. Chinese chickens were carried to South America, maize brought from the Americas to China. Votive offerings have been found in the Lamu archipelago, at Darwin and on Ruapuke beach in New Zealand.

It is the spread, depth and variety of the evidence that makes the great Chinese voyages of 1421–3 so credible. One mahogany wreck in Australia may be explained away as an Indian merchantman blown far off course, but several wrecks, accompanied by Chinese votive offerings, ceramics and adze anchors, tell an entirely different story, one corroborated by Aboriginal folklore and cave paintings and clearly recognizable charts of the Barrier Reef drawn hundreds of years before the first Europeans reached Australia. The Chinese porcelain dating from the Ming era found throughout the Indian Ocean might have come from the cargoes of shipwrecked Portuguese caravels, but again, the evidence does not exist in isolation. There are the accounts of

THE CHINESE LEGACY

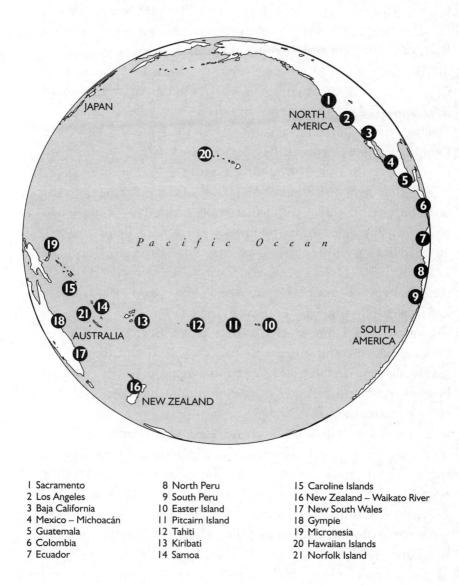

Chinese bases across the Pacific Ocean.

yellow-skinned people, the Chinese votive offerings, and silk found by the first Portuguese explorers. There is also a detailed chart of millions of square miles of ocean that was drawn before the Portuguese could have surveyed the Indian Ocean in such detail. The only explanations to date of how Antarctica could have appeared on a chart four hundred years before Europeans reached those parts have come from the pens of Erik von Daniken (aliens from outer space) and Charles Hapgood (Egyptian civilization before the Pharaohs).

Magellan saw the 'Strait of Magellan' and the Pacific depicted on a chart before he set sail; that can only mean that someone had passed through the strait and crossed the Pacific before he did, and had drawn animals native to Patagonia before any European knew of them. That the 'someone' was Chinese is confirmed by the pictures of animals (published 1430) and the Chinese artefacts along the route they followed, and the continents shown on the Chinese charts that have survived. That the Chinese had the ships, the expertise, the funds and the time to make such an extraordinary circumnavigation of the world is beyond question, just as it is beyond doubt that no-one else in that era could have done it.

These claims will doubtless be greeted with astonishment, yet if one takes a dispassionate view, there is nothing illogical about them. The Chinese enjoyed a far older and richer maritime tradition than the Europeans. When Zhu Di's fleets set sail in 1421, they had at least six centuries of ocean exploration and astro-navigation behind them; when Dias and Magellan set sail, the Portuguese had no means of accurately navigating south of the equator. Zheng He's fleets of treasure ships with their attendant supply ships were the products of a massive shipbuilding programme made possible by the economic strength of China; the tiny caravels of Cabral, Dias and Magellan would have looked like dinghies alongside the Chinese craft. Until the French built the *Dauphin Royale* – later renamed *L'Oriente* when Napoleon came to power – almost four centuries later, no wooden ship had ever approached the size of the giant treasure ships that epitomized Chinese naval supremacy and domination of the oceans. Even the European warships at Trafalgar could barely match the Chinese junks in size, range or firepower. Nelson's fleet of, at best, thirty ships carrying eighteen thousand men would have been dwarfed by Zheng He's armada of more than a hundred ships carrying twenty-eight thousand men. His treasure ships were twice the length and three times the beam of HMS *Victory*. They had far better damage control and logistical support, and could remain at sea far longer, for months on end if necessary.

The Chinese fleets had charted the world, they could determine longitude by means of lunar eclipses, and by comparing charts they were able to resolve any remaining longitudinal differences and complete the first map of the world as we know it today. But that knowledge was bought at a terrible cost. Only four of Hong Bao's ships and just one of Zhou Man's returned to China – a loss of at least fifty ships in those two fleets alone. The human toll was equally high: a mere nine hundred of the nine thousand men in Zhou Man's fleet were still with their admiral come October 1423. Up to three-quarters of the fleets' original complement must have died or been abandoned in the scattered settlements around the globe.

Twenty-four wrecks have already been located around the world; many more, carrying thousands of tons of treasure, remain to be found. The oceans will inevitably release more and more evidence as time goes by. The costs in both human and financial terms remain unparalleled – even the mightiest empire the world had ever seen was unable to sustain them – but the tasks Zhu Di had set his admirals had been achieved. It was a towering achievement, unequalled in the annals of mankind.

Zhu Di's master plan to discover and chart the entire world, and bring it into Confucian harmony through trade and foreign policy, could have succeeded, for the whole world now lay at China's feet – or so it must have seemed to his admirals when the handful of surviving ships of the treasure fleets limped home during the autumn of 1423, only to find that China, and the world, had changed for ever. Zhu Di was dying, a broken man, and the mandarins were dismantling the apparatus of the worldwide empire he had so nearly created. There would be no more tribute system, no more great scientific experiments, no more epic voyages of trade and discovery. China was entering its long night of isolation from the outside world. The eunuch admirals were dismissed, their ships broken up or left to rot at their moorings, the maps and charts and thousands of precious documents recording their exploits destroyed. Zhu Di's great achievements were disowned, ignored and, in time, forgotten.

One of the fascinating 'what ifs' of history is what would have happened had lightning not struck the Forbidden City on 9 May 1421, had fire not roared down the Imperial Way and turned the emperor's palaces and throne to cinders. Would the emperor's favourite concubine have survived? Would the emperor have kept his nerve? Would he have ordered Admiral Zheng He's squadrons to continue their voyages? Would they have carried on establishing permanent colonies in Africa, the Americas and Australia? Would New York now be called New Beijing? Would Sydney have an 'English' rather than a 'Chinese' quarter? Would Buddhism rather than Christianity have become the religion of the New World?

Instead of the cultured Chinese, instructed to 'treat distant people with kindness', it was the cruel, almost barbaric Christians who were the colonizers. Francisco Pizarro gained Peru from the Incas by massacring five thousand Indians in cold blood. Today he would be considered a war criminal.

In effect the Portuguese used Chinese cartography to show them the way to the East. Then they stole the spice trade, which the Indians and Chinese had spent centuries building. Anyone who might stop them was mown down. When da Gama reached Calicut he told his men to parade Indian prisoners, then to hack off their hands, ears and noses. All the amputated pieces were piled up in a small boat. The historian Gaspar Correa describes da Gama's next move:

When all the Indians had been thus executed [*sic*], he ordered their feet to be tied together, as they had no hands with which to untie them: and in order that they should not untie them with their teeth, he ordered them to strike upon their teeth with staves, and they knocked them down their throats \dots^7

Then a Brahmin was sent from Calicut to plead for peace. The 'brave' da Gama had his lips and ears cut off and the ears of a dog sewn on instead.

It seems certain that a further voyage by Zheng He's fleets would have included the one section of the globe they had not yet reached and charted – Europe. The upheavals in Beijing ended any possibility of that, but who can say what the subsequent history of the world would have been had the Chinese treasure ships appeared over the European horizon in the 1420s? One thing seems certain: had the emperors who followed Zhu Di not retreated into xenophobia and isolation, China, not Europe, would have become the mistress of the world.

The Forbidden City still stands as a monument to the vision of the great Zhu Di, but what more fitting epitaph could there be to the 'Emperor on Horseback' than the valiant horseman mounted on the tip of Corvo's volcano in the Azores, high above the Atlantic rollers crashing onto the cliffs far below? He pointed dramatically to the west, towards Fusang, the Americas, the land his brave and skilful mariners had discovered. As China began to draw in on itself, abandoning Zhu Di's great ambitions, others, notably the Portuguese and Spanish, began to fill the vacuum they had left. For centuries they have basked in the glory that rightfully belonged to others; it is now time, at last, for us to redress the balance of history and give credit where it is due.

To assert the primacy of the Chinese exploration of the New World and of Australia is not to denigrate the achievements and memories of Dias, Columbus, Magellan and Cook. The exploits of these brave and skilful men will never be forgotten, but it is now time to honour other men who have been allowed to languish in obscurity for too long. These remarkable Chinese admirals rounded the Cape of Good Hope sixty-six years before Dias, passed through the Strait of Magellan ninety-eight years before Magellan, surveyed Australia three centuries before Captain Cook, Antarctica and the Arctic four centuries before the first Europeans, and America seventy years before Columbus. The great admirals Zheng He, Hong Bao, Zhou Man, Zhou Wen and Yang Qing deserve to be remembered and celebrated too, for they were the first, the bravest and most daring of all. Those who followed them, no matter how great their achievements, were sailing in their wake.

BY GREAT GOOD LUCK, THE TALK I GAVE AT THE ROYAL Geographical Society in London in March 2002 was broadcast around the world, and a subsequent article in the *Daily Telegraph* was also published in seventy-four other newspapers and magazines. As a result, new evidence began to pour in from all over the world, all of which had to be evaluated and checked for accuracy by experts in each different field. The text was continually expanded and rewritten to incorporate this new material, but eventually a line had to be drawn for publication. However, emails, faxes and letters about exciting new discoveries have continued to arrive almost every day, and as the book goes to press, this postscript allows me a final opportunity to summarize the very latest evidence available.

Perhaps the most striking recent discovery has been the wreck of a very old and large ship or junk found near Fraser Island, off Queensland in Australia. It was unearthed as a result of research by a local historian, Brett Green, followed by a sonar search of the sands of the eastern part of the island. On 5 October 2002, during the period of the lowest tides of the year, a private firm of salvage experts deployed huge sand pumps over the area where metal traces had been detected by the sonar scan. They unearthed three cast-iron cannon in a remarkable state of preservation, as well as the huge wooden ribs of the wreck. The provisional analysis was that the wreck was around six hundred years old and the cannon of hitherto unknown origin. However, on 8 November, before the cannon or other artefacts could be raised from the sea-bed, the local authorities reclassified the area as a heritage site. Only government-appointed archaeologists are now allowed to continue investigations there, and I await their findings with great interest. The wreck is almost certainly of Portuguese or Chinese origin, and in either case it should provide definitive proof that Captain Cook was not the first to discover the eastern coast of Australia.

The great majority of the other new evidence I have received

relates to the Pacific and Atlantic coasts of North and South America. I have been notified of countless new discoveries from Vancouver Island in the north to Chile in the south, and the evidence takes many different forms. Dr Annabel Arends and her colleagues are continuing the pioneering work begun by her father, Dr Tulio Arends, and Dr Gallengo into the DNA (transferrins) of the Indians of northern Brazil, Venezuela, Surinam and Guyana, proving that these transferrins are otherwise unique to natives of Kwantung province in China. Diseases previously unknown in South America but common in southeast Asia - hookworm, roundworm, lice and nits - were also found among the indigenous population of Mexico, where Chinese methods of extracting dyes from roots, insects, tubers and leaves were commonplace, as were complex, timeconsuming and highly individualistic methods of lacquer technology.

In addition to that discussed in the book, there is other evidence that a wide variety of animals and birds were carried to and from the Americas in pre-Columbian times. Wild pigs (*babiroussa*) were brought from Sulawesi in Indonesia to British Columbia; horses – extinct in the Americas by around 10,000 BC – were found by the first Europeans in Peru; the almost flightless fulvous (tawny) tree duck is found only in pockets in India and on the Caribbean coast of South America; turkeys – a type of large Central American pheasant – reached Turkey via the Silk Road before Columbus set sail; and camels indigenous to the Mahgreb area of Morocco and the Canary Islands were found in South America by the first European explorers.

Plants provide still more evidence: the Europeans found fields of rice – a crop foreign to the Americas – in Mexico and Brazil; cotton with chromosomes otherwise unique to North America were found in the Cape Verde Islands by the first Europeans to arrive there, long before Columbus set sail; and coconuts brought from the South Pacific grew in Puerto Rico and right across the

isthmus of Darién to the Pacific coast, sugar cane in plantations besides the Amazon and Orinoco Rivers, and bananas beside tributaries of the Amazon, where there were also Chinese root crops. Tobacco, sweet potatoes and maize from the same area were exported to south-east Asia and the Pacific. All of these animals and plants confirm that there were seaborne voyages to and from the Americas prior to Columbus.

Linguistics provide further evidence. The people of the Eten and Monsefu villages in the Lambayeque province of Peru can understand Chinese but not each other's patois, despite living only three miles apart. Stephen Powers, a nineteenth-century inspector employed by the government of California to survey the native population, found linguistic evidence of a Chinesespeaking colony in the state,¹ and research among the Othomis people of Mexico also suggests a Chinese connection.

In Mexico, a Nayarit legend tells of 'ships like houses' arriving off the coast. At the nearby beach of Playa la Ropa, on the seaward end of the Rio Balsas, is a Chinese wreck that even now disgorges Chinese cloth after storms at sea. There are also many other Chinese artefacts: a statue unearthed at Huehuetla, a vase at Azcapotzalco, ceramic horses on the coast, lions and horses on medallions at Palenque, amulets and earplugs found at Teotihuacan (Mexico City) and numerous carvings of horses on the Yucatán peninsula and at Teotihuacan.

There is strong evidence of a Chinese presence in the old Mexican capital at Teotihuacan, and another beside the River Balsas leading from Uruapan to the coast. A further search for records of finds, focused in Teotihuacan, produced Chinese jade earplugs, jade medallions and, most fascinating of all, a tomb at the base of the Pyramid of the Sun which housed a Mongolian or Chinese body of an important person, for the tomb bore a small statue that was clearly a portrait of the buried individual² and the body itself was adorned with jade jewellery.³ Professor William Niven 'found slabs at Teotihuacan containing Chinese characters

that were easily read by the secretary of the Chinese legation, as well as a tomb and statue said to be "wholly Chinese" in design. The "Mongol-type" skeleton in the tomb was said to have borne a necklace of green jade,"⁴ which was unknown in Mexico. The new information – presented in the synopsis that follows – together with the material I have already assembled, produces an overwhelming impression of a widespread and long-standing Chinese presence in the New World that was later 'discovered' by Columbus and other European explorers.

Emboldened by the new evidence of Chinese colonies in Mexico, I next turned my attention to Queen Charlotte Island, off British Columbia in Canada. The Waldseemüller map clearly depicts the island, and the Kurashio current off the coast of north-west Canada could have carried Zhou Man's junks there. If they did make landfall, there should be evidence of the Chinese presence. Like the Waldseemüller chart, another map of Queen Charlotte Island, called 'colonia dei Chinesi' by its Venetian cartographer Antonio Zatta, was published before Vancouver or Cook 'discovered' the island. The Squamish Indians there have more than forty words in common with Chinese, including *tsil* (wet), also *tsil* in Chinese; *chi* (wood), which is *chin* in Chinese; and *tsu* (grandmother), which is *etsu* in Chinese.

Grant Keddie, curator of archaeology at the Royal British Columbia Museum in Victoria, has analysed the evidence that the Native American cultures of the north Pacific coast may have been influenced by contact with ancient Chinese culture.⁵ Thousands of Chinese coins have been found in the area, but Keddie considers that most were probably brought by later Chinese traders, and none provides direct evidence of pre-Columbian voyages by the Chinese. However, the discovery of a Taoist talisman and a Chinese stone lamp were far more significant. The talisman may be identified 'with Shou Lau',⁶ whose talismans I have seen in many locations around the world.

In 1747, a boy from Attu in the Aleutians spoke of a legend in which 'men dressed in long, many-coloured silk and cotton clothing came to the island in small ships with one sail, their heads were shaved to the crown and the hair on the back was plaited into tresses'.7 Scholars have been discussing the parallels between the culture of ancient China and the advanced societies of the New World ever since the Dutch jurist and politician Hugo Grotius (1583-1645) wrote of the accounts of Spaniards who observed 'Asiatic' shipwrecks on the Pacific coast of Mexico.8 The Portuguese sailor Antonio Galvão was told about early Chinese voyages to the New World when he visited China in 1555, and he noted that 'the people of China were sometimes lords of the most parts of Syria and sailed ordinarily the coast which seemeth to reach unto seventy degrees towards the north'9 - the latitude of Baffin Island in Canada and the north coasts of Alaska and Siberia.

The advance royalties from my book enabled me to set up a small team of researchers who could read medieval Spanish and Portuguese, including Brazilian Portuguese. I put them to work on the first-hand accounts of the early Spanish and Portuguese explorers to the New World, many of which had never before been translated. I decided to concentrate on areas where the accumulation of evidence of Chinese influence was strongest: California, around San Francisco; the Mississippi River west of Kansas City; Florida; Mexico between the Pacific coast and Mexico City; the Caribbean coast of Venezuela, Colombia and Guyana; the Amazon, particularly around Santarém, where the Tapajos River branches south from the main Amazon stream; and the far south of Brazil near Cuiabá, where the Paraná River of Paraguay and the São Francisco branch of the Amazon both rise.

At first sight it appeared unlikely that the Chinese would have voyaged so far inland – nearly three thousand miles in the case of the Amazon – but there was compelling evidence in a series

of charts clearly showing the course of North and South American rivers before Europeans had reached and 'discovered' them. Just as the Toscanelli chart (1474) shows the Murray, Darling, Cooper, Diamantina and Flinders Rivers of Australia, so the Martellus map (1489) depicts the Magdalena in Colombia, the Orinoco in Venezuela, the Amazon and its tributary the São Francisco, the Paraná and Paraguay Rivers in Paraguay, the Colorado and Negro in Argentina, and the Chubut in Patagonia. The Magdalena River also appears on the Cantino (1502), as does the Cavra branch of the Orinoco, while the Waldseemüller (1507) shows nearly a thousand miles of the Mississippi as well as the Brazos, Alabama, Roanoke, Delaware and Hudson Rivers of North America.

The rivers of Colombia and Venezuela are also linked to the Chinese voyages by the DNA (transferrins) of the people who lived beside them. Surinam, Guyana and the Orinoco delta also have a similar 'Chinese' connection; as in parts of China, the native tribes of the Mato Grosso in Brazil have an absence of Duffy blood groups (a system of classifying blood used in tracing and predicting the spread of certain sorts of malaria). There are also skin diseases in the flood plains of the São Francisco and Xingu Rivers and the Mato Grosso of southern Brazil that can only have been transmitted by seaborne voyages from south-east Asia.

Ancient stone carvings from the floodplains of the Mississippi and Missouri Rivers also yield fascinating evidence. There are clear depictions of horses in the Oklahoma Panhandle; near Springfield, Colorado; in Hickling Springs, Colorado; and in Le Flore County on the borders of Arkansas and Oklahoma. Somebody must have brought horses to the area, for how else could the unknown artists have drawn them? There are also many petroglyphs of ships, most in the same areas: Picture Canyon, Colorado, near the Oklahoma border; Le Flore County, Oklahoma; the Oklahoma Panhandle; Baca County, Colorado; and beside the Arkansas River in Colorado. In total there are

more than fifty carvings of ships and forty of horses, strongly suggesting that the horses were brought by ship.

These findings prompted me to devote some effort to researching the diaries of the first European explorers to reach the Mississippi and its tributaries, especially the Missouri. In 1540, Francisco Vasquez de Coronado (c.1510-54), the Spanish governor of an important Mexican province, led an enormous expedition through what is now the American West, searching for the fabled 'seven cities of Cibola', first described to an earlier Spanish conquistador, Cabeza de Vaca, on his expedition from Florida to the Pacific coast of Mexico in 1528–36. These lost cities were supposedly built on land rich in gold somewhere on the alluvial plains between the Mississippi and the Rio Grande. The historian Pedro de Castaneda recorded Coronado searching first for the lost city of Quivira, which he believed to be 'not far from the great bend in the Arkansas River whose course they had followed from the neighbourhood of [Dodge City]'.10 Coronado described encounters with Indian hunters, and then an entirely different people:

These people, since they are few, and their manners, government and habits so different from all the nations [peoples] that have been seen and discovered in these western regions, must come from that part of Greater India, the coast of which lies to the West of this country [i.e. China], crossing the mountain chains and following down the river, settling in what seemed to be the best place. The settlements and people already named were all that were seen 70 leagues wide and 130 long in the settled country along the river Tiguex [Missouri] ... Silver metals were found in many of their villages, which they use for glazing and painting their earthenware.¹¹

Even more fascinating, 'vessels were found of which the sterns were gilded, and Pedro Menendez, in Acosta, speaks of the

wrecks of Chinese vessels seen upon the coast. It is also an unquestionable fact that foreign merchants clothed in silk formerly came among the Catualcans. All of these accounts, added to those which we have adduced, became so many proofs that the Chinese traded at the north of California, near the county of Quivira.¹²

The story is the same further east. Acosta, the great sixteenthcentury historian, described meeting Chinese people in Mexico, and wrote of

the Strait which some hold to be in Florida ... Even as Magellan found out this strait from the south [the Straits of Magellan], so some have pretended to discover another strait, which they say is in the north, and suppose it to be in Florida ... Pedro Menendez, the Adelantado, a man very expert at sea, affirmeth for certaine that there is a strait and that the king had commanded him to discover it, wherein he showed a great desire; he propounded his reasons to prove his opinion, saying that they have seene some remainders of shippes in the North Sea [Atlantic] like unto those which the Chinois use, which had become impossible if there were no passage from one sea into another.¹³

The Caribbean, too, and the areas bordering it, are full of legacies of Chinese voyages, but the evidence strewn along the banks of the Amazon is perhaps the most compelling of all. The earliest maps of these regions show that seafarers had travelled far down the Amazon towards Cuiabá, and when I began research into the Tapajos tributary that joins the Amazon by the modern town of Santarém, I learned that a mass of jade and other Asian artefacts had been found there. Senhor João Barbosa Rodrigues, a Brazilian botanist and anthropologist, argued that the jade amulets he named Muyrakyta had come from China.¹⁴ The written opinions of several professors supported his contention that at least some of the jade found by

the first Europeans in Central and South America was 'unquestionably Chinese' in origin, and a jade duck found in a hoard near Santarém was strikingly similar to a duck found in New Zealand. I now had evidence of jade talismans the length of Central and South America. Some of this may eventually prove to be Guatemalan, but the bulk of it is undoubtedly of Chinese origin. Moreover, much of the jade, especially that found in Brazil and Venezuela, was discovered in the places where the native people have DNA or intestinal afflictions otherwise unique to China and south-east Asia. As this book goes to press, it appears that yet another hoard of jade has been unearthed at Maracay in Venezuela.

The jade artefacts were found where today there is only jungle, but I was certain that the Chinese would only have traded these exquisite pieces if they stood to gain something of real value in return. I returned to the diaries of the first Europeans to sail down the Amazon to Peru, notably the conquistador Francisco de Orellana (1511–46), second in command of Pizarro's 1542 expedition to the east of the Andes; the Portuguese explorer Gabriel Soares de Sousa (1558); and the Spanish friar Gaspar de Carvajal (1539–96). Carvajal's accounts are particularly riveting. At the confluence of the Amazon and the Tapajos, he discovered 'a vast city' of splendid buildings, filled with beautiful, multicoloured ceramics of very fine quality.

There may now be much more recent confirmation of his discovery. On 7 September 2002, Dr Denise Gomes of São Paulo University described a lost city amid a 'green hell entirely peopled by Indians'¹⁵ in the jungle near Santarém, but was it built by the indigenous people or by the Chinese eunuch admirals as the range of Chinese artefacts discovered there might suggest? The nephrite amulets are similar in origin, form, colour, density and chemical composition to Chinese jade amulets, as are items found in Nicaragua and Costa Rica. All are 'unquestionably Chinese jade'.¹⁶ Terracotta amulets have also

been found inscribed with the Chinese yin-yang symbol, and terracotta urns were found near Santarém. They were painted in the traditional symbolic colours of Asia – red, yellow, black and white. Why were these four 'Chinese' mineral colours used, given the local availability of vegetable dyes? The mountain range near the site of the Muyrakyta find is named Serra da Chinella; *chinella* means 'sandal/slipper' in Brazilian Portuguese, an item of Chinese origin and possibly an early variation of the Portuguese word for the Chinese, *chinês*.

These finds, together with mortuary customs, folklore very similar to that of China, and the divination processes using chickens and chicken blood on paper, all signify indoctrination over an extended period. The substantial evidence of a Chinese presence, coupled with the vast wealth that could have been extracted from the Brazilian diamond mines and the silver mines of the Chapada Range, make it quite conceivable that the Chinese set up a network of trading posts and settlements along the Amazon and its tributaries. Several expeditions have been mounted in search of these lost cities, yet the majority of explorers have returned empty-handed, or indeed – like Colonel Percy Fawcett, who set off into the jungle in search of fabled riches but disappeared soon afterwards – never returned at all.

Over the years of researching and writing this book, I have been struck again and again by the truth and accuracy of the descriptions recorded by the early explorers. Far from being fanciful or bizarre exaggerations, almost everything I have investigated as a result of reading their accounts has turned out to be true. For example, the 'Island of the Seven Cities' was Antilia, and the Portuguese did travel to and from it long before Columbus. Hence, there seems good reason to believe that many of the early European accounts of lost cities in North and South America will also turn out to be correct. Friar Gaspar de Carvajal recorded these impressions as he travelled down the Amazon in the 1540s:

We saw emptying into the river another very powerful and wider river on the right; so wide was it that at the place where it emptied in it formed three islands . . . At this junction there were numerous and very large settlements and very fruitful country and very fruitful land ... There was a great deal of porcelain ware of various makes, both jars and pitchers, very large with a capacity of more than 25 arrovas [100 gallons] and other small pieces such as plates and bowls and candelabra of this porcelain of the best that has ever been seen for that of Malaga is not its equal for it is all glazed and embellished with all colours so bright that they astonish, and more than this, the drawings and paintings which they make on them are so accurately worked out ... and the Indians have told us that as much as there was porcelain in this house, so much there was back in the country in gold and silver ... From this village there went out many roads and fine highways inland ... Cristobal Maldonado . . . and some other companions started to follow them and had not gone half a league when the roads became more like royal highways and wider ... Countries very rich in silver ... and plentifully supplied with all kinds of fruit, pineapples, pears, plums and custard apples.¹⁷

After studying the rest of Friar Carvajal's account, I was certain that the 'very powerful and wider river on the right' was the Tapajos and the three islands were those in the stream to the north of Santarém. The mention of large royal highways is very important, for today this area is jungle. The people who created the highways that astonished the Spanish must have had substantial surplus capacity and engineering skill. The excavation of the lost city reported by Dr Gomes will be of great interest.

The Tapajos River splits into several tributaries further south, the southernmost of which rises in the Chapada Range in the Mato Grosso, north-east of Cuíaba.¹⁸ This small area is also where the Paraná rises – a mighty river that runs first west and then south-east to empty into the estuary of the River Plate.

When the Portuguese reached this area a century after Friar Carvajal, they found a way of sailing with the wind from the coast against the current all the way up to Cuíaba. It is entirely possible that the Chinese had also done so: the first Europeans saw rice growing beside the Paraná, and the skin diseases of south-east Asia are endemic among the native population. There are substantial silver mines around the headwaters of these rivers. The Chapada Range is a far healthier environment than the marshy plains below and therefore would have been a sensible place to build a city. A map of lost cities of the Americas¹⁹ states that this is where Colonel Fawcett vanished in 1925 while searching for the legendary lost city of Moribeca.

In 1743, a native of Minas Gerais made a search for Moribeca with a party of a few Portuguese, Indians and Negro slaves. After a fruitless ten-year search, they were scouting for food one day when the pursuit of a deer led them through a deep crevice in a precipice. Gaining the summit, they 'stood dumb at the view spread before them'.

In the immediate foreground lay extensive plains brilliantly green, with patches here and there of silver water, changing to yellowish brown and dull greens as they drew near the foothills. On this was a sight that made the adventurers gasp and hastily draw back behind the crest line. For at a distance of some three or four miles and so clear that buildings could be distinctly made out, was a huge city...

The overwhelming dignity of the design, the awesome silence and mystery of an old abandoned city possessed them, rough men as they were. High above the crown of the central arch and deeply engraved into the weathered stone were characters of some sort. They knew enough to realize this was no familiar script. The arches were in a good state of preservation; the very few huge blocks had fallen from the summit, and portions had slipped somewhere out of plumb. Passing through the archway they found

themselves in a wide street, littered with fallen masonry and broken pillars. They gazed in amazement. There was not a sign of human occupation. It was all incredibly old, and yet for its age amazingly perfect. Here were two storeyed houses on either side all built up of carefully squared blocks carved in elaborate time-worn designs. In many cases roofs had fallen in, in others great stone slabs still covered the dark interiors, and he who had the temerity to enter the windowless chambers through the vaulted doorways and to raise his voice, fled at the echoes hurled at him by the vaulted ceilings and solid walls...

Dumb with amazement, the party, huddled together like a flock of scared sheep, passed down the street into a vast square or plaza ... In the centre of the plaza, dominating its surroundings in sublime majesty, was a gigantic black stone column set upon a plinth of the same rock, and upon it the statue of a man, one hand on his hip, the other arm extended with the index finger pointing to the north ... Magnificent in design, perfect in preservation. In each corner of the plaza had been great obelisks in black stone covered with carvings ... The whole of the right-hand side of the plaza was occupied by a building so magnificent in its design as to have been obviously a palace, its square columns intact with walls and roof partly demolished. A vast entrance hall was approached by a broad flight of steps, much of which was displaced. The interior of this hall was rich in exquisite carving, and still showed signs of a brilliance of colouring comparable with some of the finest relics of Egypt ...

On the far side of the plaza the city was open to a river some thirty yards or so in width ... evidently there had been a highly decorative terrace to this river, and most of it had been swallowed up or lay beneath the waters ... About a quarter of a mile outside the city and standing by itself was a palatial building with a front of 250 paces approached by a broad flight of steps of many coloured stones. It was heavily columned all round, and the noble portico opened up upon a vast hall, with mural decorations and

471

gorgeous colouring that still remained more or less intact. From this hall opened fifteen smaller chambers, in each of which was the carved head of a serpent; from his opened jaws poured a small stream of water ...

The leader decided to follow the river down on the chance of striking some civilized settlement ... Soon after the departure of this party he found to the east of the fall unmistakable signs of mining. The shafts whose depths he had no means of plumbing excited his curiosity. On the surface of the ground were specimens of silver ore of great richness, presumably brought up from the shafts, encouraging him to believe he had really discovered the lost mines of Moribeca.²⁰

It is hoped that a fresh expedition will be mounted to find the lost city of Moribeca, following in the footsteps of Colonel Fawcett. We have enough clues of where to look!

A third lost city, Quivira, another of the fabled 'seven cities of Cibola', was reputedly located in the area of modern Wichita. Coronado's expedition set out from Compostela on the Pacific coast and marched northwards along the Gulf of California to what is now Sonora. Near Zuni, he turned eastwards towards what is now Albuquerque, and then made his way north-east from there to the Missouri. The land between the Rocky Mountains and the Missouri he named Tiguex, and there he encountered Chinese people. Coronado sent exploratory parties in all directions, one of which, under the command of Garcia Lopez de Cardeno, discovered the Grand Canyon of Colorado. In the spring of 1541, Coronado's main party reached what is now Wichita, but though they found 'ships with gilded sterns' there, they did not discover the lost city of Quivira that they were seeking. Is that the end of the matter? I certainly do not think so. There are far too many carvings of foreign ships and horses in western Oklahoma filled with a wealth of ancient writing and related petroglyphs.

Further up the Mississippi, in Wisconsin and Michigan, native American lore cites 'ancient maritime foreigners who came to mine the "red rock", and Rock Lake, Wisconsin, holds in its depths a possible clue to these 'ancient foreigners'. It is an area rich in copper, perhaps the 'red rock' of native lore. By AD 900 copper had become the coin of the Mayan realm. Mayan miners and astronomers knew of copper deposits in northern Michigan and sent expeditions to establish control of the area. They built a large settlement at 'Aztalan', which became the centre of copper trading for several centuries, but in about 1300, copper deposits were found in Mexico itself and Aztalan was apparently abandoned.

For five centuries, including the period of the great Chinese voyages of exploration, its history went unrecorded, but between 1830 and 1840 early settlers in the Rock Lake area saw strange protrusions sticking out of the water, described by the natives as the 'rock tepees of the ancient foreigners'. Within twenty years, the sawmill dams built by the settlers led to a rise in the water level of Rock Lake and the structures were completely submerged. But after a prolonged drought in the autumn of 1900, two local residents out duck-shooting saw mysterious structures under the water. Dozens of local people converged on the lake, and several young boys dived down and touched the flat-topped pyramids, one of which was described as 'a long tentshaped structure' approximately eight hundred feet in length. However, the very next day the drought broke, the water became murky and no more sightings were made.

In the 1980s, a team led by local journalist and author Frank Joseph began sonar sweeps of the lake and photographed the underwater structures,²¹ and between 2000 and 2002 the Rock Lake Research Society carried out further sonar scans, attempting to fix the location of the structures using ground positioning systems. A diver recorded his impressions:

I would say the first one is about eight feet high, twelve to fifteen feet wide, and more than a hundred feet long. The second is ten to twenty feet south of the first and about the same width, with a steeper slant to the sides, and is shorter in length. They look to be the same height and exactly north and south on a compass alignment ... The area of rocks looks like a tent-shaped pyramid, collapsed ... It is like a pile of rubble, large stones on the bottom and smaller ones on top ... Some kind of plaster had been used on the sides. Slabs of fragments of cement or plaster, or at least something man-made, were on top of the large one.²²

Local historians developed a theory that these truncated pyramids of 'Aztalan' were used as observation points to record the movements of the sun and planets.

The Louisiana Mounds Society refers to remains of horses in Wisconsin,²³ and a horse's skull was found with other Indian artefacts in a burial mound in Wisconsin, long before Columbus' era. A vertebrate palaeontologist pronounced the bones to be 'those of a horse and not petrified'.²⁴ In addition, recent test results have shown that the Sioux and Cree Ojibwa people native to the region have 'Chinese' DNA (please refer to *Synopsis of Evidence*).

Taken together, all this evidence makes it at least arguable that the Chinese came to mine copper at Aztalan. There is certainly enough cause to mount further explorations near there. Truth, after all, as I have found many times earlier in the course of my researches, really is far stranger than fiction.

When I began my research years ago, all I had was a blank sheet of paper. As I write this in the late autumn of 2002, my book is soon to be published in the USA, Canada, Australia, New Zealand, South Africa, China, Spain, Portugal, Italy, Poland, Finland, Holland, Scandinavia, West Germany, Japan and a host of other countries. Television rights have also been sold worldwide. A potential worldwide audience and readership

of millions have the opportunity to join in the quest for further evidence of those great Chinese voyages of the early fifteenth century. A 1421 website (www.1421.tv) has been established, and I welcome all contributions and help, especially in the search for those fabled lost cities. The great adventure has only just begun.

In the hectic months since I wrote this postscript for the American edition of 1421, a stream of invaluable evidence has poured into our website from 127 countries around the world. We now have very persuasive information, not least from DNA evidence, of where the Chinese fleets created settlements in the New World.

In October 2002, my wife Marcella, four researchers and I set off for Nanjing, some two hundred miles up the Yangtze, the great river that enters the Yellow Sea near Shanghai. Every two years, the Association of Zheng He Studies holds a conference in Nanjing to which leading scholars of Zheng He are invited about a hundred of them attended this one. Professor Yingsheng Liu of Nanjing University very kindly invited me to give the keynote address; afterwards, many learned professors who had spent their lives researching Zheng He were kind enough to share with me the fruits of their lifetime's labours. Thus we returned home with an almost priceless cache of published and unpublished works about the great admiral and his voyages. I had dreaded this conference, fearing there might be some bombshell that would destroy my theory. However, it was not to be. Not only did the Nanjing conference enable me to have my book vetted by the world's leading experts on Zheng He, it also gave me confidence in my overall argument. Indeed, the majority considered my central thesis to be essentially correct.

At the end of the conference, the leader of Taicang's Communist Party kindly invited me to stay in their sumptuous guest apartments. Taicang was the port which provisioned the treasure ships after they had sailed downriver from the shipyards

at Nanjing. When I arrived, I found the committee, all twelve of them, standing on the step of the banqueting hall, each holding a large glass of water buffalo milk. The reason soon became apparent: local custom has it that during a banquet each person may propose one toast to the guest and a second to their particular friend – that meant twenty-four glasses of Mao Tai. That wonderful stuff was still coursing through my veins the following morning as we staggered around Taicang's old harbour and into the temple dedicated to the Goddess of the Sea. This temple also serves as Admiral Chou Wen's family mausoleum. Recently discovered family records confirm that he spent twelve years at sea with Admiral Zheng He. It appears Chou Wen was the one vice-admiral who was not a eunuch, for he had a wife and children.

In December, Marcella and I returned to Yunnan in southwest China to honour the invitation of Professor Yao Jide and Professor Fayuan Gao to the Kunming Conference on Zheng He studies. This, too, is held biannually, and the emphasis is on Zheng He's life, for Yunnan is where he was born. Once again, nearly a hundred distinguished professors attended the conference, their field of research China's relations with overseas countries. Once again they very kindly offered me the keynote speech on the first day. Professor Bi Quanzhong followed me. His speech was enthralling.

Some years ago, while researching into the prefecture of Fujian province, he had come across accounts of a Brazilian delegation that had landed in the Fujian province after leaving Brazil some ten years earlier, in 1501. They had found their way from Brazil to China by means of a map and had brought very valuable tribute in the form of six wooden boxes of emeralds. Their letters of credential were embossed in gold, so it was a very important delegation. Professor Bi Quanzhong realized that in 1501 Europeans had not yet reached Brazil and China and therefore could not have provided the maps on which the Brazilian

delegation relied. Moreover, China was sealed in 1431; this led the professor to the conclusion that the Brazilian delegation must have used a map drawn by the Chinese before that date. He began to research Zheng He's voyages but found, as I had done, that the records had been destroyed. He therefore decided to pursue research into the accounts of private individuals to see if there were any who had sailed with Zheng He. He found two separate accounts: the first told him that the Chinese fleets had reached Brazil, the second that they had reached North America.

The professor decided to write a book in which he would claim that the Chinese had discovered the Americas before Europeans, and he was in negotiations with his publisher when he heard of the talk I gave at the Royal Geographical Society in March 2002. He therefore decided to postpone the publication of his book until he had read mine; I understand his will be published shortly. Professor Bi Quanzhong's evidence, much more succinctly and elegantly presented than mine, stunned the Kunming Conference, for here was a wholly independent Chinese expert who had come to exactly the same conclusions as I had!

Another bombshell followed. Admiral Zheng Ming, former comptroller of the Chinese Navy, described an airport-runwayextension excavation in Fujian during which workmen had come across an underground palace. In the palace were statues of Zheng He and his vice-admirals shown planning the voyage – the first recorded description of Zheng He, faithfully depicting his immense height and his red uniform. This in itself was of great importance, for it enabled me to compare the Fujian statues with the descriptions, drawings and paintings I had found around the world – not least in terms of the colour and shape of the admiral's robes and his strange cap. However, even more exciting was that standing next to Zheng He, and closer to him than his vice-admirals, was a small European with a bulbous

nose and large ears. In his hand he clutched a bundle of documents or maps. He looked like the Venetian drawn in the *Illustrated Record of Strange Countries*. Obviously this European was of considerable importance to Admiral Zheng He – here, I realized, was Niccolò da Conti!

Admiral Zheng Ming's talk, following on from mine and Professor Bi Quanzhong's, electrified the conference, which split into three groups to discuss the evidence. At the end of three days the conference unanimously voted to adopt my evidence. There was barely a voice against the motion.

On the last day of the conference, we visited Zheng He's family estate on the banks of a beautiful lake near the Burmese border. There, surrounded by pine trees and in the shadow of the statue of the great man, the proceedings were brought to a close. I was immensely honoured to be granted the keys – that is, the freedom – of the city of Kunming and to be elected a visiting professor of Yunnan University. The university has a great reputation, not least for its genetic studies into minority Chinese peoples. They kindly agreed to make available their resources to carry out DNA analysis of the peoples in the New World among whom, I believe, the Chinese settled on their great voyage. This was a significant breakthrough.

Now that my central thesis was accepted, many Chinese historians cast their eyes once again over official Chinese histories. Many separate accounts were found claiming that not only had Zheng He's fleets been away for more than four years (not two and a half, as I stated) but that his fleets had reached North and South America and Australia. No longer were Professor Bi Quanzhong and I lone voices; we were suddenly in the majority. (Please refer to the Synopsis of Evidence for details of official records recently found or retranslated.)

It also transpired that I may have been too conservative in my estimate of the size of the Chinese fleets. Professor Robert Finlay called my attention to the accounts of Vasco da Gama arriving in

Calicut to be told of a fleet of eight hundred ships having visited the port some eighty years earlier; the fleet had been joined by junks from the Ryuku Islands (Japan) and by Korean, Burmese and Indian ships. That would explain not only the wealth of evidence left around the world but the traces of the Japanese language and 'Chinese' DNA found among the Zuni peoples of Pacific America. It also explains the Korean DNA that regularly turns up in the blood of Norwegian fishermen – in my book I contend that one squadron had sailed past the north coast of Norway, along the coast of Siberia and through the Bering Straits.

I was also delighted to have independent evidence for the authenticity of the Vinland Map and the capacity of the Chinese to circumnavigate Greenland in 1422. I knew that bringing the Vinland Map into the book would unleash a storm, as indeed it did. The nitpickers had a field day, for they claimed a mini ice age had started in the fourteenth century, Greenland could not have been circumnavigated, the Vinland Map could not have been drawn and thus my book was clearly rubbish from beginning to end. Late in 2002, the age of the parchment of the Vinland Map was dated by D. J. Donahue, J. S. Olin and G. Harbottle, and the results were published in Radiocarbon (vol. 44). The radiocarbon age of the map's parchment, as determined by accelerator mass spectrometry with a 95 per cent confidence level, is AD 1411-1468. Even more devastating for the 'forgery' school, an ink transfer was found hidden under the end papers of the binding. It related to the appointment of the notary Bartholomaeus Poignare to the Council of Basle on 16 September 1435. The Delft Technical University in the Netherlands has carried out a study into Arctic sea ice and concluded that 'Five consecutive extremely warm winters could lead to the complete melting of the ice in the Arctic Sea.' The Dutch Meteorological Institute KNMI, in collaboration with the European Union, found that the 1420, 1422 and 1428 summers in

northern Europe were extremely dry and hot. This backed up my evidence of the strontium 90 levels in Greenland's glaciers between 1400 and 1450, of the thickness of tooth enamel on skeletons in graves in Greenland, and of the absence of certain houseflies in Greenland's dwellings. In short, not only was the Vinland map genuine, Greenland could indeed have been circumnavigated in 1422.

Our travels, delightful as they were, ensured that we missed the traditional parties leading up to Christmas with the result that I set off for the launch of the American edition of this book on 4 January 2003 with a reasonably clear head and healthy liver. Shortly before leaving for America I had received a summary of a review which, it was said, would skewer my arguments. Arriving gravely concerned in a blizzard in New York, I hastily scanned the *New York Times*. Its review was, in my opinion, pretty awful, but the public ignored it for the book went from 2,834th in the *New York Times* list to the third-placed bestseller in a week, and it stayed a bestseller until April.

By this stage we had our website, www.1421.tv, up and running with a team to handle the torrent of new evidence (we'd received 16,000 emails since the book was published in the UK in the autumn of 2002). Every day while I was in America, I emailed my team in London a summary of the phone calls and emails I had received, and they in turn emailed me a synopsis of everything they had received. The stream of evidence became a river, then a flood. It became clear after a few days that thousands of people agreed with my theories.

As more time went by, I became less defensive and started to ask people what they thought. For example, I asked Bostonians whether they had ever had their blood analysed to see if they had Chinese forebears (this, incidentally, produced several who had Chinese teeth, or the Chinese 'purple spot' on their buttocks, and a score of them went off to have their DNA tested). In California, I asked how many of the audience had collected

Guadeloupe. Les Saintes, approached from the south-east (*below*), would look like one island curving to the north-west. La Souffrière (*above*) on Basse Terre is not far to the north.

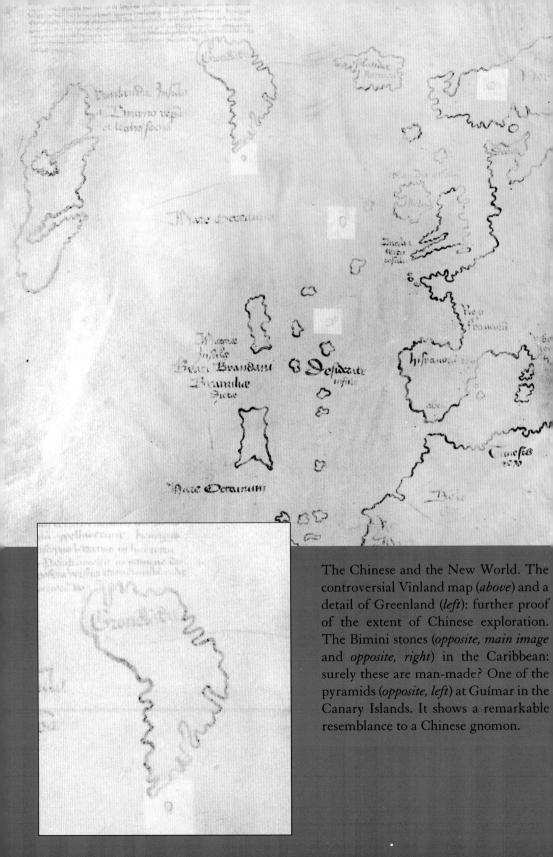

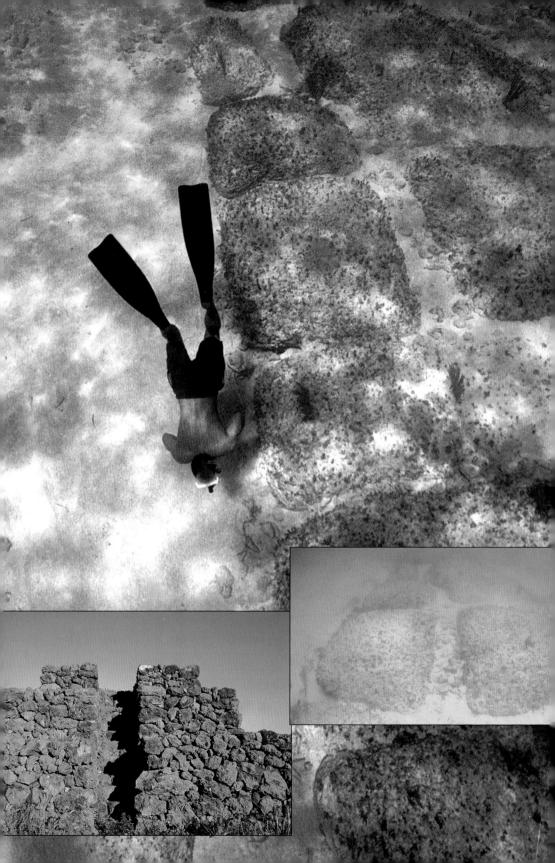

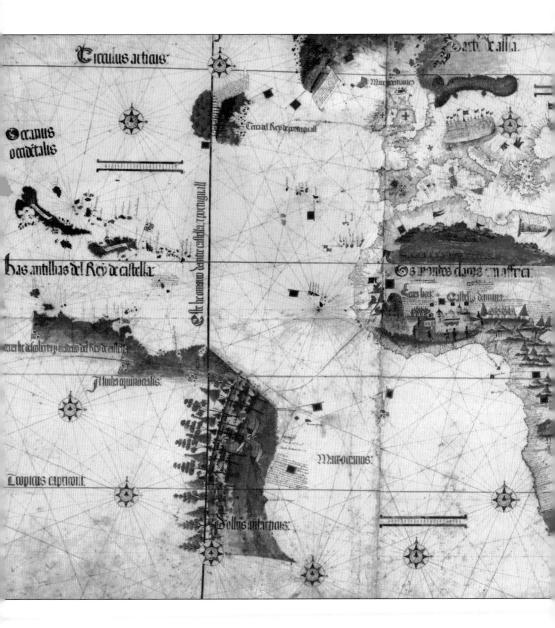

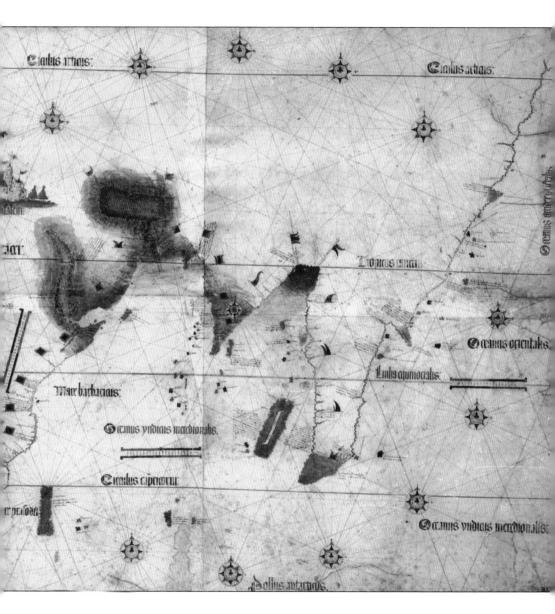

The influential Cantino world chart of 1502.

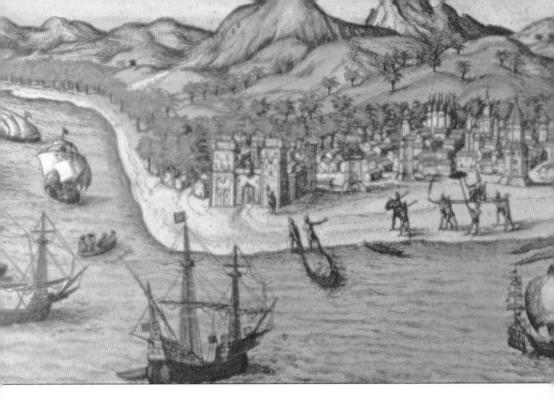

European exploration: in the fourteenth century Marco Polo with his father and uncle (*below*); in the fifteenth (*opposite, centre, left to right*) Christopher Columbus; Vasco da Gama and Ferdinand Magellan. By the sixteenth century trade with ports such as Calicut was thriving (*above*), but the level of scientific inquiry did not reach Chinese proportions until the advent of Captain James Cook and Joseph Banks (*opposite, bottom left*), who stopped off for water in Tierra del Fuego en route for Tahiti in 1769 (*opposite, bottom right*).

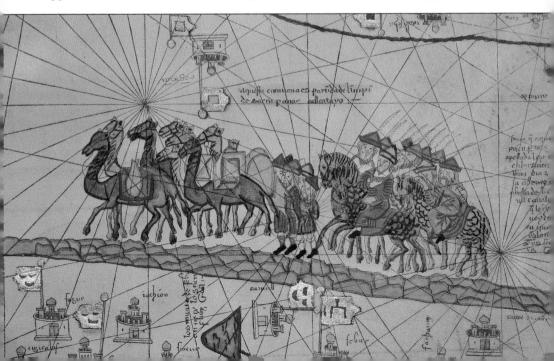

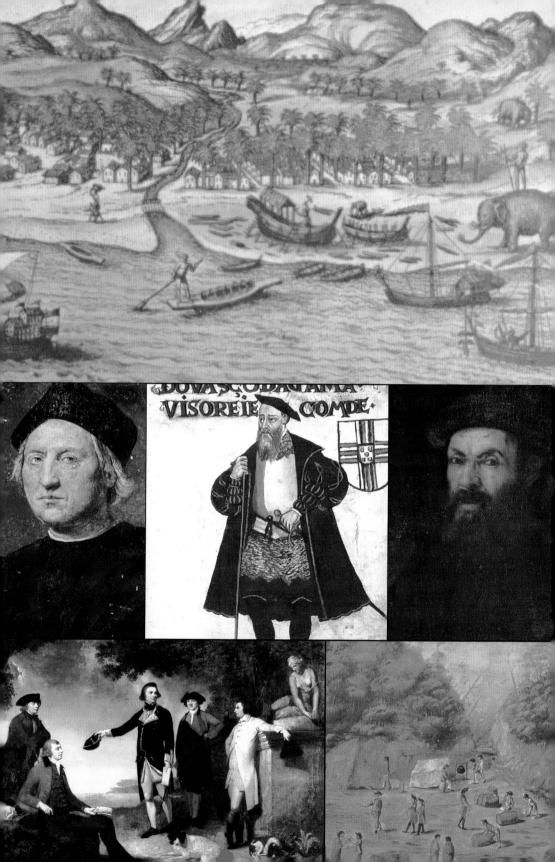

Prince Henry the Navigator looking westwards from the prow of the monument at Belèm to four hundred years of Portuguese exploration.

Chinese artefacts from the seashore. This triggered dozens of emails: people had found Ming brass plates, ceramics, stones incised with Chinese writings and Chinese jade. They knew of local legends describing Chinese people landing in California; they knew of a Chinese wreck off Santa Catalina; they knew of Chinese trees, plants and bushes; they knew of Chinese colonies that had existed in California until the last century: they knew of Native Americans in California who understood Chinese; they knew that early European explorers had found Chinese people, and that Jesuit and Franciscan missionaries found those same people a century later toiling away in California's rice fields. Hardly anyone doubted that the Chinese had arrived in California before Europeans. With this new evidence we could pinpoint the locations of Chinese colonies down the Pacific coast of North America: in Queen Charlotte Islands, British Columbia; in Washington State; in Oregon near Neahkahnie Beach; in California between the Sacramento and Russian Rivers; in Mexico on the Yucatán peninsula.

The next step was obvious - to read and, if necessary, translate the original diaries of the Europeans who first arrived in those places. Did they find Chinese people? The full results are on the website, but in short in almost every place where I claim the Chinese settled, the first Europeans met Chinese people. To me, this was once again incredible. How had 'professional' historians managed to ignore Coronado's accounts of finding Chinese junks with gilded sterns? How could they explain away Columbus's secret records describing his meeting with Chinese miners in 'bird' ships, or the accounts of José de Acosta, Antonio Galvão, Giovanni de Verrazzano, Pedro de Castaneda, González de Mendoza, Father Antonio de la Calancha, Carlos Prince, Cabrillo, Bartolomeo Ferrello, Pedro Menendez de Aviles and Father Louis Sales OP, all of whom found Chinese people or Chinese junks when they first arrived in the Americas? How could they not have tackled the fact that all the great European

explorers – da Gama, Columbus, Magellan, Dias, Cabral – set sail with maps showing them their destination.

The final piece of the jigsaw was DNA evidence. In the places where the first European explorers met Chinese people, did the indigenous Native American people have Chinese DNA?

I was not prepared for how immediate and powerful the DNA evidence would be. When my researcher Antonia Bowen-Jones handed me a copy of Professor Novick and colleague's report in *Human Biology* (vol. 70) entitled 'Polymorphic Alu Insertions and the Asian Origin of Native American Populations', I nearly fainted. *Alu* sequences are, the authors state, 'exceptional genetic markers'. The report summarises:

The results corroborate the Asian origin of Native American populations but do not support the multiple-wave hypothesis supposedly responsible for the tripartite Eskaleut, Nadene and Amerind linguistic groups. Instead, these populations exhibit three major identifiable clusters reflecting geographic distribution. Close similarity between the Chinese and Native Americans suggests recent gene flow from Asia.

Figure 1 of that report shows the geographic distribution of the people tested – it was as if my map showing where the Chinese had settled had been transcribed by Professor Novick and his colleagues. (This, of course, could not have been the case, for their research had been carried out years before my book was written and I did not read their report until five months after my book was published.) Figure 2 shows the 'maximum likelihood tree' – that is, how close Native American peoples' DNA is to Chinese DNA, and how much that DNA has been diluted over the years. It can be seen that the phylogenetic link between the Buctzozt Maya (Yucatán peninsula) and the Chinese is so close that these people could be more accurately classified as Chinese. In short, 22 of the 24 Native American populations whose DNA

was analysed are from areas where I contend the Chinese fleet settled: far down the Amazon River; on the banks of the Paraná and Paraguay tributaries; in California; in Tiguex (Colorado/Arizona); on the Yucatán peninsula; in Peru; on the Venezuela/Colombian borders; and even at Hvalsey in south Greenland, where the Pope described the local people being carried off by barbarians before being brought home. Professor Novick's report will be placed on my website once his permission is obtained.

Figure 2 also shows that the DNA of the Aleut people of Alaska is virtually identical to that found in Hvalsey, yet these places are thousands of miles apart. If the people of Greenland had started their journey in the Aleutians, then marched eastward to Greenland, the people of North America between those two areas should have similar DNA - but they don't. Similarly, the DNA of the Maya people of Yucatán is far closer to the Chinese, Aleuts and Greenlanders than to that of the native populations who lived around them. All the Native American peoples with DNA described in the Novick report as having close similarity with Chinese DNA can be reached by sea. This also applies to the Amazon and Paraguay River peoples, and to the Sioux and Cree Ojibwa, reached via the Mississippi. The inescapable conclusion is that Chinese DNA was brought by sea, and the only recent sea voyage carried out by very large numbers of Chinese - sufficient to create the twenty-four settlements cited in Professor Novick's report - was that of Admiral Zheng He. In my submission, Carlos Prince was correct all those centuries ago. He researched Chinese records that claimed 'Chinese ... with Tartairs, Japanese and Koreans ... crossed the maritime stretch ... into the Kingdom of Quivira [Arkansas], Mexico, Panama, Peru and other eastern countries of the Indies ...' long before Europeans reached the Americas. The synopsis (and my website) details more supporting evidence, such as the existence of American populations with genetic markers for hookworm and

roundworm, which cannot survive Arctic crossings on account of the cold.

I believe the evidence to be near incontrovertible, and more evidence continues to pour in. The talk I gave at the Royal Geographical Society in March 2002 created such interest and produced so much new evidence that by the time the UK book went to print that summer it had trebled in size. In the months since then, people who had been chary of giving me explosive evidence came forward in large numbers. As a result, I now feel free to throw off the constraining shackles of caution and go much further than I've gone so far – starting in North America with the research of Jerry Warsing.

Several years ago, long before my book was published, Jerry came to the conclusion that a huge Chinese fleet under the command of Admiral Zheng He encountered a severe storm off South Africa and was blown north-westwards to the Atlantic coast of North America. His evidence, which has taken years to assemble, is wide-ranging and fascinating. Jerry believes up to two hundred ships were wrecked on the coast between Florida and Newport, Virginia; separated by the storm, they landed in small numbers at different places. Because of the close similarity between the Ming dynasty spoken language and the language of earlier Chinese who had come across the Bering Straits, they were able to understand the local people and assimilate. One of these groups was the Oceanye Ho, who landed near Norfolk, Virginia. Oceanye Ho has since been corrupted to Shawnee. Another group, the Ming Ho, landed 150 miles further south, near Southport, North Carolina. A third group, the Wyo Ming, marched inland and settled in a rugged mountainous area of the Appalachians. A fourth, the Lyco Ming, trekked from the coast to a county in Pennsylvania adjacent to Wyoming country.

Jerry's first line of evidence is Machado-Joseph disease, which is prevalent among these peoples. It is 'accepted' that

Machado-Joseph disease spread via Portuguese sea routes in the mid to late fifteenth century. However, the disease appeared in the Yunnan province of China (Zheng He's birthplace) before the Portuguese reached China. It was also found in Arnhem Land and the Yemen, which were not visited on early Portuguese voyages. Every place the disease has been found is a location where the Chinese fleet visited. It is at the least arguable that the Chinese brought Machado-Joseph disease to the eastern seaboard of North America, and to the Azores, where the Portuguese contracted it.

Jerry's second line of evidence comes from the accounts of captured Shawnee prisoners at the battle of Fallen Timbers (1794), who protested they were not Native Americans (as reported by Captain John Smith in his Notes taken while Prisoner of Powhatan). The third line of evidence is Chinese plants and trees found by the first European settlers. His fourth is Virginia's array of ancient stone buildings - Native American peoples did not build in stone. My evidence is the DNA of the local (Moskoke) people mentioned earlier; Pedro Menendez de Aviles' accounts of finding Chinese junks wrecked off the coast when he arrived; and Giovanni de Verrazzano's report to the King of France that he found Chinese people in what is now New York. Finally, an old Chinese junk was discovered by George Washington's friends when they started draining the Great Dismal Swamp - further evidence that the Chinese landed on the eastern seaboard before Europeans arrived. The theory can be further validated by DNA tests on the Ming Ho people, and Jerry is attempting to obtain their co-operation for this.

We now get progressively more controversial. In the first part of this postscript, published in the American edition of 1421, I wrote, 'the wreck of a very old, large ship or junk [was] found near Fraser Island, off Queensland in Australia', and continued, 'however, on 8 November 2002, before the cannon or other artefacts could be raised from the sea-bed, the local authorities

reclassified the area as a "heritage" site. Only governmentappointed archaeologists are now allowed to continue investigations there...?

As may be expected my book raised a furore in Australia. Those who wished to maintain the fairy tales that the Dutch or Captain Cook first discovered Australia leapt on the retraction Greg Jeffreys, leader of the excavation team, was forced to make about the Fraser Island junk. He accepted the local authority's claim that in fact it was an Italian liner, the Marloo, which sank there last century, and that the cannon found by Jeffreys' team are in fact the stanchions of the Marloo's lifeboats. But why classify the wreck of an Italian liner as a National Heritage site? I have seen photographs of the same wreck taken in 1919 and again in 1972; the earlier ones clearly show wooden ribs that had washed away by October 2002, when Jeffreys' team excavated again. All three sets of photos were taken exactly where John Green vividly described the Chinese junk rising out of the sea on 28 February 1862. In addition, I have received photos of a Ming wine cooler excavated from the site and Chinese teak wood (the Marloo was built of steel), which is currently being dated. It is a great pity that those dedicated to the memory of Captain Cook, the finest navigator of all time, should wish to deny the public the opportunity of having the Fraser Island wreck excavated.

The same goes for southern Australia, where my claim that the Warrnambool wreck was a Chinese junk created hysteria among 'professional' Australian historians. Since my book was published, a huge amount of new evidence has poured in about Zhou Man's fleet reaching southern Australia from the Antarctic, but only a short synopsis can be given here. What happened was that Zhou Man lost one junk in Storm Bay, Tasmania, and a second on King Island in the Bass Strait; the third made it to Warrnambool, where it was wrecked. The survivors clambered ashore with their horses and set up a farm, connected

to the sea near Warrnambool, where they smoked eels and elvers exported by horseback up the Glenlenty, Murray, Darling and Murrambidgee Rivers – hence the depiction of Australia's rivers on Toscanelli's chart of 1474 and Vallard's 1536 map of Australia, and of Chinese people on horseback in Aboriginal paintings.

We now up the ante once again, this time in Peru. My claim that Peru was de facto a Chinese colony was greeted with incredulity, not least the fact that nearly a hundred villages to this day have Chinese names. Not one of the detractors took up my offer to visit us to inspect our large-scale maps of the Ancash province to see the Chinese names for themselves. No-one has any explanation of Father Antonio de la Calancha's description of Chinese cavalry; neither could anyone explain the mass of Chinese artefacts, plants and animals found by the first Europeans to reach Peru. Now we have the DNA of the Incas from two sources: the Novick report, and the analysis of the body of the ice maiden 'Juanita' carried out in Japan. Inca DNA is so close to Chinese (Novick et al) that one can reasonably argue that some of them were Chinese.

And last of all comes the biggest controversy. New Zealand historians have been the most apoplectic of all about my book. Anything that challenges Maori legend is to be resisted at all costs! Accepted New Zealand history has it that the foreign animals and plants found by the first Europeans were brought by the Maoris in their open canoes – that is, horses, pigs, dogs, rats and an array of plants from South America, North America, Asia and the Pacific. According to New Zealand historians, the Maoris traded all over the world.

A number of critics have emailed me about the size of the tankers required by Zheng He's fleets to provide water for horses, arguing that the limiting factor on the number of horses was the number of water tankers; it would have been impossible to desalinate anywhere near enough water to satisfy more than a handful of horses as each needs about three gallons a day. Now,

apply this to the Maori scenario, travelling from Tahiti to New Zealand in open canoes. They must have brought at least two horses to breed as one pregnant mare would not produce a line. I have taken my submarine from New Zealand to Tahiti; the seas are short and choppy most of the year which makes for a difficult journey which would probably have taken at least six weeks. Horses drink more in exposed conditions of high humidity such as spray in an open boat, so the consumption is likely to have been at least five gallons a day per horse, which for a six-week journey amounts to 420 gallons or around a ton of water per animal. Then, of course, the animals would have needed hay, and that's not to mention food and water for the boats' crews. I submit that it would have been impossible for Maoris to bring horses to New Zealand. The wild Kaimanawa ponies on North Island must therefore have been brought by others, either Europeans or Chinese. DNA tests are in hand for the Kaimanawa, the Pasos of Peru, the Assateague of the islands off Virginia and the Kiger mustangs of North America. I believe their common ancestor will turn out to be the blood horses of Tajikistan which were the mounts of the Chinese cavalry. Emperor Zhu Di imported millions to China during his reign.

When the first Europeans arrived in New Zealand they came across an array of plants foreign to the island. The most common was *Chenopodium album*, introduced from North America, where it has been used by native peoples to make cakes since time immemorial. Captain Cook discovered it in 1769. The second is marsh cress, *Rorippa palustris*, identified by the French expedition of 1826–9 aboard *L'Astrobole*. Again, this was used by the Navajo – who have Chinese DNA, and whose elders to this day understand Chinese – as a ritual eyewash. Others include maize, which originated in Peru; scented grass from Colombia; taro from China (Captain Cook); yams from the Pacific (Captain Cook); and, most celebrated of all, the kumara, the sweet potato, from South America (where it is called kumar), which, as

Captain Cook rightly said, was a vitally important food for Maori people.

Someone, either Maoris, Polynesians, South American Indians or Chinese, must have brought these plants to New Zealand. The carriers clearly were not Europeans for they found the plants there. Thor Heyerdahl, to my mind one of the greatest explorers of all time, argued that it was Incas who had sailed from Peru to Tahiti then onwards. Regrettably, DNA has shown that his hypothesis is incorrect; if it were true, Inca DNA should be found on the Pacific islands. An investigative team of Cambridge archaeologists and geneticists led by Matt Hurles published their findings in the *American Journal of Human Genetics*: only on one island around Tahiti, Rapa, did they find the distinctive DNA of native South Americans, and these Rapa genes had come from the crew of a Peruvian ship that stopped off at the island in 1862 to kidnap slaves.

Could it have been Maoris or Polynesians who travelled to South America and returned with the plants? This possibility has been examined by Professor Bryan Sykes and his team at Oxford University and written up in Bryan's wonderful book *The Seven Daughters of Eve.* 'If we found DNA matches [of Polynesians] in Chile or Peru, or even in coastal North America,' he wrote, 'then Heyerdahl was right. If we found them in southeast Asia, he was wrong.' Later, he concluded: 'I had to be sure that 247, the defining variant of Polynesian mitochondrial DNA, was not abundant in the Americas. No-one had ever seen it. Not even once. Heyerdahl was wrong.'

So that, in my view, leaves only the Chinese as the possible carriers to Australia (seventy-four species) and New Zealand (eight species) of those South American plants found by the first Europeans. If it was the Chinese, their DNA should be found on both sides of the Pacific, in the Incas and the Maoris. We know that's true for the Incas, but does Chinese DNA turn up in the Maoris?

First, a short digression. The Maoris were not the first to settle in New Zealand. Carbon dating of rat bones found in Hawkes Bay on the east coast of North Island shows them to be at least two thousand years old. The oldest Maori settlement dates back to AD 800. Dr Richard Holdaway, a Christchurch palaeontologist, says the rats must have arrived with human voyagers – in short, humans must have arrived 800 years before the Maoris. As Dr Rau Kirikiri, a leading Maori academic, reflected, 'this could lead Maoris to question their own history'.

Back to Maori DNA. For the past fifty years debate has raged over where the Maori came from. Some say China (Taiwan), others Indonesia. Events have recently taken a startling turn. Adele White, for the ABC television programme *Catalyst* (broadcast on 27 March 2003), used mitochondrial (female line) DNA to trace Maori origins back as far as mainland Asia. But where in mainland Asia? The answer came from a surprising quarter – by looking at the gene for alcohol. Adele's supervisor, Dr Geoff Chambers, found a match between one of the variant genes for alcohol with people from Taiwan, so it seemed the original homeland of the Maori people was Taiwan. Or was it? When Dr Chambers' team studied the Y (male) chromosome, they found a different story. While the females came from China, most of the men came from Melanesia.

What might have happened is that a small number of Melanesians settled in New Zealand about two thousand years ago; it was they who brought the rats whose bones have been carbon dated. Zhou Man's fleet arrived from the Antarctic (Campbell Island) in 1422/23. They landed in substantial numbers in South Island and some ships were wrecked on North Island (Ruapuke Beach). The fleets carried Chinese Tanka concubines. The Melanesians murdered the Chinese men and took the concubines as their wives. If this was the case, evidence of the Chinese visit to South Island should be there. Thanks to Cedric Bell, to whom I am indebted, that evidence has been

found. We have carbon dating of wood, mortar, stone and slag as evidence that the Chinese lived on South Island and mined her minerals for five centuries before Captain Cook 'discovered' New Zealand.

I am, now more than ever, convinced that accepted history has been turned upside down, not only in New Zealand and Australia but in North and South America, across the Pacific and in the Arctic and Antarctic. The great bulk of the new evidence that has enabled me to make such startling claims has come from readers of my book. It is you, not historians or academics, who have rewritten history.

> Gavin Menzies London, May 2003

CHINESE

CIRCUMNAVIGATION OF THE WORLD 1421-3: SYNOPSIS OF EVIDENCE

As well as consulting the historians mentioned in the Acknowledgements, in October, November and December 2002 the author visited Nanjing, Shanghai, Taicang, Kunming and Beijing and presented one hundred copies of his book to professors and historians at the following institutions, together with his latest synopses of evidence translated into Chinese: Chinese Academy of Sciences, Chinese Academy of Social Sciences, National Museum of Chinese History, History Institute of Chinese Academy of Social Sciences, Chinese Society on Ming Dynasty History, Ming Division of the History Institute of China, Chinese Society of Histories of China's Foreign Relations, Chinese Institute for Marine Affairs, C.S. Name Consultancy Group, CMHIA Ocean Association, CSO Military Oceanography Committee, Association of Studies of Ming Dynasty, Overseas Chinese Affairs Office of the State Council of the People's Republic of China, History and Natural Science and Technology Institute of Chinese Academy of Sciences, Geographical Studies Institute, Beijing Academy of Social Sciences, Ministry of Transport Research Institute, Yunnan University (Kunming), Peking University (Beijing), Nanjing University, Chinese Society for Historians of China's Foreign Relations, Chinese American Oceanic and Atmospheric Association, Shanghai Society for International Relations, Shanghai Centre for Strategic and International Societies, Zheng He Memorial Hall of Liu He (Taicang), Chinese Marine History Researchers Association, Zheng He Research Association, Navy Command College of the People's Republic of China, National Cheng Kung University, Zheng He family archives, Taicang Museum, Zheng He's Museum (Mausoleum) in Nanjing, Zheng He's Museum (birthplace) in Kunming, Cheng He Navigation Research Foundation, Jiantong University (Shanghai), and the China Institute for Ethnic Chinese History Studies. The evidence has been carefully considered by more than two hundred experts. Of these, approximately 85 per cent accept the author's argument that Chinese fleets discovered the New World before Europeans. Details of the issues over which about 15 per cent disagree will be provided to any researcher who requests them.

Part I: European explorers did not discover the New World

Part II: Only the Chinese had the capacity to chart the world at that time

Part III: Evidence of the voyages of Zheng He's fleets

- Key to the discoveries: the determination of latitude and longitude
- Chinese maps, star charts and records that escaped destruction
- Chinese or Asiatic peoples found by the first European explorers
- Local peoples' descriptions of Chinese or Asiatic peoples who settled among them before Europeans arrived
- Linguistics and languages common to New World and China
- Accounts of contemporary and other historians
- Shipwrecks
- Chinese porcelain/ceramics found in wake of Zheng He's fleets
- Pre-Columbian Chinese jade found in wake of Zheng He's fleets
- Artefacts, gems and votive offerings found in wake of Zheng He's fleets
- Stone buildings or artefacts found in wake of Zheng He's fleets
- Mining operations found by Europeans when they reached the New World
- Advanced technologies found by first Europeans
- Plants indigenous to one continent found on another by early European explorers
- Animals indigenous to one continent found on another by early European explorers
- Art exported by Zheng He's fleets
- Customs and games exported from China to the New World, as found by European explorers
- Armour
- Links with the years 1421–3
- Chinese already in the Americas when the first Europeans arrived: bibliographical evidence

Part IV: Evidence of Zheng He's fleets' visits to specific places

- Indian Ocean
- East Africa
- The Atlantic and the Cape Verde Islands

- The Caribbean
- Florida (including 'Florida' as defined in 17th century)
- The Carolinas/Virginia
- New England, Massachusetts and Boston/New York
- Upper Mississippi
- British Columbia (Queen Charlotte and Vancouver Islands) and Washington State
- Arizona, New Mexico, Texas, Oklahoma, Arkansas, Colorado and Oregon
- California
- The Azores
- Mexico
- Panama and Venezuela
- Peru
- Brazil (1421–5)
- Patagonia and Straits of Magellan
- Greenland to North Pole, across Arctic to Bering Straits
- Antarctica
- The Pacific
- New Zealand
- Australia
- The Spice Islands, Indonesia and the Philippines

Part V: Genetic fingerprints left by Zheng He's fleets – the DNA evidence

- The Navajo
- The Mazatec people of Mexico (Olmec culture)
- Campeche and Buctzozt Maya
- Waunana and Ngobe peoples of Panama
- Inca peoples
- Indian peoples of Venezuela and Colombia: Irapa, Paraujano and Macoita
- Surui people of Amazonia and Solimões/Rio Negro Junction
- Quechua (Bolivia/Mato Grosso borders) and Toba (NW Argentina, Salado River) peoples
- Haida and Aleut peoples
- Moskoke people of SE USA and NW Florida

- Ming Ho and Melungeon peoples
- Sioux and Cree Ojibwa peoples of America and Canada
- Maidu, Yuki, Pima and Wintun peoples of California
- Maori people of New Zealand, North Island
- Gunditimara Aborigines of Victoria, South Australia

Part I: European explorers did not discover the New World

- Evidence provided at the Royal Geographical Society 15 March 2002 (which included charts, medieval documents and the evidence of Dr Eusebio Dizon – circulated separately).
- 2. The whole world was charted by 1423, before European voyages of discovery started.

THEORY

- Four huge Chinese fleets circumnavigated the world between March 1421 and October 1423. The fleets comprised more than 800 vessels. These fleets charted the world.
- Sailors and concubines from those great fleets settled in Malaysia, India, Africa, North and South America, Australia, New Zealand and on islands across the Pacific.
- The first European explorers had maps showing where they were going before they set sail. They met Chinese settlers when they arrived in the New World.
- China, not Europe, discovered and settled the New World. European 'discoveries' relied on China leading the way.

(i) The whole world was charted by 1428 – by whom?

- Portuguese claim they had a chart of the whole world by then. They do not claim to have created that chart.
- Pizzigano, Fra Mauro, Piri Reis, Cantino, Caverio, Waldseemüller and Jean Rotz charts show whole world charted before Europeans set sail.
- European explorers referred to earlier maps made before they set sail – contemporary accounts of Columbus, Dias, Cabral, da Gama and Magellan's voyages are the evidence.
- (ii) Continents shown on maps before European explorers set sail for that particular region:
 - (a) North America shown on Waldseemüller, Cantino and Caverio charts
 - (b) Caribbean Pizzigano, Cantino, Caverio and Waldseemüller
 - (c) South America Piri Reis, Cantino and Waldseemüller

- (d) Africa, India and East Cantino, Jean Rotz, Fra Mauro, Waldseemüller and Kangnido
- (e) Antarctica Piri Reis and Francesco Roselli
- (f) Arctic and Siberia Waldseemüller (1507)
- (g) Australia Jean Rotz, Desliens, Vallard, Desceliers
- (h) China and Far East Jean Rotz
- (i) Canada (Vancouver and Queen Charlotte Islands) Zatta
- (j) Straits of Magellan Waldseemüller (Small Globes)
- (k) South Africa Fra Mauro, Kangnido and Da Ming Yi Tu
- (iii) The great rivers of the world were shown on the key charts long before Europeans set sail
 - (a) The Martellus Maps (1489), Gallez, P. and Davis, H. South America: Colombia – Magdalena Venezuela – Orinoco (Meta) Brazil – Amazon, São Francisco Paraguay – Paraguay, Paraná Argentina – Colorado, Negro, Chubut (Patagonia)
 - (b) Cantino (1502)
 South America:
 Colombia Magdalena
 Venezuela Apure, Orinoco (Cavra)
 - (c) Waldseemüller (1507)
 Siberia: Ob, Yenisei, Kotuy, Olenek, Lena, Yana, Indigirka and Kolyma
 North America: Mississippi, Brazos, Alabama, Roanoke, Delaware, Hudson
 - (d) Toscanelli (1474) Australia: Murray, Darling, Cooper, Diamantina, Flinders

(iv) Straits of Magellan/Patagonia

'Dragon's Tail' (1428 chart) and its giants described on anon. (Durand 1440) and Walsperger (1448), and shown on Waldseemüller globe.

(v) Correlations between charts of the world before Europeans set sail and the 1428 master chart of the world

- (a) Waldseemüller (1507), Cantino (1502) and Caverio (1505). These three draw the Great Bahamas Bank identically and as it would have appeared in 1421 with water levels one fathom lower than today. However, the earlier charts have features which do not appear on later ones, viz. Waldseemüller shows Pacific coast of America, the later ones do not; the (earlier) Cantino shows Florida, the later Caverio does not. The three charts must therefore be based on an earlier original.
- (b) Anon. (Durand 1440) and Walsperger (1448). Both refer to Tierra del Fuego as the 'Dragon's Tail', the name given by the 1428 master. Both refer in identical terms to the Giants of Patagonia, hence must have a common source.
- (c) Desliens, Desceliers, Vallard and Jean Rotz all show Australia with great similarity – but each has original features, e.g. Vallard has horses. All must have been based on an earlier original that was subsequently lost.
- (d) Waldseemüller and Martellus (1489). Both show the Cape of Good Hope at 45°S and the same 'dogleg', 'India Meridionales', in the east. The Waldseemüller shows South America, the Martellus does not. Both must have been based on an earlier original.
- (e) Piri Reis and Pizzigano are linked by Columbus's description (note on Piri Reis) of Antilia (on Pizzigano).
- (f) Anon. (Durand 1440), Walsperger (1448) and Piri Reis 1513 (1501) are linked by descriptions of the giants of Tierra del Fuego and of Columbus' description of two hours' daylight (Piri Reis).
- (g) Waldseemüller (1507), Cantino (1502) and Piri Reis 1513 (1501) are linked by their drawings of Arecibo (Venezuela).

These maps between them chart the entire world. They must, because of the links, have been based on an earlier original which must have been made before 1440 (Durand) and after 1423 (Pizzigano).

(vi) Links connecting the charts with the Chinese

The charts described below were published before Europeans reached that particular part of the world.

- (a) Jean Rotz: depiction of China, Australia and Hong Kong; link – kangaroos in Chinese emperor's zoo
- (b) Martellus (1489): the Orinoco and Amazon Rivers; link Chinese DNA is found among American Indian peoples there, pre-Columbus (Arends and Gallengo)
- (c) Piri Reis (1501): link animals unique to Patagonia are shown and are also to be seen in *The Chinese Illustrated Record of Strange Countries* (1430). Description of the mylodon in Chinese records.
- (d) Anon. (Durand 1440), Walsperger (1448) and 1428 chart: link

 description of the giants found in Patagonia and described in *The Chinese Illustrated Record of Strange Countries* (1430).
 The name 'Dragon's Tail' is found in the three charts, denoting Tierra del Fuego.
- (e) Cantino: link longitude of East Africa almost perfect (± 30 miles). The Chinese alone could determine longitude at that time.
- (f) Cantino, Waldseemüller and Caverio: Arecibo; link –
 Venezuelan tribes have Chinese DNA (Arends and Gallengo)
- (vii) Chinese cartography and transmission of maps to the West
 - (a) The author contends Europeans could 'translate' Chinese maps into ones understandable to Europeans. Australia appeared on Father Ricci's map (1589) and on Hessel Gerrit's chart (1618 – Seville) (M. Righton); the Pacific from Vancouver to 'the Straits of Magellan' appeared on the Waldseemüller (1507) before Balboa 'discovered' the Pacific; the Amazon appeared on the Piri Reis (1513 [1501]) before Orellana 'discovered' the river.
 - (b) The author contends the Chinese had the best cartographers in the world prior to the Renaissance – witness: Chang Heng (AD 78–139), flat surface grid system (Bob Butcher's evidence); Phei Hsiu (224–71), grid system; Phei Chu (605), classic grid map; Chia Tan (730–805), map of empire; cartographer unknown (940), cylindrical projection (precursor of Mercator); cartographer unknown (1137), Yu Chi Thu stone map; cartographer unknown (1155), first

Chinese printed map (predates European by two centuries); Chu Ssu Pen (1273–1337), map of China, Asia, Africa (with triangular shape) and Europe; Li Tse-Min and Ching-Chun (1328–92) expand on Chu Ssu Pen.

(c) Star charts – *Wu Pei Chi* and Gan D. E. (Jupiter's moons c. 200 BC)

(viii) China sends her maps to the West

The author contends it was Chinese policy to send her maps to the West – otherwise how could countries reach China to pay tribute? Evidence:

- (a) Brazilian delegation setting sail for China in 1501/02 with map showing route (Professor Bi Quanzhong, evidence to Kunming Conference, 10 December 2002)
- (b) Chinese emperor's order to send maps to West which resulted in Liu Daxia destroying all available records of Zheng He's voyage (Professor Bi Quanzhong, evidence, 10 December 2002)

(ix) Niccolò da Conti as the intermediary between the Chinese and Europeans

The author relies upon the evidence given in his book and that recently found in the Fujian Palace (Admiral Zheng Ming's evidence to Kunming Conference, 10 December 2002). In the Fujian Palace, uncovered during runway-extension works at Fujian International airport, are statues of Zheng He and his admirals. Standing next to Zheng He, and closer to him than his admirals, is a European medieval merchant, as evidenced by his clothes and hat. The merchant carries documents/maps. The most likely explanation is that this statue is of Niccolò da Conti, who describes his passage from Calicut to China via Australia and who was in Calicut when the Chinese fleets arrived in 1421. His statue resembles the drawing in *The Illustrated Record of Strange Countries* (1430).

(x) The Portuguese claim

Antonio Galvão's description of the world map which the Portuguese

Dauphin Dom Pedro brought back with him from Venice in 1428: 'Dom Peter, the King of Portugal's eldest sonne, was a great traveller ... came home by Italie, taking Rome and Venice in his way from where he brought a map of the world which had all the parts of the world and earth described. The Strait of Magellan was called in it "the dragon's taile": the Cape of Bona Sperancia, the forefront of Afrike and so forth.'

Galvão again: 'It was told me by Francis de Sousa Tavares that in the year 1528 Don Fernando the King's eldest son showed him a map found in the study of the Alcobaza that had been made 120 years before which map set forth all the navigation of the East Indies, with the Cape of Bona Sperancia as our later maps have described it; whereby it appeareth that in ancient times that was as much or more discovered than there is now.'

So who drew the 1428 chart? It is the author's claim that Dom Pedro debriefed Niccolò da Conti in Florence in 1424. Da Conti had sailed with the Chinese fleet from India to Australia and China (*Travels of Niccolò da Conti*).

3. Europeans set sail with accurate maps showing their destination.

Accounts of first European explorers to reach land it is claimed they discovered:

Columbus's 'discovery' of the Americas.

Letter from Toscanelli to Columbus: 'I notice your splendid and lofty desire to sail to the regions of the East by those of the West [i.e. to sail to China westabout] . . . as is shown by the chart which I send you . . .' [chart is excerpt of Portuguese 1428 chart of world showing Antilia].

Letter from Toscanelli to the King of Portugal: '[before Christopher Columbus set sail] . . . from the island of Antilia known to you [Antilia is Puerto Rico, discovered by the Chinese in 1421] . . . to Cepangu [China].'

Columbus's log, Wednesday, 24 October 1492 (when in west Atlantic): 'I should steer west-south-west to go there [to reach Antilia] . . . and in the sphere which I have seen and in the drawings and mappae mundi it is in this region.' Thus, according to Columbus, Caribbean islands appeared on Portuguese

maps of the world ('mappae mundi') before Columbus set sail. Cabral expedition to South America.

- João de Barros, arriving on the first expedition to South America, writes to King Manuel of Portugal: 'The lands might the king see represented on the Mappa Mundi whom Pero daz Bisagudo has.' De Barros continues that the only difference between the Brazil the Portuguese have discovered in 1500 and the Brazil shown on Bisagudo [da Cunha] was whether or not Brazil was inhabited. Thus, Brazil had appeared on a Portuguese map before the first European expedition set forth.
- Dias and da Gama rounding the Cape of Good Hope. Dias' chronicler describing their approach to Cape of Good Hope: 'They came in sight of that Great and Famous Cape concealed for so many centuries . . .' This is the Cape drawn on Fra Mauro's planisphere of 1459 (Fra Mauro was working for the Portuguese government when making his planisphere). Thus, southern Africa appeared on Fra Mauro's map, prepared for the Portuguese, before the first European expedition reached the Cape.
- Magellan, 'first circumnavigation of the world'. On entering the 'Straits of Magellan', Magellan faced a mutiny, but he managed to quell it. 'The Captain General said there was another Strait which led out [to the Pacific], saying he knew it well and had seen it in a marine chart of the King of Portugal ... Later, Magellan, having crossed the Pacific, met the King of Limasarra.' Note from Magellan's chronicler: 'And he [Magellan] shows him the marine chart ... telling him how he had found the Strait to come hither.' Thus, according to Magellan's official chronicler, the so-called Straits of Magellan appeared on a Portuguese chart before Magellan set sail, as did the Pacific.
- Cook's 'discovery' of Australia and New Zealand. The 'Dauphin' map (1536) showing Australia was owned by the First Lord of the British Admiralty Edward Harley. Dr Joseph Banks, who travelled with Captain Cook, bought it. Since Henry VIII's day the British government had owned the Jean Rotz chart, which also showed Australia. Thus, Australia was

known to the Admiralty from two sources before Captain Cook set sail.

Part II: Only the Chinese had the capacity to chart the world at that time

1. CHINESE RECORDS

- (i) Orders to sail
 - (a) 13 January 1421, to Yang Qing, sending him to 'Hormuz and other places' to present all foreign rulers with gifts (Shih – Erh – Yüeh Ch'u Shih Jih) – Professor Ptak
 - (b) 3 March 1421, to Zheng He, to 'take the envoys' (KC ch.17 p.1117; MC ch.10 p.99; MS ch.7 p.100; MTC ch.17 p.743) – Professor Ptak
 - (c) 10 November 1421, to Zheng He (now that Hong Bao is entrusted to return envoys . . .)
- (ii) Dates of return
 - (a) 8 October 1423, Zhou Man with 93 men (YLSL ch.26 p.2401). Chan Cheng vol. I, p.165 – Professor Duyvendak, Dates, p. 385.
 - (b) 24 October 1423. Envoys of 16 countries, a total of 1,200 people, arrive with tribute (YLSL p.2403; KC ch.17, p.1205; TWL ch.36 p.69; MS ch.7 p.102 and ch.326 p.8440; KTTC ch.30 p.516) – Professor Ptak
 - (c) 1425 by then part of Zheng He's fleet has still not returned – Professor Zhu Jianqui (paper 24, Nanjing Conference, October 2002). Ming Record Xiang Chen Ming (Zhu Jian Qiu – Navy Ocean Research Institute, 28 November 2002)
 - (d) One squadron lagged behind. Not back ZD23 (1426) Director of Studies Ming History, Chinese Academy Social Sciences.

Author contends that the Chinese fleet could have circumnavigated the whole world four times between 1421 and 1426.

2. CHINESE KNOWLEDGE OF THE WORLD IN 1421

(i) Four major expeditions had been conducted by Zheng He, the

first in 1405. Fleets had acted independently in voyages to Pacific, Indian Ocean, the Persian Gulf and Africa (Ma Huan).

- (ii) Japan, Korea and central Asia had been known for centuries (Ma Huan).
- (iii) Chinese had known of North and South Poles since 3rd century BC (Zhuangzi) and that the earth was round (para 9(b))
- (iv) Australia had been known since AD 316 (para 9)
- (v) Americas known since 6th century AD. Fu Sang, the accounts of the monk Huei Sen, were entered in Chinese official records (Annals).
- (vi) Three Chinese path-breaking books summarising knowledge of world (Martin Tai evidence): Knowledge of South China and Beyond (Lingwai Daida) by Qhou Qu Fei, 1178; Records of Foreign Peoples (Zhu Fan Zhi) by Zhao Ru Kua, 1225; Records of Overseas Countries and Peoples (Daoyi Zhilue) by Wang Da Yuan, 1349.
- (vii) The Yuan traveller of the world Wang Da Yuan Barbarians of the Isles (includes Australia). T'oung Pao vol.16, 1915 (Martin Tai).
- (viii) Chinese knowledge of Australia Melchior Thevenot, *Relations*, 1663 (M. Righton)
- (ix) British missionary to Beijing map of Australia (Martin Tai)
- (x) Father Ricci's 1589 map of Australia
- (xi) Dong Fan Shue of Western Han dynasty reached North Pole in 132 BC (*Beijing Morning News*, 9 February 2003 – report of historian Ju de Yuan)
- (xii) Trade with Spain: Zhao Ru Kua's (1170–1228) Zhu Fan Zhi (description of various barbarians) has chapter on 'Muranbi Kingdom' = Al Murabitum (Kingdom of Spain) – Rock Hill (Martin Tai).

Author submits that by 1421 China knew of the whole world.

3. CHINESE CLAIMS AS TO WHERE ZHENG HE'S FLEETS SAILED

- (i) Worldwide Zheng He's evidence
 - (a) To '3,000 countries' large and small (Duyvendak's first translation). A voyage of 40,000 *li* (100,000 miles) recorded on

stone memorials erected by Zheng He at Liu Shia Chang (31°07′N, 121°35′E) and Ch'ang Su (26°08′N, 119°35′E).

- (b Further carved stone tablets at Malacca, Dondra Head (Ceylon), Calicut and the Malabar coast of India.
- (c) Master Bentou (Zheng He's navigator) diaries (evidence of Kerson Huang), 1403–30.
- (ii) Australia
 - (a) Zheng He's passage chart which shows coral reef from NE Australian coast – Zhao Zhi Hua 1990 (Zhu Jian Qiu, November 2002) (Martin Tai translation).
 - (b) Professor Wei Chu Hsieh, The Chinese Discovery of Australia.
 - (c) Professor Liu Manchum, paper 26, Nanjing Conference (October 2002) – 'Beira' or 'Sunla' is Australia.
 - (d) Ma Huan (Martin Tai evidence, 26 February 2003), Wang Da Huan/Barbarians of the Isles. T'oung Pao vol.16, 1915, Ropose = Australia, Marani = Darwin.
 - (e) Records of kangaroos in Chinese emperor's zoo.
 - (f) Chinese knowledge of Australia Melchior Thevenot, *Relations*, 1663 (M. Righton).
 - (g) The Wu Pei Chi shows Australia (Sun Shuyun translation).
- (iii Reaching America
 - (a) Professor Liu Manchum (paper 26, Nanjing Conference, October 2002). Fleet reached 'extremely far Beira' [= America].
 - (b) Professor Bi Quanzhong's evidence to Kunming Conference (December 2002). Fleet reached Brazil – Brazil delegation to China.
 - (c) The sailor Zayan's claim to have sailed to America with Zheng He's fleet (Professor Bi Quanzhong's evidence).
 - (d) Chinese pictorial record, *The Illustrated Record of Strange Countries* (I Yü Thu Chih), published 1430, which shows animals unique to South America, e.g. armadillos Professor Wade's collection.
 - (e) Chinese pictorial record of herbs and plants known to China (published 1511) which includes plants unique to the

Americas (e.g. peanuts) – Zhong Guo Ben Cao Quanshan (Key Sun's evidence).

- (f) The Notebook of Wilderness by Ming dynasty writer Zu Yun Ming about the official delegation to China from Balazi = Brazil. Brazilians left in 1500 with Chinese map showing route (Martin Tai translation).
- (g) The Ming Shi history of the Ming Empire and The General Registry of Sea Countries by Shen Mao Shang which names Balazi (Brazil) as a place visited (Zhu Jian Qiu, Navy Ocean Survey – 28 November 2002) (Martin Tai translation).

The author submits that official Chinese records do claim Zheng He's fleets reached Australia, America and Brazil. Their reinterpretation follows Professor Bi Quanzhong's evidence to the Nanjing Conference. The author also contends that not only did the Chinese know of the whole world before 1421, the fleets were away for five years, long enough to circumnavigate the world four times, and they had the experience, expertise and ships to explore the globe.

Part III: Evidence of the voyages of Zheng He's fleets

Key to the discoveries: the determination of latitude and longitude

- The extraordinary precision of the southern portion of the Piri Reis map showing Patagonia's coast, the Falklands, South Shetlands and South Sandwich Islands. Not only is the coast perfectly drawn but animals unique to South America – huemils, guanacos and the mylodon – appear. (They also appear in the I Yü Thu Chih – i.e. they were known to the Chinese before Europeans got to South America.)
- The Piri Reis was drawn 400 years before Europeans reached Antarctica. It shows the Andes as far north as Ecuador. The precision of the Piri Reis coupled with the extent of the coastline from the equator to the Antarctic can only mean the cartography was carried out by people who could determine latitude even in the Antarctic with dozens of ships surveying simultaneously. This was achieved long before European explorers set sail for South America.
- Who but the Chinese with six centuries of experience of ocean

navigation could have reached the Antarctic? Chinese records claim their fleets reached both North Pole (30 claims) and South Pole (5 claims) (Professor Wei).

- Do Chinese navigational and star charts provide the answer? The most notable is the Wu Pei Chi. The problem is the Wu Pei Chi has been amended over the years and not all the amendments were dated. Chinese sailing instructions (Wu Pei Chi) give the course to steer between Dondra Head (Ceylon) and Sumatra. By a very fortunate coincidence, this course is due east. The current latitude of their track is 06°N. However, Chinese navigators were advised to keep Polaris 1 chih above the horizon; this means there is a difference of 3°40' between the position of Polaris in Wu Pei Chi and its position today. Using the Microsoft Starry Night computer program (which enables the position of the stars in the night sky to be determined every night for the past two millennia) enables us to date the Wu Pei Chi to 1420-30 (Polaris's apparent position changes one degree every 175 years due to the earth's precession.) Knowing the Wu Pei Chi date, we can compare the stars on it with the Starry Night program. We can also establish that near the 'compass rose' position shown on the Piri Reis (SW Falklands), Canopus is at 90° elevation. The reason the cartographers took such inordinate trouble surveying the coast of Patagonia is that they established the declination and right ascension of Canopus when it was above them. Chinese records reveal that the need to 'fix' the position of Canopus and the Southern Cross constellation had long preoccupied Chinese astronomers. Conference in Nanjing, October 2002, emphasised this preoccupation with Canopus; Kunming Conference (December 2002) emphasised the Chinese standard operating procedure of sailing directly beneath (90° altitude) selected stars. Knowing the position of Canopus, latitude in the southern hemisphere can be determined by cross- referencing Canopus with Polaris in the northern hemisphere.
- These measurements gave the Chinese the capacity to chart the whole world, but where would they have been likely to do so? At 52°40′S, the declination of Canopus, all ships could keep the star right overhead, all thus surveying from the same base line.

Evidence of the Chinese voyage is indeed found all the way across the world at 52°40'S, in Patagonia, Kerguelen and Campbell Island (which appears precisely drawn on the Jean Rotz). (Evidence of this method of sailing given by Chinese professors at Kunming Conference, December 2002.) At which other latitudes would it have been sensible to survey? Where Canopus disappeared below the horizon at 38°30'N (evidence is found at this latitude around the world) and at 3°20'N where Polaris disappeared below the horizon in 1421 (evidence of the Chinese voyage also found here).

For the determination of longitude, see Appendix 2.

Observation platforms used by the Chinese 1421-2

South America to Australia		
Marquesas (Temoe)	134°29′W	23°22′S
Society Islands (Tahiti)	149°00′W	17°50′S
Bora Bora	151°00′W	17°30′S
W. Samoa (Savai)	172°42′W	13°30′S
Tonga Tabu	175°04′W	19°43′S
Gympie (Australia)	152°42′E	26°12′S
Gosford (NSW)	151°13′E	33°26′S
New Zealand (Komowin Hill)	175°52′E	38°59′S
South America to Indonesia		Sec. 1
Temoe	134°28′W	23°22′S
Tahiti	149°00′W	17°50′S
Malden (Kirimati)	157°43′E	01°55′N
Solomons (San Cristobal)	161°51′E	10°26′S
Carolines (Nan Madol)	158°21′E	06°51′N
Mariannas (Saipan)	145°45′E	15°09′N
Carolines (Yap)	138°09′E	09°31′N
New Guinea	140°00′E	05°00′S
Nanjing	118°45′E	32°06′N
Beijing	116°25′E	39°55′N

Areas of the world surveyed: fleets required

- Indian Ocean (Cantino): nine million square miles and thousands of islands. Assuming ships 15 miles apart, sailing at 4.8 knots and surveying for 10 hours a day, then 30 ships would have had to be at sea for 18 months.
- South America and Antarctic (Piri Reis): approximately 6 million square miles about 20 ships required over an 18-month period.
- North America and North Atlantic (Cantino): approximately 12 million square miles about 40 ships.
- Far East (Rotz): no fewer than 20 ships over an 18-month period.
- Australasia (Rotz): no fewer than 20 ships over an 18-month period.
- Rivers of the world (Waldseemüller): thousands of miles of the Orinoco, Amazon and Mississippi and hundreds of miles of rivers in Siberia, Australia and Pacific America are depicted on European charts before voyages of discovery. No fewer than 130 ships over 18 months would be required.

The Chinese fleet

'In its heyday, about +1420, the Ming navy probably outclassed that of any other Asian nation at any time in history, and would have been more than a match for that of any contemporary European state or even a combination of them. Under the Yung-Lo emperor it consisted of some 3,800 ships in all: 1,350 patrol vessels and 1,350 combat ships attached to guard stations (wei and so) or island bases (chai), a main fleet of 400 large warships stationed at Hsin-chiang-khou near Nanking, and 400 grain-transport freighters. In addition there were more than 250 long-distance "treasure ships" or galleons (pao chuan), the average complement of which grew from 450 men in +1403 to over 690 in 1431, and certainly overstepped 1,000 in the largest vessels. A further 3,000 merchantmen were always ready as auxiliaries, and a host of small craft did duty as despatch-boats and police launches. But the peak of the development which had started in 1130 came in 1433, and after the great reversal of policy the navy declined much more rapidly than it had grown, so that by the middle of the 16th century almost nothing was left of its former grandeur.' (Needham, vol.3, p.484)

'More than eight hundred sail of large and small ships had come to India from the ports of Malacca and China and the Lequeos [Ryuku Islands], with people of many nations, and all laden with merchandise of great value which they brought for sale . . . they were so numerous that they filled the country and settled as dwellers in all of the towns of the sea coast.' (Chaudhuri, p.154; evidence provided by Professor Robert Finlay of Arkansas University)

In parallel with Zheng He's development of his fleet went that of overseas bases. By 1421, the Chinese had bases around the Indian Ocean and down the east African coast to Sofala. They already had an extensive network across Indonesia and the South China Sea. Since 1405 there had been five voyages becoming progressively more adventurous as the years went by. During the fourth voyage the Chinese had separated their fleets and sailed far down the east African coast: 'Chinese . . . with Tartairs, Japanese and Koreans . . . crossed the Maritime Stretch . . . into the Kingdoms of Quivira populating Mexico, Peru and other eastern countries of the Indies [America].' (Carlos Prince)

The author contends that the whole world had been charted before Europeans set sail, and that only the Chinese could have done so.

1. Chinese maps, star charts and records that escaped destruction

Title and approx. date of amendments	Subject/relevance
Wu Pei Chi, c.1422 (only a	Chinese accept this contains information
small part translated)	brought by Zheng He. It gives courses to steer
	between China and Africa and between other continents, and shows Australia.
Mao Kun, c.1422	Kerguelen, Indian Ocean and Islands. East
	African coast.
Kangnido (1402–73)	Asia, East, South and West Africa including
	Atlantic, Azores.
Star Chart (Mao Kun) c.1422	Polaris compared with Southern Cross and
	Alpha Centauri.

Matteo Ricci (c.1588) globe

Australia (drawn when Fra Ricci was in China) Description of Barbarian Countries of the West.

Xi Yang Fang No Zhi by Gong Zhen, navigator on Zheng He's seventh voyage (Tai-Peng Wang) Taiwan Porcelain Map (1447) painted by Chinese

Australian east coast down to Tasmania. See also accounts of missionary to Beijing and Chinese fisherman's charts (Martin Tai evidence). South Africa (Map of the Great Amalgamated

Da Ming Hun Yu Ti

These charts describe the whole world save for the Americas. The following list of extant records is taken from *Chinese Discovery of Australia* by Professor Wei Ju Xian.

Ming Empire)

- (i) Australia
 - (a) Confucius: *Spring and Autumn Annals* (481 BC) recorded solar eclipses in Australia on 17 April 592 and 11 August 553.
 - (b) *Classics of Mountains and Seas* (338 BC) describes boomerangs, black millet and kangaroos.
 - (c) Atlas of Foreign Countries (AD 265–316) describes small black natives of northern Australia.
- (ii) North Pole
 - (a) Zhuangzi (3rd century BC): 'It takes six months including flying and resting time for seagulls to fly 90,000 *li* from North to South Pole.' (Old Chinese *li* = half a kilometre.) Zhuangzi also mentions going round the earth from east to west, as does Xun Zi (40 years after Zhuangzi).
 - (b) Ancient Chinese books: 'Distance North Pole to South Pole is more than 80,000 *li*.'
 - (c) Qi-xie (643 BC): 'If a person of Yan State [Hebei province] goes north and a person of Yue State [Zhejian, South China] goes south they will meet each other at the very end of their journey.'
 - (d) Lienzi (3rd century BC): 'South of Africa sun cannot be seen

for 50 consecutive days."

(e) Illustrated Record of Strange Countries (published 1430) describes North Pole: Eskimos, coldness, sunshine, polar lights, sea elephants and seals.

2. Chinese or Asiatic peoples found by the first European explorers

- (i) Far East and Indian Ocean: Chinese found throughout Indian Ocean to China. Chinese graveyards remain today in Malacca, Indonesia and Philippines (Sulu).
- (ii) Africa: Pate Father Monclavo.
- (iii) Atlantic: Azores bodies from Corvo (Columbus).(Azores/Machado-Joseph disease there.)
- (iv) Greenland: 'People from Cathay have visited here' (Columbus). (Greenland peoples have Chinese DNA.)

(v) South America

Brazil: Cabral – 'Men with pale skins'; Orellana – Apara, meets 'white men' (B. McEwen). (Chinese DNA in Amazonian Indians.)

Peru: Chinese-speaking (understanding) villages (Eten and Monsefu) Ludovico de Varthema (voyages to Antarctica). (Chinese DNA in Incas.)

Chile: S Arias (Pacific crossing); Hugo Grotius – Chinese junks found off Chile

Venezuela: Vespucci 'brownish yellow' – Maracaibo (B. McEwen). (Chinese DNA.)

(vi) Mesoamerica and Caribbean

California: Stephen Powers, Chinese colony between Sacramento and Russian Rivers. Antonio Galvão (1555) – 'Chinese ruled over locations in Central and South America'. Grotius – Asiatic shipwrecks on Pacific coast. (Chinese DNA.) Mexico: Acosta and Vasquez de Coronado's expedition met Chinese. (Mazatecs – Chinese DNA.) Gregorio Garcia – 'Chinese coming to populate Mexico' (before European voyages). Hernán Cortes – Montezuma recounting grandfather (lightcoloured people from East returning).

Lower California to Kansas City (Tiguex): Coronado expedition – Coronado, Mafeo and Frois – Chinese ships, Chinese

merchants had come to Quatulco and Panuco all dressed in silk (Loayza). (Chinese DNA in Navajo/Zuni.)

Cuba: Columbus' expedition (men in white robes, Washington Irvine); Columbus' secret report (met Chinese); Columbus met Muslims (Dr Shou).

(vii) North America/Florida

Rhode Island: Verrazzano – 'Chinese' people (Hakluyt, vol. III, 1910, p.350).

Florida: Pedro Menendez de Aviles – Chinese junks. (Chinese DNA in Moskoke.) Plus Powhatan's account to Captain John Smith; Virginia – Jerry Warsing; Alexander von Wuthenau, *Unexpected Faces in Ancient America*, shows Chinese (B.

McEwan). (Sioux, Cree Ojibwa – Chinese DNA.)

(viii)Pacific

Bougainville, Wallace – found Chinese people on many islands Bodies of Chinese in Indonesia

Saavedra – Micronesia

 (ix) Australasia: Cook was not the first – men preceded Cook in 'ships like clouds'; descriptions of local people. (Maori – Chinese DNA.)

3. Local peoples' descriptions of Chinese or Asiatic peoples who settled among them before Europeans arrived

- (i) Far East and Indian Ocean: too numerous to include. Widespread intermarriages between Chinese men and local women.
- (ii) Africa: Pate story of giraffe presented in 1416 to Chinese emperor

(iii) North America and Atlantic coast

Rhode Island: 'great ship-like house firing cannon sailing upriver'; carvings of foreign ship and shipwreck (Chelmsford and Dighton Rocks); Pope's letter to Bishop of Greenland;' Chinese naval party landed and murdered (Frank Fitch); Cherokees murdered foreign miners near Minay Sotor River (Scott McLean); barbarians' ship attacking local people. Florida: (as defined in 17th century) Natchez people – 'Ancestors came from East by sea' (Pratz).

Mississippi and tributaries: numerous (more than 100) carvings of foreign ships and horses (extinct in Americas by c.10,000 BC); Powhatan's account to Captain John Smith.

- (iv) North America and Pacific coast Canada: Huron Indians – 'very far to the West, epicureans without beards came to trade their wool' (Loayza) Haida: 'people sailing from west' (Marius Barbeau) (R. Hassell) California: 'ships like great houses' off coast; Cherokees slaughter strangers with yellow countenances (S. McLean).
- (v) Mexico: Nayarit legends of Asian ships (Mazatecs Chinese DNA); Lienzo of Jucutácato foreign visitors arriving on horseback; Cueva Pintada foreigners being shot at; Yucatán six carvings of horses and possibly elephants (Campeche Maya Chinese DNA); legend of wrecked Chinese junk (Joel Fressa); Indian pueblos Chinese warriors (A. Moya); Montezuma ancestors came by sea from East in company with a mighty lord (Ranking pp.257–326).

(vi) South America

Peru: pre-Columbian pictures of Chinese cavalry at Trujillo (Friar Antonio de la Calancha) and at Ayacucho (G. Squier); 'Giants came by sea to settle amongst them' (Garcilaso de la Vega/Pedro Cieza de Leon).

Brazil: paintings of foreign horses (Confins cave).

Patagonia: anonymous (1440) and Durand (1448) maps describing giants of Patagonia; yellow-skinned people crossed Pacific before Europeans (S. Arias); Afghanistan legend (Z. Pradya) – Indian ships accompanied Chinese to South America prior to European voyages; Guarani – ancestors crossed ocean from a far land to settle in Amazon (M. Garcia).

(vii Pacific

Fiji: Yasawa Islands – 'yellow men visited us'.

Hawaii/Oahu: Menehune legends (A. Armstrong) – are Menehune Chinese?

(viii) Australia

Arnhem Land: paintings of men on horseback (Vallard); 'honeycoloured people' settle, 'women in pantaloons, men in long robes'; painting of robed strangers (Governor Grey); painting of man being thrown from horse (Glenelg River); drawings of

trees, fauna and flora (Rotz); visits of Chinese junks. Gympie: men in stone garments attempt to mine Mount Warning area; 'culture heroes' sail into Gympie harbour and take away rocks; Dhamuri people – foreigners land to build pyramids (J. Green).

Fraser Island – small boats leave big ship (J. Green 1862) Sydney/Newcastle, carvings: Hawkesbury River, strange visitors in long robes; foreign ship and funeral of foreign visitors; Byron Bay, massacre of foreign sailors

Warrnambool: Yangerry tribe – yellow people from shipwreck settled among them and created farms

Glenelty River: carving of foreign sailors.

(ix) New Zealand

North Island: two large ships preceded Captain Cook (Maori accounts); light-coloured people settled among Maoris and begat children; Tamil calligraphy.

South Island: large ship wrecked; Tamil calligraphy.

4. Linguistics and languages common to New World and China

(i) Chinese spoken

California: Chinese-speaking colony on Russian River (Powers) Mexico: Othomis people

Canada, British Columbia: 'Colonia dei Chinesi' (Zatta) Peru: Eten and Monsefu villages (Lambaeque Province) three miles apart understood Chinese (19th century) but did not understand each other's patois.

(ii) Chinese names

In northern Peru, mainly in the Ancash province, there are 95 geographical names which are Chinese words and have no significance in Quechua, Aymara or any of the other dialects of northern Peru (examples follow). There are also 130 geographical names in Peru which correspond to names in China. The very name 'Peru' means 'white mist' in Chinese – the white mist which cloaks the coast many days each year. The name given to Chile (Ch-Li) was pre-Spanish (= 'dependent territory' in Chinese).

Peruvian Name

Cha-Wan (La Pampa) Chancan (Tarma) Chamtan (San Gregorio) Chaolan (Margos)

Chulin (Caras) (Har) (Bongara) Hu-Pa (Huasta) Colan Chanchan (area between Moche and Viru Rivers) Laychi (Ochros) Lahan (Huancay) Linche (Chincha) Mongtan (Cochabamba) Payhan (Trujillo) Hon Kon (Moche River) Chinese Translation Land prepared for sowing To harden metals Covered in sand Ready for combustion (viz. coal-mine) Forest Red (i.e. red earth) Leguminous plant Difficult passage Canton

Small fruit Clamour (viz. waterfall) Snake Big stream Damaging drought Red hole

(iii) Linguistics

East Africa: bajun (local name for boat people)

Australia: *bajun* (SW Australia), and Japanese (Lynda Nutter) simulants

China (Hokkien): *joon* (boat which persists southwards to Amoy in Taiwan, and the ports of Bangkok, Penang and Singapore) (Dr Tan Koolin evidence)

Peru: (Loayza) at least 37 words other than the village names given above, including *quipu* (knotted string) – China *qipu*, Hawaii kiipúu, Marquesas KaulaKipu'u (Duncan Craig)

New Zealand: kumara (sweet potato); Peru - kumar

Mesoamerica: kik (chicken); India – kikh (chicken)

South America: sampan (boat), China – sampan; balsa (raft), China – balsa

Pacific America: Zuni language and Japanese (Nancy Yaw Davis) British Columbia (Squamish Indians): *tsil* (wet), *chi* (wood), *tsu* (grandmother); China – *tsil* (wet), *chin* (wood), *etsu* (grandmother), and another 37 words.

North America (Virginia): Ming Ho people (J Warsing), Wyo Ming

county, Lyco Ming people, Ho down, ho cakes Tiguex: 'Huri Shan' Mexico: Pi k'w; Saka (Henriette Mertz – *Pale Ink*). Towns are strung out from central Arizona to Yucatán – viz. Huetamo, Huichol, Huizontla, Huepac, Huitzo, Huila, Huitepec, etc., to Zacapa. The cultures these towns possess have no linguistic affinity for one another. In none of the cultures is there a meaning for any one of the three base words. Chiapas: Tse-Tsai; tso tsil (R. Banzo)

Guatemala: Lord of Guatama? (H. Mertz and J.D. van Horn)

Turkeys and maize originated in America and reached Europe from two directions: from China then the Silk Road to Turkey (here the words are *granoturco* (maize) and *turco* (turkey) – the names in Italy and England); and brought back by Spaniards (the word in France for turkey is *dindon* – de l'Inde).

The fulvous tree duck is a poor flyer found in Brazil but which originally came from India (Bengal): *irere* (Brazil and Guyana), *sarere* (Burma), *sarara* (India).

American Indian names that are Chinese (Martin Tai): on his arrival, Columbus met Indians = Yin Dian (people from Yin [China]); Pizarro, Inca = Yinca (people who live in Yin); Vancouver, Inuit = Yin Uit (people originating in Yin).

5. Accounts of contemporary and other historians

Author	Title/Description	Date Written (Published)
Chen Cheng	Diary of Travel in the Western	1405–14 (1414)
(Chinese)	Regions. Chinese emperor's overtures	
	to Persia and description of reopening	
	trade to Mediterranean.	
Ma Huan	Ying Yai Shenlan: the overall survey of	1416–31 (1435)
(Chinese)	the ocean shores. Chinese fleet in	
	south-east Asia and Indian Ocean.	

Fei Xin (Chinese)	Marvellous Visions from the Star Raft. Chinese fleet reaching Africa and then Timor (east Indonesia), 300 miles from Australia.	1405–31
Ibn Tagri Birdi (Egyptian)	Nujum (A History of Egypt). Chinese fleet reaching Red Sea and Jeddah.	1431
Ghiyash D Din Naqqash	Subdatu-T'Tawarikh (Cream of Chronicles). Inauguration of the	1419–22 (1424)
(dictated to Hafez Abru) (Persian)	Forbidden City, 2 February 1421, delegates arriving and returning.	
Niccolò da	The Travels of Niccolò da Conti.	c.1420–4 (1434)
Conti (Venetian)	Claims to have travelled to Australia. Describes Chinese fleet passing through Indian Ocean and his passage to Australia and China. Corroborated by statue in Fujian Palace.	
Fra Mauro (Venetian)	Planisphere notes. Describe Chinese junk sailing across Indian Ocean non-stop (about end of 1420), rounding Cape of Good Hope to Cape Verde Islands and 'obscured islands'.	c.1420 (1459)
Ibn Battuta (Moroccan) Acosta (Spanish	<i>The Travels of Ibn Battuta</i> describes huge Chinese ships in Indian Ocean. Chinese ships – Florida	
Jesuit) Coronado (Castilian) Hugo Grotius (Dutch)	Chinese people – Mexico Chinese people, Mexico (Tiguex); ships with golden sterns (Mississippi, Missouri) <i>Bibliotheca Cuirosa</i> , 'Asiatic shipwrecks on Pacific coast of Mexico'. Wrecks of	
	Chinese junks seen by first Spanish to reach Chile.	
Father Luis Sales OP	<i>Observations on California</i> – Chinese colony – Santa Barbara.	1772–90 1772–90 (translated and re
		edited by Charles N. Rudkin, L.A. 1956)

Antonio Galvão	A Selection of Curious Rare and Early	1555
(quoted by	Voyages. 'Chinese ruled over locations in	
Richard	Central and South America'.	
Hakluyt)		
(Spanish)		
Zatta (Italian)	Describes Queen Charlotte Island as	
	'Colonia dei Chinesi'.	
Juan Gonzales	The Historie of the Great and Mighty	
de Mendoza	Kingdom of China and the Situation	
(Castilian)	Thereof.	
da Gama	Journal of the First Voyage of Vasco da	
(Portuguese)	Gama, p.131. As quoted by Professor	
	Robert Finlay in Terrae Incognitae,	e' i fandie i
	vol. XXIII. Chinese fleet (c.1421) was	
	of 800 vessels.	
John Brereton	Diary of Bartholomew Grisnold's 1602	
	voyage: at Buzzards Bay he found	
	Indian people wearing armour, as did	
	Martin Pring at Cape Cod the	
	following year.	
Christopher	Christopher Columbus' secret report	Describes meeting
Columbus		Chinese (Martin
(Genoese)		Tai)
Gonzalo	Travelled from River Magdalena to	1537
Ximenez de	Attiphare near Bogotà. Meets Muyscas,	
Quesada	Guanes, Myuzoes, Calimas in cotton,	
Cl	entirely different from other tribes.	London 1787
0 .	, History of Mexico (2 vols)	London 1787
Don Francisco		
Saverio Garcilaso de	Histoire de la Conquête de la Floride	London 1731
le Vega	(trans. P. Richelet)	(translation)
Vega	Commentarios Reales del Origen de los	1609 Madrid
vega	Incas, Reyes del Peru (describes Chinese	1007 Madrid
	in Peru and Chile)	
Barton,	New Views of the Origin of the Tribes and	1797 Philadelphia
Benjamin	Nations of America (8 vols)	I PM
,		

Carver, J.	Travels in the Interior of North America (8 vols)	London 1779
Chappe	Voyage to California	London 1778
d'Anteroche		
Jefferson, T.	Notes on the State of Virginia	Philadelphia 1794
Humboldt, A. de	Researches concerning the Ancient London Americas	1814
Venegas, M. (Jesuit)	History of California	London 1759
Ulloa, Don Antonio	Voyage to South America	Dublin 1758
Terry	Voyages to the East Indies	London 1665
Cochrane,	Journal in Colombia (2 vols)	
Captain C. S.		
Molina	History of Chile (see Ranking – renamed)	1726
Du Pratz	Unexpected Faces in Ancient America	
Von Wuthenau,	(p.210 and fig.75c); The Art of Terracotta	
Alexander	Pottery in Central and South America.	
	Numerous Chinese people in North and South America before Columbus.	
Kotztbue	First Voyage (Darwin, p.456)	
Padre Kino	The Padre on Horseback	1542-1606

6. Shipwrecks

(i) Large shipwrecks with 'Chinese' characteristics found in the wake of the Chinese fleets by European explorers

	Location	Details	Year	Contacts
1	China,	The giant rudder (42 ft		Mayor of Nanjing,
	Nanjing dry dock No. 6	high) was found here, also much very old teak – with which local people make		Professor Yinsheng Liu o Admiral Zheng Ming.
		furniture. Dock is huge: 500m × 80m. Flooded 143	1	
		until today.		
2	Philippines, North	All contents brought from seabed under direction of		Dr Eusebio Dizon's information. Junk from

Pandanan Island (S tip, Palowan Island) Dr Eusebio Dizon – an amazing haul of more than 4,700 pieces giving a graphic view of trade in the Pacific and Indian Ocean in 1421 – including Zhu Di's coins.

3 Philippines, Santa Cruz Off Santa Cruz (N. Philippines). More than 11,500 pieces of 15th-century Chinese porcelain of the finest quality and of incredible value have been recovered in perfect condition. Zheng He's fleet $30m \times 8m$. Second junk discovered off Pandanan 1995 with 3,000 pieces. The Pearl Road. Frank Goddio's information. In 32m water discovered 2001. in v. good condition - 5m \times 5.8m. Goods packed perfectly. For info: Iris Weissen, +49(40) 22658 323.

4 Singapore Straits, Bakau

5 Thailand, Longquan 23m, wrecked early 15th century, Chinese construction, hull of hard pine *Pinus sylvesteris* group, iron nails, chu-nam caulking, flat bottom, Zhu Di (1403–24) coins, bronze guns, bronze mirrors and handles, cast stones, iron pots, grindstones kendis, numerous copper artefacts, sounding weight – fascinating for comparison with Jucutácato shroud and Sacramento.

Wrecked 1390–1420 in 63m of water, $30m \times 8m$. Wreck largely intact with largest ever cargo of Ming porcelain – possibly 100,000 pieces including Celadon. Tin sounding weights (compare with Fraser Island).

Obviously of colossal value but deep and difficult. Wreck should yield

hugely important details of Chinese junk design. No-one is attempting to raise it.

Sunk late 1400/early 1500. Stuffed with Ming porcelain which is now being auctioned. D.F. Sedwick information.

Captain Wilson's Mariners' Mirror 1924, reporting earlier French missionaries and Cornelius Schouten in Eindracht 1616. Archaeology, Feb 03. Edwin Davey information.

Report in Turiang, Malaysian branch, Royal Asiatic Society. King Edward Island 150 nautical miles away. Desliens world map depicts coastline - drawn two centuries before Captain Cook. E.O. Jeago information. Warrnambool

6 Vietnam, Hoi An (off Da Nang)

7 Vietnam, Phu Quoc

8 Fiji, Nanuku Passage 14°15′S, 178°10′W Vivid description of Chinese 1875 landing and being murdered by Fijians (French missionaries' accounts of c. 1550) after they had intermarried. Chinese tomb on Alofi.

Wrecks of Genghis Khan's fleet

which invaded Japan 1281.

Amazing finds - watertight

compartments, mortars,

fragmentation bombs, etc.

Cargo Chinese, Vietnamese,

Thai ceramics, iron ore, fish.

Double planking. Brass bolt.

Now lost because junk appears

by iron nails.

to have drifted.

Wood: temperate wood joined

Chinese junk sailing to Borneo.

9 Japan

- 10 Malaysia, Turiang
- 11 Warrnambool (South Australia)

Double planking; brass pins c. (5/8 inch). Among sand dunes near sea, Elephant River.

524

12 King Edward Island c.1980

c.1880

c. 1880

(South Australia) 39°49'S, 144° 67'E

13 Tasmania, Storm Bay14 Australia,

King Sound

Disgorges Hong Wu coins after storms Discovered by Allan Robinson on sea bed. Local legends say yellow people settled among them. Linguistic similarities Aborigines with Japanese.

- 15 Blackwood River, South Australia
- 16 East Australia, Fraser Island

River'. River enters sea at Augusta close to Cape Leeuwin. Unknown graves in Julien Bay. Aborigines pale colour. Aboriginal legends of visiting ship.

Junk '1km east of Blackwood

John Green (1862) saw a Chinese junk rise out of the sea following a great storm. Numerous local legends collected by J. Green report foreign ship landing small boats to mine minerals. Photos 1919, 1972, 2002.

17 East Australia, Stradbrooke Island swamp Accessible on foot; 4WD can get within 200 metres. Need chopper for precise location. Should be easy to spot from small aircraft. Cost Aus \$350 approx. 150 nautical miles away. Desliens world map depicts coastline.

DNA has been carried out on certain Aborigines but Australian government will not allow release. Legend of Sam Chalwell. Jim Mullins' information, organising overflying in April 03. B. Green information from J. Green account. B. Green found wine cooler. 1972 photos of cannon. Gympie pyramid nearby. Local report (via Greg Jeffer) wreck in swamp called Golden Dragon – a Chinese junk. Three other wrecks nearby to predate Cook.

18 East Australia, Indian Head, Fraser Island

19 New

Zealand.

Ruapuke

sighting)

Zealand.

south

coast,

Dusky Sound

America.

east coast.

Bimini -

mounds'

America,

east

coast.

Great

Dismal

Swamp

'shark

Beach

(1890)

20 New

21

22

Wreck near shore, approachable by Zodiac, not deeply buried, visible at low spring tides (Greg J.).

Nearby Colenso Bell (Tamil) carved stone (Tamil), carved jade duck (Chinese), Mauku figurine (Chinese), Komowin (stepped pyramid – ?Chinese). Local legends. Teak built, triple hull, willow pattern plate.

The wreck disappeared many years ago. It was classified as a Chinese junk by local people.

Six mounds in swamp on E. Bimini, second Bimini road found Anguilla, Cay Sal, stone reservoir Andros. Florida – Menendez reports junks. Chinese landing party massacred – Frank Fitch.

To west of Norfolk, VA. Sarah Jackson's story of discovery of 'an ancient Chinese sailing ship uncovered when the swamp was first drained by George Washington and his friends'. Bartlett Doty investigating.

Greg Jeffer's and Bill Ward information. Bill Ward has found ancient lead weight (Oceania, vol. 34). Vaughan Cullen information. The wreck is offshore. has shifted position and is lost. Latest finds by David Sims (rivet, teak wood). Robyn Gossett information. New Zealand Mysteries.

Bill Swinley has most info on second Bimini Road. 'Bruce' information. Andros Reservoir C. Huegy. Larry D. Clark information (01/ 03) from Merrill Reading Skill Text Series 1977. Bell & Howell, ISBN 0-675-06757.

23 America, west coast, Vancouver Island, Schooner Cove/ Lovekin Rock Wreck is approx $130 \times 30 \times$ 27ft – longer than Cook's *Endeavour* or Vancouver's *Discovery*. Many Chinese artefacts found nearby. (Lake River Potters, Chinese vases, etc). Wreck of teak (?), carrying rice (?).

24 America, west coast, Vancouver Island 'Asian Ucluelet' 'Asian Pot Wreck' 15 nautical miles off mouth of Juan de Fuca Strait hauled up Asian pot. Numerous articles of Japanese/ Korean/Chinese origin on Vancouver Island. Hector Williams and Bob Hassell's information: HW to London 04/03 with Park Canada file on wreck. Exact location known. Magnetometer surveys bronze fastenings. In c.1400 mysterious colony of potters settled in valley between Vancouver Lake and Columbus River (Robert Hassell's information) and disappeared c. 1700.

25 America, west coast, Vancouver Island (Clatsop Beach) Point Adams, mouth of Columbia River. Swan, J. G., *The Northwest Coast*, 1857.

26 America, west coast, Oregon, near Neahkahnie Beach

Ming porcelain found on Netarts sand spit. Pulley made of SE Asian hardwood dated c. 1410. Cabrillo's map of California (c. 1543) shows wrecked Chinese junks. Cabrillo – Goetzman & Williams of Oklahoma Pub 1992, Atlas of N. American Exploration.

- 27 South America, west coast, Chile
- 28 America, west coast, California, Drake's Bay
- 29 America, west coast, Sacramento

- 30 America/ Mexico, west coast, Bahia de
- 31 America, west coast
- 32 Americas, Caribbean33 Americas, Mississippi, Caribbean

Grotius p. 68, first Spanish to round Horn, found junks near Taroja (22°S)

Considerable amount of Chinese porcelain found here. Drake reported to have 'chased a junk'. Cabrillo's map shows junk.

Pearson investigating. Core drilling April 03. Electromagnetic survey completed 02/03. Wood carbon dated c. 1410 (Beta Analytic Lab, Miami, Florida). Chinese brass plate found buried Susanville. Wreck disgorges Chinese (Nanking) cloth after storms, hence name 'Playa la Ropa'. Exact location unknown.

Grimes and Knights landing. Appears to be very old ship/junk full of seeds, accessible at low water. Kathleen Pickard nearest to site. Guadeloupe – wreck found by Columbus. Coronado's junks with gilded sterns: 'Three shippes on the sea coast which bore Alcatarzes or pelicans of gold and silver in their prows.' Ranking Supplement p.35.

Drake and Cermeno in California: 16thcentury Chinese ceramics -Navigator's Guild, 1965, 1968, 1972 Dr John Furry and Mr David Stewart information. Approx 30m × 8m (as Report by Pro Convers, Oct 2002 Ming porcelain in local museum. Local legends -Joel Fressa information Mary Doerflein information. Mary lives near Seattle, Washington.)

See Haykluyt's Voyages under Vasquez de Coronado

34	Caribbean	Columbus secret report. The	Historian Fang
		Origin of Dragon and Phoenix	Zhong Pu.
		Culture, 1988 – Wang da Yiu, song	
		Bao Zhong, Chinese mirrors in	
		'Bird boats'.	
35	Peru	Wrecks of Chinese Ships	Ranking J.,
			Conquest of Peru,
			London 1827
36	Chile	Grotius, p. 68	Ranking J.,
			Conquest of Peru,
			London 1827
37	California	Santa Catalina Island (Channel Island)	

The following are wrecks identified by magnetic anomaly survey. Permission is being requested from the relevant authorities to carry out corroborative testing using different types of equipment.

No.	Type/Codenan	ne Lat/Long	Barracks Harboured Yes/No
			Barracks – Ref. Para 19(x)
38	Rorqual	AB°38′28″	Yes. Boulge (para 10 (xi))
		T°38′53″	
39 .	Rorqual	AB°50′50″	Yes. Boulge (para 10 (xi))
		M°57′45″	Otley
			Orwell
40	Rorqual	AB°50′50″	Yes. Orford, Orwell
		M°57′45″	
41	Rorqual	AB°51′20″	Yes, Orford, Bairdsey
		M°02′30″	
42	Alcide	AB°50′30″	Yes. Otley, Orwell
		M°03′30″	
43	X Craft	AB°44′48″	No. Nacton
		M°05′45″	
44	Rorqual	AB°44′44″	Yes. Nacton
		M°05′51"	
45	Resolution	AB°44′47″	No. Nacton
		M°05′48″	이 지않는 것이 하는 것이 같아요.

Alcide	AB°44′48″	Yes. Nacton
	M°05′45″	
Seraph	AB°44′48″	Yes. Nacton
	M°05′45″	
Rorqual	AY°27′50″	Yes. Loxfield, Iken
a long a star	S°45′30″	
Rorqual	AY°27′50″	Yes. Loxfield
	S°45′30″	
Rorqual	AY°28′29″	Yes. Loxfield
	S°45′07″	
Rorqual	AY°28′40″	Yes. Loxfield
	S°44′33″	
Rorqual	AY°28′41″	Yes. Loxfield
	S°44′24″	
Rorqual	AY°28′44″	No. Loxfield
	S°44′15″	
Rorqual	AY°28′47″	Unfinished Loxfield
	S°43′48″	
Rorqual	AY°28′47″	Yes. Loxfield
Rorqual		No. Loxfield
	S°43′27″	
Resolution	AY°28′51″	No. Loxfield
	S°43′00″	
Seraph		Yes. Trimley
Seraph		Yes. Trimley
X Craft		Yes. Trimley
X Craft		Yes. Trimley
Rorqual		No. Trimley
Rorqual		No. Trimley
Rorqual		Yes. Trimley
	S°28′03″	
	Seraph Rorqual Rorqual Rorqual Rorqual Rorqual Rorqual Rorqual	$\begin{array}{llllllllllllllllllllllllllllllllllll$

530

65	Resolution	AY°33′44″	Ballast blocks alongside
		S°28′03″	Trimley
			Bows on to beach
66	Resolution	AY°33′42″	Ballast blocks alongside
		S°27′55″	Trimley
			Broached
67	Vanguard	AY°33′46″	Ballast blocks alongside
~	8	S°28′00″	Trimley
			Bows on to beach.
68	Seraph	AY°37′00″	No. Trimley?(four-mile
00	e e a a a a a a a a a a a a a a a a a a	S°22′15″	walk)
69	Seraph	AY°37′00″	No. Trimley
0,	oonupii	S°22′15″	
70	X Craft	AY°37′00″	No. Trimley?
	ii orare	S°22′15″	,
71	Rorqual	AY°39′50″	Yes. Trimley? (six-mile
			walk)
		S°06′00″	
72	Rorqual	AY°39′50″	Yes. Trimley (seven-mile
	1	S°06′00″	walk)
73	Rorqual	AY°39′50″	No. Trimley (seven-mile
	1	S°39′50″	walk)
74	Rorqual	AY°45′16″	Yes. Holbrook
	1	V°38′51″	
75	Resolution	AY°20′45″	No barracks, but there
		S°49′34″	should be. A mystery – all
			crew lost?
76	Resolution	AY°20′45″	No. A mystery. All crew
lost?	resolution		
1050.		V°49′34″	
77	Vanguard	AY°20′44″	No. A mystery. All crew
lost?	, unguard		
1031.		V°49′34″	

(i) 'Chinese' anchors and fishing gear

(a) Indian Ocean/Far East/Pacific: Chinese 'butterfly' fishing nets throughout.

- (b) California: stone anchors in San Pedro Bay, Redondo Beach, Palos Verdes, central Los Angeles (under subway); Santa Barbara – fish hooks. (Barnacles dated pre-Columbian radiometric dating. Professor Lin Xiao Han of Beijing.)
- (c) Ecuador: fish hooks and labrets.
- (d) Australia, Arnhem Land and Gulf of Carpenteria: anchors, fish hooks.
- (e) Mexico: Rio Balsas butterfly fishing nets; Yucatán (Chinese? anchor used for worship).

7. Chinese porcelain/ceramics found in wake of Zheng He's fleets

- Indian Ocean and East Africa: early Ming porcelain found by first European explorers in palaces of rulers the length of the east African coast from Djibouti to Sofala and inland as far as Zimbabwe (Philip Snow/Martin Tai evidence); Mauritius – Celadon
- (ii) North America, Pacific coast Oregon: the Netarts sand spit (Site 35-Ti) – including some of Zhu Di's reign California: dates to be confirmed Canada, Vancouver Island (BC): Chinese clay vase (B. Morelan); Chinese storage jars from seabed (Tofino) (Hector Williams) Washington State: (Ken Holmes and Sean Griffin); Lake River Potters – Washington coast (R Hassell)
 (iii) Central and South America
- Mexico, Zihuantanejo Peru: Ica, Chan Chan, Miraflores – Tai chih symbols Amazonia: (Paul Yih and Beloit University, Wisconsin)
- (iv) Australia: Bradshaw, Elecho Island, Yirrkalla, Winchelsea Island, Cape York, Gympie, Tasmania.
- (v) Pacific: Magellan's descriptions of rulers dressed in silk, eating off Ming porcelain from Leyte to Spice Islands.
- 8. Pre-Columbian Chinese jade found in wake of Zheng He's fleets
- (i) Amazon/Tapajos River juncture (Barbosa Rodrigues): Trombetas River; Lago Sapakua; Lago de Faro; Serra da

Chinella (Hill of Chinese); unnamed island; Ilha Jacinta; Costa do Parvo; Villa de Faro; Rio Yamunda; Cujumu

- (ii) Elsewhere in Brazil (Barbosa Rodrigues): Amargosa (BA);
 Campanas (SP); Pivi (MG); Pinheiros (RJ); Olinda (PE); Obidos (AM); São Francisco River
- (iii) Argentina: (Barbosa Rodrigues and Palmatory)
- (iv) Colombia: (Barbosa Rodrigues and Palmatory)
- (v) Panama: (Barbosa Rodrigues and Palmatory)
- (vi) Costa Rica: (A131; P2698)
- (vii) Guatemala (border El Salvador): figurines (BN139)
- (viii) Mexico: Teotihuacan; Isthmus of Tehuantepec; Chiapas de Corzo; La Venta (L273; K094; M342C; L240; W154; P269B)
- (ix) Nicaragua (A131; P269B)
- (x) North America: Georgia (Nacooche Mound); Michigan Mound (P269B)
- (xi) Cuba: (Barbosa Rodrigues and Palmatory)
- (xii) Virgin Islands: (Barbosa Rodrigues and Palmatory)
- (xiii) Canada, British Columbia: (C405; H070); Shu Lao Buddha lamp
- (xiv) Australia: Darwin Shu Lao; NSW Ganesh, Hanuman; Queensland – Buddha; Gympie – orange-coloured jade belt buckle, carved monkey/bear/animal and blue jade necklace (Brett Green)
- (xv) New Zealand: Ruapuke Beach korotangi duck; Mauku Mongol warrior
- (xvi) Pacific/Polynesia: to follow
- (xvii)Galapagos: (Barbosa Rodrigues and Palmatory)

(xviii) Peru: mummy – Mongolian features with jade necklace (Lima Museum) (Loayza)

9. Artefacts, gems and votive offerings found in wake of Zheng He's fleets

- (i) Far East and Indian Ocean: all over the area, too numerous to mention
- (ii) Africa: Pate bronze lion
- (iii) Atlantic and Caribbean: Azores Corvo statue of rider on horseback; Bimini marble head
- (iv) Meso and Central America Mexico: lacquer boxes, Roman bust (Joluca), dyestuffs,

Jucutácato shroud, copper ornaments, Chinese vases (Azacapotazlo and Hue Hutitlan); little Chinaman (Teotihuacan), terracotta figurines of SE Asian people (Niven); Chinese bronzes (Romeo Hristov); Chinese totems (I. B. Remsen).

(v) North America (Pacific coast)

Washington: ceramic artefacts, Lake River (Terry Glavin, *The Last Great Sea*)

British Columbia: carved totem faces (Wu Han), 'Chinese' lamp, votive offerings, Shu Lao, sackfuls of Chinese coins, Buddhist statuette, Korean burial urn (R. Hassell)

California: early Ming brass plate (A. D. Palmer), Avalon Harbour treasure box (Steve Haynes), stone with Chinese writing (Steve Elkins)

Arizona, Grand Canyon: statuettes of Buddha (Jake Smothers) Colorado, Granby Dam: 'guardian' statue with Chinese inscriptions (Thad Daly)

(vi) South America

Peru: bronzes with Chinese inscriptions (Trujillo), pottery with Chinese inscriptions (Nasca), figurines with Chinese inscriptions, e.g. Tai-chi, silver idol with Chinese inscriptions

(Trujillo) and clay figurines.

Brazil, Surui: gems (Paul Yih)

(vii) Australia

NSW: onyx scarab, Shao Lin's head, stone heads Queensland: Hanuman, Ganesh, onyx scarab

Arnhem Land: figurine of Shu Lao

(viii) Pacific

Hua Atoll (Tuomotu Archipelago): emerald ring Hawaii: helmet and iron weapons (there is no iron in Hawaii)

(ix) New Zealand: two lions (Brett Green)

10. Stone buildings or artefacts found in wake of Zheng He's fleets

- (i) Observation platforms and observatories
 - (a) Australia (5): Penrith; west of Blue Mountains; Gympie; central NSW coast; Atherton

- (b) North Atlantic: Newport round tower (mortar contains gypsum, foreign to area); Canaries
- (c) Arctic Kane basin
- (d) Pacific Tuomotu (Tahiti); Marquesas; Society Islands; Carolines – Lele, Ponape, Nan Madol, Yap, Tobi; Marianas – Saipan; Gilberts –Kiribati; Solomons – San Cristobal; Mala; New Guinea (5); Malden Island; Magnetic Island; Samoa (Jenny Gore evidence)
- (e) North America: Casa Grande (Grand Canyon) (J. Andrews)

Note: An analysis of the mortar of as many of these platforms as possible will be conducted; results will be posted on the website.

- (ii) Carved stones recording voyage China – Liu Shia Chang (Fukien province); Lingshan Mountain (Quanzhow); Malaya – Malacca; Thailand; Ceylon – Dondra Head; India – Guli, Calicut, Cochin; Africa – Matadi Falls (Congo); Cape Verde Islands (Janela); South America – Santa Catarina; New Zealand – Ruapuke Beach and South Island; North America – Dighton Rock and McCook Point (B. Trinque); American Pacific coast – 'Sacramento stone'?
- (iii) Stone markers to denote position North America (South Peabody, Royaston, Barre, Shutesbury, Chelmsford, Upton, Concord, Waltham, Carlisle, Acton, Lynn, Cohasset, Newport, California), Newfoundland, Labrador, Kane Basin, Outer Hebrides?, Patagonia – S Julien (Darwin), British Columbia coast, Queen Charlotte Island (Margo Donovan evidence).
- iv) Miscellaneous stone dwellings North America: Narraganset Beach, ruins of village High Arctic: Newfoundland, Labrador, Kane Basin Australia: Newcastle, Sydney California: east of San Francisco Bay (Chinese village) Azores: Corvo (on beach) Peru: the great wall of Chimu (compare with Vietnam) – 40 miles long near Chan-Chan; Quinoa subterranean palace

(Geographical Review, vol. XXIII, 1932)

Mexico: Teotihuacan, inscribed rocks (Professor Niven) Vietnam: great wall of Vietnam (evidence Ms Fran, Kunming Conference, 2002) British Columbia/Washington State: submerged village

Mississippi (44°10'N 93°W), circular fortress (to house 5,000 men)

- (v) The Newport Round Tower astronomical alignments Carbon dating of tower now puts earliest date as 1410. Professor William S. Penhallow, Professor Emeritus of Physics, University of Rhode Island, has concluded the tower is a cylinder with arches sitting on eight pillars whose windows are cut so as to enable astronomical sightings (in 3D) of the sun, moon, Polaris and Dubhe (Ursa Major) at spring equinox and winter solstice. Everything required to determine longitude by an eclipse of the moon is found in the alignment of the windows. A structure north-east of the tower has been located (gnomon line?) and is being investigated. The author has requested an analysis of the mortar of the tower to see whether it contains rice flour, an ingredient used by the Chinese to add strength to mortar. Results will be posted on website.
- (vi) Stone dams and fishponds

Hawaii: (M Armstrong) Menehune (Oahu) Virginia: (J Warsing) Wyoming County – forts, dams New Zealand (South Island): (Fletcher) Westport, Mass.: (Jean Elder) Fiji, Alof islet: (Fortune) – mariner's mirror (14°15'S 178°10'W)

(vii) Carved stone artwork

Easter Island: Chinese lion's head (Kerson Huang) Honan: Chinese lion head (T. Brooks) Bali: Chinese lion head Yucatán: Mayan gargoyles – serpents (Alan Moks); carvings on temple wall in Chinese (R. Wertz); Phaspa writing (R. Wertz); elephants; Chinese heron Copan: Chinese heron (Dean Dey); lion's head (Dean Dey);

Chinese man with moustache (Mrazekts)

Guatemala, La Democracia: carved Chinese stones (C. Skinner) Massachusetts: carved Buddha (Shutesbury)

California: sculpture (C. Marschner); carved stone with Chinese writing (Steve Elkins)

(viii) Slipways

Bimini North Island, Bahamas): hull ballast and slipway, walls (Andros); Bimini Road (B. Swinley) Anguilla, Bahamas: (Bruce, Andros) harbour (Charles Huegy)

(ix) Factories/wells Malacca (Ta Tan Sen)

(x) Barrack blocks

Note: standard block = 40×30 metres

	Codename	Position (Code)	No. of blocks
1	Burgh	AX°09′29″	3
		D°47′29″	
2	Boulge	AB°38′28″	4
		J°38′53″	
3	Debach		
4	Otley	AB°50′30″	3
		J°57′45″	
5	Orford	AB°52′05″	3
		M°00′25″	
6	Snape	AB°52′05″	3
		M°00′25″	
7	Tunstall	AB°52′05″	3
		M°00′25″	
8	Bawdsey	AB°51′20″	4
		M°02′30″	
9 & 10	Orwell	AB°50′30″	6
		M°03′30″	
11	Shotley	AB°48′40″	3?
		M°59′15″	

12	Naoton	AB°44′48″	1 + 9?
		M°05′45″	
13	Hoo	AB°48′06″	24
		T°59′01″	
14	Iken	AY°23′26″	Not yet surveyed
		S°14′34″	
15	Laxfield	AY°28′29″	3 (cannibals)
		S°45′07″	
16	Bauton	AY°28′51″	Not yet surveyed
		S°43′27″	
17	Butley	AY°33′31″	3
		S°27′30″	
18	Blyth	AY°33′43″	3
		S°28′20″	
19	Trimley	AY°33′40″	200 (2 \times Seraph; 2 \times
		S°29′03″	Craft' 3 \times Rorqual; 2 \times
			Resolution; 1 $ imes$
			Vanguard, wrecked
			nearby)
20	Harwich	AY°39′50″	Not surveyed yet
		S°06′00″	
21	Holbrook	AR°51′30″	8
		S°31′14″	
22	Clopton	AR°45′16″	3
		V°38′51″	
23	Kersey	AR°48′53″	Not surveyed
		V°41′25″	
24	Eye	AR°20′56″	3 (a mystery – there
		V°49′34″	should be a lot more)
25	Hoxne	AA°29′10″	2
		V°57′59″	

If each barrack block housed 64 people and 293 located, then at least 18,752 sailors and/or concubines survived – see Shipwrecks 38 to 77. But there are no barracks for wrecks 75 to 77 comprising two Resolution and one Vanguard class – another 3,000 people, viz. at least 22,000 men sailed with this fleet.

11. Mining operations found by Europeans when they reached the New World

- (i) Australia: gold (Gympie); lead, uranium (Arnhem Land) (J. Green)
- (ii) Fiji: copper (Lasawa)
- (iii) Arctic: smelted bronze, iron, copper (Devon Island and Bathurst Island)
- (iv) North America: coal (Newport Island to Greenland); St Peter's River (Minay Sotor); Cherokee country east coast (Scott McLean), Chinese miners
- (v) Mexico: copper and gold
- (vi) Canada: jadeite (British Columbia)
- (vii) New Zealand: antimony, iron and gold (Cedric Bell)
- 12. Advanced technologies found by first Europeans
- Mexico: extraction of dyestuffs from insects, roots, leaves, barks, identical to Chinese processes; lacquer and boxes using complicated technology identical to Chinese methods; mirror manufacture very similar to Lamaist designs; copper technology similar to Chinese Aztec papermaking; metal working (Gary Jennings, Howard Smith)
- (ii) South America: Inca cotton; Inca roads using cement road systems more extensive than those of Rome

13. Plants indigenous to one continent found on another by early European explorers

- (i) From China to:
- Australia lotuses and papyrus
- North America rice, poppy seeds, keteleria, roses (*R. Laevigata*), hibiscus (*Rosa sinensis*) (Dr Tan Koolin); Monterey pines (California) (Bruce Tickell Taylor/Sandy Lydon)
- Pacific islands mulberries, hibiscus (Rosa sinensis)
- Amazon (Goyaz)- rice (Paraguayan Chaco (C229))
- Mexico rice, hibiscus (*Rosa sinensis* Mexican national flower) (Secret Journal)
- Malaysia *Rosa sinensis* (Malaysian national flower)
- Brazil oats (Svetlana)

• USA, Virginia – mulberry trees, honeywort, *Paulownia* tomentosae trees (Pallowaddies), 'Yellow Delicious' apples (J. Warsing)

From Tropical Asia to:

- Pacific Islands taro, yam, banana, turmeric, bottle gourds
- Amazon bananas
- New Zealand taro, yam (Captain Cook)

From Malaysia to:

- Pacific Islands arrowroot (pia)
- China rubber (*damar*), pepper (Ma Huan)

From India to:

- China cotton
- North Pacific islands sugar cane, wild ginger
- North and Central America cotton (via China)
- North Africa and Cape Verde Islands cotton (from China and America)
- Marquesas (and across the world) 26 chromosome cotton
- Pacific islands cotton
- Brazil sugar cane

From Africa to:

- Central Pacific bottle gourds
- Puerto Rico coffee
- Brazil root crops

From South America to:

- China maize
- South-east Asia maize
- New Zealand kumera
- Pacific islands yams, sweet potato
- Australia separate list of 74 items
- Philippines potatoes, maize (and metates)
- South America rice, bananas, sugar cane, coconuts, root crops

From South Pacific to:

• North Pacific (Hawaii) – bamboo, coconuts, kava, candlenut

- tree, hibiscus
- Central America (Pacific coast) coconuts
- Brazil coconuts
- Puerto Rico coconuts

From Norfolk Island to:

Campbell Island – Norfolk pines

From Indonesia to:

• China – spice

From Spice Islands to:

• China – pepper

From North America to:

- China maize, amaranth
- New Zealand *Chenopodium album* (Durdock Riley, Dave Bell), discovered by Cook, 1769; marsh cress (Navajo cosmetic)

From Mexico to:

- Philippines tobacco, sweet potatoes, maize seen by Magellan (first European); possibly pineapple, arrowroot, peanut, lima and yam beans, balimbing, cassava, chico, papaya, zapute, tomato and squash (Magellan does not record seeing these)
- India and SE Africa cochineal

To South America (Amazonia):

- Rice
- Bananas
- Sugar cane
- Coconuts
- Root crops
- (ii) Found in Hawaii by early European explorers
- from Tropical America sweet potatoes
- from India wild ginger
- from Pacific islands bamboo, breadfruit, candlenut trees, hibiscus, kava

- from Tropical Asia taro, ti plants, yam (five-leafed), banana, turmeric
- from Malayan Archipelago arrowroot
- from east Asia paper, mulberry
- (iii) Found on Easter Island before early European explorers
- from South America totora reeds (originally from Egypt), tomato, tobacco, sweet potato, 26 chromosome cotton.
- South Pacific coconuts
- SE Asia yam
- Mesoamerica papaya
- (iv) Found in New Zealand by early European explorers
- from South America kumara
- from Colombia 'scented grass'
- from Asia dove's foot geranium
- from China taro
- from North America *Chenopodium album* and marsh cress
- (v) Tobacco: pre-Columbian dispersion

From America to:

- India (A176)
- Australia, Indonesia, New Guinea, Melanesia (F027)
- Africa (before 1525) (J058B)
- New Guinea (L194)

(vi) Californian trees

San Diego County Park: markings on trees cut by Chinese explorers (Esther Daniels)

(vii) Shell mounds on uninhabited islands which the Chinese passed

- Caribbean (Bimini)
- Pacific: Kuriles, Aleutians, Kamchatka, Chuchoi
- New Zealand (Cedric and Dave Bell)

14. Animals indigenous to one continent found on another by early European explorers

(i) Asiatic chickens in South America. The chickens found by the Spanish and Portuguese arriving in South America were entirely different from those they had left at home. Amerind chickens laid blue-shelled eggs, had Asiatic names and were not used for food – rather for religious practices. They had different combs, feathers, spurs, sizes, shapes, legs, necks and heads and names – Malayan, Melanotic silkies, frizzle fowls and Cochin Chinese. As late as 1600 Mediterranean peoples did not have and did not know of the galaxy of Asiatic chickens found in the Americas. Asiatic chickens cannot fly; someone took them to the Americas before Europeans got there. (See Acosta for South America, Coronado for Tiguex.) (Evidence from William Goggins.)

(ii) Horses. Venezuela; Peru (Acosta); North America (bones and skulls); Mississippi drainage area and Canada; Brazil (Confins cave); pictures/carvings of horses in Australia; Mexico (Jucutácato shroud); Yucatán and South America (Trujillo and Ayacucho); Panama (Columbus); Tierra del Fuego (Sarmiento) (Evidence from Gerald Thompson, Katrina Van Tassell); Fraser Island (Australia), Carolines (Assateague ponies), Peruvian Pasos, Kaimanawa wild horses (New Zealand)).

(iii

Chinese ship's dogs. Mexico (Acosta), South America, Peru, South Africa, SE Asia, Pacific (further details to be provided); Falklands; Tahiti (Captain Cook); New Zealand (Captain Cook) (Crozet 1771) (Gossett p.158); Santo Domingo (Acosta); Wooldogs – Washington State and British Columbia; Kuri dog to New Zealand? (Evidence from Elizabeth Miller, Philip Mulholland, Greg Autry, Bernard Chang.)

- (iv) Otters found in New Zealand, South Island (Gossett p.151)
- (v) Giraffes and zebras from Africa, kangaroos from Australia to Chinese emperor's zoo
- (vi) Mylodons? Dusky Sound (Gossett, p.148) Vancouver Island?, Gympie?, China?
- (vii) Camels to Peru (Acosta)

- (viii) Pigs from Sulawesi/Java to British Columbia (*babiroussa*);
 Asiatic or Chinese pigs (*tatu*) to Brazil (São Paulo and Minas Gerais Pirapenga), Mexico (*cuino*) and New Zealand (*kune kune*)
- (ix) Fulvous tree duck from Bengal to Madagascar, Brazil and Venezuela
- (x) Australian dingo to Carolina (wild dog)?
- (xi) Hippopotamus from Africa to China (Beijing Museum 'Western Han c.208 BC')
- (xii) Water buffalo to South America
- (xiii) Elephants from Africa to Yucatán, Chile, Peru and Ecuador, and (note: authority/junks built to accommodate them – Terry 1665, p.137) from Africa/India to:
 - Mexico: Mexico City (Clavigero 1 p.84, Vega ii p.394);
 Culican (lat 23°30'), ambassador despatched to Montezuma (Ranking Supplement)
 - (b) Colombia: Bogotà (Ranking, p.23); Choco near Granada (Ranking, p.396 and Captain Cochran's Journal ii, p.390)
 - (c) Mississippi/Missouri: Mr Stanley captured and taken by elephant over mountains west of Missouri (Ranking, p.401); elephant bones 36°30'N 83°00'W and 32°50'N 80°10'W
 - (d) Chile: Tarija (22°S Ranking Supplement)
 - (e) Elephants on Chinese ships Polly Midgley

15. Art exported by Zheng He's fleets

From China to:

- New Zealand and Pacific coast NW Canada: 'The Protruding Tongue' and related motifs (Mino Baders 1966 in *Wiener Beithraege zur Kultur Geschichte und Lingvistik*, vol.15, Vienna)
- The Inuits: masks Henry Collins, many articles
- Easter Island and the Maya (Copan): carved stone lions (Brooks) - Copan (Dean Dey), Easter Island (Kerson Huang) and Bali
- The Peoples of the Andes Music: inland from the Peruvian coast Chinese pentatonic scales (C D E G A) prevail, as does a large quarter higher on the piano (FX_x GX_x AX _x CX_x DX_x). Indian peoples of North and Central America do not deploy the Chinese scales. Thus either Chinese music scales somehow

'leapfrogged' North and Central America or were brought by sea to Peru (Ger Nijman).

- Vancouver Island and Wuhan Totem Poles: totem poles are identical
- Central America: carved stonework Chichen Itza, Copan
- South America: pottery styles South American puma ware/Chinese tiger ware (Professor Gary Tee)
- The Americas: clothes styles see Alexander von Wuthenau, Unexpected Faces in Ancient America, in which pre-Columbian peoples are depicted with their distinctive clothes and hats living among Indian peoples.
- Washington Potters (R. Hassel evidence)
- Peru, British Columbia (Wampandaa) and Hawaii (Marquesas): *quipus* (Carver p.362)

From Burma to:

• Sioux: the Burmese swastika sign on Sioux and Ladoga peoples; tilted stone of Kyaiktiyo to Massachusetts, USA

16. Customs and games exported from China to the New World, as found by European explorers

- (i) To Mexico and Central America:
- Complicated rain-making ceremonies, identical in every detail
- Jade, with its complex panoply of beliefs
- Music more than 50 per cent of Central American music instruments occur in Burmese hinterland
- Neck-rest pillows and Chinese carrying poles
- Identical children's fairy stories 'Rabbit in the Moon'
- Papermaking and dye extraction
- Copper processing
- Divination rituals using chickens
- Tao/tie in Mayan artwork (Karin)
- Lakota tribe 'swastika' symbol/Tibetan peace and harmony (R. Chauvet)

- (ii) To California (between Russian and Sacramento Rivers) (Stephen Powers' report):
- Chinese-speaking
- Farmers and hunters
- Language
- Gambling
- Theatrical performances
- Women's dresses and hairstyles
- Snaring wildfowl with decoys
- Burying in ancestral soil
- Men with beards
- Sophisticated pottery
- Elegant carved jasper knives
- Methods of irrigation
- Stone villages

(iii) To South America:

Peru

- Roads using gypsum cement
- Cotton manufacture
- Games (Patolli)
- Quipus
- Computing devices
- Tripod pottery
- Divination rituals using chickens
- Jade rituals
- Musical jade gongs
- Inheritance traditions
- Mortuary customs
- Sacrificial customs
- Observation and cataloguing of lunar cycles and equinoxes
- Castration of criminals

Brazil

- Divination rituals using chickens
- Jade, with its complex panoply of beliefs
- Bearded men (karayaba)

546

- (iv) To British Columbia (NW Canada)
- Chinese secret societies
- Song similarities
- Chinese origin of Indian names
- Similarities with potlatch ceremonies
- Wampum (compare with quipus in Peru and China) (Ranking)

17. Armour

- (i) New Zealand: Pitu peninsula (Dave Bell), 'Spanish helmet' (Robin Watt
- (ii) North America: copper breastplates (Kotze Bue); Mississippi; Sacramento (Dr John Furry); Buzzards Bay (Bartholomew Griswold, 1602); Cape Cod (Martin Prinz, 1603)

18. Links with the years 1421-3

A number of historians, while accepting the author's contention that China reached the New World before Europeans, contend that they did so in sporadic voyages over centuries. The author relies on the scale of the voyages as well as detailed evidence linking settlements to the 1421–3 voyage. The author contends that at least 10,000 people settled in Peru, at least 25,000 in Australasia, and at least 5,000 in Mexico.

Scale

- Evidence of da Gama's voyage is that '800 sail' preceded him to Calicut 80 years earlier (viz. 1421–2, before China was sealed in 1431), and that the population of the fleet was greater than any city between China and India – virtually a small nation on the move (Professor Finlay, *Terrae Incognitae*, vol.xxiii)
- (ii) The whole world was charted by 1428. This massive undertaking across tens of millions of square miles of ocean would have required at least 120 ships working for 18 months. Several hundred ships would be required to transport 50,000 people.
- (iii) Evidence has been provided of Chinese settlements in Australia and New Zealand, the length and breadth of the

Indian Ocean, across the Pacific and the lengths of the Pacific and Atlantic coasts of North and South America. Again, this would have involved hundreds of ships.

- (iv) Nearly a hundred villages in Peru have Chinese names around 10,000 people must have settled
- (v) 'The treasure hunt' at least 2,500 people in Australasia.

Detailed evidence

- (i) Eruption of Soufriere, La Citerne and L'Echelle volcanoes on Pizzigano chart, twice between 1400 and 1440 (1424 chart)
- Wrecks with gilded sterns: Chinese junks in Mississippi near Quivira (Coronado 1550) and in Caribbean (Mafeo) and north Atlantic (Menendez); gilt does not last, so junks wrecked relatively recently
- (iii) Chinese people not intermarried seen in California, Mexico, Texas and Florida by Coronado, Acosta, Menendez and Mafeo (1550s)
- (iv) Ming porcelain dated either by cobalt or by Zhu Di's stamp 1403 to 1421 – found in Americas, Africa, Australia
- (v) Hull wood of junks carbon dated: Pandanan 1410, Nanjing 1406, Sacramento 1410, Turiang early 15th century, Bakau c.1410, Santa Cruz (Philippines) 15th century, Byron's Bay (Australia) 1410 and some of these contain evidence of voyages to America
- (vi) Jade figurine at Darwin dated by shape of Canopus head to early Ming, between 1008 and 1523 (Professor Wei's evidence)
- (vii) Zheng He states '3,000 countries large and small' visited; Liu Shia Chang, Chian Su (unveiled 1431) – Duyvendak first translation
- (viii) Pope's letter, 1448, about Chinese/Asians in Greenland 'about 30 years ago', viz. c.1421/2; Chinese DNA in Greenland people of Hvalsey
- (ix) Columbus's records (1477), '70 years before, people from Cathay in Orient' (Greenland)
- (x) Fra Mauro's map, 'about the year 1420', ship or junk from India
- (xi) Zhu Di coins (1403–24) found in wrecks dated by hull wood, for example Pandanan

- (xii) Chinese star charts (*Wu Pei Chi*) dated by precession of Polaris to 1420 ± 20 years
- (xiii) Mao Kun map, Chinese dated 1422, shows Australia (Sun Shuyun)
- (xiv) Chinese records give dates fleet set sail, dates returned, and ambassadors brought – Ming Shi (MS); Ming Shi W (MSL); Hsi Yang Fan Kuo Chih (HYFKC); Kio Ch'veh; Hsu Chiao Min Tung; Chien (MTC), Ming Chih (MC), all early Ming; see Part II of this synopsis.
- (xv) Illustrated Record of Strange Countries published 1430 featuring animals from across the world
- (xvi) Chinese official records (Qing) listing countries visited by Zheng He's fleet includes America and Australia
- (xvii) Newport Round Tower mortar (post 1409)
- (xviii) Bimini hull ballast (after last 600 years) (evidence of Admiral Zheng Ming)
- (xix) Dating of Pizzigano, Piri Reis, Jean Rotz, Waldseemüller, Cantino charts, and Vinland map (2002 radiocarbon dating); Portuguese master chart of world dated 1428; Brazilian chart showing route to China (1501)

19. Chinese already in the Americas when the first Europeans arrived: bibliographical evidence

Giovanni di	Met Chinese near (modern)	Verrazzano's letter to
Verrazzano	New York; met Asiatic people	Fancis I of France.
(1480–1524)	near Rhode Island	Hakluyt's Collection of the
		Early Voyages and Discoveries
		of the English Nation, London
		1810, pp. 358 et seq.
Francis	Met people 'so different from	Coronado was despatched
Vasquez de	all the nations that [we] have	by Viceroy Antonio de
Coronado	seen must have come from	Mendoza in April 1541 to
(1510–1554)	that part of Greater India the	seek Quivira beyond the
	coast of which lies to the west	Arkansas River.
	of this country' (viz. China)	
Pedro de	Official chronicler to	The Journey of Coronado,
Castaneda	Coronado's expedition,	trans. George Parker

		지원은 영상에 대한 방송을 날 같아요.
(1544)	reported the journey and peoples above described	Winship, Dover Publications New York 1933, at pp.58 et
Antonio	The Apostle of the Moluccas	seq. An Excellent Treatise of
Galvão	reports pre-Columbian voy-	Antonio Galvão, Hakluyt,
(c.1563)	ages from China to America	London 1812 (British
(0.1903)	and Chinese settlements	Library 209 h.z.)
	in America	
José de Acosta	Spanish Jesuit missionary	Historia Natural y Moral de
(1540–1600)	who describes the people,	Las Indias, pub. Salamanca
(1)10–1000)	animals, birds, plants and	1588–90 by Society of Jesus.
	flowers found by the first	Chinese in Mexico (272),
	Europeans in Americas	horses (273), dogs (274), hens
	Europeans in Americas	(284), coconuts (253), etc.
Juan Conzelez	Chinese voyages to the New	The Historie of the Great and
de Mendoza	World before Europeans	Mighty Kingdom of China
	world before Europeans	trans. Robert Parke 1588, pub.
(1588)		
		Hakluyt Society 1853–4, London
Contraction	Chinese coming to populate	London
Gregorio Garcia	Chinese coming to populate	
Garcia	Mexico (before Europeans) in El Reino de Anian	
		Dillighter Comises and
Hugo Grotius	Report of Asiatic shipwrecks	Bibliotheca Curiosa, pub.
(1583–1645)	(pre-Columbus) on the Pacific	Hakluyt Society, London 1884
E.J.	coast of Mexico	
Father	Describes Chinese graves and	Crónica Moralizadora, Barcelona 1638, Book II,
Antonio de la	pictures of Chinese horsemen	
Calancha	in Peru, pre-Columbus	p.486 et seq.
(1638) F. de	Collates earlier accounts of	Recherches sur les Navigations
Guignes	pre-Columbian Chinese	des Chinois du Côte de
(1761)	people and ships in Americas	l'Amerique et sur Quelques
	– Coronado's 'gilded sterns'	Peuples Situées a l'Extrémité
	at Quivira, Chinese mer-	Orientale de l'Asie, Paris 1761
	chants in Quatulco and	
	among Catualcans	
Antonio Zatta	Published map showing	Queen Charlotte Islands
(1775)	Queen Charlotte Islands	described as 'Colonia dei
	(British Columbia) which	Chinesi'. Published Venice

preceded Captain Cook or Vancouver's 'discovery' of that island

Describes Chinese colony in Powers (1877) California between Russian and Sacramento Rivers

1775. (British Library (Maps) c. 26.6.14)

Anthropological Journal of Canada, vol.14, no.1, 1976; and 'Tribes of California' in Contributing to North American Ethnology, Washington 1877, vols 1-3 Chinos Ilegaron antes que Colon, pub. D. Miranda, Lima 1948; Chinese in Peru (p.42); Chinese in Mexico (p.67); Chinese bodies

Loayza, F.

Stephen

A summary of the discoveries made by the first Europeans to the Americas who found Chinese people, villages, bodies, relics and Chinese animals, plants, birds, etc. (trans. Ian Hudson) Biographer of Pedro Menendez de Aviles the Adelantado,who found pre-Columbian junks in the North Sea

Carlos Prince

Japanese and Koreans ... crossed the maritime stretch . . . into the Kingdom of Quivira, populating Mexico, Panama, Peru and other eastern countries of the Indies' 'Mélanges et Nouvelles Americanistes', Journal de la Société de Americanistes de Paris, vol.X, p.303 et seq. d Biography in 1421

'Chinese . . . with Tartairs,

Professor	Found the body of an
William Niven	important Chinese navigator
	buried with pomp
	(pre-Columbian)
Christopher	Met Chinese when he arrived
Columbus	in Cuba, and reported
	Chinese visitors to Greenland
	before 1477 and Chinese
	bodies in Azores before 1492
Christopher	Secret report (Madrid)

Columbus Cabrillo

Chinese junk seen by Bartolomeo Ferrello in 1543 Chinese miners in 'bird ship' (Martin Tai) Cabrillo's map of California shows 'Nave de Cataio' in Atlas 9 of American Civilisation, University of Oklahoma Press 1992

Pedro	Chinese junks in north	
Menendez	Atlantic off Florida coast	
de Aviles		
Jodicus	Chinese junk in Pacific	Robert Hassell's evidence
Hondius (1606))	
Alexander		Unexpected Faces in Ancient
von Wuthenau		America; many Chinese faces
		in pre-Columbian America
Father Luis	Chinese colony from Santa	Observations on California
Sales OP	Barbara to San Francisco	1772–90, republished 1956
		Los Angeles
Gonzales	Muyscas, Guanes, Calimas of	
Ximenez de	Colombia entirely different	
Quesada	from local Indian people	
Garcilaso de	Chinese in Peru and Chile	Commentarios Reales del
La Vega	before Europeans	Origin de los Incas, Reis del

Part IV: Evidence of Zheng He's fleets' visits to specific places

Peru

1. Indian Ocean

- (i) Ma Huan
- (ii) Fei Xin
- (iii) Vasco da Gama 'fleet of 800 ships reached Calicut 80 years earlier'
- (iv) Malacca graveyards, factory, well (Ta Tan Sen), Zheng He's temple (Mark Zhong)

2. East Africa

- (i) Substantial early blue and white Ming the length of East African coast (Philip Snow)
- (ii) Pate Island (evidence in book)
- (iii) Fleet visited city of Zimbabwe (Martin Tai evidence) and Ming blue and white finds
- (iv) Mao Kun/Wu Pei Chi (1422) show Chinese fleet proceeding south off East African coast
- (v) Fei Xin
- (vi) Needham

3. The Atlantic and the Cape Verde Islands

- Cape of Good Hope and West Africa appear on charts drawn before Europeans reached Cape (Fra Mauro 1459, Mao Kun c.1402, Da Ming Yi Tu 1389)
- (ii) Fra Mauro drew Chinese junks accurately
- (iii) Fra Mauro's story of ship or junks from India rounding Cape
- (iv) 26 chromosome American cotton, originally from North America then to Africa and Cape Verde Islands, found by first Europeans in Cape Verde
- (v) the carved (Malayalam) stone on Cape Verde Islands at Santo Antão (Janela)
- (vi) the similar carved stone at Matadi Falls

4. The Caribbean

- (i) The Caribbean appears on the Cantino, Caverio and Waldseemüller maps published before Europeans arrived there
- (ii) Vasquez de Coronado met Chinese people in Tiguex and found Chinese junks with gilded sterns
- João de Acosta found coconuts in Puerto Rico (originated SE Asia) and dogs (originated China) in San Domingo.
- (iv) The Moskoke tribe in south-east USA and the Campeche Maya and Buctzozt Maya of the Yucatán have Chinese (post Bering Straits flooding) DNA
- (v) Chinese carvings at Maya sites in Yucatán
- (vi) Carvings of horses and elephants at Maya sites in Yucatán
- (vii) Chinese anchor, Yucatán
- (viii) Chinese jade and ceramics, Yucatán
- (ix) Horses in Panama (Columbus) (Barbara McEwen)
- (x) Chinese miners in bird boats (Columbus) (Martin Tai)
- (xi) Possible Chinese ceramic shards, Indian Quay (Ken Welch)
- (xii) Bimini Road (Bill Swinley)
- (xiii) Anguilla road (Bruce) (Third Bimini Road)
- (xiv) Andros reservoir (Charles Huegy)
- (xv) Chinese ship's dogs (B. Chang)
- (xvi) Columbus, and people who call themselves Indian = Yin Dian (people from Yin) (Martin Tai)
- (xvii) Elephants from Africa to Yucatán and Colombia (Ranking)
- (xviii) Wreck at Guadeloupe (Columbus)

5. Florida (including 'Florida' as defined in 17th century)

- (i) Moskoke tribe have Chinese DNA, inherited after Bering landbridge flooded (Novick et al)
- (ii) Pedro Menendez de Aviles (first European) found wrecks of Chinese junks off Florida coast
- (iii) Columbus' secret report describes Chinese mining operations
- (iv) Florida appears on Cantino chart published before Europeans reached Florida
- (v) Chinese jade in Indian burial mounds (Barbosa Rodrigues)
- (vi) Chinese themselves claim Zheng He's fleet reached North America (Zayan) (Professor Bi Quanzhong)
- (vii) Cotton plants exported from North America to Africa before Columbus (thence to Cape Verde Islands)
- (viii) Columbus, and people who call themselves Indian = Yin Dian (people from Yin) (Martin Tai)
- (ix) Nayarit legends, 'ancestors came by sea from the east' (Dr Pratzii 123)
- (x) Columbus describes horses (Barbara McEwan) and meeting Muslims (Dr Shong)
- (xi) Columbus saw great ship (Jerry Warsing)
- (xii) Second 'Bimini Road' at Palar Beach (W. Feickert)

6. The Carolinas Virginia

- (i) Chinese junk found by early settlers buried in Great Dismal Swamp (L. A. R. Clark)
- (ii) Linguistics (Ming Ho, Lyco Ming, Wyo Ming), customs and Machado-Joseph disease (Jerry Warsing)
- (iii) Early European settlers met Chinese miners on the Minay Sotor – later murdered by Cherokees (Scott McLean)
- (iv) The Cherokee rose a Chinese flower found by first Europeans
- (v) Maize exported from North America pre-Columbus found by da Gama in South Africa and by Magellan in Philippines
- (vi) Chinese landing party ambushed and murdered (Frank Fitch)
- (vii) Chinese hens
- (viii) Assateague wild horses
- Mulberry trees, honeywort root and *Paulownia tomentosae* (or Pallowaddie) trees from China and 'Yellow Delicious' apples (Warsing)

- (x) Turkeys reached Europe before Columbus set sail (Professor Wu)
- (xi) Melungeons are Chinese (J. Warsing, Brent Kennedy)
- 7. New England Massachusetts and Boston/New York
- (i) Sioux tribe have Chinese DNA (post Bering Straits flooding)
- (ii) Dighton Rock carvings/writings/local Indian legends (giant foreign ship like a house sailing upriver firing cannon);
 Dighton Rock writing Mongolian (Humboldt, vol.i p.15, and Ranking, pp.419, 562); similar stones at McCook Point and Niantic Bay (B. Trinque)
- (iii) Newport Round Tower/Chinese observatory
- (iv) Rhode Island Reds a Chinese chicken found by first Europeans (Jack Pizzey)
- (v) Professor de la Barre's evidence local people have Asian characteristics
- (vi) The Salem horse carving
- (vii) 'Buddhist' stones of New England
- (viii) Massachusetts, buried soldier in armour
- (ix) Giovanni di Verrazzano met Asian people quite different from local Indians; he described some as Chinese
- (x) Area appears on Vinland map (1440) genuine (see Radiocarbon, vol. 44, no.1, 2002, and postscript) – and on the Waldseemüller map (1507)
- (xi) Navajo, Chamorro and Flathead tribes have unique retrovirus gene (Natural Academy of Sciences, 1997)
- (xii) Elephants from Africa (Ranking)
- (xiii) Rice found by early explorers
- (xiv) Pedro Menendez de Aviles found Chinese junks wrecked in North Atlantic – wind would have carried surviving junks to Rhode Island
- (xv) People around Newport different from other Indian tribes (Professor de la Barre)
- (xvi) 'Stone village' (pre-Columbian) near Dighton Rock
- (xvii) Shutesbury Stone 'Buddha contemplating the truth of ageing' (Theravada Buddhism)
- (xviii) Carving of a pre-Columbian horse 100 miles west of the Shutesbury Stone at N. Salem

- (xix) Tilted stones, similar in posture to the holy (Theravada Buddhism) boulder at Kyaiktiyo in Burma.
- (xx) Teeth of Narragansetts (Wydants) have 'Chinese characteristics' (Katrina van Tassel) (similar story Marty Brodell)
- (xxi) Machado-Joseph disease (Warsing)
- (xxii) Bishop Berkeley's accounts of Mongolian peoples living around Dighton Rock (Ranking, Smibert).
- (xxiii) Skeleton and brass objects found at Permaquid near Portland, Maine (www.frpd.org/historicalskeleton)
- (xxiv) Stone graveyard/Westport River (Jean Elder)

The author submits that only one explanation is consistent with Verrazzano's sightings – the Shutesbury Stone, the carved horse's head and the balanced rocks at Savoy, Upton, Prospect Park, South Peabody, Royalston, Barr, Cape Ann, Athol (and six more), the rice and the Chinese chickens – and that is that Chinese junks manned in part by Theravada Buddhists sailed up the Connecticut and Taunton Rivers and created the settlements Verrazzano came across. This explanation accords with Professor de la Barre's and Bishop Berkeley's evidence.

8. Upper Mississippi

- (i) The Upper Mississippi appears on charts drawn before Europeans arrived there, e.g. Waldseemüller (1507)
- (ii) Native carvings of foreign ships and horses found near tributaries of the Mississippi
- (iii) Chinese jade found in tombs near the Mississippi (Georgia Nacooche Mound; Michigan Mound, p.269B)
- (iv) Coronado report of junks with gilded sterns found near estuary of Mississippi
- (v) Chinese DNA found among Sioux and Cree Ojibwa peoples of Upper Mississippi
- (vi) Horse remains found near Lake Superior
- (vii) Elephant remains at 32°50'N, 80°10'W
- (viii) Carvings of monkeys and elephants
- (ix) Buried stone observation platforms at Rock Lake
- (x) Stone fortresses at 44°10′N, 93°00′W
- (xi) Turkeys exported from North America to Europe (via Silk

Road) before Columbus set sail

- (xii) Chinese hens found by first Europeans in North America
- (xiii). Amaranth exported to China before Europeans reached North America
- (xiv) Cherokees murder foreign miners near St Peter's River Minay Sotor (Scott McLean)
- (xv) 26 chromosome cotton from North America to Africa
- (xvi) Chenopodium album and marsh cress to New Zealand
- (xvii) Mustangs?

9. British Columbia (Queen Charlotte and Vancouver Islands) and Washington State

- Queen Charlotte and Vancouver Islands appear on the Waldseemüller and Zatta maps drawn before Europeans arrived in British Columbia; on Zatta's map, Queen Charlotte Island is called 'Colonia dei Chinesi'
- (ii) Hugo Grotius (1624), reporting Galvão: 'The people of China
 ... sailed ordinarily the coast, which seems to reach unto 70
 degrees towards the north', viz. as far north as the Bering
 Straits
- (iii) Squamish Indian accounts of visits of Chinese traders before Europeans (Robert Hassell)
- (iv) Tens of thousands of Chinese copper coins found either buried or attached as ornaments to Native American and Chinese objects on Vancouver Island, dated pre-Columbus
- (v) Chinese talisman and lamp, dated pre-Columbus (Vancouver Island)
- (vi) Bronze figurine of Garuda pre-European arrival (John Grubber)
- (vii) Babiroussa wild pigs of Sulawesi found buried in chieftain's grave (Vancouver Island)
- (viii) Squamish Indians have identical words to Chinese, more than 37 examples, e.g. *tsil* (wet) and *chin* (wood)
- (ix) Recent (post Bering Straits flooding) Chinese DNA in Qucen Charlotte Islands people (Professor Bryan Sykes, Seven Daughters of Eve)
- (x) Chinese storage jars, Tofino (Hector Williams)
- (xi) Chinese clay vase, Vancouver Island (B. Morelan)

- (xii) Totem poles identical to Wuhan (Geoff McCabe)
- (xiii) Washington Potters Lake River (Terry Glavin, *The Last Great Sea*)
- (xiv) Lovekin Rock wreck (R. Hassell)
- (xv) Long Beach wreck (R. Hassell)
- (xvi) Haida myths people sailing from west towards sunrise before Europeans (Paul Wagner)
- (xvii) Queen Charlotte Islands small deer (G. Berteig)
- (xviii) Chinese coins on coast (G. Berteig)
- (xix) Ancient Chinese bronzes (John Grubber); ancient Asian ceramics (Hector Williams); Jodicus Hondius map (Chinese junk) (Robert Hassell)
- (xx) Washington State Pacific coast, Ozette Lake site Chinese artefacts (Don Mollick)
- (xxi) Point Adams wreck (Clatsop Beach) (Ed Mitchell); Asian pot wreck (H. Williams)
- (xxii) Neahkahnie Beach wreck (Cabrillo)
- (xxiii) Washington State dig Ming porcelain (Ken Holmes, Sean Griffin, Terry Glavin)
- (xxiv) Wool dogs (E. Miller and Susan Crockford)
- (xxv) Inuit = Yin Uit (people from Yin) (Martin Tai)
- (xxvi) Aleut people have Chinese DNA
- (xxvii) Haida and Aleut people have same language
- (xxviii) Lakotas resemble Chinese clothes/swastikas (Richard Chauvet)

10. Arizona, New Mexico, Texas, Oklahoma, Arkansas, Colorado and Oregon

- (i) The area appears on the Cantino (1502) and Waldseemüller (1507) charts, drawn before Europeans arrived there
- (ii) Antonio Galvão (1555) reports Chinese claims to be 'lords' of Mexico
- (iii) Coronado found Chinese people in Tiguex (near Albuquerque)
- (iv) Coronado's expedition found ships with gilded sterns (Mafeo and Frois corroborate); treasure ships had large gilded carvings of an eagle on their sterns
- (v) Chinese merchants reported in ports of Quatulco and Panuco (Gregorio Garcia)

- (vi) Acosta met Chinese
- (vii) Asiatic shipwrecks on Mexican Pacific coast (Hugo Grotius)
- (viii) Chinese jade buried in Nacooche Mound, Michigan Mound
- Pictures of horses (foreign to Americas prior to Columbus) and foreign ships carved by Indian peoples (more than 100), dated pre-Columbus
- (x) Hibiscus (*Rosa sinensis*) and Chinese roses found by first Europeans (Secret Journal) (Dr Tan Koolin)
- (xi) Chinese ship's dogs (Acosta)
- (xii) Maize (Mexican corn) found by first Europeans to reach China
- (xiii) Chinese chickens found by Coronado (Topira)
- (xiv) The Navajo and Zuni tribes have Chinese DNA (post Bering Straits flooding) (Novick et al)
- (xv) Maize found by da Gama Cape of Good Hope
- (xvi) Statuettes of Buddha, Grand Canyon; Buddhist ceremonial dishes of solid silver (J. Smothers)
- (xvii) Names of towns (Henriette Merz)
- (xviii) Granby Dam, Colorado statuette (Thad Daly)
- (xix) Navajo people understood Chinese last century (John Ting)
- (xx) Zuni people understand Japanese (Jim Tanner, Nancy Yaw Davis, Barbara Vibbert)
- (xxi) Cabrillo/Bartholomeu Ferreiro, *Nave de Cataio* ship of China wrecked at Oregon

11. California

- (i) California is accurately depicted on the Waldseemüller map (1507), drawn before the first Europeans arrived
- (ii) Antonio Galvão (1555) reports Chinese claims to be 'lords' of the Pacific coast of America
- (iii) Major Powers describes a Chinese colony between the Russian and Sacramento Rivers
- (iv) Professor Fryer describes Chinese as the builders of the stone walls on the eastern side of San Francisco Bay (Clayton Roberts, Andy Asp)
- (v) Wreck of junk at Sacramento (Dr John Furry): hull wood dated to 1410; magnetometer reading showing iron in hull;

seeds in hull; rice in hold (supposedly brought to the Americas by Europeans)

- (vi) Diseases of Native American peoples otherwise found in China and SE Asia – hookworm, roundworm; Chinese DNA in Navajo and Zuni peoples (Novick et al)
- (vii) Chinese chickens, which cannot fly or swim, found by first Europeans (Acosta)
- (viii) Chinese anchors Palos Verdes, San Pedro Bay, Redondo Beach (barnacles dated pre-Columbian) (Elliot Stiles, Michael Bleidistel)
- (ix) Chinese roses and hibiscus (*Rosa sinensis*) found by first Europeans (Dr Tan Koolin)
- (x) Chinese porcelain
- (xi) Chinese jade (Bill McVicar)
- (xii) Turkeys and maize exported to China before Columbus set sail
- (xiii) Drake chased a Chinese junk
- (xiv) Gregorio Garcia, *El Reino de Anian* Chinese came to Pacific coast before Europeans
- (xv) Avalon Harbour treasure box (Steve Hayes)
- (xvi) Chinese carved stone (Steve Elkins) raised ink characters
- (xvii) Founder of LA was Chinese (Sylia)
- (xviii) San Francisco Chinese can trace ancestry to before Europeans (R. Ohlsen)
- (xix) Chinese stone sculpture (C. Marschner)
- (xx) Early Ming bronze plate buried at Susanville (A. D. Palmer)
- (xxi) Monterey Pines indigenous to China (Bruce Tickell Taylor, Sandy Lydon)
- (xxii) Father Luis Sales OP finds Chinese colony at Santa Barbara, 1772–90
- (xxiii) Navajo elders understand Chinese (Jim Tanner and John Ting)
- (xxiv) Zuni understand Japanese (Jim Tanner and Nancy Yaw Davis)
- (xxv) Similarities between Zuni and Jomon of Japan (F. Lizuka)
- (xxvi) 'Dragon' ships before Columbus (Theodore Bainbridge)
- (xxvii) Santa Catalina Island wrecked junk

- 12. The Azores
- Sorensen & Raish B 003 007, C 116 383, F 112 B, G 066B (big storm – ancient street appears on Corvo), 071, L 364 B, R 017 074 B, S 155
- (ii) Islands appear on Kangnido published before Europeans arrived there
- (iii) First Portuguese found a statue of mounted horsemen 'with writing we could not understand'
- (iv) Columbus reported Chinese bodies washed ashore at Flores
- (v) After great storm of 1870 stone village was exposed on Corvo
- (vi) Azores lies on the route from America with wind and current – Chinese had been in America
- (vii) Machado-Joseph disease is prevalent among Flores natives; author believes this disease originated in China.
- (viii) In 1421 there was 0° magnetic variation on the summit of Corvo – important to medieval navigators; this is where the statue was found
- 13. Mexico
- (i) Mexico appears on Waldseemüller chart (1507) before Europeans set sail
- (ii) Chinese body in tomb at Teotihuacan (NE of Mexico City) (Professor Niven)
- (iii) Chinese people described by Europeans Coronado, Acosta, Galvão
- (iv) Jucutácato shroud depicting arrival of horsemen and Chinese ship's dogs
- (v) Chinese wreck Playa La Ropa (Bahia de Zihuatanejo) and on coast (Acosta)
- (vi) Chinese figurine beside body in tomb at Teotihuacan
- (vii) Chinese chickens (Acosta)
- (viii) Chinese roses and hibiscus (Rosa sinensis) (Dr Tan Koolin)
- (ix) Chinese lacquer technology
- (x) Chinese jade medallions and ear plugs Teotihuacan
- (xi) Diseases otherwise unique to Far East roundworm, hookworm, lice and nits
- (xii) Pictures of horses (unknown in Americas prior to Columbus) in Mayapan, Chichen Itza and Teotihuacan

- (xiii) Nayarit legends: 'ships like houses' visited them before Europeans
- (xiv) Chinese rice found by first Europeans
- (xv) Chinese paper-making technology
- (xvi) Mexican plants taken to China and Far East maize, papaya, tobacco – before European voyages
- (xvii) Chinese butterfly fishing nets Rio Balsas
- (xviii) Chinese statue Teotitlan
- (xix) Chinese vase Azacapotzaco
- (xx) Chinese dyestuff technology practised by local people
- (xxi) Chinese ship's dogs (Acosta and B. Chang)
- (xxii) Chinese merchants visited port of Quatulco before Europeans (Loayza)
- (xxiii) Export of tobacco, sweet potatoes, maize to Philippines (Magellan/Pigafetta); tortora reeds, tomatoes, sweet potatoes to Easter Island; and sweet potato to Hawaii
- (xxiv) The Campeche Maya and Buctzozt Maya have Chinese DNA (post Bering Straits flooding)
- (xxv) The Othmis tribe closely resemble the Chinese
- (xxvi) Zecharia Sitchin's website extraordinary similarity between late Mayan/Chinese art
- (xxvii) Chinese musical instruments more than 50 per cent of Central American instruments occur in Burma (Needham)
- (xxviii) Neck-rest pillows and Chinese carrying pots (Needham)
- (xxix) Identical fairy stories 'Rabbit in the Moon' (Needham)
- (xxx) Chinese artefacts Isthmus of Tehuantepec, Chiapas do Corzo, La Venta (L27, K094, M342C, L240, W269)
- (xxxi) Chinese bronzes (R. Hristov) (Ming Mixtec Tomb, Oaxaca)
- (xxxii) Stone carvings in Chichen Itza almost identical to Beijing snake head fountains/drainage spouts (Zecharia Sitchin)
- (xxxiii) Toy elephant, Jalapa
- (xxxiv) Mayan glyphs on west wall of temple are Chinese; Mongolian script on same wall Phaspa (R. Wertz)
- (xxxv) Certain tribes worked in metal pre-Europeans (Gary Jennings, Howard Smith)
- (xxxvi) New Mexico Indian Pueblos legend of Chinese warriors (A. Moya)
- (xxxvii)Linguistics Chiapas Tse-Tsal, Tso Tsil (R. Banzo)

(xxxviii)Legend of wrecked Chinese junk (Joel Fressa)

- (xxxix) 'Chinese totem figurines' of west Mexico (I. B. Remsen, Clay Ranger)
- (xl) Copan (Honduras) Chinese man with moustache (Mrazerts)
- (xli) Montezuma Aztec ancestors came from east by sea in company of a great lord (Ranking)
- (xlii) First Spaniards found rulers wearing silk (Ranking; Cortez to Charles V)
- (xliii) First Spaniards found Mongol script written on paper (Ranking – Staenburg 325)
- (xliv) Alexander von Wuthenau 'pre-Columbian statues of Chinese', Tlapacoya, Guerro, La Venta (fig.77 and p.210)
- (xlv) Similarity between late Mayan/Chinese art/Tao Taio (Karin and Alan Moks)
- (xlvi) Guatemala/La Democracia Chinese carved stones (Catherine Skinner)
- (xlvii) Copan Maya/Chinese art (Heron) (Dean Dey)
- (xlviii) Chinese pigs (cuino)

14. Panama and Venezuela

- Venezuela shown on maps before Europeans set sail Cantino (1502), Waldseemüller (1507); Orinoco shown on Martellus (1489)
- (ii) DNA of Indian people shows transferrins otherwise unique to Kwantung, SW China (Arends and Gallengo); DNA of Indian peoples of Surinam, Guyana and northern Brazil shows similar 'Chinese' connection (Arends and colleagues – M443)
- (iii) Chinese chickens found the length of Peru; Peruvian emperors use the Chinese name for chickens, *atahualpa*
- (iv) Coconuts, native to south Pacific, found by first Europeans (Acosta), and bananas (Maldonado's expedition)
- (v) *Illustrated Record of Strange Countries* (published China, 1430) shows armadillos, unique to South America
- (vi) Sampan (boat), balsa (raft) identical words in Chinese
- (vii) Chinese claim to have ruled over 'locations in Central and South America' – Antonio Galvão, quoted by Richard Hakluyt
- (viii) Chinese jade Panama and Costa Rica (Barbosa Rodrigues

and Palmatory)

- (ix) Rice, cotton from India and Chinese ship's dogs found by first Europeans
- (x) Papayas (unique to Central America) found by first Europeans on Easter Island
- (xi) The Waunaba and Ngoye people have Chinese DNA (post Bering Straits flooding)
- (xii) Horses in Panama (Columbus) (B. McEwan)
- (xiii) Columbus's secret report Chinese miners in bird boats (Martin Tai)

15. Peru

- (i) Waldseemüller (1507) and Piri Reis (1513) show Peru before Europeans arrived there
- (ii) Pictures of Chinese horsemen at Trujillo (Friar Antonio de la Calancha) and Ayacucho (G. Squier); lances and swords are similar to early Ming in the National History Museum, Beijing
- (iii) Names of 95 villages are Chinese and have no significance in Quechua or Aymara (Loayza) – listed earlier
- (iv) Villages of Eten and Monsefu (three miles apart) understand Chinese but not each other's patois
- (v) 'Great wall of Chimu', 40 miles long, in shape and size resembling Great Wall of China, and great wall of Vietnam (built by Zheng He)
- (vi) Pottery decorated with Chinese calligraphy Las Trancas, Nazca and Ica (Pablo Patron), and Cajamarca (Zerallos Palmer)
- (vii) Mummy with Chinese inscriptions (Loayza, Cultural College Lima)
- (viii) Tomb with Chinese statues, Chan Chan (Gustavo de la Torre)
- (ix) Linguistic similarities, and folklore and divination practices identical to Chinese
- (x) Roundworm found in local people, otherwise found in SE Asia
- (xi) Sweet potatoes exported from South America found by first Europeans in New Zealand and across Pacific

- (xii) 74 separate plants exported from South America to Australia found by first Europeans
- (xiii) Chinese jade
- (xiv) Inca cotton technology crib of Chinese methods
- (xv) Horses and Chinese ship's dogs seen by first Europeans (Acosta)
- (xvi) Chinese book *Illustrated Record of Strange Countries* (1430) shows animals unique to South America
- (xvii) Inca cement/road building
- (xviii) The Paez, Guambiano, Ingano, Guayabero and Inca peoples have Chinese DNA (post Bering Straits flooding) (Novick et al)
- (xix) The name Inca = Yinca (people from Yin) (Martin Tai)
- (xx) Legend of local people: 'Giants came by sea to settle amongst them' (Garcilaso de la Vega and Pedro Cieza de Leon)
- (xxi) Elephants to Peru and Chile (Ranking); elephants seen, wild, by Captain Cochrane
- (xxii) First Spaniards in Chile found wrecked Chinese junks (Grotius)
- (xxiii) Elephant bones at Tarija, 22°S
- (xxiv) Chile was named before Spanish arrived (Molina): Chi-le = 'dependent colony' in Chinese

16. Brazil (1421-5)

The author contends that a cultured and wealthy civilisation existed in 1421 at the confluence of the Amazon and Tapajos Rivers (near modern Santarem) and at the confluence of the Negro and Solimões Rivers in the region of Iranduba (near Manaus) where today there is nothing but jungle. This civilisation sent a delegation to China in 1502 with six boxes of emeralds as tribute. They reached China by means of a map left by the Chinese on the 1421–5 voyage (Professor Bi Quanzhong evidence).

(i) Maps

 (a) Brazil is shown on maps published before Columbus set sail (1492) and before Brazil was 'discovered' by Cabral (1500), viz. 1428 master chart of world, 1448 Andrea Bianco, and 1489 Martellus showing the rivers Magdalena, Amazon–São Francisco, Paraguay, Panama, Colorado, Negro and Chubut.

- (b) The Treaty of Tordesillas (1474) only makes sense if the Portuguese already knew of Brazil by then.
- (c) Report by João de Barros to King of Portugal; Columbus he should steer south 'to enquire of the meaning of the King of Portugal who says land is there'.
- (ii) DNA
 - (a) Indian peoples living west of Arecibo have Chinese DNA (Arends and Gallengo)
 - (b) Indian peoples of Guyana, Surinam and Venezuela have a similar Chinese connection (Dr Annabel Arends)
 - (c) The Karitiana and Surui peoples of Amazonia have Chinese DNA (post Bering Straits flooding) (Novick et al)
 - (d) The Quechua and Toba peoples of the Mato Grosso have Chinese DNA (post Bering Straits flooding) (Novick et al)
 - (e) Absence of Duffy blood groups in Indians of Mato Grosso
 - (f) Hookworm among Lengua, and roundworm (Fonseca)
 - (g) Tokelau in Amazonian people (Fonseca)

(iii) What the first Europeans found

- (a) Cabral: 'men with pale skins'
- (b) Franciso de Orellana, as reported by Friar Antonio de Carvajal: rice fields (Chinese), bananas (originated in Pacific islands) and coconuts (originated in south Pacific)
- (c) Maldonado: sugar cane (India)
- (d) José de Acosta: chickens Frizzle fowl (China), Black Melanotic (China/SE Asia), Asian jungle fowl (SE Asia), Langerian gourds (SE Asia) – and Chinese ship's dogs (B. Chang)
- Marajoara pre-Columbian culture where people, tall or pale-skinned, made fine ceramics (Martin Tai evidence); water buffalo found there
- (f) Chinese pigs (canastrinho) in São Paulo and Minas Gerais
- (g) Horses remains found in Confins cave
- (h) Fulvous tree duck (from Bengal)

 (i) Chinese jade (pre-Columbus), near Amazon/Tapajos River juncture (Barbosa Rodrigues), at Trombetas River, Lago Sapakua, Lago de Faro, Ilha Jacinta, Costa do Parvo, Villa de Faro, Rio Yamunda, Cojmuru

(iv) Linguistics

- (a) Sampan = boat in Brazil and China
- (b) Balsa = raft in Brazil and China
- (c) Chickens = kik (Venezuela), kikh (India)
- (d) Sweet potato = kumar (Peru), kumara (Pacific)
- (e) Fulvous tree duck (which fly with difficulty) = *irere* (Brazil), *irere* (Guyana), *Sarere* (Burma), *Sarari* (India)
- (v) Local legends

Guarani legend – their ancestors crossed a great and wide ocean to settle in Amazonia (M. Garcia)

(vi) Chinese claims to have discovered Brazil before Cabral

- (a) Professor Liu Manchum: 'extremely far Beira' refers to Brazil
- (b) Professor Zhu Jianqui: Zheng He's fleet still at sea in 1425
- (c) Professor Bi Quanzhong: Brazilian delegation left for China in 1501 with map showing way (*Notebook of Wilderness –* Ming dynasty writer Zu Yun Ming, delegation from Balazi = Brazil)
- (d) Illustrated Record of Strange Countries (1430) shows armadillo (unique to South America)
- (e) *The Complete Herb Book of China* (1530) shows herbs unique to South America Zhong Guo Ben Cao Quan Shu
- (f) The Karayaba tribe have Chinese features, skin and hands
- (g) Ceramics Amazonia (Paul Yih and Beloit University Wisconsin)

17. Patagonia and Straits of Magellan

- (i) The name 'Chile' is Chinese for 'dependent territory', and was in use before the Spanish arrived (Molina)
- (ii) The first Spanish to round the Horn found wrecked junks (Grotius) at Taroja (22°S)
- (iii) Molina ancestors of Chileans

- (iv) Chilean *palican* (a ball game) is the same as *Chowgar* (Molina 1)
- (v) Chilean chess, Comican (Molina ii 125)
- (vi) Custom of covering chicken heads (Molina ii 25) 1726
- (vii) Chileans treat smallpox with milk, similar to Chinese (Molina ii 321)
- (viii) Chilean knowledge of iron metallurgy (Molina ii 22)
- (ix) Lassos same as in China (Molina ii 26)
- (x) *Qipus* as in China (Molina ii 26), and in Marquesas and Hawaii
- (xi) Characteristics of Chilean tribes (Molina)
- (xii) Names of tribes of Chile (Molina): Arvacans from Arracan (Burma); Promancians – from Prome (on borders of Arracan); Poy-yus – from Po Yeon in Cochin, China; Chuotes from Che Li; Cunches from Cunchi, Szechuan; Pi-Cunches – Northern Condis (Pi = North); Mappuchinians (Mapa in Chinese)
- (xiii) Chinese inscribed stones between Mendoza and La Punta (lats 33°–34°S) and near Diamond River (Ranking)
- (xiv) Legends of giants coming ashore on coast Garcilaso de la Vega and Pedro Cieza de Leon
- (xv) Illustrated Record of Strange Countries (1430) shows armadillo (unique to South America)
- (xvi) The Karayaba tribe have Chinese features, skin and hands
- (xvii) Horses on Tierra del Fuego (Sarmiento)
- (xviii) Rabbits on Tierra del Fuego (Magellan)
- (xix) Chinese DNA (post Bering Straits flooding) of the Toba Indian people of Patagonia
- (xx) Hookworm/roundworm afflictions of the Lengua people of the Mato Grosso
- (xxi) Piri Reis map shows Patagonia before Europeans arrived, with pictures of guanacos and pumas
- (xxii) The mylodon (alive in 19th century Darwin) shown in *Illustrated Record of Strange Countries* and on Piri Reis
- (xxiii) First Europeans found rice in Mato Grosso

18. Greenland to North Pole, across Arctic to Bering Straits

(i) Greenland appears on Vinland Map (c.1440) published before Europeans 'discovered' the island; map is genuine

(2002 radiocarbon dating)

- Pope's letter describes barbarian ship destroying local people by fire and taking them captive c.1418
- (iii) Columbus reports Chinese people had preceded him to Greenland
- (iv) Greenland native people (of Hvalsey) have Chinese DNA (post Bering Straits flooding)
- (v) Inuit people = Yin Uit (people from Yin) (Martin Tai)
- (vi) Greenland was habitable for Europeans in 1420 (Sigrid Bjorndottir)
- (vii) In 1421, climate was warmer than today, evidenced by horse flies; enamel on teeth in graves in Hvalsey; strontium levels in core ice samples taken from Greenland's glaciers
- (viii) Due to the earth's precession, the North Pole as determined by Polaris at 90° elevation was approx. 200nm nearer to Greenland than it is today
- (ix) Chinese claim to have reached North Pole (Professor Wei's evidence) which is corroborated by Ju de Yuan's account of the explorer Dong Fang Shuo (Martin Tai)
- (x) Chinese circumpolar star charts, which could only have been drawn by people who had seen the stars at a latitude north of 73°N
- In 1870s, a British expedition got to within 19 miles of the latitude of the northern cape of Greenland – by then climate far colder than in 1421
- (xii) The 'mini Ice Age' started in 1432 (Buisman Dutch Meteorological Institute KNMI and European Union) (G. E. R. Nijman evidence)
- (xiii) 1420, 1422 and 1428 summers were extremely dry and hot, and the Arctic north of Siberia was clear of ice in summers of 1422 and 1428 (Buisman)
- (xiv) 'Five consecutive warm winters could lead to the complete melting of the ice in the Arctic Sea' (Delft Technical University NL)
- (xv) Siberia appears on Waldseemüller map (1507) drawn two centuries before Europeans 'discovered' Siberian coast
- (xvi) The Illustrated Record of Strange Countries (1430) describes Eskimos

- (xvii) D. D. Jevans evidence Latin MS Barbarians on the Coast
- (xviii) Korean DNA in north Norwegian and Hebridean fishermen (Professor Bryan Sykes)
- (xix) Stone cairns
- (xx) Innu are Chinese (Baxter Smith)

19. Antarctica

- (i) Falkland Islands dog 'the Warrah' (Charles Darwin); recent DNA investigation
- (ii) 'Lt Kendall's foreign seaman's body' deep frozen on Deception Island (*Geographical Journal* 1830 pp.65, 66)
- (iii) Piri Reis map shows Antarctica well before Europeans arrived
- (iv) Chinese claims to have reached South Pole (Professor Wei)
- (v) Diego Hominems' map showing Antarctica a decade before Magellan set sail
- (vi) Ludovico de Varthema's story of Chinese people setting sail for South Pole by following Southern Cross

20. The Pacific

Note: No Polynesian DNA has been found in South American people (Professor Bryan Sykes); no Inca DNA has been found in Pacific people (Cambridge Study).

Southern route

- (i) Senőr Arias' story of Asian people setting sail across Pacific from South America.
- Easter Island: Chinese carved lion (Kerson Huang); array of plants from across the world found by first Europeans; quadrangular observation platform (John Robinson)
- (iii) Pitcairn: quadrangular stepped observation platform; carved rocks showing star alignments; skeleton with pearl shell from Tuamotu archipelago
- (iv) Temoe: raised stepped stone observation platform; cotton wild form of cultivated *Gossypium amphidiploid* species H.
- (v) Tuamotu Bora Bora: stone platforms
- (vi) Raia Tea: raised stone platform
- (vii) Tahiti: ziggurat stone observation platform (Marae of Mahaiatea); cotton as for Temoe

- (viii) Society Islands Tuahaia: round stepped stone observation platform; tokelau disease
- (ix) Samoa Savai: tiered observation platforms; tokelau disease
- Tonga Tabu: ziggurat observation platforms and stone archway; tokelau disease; 'Chinese' people (Craig Hill Handy)
- (xi) Fiji: cotton as for Tahiti and Temoe; tokelau disease
- (xii) New Caledonia, Magnetic Island: stone pyramid observation platform
- (xiii) Cape York (Australia): cotton, as for Revilagigedo Islands, Marquesas (Temoe), Tahiti, Fiji

The author contends that the people who built the stepped pyramids (see table on p. 572) also brought cotton from the Americas, where no Polynesian DNA has been found. They also brought tokelau disease from Malaysia and China (Fonseca).

Northern route

- (i) Revilagigedo Archipelago: cotton wild form of cultivated *Gossypium amphidiploid* species H.
- (ii) Hawaii: stone fishponds; Menehune aqueduct; Menehune lizards; plants foreign to Hawaii found by first Europeans; stone platforms (Necker) remarkably similar to those of Marquesas
 - (iii) Kiribati (Gilberts)/Malden: stepped stone observation platforms; tokelau disease (Fonseca)
 - (iv) Micronesia: cotton, as in Revilagigedo Archipelago
 - (v) Marshalls/Marianas: cotton, as in Revilagigedo Archipelago; tokelau disease; stepped stone observation platforms
 - (vi) Solomons Mala, Ulawa and San Cristobal: stone observation platforms; tokelau disease
 - (vii) Carolines Pohn Pei, Nan Madol and Tobi: Nan Madol, stone canals, observation platforms and fishponds; Tobi, stone observation platforms; Yao, stone wharves; Lele, canals, stepped stone observation platforms, shell money from North America

(viii) New Guinea: tokelau disease

Note: For information on cotton, see Man Across the Sea (ed. Carol

Riley, ch.22); for information on stone platforms, see *Geographical Journal* XIII (1899).

Stepped Pyramid Sizes

Place/ Lat/ Long	Discoverer/ Description	Length/ Width (feet)	Height (feet)	Remarks
*Tahiti	Capt Cook	259 × 85	c. 45 stepped	Drawn by Domany de
(Marae)	(McDuff)		pyramid	Rienzi
149°W,				
175°S				
*Savai'I		200×160	Approx. 37	Squarely oriented with
Pulenei				compass directions.
				Platform 40m with con-
				necting walkway.
*Tonga	Local artists			Ziggurat pyramid
Tabu	painted it			
175°4′W,				
19°14′S*				
Malden	Drawn by			'Great temple
(Line	Dr Macmillar	ı		pyramids', 'early
Islands)	Brown & K. I	2		Chinese navigators'
	Emory			
San		60×40	20	Mound with shaft
Cristobal				
(Solomons))			
*Pohn Pei		185×115	Approx. 40	Stepped pyramids
*Gympie,		100 high,	Terraces 100	
Australia		terraces 4		
*Kaimanay	w B.	Blocks,		Axes facing north-east;
a Wall	Brailsford,	stones		possible step pyramid
(New	D. H.	approx		structure
Zealand)	Childress	1.5×1		
	(May 1946)			

Canaries

Compare with Korean

(Guimar) 28°N, 16°S King Jiang Jung Toms (base 31.6m). More than 1,000 blocks

21. New Zealand

- New Zealand appears on maps published two centuries before Captain Cook 'discovered' the islands, viz. Jean Rotz, where the bays of Auckland Island and Campbell Island are drawn with correct latitudes
- (ii) Captain Cook accepts he was not the first to Australasia
- (iii) Kumera and cassava were found by first Europeans the plants originate in South America, and no Polynesian DNA has ever been found in peoples of South America (Professor Bryan Sykes), thus some non-Polynesian people must have charted the islands and brought kumera (Inca people's DNA is absent from Pacific)

North Island

- (i) The Ruapuke wreck, associated with: the 'Colenso' bell with its Tamil inscription naming the ship's owner; the rivet; the jade korotangi – Chinese (F. Hochstetter and V. S. Cullen); inscribed writing on two stones nearby; Tamil plaque on ship (V.S. Cullen); willow-pattern ceramics in ship (E. Allen Aubin); teak wood from wreck (T. B. Hill); copper and iron bolts (Phillips & Liddell); triple hull
- (ii) Mauku steatite figure
- (iii) Stone wall at Lake Taupo (Kaimanawa) a Chinese observation platform
- (iv) Maori claims that foreigners settled among them and begat children; Maori mitochondrial DNA shows a 'Chinese' connection

South Island

- (i) Campbell Island tree from Norfolk Island
- (ii) Dusky Sound 'Chinese' wreck coupled with local history (Robyn Gossett)
- (iii) *Chenopodium album* discovered by Cook, 1769 (indigenous to China and North America) (Dave Bell)

- (iv) Marsh cress (Navajo Indian cosmetic) discovered by French, 1828 (Dave Bell)
- (v) Scented grass from Colombia (Dave Bell)
- (vi) Taro from China
- (vii) Chinese pigs kune kune
- (viii) Kaimanawa wild horses (from Tajikistan?)

New evidence for Zhou Man fleet wreck on south coast

- (i) The tsunami off New Zealand can be dated to 1422 (Professor Bryant); Chinese plates have been discovered on cliff tops in South Australia among tsunami debris; meeting waves as high as mountains, as described by Zheng He
- (ii) A meteorite impact in position 50°S 175°E (Lamont Doherty Observatory USA) could have triggered the tsunami; it hit the sea approximately 100km east of Zhou Man's track
- (iii) Classification of wood near wreck (Dave Bell) from Pitcairn
- (iv) Maori history, extinction of the moa in North Island and the economic consequences (Dave Bell).
- (v) Fernandez 1569 expedition to New Zealand, met 'Chinese' people wearing white woven garments
- (vi) Dating of mortar (1676–1764) and wood (1360–1380) from South Island (Rafter Radiocarbon Laboratory)
- (vii) Chinese junk and Chinese Hottentots of south-west Africa (J. Parkinson); flightless duck found in Amazon, Falklands and Campbell Islands; Pitcairn (wood to New Zealand); Niue Island (Chinese linguistics)
- (viii) Megalithic history of New Żealand people lived there before Maoris (Dave Bell)
- (ix) The New Zealand wild pig Chinese DNA (Antonia Bowen-Jones & Dave Bell)
- (x) Maori axes (Perry Debell)
- (xi) Preliminary discussion on DNA with Professor Susan Povey

Possible scenario

- March 1421, fleets sailed; July, Cape of Good Hope; junks wrecked Namibia, crew got ashore (Chinese Hottentots)
- October, Amazon; November, Falklands left flightless ducks, dogs, horses, DNA, diseases

- December to May 1422, crossed Pacific leaving trail of evidence
- June 1422, landfall SE Australia; sail for Campbell Island (52°40'S, Canopus); leave wreck, Norfolk Islands pine, flightless ducks
- August/September, set sail for home; at 50°S 160°E meet tsunami generated by large meteorite, which hit ocean and penetrated the seabed at 50°S 175°E; junks hurled north-west to South Australia and north-north-west to New Zealand's South Island
- Survivors on South Island live peacefully among Melanesians building barracks, reservoirs, fishponds, pig sties, stables; visited by Fernandez' small fleet in 1569; moa nearing extinction on North Island by 1660s; food scarce; Maoris invade South Island; Chinese build forts (mortar dating) but are eventually wiped out; some are eaten by Maoris, who also take the Chinese women, resulting in 'modern' Maori mitochondrial DNA being Chinese and male (Y chromosome) Melanesian

22. Australia

- (i) Maps
 - (a) Australia appears on European maps of the Dieppe school published well before Europeans reached Australia, viz. Desliens, Vallard (showing horses), Desceliers, Jean Rotz (1540s)
 - (b) Australia appears on Jesuit maps drawn when in China, based on Chinese maps, viz. Father Ricci (1589) and Taiwan porcelain map (1447) showing east coast to Tasmania
 - (c) Zheng He's passage chart shows Barrier Reef (Martin Tai)
 - (d) Australia shown on Wu Pei Chi (Sun Shuyun)
- (ii) Chinese claims (Professor Wei)
 - (a) Confucius, *Spring and Autumn Annals* (481 BC), recording solar eclipses in Australia
 - (b) *Classics of Mountains and Seas* (338 BC) describes kangaroos, quiong-giong, boomerangs and black millet (South Australia)
 - (c) Shizi (338 BC) reports kangaroos in China
 - (d) Atlas of Foreign Countries (AD 265–316) describes small black pygmies (North Australia), Jiaojiao people; plants grow leaves in winter, shed them in summer

- (e) 11th- and 12th-century Franciscan missionaries' evidence describes voyages by huge fleets of junks (60 to 100) sailing for Australia to mine minerals
- (iii) Accounts of local people
 - (a) Arnhem Land: paintings of men on horseback (Vallard); 'honey-coloured people settle amongst us'; 'women in pantaloons, men in long robes'; cave painting (Governor Grey) of Chinese – compare with Zheng He's statue in Fujian Palace; painting of man being thrown from horse (Glenelg River); drawings of trees, fauna and flora (Rotz) which are found in Arnhem Land, together with written descriptions
 - (b) Cape York/Gympie (John Green's evidence 1862): Fraser Island, 'small boats leave big ship'; 'culture heroes sail into Gympie harbour and take away rocks'; Dhamuri people – 'foreigners land to build pyramids'
 - (c) South Australia: Warrnambool, Yanguy tribe yellow people from shipwreck settle amongst them and create eel farms; Glenelty River – drawings of foreign sailors

(iv) Linguistics

Bajuni – boat people in Australia (Arnhem Land); in Chinese (Hokkien), joon = boat.

- (v) Shipwrecks with 'Chinese' characteristics
 - (a) South coast: Warrnambool, mahogany ships (1980 Symposium and Avis Quarrey's evidence); King Island (Bass Strait); Tasmania (Storm Bay)
 - (b) West coast: Blackwood River estuary, 34°19'S, 115°11'E (Legend of Sam Chalwell); Perth, King Sound (evidence of Jim Mullins/Norm Fuller)
 - (c) East coast: Byron Bay remains 40ft rudder; Woolongong (dated 1410)
 - (d) Queensland: Fraser Island (J. Green account 1862); 1919 and 1972 photos of cannon (compare with Nanjing photos); North Stradbrooke Island, 18-mile swamp (27°30'S, 153°27'E approx. position); wrecks of Indian Head (Bill Ward); ancient lead weight with Loisels pumice dated 1410–1630 (Bill Ward)

- (e) Arnhem Land and Gulf of Carpentaria: anchors, fish hooks
- (vi) Chinese porcelain/ceramics/coins/bronzes
 - (a) Bradshaw, Elecho Island, Yirrkalla, Winchelsea Island, Cape York, Gympie, Tasmania
 - (b) Chinese wine cooler, Fraser's Island
 - (c) Palmer River goldfields Chinese coins

(vii) 'Chinese' jade artefacts

- (a) Darwin: Chu Lao (Professor Wei and Professor Needham's evidence)
- (b) NSW: Ganesh and Hanuman statuettes
- (c) Queensland: Buddha
- (d) Gympie (Brett Green): orange-coloured jade carvings of bear/monkey plus belt buckle; necklace of jade on silk cord

(viii) Observation platforms

West of Blue Mountains; Penrith; Gympie; Atherton; central NSW coast; Blaxlands Flat, Nymboida, NSW – stone cairns (A. D. Fletcher); Copmanhurst stone cairns (E. N. R. Fletcher)

(ix) Ancient mining operations found by first Europeans

- (a) Gympie: gold, silver, copper, quartz crystals, pure white ceramic clay, limestone, antimony (Brett Green)
- (b) Arnhem Land: lead, uranium

(x) Metalwork

Gympie/Fraser Island: bronze Chinese wine cooler (Brett Green)

(xi) Plants and animals foreign to Australia

- (a) From China: lotus and papyrus; from South America: 74 plant species
- (b) Brumby horses from Fraser Island (originally from Tajikistan?)
- (c) Ma Huan (= Australia, Darwin and Marani) (Martin Tai)
- (d) Father Ricci's map (1589)
- (e) Hessel Gerrit's chart (1618) (M. Righton)

23. The Spice Islands, Indonesia and the Philippines

- (i) Fei Xin's poems Chinese fleet reached Sulu
- (ii) Zheng He Research Institute director Nin Dian Nian, published article, 'Zheng He reached Philippines'
- (iii) The Pandanan junk: hull wood dated 1440; Zhu Di (1403–24) coins aboard and Zhu Di blue and white porcelain; Dr Dizon's evidence at Royal Geographical Society, 15 March 2002; in hold were metates from South America
- (iv) Chinese sailor's grave at Sulu
- (v) Tokelau (Fonseca)
- (vi) Diaries of Master Bentou (Zheng He's navigator) (Kerson Huang)

Part V: Genetic fingerprints left by Zheng He's fleets – the DNA evidence

The following is the author's draft. It will be radically revised when experts' views have been received.

We know from an accumulation of different strands of evidence (not least from the reports of the first Europeans to reach the New World) where the Chinese settled. It has been relatively easy to obtain DNA results from local peoples who live in these areas today. To date, the principal report relied upon is that of Professor Novick and his colleagues (Corina C. Novick, Juan Yunis, Emilio Yunis, Pamela Antunez de Mayolo, W. Douglas Scheer, Prescott L. Deininger, Mark Stoneking, Daniel S. York, Mark A. Batzer and Rene J. Herrera), 'Polymorphic Alu Insertions and the Asian Origin of Native American Populations'. After studying twenty-four peoples of North and South America in locations in which Zheng He's fleets settled, Professor Novick found that 'close similarity between the Chinese and native Americans suggests recent gene flow from Asia'. This leaves a few gaps, i.e. places where the Chinese settled not covered by Professor Novick's report, but again, it has been relatively easy to fill in these gaps with other DNA reports by distinguished geneticists, reports which also show close similarity between the Chinese and native people in all the areas in which the author claims the Chinese settled.

The author wishes to date as accurately as possible the 'recent gene flow' described by Professor Novick et al. It seems dating by mutation rate is far too controversial to say with any certainty that 'recent' means settlements arising from the 1421–3 voyages. Other methods must be found. It seems to the author that this can be achieved in stages: to show the DNA came as a result of seaborne voyages post Bering Straits flooding; to determine which seaborne voyage; and to adduce the corroborative evidence – i.e. wrecked junks containing coins of Zhu Di's era but no later.

1. Seaborne voyages

Certain diseases or afflictions cannot survive in the extremely cold conditions of a frozen Bering Straits crossing, e.g. hookworm and roundworm, where the eggs need moisture and warmth to propagate. Linking hookworm and roundworm diseases found in the Indian people of the Mato Grosso area of Brazil with peoples who have 'recent' Chinese DNA (Novick et al) is thus evidence that the 'recent' DNA was brought by sea post Bering Straits thawing. The author thinks (but needs advice on this) that the following may provide corroborative evidence of seaborne DNA.

- (i) Hookworm/roundworm/A Duodenale Necator (Dr Olympio Fonseca)
- (ii) Machado-Joseph disease (Jerry Warsing). This disease appears to have originated in the Yunnan province of SW China and spread along the sea routes of Zheng He's fleets, viz. India, the Carolines (USA), the Azores, Brazil, San Francisco, Yemen and NW Australia.
- (iii) Tokelau (Dr Olympio Fonseca). This highly distinctive infection was found in 1928 among native Indian people of the Mato Grosso area of Brazil. These people had lived isolated from Europeans for centuries. This endemic parasitic disease has such a unique appearance that ancient narrators and naturalists referred to it even if they were not medical experts. The centre of tokelau's sphere of affliction is the Malayan peninsula. It is found on the southern coast of China in the Honnan province and the coasts and hinterland of Indochina (Cambodia, Thailand, Annam, Vietnam) to the

Yunnan province of China, Burma and Bangladesh. It is prevalent across the Pacific: Formosa, Marianas, Moluccas, Gilbert and Marshall groups, New Caledonia, Fiji, Samoa and Tonga groups, Tokelau islands, Society and Celebes groups, Solomons and Loyalty Islands, Sumatra and New Guinea – all places visited by Chinese fleets. It is the author's contention that the Chinese also sailed down the Amazon to the Mato Grosso.

- (iv) Hanta virus (Dr Alan Leibowitz). Carried by rats and found among Indian peoples of the Rio Grande (west Texas and Mexico). The Zuni and Navajo peoples in the upper reaches of the Rio Grande have 'recent' Chinese DNA (Novick et al).
- (v) Smallpox (Jonathan F. Ormes and Chris Spedding). The Native American population was decimated by smallpox before most of them had ever seen a European. How was it brought to the Americas?
- (vi) *Paragorimus westermani* lung fluke (Dr John S. Marr). As with hookworm, roundworm, Machado-Joseph disease and tokelau, this is common in China and South America.
- (vii) Herpes? (Sorenson and Raish S479, F119 & 120)
- (viii) Polio? (Sorenson and Raish S479, F119 & 120)
- (ix) Pertussi? (Sorenson and Raish S479, F119 & 120)
- (x) Hepatitis B? (Dr John S. Marr)
- (xi) Pierre Noire (Sorenson and Raish L014, F119 & 120)
- (xii) Typhus Murin (Sorenson and Raish L014, F119 & 120)
- (xiii) Tinea imbicata (Sorenson and Raish L014, F119 & 120)
- (xiv) Lice and nits/tick-borne diseases (Sorenson and Raish S479, F119 & 120)

2. To determine which seaborne voyage

Professor Novick et al report: 'The results corroborate the Asian origin of native American populations but do not support the multiple-wave migration hypothesis supposedly responsible for the tripartite Eskaleut, Nadene and Amerind linguistic groups.' The multiple-wave hypothesis refers to the waves across the Bering Straits. Table 1 of Professor Novick's report shows the geographical distribution of the twenty-four studied Native American peoples; Figure 2 is a maximum likelihood tree showing (inter alia) the closeness of the studied peoples' DNA to Chinese and to one another. Comparing the two reveals that Greenland natives, Alaska natives, Inca, Buctzozt Maya and Campeche Maya are all closer to Chinese DNA than to the DNA of the Indian peoples who surround them.

- (i) The Greenland natives and Alaska natives are 3,000 miles apart. If the 'Chinese' DNA was brought across the Bering Straits to Alaska by people who then marched across northern Canada to Greenland, one would expect the DNA of intervening peoples initially to resemble Alaskan DNA then gradually mutate. This is not the case. For the Greenland and Alaska natives' DNA to be so strikingly similar, the implication must be that these peoples received 'recent gene flow from Asia' at about the same time. Alaska is on the Pacific coast, Greenland in the Atlantic. The only way the Greenland and Alaska people could have received the gene flow at about the same time is by ship, moreover by ships which sailed in the Pacific and the Atlantic. Because of the prevailing winds and tides these simultaneous voyages must have been conducted by different fleets.
- (ii) The Greenland and Alaska natives and the Maya of the Yucatán Peninsula are thousands of miles apart. Had the 'recent gene flow' from Asia been across the Bering Straits, one would expect intervening peoples between Alaska and the Yucatán to have DNA which gradually mutates from Alaska until Yucatán, and this gradual mutation should be reflected in intervening peoples. This is not the case. Buctzozt Maya DNA is so close to Chinese that the Buctzozt could almost be called Chinese. Mayan DNA is far closer to Alaskan DNA than it is to the Indian people who live along the route from Alaska to Yucatán (viz. Navajo). The Maya on the Atlantic coast and the Alaskans on the Pacific coast must have received their 'recent gene flow from Asia' at about the same time. Again, multiple fleets would be required.
- (iii) The same argument can be applied to the Incas of Pacific South America, whose DNA is closer to the Chinese and Maya of the

Atlantic coast and to the Aleuts of Alaska than it is to other Indian peoples of South America. In addition, Professor Novick reports that the 'close similarity between the Chinese and native Americans' covers people far distant from one another: Atlantic – High Arctic; Pacific – High Arctic; Amazonia – thousands of miles upriver; and Patagonia/Bolivia – again, thousands of miles upriver.

To reach these places thousands of miles apart in different hemispheres at about the same time, not only would different fleets be required, but huge fleets: the Atlantic fleet sailing to Greenland, the Yucatán, the Caribbean, the Amazon and Patagonia; the Pacific fleet from Alaska right down the coast to South America. The author contends that the only huge fleets which sailed to North and South America were those under the command of Admiral Zheng He, and that there is a wealth of supporting evidence summarised in this synopsis that Admiral Zheng He's fleets visited each place where Professor Novick's team has found DNA evidence of 'recent gene flow from Asia'.

3. Chinese settlers from Zheng He's voyages - DNA evidence

- (i) The Navajo
 - (a) Principal DNA report relied upon: Novick et al
 - (b) Précis of the report's findings: close similarity between the Chinese and Native Americans suggests recent gene flow from Asia
 - (c) Corroboration or supporting DNA reports
 - Professor Bryan Sykes, Seven Daughters of Eve, p.282
 - Study (1997) by US National Academy of Sciences Navajo possess unique type of retrovirus gene JCV found only in China and Japan
 - (d) Corroboration or supporting reports into ailments or diseases that suggest Chinese arrived by sea
 - 'Amerindian mitochondrial DNAs have rare Asian mutations at high frequencies suggesting they derived from four primary maternal lineages', Schurr et al (see 'papers referred to' at end)
 - (e) Did the first Europeans to reach the area in which the

Navajo people live find Chinese already there?

- Yes. Francis Vasquez de Coronado (1510–1554) found Chinese people in Tiguex, home of the Navajo. He also found junks with gilded sterns.
- (f) Other evidence showing links with China
 - The Navajo elders could, 70 years ago, converse in Chinese with missionaries from SW China. Many visitors to www.1421.tv have commented on the striking physical similarities between the Navajo and the Chinese.
 - Local legends telling of pre-Columbian visitors from the West. Certain linguistics. Accounts of European historians (Acosta, Grotius). Wrecks of probable junks - Sacramento and Coronado/Mafeo and Frois accounts. Europeans found Chinese plants (Cherokee rose, hibiscus (Rosa sinensis), rice, 26 chromosome cotton); Europeans found Chinese animals - hens (Melanotic silkie, Frizzle fowl), Chinese ship's dogs (Acosta), carvings of horses. 'Tiguex' (name of Navajo) appeared on European maps before Europeans arrived there (Cantino 1502, Waldseemüller 1507). Antonio Galvão reports Chinese claims to be 'Lords of Mexico' pre-European voyages. Garcia reports Chinese merchants in ports of Quatulco and Panuco. Asiatic shipwrecks on coast (Hugo Grotius). Foreign ships carved by Indian people of Tiguex. Statuettes of Buddha – Grand Canyon, Granby Dam. Colorado.
- (g) See Synopsis of Evidence on www.1421.tv, paras 3, 6, 7, 8(a), 15, 16 and Annex XVIII
- (ii) The Mazatec people of Mexico (Olmec culture)
 - (a) Principal DNA report relied upon: *H.L.A. Genes and the Origins of the Amerindians*, Dr Felipe Vilchis
 - (b) Précis of the report's findings: 'The results of the phylogenetic analysis reported here support the idea that the autochthonous pueblos based in Meso-America and South America had common ancestors, with as many coming with the migratory wave from the north as those that took the transpacific route.' Allelic distribution among the Mazatecs showed a garotypic pattern that was very similar to that

found among Asian peoples.

- (c) Corroboration or supporting DNA reports: A. Arnaiz-Villena, J. Granados
- (d) Corroboration or supporting reports into ailments or diseases that suggest Chinese arrived by sea
 - Hookworm and roundworm
 - Greenbeak, J. H. et al, The Settlement of the Americas
 - Vilchis et al, Clin Genet, 1997
- (e) Did the first Europeans to reach the area in which the Mazatec people live find Chinese already there?
 - Yes Acosta (people); Coronado (people and junks); Galvão (junks); Gregorio Garcia (people)
- (f) Other evidence showing links with China
 - Pre-Columbian Chinese presence in Mexico Chinese who came by sea is overwhelming
- (g) See Synopsis of Evidence on www.1421.tv, paras 1 to 21 incl., Annexes XIX, XXVI and XXVII

(iii) Campeche and Buctzozt Maya

- (a) Principal DNA report relied upon: Novick et al
- (b) Précis of the report's findings: close similarity between the Chinese and Native Americans suggests recent gene flow from Asia
- (c) Corroboration or supporting DNA reports
 - 'Amerindian mitochondrial DNAs have rare Asian mutations at high frequencies . . .', Schurr et al. Investigated Maya, Ticuna (South America) and Pima (North America).
- (d) Corroboration or supporting reports into ailments or diseases that suggest Chinese arrived by sea
 - The astonishing finding by Novick et al that Mayan DNA is closer to Chinese DNA than Mayan DNA is to North, Central or South American DNA
 - Hookworm/roundworm diseases endemic to SE Asia and China
- (e) Did the first Europeans to reach the area in which the Campeche and Buctzozt peoples live find Chinese already there?

• Yes, Columbus (secret report)

- (f) Other evidence showing links with China
 - Late Mayan art at Chichen Itza and Copan is Chinese art. Yucatán appears on world maps, viz. Cantino, Caverio, before Europeans arrived there. Jucutácato shroud shows foreign visitors on horseback, and dogs. Chinese figurines at Teotihuacan. Chinese body entombed, Teotihuacan. Chinese chickens, roses, hibiscus, rice, ship's dogs found by first Europeans. Chinese lacquer technology used by Maya. Chinese jade medallions and earplugs. Chinese dyestuff technology used by Maya. Close physical similarity between Othomi, Maya and Chinese. Mayan glyphs in temples interspersed with Chinese and Phaspa (eunuch secret language).
- (g) See Synopsis of Evidence on www.1421.tv, paras 2–4, 6–11, 14–20, Annex XIX
- (iv) Waunana and Ngobe peoples of Panama
 - (a) Principal DNA report relied upon: Novick et al
 - (b) Précis of the report's findings: close similarity between the Chinese and Native Americans suggests recent gene flow from Asia
 - (c) Corroboration or supporting DNA reports
 - Peoples of Venezuela, Surinam and Guyana, Dr Annabel Arends
 - Peoples of Venezuela, Arends and Gallengo
 - (d) Corroboration or supporting reports into ailments or diseases that suggest Chinese arrived by sea

• Hookworm/roundworm

(e) Did the first Europeans to reach the area in which the Waunana and Ngobe peoples live find Chinese already there?

• Yes, Columbus (secret report)

- (f) Other evidence showing links with China
 - Chinese claims to have ruled over 'locations in Central and South America' before Europeans arrived (Antonio Galvão). Substantial evidence of Chinese settlements in Panama pre-Columbus.
- (g) See Synopsis of Evidence on www.1421.tv, paras 2, 3, 7–11, 20, Annexes XX, XXV, XXVI, XXVII

- (v) Inca peoples
 - (a) Principal DNA report relied upon: Novick et al
 - (b) Précis of the report's findings: close similarity between the Chinese and Native Americans suggests recent gene flow from Asia
 - (c) Corroboration or supporting DNA reports
 DNA of 'Juanita' the ice maiden (Kyoto University) shows she has 'Taiwanese' DNA
 - (d) Corroboration or supporting reports into ailments or diseases that suggest Chinese arrived by sea
 - Hookworm/roundworm
 - (e) Did the first Europeans to reach the area in which the Inca people live find Chinese already there?
 - Yes, dead ones, and wrecked junks on Chilean coast (Grotius)
 - Garcilaso de la Vega (Chinese in Peru and Chile)

(f) Other evidence showing links with China

- 'Peru' is a Chinese name; villagers of Eten and Monsefu understood Chinese until a century ago; nearly 100 Peruvian villages have Chinese names to this day. First (British) colonists saw wild elephants (Ecuador/Colombia border) brought by Chinese. Friar Antonio de la Calancha found pictures of Chinese cavalry. Chinese body found entombed at Trujillo (Calancha/Loayza). Peru shown on maps before Europeans arrived there – Waldseemüller 1507, Martellus 1489. Chinese chickens found the length of Peru. Coconuts and bananas (indigenous to SE Asia) found by first Europeans; 74 other plants carried to Australasia, etc. 'Great wall of Chimu' built by Chinese. Inca pottery with Chinese calligraphy. Folklore identical to Chinese, as are divination ceremonies.
- (g) See Synopsis of Evidence on www.1421.tv, paras 2–19 incl., Annex XXI
- (vi) Indian peoples of Venezuela and Colombia: Irapa, Paraujano and Macoita
 - (a) Principal DNA report relied upon: Transferrins in Venezuelan Indians: High Frequency of a Slow-Moving Variant, Drs

Arends and Gallengo

- (b) Précis of the report's findings: in 50 per cent of the Yupa Indians of Venezuela there is a slow-moving transferrin electrophonetically indistinguishable from Tf Dchi which to date has only been found in Chinese. This finding is additional evidence for the existence of a racial link between South American Indians and Chinese.
- (c) Corroboration or supporting DNA Reports
 - Parker and Bearn
 - Novick et al report into Kobi, Chimilia and Wayuu peoples of Venezuela/Colombia
- (d) Corroboration or supporting reports into ailments or diseases that suggest Chinese arrived by sea
 - Hookworm/roundworm
 - 'Amerindian mitrochondrial DNAs have rare Asian mutations at high frequencies', Schurr et al
 - the work of Dr Annabel Arends
- (e) Did the first Europeans to reach the area in which the Irapa, Paraujano and Macoita peoples live find Chinese already there?
 - Yes, Gonzalo Ximenez de Quesoa (Muyscas, Guanes and Calima peoples)
- (f) Other evidence showing links with China
 - The combination of the work of Arends and Gallengo, Professor Novick and Parker and Bearn seems to make an overwhelming case that a Chinese colony existed in the foothills west of Maracaibo
 - Venezuela shown on maps before Europeans arrived there

 Cantino (1502), Martellus (1484), Waldseemüller (1507).
 Chinese chickens and coconuts found by first Europeans.

 Illustrated Record of Strange Countries published 1430 in

 China shows South American animals. Antonio Galvão
 cites Chinese claims to have ruled South America before
 Europeans. Chinese jade in Costa Rica/Panama. 26
 chromosome cotton in Revilagigedo Islands. Columbus
 found Chinese people and horses in Panama; Chinese ship's dogs also found.
- (g) See Synopsis of Evidence on www.1421.tv, paras 4, 5, 10,

15–17, 20, Annex XX

(vii) Surui people of Amazonia and Solimões/Rio Negro Junction

- (a) Principal DNA report relied upon: Novick et al
- (b) Précis of the report's findings: close similarity between the Chinese and Native Americans suggests recent gene flow from Asia
- (c) Corroboration or supporting DNA reports: none yet
- (d) Corroboration or supporting reports into ailments or diseases that suggest Chinese arrived by sea
 - Tokelau/chimbere found in Amazonian people tokelau a disease of SE Asia (Fonseca)
 - Hepatitis B prevalent
 - Hookworm/roundworm prevalent
 - Absence of Duffy blood groups
 - Lung fluke (Paragorimus westermani)
- (e) Did the first Europeans to reach the area in which the Surui people live find Chinese already there?
 - Yes, Friar Gaspar de Carvajal 'men with pale skins'
- (f) Other evidence showing links with China

• Diseases common to SE Asia but not to Americas found in Amazonian people who had been isolated from European contact for centuries; tokelau, hepatitis B and hookworm/roundworm could not have been carried over Bering Straits on account of the cold. The site of Hatahara recently discovered at junction of Negro and Solimões Rivers indicates very old settlement. Brazilian delegation reached China before Europeans reached Brazil and China (Professor Bi Quanzhong). Brazil shown on maps before Columbus set sail and before Europeans arrived there -1436 Andrea Bianco. First Europeans (Orellana/Carvajal) found rice fields, banana and coconut plantations, frizzle fowl, black Melanotic, Asian jungle fowl, water buffalo all indigenous to China/SE Asia; subsequent finds of pre-European Chinese animals and artefacts: fulvous tree duck, jade at Amazon/Tapajos and Solimões/Rio Negro junctions, Lago Sapakua, Lago de Faro.

(g)

s) See Synopsis of Evidence on www.1421.tv, paras 1–7, 10,

15–17, Annex X

- (viii) Quechua (Bolivia/Mato Grosso borders) and Toba (NW Argentina, Salado River) peoples
 - (a) Principal DNA report relied upon: Novick et al
 - (b) Précis of the report's findings: close similarity between the Chinese and Native Americans suggests recent gene flow from Asia
 - (c) Corroboration or supporting DNA reports: none yet
 - (d) Corroboration or supporting reports into ailments or diseases that suggest Chinese arrived by sea
 - Tokelau, hepatitis B and hookworm/roundworm
 - (e) Did the first Europeans to reach the area in which the Quechua and Toba peoples live find Chinese already there?
 - Not as far as we know, but we have not yet studied the reports of the Jesuits, a project we hope to undertake shortly
 - (f) Other evidence showing links with China
 - Rice fields found by the first Europeans to reach the Paraguay and Panama Rivers. Chinese junks found wrecked by the first Spaniards to round the Horn. Drawings on the Piri Reis (and in *The Illustrated Record of Strange Countries* published in China in 1430) show animals of Patagonia drawn long before Europeans arrived there.
 - (g) See Synopsis of Evidence on www.1421.tv, paras 1, 4, 5, 8, 15–17, 20A, Annexes XXII, XXVI, XXVII
- (ix) Haida and Aleut peoples
 - (a) Principal DNA report relied upon: Novick et al
 - (b) Précis of the report's findings: close similarity between the Chinese and Native Americans suggests recent gene flow from Asia
 - (c) Corroboration or supporting DNA reports
 - The astonishing similarity between Alaska (Aleut) and Chinese DNA – closer to each other than North American DNA is to Aleut
 - Professor Bryan Sykes, 'Chinese DNA in Vancouver Island people'

- (d) Corroboration or supporting reports into ailments or diseases that suggest Chinese arrived by sea: none yet
- (e) Did the first Europeans to reach the area in which the Haida and Aleut peoples live find Chinese already there?
 - Yes, Zatta (pre-Vancouver and pre-Cook) described Queen Charlotte Islands as 'Colonia dei Chinesi'
- (f) Other evidence showing links with China
 - Haida lore states their ancestors came from the Aleut Islands, which they did, because the Aleut and Haida languages are one. Hugo Grotius – Chinese sail to 70°N. Jodicus Hondius map shows junk. Overwhelming evidence of pre-Columbian presence of Chinese people on Vancouver and Queen Charlotte Islands, the home of the Haida.
- (g) See Synopsis of Evidence on www.1421.tv, paras 2-4, 6-9, 11-13, 19-20, Annexes XVI, XXVI and XXVII
- (x) Moskoke people of SE USA and NW Florida
 - (a) Principal DNA report relied upon: Novick et al
 - (b) Précis of the report's findings: close similarity between the Chinese and Native Americans suggests recent gene flow from Asia (note: the Moskoke are the furthest away from the Chinese on the 'tree' – further DNA evidence for Florida people is advisable)
 - (c) Corroboration or supporting DNA reports: none yet
 - (d) Corroboration or supporting reports into ailments or diseases that suggest Chinese arrived by sea
 - Machado-Joseph disease prevalent among Melungeon people to the north of Moskoke
 - (e) Did the first Europeans to reach the area in which the Moskoke people live find Chinese already there?
 - Yes, Pedro Menendez de Aviles found Chinese junks wrecked off Florida
 - (f) Other evidence showing links with China
 - Wrecked junks in Caribbean, off Florida coast and in Great Dismal Swamp (Virginia) found by first Europeans. Chinese people met by Giovanni de Verrazzano off what is now New York. Overwhelming evidence of pre-

Columbian visits to the Caribbean and up the east coast of North America.

- (g) See Synopsis of Evidence on www.1421.tv, Annexes IV, V, XXIV, XXVI and XXVII
- (xi) Ming Ho and Melungeon peoples
 - (a) Principal DNA report relied upon: none yet
 - (b) Précis of the report's findings: N/A
 - (c) Corroboration or supporting DNA reports: none yet
 - (d) Corroboration or supporting reports into ailments or diseases that suggest Chinese arrived by sea
 - Machado-Joseph disease is prevalent among the Melungeons (Jerry Warsing)
 - (e) Did the first Europeans to reach the area in which the Ming Ho and Melungeon peoples live find Chinese already there?
 - Yes Captain John Smith's accounts (Jerry Warsing, *Battle of the Fallen Timbers*)
 - (f) Other evidence showing links with China
 - Wrecked Chinese junks found by first Europeans (Pedro Menendez de Aviles) downwind from Virginia, off Florida and upwind, Great Dismal Swamp. Chinese people found on Atlantic coast of North America (Giovanni di Verrazzano). Many readers have commented on the 'Chinese' appearance of the Melungeons.
 - (g) See Synopsis of Evidence on www.1421.tv, paras 1–20, Annexes V, VI, XXIV, XXVI and XXVII

(xii) Sioux and Cree Ojibwa peoples of America and Canada

- (a) Principal DNA report relied upon: Novick et al
- (b) Précis of the report's findings: close similarity between the Chinese and Native Americans suggests recent gene flow from Asia
- (c) Corroboration or supporting DNA reports
 - A 1997 study published by the National Academy of Sciences appears to support the fact that the New World's first migrants came from Asia. Researchers studied Native Americans from the Navajo, Chamorro and Flathead tribes (Montana) and determined that all three groups possess a

unique type of retrovirus gene JCV found only in China and Japan.

- (d) Corroboration or supporting reports into ailments or diseases that suggest Chinese arrived by sea: none yet
- (e) Did the first Europeans to reach the area in which the Sioux and Cree Ojibwa peoples live find Chinese already there? Not known.
- (f) Other evidence showing links with China
 - Substantial evidence that foreign visitors came by ship with horses and sailed up the Mississippi. Horse remains (pre-Columbus) have been found near Thunder Bay, Lake Superior. Rock Lake, Wisconsin, contains flat-topped stepped pyramids under its waters. Elephant bones have been found, and a round stone fortress.
- (g) See Synopsis of Evidence on www.1421.tv, paras 12 and 16, Annex VIII

(xiii) Maidu, Yuki, Pima and Wintun peoples of California

- (a) Principal DNA report relied upon: (Schurr et al on the Pima)
- (b) Précis of the report's findings: N/A
- (c) Corroboration or supporting DNA reports: none yet
- (d) Corroboration or supporting reports into ailments or diseases which suggest Chinese arrived by sea: none yet
- (e) Did the first Europeans to reach the area in which the Maidu, Yuki, Pima and Wintun peoples live find Chinese already there?
 - Yes Cabrillo/Ferrello found wrecked Chinese junks off the north California/Oregon coast
- (f) Other evidence showing links with China
 - After Cabrillo and Ferrello's sightings, a stream of European explorers found Chinese people or colonies existing in California. There is overwhelming evidence of a Chinese settlement in California before Europeans arrived. Stephen Powers found a Chinese-speaking colony between the Russian and Sacramento Rivers; Father Luis Sales found one between San Francisco and Santa Barbara. All manner of pre-Columbian Chinese plants, trees, animals, porcelain, jade, stones, bronzes. Gregorio Garcia and

Antonio Galvão describe pre-European Chinese settlements in California. Professor Fryer reports Chinese walls.

(g) See Synopsis of Evidence on www.1421.tv, paras 2, 3, 6–12, 15–16, 18, Annexes XVII, XXV and XXVI

(xiv) Maori people of New Zealand, North Island

- (a) Principal DNA report relied upon: not known; reported on ABC programme *Catalyst*, 27 March 2003, author Dr Gregory Chambers
- (b) Précis of the report's findings: (as reported by David Knight 7.4.03) mitochondrial DNA shows female line is entirely Asian while Y chromosome DNA shows males came from Papua New Guinea
- (c) Corroboration or supporting DNA reports: none yet
- (d) Corroboration or supporting reports into ailments or diseases which suggest Chinese arrived by sea: none yet
- (e) Did the first Europeans to reach the area in which the Maori people live find Chinese already there?
 - Captain Cook's diaries do not say Chinese, but they do say Maoris had met earlier seafarers in New Zealand
- (f) Other evidence showing links with China
 - Plants and animals foreign to New Zealand were already there when the first Europeans arrived. The Ruapuke wreck and its associated Chinese artefacts. Campbell and Auckland Islands are shown on the Jean Rotz chart two centuries before Cook arrived.
- (g) See Synopsis of Evidence on www.1421.tv

(xv) Gunditimara Aborigines of Victoria, South Australia

- (a) Principal DNA report relied upon: 'Evolution of Modern Humans' by Joanna Mountain in *Philosophical Transactions of* the Royal Society of London 337 (1992) 159–165
- (b) Précis of the report's findings: this is a very generalised report and weak evidence of recent Chinese voyages
- (c) Corroboration or supporting DNA reports: it is believed there are reports which the Australian government does not wish to have published

- (d) Corroboration or supporting reports into ailments or diseases which suggest Chinese arrived by sea: none that are known, save for Machado-Joseph disease among the Aborigines of Arnhem Land
- (e) Did the first Europeans to reach the area in which the Gunditjmara people live find Chinese already there? Not known.
- (f) Other evidence showing links with China
 - The Gunditjmara people claim their ancestors came from overseas and instituted eel farming in Australia. Wrecked junks at Warrnambool and King Island. Maps of Australia drawn centuries before Europeans arrived there, e.g. Toscanelli (1474), which shows the internal river systems of Australia.
- (g) See Synopsis of Evidence on www.1421.tv

Papers referred to

Araújo, Adauto José Goncalves de, 'Contribuição ao Estudo de Helmintos encontrados em Material Arqueológico do Brasil' (parasites common to Asia and South America)

Arnaiz-Villena, A., Vargas-Alarón Granados, J. et al, 'HCA Genes in Mexican Mazatecans, the peopling of the Americas, and the uniqueness of Amerindians', Tissue Antigero 2000

Biocca, Ettore, 'Hookworms and the Origin of American Indians', L'Anthropologie 55/5

Bruce-Chwatt, L. J., 'Paleogenesis and paleo-epidemiology of primate malaria', *Bulletin, World Health Organisation* 32: pp.363–87 (malaria in pre-Columbian America)

Cambridge Study (Incas to Polynesia) - see postscript

Darling, S. T., 'Hookworms, Ancylostoria and Necator in Pre-

Columbian America', Parasitology, 12/3

Fonseca, Olympio da, 'Parasitismo e Migrações da Parasitologia', 'Contribuiçõés das origens do Hominem Americano' (para 15 in *The Americans re Human Migration*), Estudos da Préhistoria Geral e Brasileira, São Paolo, 1970

Laming-Emperaire, Annette, 'Le Problème de Origines Américains: théories, hypotheses, documents', Editions de la Maison des Sciences de l'Homme, Presses Universitaires de Lille, Lille 1980 (summary of

diseases shared between Old World and pre-Columbian Indians) Morael, Virginia, 'Research News: Confusion in Earliest America', *Science*, no.248 (genetic diversity of American Indians)

Needham, J., 'The mountain of evidence of pre-Columbian contact with the Americas before Columbus', *Science and Civilisation in China*, vol.4, p.540

New Zealand Study (Maori DNA) – see postscript (Dr Gregory Chambers)

Nicolle, Charles, 'Un argument medical en faveur de l'opinion de Paul Rivet sur l'origine océanienne du certain tribus indiennes du Nouveau Monde', *Journal de la société des Américanistes de Paris 24* (typhus of Mexico and Guatemala differs from Eurasian) Novick, Gabriel E., Corina C. Novick, Juan Yunis, Emilio Yunis, Pamela Antunez de Mayolo, W. Douglas Scheer, Prescott L. Deininger, Mark Stoneking, Daniel S. York, Mark A. Batzer and Rene J. Herrera, 'Polymorphic Alu Insertions and the Asian Origin of Native American Populations', *Human Biology*, vol.70, no.1, p.23, copyright 1998 Wayne State University Press, Detroit, Michigan. Sandison, A. T., 'Diseases in antiquity: a survey of the diseases, injuries and surgery of early populations', in *Parasitic Diseases*, C. T. Thomas, Springhurst, Illinois, 1967

Schurr, T. G., Ballinger, S. W., Gan Y-Y et al, 'Amerindian mitrochondrial DNAs have rare Asian mutations at high frequencies', *American Journal of Human Genetics*, 46, 1990, 613–23

Soper, T., 'The report of a nearly pure Ancylostoma duodenale infestation in native South American Indians and a discussion of ethnological signatures', *American Journal of Hygiene*, 1927 Sykes, Bryan, *The Seven Daughters of Eve*, Bantam Press, 2000, pp.101–6 and 282–95

Vilchis, F., Zúñiga, J., Granados, J. et al, 'Análisis del polimorfismo V89L de Sa esteroide reductasa en un groupo étnicamente preservado', *Genética y Biomedicina Molecular 200*, Resumen C., Monterrey, NL (Mexico)

NOTE: for a full bibliography for 1421, please refer to the website www.1421.tv

THE DETERMINATION OF LONGITUDE BY THE CHINESE IN THE EARLY FIFTEENTH CENTURY

Authors: Professor John Oliver, co-chairman and Professor of the Department of Astronomy, University of Florida (JO)

Mr Marshall Payn (MP)

Gavin Menzies, author of 1421 – The Year China Discovered the World (GM)

This paper is set out as follows:

Introduction Chinese astronomical knowledge in 1421 The Chinese determination of elapsed time Chinese observatories Eclipses Passage of events during a lunar eclipse Longitude determined by elapsed time during a lunar eclipse Proof of the theory Practical implementation

Introduction (GM)

GM contends that during its sixth voyage (1421–3), the Chinese fleet perfected a method of determining longitude. This is illustrated by the longitude of the East African coast being accurately charted by the Chinese, then later shown on the Cantino map (1502) some three centuries before John Harrison invented the chronometer. Longitude on the East African coast between Cape Town and Djibouti, a distance of seven thousand nautical miles, is correct to within twenty nautical miles (twenty seconds of time). Detailed reasons for concluding that the Chinese were the original surveyors whose work was used to create the Cantino can be found in chapter 6 of this book.

Chinese astronomical knowledge in 1421 (GM)

By the time of their sixth voyage Zheng He's fleets had inherited expertise gained from six centuries of charting the stars in the night sky and had predicted and noted the return of Halley's comet on every pass since the second century BC. They were aware that the earth was a globe and had divided it into 365 and a quarter degrees (the number of days in the year) of latitude and longitude. Longitude was determined by the position on the globe east or west of Beijing; latitude was determined not from the equator but from Polaris in the north and the mid-point of the circumpolar stars in the south. The end result was the same as achieved later by Europeans. Following the voyage of Grand Eunuch Hong Bao to the Antarctic in early 1422, the Chinese knew the correct position of the South Pole. They were thus able to eliminate magnetic variation and to calculate latitude in the southern hemisphere as they did with Polaris in the north. In the early Ming era, Beijing's astronomers charted no fewer than 1,400 stars each night as they traversed the sky, a practice Emperor Zhu Di had reinstated. The Chinese were able to predict both solar and lunar eclipses with considerable accuracy.

The Chinese determination of elapsed time (GM)

An essential requirement for determining longitude was a precise measurement of elapsed time. The Chinese measured the passage of time by the sun's shadow.

The most famous existing observatory is the Zhou Gong Tower, built seven centuries ago. It is a truncated pyramid measuring twentyfive feet square at the top. Stairways lead from ground level to the platform on the top, upon which stands a three-roomed building with a good view to the north of a forty-foot gnomon, or vertical pole. The observatory, too, has a thin vertical rod for observation of meridian transits, and one of the rooms is equipped with a clepsydra, or large water clock.

Lying on the ground to the north of the tower and extending for 120 feet is the device for measuring the sun's shadow. To ensure this device was level, two parallel troughs of water extended along its length, enabling its stones to be laid precisely parallel with the water.

The gnomon itself extended forty feet into the sky. This enabled the sun's shadow thrown by the pole to be measured. As an illustration, at the equinox on the equator the sun rises in the east and sets in the west. At midday it is exactly above the observer and hence casts no shadow – it is a dot. The longest shadows are cast at sunrise and sunset. The length of the shadow will tell the time on that particular day at that particular place.

Back in ad 721, the Chinese realized that the length of the sun's shadow varied not only according to the time of day but for every day of the year, and depended on the observer's latitude. They conducted an experiment between latitudes 17°209N and 40°N. Along this meridian line, thousands of miles long, they measured simultaneously the length of shadows at the summer and winter solstices using a standard eight-foot gnomon. This showed that shadow lengths varied just over 3.56 inches for each four hundred miles of latitude. They could thus make corrections for their position.

They also appreciated that the length of shadow varied with the seasons. In one celebrated measurement, it was 12.3695 feet at the summer solstice and 76.7400 feet at the winter. This enabled them to make corrections for each day of the year as well as for different positions on the earth's surface.

The final adjustment was to correct the irregular motion of the earth around the sun occasioned by the eccentricity of the earth's orbit and the difference between the equator and the ecliptic – this is known as 'The Equation of Time'. It causes differences between absolute and solar time, reaching a maximum positive difference of fourteen minutes and thirty seconds in February and a maximum negative difference of sixteen minutes and thirty seconds in November. So accurately did the Chinese determine this equation of time that the great mathematician Laplace wrote: 'The [Chinese] observations made from 1277 to 1280 are valuable on account of their great precision and prove incontestably the diminution of the obliquity of the ecliptic and the eccentricity of the earth's orbit between then and now' (Needham, 1954, vol. 3, p. 398). This outstanding precision is illustrated by their estimate of the length of lunation at 29.530591 days – an error of less than one second in a month.

Chinese observatories (GM)

The Chinese replicated the Zhou Gong Tower, first in Nanjing, then, when the capital was moved north in 1421, in Beijing. Later, as noted in chapters 4 and 8, they built observatories around the world. We know what equipment was in the observatories from an inventory listed in *History of the Yuan Dynasty* (1276–9) (Needham, 1954, vol. 3, p. 369). Here are the principal pieces of equipment:

Hun thien hsiang – celestial globe (Ricci's first instrument) Yang i – hemispherical sundial Kao piao – lofty gnomon, forty feet, as at Yang Cheng Li yun i – theodolite Cheng li – verification instrument to determine exact positions of sun and moon near eclipse Ching-fu – shadow amplifier Jih yueh shi yi – instrument for observation of solar and lunar eclipses I sing kuei – star dial Ting shih – time-determining instrument

Hou chi – pole-observing instrument

Chiu piao hsuan – plumb lines Chengi – rectifying instrument

As may be seen, the list has instruments for recognizing stars in the sky (celestial globe); for measuring the length of the sun's shadow (lofty gnomon); for determining exact positions of the sun and moon at eclipses (cheng li); for amplifying the sun's shadow (ching-fu); for observing lunar eclipses (jih yueh shi yi); and for observing the Pole Star (hou chi).

Some of the instruments need explanation. The Chinese had long known that the longer the sun's shadow (i.e. the bigger the gnomon), the more accurate the measurement of time. However, the longer the shadow got, the more attenuated and fainter it became. In the early Ming era they devised a 'camera obscura', a hole in the top of the roof of the observation chamber which resulted in a sharper shadow. They intensified this with a type of magnifying glass. The upshot was that a long shadow could now be measured to within one-hundredth of an inch.

The measurements of time so far described would only work when the sun was out. Measuring time in darkness was accomplished using various types of water clock – clepsydras – which themselves were calibrated by day against the gnomons. There were several types of clepsydra; one of the best known was a steelyard type (chheng lou) which had compensating mechanisms to take account of both air pressure in the atmosphere and the height of water in the clock itself. One of these was found in the Pandanan junk wreck. We can see and marvel at the ingenuity of these astonishing devices for the polyvascular type is illustrated and explained in the Chinese encyclopedia printed in 1478 (*Shi Lin Guang Ji*) now in the Cambridge University Library. We can summarize by saying that by the end of the voyage of 1421–3 the Chinese had the ability to measure time from their observation platforms which by then straddled the globe.

Eclipses (GM)

Eclipses of the earth's moon and the sun, that is solar and lunar eclipses, occur when the sun, moon and earth are in line with one

another and when the moon's orbit around the earth is in the same plane as the earth's orbit around the sun. When these planes differ the result is a new or full moon rather than an eclipse.

Solar eclipse

In an eclipse of the sun, the line-up is like this:

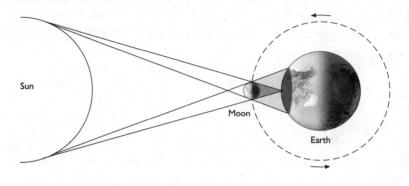

The moon's shadow blots out the sun over a small portion of the earth. It becomes night for a very short period. The spot of darkness, the umbra, travels across the earth as the moon rotates around the earth, and the earth itself rotates. Thus, observers in different locations see the solar eclipse at different times.

Lunar eclipse

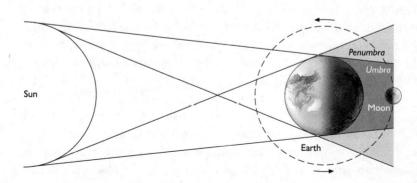

In a lunar eclipse, the earth is between sun and moon. Because the earth is so much bigger than the moon, the earth's shadow blots out the moon. The great difference, insofar as astronomical observations are concerned, is that in a lunar eclipse the event may be seen simultaneously by observers across half the earth, whereas in a solar eclipse the event occurs only above a small piece of earth at any one time.

The key to using a lunar eclipse to determine longitude is (i) that the event is seen across the world simultaneously; and (ii) while the event is seen, the earth is rotating, which has the effect that the heavens appear to rotate in the opposite direction to the earth.

Passage of events during a lunar eclipse (JO and MP)

There are four distinguishable events during an eclipse: U1 - first contact, when the moon enters the dark umbral shadow; U2 - second contact, when the moon has just fully entered the umbra (totally covered); U3 - third contact, when the moon first starts to emerge; and U4 - fourth contact, when the moon has just fully emerged. These events can be observed across almost 180 degrees of longitude (east to west).

Longitude determined by elapsed time during a lunar eclipse (JO and MP)

With their gnomons and water clocks, the Chinese were able to determine the passage of time, minute by minute, throughout the day and night. They could also forecast when a full lunar eclipse would occur – about every six months somewhere across the globe. The instruction to the navigators and astronomers was as follows: 'After landing in unknown territory, when the next total eclipse begins, wait until the third event [U3] occurs and the last bit of darkness disappears. Just when the first sliver of light appears as the moon starts to come out of its eclipse [U3], both the observer in the new territories and the astronomer in Beijing look into the night sky and determine which major star is transiting the local meridian.' The local meridian is an imaginary line on the celestial sphere which starts at the celestial pole north of the observer, extends directly over the observer's head

(the observer's zenith), and ends at the celestial pole south of the observer. Along this imaginary line, the observer selects a known star crossing the line. This is both observers' key sighting at this point.

When the astronomer in the newly discovered territories has returned to Beijing, he and the astronomer at Beijing's observatory compare notes. The one who has returned from abroad relates that at event U3, star alpha was transiting his local meridian. The Beijing observer relates that at that U3 moment, star beta was transiting his local meridian, both well-known stars. They now get out their timekeeping device. This has been calibrated from the gnomons. They wait until star alpha crosses the zenith and then start counting with their time-measuring device until star beta crosses their zenith. The time elapsed between star alpha and star beta crossing the zenith is the distance the earth has rotated between the two observers - the one in Beijing, the other in the newly discovered lands. The earth rotates 360 degrees every twenty-four hours. Thus, if we assume that the time elapsed between the transit of star alpha and star beta was exactly six hours (i.e. a quarter of the time it takes the earth to rotate). then the difference in longitude between Beijing and the new territory is also a quarter of the total longitude around the world, i.e. one-quarter of 360 degrees, or 90 degrees.

Note by GM: Refinements can be introduced by conducting this procedure four times at U1, U2, U3 and U4 and then applying the averages to reduce errors.

Proof of the theory (JO and MP)

We decided to test our theory by observing the lunar eclipse of 16 and 17 July 2000. We positioned our team across the Pacific from Tahiti to Singapore. By a happy coincidence, we chose the same positions on which the Chinese had erected observation platforms.

			Observations				Local Sidereal Time			Uobs-LST				Error		
Where	Long	Obs?	UI	U2	U3	U4	LST1	LST2	LST3	LST4	U1	U2	U3	U4	Ave	rms
Papeele, Tahiti	-149°	yes		339°	0.8°	1	1.1	341.2°	08.0°		1.	-2.2°	-0.0°		-1.1°	±1.5°
Singapore	103.8°	yes		235°		276°		234.0°		277.1°		-1.0°		-1.1°	0.0°	±1.5°
near Melbourne, Australia	145°	yes	258°	275°	301°		258.4°	274.7°	301.5°		-0.4°	0.3°	-0.5°		-0.2°	±0.5°
Tekapo, New Zealand	170.5°	yes	284°	301°	329°	343°	284.4°	300.7°	327.5°	343.8°	-0.4°	0.3°	1.5°	-0.8°	0.1°	±1.0°
Nelson, New Zealand	173.1°	yes	285°	305°	330°	345°	287.0°	303.3°	330.1°	346.4°	-2.0°	1.7°	-0.1°	-1.4°	-0.5°	±1.6°

Table 1: Observations of the 16/17 July 2000 lunar eclipse. As can be seen, the error of a single observation was typically $\pm 1.5^{\circ}$ or better. Since one degree is the equivalent of four minutes of time, this error

is the equivalent of about six minutes of time. The error of the combination of two observations would be better by $\sqrt{2}$ and would thus be about $\pm 1^{\circ}$.

The observations list the celestial longitude measured from the vernal equinox of whatever star was transiting the local meridian – that is, the straight line passing from north over the observer's head to south. The celestial longitude is measured along the equator of a star map. Thus, 339° (Tahiti) measures the position of a rotating cylindrical star map. The time elapsed between U2 and U3 enabled that cylindrical star map to rotate for 339° past 360° to 8° – about two hours. Average errors were: Tahiti 1.1 degrees, New Zealand 0.1 degree, Melbourne 0.1 degree, Singapore zero degrees. Our observers were amateurs; with more training and experience than we could provide the errors could be reduced.

Practical implementation (GM)

The result has startling implications, for longitude has been calculated from Tahiti in the east with sixty-six nautical miles' error to Singapore in the west with no longitudinal error. There is six nautical miles' longitudinal error between Singapore and New Zealand, none between New Zealand and Australia. Longitude has been calculated across nearly one-third of the world correct to within sixty-six miles.

The Chinese could have determined longitude just as accurately as Professor Oliver's team did. The brilliance of this method is that, unlike calculations for latitude, no sextant is required. Neither is a clock; the only instrument needed is one to accurately determine elapsed time, a role fulfilled by the gnomon.

Having accurately determined the longitude of Malacca (Singapore), the Chinese fleets could now use observation platforms and gnomons on their bases around the Indian Ocean – at Semudera (Sumatra), the Andamans, Dondra Head (Ceylon/Sri Lanka), Calicut on the Malabar coast of India, Zanzibar in East Africa, the Seychelles and Maldive archipelagos – all of which appear on the *Wu Pei Chi* charts which credit Zheng He with providing the information. There is no reason why longitudes across the whole Indian Ocean should not have been determined in one eclipse, provided a sufficiently large fleet was deployed. This, I think, happened with the results seen in the Cantino, where the coast of East Africa appears as if drawn with the aid of satellite navigation.

The brilliance of Zheng He's astro-navigation arises both from its simplicity and because each part contributes towards a composite whole greater than its parts.

Establishing the right ascension and declination of Canopus and of Crucis Alpha and Beta (Southern Cross) had enabled them to be cross-referenced to Polaris (see *Wu Pei Chi* chart for passage between Dondra Head and Sumatra). Measuring Polaris's altitude as they sailed north would have enabled Chinese navigators to calculate half the circumference of the earth. Sailing due north between the equator and 40°N was 2,400 nautical miles (10,000 *li*); thus, continuing to the North Pole would be a further 50° or 12,500 *li*; thus, the earth's circumference must be 100,000 *li*. Because they knew the position of Canopus and the Southern Cross, they could use the size of the earth to determine the true position of the South Pole (the centre of the cirumpolar stars – Canopus becomes circumpolar below 68°S). Hence, they could determine the position of the South Magnetic Pole so as to establish true south and north.

The Chinese now had everything needed to accurately chart the world – latitude, longitude, size, direction. They went on to chart every continent with great accuracy. The fruits of their labours reached Europe via Niccolò da Conti and enabled Europeans to set

sail on their voyages of discovery with maps based on Chinese cartography.

OBSERVATION PLATFORMS USED BY THE CHINESE 1421–3

Pacific, east to west		
Marquesas	140°W	9°30′S
Tahiti	149°W	17°50'S
Society Islands (Bora Bora)	151°W	17°30'S
Kiribati (Gilberts, Phoenix) Islands	160°4′W	0°24′N
Ruapuke beach	174°47′E	37°56'S
Nan Madol	158°21′E	6°51′N
Gympie (New South Wales)	152°42′E	26°12'S
Gosford (central NSW)	151°13′E	33°26′S
New Guinea	143°38′E	3°35′S
Yap Island	138°9′E	9°31′N
Nanjing	118°45′E	32°6′N
Beijing	116°25′E	39°55′N
Indian Ocean		
Malacca	102°15′E	2°11′N
Semudera (Bandar Aceh)	95°19′E	5°32′N
Nicobars (Polo Milo)	93°42′E	7°27′N
Andamans (Lapatte)	92°47′E	9°22′N
Ceylon/Sri Lanka (Dondra Head)	80°13′E	6°02′N
Calicut	75°49′E	11°16′N
Maldives (Male)	73°30′E	4°7′N
Seychelles	55°29′E	4°36′N
Madagascar (Mahajanga)	46°14′E	15°45′S
Zanzibar	39°11′E	6°11′N
Sofala	39°44′E	20°9'S

NOTES

Chapter 1: The Emperor's Grand Plan

- 1 Anlui province on the north bank of the Yangtze in eastern central China.
- 2 Chinese emperors were known not by their personal name but by their title, and, after death, a 'temple name', such as 'Sincere Emperor', reflecting the course of their life.
- 3 Mary M. Anderson, *Hidden Power: The Palace Eunuchs of Imperial China*, Prometheus, Buffalo, New York, 1990, pp. 15–18, 307–11.
- 4 R.H. Van Gulik, Sexual Life in Ancient China, Leiden, 1961, p. 256.
- 5 Anderson, op. cit.
- 6 Dorothy and Thomas Hoobler, Images across the Ages: Chinese Portraits, Raintree, Austin, Texas, 1993.
- 7 Confucius, as quoted by F. Braudel in *A History of Civilisations*, trs.R. Mayne, Penguin, Harmondsworth, 1994, p. 178.
- 8 The dragon was credited with miraculous powers and was used as a metaphor for people of great virtue and talent. Almost all the items and artefacts closely connected with the emperor his throne, his robes, his bed, etc. were prefixed with 'dragon' or 'phoenix', the phoenix being another mystical creature with extraordinary powers.
- 9 In early 2002 the Chinese government announced ambitious plans to restore the dry-docks and build a full-size replica of one of Zheng He's junks.
- 10 Ming Tong Jian, Comprehensive Mirror of Ming History, 1873, Ch. 14, quoted in Louise Levathes, When China Ruled the Seas, Simon & Schuster, 1994, pp. 73–4.
- 11 Ahmad ibn Arabshah, Miracles of Destiny in Timur's History, 1636.
- 12 Shun Feng Hsiang Seng ('Fair Winds for Escort'), anon., c. 1430, Bodleian Library.
- 13 Miles Menander Dawson, *The Wisdom of Confucius*, Boston, Mass., 1932, pp. 57–8.
- 14 Quoted by Edmund L. Dreyer in *Early Ming China: A Political History* 1355–1435, Stanford University Press, Calif., p. 204.
- 15 Hafiz Abru, *A Persian Embassy in China*, 1421, trs. K.M. Maitra, Lahore, 1934, p. 55.
- 16 Emperor Zhu Di's instructions to Zheng He, paraphrased from the two stone steles of 1431.
- 17 The number of voyages made by the treasure fleets is, and will continue to be, a matter of dispute. The inscriptions on commemorative stones erected by Zheng He before his final voyage claim that his fleets had, until then, made seven. Most authorities classify his fourth and fifth

NOTES

voyages as one. I have adhered to this classification; the voyages beginning in 1421 were therefore the sixth.

- 18 Hoobler, op. cit.
- 19 L. Carrington Goodrich (ed.), *The Dictionary of Ming Biography*, Columbia UP, New York, 1976, p. 1365.
- N.I. Vavilov, 'The Origin, Variation, Immunity and Breeding of Cultivated Plants', trs. K.S. Chester, *Chronica Botanica*, Vol. 13, Waltham, Mass., 1949–50; and J. Needham, *Science and Civilisation in China*, Vol. VI, Pt 2, sec. 41, p. 428.

Chapter 2: A Thunderbolt Strikes

- 1 Hafiz Abru, A Persian Embassy to China, 1421, trs. K.M. Maitra, Lahore, 1934, pp. 113–15.
- 2 Ibid., p. 115.
- 3 Ibid., pp. 115-17.
- 4 Ibid., p. 117
- 5 Shang Chuan, Yongle Huang Di, Beijing, 1989, pp. 214–15, citing the Cochin tablet 'Taizong Shi Lu', ch. 236.
- S.W. Mote and Denis Twitchett (eds), *The Cambridge History of China*, Vol. 7, *The Ming Dynasty*, Cambridge UP, Cambridge, 1988, p. 292.
- 7 Abru, op. cit., p. 108.
- 8 Quoted in Louise Levathes, *When China Ruled the Seas*, Oxford UP, Oxford, 1994, p. 157.
- 9 Ellen F. Soullière, *Palace Women in the Ming Dynasty*, Princeton University doctoral thesis, 1987, quoted in Levathes, op. cit., p. 226.
- 10 Levathes, op. cit., pp. 163 and 164.
- 11 P.B. Ebrey, *The Cambridge Illustrated History of China*, Cambridge UP, Cambridge, 1996, p. 278.
- 12 Quoted in L. Carrington Goodrich (ed.), *The Dictionary of Ming Biography*, Columbia UP, New York, 1976, p. 338.
- 13 See J. Needham, Science and Civilisation in China, Vol. 4, Pt 3, Cambridge UP, Cambridge, 1954, p. 525; and J.J.L. Duyvendak, China's Discovery of Africa, Probsthain, 1949, p. 27, and 'The True Dates of the Chinese Maritime Expeditions in the Early Fifteenth Century', T'oung Pao, XXXIV, pp. 395–8.

Chapter 3: The Fleets Set Sail

- 1 The originals are in Beijing, but the British Library holds copies.
- 2 J. Needham, *Science and Civilisation in China*, Vol. 3, sec. 20, Cambridge UP, Cambridge, 1954, p. 230.
- 3 Ibid., Vol. 4, Pt 3, pp. 565ff.
- 4 Ibid., Vol. 6, Pt 1, pp. 365ff.
- 5 Ibid., Vol. 6, Pt 5, pp. 19ff.
- 6 Ibid.
- 7 Antonio Pigafetta, *Magellan's Voyage*, trs. R.A. Skelton, Yale UP, New Haven, Conn., 1969, p. 56.
- 8 R.H. Van Gulik, Sexual Life in Ancient China, Leiden, 1961, pp. 308ff.
- 9 Ibid., p. 125.
- 10 Ibid., p. 265.
- 11 Ibid., p. 133.
- 12 Ibid.
- 13 Ibn Taghri-Birdi, *A History of Egypt, 1382–1469 AD,* Berkeley, California, 1954.
- 14 Ma Huan, *The Overall Survey of the Ocean Shores*, Beijing, 1433, trs. J.V.G. Mills, Cambridge UP (for Hakluyt Society), 1970, p. 108.
- 15 Ibid., p. 143.
- 16 Ma Huan, op. cit., trs. Paul Wheatley in *The Golden Khersonese*, University of Malaya Press, Kuala Lumpur, 1961, p. 143.
- 17 Ma Huan, op. cit., trs. Mills, p. 104.
- 18 Ibid. A slightly different translation is quoted by Richard Hall in Empires of the Monsoon. HarperCollins, 1996, p 89.
- F. Braudel, *The Wheels of Commerce*, trs. Siân Reynolds, Fontana, 1985, p. 130.
- 20 Ibid., p. 131.
- 21 Zheng He, quoted in Dorothy and Thomas Hoobler, *Images across the Ages: Chinese Portraits*, Raintree, Austin, Texas, 1993.
- 22 The identity of the admiral in command of the third fleet is not known with absolute certainty, but after corresponding with Professor Roderich Ptak of the University of Munich I believe Chou Wen to be the most probable leader.

Chapter 4: Rounding the Cape

2 Stone inscription in the Palace of the Celestial Spouse at Chiang-su,

¹ See ch. 3, n. 22.

dated 1431, trs. J.J.L. Duyvendak, 'The True Dates of the Chinese Maritime Expeditions in the Early Fifteenth Century', *T'oung Pao*, XXXIV, p. 347.

- 3 Stone inscription in the Palace of the Celestial Spouse at Liu-Chia-Chang, dated 1431, trs. J.J.L. Duyvendak, *China's Discovery of Africa*, Probsthain, 1949, p. 29.
- 4 Professor Needham, Richard Hall and Louise Levathes.
- 5 Richard Hall, *Empires of the Monsoon*, HarperCollins, 1996, p. 550, has splendid illustrations.
- 6 Ma Huan, *The Overall Survey of the Ocean Shores*, Beijing, 1433, trs. J.V.G. Mills, Cambridge UP (for Hakluyt Society), 1970, p. 138. It can be seen that Muslim people are ruling Hindus.
- 7 Ibid., pp. 140 and 141.
- 8 Poggio Bracciolini, The Travels of Niccolò da Conti, 1434, partial translation in R.H. Major (ed.), India in the Fifteenth Century, Hakluyt Society, 1857.
- 9 The Travels of Niccolò da Conti, quoted in Hall, op. cit., p. 124.
- 10 J.H. Parry, The Discovery of the Sea, Elek, 1979, p. 45.
- 11 See postscript for details of this and a further conference in Kunming.
- 12 100,000 *li* equals 40,000 nautical miles. The circumference of the globe is 21,600 nautical miles.
- 13 As translated by J. Needham in *Science and Civilisation in China*, Vol. 4, Pt 3, Cambridge UP, Cambridge, 1954, p. 572.
- 14 Ibid.
- 15 Quoted by Eannes de Zuzara, *The Chronicle of the Discovery and Conquest of Guinea*, trs. C.R. Beazley, Hakluyt Society, 1896–9.
- 16 Hall, op. cit., pp. 124–6. See postscript for an important update on the status of da Conti.
- 17 Vice-Admiral Sir Ian McIntosh, letter to the author, 2001.
- 18 Chuan Chin, one of the Koreans who organized the publication of the Kangnido.
- 19 The work of M. Chevalier and his colleagues.
- 20 Antonio Galvão, Tratado Dos Diversos e Desayados Caminhos, Lisbon, 1563. The translation I have used is that of Richard Hakluyt, 1601, pp. 23–4, quoted by F.M. Rogers in The Travels of the Infante Dom Pedro, Harvard UP, Cambridge, Mass., 1961, p. 48.
- 21 Ibid.
- 22 H. Harisse, The Discovery of North America, 1892, p. 272.
- 23 [British] Admiralty, Ocean Passages of the World, third edn, 1973.

Chapter 5: The New World

- 1 Bibliography in J. Needham, *Science and Civilisation in China*, Vol. 4, Pt 3, sec. 29, Cambridge UP, Cambridge, 1954, p. 542.
- 2 Note VII on the Piri Reis map, translated by G.C. McIntosh in *The Piri Reis Map of 1513*, University of Georgia Press, Athens, Georgia, 2000, p. 46.
- 3 Charles R. Darwin, *Journal of Researches into the Geology and Natural History of the Various Countries Visited by HMS Beagle, 1832–36*, Henry Colburn, 1839, pp. 54 and 124.
- 4 Antonio Pigafetta, *Magellan's Voyage*, trs. R.A. Skelton, Yale UP, New Haven, Conn., 1934, p. 54.
- 5 Note XXIII, in McIntosh, op. cit., p. 44.
- 6 Note XXIV, ibid.
- 7 Ibid.
- 8 Ma Huan, *The Overall Survey of the Ocean Shores*, Beijing, 1433, trs. J.V.G. Mills, Cambridge UP (for Hakluyt Society), 1970, p. 155.
- 9 See chapter 9.
- 10 A detailed and extensive bibliography of plants and animals brought to the Americas before the European voyages of exploration is contained in J.L. Sorenson and M.H. Raish, *Pre-Columbian Contact with the Americas across the Oceans: An Annotated Bibliography*, Provo Research Press, 1990.
- 11 Ferdinand Magellan, 13 December 1519, in *The First Voyage round the World by Magellan*, translated from the Accounts of Pigafetta by Lord Stanley of Alderley, Hakluyt Society, 1874, and Antonio Pigafetta, *Primer Viage Alrededor del Mundo*, Leoncio Cabrero Fernandez, Madrid, 1985.
- 12 J. de Acosta, '*Historia Natural y Moral de las Indias*', No. 34, Cronic., Venice, 1596. Acosta used linguistic evidence to demonstrate the spread of pre-Columbian chickens in South America.
- 13 George F. Carter, 'The Chicken in America', in Donald Y. Gilmore and Linda S. McElroy (eds), *Across before Columbus*?, NEARA Publications, Edgecomb, Maine, 1998, p. 154.
- 14 Ibid., p. 158.
- 15 M.D.W. Jeffreys, 'Pre-Columbian Maize in Asia', in Carroll Riley et al. (eds), *Men across the Sea*, University of Texas Press, 1971, pp. 382ff.
- Maize: Antonio Pigafetta, Primo Viaggio intorno al Mondo, MS version of c. 1524 translated in E.H. Blair and J.A. Robertson, The Philippine Islands 1493–1893, 1906, Vols 33 and 34, pp. 154, 164, 182 and 186;
 M.D.W. Jeffreys, 'Who Introduced Maize into Southern Africa?', South Africa Journal of Science, Vol. 63, Johannesburg, 1963, pp. 23–40; A. de

Candolle, Origin of Cultivated Plants, 1967, p. 355. See also ch. 8, n. 20, and ch. 5, n. 18.

- 17 Ibid.
- 18 J.J.L. Duyvendak, China's Discovery of Africa, Probsthain, 1949, p. 32.
- 19 Wu Pei Chi and the Shun Feng Hsiang Seng, Beijing.
- 20 Chiu Thang Shu, quoted in J. Needham, *Science and Civilisation in China*, Vol. 4, sec. 20, Cambridge UP, Cambridge, 1954, p. 274.

Chapter 6: Voyage to Antarctica and Australia

- 1 Charles R. Darwin, Journal of Researches into the Geology and Natural History of the Various Countries Visited by HMS Beagle, 1832–36, 1839.
- 2 Ibid.
- 3 Antonio Pigafetta, *Magellan's Voyage*, trs. R.A. Skelton, Folio Society, 1975, p. 49.
- 4 Ibid.
- 5 Ibid., p. 50.
- 6 Ibid., p. 57.
- 7 Professor C.H. Hapgood, *Maps of the Ancient Sea Kings*, Chilton Books, New York, 1966, pp. 193ff.
- 8 Erich von Daniken, *Chariots of the Gods*, trans. M. Heron, Souvenir, 1969, p. 20.
- 9 British Admiralty Chart 554.
- 10 Ludovico Varthema, *Travels of L. de Varthema* (1510), trs. J.W. Jones, Hakluyt Society, 1863, p. 249. 'He told us that on the other side of the said island [Java]... there are some other races who navigate by the said four or five stars opposite to ours [the Southern Cross] and moreover... beyond the said island the day does not last more than four hours, and that it was colder than in any other part of the world.'
- 11 Ibid.
- 12 Longitude 70°W.
- 13 Latitude 60°S.
- 14 Latitude 64°S.
- 15 The Scott Polar Research Institute of Cambridge has kindly provided ice charts for the Antarctic.
- 16 As may be verified with the Microsoft computer program *Starry Night*.
- 17 See Note VI on the Piri Reis map, translated by G.C. McIntosh in *The Piri Reis Map of 1513*, University of Georgia Press, Athens, Georgia, 2000, pp. 16 and 17.

- 18 L. Carrington Goodrich (ed.), *The Dictionary of Ming Biography*, Columbia UP, New York, 1976, p. 1365.
- 19 Ibid., p. 199.
- 20 Zvi Dor-Ner, Columbus and the Age of Discovery, Grafton, 1992, p. 10, and Richard Hall, Empires of the Monsoon, HarperCollins, 1996, p. 92.
- 21 Vanessa Collingridge, Captain Cook, Obsession and Betrayal in the New World, Ebury, 2002.
- 22 K.G. McIntyre, *The Secret Discovery of Australia*, Souvenir, Melbourne, 1977, p. 268.
- 23 Ibid., p. 269.
- 24 Ibid., pp. 271ff.
- 25 See postscript for an update.
- 26 Ibid., p. 289.
- 27 Professor Wei Chuh-Hsien, *The Chinese Discovery of Australia*, Hong Kong, 1961.

Chapter 7: Australia

- 1 The southern portion of the map was based on a chart found on the person of a Spanish seaman captured by the Ottomans in 1501.
- 2 Hsi-Yang-Chi, quoted by J.J.L. Duyvendak in 'Desultory Notes on the Hsi-Yang-Chi', T'oung Pao, XLII, 1953, pp. 20ff.
- 3 Don Luis Arias, letter to the King of Spain, quoted in A.W. Miller, *The Straits of Magellan*, Portsmouth, 1884, p. 7.
- 4 F. Fernández-Armesto (ed.), *Times Atlas of World Exploration*, Times, 1991, p. 167.
- 5 Lin Dao, Sui Shu (official history of the Sui dynasty), AD 636, ch. 82.
- 6 32°40'S; 152°11'E.
- 7 43°42'S; 146°32'E.
- 8 Rex Gilroy, Pyramids in the Pacific, Gympie, Australia, 1999.
- 9 Robyn Gossett, New Zealand Mysteries, Auckland, 1996, p. 31.
- 10 Gilroy, op. cit.; Brett J. Green, *The Gympie Pyramid Story*, Gympie, Australia, 2000, and Gossett, op. cit., p. 148.
- 11 B. Hilder, 'The Story of the Tamil Bell', in *Journal of the Polynesian* Society, Vol. 84, 1975.
- 12 Elsdon Best, 'Note on a Curious Steatite Figurine Found at Mauku, Auckland', in NZ Journal of Science and Technology, Vol. II, 1919, p. 77.
- 13 Gossett, op. cit.

Chapter 8: The Barrier Reef and the Spice Islands

- 1 K.G. McIntyre, *The Secret Discovery of Australia*, Souvenir, 1977, and 'Early European Exploration of Australia', unpublished paper, p. 11.
- 2 China 29%, India 16% Angus Maddison, Class Structure and Economic Growth in India and Pakistan since the Moghuls, Allen & Unwin, 1971.
- 3 Those records seen by Fr Ricci and early Jesuit missionaries to China: *Chui Hiao* ('Atlas of Foreign Countries') and sixth-century scrolls telling of voyages of massive junks to Australia, and *The Classics of Shan Hai Jing*. Rex Gilroy, *Pyramids in the Pacific*, Gympie, Australia, 1999.
- 4 Saltpetre, copper, carbonates, haematites, quartz, amethyst, alum and cinnabar formed the first; the second comprised sulphur, mercury, feldspar, copper sulphate, magnetite, azurite and realgar; and the third group included stalagmites, iron, iron oxides, lead carbonate, lead tetroxide, tin, agate and fuller's earth. J. Needham, *Science and Civilisation in China*, Vol. 3, sec. 25, Cambridge UP, Cambridge, 1954, p. 643.
- 5 Ibid., pp. 653ff.
- 6 Warren, Delavault, Hawksworth and others. Ibid., p. 678.
- 7 Ibid., pp. 653ff.
- 8 For this information I am indebted to Brett Green, whose family recorded the Aboriginal songs and folklore of this coast. See Brett J. Green, *The Gympie Pyramid Story*, Gympie, Australia, 1998, and Gilroy, op. cit.
- 9 Needham, op. cit.
- 10 Gilroy, op. cit., and Green, op. cit.
- 11 Green, op. cit.
- 12 A. Grenfell Pike (ed.), *The Explorations of Captain James Cook in the Pacific*, Limited Editions Club, New York, 1957, p. 77.
- 13 Other cartographers of the Dieppe School depicted the Gulf differently: Desliens showed it narrower than it should be while Desceliers depicted it close to its actual size, suggesting that the Dieppe cartographers were using more than one Portuguese chart – a note on the Piri Reis map referred to four Portuguese mappae mundi.
- 14 Governor Grey, quoted in McIntyre, Secret Discovery, p. 79.
- 15 The date of this figurine has recently been disputed. Professor Needham, in Science and Civilisation in China, Vol. 4, Pt 3, p. 537 and at Fig. 991, states, 'The statuette is in style Ming or early Ching, quite reasonably contemporary with Cheng Ho.' He writes at p. 537, 'Wei Chu-Hsien (4), p. 99, concurs.' (This reference is to The Chinese Discovery of Australia, Hong Kong, 1960). Professor Needham further

cites H. Doré, *Recherches sur les superstitions en Chine*, Vol. XI, p. 966, and P.M. Worsley, 'Early Asian Contacts with Australia', in *Past and Present*, No. 7, 1955. The current curator of the Technological Museum in Sydney, where the statuette is housed, states, 'The Museum's preferred dating of this object is the early nineteenth century.'

- 16 Admiralty sailing instructions, Cook, op. cit.
- 17 Cdr A.W. Miller, RN, *The Straits of Magellan*, Griffin, Portsmouth, 1884, p. 7.
- 18 Don Luis Arias, letter to the King of Spain, quoted, ibid.
- 19 John Merson, Roads to Xanadu, Weidenfeld and Nicolson, 1989, p. 75.
- On maize found in the Philippines: M.D.W. Jeffreys, 'Pre-Columbian 20 Maize in Asia', in Carroll Riley et al. (eds), Men across the Sea, University of Texas Press, 1971, pp. 382ff.; E.L. Sturtevant, 'Notes on Edible Plants', New York State Department of Agriculture 27th Annual Report, 1919, p. 616 ('In 1521 maize was found by Magellan at the island of Limasava'); H.W. Krueger, 'Peoples of the Philippines', Smithsonian Institution War Background Studies No. 4, Washington DC, 1942, p. 23 (Pigafetta observing maize cultivation on Limasava); W. Richardson, General Collection of Voyages and Discoveries Made by the Portuguese and Spaniards during the 15th and 16th Centuries, 1789, p. 496 ('The islanders invited the General into their boats in which were their merchandise viz cloves ... and maize'; C.O. Saver, 'Maize into Europe', in Accounts 34th Int. Cong. Amer., Vienna, 1960, pp. 777-88 (Pigafetta's 'miglio' translated as maize); Antonio Pigafetta, Primo Viaggio intorno al Mondo, MS version of c. 1524 translated in E.H. Blair and J.A. Robertson, The Philippine Islands 1493-1893, 1906, pp. 164 and 182 (cakes of 'riso e miglio' on island of Zubu (Cebu)); Pigafetta, op. cit., p. 154 ('ears like Indian corn ... shelled off like lada'); J.J.L. Duyvendak, China's Discovery of Africa, Probsthain, 1949, p. 32.

Chapter 9: The First Colony in the Americas

- 1 11°N.
- 2 Peter Whitfield, New Found Lands: Maps in the History of Exploration, British Library, 1998, pp. 54–5.
- 3 Article by Dr Tan Koonlin in *The Rose* (journal of the American Rose Society), Vol. 92, Pt 4; R.E. Shepherd, *History of the Rose*, Macmillan, New York, 1954; E. Wilson, *Plant Hunting*, Vol. 2, Stratford, Boston, Mass., 1927.
- 4 Sacramento Bee, 26 January 2001, and Enterprise Record of Chico, 23 January 2001.

- 5 Carey McWilliams, *Factories in the Field*, University of California Press, Berkeley, 2000, pp. 68–80.
- 6 Stephen Powers, 'Aborigines of California: An Indo-Chinese Study' in Atlantic, Vol. 33, 1874, and Stephen Powers, Contributions to North American Ethnology, Vol. 3, Department of the Interior, Washington DC, 1877.
- 7 Powers, Ethnology, p. 417.
- 8 All ibid., introduction and pp. 146-434.
- 9 Referring to California's East Bay walls in John Fryer, Ancients in America.
- 10 Fra Bernardino de Sahagún, The Florentine Codex: General History of the Things of New Spain 1325–1550, School of American Research, Santa Fe, 11 vols, 1950–69.
- 11 Bernardino Diaz del Castillo, *The Conquest of New Spain*, New York, 1956.
- 12 Barbara Pickersgill, 'Origin and Evolution of Cultivated Plants in the New World', *Nature*, 268 (18), pp. 591–4.
- 13 Alberto Ruz Lhuillier, 'The Mystery of the Temple of the Inscriptions', Archaeology, Vol. 6, No. 1, 1953, as quoted by Charles Gallenkamp in Maya: The Riddle and Rediscovery of a Lost Civilisation, Penguin, Harmondsworth, 1987, pp. 93–104.

Chapter 10: Colonies in Central America

- Lacquering is described by Fra Bernadino de Sahagún in *The Florentine Codex: General History of the Affairs of New Spain 1325–1550*, trs. A.J.O. Anderson and C.E. Dibble, Salt Lake City, 1970.
- 2 Ma Huan, *The Overall Survey of the Ocean Shores*, trs. J.V.G. Mills, Cambridge UP (for Hakluyt Society), Cambridge, 1970.
- 3 H. Mertz, Gods from the Far East: How the Chinese Discovered America, New York, 1972, pp. 72–3.
- 4 Stephen C. Jett, 'Dyestuffs and Possible Early Contacts between South Western Asia and Nuclear America', in *Across before Columbus*?, NEARA Publications, Edgecomb, Maine, 1998, pp. 141ff.
- 5 Ibid., p. 146.
- 6 De Sahagún, op. cit.
- 7 An attempt is being made to compare DNA of Michoacán dogs with that of shar-peis. The results will be posted on the website.
- 8 Nicolás León, 'Studies in the Archaeology of Michoacán: The Lienzo of Jucutácato', in Smithsonian Institution Annual Report, Washington DC, 1889.

- 9 J. Needham, *Science and Civilisation in China*, Vol. 4, Pt. 3, Cambridge UP, Cambridge, 1954, pp. 540–3.
- 10 The Peruvian historian Pablo Padron, 'Un Huaco con Caracteres Chinos', Sociedad Geográfica de Lima, Vol. 23, pp. 24–5.
- 11 Carl Johannessen and M. Fogg, 'Melanotic Chicken Use and Chinese Traits in Guatemala', in *Revista de Historia de América*, Vol. 93, 1962, p. 75.
- 12 W.C. Parker and A.G. Bearn, Annals of Human Genetics 25, 1961 (227).
- 13 Padron, op. cit.
- 14 This is the only part of the *I Yü Thu Chih* to have been translated by Viviana Wong, to whom I am most grateful.
- 15 In the Atlas of Foreign Countries, anon., AD 265–316, China.
- 16 K.G. McIntyre, *The Secret Discovery of Australia*, Souvenir, Melbourne, 1977.
- 17 J.L. Sorenson and M.H. Raish, Pre-Columbian Contact with the Americas across the Oceans: An Annotated Bibliography, Provo Research Press, 1990.
- 18 George F. Carter, 'Fusang: Chinese Contact with America', in *Anthropological Journal of Canada*, 14, No. 1, 1976.

Chapter 11: Satan's Island

- 1 [British] Admiralty, Ocean Passages of the World, third edn, 1973.
- 2 Armando Cortesão, *The Nautical Chart of 1424*, University of Coimbra, Portugal, 1954, pp. 105 and 110.
- 3 Bartolomeu las Casas, Historia de las Indias, Lisbon, 1552.
- 4 Antonio Galvão, *Tratado Dos Diversos e Desayados Caminhos*, Lisbon, 1563, and Cortesão, op. cit., p. 73.
- 5 Dr Chanca, quoted in J.H. Longille, *Christopher Columbus*, Inscribers, Washington DC, 1903, p. 184.
- 6 Chanca, ibid., p. 187.
- 7 Ibid., p. 184.
- 8 Syllacius, quoted, ibid., pp. 184ff.
- 9 Chanca, quoted, ibid., pp. 181 and 182.
- 10 See the website for more detailed information.
- 11 Letters between Smithsonian Institution, Washington DC, and author, 6 and 7 July 2002.
- 12 Syllacius, quoted in Longille, op. cit., pp. 184ff.
- 13 Ibid., p. 185.
- 14 This is explained in more detail on the website.
- 15 Inscription translated by J.J.L. Duyvendak, *China's Discovery of Africa*, Probsthain, 1949, p. 28.

- 16 4403, 3912 and 2710 (see the website for more detailed information).
- 17 3912.
- 18 77°30'W between 23°10' and 23°50'N.

Chapter 12: The Treasure Fleet Runs Aground

- 1 2710, 3810 and 3912.
- 2 F.L. Coffman, Atlas of Treasure Maps, New York, 1957.
- 3 26, 61, 63 and 64 in Coffman's numbering system.
- 4 27, 28, 29 and 30 in Coffman's numbering system.
- 5 Peter Martyr, quoted in E.W. Lawson, *The Discovery of Florida and Its Discoverer Juan Ponce de León*, 1946, p. 8.
- 6 Martyr, quoted, ibid., p. 11.
- 7 The Undersea World of Jacques Cousteau and the TV series In Search Of ... Atlantis, narrated by Leonard Nimoy, Channel 4 (UK) and National Geographical Channel (USA).
- 8 Dr David Zink's discoveries are featured in two books, *The Ancient Stones Speak*, Dutton, 1979, and *The Stones of Atlantis*, W.H. Allen, 1978.
- 9 J. Needham, *Science and Civilisation in China*, Vol. 4, Pt 3, Cambridge UP, Cambridge, 1954, p. 669.
- 10 This was confirmed by the Old Dominion University of Virginia, to which Dr Zink sent samples.
- 11 Alemanide, rhaotide and celtide.
- 12 At Christie's.
- 13 Washington Irving, *Life and Voyages of Christopher Columbus*, quoted in Loren Coleman, *Mysterious America*, Faber, 1983, p. 218.
- 14 Ferdinand Columbus, *La Historia della Vita di Cristoforo Columbus*, Milan, 1930.

Chapter 13: Settlement in North America

- 1 Francis I, King of France, to Verrazzano, quoted in D.B. Quinn (ed.), North American Discovery, Harper & Row, 1971.
- 2 The account of Verrazzano's voyage is given in his letter of 8 July 1524 to Francis I, quoted, ibid., p. 65.
- 3 Ibid.
- 4 Suzanne O. Carlson's finds were published in an article on the internet on 4 March 2002: www.neara.org/carlson/atlantic.html.
- 5 Professor F.J. Pohl, Atlantic Crossings before Columbus, W.W. Norton, New York, 1961, pp. 185ff.

- 6 Marco Polo, *The Travels of Marco Polo*, trs. R. Latham, Penguin, Harmondsworth, 1958, p. 237.
- 7 William S. Penhallow, 'Astronomical Alignments in the Newport Tower', in Across before Columbus?, NEARA Publications, Edgecombe, Maine, 1998, pp. 85ff.
- 8 This is explained more fully in chapter 15.
- 9 E.R. Snow, Tales of the Atlantic Coast, Redman, 1962, p. 19.
- 10 Ibid., pp. 26ff.
- 11 David Borden, of Marblehead, Massachusetts, and his friend Fred Chester, who grew up near the Dighton Rock State Park, gave me this information.
- 12 Borden to author.
- 13 Borden to author.
- 14 A full list, together with a photograph, is shown on the website.

Chapter 14: Expedition to the North Pole

- 1 Manuel Faria de Souza, *Epítome de las Historias Portuguesas*, Madrid, 1638 (my translation of his Medieval Castilian).
- 2 Rebecca Catz, 'Spain and Portugal and the Navigators', unpublished paper presented 25 September 1990, Washington DC.
- 3 About 51°40'W.
- 4 Quoted in Farley Mowat, *The Farfarers: Before the Norse*, Seal Books, Toronto, 1998, p. 176.
- 5 Pope Nicholas V, quoted ibid., p. 308.
- 6 Peter Schlederman, *Voices in Stone*, Calgary, Canada, 1996, and Mowat, op. cit. Although my conclusions differ from those drawn by Peter Schlederman and Farley Mowat, I rely heavily on their research, without which this chapter could not have been written.
- 7 Schlederman, op. cit., p. 127.
- 8 Canadian Government maps of the Canadian Arctic (Hydrographic and Map Service of Canada, Map X1734); *Eskimo Maps of the Canadian Eastern Arctic* by John Spink and D.W. Moodie (1972); the Sea Ice Atlas of Arctic Canada, published by the Ottawa Department of Energy, Mines and Resources, 1982, and the map of Greenland drawn by the Geo Daetisk Institut of Copenhagen, 2000.
- 9 Ferdinand Columbus, *La Historia della Vita di Cristoforo Columbus*, Milan, 1930, quoting a now lost memorandum by his father, seeking to prove that the Arctic was habitable.
- 10 Catz, translation of Columbus's note in a copy of Pope Pius II, *History of Remarkable Things that Happened in My Time*, in op. cit.

11 J. Needham, *Science and Civilisation in China*, Cambridge UP, Cambridge, 1954.

Chapter 15: Solving the Riddle

- 1 Antonio Galvão, *The Discoveries of the World*, Hakluyt Society, 1862, p. 369.
- 2 The Portuguese historian Castaneda.
- 3 Eric Axelson (ed.), *Dias and His Successors*, Saayman & Weber, Cape Town, 1988, p. 66.
- 4 The Jesuit Father Monclaro, 1569, quoted in Louise Levathes, *When China Ruled the Seas*, Simon & Schuster, 1994, p. 198.
- 5 N. Puccioni, *Giuba e OltreGiuba* ('The River Juba and Beyond'), Florence, 1937, p. 110.
- 6 Levathes, op. cit., p. 199.
- 7 H.D. Howse, *Greenwich Time and the Discovery of Longitude*, National Maritime Museum, Greenwich, 1980, p. 2.
- 8 J. Needham, citing *History of the Yan Dynasty*, in *Science and Civilisation in China*, Vol. 3, Pt 2, sec. 20, Cambridge UP, Cambridge, 1954, p. 398, and La Place calculations, p. 299.
- 9 Ibid., p. 369.
- 10 Ibid., p. 392.
- 11 Those wishing to marvel at the ingenuity of these astonishing devices will find an illustration of the polyvascular type in a Chinese encyclopedia, the Shi Lin Kuang Chi of 1478, held by Cambridge University Library, England.
- 12 Marco Polo, *The Travels of Marco Polo*, trs. R. Latham, Penguin, Harmondsworth, 1958, p. 288.

Chapter 16: Where the Earth Ends

- 1 Francisco Alcaforado, report of proceedings to Prince Henry the Navigator.
- 2 Gomes Eannes de Zuzara, *The Chronicle of the Discovery and Conquest of Guinea*, trs. C.R. Beazley, Hakluyt Society, 1896–9.
- 3 E.D.S. Bradford, Southward the Caravels, Hutchinson, 1961, p. 8.
- 4 Vasco Lobeira, Amadis de Gaul, ed. and trs. R. Southey, 1872.
- 5 Malcolm Letts (ed. and trans.), *Mandeville's Travels*, Hakluyt Society, 1953, p. 116 (Egerton text), p. 321 (Paris text). Mandeville was an English squire with a vivid imagination that allowed him to describe far-off

lands without visiting them.

6 Ibid.

- 7 Camões, Os Luciades ('The Luciads'), Lisbon, 1572.
- 8 This is a simplified explanation; there are refinements to take into account the earth's tilt and curvature.
- 9 Quoted in F.M. Rogers, *The Travels of the Infante Dom Pedro of Portugal*, Harvard UP, Cambridge, Mass., 1961.
- 10 Ibid.
- 11 I have used the chronology of Oliveira Martins, but the precise details of Dom Pedro's itinerary are disputed by different historians. The confusion arises because many countries used different calendars, and because Dom Pedro made not one but many journeys between 1416 and 1428. It is most probable that he left Portugal again in 1419 to visit the Emperor Sigismund and served the Emperor in the wars against the Ottomans. He then settled in Treviso and visited Venice in the summer of 1421, as soon as another war, between the Emperor and Venice, was over. He then went to Egypt in 1424, returning via England (1426) and Venice again (1428) to Portugal.
- 12 Antonio Galvão, *The Discoveries of the World*, Hakluyt Society, 1862. See p. 107.
- 13 For the connection between Niccolò da Conti and 'Bartholomew the Florentine', see F.M. Rogers, op. cit., pp. 42 and 264; Gustavo Uzielli, La Vita e i Tempi di Paolo dal Pozzo Toscanelli, Rome, 1894, and W. Sensburg, Poggio Bracciolini und Niccolò da Conti, Vienna, 1906. For the connection between Toscanelli and 'Bartholomew the Florentine', see Gustavo Uzielli, Paolo dal Pozzo Toscanelli: Iniziatore della Scoperta d'America, Florence, 1892; Sidney Welch, Europe's Discovery of South Africa; Arnold J. Pomerans, The Great Age of Discovery, New York, 1958, p. 18, and P. Kermann, Zeigt Mir Adams Testament. For the connection between Toscanelli and Dom Pedro, see Uzielli, Toscanelli: Iniziatore, p. 76. For the connection between 'Bartholomew the Florentine' and Martin Behaim, see F.M. Rogers, The Quest for Eastern Christians, University of Minnesota Press, 1962, pp. 42 and 95.
- For Niccolò da Conti, see: (i) G. Uzielli, La Vita e i Tempi di Paolo dal Pozzo Toscanelli, Rome, 1894, pp. 10, 11, 63, 90, 122, 141, 154–75, 189–92, 228, 246, 386, 566–7; (ii) 'The Travels of Niccolò da Conti', partial translation in R.H. Major (ed.), India in the Fifteenth Century, Hakluyt Society, 1857; (iii) W. Heyd, Histoire, Vol. 1, 1885, pp. 378, 380; (iv) V. Bellemo, Nicolo da Conti, 1882, pp. 331–47; C. Desimoni, Pero Tafur, 1882, pp. 331–47; (vi) F. Kunstman, Afrika vor den Entdeckungen der Portugiesen, Aufrosten der Academie, Munich, 1853. For 'Bartholomew the Florentine', see: (i) Uzielli, La Vita e i Tempi, pp. 63, 165–6; (ii) T. de Mura, M. Behaim, Treutel et Wurz, Strasbourg, 1802, pp. 33–5; (iii) p. Amat (ed.), Studi Bibliografichi in Italia, Pt 1, Ed.

2, Rome, 1882, p. 123.

For Pope Eugenius IV (Gabriele Condulmaro), see Uzielli, *La Vita e i Tempi*, p. 166: 'Gabriele Condulmaro poteva essere a Venezia nel 1424, ma non era ancora Papa, essendo stato assunto alla tiara soltanto nel 1431.'

For Bartholomew of Florence's journey, see Uzielli, *La Vita e i Tempi*, p. 63: 'Ecco ciò che ne dice maestro Bartolomeo Florentino che tornò dalle Indie nel 1424 e che accompagnò a Venezia il Papa Eugenio IV, e al quale raffontò ciò aveva veduto e osservato in un soggiorno di ventiquattro anni in oriente.'

- 15 See n. 13.
- 16 Paolo Toscanelli, letter to Columbus, in H. Vignaud, *Toscanelli and Columbus*, Sands, 1902, pp. 322 and 323.
- 17 Also known as 'Behaim' and 'Martin of Bohemia'. See note 13.
- 18 Antonio Pigafetta, Magellan's Voyage, trs. R.A. Skelton, New Haven, Conn., 1969, pp. 58ff.
- 19 See ns 13 and 14.
- 20 See ns 13 and 14, and p. 107.
- 21 See n. 13.

Chapter 17: Colonizing the New World

- 1 Antonio Galvão, *Tratado Dos Diversos e Desayados Caminhos*, Lisbon, 1563, and Antonio Cordeyro, *Historia Insulana*, Lisbon, 1717, quoted in H. Harrisse, *The Discovery of North America*, 1892, p. 51.
- 2 J.H. Longille, *Christopher Columbus*, Inscribers, Washington DC, 1903, p. 191.
- 3 Extract from Columbus's notebook, quoted in Bartolomeu las Casas, *Historia de las Indias*, Lisbon, 1552.
- 4 Galvão, op. cit., p. 370.
- 5 Those of Andrea Bianco in 1448; Grazioso Benincasa in 1463, 1470 and 1482; Andrea Benincasa in 1476, and Albino Canepa in 1480 and 1489.
- 6 Cf. Armando Cortesão, *The Nautical Chart of 1424*, Coimbra, 1954, p. 106.
- 7 Carol Urness, *Portolan Charts*, James Ford Bell Library, University of Minnesota, 1999.
- 8 Published by the Lisbon Academy of Sciences.
- 9 For coffee in Puerto Rico before European voyages, see D. Maclellan, 'Coffee Varieties in Puerto Rico', *Puerto Rico Agriculture Station Bulletin* No. 30, Mayaguez, Puerto Rico, 1924; P.C. Stanley, *The Rubiaceae of Central America*, Chicago, 1930 (Field Museum of Natural History, Botanical Series Vol. 7, no. 1); E.C. Hill, *Coffee Planting*, Higginbotham, Madias, 1877, pp. 1–3 and 17–19; E.R. Thurber, *Coffee from Plantation to*

Cup, American Grocer Publishing Association, New York, 1881, intro. and pp. 4-5.

- 10 Produce photographed at Mayaguez Agricultural Station.
- 11 Albino Canepa: the domain of *saluagio viúadi (nom vulgar des alguns brasilieros)*, the common name for people coming from Brazil, the Caribs.
- 12 Using the average flows described in the Admiralty's Ocean Passages of the World and the relevant Admiralty pilots.
- 13 To date I have only studied the catalogue of Prince Youssuf Kamal to see how many corrections or additions were made to Antilia. This discloses fourteen before Columbus set sail: by the Beccarios (1435 and 1436), Andrea Bianco (1436 and 1448), Parreto (1455), the Benincasas (1463, 1470, 1476 and 1482), Toscanelli (1474), the Canepas (1480 and 1489), Jaime Bertram (1482) and Christofal Soligo (1489).
- 14 Prince Youssuf Kamal, *Monumenta Cartographica Africae et Aegypti*, 16 vols, Cairo, 1926–51. This catalogue lists an enormously valuable collection of surviving charts and maps showing European and Chinese exploration of West Africa.
- 15 Quoted in E.D.S. Bradford, *Southward the Caravels*, Hutchinson, 1961, p. 107.

Chapter 18: On the Shoulders of Giants

- 1 João de Barros, letter to the future King Manuel of Portugal, quoted in Eric Axelson, *Dias and His Successors*, Cape Town, 1988, p. 3.
- 2 K.G. Jayne, Vasco da Gama and His Successors 1460–1580, Methuen, 1970, p. 36.
- 3 João de Barros, letter to the King of Portugal, 1 May 1500, quoted in Jaime Batalha Reis, *Estudios Géográficos y Históricos*, Ministry of Colonial Affairs, Lisbon, 1941, p. 286.
- 4 S.E. Morison, *Portuguese Voyages to America in the Fifteenth Century*, Harvard UP, Cambridge, Mass., 1940, p. 131.
- 5 See chs 5 and 6, where these matters are considered in detail.
- 6 As above, and ch. 8.
- 7 Sebastian Alvarez, the King of Castile's factor, quoted in Cdr A.W. Miller, RN, *The Straits of Magellan*, Griffin, Portsmouth, 1884, p. 7.
- 8 *The Journal of Columbus*, trs. Cecil Jane, revised and annotated by L.A. Vigneras, Anthony Blond and Orion Press, 1960, pp. 12, 43 and 62.
- 9 H. Vignaud, Toscanelli and Columbus, Sands, 1902, p. 323.
- 10 Toscanelli, letter to the King of Spain, 1474, quoted in J.H. Parry, *The Discovery of South America*, Elek, 1979, p. 48.
- 11 Note VII on the Piri Reis map, translated by G.C. McIntosh in *The Piri Reis Map of 1513*, University of Georgia Press, Athens, Georgia, 2000, p. 46.

- 12 Arthur Davies, 'Behain, Marcellus and Columbus', *Geographical Journal*, Vol. 143, p. 454.
- 13 A.O. Vietor, 'A Pre-Columbian Map of the World circa 1489', *Imago Mundi* xvii, 1963.
- 14 Davies, op. cit., p. 458.
- 15 Davies, op. cit.
- 16 Lord Palliser, Captain Cook's commander.
- 17 K.G. McIntyre, *Early European Exploration of Australia*, unpublished paper, p. 12.

Epilogue: The Chinese Legacy

- 1 Barbara Pickersgill, 'Origin and Evolution of Cultivated Plants in the New World', *Nature* 268 (18), pp. 591–4.
- 2 R.A. Whitehead, Evolution of Crop Plants, Longman, 1996, pp. 221-5.
- 3 F. Braudel, *A History of Civilisations*, trs. R. Mayne, Penguin, 1994, pp. 158–9.
- 4 Judith A. Carney, Professor of Geography at the University of California, Los Angeles, has written a fascinating book, *Black Rice: The African Origins of Rice Cultivation in the Americas* (Harvard UP, Cambridge, Mass., 2001), which tells the story of the true origins of rice in the Americas and argues that the standard belief that Europeans introduced rice to West Africa and then brought the knowledge of its cultivation to the Americas is a fundamental fallacy.
- 5 Roderich Ptak, 'China and Calicut in the Early Ming Period: Envoys and Tribute Emissaries', in *Journal of the Royal Asiatic Society*, 1989, St 447, and private letters between Professor Ptak and the author.
- 6 Cochin tablet, 'Taizong Shi Lu', ch. 183, quoted in Louise Levathes, When China Ruled the Seas, Oxford UP, Oxford, 1996, p. 145.
- 7 Gaspar Correa, *The Three Voyages of Vasco da Gama*, trs. H.E.J. Stanley from *Lendas da India*, 1869.

Postscript

- 1 See Chapter 9.
- 2 Leon Poutrin, 'L'origine Chinois de Anciennes Civilisations de Mexico et du Peru', in *Journal de la Société des Américanistes de Paris*, 1913.
- 3 Francisco A. Loayza, Chins Ilegaron antes que Colon: Tesis arqueológica, transcendental, sustenada por 150 de los más famosos autores, antiguos y modernos, Lima, Peru, 1948, pp. 44–45.
- 4 Journal de la Société des Américanistes de Paris 10 (1913), p. 303.
- 5 Grant Keddie, 'Contributions to Human History', Royal British

Columbian Museum Publication, No. 3, 19 March 1990, Victoria, B.C., Canada.

- 6 Letter from Professor Hummel (an expert on medieval Chinese art), 29 August 1927, quoted in Keddie, op. cit.
- 7 Professor Hummel, op. cit.
- 8 Hugo Grotius, On the Law of War and Peace, London, 1884, p. 18.
- 9 Lee Eldridge Huddleston, Origins of American Indians, University of Texas Press, Austin, 1967, p. 27.
- 10 Pedro de Castaneda, *The Journey of Coronado, 1540–42*, trs. George Parker Winship, Dover Publications, New York, 1933.
- 11 de Castaneda, op. cit.
- 12 M. De Guignes, Memoires, Paris, 1761, p. 31.
- 13 Jose de Acosta, Historia natural y moral de las Indias, Seville, 1590, p. 140.
- 14 João Barbosa Rodrigues, Estudo da origen Asiatica da civilizção Amazónica, Manaus, Brazil, 1889.
- 15 'Nouvelles Découvertes sur les Société Complexes d'Amazonie,' *Le Monde*, Paris, 7 September 2002.
- 16 At the semiannual meeting of the American Antiquarian Society Proceedings, 28 April 1886, F.W. Putnam exhibited specimens of jade from old and new worlds and appended a letter from the chemical laboratory of Harvard University, stating that the three Central American specimens of jade it had tested were 'unquestionably Chinese jade'.
- 17 Gaspar de Carvajal, The Discovery of the Amazon, 1542.
- 18 In about 16° 01'S, 52° 20'N.
- 19 Harold T. Wilkins, Secret Cities of Old South America, New York, 1952.
- 20 Blackmore's Magazine, January 1933, quoted in Colonel Percy Fawcett, Lost Trails, Lost Cities, New York, 1953.
- 21 See Frank Joseph, *The Lost Pyramids of Rock Lake: Wisconsin's Sunken Civilization*, Galde Press, Lakeville, Minn., 1992.
- 22 John Shulak of Lake Mill, quoted in Janesville, Wis. *Gazette*, 7 June 1989.
- 23 Newsletters of the Louisiana Mounds Society, January-March 1990.
- 24 Laurence I. Lambe, quoted in T. L. Tanton in *Geological Survey of Canada Memoir* 167, Ottawa, 1931.

Adams, Mount, 160, 161 Africa: ambassadors, 118; animals and birds from, 58, 60, 122; Cantino chart, 367; colonies, 84; inhabitants, 190; maps of, 128-31, 375-7; mining, 218; plants from, 443; Zheng He's expeditions, 100-1,105 Aghulas current, 124-5 Alarcón, Hernando de, 238 Aldrovandi, Ulisse, 158 Alfonso, Diego, 134 alum, 220 Alvarez, Sebastian, 232 amaranth, 240 Amazon delta, 146, 158, 424 ambergris, 60, 63, 198 anchors, 227, 450 Andaman Islands, 375 Andes, 32, 34 Andros Island, 300, 303 animals indigenous in one continent found in another, 38, 543-4, see also chickens, dogs, giraffes, horses, kangaroos, ostriches, otters Annam, 58, 59, 79, 189 Antarctic Circle, 176 Antarctica: Chinese exploration, 37; Hong Bao's expedition, 176-9, 182-3, 318, 436; ice, 148; maps of, 32, 34, 155, 178, 182, 452; uninhabited, 190 Antilia, island of: on Benincasa map, 406, 407; on Canepa chart, 410; Columbus's voyages, 397, 427; on Piri Reis

chart, 285; on Pizzigano chart, 29-30, 284, 295, 298, 406, 408, 411, 413-15, 426; place names, 406-12; Portuguese expedition, 31, 285, 403-5, 414-15, 426; Puerto Rico identification, 30, 295-9, 403–12, 414–15, 426; on Rotz chart, 285; size, 413; on Toscanelli chart, 397, 426 Antonio of Fez, 134 Arab: astronomy, 392-3; dhows, 291-2; maps, 121, 377, 388-9; navigators, 128, 377, 392-3; ports, 101, 363; traders, 101. 121, 388–9 Arends, Tulio, 266 Arias, Don Luis, 199, 318 Aristotle, 91 armour, 242 Arnhem Land, 225-7, 318 Arnold, Benedict, 328 Arrorado Island, 210 arsenic, 220 Arughtai, 80-1 asbestos, 220 astronomy: Arab, 392-3; Chinese tradition, 54-5, 89-92; Newport Round Tower, 331-2; Western, 91; Zhu Di's interest, 54-5, see also eclipses, latitude, longitude, observation platforms, observatories Atahualpa, 157 Auckland Island, 206-8 Australia: animals, 202; Chinese presence, 37, 84, 188–91, 203-6, 272-3, 318, 450; Cook's

Australia (cont.) voyages, 32, 186, 229, 434-5, 436; on Dieppe School maps, 435; Hong Bao's voyage, 185, 188-91, 202; maps of, 32, 186-8; on Piri Reis map, 206; on Rotz chart, 186-8, 190, 206, 435; wrecks, 188-9, 205-6, 450; Zhou Man's voyage, 191, 202-8, 222-4 Aylmer, Charles, 270, 271 Azores: Chinese presence, 332, 337, 343-5, 421, 455; Gulf Stream, 325; Portuguese colony, 415-16, 421 Aztecs, 198, 250 Bache Peninsula, 352–3 Baillie, Mike, 355 Bajun Islands, 365–7 ballast, 315 bananas, 442, 445, 447 Banks, Joseph, 229, 435 banyan tree, 227-8 Barouwi, Al, 388 Barrier Reef, see Great Barrier Reef Barros, João de, 423 Barsbey, Sultan, 139 Bastida, Rodrigo de, 282 Behain, Martin, 173, 397, 431 Beijing: defence of, 48-9; distances from, 162; envoys to, 62, 63-4, 98, 105, 114; fire damage, 75, 435, 454; Forbidden City, 53, 54, 57-9, 62-4, 75, 105, 114, 435, 454, 455; Grand Canal, 56-7, 58,

59; latitude, 162; name, 47; observatory, 54; Zhu Di's capital, 53, 55-6, 59, 62 bells, 210, 212, 262 Bengal, 105 Benguela current, 125 Benincasa, Grazioso, 406, 407 Berry Islands, 303-4, 307 Best, Eldon, 212 Biafra, Bay of, 128, 130, 131 Bianco, Andrea, 403, 414, 423, 426 Biblioteca Nazionale Marciana, 121 Bimini Islands, 307–17, 332 Bimini Road, 310–16 Bird Island, 183 birds, 60, 156–9, 184 Bisagudo, see da Cunha Bittangabee Bay, 203 Bjornsdottir, Sigrid, 349, 351 Bonnisegni, 396 Borneo, 64, 190 Bougainville, Louis-Antoine de, 197, 318–19 Boyd, Benjamin, 203 Brazil, 145, 146, 148, 158, 423, 426 Brisbane, 217, 223 British Library, 121, 185-6, 231, 293, 295, 377, 406 Brunswick Peninsula, 170 Buddhism, 67, 95, 98, 133, 262, 271 Burma, 66, 228, 262, 265 Byron Bay, 203, 205 Byzantium, 368, 396, 397

Cà da Mosto, Alvise, 133, 134 Cabo Blanco, 148 Cabral, Gonzalo Velho, 403 Cabral, Pedro Álvares, 124, 376, 423, 425, 452 Cahill, Thomas, 347, 349 Calicut (Ku-Li): ambassadors, 64; Chinese base, 100, 113-14, 118, 375; Chinese inscriptions, 120, 133, 137; da Conti's account, 115-17, 398; da Gama's voyage, 376, 455; dyes, 260; gold cloth from, 60; Hong Bao's expedition, 163; Kerala capital, 135; Ma Huan's account, 114-15, 116-18, 137; trading port, 66, 102, 113-14; Zheng He's expeditions, 105 California: agriculture, 245; Chinese colony, 245-7; Chinese roses, 240, 248, 443; current, 237; maps of, 238-9, 240; Ming ceramics, 241; Sacramento wreck, 241-4; Zhou Man's voyage, 238, 245, 247 Cambodia, 105, 186 Camilo dos Santos, João, 31, 289 Campbell Island, 206-8, 217, 222 Canary Islands, 181, 285, 416, 421, 423 Canepa, Albino, 410, 411 cannibalism, 286-7 Canopus: navigation by, 36, 161-3, 190, 197, 202, 363; position of, 161-2, 170-1, 175, 222; visibility, 178, 181, 184

Cantino, Alberto, 299, 426 Cantino map: African coast, 375, 376; Bimini position, 309-10; Caribbean, 299, 300-3; Chinese voyages, 347, 363; date, 325; Florida coast, 323; genuine, 436, 449; longitudes, 367-8; origins, 239, 299 Cape Bojador, 416-7 Cape Canaveral, 323 Cape Hatteras, 325 Cape Horn, 125, 178 Cape of Good Hope: author's voyage, 113; Cabral's voyage, 124; Chinese voyage, 37, 124-7, 130; da Gama's voyage, 33; Dias's voyage, 33, 122, 124, 428, 430; on Fra Mauro's map, 122-3, 124, 174; Kangnido map, 128, 137; latitude, 428; Portuguese expeditions, 325, 424, 427; winds and currents, 124-7; World Map (1428), 139, 140, 363-4, 395, 421 Cape Town, 113 Cape Verde Islands: author's voyage, 113; Chinese voyage, 131-6, 137, 145, 281-2, 345; Indian voyage, 135; landscape, 132-3, 343; Portuguese

voyages, 423; Stone of Letters, 134–6, 334, 336–7, 450; winds and currents, 140, 281–2, 421 caravels, 391–2, 393

carbon-dating, 242-3, 290, 329

Caribbean: Chinese voyage, 282–3, 286, 333, 337; coconuts, 443–4; Columbus's voyage, 30,

Caribbean (cont.) 286; maps of, 30-2, 239, 299-303; winds and currents, 281 - 2Caribs, 286-7, 293-4 Carlson, Suzanne O., 328-30 Carney, Judith A., 245 Caroline Islands, 200 Carpentaria, Gulf of, 224, 227 Carter, George F., 273 Carteret, Philip, 197 Castilian language, 407–9 Catalan: charts, 284, 429; language, 407-8 Cathay, 397 Catherine de Valois, 63 Caverio map, 239 Celestial Spouse, Palace of the, 111, 120 Ceuta, 386, 387-8, 394 Chêng Lei Pên Tshao, 68 Chevalier, M., 134 Chanca, Dr, 286 Chiang-su, inscription, 111-12 chickens: in America, 156-9, 199, 222, 248, 264, 265-6, 273, 424, 443, 450; Asiatic, 156-8, 199, 222, 240, 248, 264, 265, 266, 424, 443, 450; Chinese gifts of, 69; divination by, 97, 157, 248, 266 Chile, 158, 174, 197 Cholula ware, 198, 253, 268 Chu Ssu Pen, 281 circumnavigation, Magellan's, 34, 172, 230, 325, 436 Clavius, Claudius, 348 Clutton-Brock, Juliet, 169

Cochin: ambassadors, 64; carved stone, 120, 133, 137, 210; Chinese base, 375; Chinese influence, 447 cochineal, 260 coconuts, 102, 240, 410, 442, 443-4, 447 coffee, 409–10 Coffman's treasure atlas, 307 Colenso Bell, 210-12 Colombia, 199, 269 Columbus, Bartholomew, 427, 428-34 Columbus, Christopher: Azores evidence, 345; books, 430-1; on Brazil, 423; Caribbean voyages, 30, 33-4, 282, 285-8, 289, 292-4, 297, 403-5, 442; Cuba colony, 317-18; 'discoveries', 38, 425, 436, 442, 456; forgery, 428, 434; Iceland voyage, 355; maps, 139-40, 301, 426-8, 436; marriage, 426; ships, 70; on South America, 146-8; Toscanelli's letters, 397-8, 426, 437; voyages, 427 - 8compass, 92, 181, 392, 412 concubines, 63, 75, 97-9, 323, 327, 337, 339 Confucianism, 49-50, 64, 67, 82-3,91 Confucius, 49-50, 58 Conti, Niccolò da: account of travels, 115-18, 228-9, 260, 268; career, 115, 396; connection with Chinese fleet, 116, 413, 435; connection with

Fra Mauro chart, 123, 128, 132, 135-6, 146; connection with Portugal, 396-9, 413, 436; description of junks, 116, 334 Cook, James: Australian voyages, 32, 186, 229, 434-5, 436, 456; 'discoveries', 38, 186, 435, 436; maps, 223–4, 435–6; in New Zealand, 446; scientific expedition, 69 Cook Bay, 174, 176 copper: Australian mining, 221; Chinese coins, 82; Chinese mining, 218–19, 316, 354; Fiji mining, 200; in Greenland, 353, 354; Mexican, 261, 264; prospecting for, 218; uses, 220 Coral Island, 210 Coronado, Francisco Vázquez de, 238 Correa, Gaspar, 455 Cortreal, Miguel, 336 Corvo, 343-5, 455 Cosa, Juan de la, 282 cotton, 64, 445, 446-7 Cousteau, Jacques, 311 Covilha, Pêro da, 364, 421 Crab Nebula supernova (1054), 55, 266 crew, 95, 267, 323, 375-6 Cuba, 299–300, 317–18 Cunha, Pêro da (Bisagudo), 423 currents: Aghulas, 124-5; Atlantic, 125, 130-1, 140, 281-2, 345-6; Pacific, 197, 199, 237

da Gama, see Gama Dalrymple, Alexander, 435 Danforth, Mr, 334-5 Daniken, Erik von, 452 Dar es Salaam, 113 Darwin, 227-8, 450 Darwin, Charles, 152, 169, 171 Dati, Giuliano, 404 Datini, Francesco, 62 Dauphin chart, 217, 229, 435 Davies, Arthur, 429, 432 de Sousa Tavares, Francis, 138 Deception Island, 179, 182, 183 Delabarre, Professor, 336 Desceliers chart, 217, 435 Desliens chart, 217, 435 d'Este, Duke Ercole, 299 dhows, 366, 389, 391 Dias, Bartolomeu: Cape of Good Hope voyage, 33, 122, 124, 364, 421–2, 427, 428, 452, 456; 'discoveries', 364, 425; map, 421, 435; Martellus map, 429-30, 433 Dias, Diego, 376 Diaz del Castillo, Bernal, 248 Dieppe School of Cartography, 186, 217, 219, 224, 225, 435 Dighton Rock, 333-6, 337 Dimisqui, Al, 388 divination, 97, 157, 248, 266 dogs: Chinese ship dogs, 69, 97, 222; as food, 69, 97, 169, 356; in Mexico, 263; warrah ancestry, 169 Dominica, 282, 286, 288

da Conti, see Conti

Dondra Head, 133, 137, 210, 375 dress: Californian Indians, 246;

dress (cont.) concubines, 99, 327; legends, 199, 214, 220, 227, 318–19; Narragansett Indians, 327; pantaloons, 99, 227, 318; Rhode Island women, 333; robes, 95, 204, 227, 318, 367; silk, 441 Dusky Sound, 209 Duyvendak, J.J.L., 112 dyes, 259–61

Eannes, Gil, 393, 416–17 East London, 113 eclipses: lunar, 368, 370–5, 453; solar, 371 Ecuador, 199, 239 Egypt, 32 Elephant Island, 182 Ellesmere Island, 352–3 *Endeavour*, HMS, 224, 229, 436 Eskimos, 272 Eugenius IV, Pope, 115 eunuchs, 46–7, 49–51, 80, 83

Falchetta, Piero, 121–2
Falkland Islands: animals, 169; Chinese navigation, 161–2; food supply, 169, 170; maps of, 154, 160, 183; Mount Adams, 160
Fang Bin, 81
Fei Xin, 364
Ferdinand of Aragon, King of Spain, 404, 428
Fiji, 200
Florida, 239, 282, 299–300, 302, 323 Florida Keys, 323, 324 Florida Strait, 307 Fogg, M., 266 food supply, 96-7, 133, 169, 179, 185, 188, 316 Francis I, King of France, 325 Fryer, John, 246-7 Furry, John, 242, 244 Fujian Palace 264 Fusang, 145-6, 281, 455 Gallengo, M.L., 266 Galle, 120, 133 Galvão, Antonio, 138-40, 363, 405 Gama, Vasco da: brutality in India, 455; 'discoveries', 425, 436; journey time, 132; maps, 422, 436; voyages, 33, 38, 122, 132, 376, 422 Garbin, 123, 127, 128, 136-7 Genghis Khan, 45, 53 Genoese map (1457), 429 Geronimo, Canal, 170 Gilroy, Rex, 221 giraffes, 58, 153, 318, 366 Goa, 117 gold: in Africa, 218; in Australia, 219, 221; mining, 82; prospecting for, 218; trade, 386-7; Tuamotu ring, 199 Graham Land, 178 Grand Banks, 389 Great Bahama Bank, 300, 303, 312 Great Barrier Reef, 222–5, 450 Great Wall, 53-4, 312, 332, 442 Greater Java, 187-8, 202, 225, 228

638

Greenland, 32, 333, 345–56 Grey, George, 226-7 Guadeloupe: Chinese landing, 288-92; Columbus's landing, 286-8; passage, 282; population, 286-8, 403; Portuguese expedition, 412-13; Satanazes identification, 30, 31-2, 289-92, 295, 411-13; volcanoes, 31, 289-90, 343, 411; waterfalls, 289, 290, 411 guanaco, 150, 170 Guatemala, 199, 247 Gulf Stream, 282, 325, 345, 356 gunpowder, 70, 106, 220, 312 Gutenberg, Johannes, 62 Gympie, 221–2

Ha-bu-er, 185 Ha San, 67 Haji Maulana, 60 Han dynasty, 227 Hapgood, Charles, 452 Harrison, John, 92, 377 Hasseburg, Frederick, 208 Hau-Xian, 61 Hawaii, 442 Hawkesbury River, 204 Heard Island, 184 Hemingway, Ernest, 310 Henry V, King of England, 62-3, 386 Henry VIII, King of England, 186, 225 Henry the Navigator, Prince: achievements, 34, 421, 435,

achievements, 34, 421, 435, 437; Antilia expedition, 31,

285, 403, 404; Bojador expedition, 416; Cape Verde expedition, 133; Ceuta victory, 386-8, 394; education, 386, 388, 395; funds, 399, 400; knowledge of Chinese explorations, 123-4; Madeira colonization, 383-4, 399-400; navigation skills, 392-3, 399; Sagres establishment, 389-91; shipbuilding, 390-2, 394, 399; statue, 383 hens, see chickens Hertz, Johannes, 328 Hezlet, Sir Arthur, 113 Hinduism, 67, 221, 271 Hipparchos, 368 Hispaniola, 299, 403, 414 Hoei-Shin, 145 honey, 250 Hong Bao: Antarctic journey, 176-7, 182-3, 190-1; Australian journey, 185, 188-90, 202, 213; Brazil discovery, 423; crew, 267; in Falkland Islands, 169-70; fleet command, 106, 436, 448, 456; in Kerguelen Islands, 184-5; losses, 453; navigating by Canopus, 170-1, 183-4, 190; passage of Strait of Magellan, 171, 173, 190; in Patagonia, 170; return to China, 162, 163, 190-1, 231, 363, 453; Southern Cross position, 180-1, 183, 190; voyage (1421–23), 111, 141, 145, 162, 163, 172, 174, 357

Hong Kong, stones, 210 Hong Wu (Zhu Yuanzhang), Emperor, 45-6, 47-8, 241 Hormuz, 64, 70, 102, 105 horses: in America, 337; in Australia, 189, 227; blood ponies, 219; Calicut presentation, 114; food and water for, 219, 239; in Mexico, 263; ships for, 69, 219; trade, 61.219 Hsi-Yang-Chi, 197 huemil, 150, 170 Humboldt current, 197 hurricanes, 70, 297, 411-12 Huss, John, 396

I Yü Thu Chih (The Illustrated Record of Strange Countries), 153, 270-2, 356 Ibn Battuta, 94, 114 Ibn Khaldun, 345 ice, 148, 175-6, 206, 208, 350 Iceland, 350, 355, 427 Idrisi, Al, 345, 377 Incas, 157, 199, 250, 454 Indian Ocean: Chinese navigation, 363-4, 367, 449; Portuguese expeditions, 376, 430; trade, 101-2, 363 indigo, 260 Indochina, 190 Indonesia, 447 Innocent VIII, Pope, 427 Irminger current, 345 iron, 145, 146, 200, 218, 219 Isabella of Castile, Queen of Spain, 428

Isiha, 61 Islam, 47, 67, 149, 271, 387, 396

jade: Chinese gifts of, 64; Chinese grave goods, 441; Chinese in Mexico, 265-6; jewellery, 63, 441; Mayan carvings, 253; quilin's message, 58-9 James Ford Bell Library, 29, 239, 284 Janela, 133, 134, 136, 137, 210 Japan, 61, 64, 66, 127, 128, 149 Japanese current, 237 Java, 64, 104, 105, 176, 202 João I, King of Portugal, 385, 394, 403 João II, King of Portugal, 364, 422-3, 432 Johannessen, Carl, 266 Juan de San Miguel, Fra, 257 Jucutácato, 227, 263-4, 318 junks: armaments, 70; Australian rock carvings, 204; ballast, 315; construction, 93; crew, 95; on Fra Mauro's map, 122, 124; handling, 94, 140; losses, 70; repairs, 240-1, 311-17; rudders, 70, 205, 206, 270; sails, 65, 94; size, 66, 69-70; watertight compartments, 66, 93, 105

kangaroos, 202, 222 Kangnido: authenticity, 436, 449; depiction of Africa, 128–30, 131, 136, 178, 281; depiction of Azores, 325, 345; history,

127-8; sources, 436 Karmapa, the, 61, 262 Keleteria, 244 Kerguelen Islands, 184–5 Kerguelen-Tremarec, Yves de, 184Kilwa: ambassador, 119; Arab port, 102; Arab traders, 121; Cabral's fleet, 376; Chinese ships, 102, 130; da Gama's visit, 376, 422 Korea, 60–1, 66, 127–8, 449 Kublai Khan, 45, 53, 442 Kuroshio current, 237 lacquer, 257-9, 365 Lamu archipelago, 365–6, 450 languages, 66, 133–4, 406, 407–12 Lappacino, 396 latitude, 91-3, 181, 392, 412, 432 - 3Le L'oi, 80 Le Qui Ly, 79 lead, 220, 226 Leigh, Raymond E., 316 León, Nicolás, 264 leopard seals, 182 leopards, 60, 61 Lepe, Diego de, 423 Les Saintes, 288, 290, 292, 294-5, 411-12 Leyte, 230-1, 237 Limasava, 159, 231–2 lions, 60 Little Java, 187, 225 Liu-Chia-Chang, inscription, 111, 112, 297 Liu Daxia, 84, 111

llamas, 199, 272
Lockwood, Lieutenant, 350
longitude: adjusting for error, 131, 178; calculation of, 367–8, 371–8; Cantino chart, 367, 375–7; Chinese navigation, 92–3, 130–1, 178–9, 181–2, 367–8, 392, 452–3; Columbus's navigation, 412
Lourenço Marques, 113
Lui Chi'ih, 62
lunar eclipse, 368, 370–5, 453

Ma He, see Zheng He Ma Huan: account of Zheng He's expedition, 95, 100, 137, 269, 364; on Calicut, 114-15, 116-17, 260, 268; on coconuts, 102; departure from treasure fleet, 117–18; lists of goods, 197-8; on Malacca, 103; publication of work, 95 Ma Tsu, 71, 95, 105, 220 McCrone, Walter, 347 McCrone Associates, 347 McDermott, Joseph, 127 McIntosh, Sir Ian, 125, 140 madder, 259 Madeira, 383-5, 399-400, 416 Magellan, Ferdinand: career, 424; circumnavigation, 34, 172, 230, 325, 437; 'discoveries', 38, 138, 171, 456; food supply, 97; knowledge of Magellan Strait, 173, 424, 437, 452; leadership, 173, 416; in Limasava, 159, 231; navigation, 452; in Patagonia,

- Magellan, Ferdinand (cont.) 148, 150, 151; pepper cargo, 232–3; Philippines food supplies, 159–60, 240, 443, 445; route, 230–1; ships, 452; South American food supplies, 156; South American journey, 197; Toscanelli charts, 397–8
- Magellan, Strait of: on Behain's maps, 173, 397–8; Chinese discovery, 171, 190; Columbus's knowledge of, 426; Magellan's knowledge of, 173, 424, 437, 452; Magellan's passage, 34, 171, 172–4, 416, 437; on Piri Reis map, 148–50; on World Map (1428), 138, 139, 395
- Mahogany Ship, 188–9, 206, 318, 450
- maize: Chinese introduction of, 445–6, 450; in Philippines, 159, 200, 233, 240, 248, 443, 445; tools for grinding, 159–60, 200, 268
- Malabar coast, 117, 375
- Malacca: accounts of, 102–5; ambassadors, 64; Calicut communications, 114; Chinese base, 100, 102, 103; Chinese overlordship, 60, 102; da Gama's voyage, 422; Hong Bao's fleet, 163, 190; journey time, 70; monsoon winds, 99–100; Portuguese conquest, 424; Straits, 101, 389; trading port, 60, 100–1; women, 103–4; Zheng He's fleet at,

100, 104-6 Malaysia, 60, 117, 186, 190 Maldives, 105, 375 Malindi: ambassadors, 64; Arab port, 102; Cabral's voyage, 376; Chinese base, 375; da Gama's voyage, 376, 422; giraffe presentation, 366 Mamluk sultans, 115, 139, 397 Manchuria, 61, 449 mandarins, 49-50, 58, 80, 82 Manifold, Mrs, 189 Manuel I, King of Portugal, 423 Mao Kun: date, 118; Ha-bu-er island, 185; position of treasure fleets, 124, 137; routes on, 121; survival, 118; translation, 118 Maoris, 210, 214, 318, 446 Marie-Galante, 286, 288 Marino, Ruggiero, 427 Martellus, Henricus, 428-9 Martellus maps, 428–33 Massachusetts, 333–8 Master Bentou, 67 Matadi Falls, Congo, 136, 137, 210, 334, 337 Mauro, Fra: da Conti connection, 123; depiction of Cape of Good Hope, 122–3; depiction of junk, 122, 124, 128; distance shown from Portugal to China, 429; on Garbin, 123, 127, 128, 136, 137; on Isole Verde, 122, 131, 132, 135, 137; on 'obscured islands', 122, 137, 146, 174; in

Venice, 284 Mayan civilization, 248, 249-53, 265-6 Mecca, 83 Medina, Pedro de, 393 Men and Women, Isles of, 123 Mena, Ramón, 265 Mendoza, Vélez de, 423 Merrimack River, 337 metal work, 261-3 Mexico: chickens, 248, 265; Chinese presence, 265-6, 267, 269; Jucutácato picture, 227, 263-4; porcelain, 198, 253, 268; pre-Columbian voyages, 199 Mills, Captain, 188-9 Mindanao, 230-1 Ming dynasty: capital, 55; ceramics, 227, 241, 247, 317, 364, 366, 441, 450; cotton, 446-7; end of, 84; exports, 199; Japanese studies, 127; military defeat, 80; mortar, 332; Needham's studies, 355; observatories, 222; origins, 45; silk, 441 mining, 217-22, 261 mirrors, 95, 262-3, 264 Mogadishu, 64, 119, 376 Moluccas, 100 Mombasa, 64, 113, 376, 422 Monclaro, Father, 318, 365 Mongols: campaigns against, 46, 47, 80-1; cotton growing, 447; defeat, 45 6; expulsion, 47, 54, 61; Kangnido map, 128; Zhu Di's parentage, 48 monsoons, 94, 99-100

Montezuma II, Emperor, 198 Moors, 385–6, 405, 428 Moskoke people, 323 mountain lions, 150, 170 Mowat, Farley, 351 Münster, Sebastian, 388 Muscovy, 272, 356 mylodons, 152–3, 209, 222, 272

Nanjing: capital relocation, 55, 59; conference (2002), 118; imperial court, 49-50, 62, 114; language school, 66; mineral supplies, 316; shipyards, 51, 316; Zheng He Museum, 270; Zheng He's position, 83; Zhou Man's return, 237; Zhu Di's conquest, 48-9, 50 Nares, George, 350 Narragansett Bay, 325, 326, 328, 333, 335, 336 navigation: Arab, 128, 377, 392-3; Chinese, 89-93, 120, 181, 367–9, 372–7, 392, 452; Portuguese, 91–2, 376, 392–3, 412-13; see also Canopus, latitude, longitude, Pole Star, Southern Cross Nayarit people, 363 Neahkahnie Beach, 239 Needham, Joseph, 265, 355 Nestorian Christians, 115 New Guinea, 200 New Mexico, 248 New Zealand: animals, 209; Chinese presence, 84, 209–14, 318, 449, 450; Cook's voyages, 434, 446; sweet potatoes, 446;

New Zealand (cont.) wrecks, 209-10, 212, 214, 217, 450; Zhou Man's voyage, 208 - 14Newcastle, Australia, 203 Newfoundland, HMS, 113, 119, 132, 364 Newport Round Tower, Rhode Island, 328-33, 370 Nicholas V, Pope, 350-1, 354 Ning Hsien Wang (Chu Chuan), 270 Noli, Antonio da, 134 Norfolk Island, 200, 208 Norsemen, 330, 333, 348, 351 North Pole, 89, 347, 354, 355-6 North Salem, 337

oak, European, 210 'obscured islands', 122, 137, 141, 146, 174 observation platforms, 222, 374 observatories, 368–70 Oliver, John, 374–5 Olmecs, 248–9, 250 Orinoco delta, 146, 158, 424 ostriches, 60, 117, 122 otters, 97, 209, 222 Owen, Richard, 152 Oxford, Edmund Harley, Earl of, 229

Pacific, Chinese bases, 451 Paiva, Alfonso de, 364 Pakal, King, 251–3 Palenque, 251–3 Panama, 247, 269 Pandanan, wreck, 267–9, 450 papayas, 248, 443 Parkinson, Sydney, 436 Patagonia: animals, 150, 151-3, 170, 209; food supply, 170; inhabitants, 160, 190; landfall, 146; landscape, 148, 160; maps of, 32, 34, 148-50, 153, 158, 160, 174; size, 155, 183 Pate, 365-6 Pedra do Letreiro, 134-6, 334, 336, 337, 450 Pedro, Dom, of Portugal: cartography, 413, 435; da Conti connection, 396, 437; education, 395; Fra Mauro's work, 121, 123; knowledge of Chinese voyages, 123-4; travels, 394-5; Treviso estates, 413; World Map (1428), 138-9, 395, 398, 405, 421, 437 Penhallow, William, 331 pepper, 82, 116, 117, 232-3, 331 Perestrello, Bartolomeu, 384 Perestrello, Felipa, 426 Perry Point, 335 Perth, wrecks, 205, 206 Peru, 156, 158, 199-200, 269, 454 Philippa, Queen, 385-6 Philippines: Chinese presence, 232, 233, 237; currents, 200; Magellan's expedition, 159, 200, 230-3, 443; maize, 159, 200, 233, 240, 248, 443, 445; wrecks, 212, 267-9, 450 Phillips, Sir Thomas, 29, 284 Pigafetta, Antonio: account of Magellan's Philippines visit, 159, 172, 231, 233; diary,

172-3, 398; on Limasava, 231-2; on Magellan Strait, 173 pineapples, 443, 447 Pinzón, Vicente Yañez, 423 Piri Reis map: animals on, 148, 150, 151, 153; authenticity, 436, 449; composition, 140, 181; depiction of Antarctica, 155, 176, 178-9, 182, 301; depiction of Brazil, 148, 424; depiction of ice, 206; depiction of South America, 301; notes on, 427; Patagonia, 149, 151, 153, 155, 160, 174; Portuguese names, 285; Rotz chart comparison, 186, 206; scale, 160; southern part, 148 Pisa, Council of (1409), 395 Pius II, Pope, 355 Pizarro, Francisco, 157, 454 Pizzigano, Zuane: Atlantic islands on chart, 29-30, 31, 284-5, 406, 411-14, 426; authenticity of chart, 284, 436; Chinese voyages, 37; date of chart, 29, 406; identification of Atlantic islands, 288-9, 295-7, 426 plants: Chinese knowledge, 67-9; European knowledge, 69; indigenous to one continent carried to another, 38, 156, 240, 409–11, 442–8 Poggio Bracciolini, Giovanni Francesco, 115, 123-4, 228-9 Pole Star (Polaris): Canopus substitute, 161-3, 175; Chinese navigation, 89, 91, 118-20,

161-3, 302; Chinese observations, 369; Portuguese navigation, 394, 412-13 Polo, Marco: in Calicut, 114; in China, 202; on Christian states, 399; Columbus's copy, 427; on Greater Java, 202; on Indies customs, 375; on Zaiton, 330-1 polynyas, 352-3, 356 Ponce de León, Juan, 309, 316 poppy seeds, 268 porcelain: Chinese in Africa, 364, 365, 422, 450; Chinese distribution, 38, 441; Chinese gifts of, 64; Chinese trade, 52, 104, 232; Cholula, 198-9, 253, 268; Ming, 227, 241, 247, 268, 317, 364, 366, 441; in Philippines, 232 Port Elizabeth, 113 portolan lines, 160 Portugal: Antilia expedition, 31, 285, 403-5, 414-15, 426; Arab influence, 387-9; Azores colony, 415-16, 421; Bojador expedition, 416-17; Cape of Good Hope voyages, 325, 421-2, 424, 427, 430; da Conti connection, 396-9, 413, 436; Dom Pedro's map, 398, see also World Map (1428); Dom Pedro's travels, 394-5; Guadeloupe expedition, 412 13; Henry the Navigator, 385-8; Indian Ocean expeditions, 376, 430; Madeira colonization, 383-4, 399-400;

Portugal (cont.) Magellan's voyage, 397-8, 424-5; Malacca conquest, 424; navigation, 91-2, 376, 392-3, 412-13; Puerto Rico settlement, 403-6, 412, 414, 426; Sagres establishment, 389-90; ship design, 391-2; South American expeditions, 423-4 Portuguese language, 406, 407-9 Powers, Stephen, 245-7 Ptolemy, 91, 187, 368, 389, 395-6 Pu He Ri, 67 Puccioni, N., 366 Puerto Rico: Antilia identification, 30, 295-9, 403-12, 414-15, 426; climate, 414; Columbus's visit, 403; Pizzigano chart, 413, 426; plants, 412; Portuguese settlement, 403, 414, 416, 426; size, 413 purple dye, 260-1

Qazami, Hama Allah Moustawfi, 389 Qin dynasty, 441 Qin Shi Huangdi, 54 Qing dynasty, 84

Razak, Abdul, 114 Regiomontanus, 393 *Resolution*, HMS, 323 Rhode Island, 326, 328–33, 370 rice, 96–7, 244–5, 247, 444–5, 446 Roaring Forties, 125, 183, 185 *Rorqual*, HMS, 223, 267, 288, 292 Rosellia, 414

roses, 71, 240, 248, 443

Rotz, Jean: authenticity of chart, 436, 449; Boke of Idrography, 186, 225; British government ownership of chart, 186; depiction of Auckland and Campbell islands, 206-7, 217; depiction of Australia, 186, 187-8, 190, 203, 206-7, 219, 222-3, 224-6, 227, 435; depiction of Great Barrier Reef, 224; depiction of Philippines, 230, 237; depiction of Spice Islands, 229-30; Dieppe school, 186; names, 285; Pandanan wreck, 267; Piri Reis comparison, 186, 206; source, 229 Royal Geographical Society, 241, 272, 406-7 Ruapuke Ship, 209, 212, 214, 270 Ruapuke stone, 210, 212, 228, 337, 450 rudders, 70, 204, 206, 270 Russian River, 245-6 Ruz Lhuillier, Alberto, 252 Ryukoku University, 127

Sacramento River, 242–6, 268, 445 Sagres, 389–90, 393–4, 407, 437 Sahagún, Bernardino de, 248, 261 Sancho I, King of Portugal, 385 Santa Catarina, 210 *Santa María*, 294 Santo Antão, 133, 137, 281, 343 Sargasso Sea, 403 Sarteano, Alberto de, 396

Satanazes, island of: Guadeloupe identification, 30, 31-2, 289-92, 295, 411-13, 414; maps of, 406; name, 287-8; on Pizzigano chart, 29-30, 31-2, 284 Savannah River, 323-4 Saya, island of, 29, 284-5, 288-9, 290, 295, 411 Sayre, Edward V., 314 sea levels, 299-300 Schlederman, Peter, 351 Schöner, Johannes, 238 Senegal, 131 Seychelles, 113, 375 Shackleton, Ernest, 353 Shah Rukh, King of Persia, 77 Shan-Hai Jing, 202 Shang dynasties, 257 Sheng Hui, 67 shipbuilding, 93-4, 315-16, 452 - 3Shu Lao, 228 Shutesbury stone, 337 Siam, 60 Sierra Leone, 113 Sigismund, Emperor, 386 silk: Chinese distribution, 38, 232-3, 365, 450, 452; Chinese dress, 63, 441; Chinese gifts of, 64; Chinese trade, 52, 104; sails, 65, 71 Silk Road, 139, 241, 326, 397, 449 silver, 82, 218 Skelton, R.A., 349, 429 slaves, 121 Sofala: Cabral's fleet, 376; Chinese fleets at, 119, 120,

124, 137; Chinese porcelain,

364; da Gama's visit, 376, 422; voyage from, 123; voyage to, 119

- Soligo, Cristobal, 414, 426
- Song dynasty, 52, 62, 330, 366, 367, 441
- South Georgia, 183
- South Pole, 176, 178, 181, 376

South Shetland Islands, 34, 155, 179, 182, 183

- Southern Cross: locating, 180, 181, 190, 363; navigation by, 36, 120, 161, 178, 318; polar navigation, 176; position of, 161, 181
- Spice Islands: Chinese trade, 363; da Gama's voyage, 422; Hong Bao's fleet, 190, 231; Malacca trade, 100, 104; Magellan's voyage, 173, 232; ocean route, 139, 325, 397, 422; overland route, 139, 326; Zhou Man's fleet, 163, 229–33, 237
- Sri Lanka, 64, 105, 117, 120, 133, 375
- stone(s): carved, 38, 134–6, 210, 333–4, 336–7, 450; Chinese inscriptions, 111–12, 120–1, 133; dwellings, 335–6; in Massachusetts, 336–7, 338 Sui dynasty, 202 Sumatra, 60, 64, 106, 190 sweet potatoes, 248, 442, 443, 446

Tafur, Pedro, 116, 334 Tamerlane, Emperor, 32, 53–4, 55–6, 59, 77

647

Tang dynasty, 54, 113, 124, 332, 364, 441 Tanggu: fleet at, 65-71, 137; icebound port, 175 Taoism, 228 taros, 446 Tasman, Abel, 190 Tasman Sea, 208 Tasmania, 190, 206, 223 Taunton River, 333-4, 335, 337 teak, 57, 59, 189, 209, 239, 267 Ternate, see Spice Islands Thien Kung Kai Wu, 57 Thomas, Saint, 115, 396 Tibet, 61, 262 Tidore, see Spice Islands Tierra del Fuego, 147, 148, 151, 171, 174-5 time, measurement of, 370 tobacco, 443 Toghon Temur, Emperor, 46 Toltecs, 250 tomatoes, 248 Torre do Tombo, 31, 34, 140, 285 Toscanelli, Paolo: da Conti meeting, 397; letter to Columbus, 397, 426, 427, 433, 437; Magellan's use of charts, 398; map (1474), 189, 412 Tuamotu archipelago, 199 Tyndale, Norman B., 272

Ulugh Begh, Prince, 55 uranium, 226 Urness, Carol, 406 Uruapan, 257–8, 261, 263, 264

Vallard chart, 219

Varthema, Ludovico de, 176 Vaz Teixeira, Tristão, 384 Venezuela, 146, 266-7, 269, 424 Venice: cartography, 137, 284; da Conti and Fra Mauro, 123; decline of naval power, 32; fleet, 70; language, 408, 413; Portuguese presence, 413 vermilion, 260 Verrazzano, Giovanni de, 325-8, 336, 337 Vespucci, Amerigo, 423 Vietnam, 58, 59, 64, 79, 186, 268 Vietor, Alexander O., 428-9, 432 Vinland map, 347-9, 351, 354, 355, 449–50 volcanoes, 31, 289-90, 295, 343, 411 votive offerings, 38, 533-4; in Australia, 220, 228, 450; in New Zealand, 212, 450; in Pate, 367

Wade, Sir Thomas Francis, 270
Waldburg-Wolfegg, Prince Johannes, 238
Waldseemüller, Martin, 238
Waldseemüller world map, 238–9, 247–8, 356, 436, 449
walrus, 353
Wampanoag people, 336
Wang Tao, 197, 273
warrah, 169
Warrnambool, wreck, 188–9, 206
Wei, Professor, 273
Wei Chuh-Hsien, 189
Wills, John E. Jr, 127
winds, 237, 421, 434, see also

currents, hurricanes, monsoons, Roaring Forties Wollongong, wreck, 205, 206 World Map (1428): Cabral's expedition, 423; Cape of Good Hope on, 139, 363–4, 395, 421; Columbus's copy of, 139, 427; description of, 138-9, 363; islands of Antilia, 31, 285, 403, 406; Magellan Strait on, 138, 395; Piri Reis map, 140, 151; Portuguese possession of, 31, 139, 395, 398, 406, 433; sources of information, 424, 437 wrecks: on American coasts, 38, 241-5, 325; in Australia, 38, 188-9, 205-6, 450; in Caribbean, 307-8; in New Zealand, 38, 208-9, 210, 211-14, 217, 450; numbers, 453; in Philippines, 212, 267-9,450 Wu Pei Chi: Chinese bases, 375; Ha-bu-er island, 185; illustrations, 90, 101, 116; latitude calculation, 181; North Pole position, 355; routes, 121, 364; survival of,

89, 269; translation, 118 Wu Zhong, 81

Xia Yuanji, 77, 80–1, 82 Xiu, Empress, 78

yams, 442, 443, 445, 446 Yang Qing: fleet command, 64, 436; longitude mission, 105, 377; route, 363; voyage, 111, 357, 363, 448, 456 Yangery people, 189, 318 Yangtze estuary, inscription, 120, 133, 210, 448 Yao Guang-Xiao, 62 Yi Pang-Won, King of Korea, 60 Ymana, island of, 29, 285, 414 Yong Le, *see* Zhu Di Yong-le-Dadian, 62, 67 Yoshimitsu, Shogun, 61 Youssuf Kamal, Prince, 121, 377 Yuan dynasty, 52 Yucatan Peninsula, 239

Zacuto, Abraham bin Samuel, 422 Zaiton, lighthouse, 331–2 Zamorin kings, 114-15 Zanzibar: ambassador, 119; Arab port, 102; author's voyage, 113; Chinese base, 102, 121, 375, 422; Portuguese arrival, 365, 422 Zarco, João Gonçalves, 383-4, 399 Zhang Wenxu, 244 Zheng He (Ma Ho, San Bao): achievements, 436, 456; background, 47; bases, 100, 104–5; bell, 210; career, 47, 48, 50-1, 64-5, 83; crews, 262; fleet, 51, 363, 398, 442, 449; Fusang stories, 146; giraffe presentation, 58-9; inscriptions, 111-12, 120, 133, 377, 448; language school, 66; museum, 270; name, 47; religion, 47, 83; return to

Zheng He (cont.) China, 83, 106; tomb, 437; voyages, 64-5, 84, 105-6, 455; warships, 70, 116 Zhou dynasty, 220 Zhou Man: American journey, 237-40, 247, 267, 268-9; Australian journey, 200-4, 214, 217, 222-9, 435; Brazil discovery, 423; Campbell Island presence, 208, 217; cargo, 229-30, 232; crew, 267; fleet command, 106, 436, 448; losses, 226, 239, 453; mineral discoveries, 220; mission, 162, 190, 197, 208; New Zealand journey, 208-12, 217; return to China, 162, 163, 237; route around Australia, 213; separation of fleet, 200; Spice Islands journey, 229-33; voyage (1421-23), 111, 140-1, 145, 163, 191, 197-8, 237, 357, 456 Zhou Wen: at Bimini, 311-17; in Caribbean, 286, 290-304, 307; fleet command, 106, 275, 312, 317, 333, 436; voyage

- (1421–23), 111, 141, 281–3,
- 319, 356–7, 410, 448, 456
- Zhu Di (Yong Le), Emperor: accession,48–9, 50; achievements, 436, 453–4;

ambassadors to, 59, 61-2, 63, 64; astronomy, 54-5, 61; Azores statue, 345, 455; banquet, 63; Beijing base, 47-8; Beijing building programme, 53-4, 55-7, 59; Beijing capital, 53, 55-6, 59; Calicut relations, 113-14; campaign against Arughtai, 80-1; concubine, 63, 75-6; death, 81, 454; encyclopedia project, 62, 67; family, 45-6; fleet, 63, 64-6, 69-70, 442, 452; Forbidden City fire, 75-6; funeral, 81; giraffe presentation, 58-9, 318; Grand Canal, 56-7, 77; horses, 114, 219; household, 47; illness, 77-8; library, 62; mandarin opposition to, 58, 76-7, 80-1; rebellions against, 79-80; religion, 67, 133, 262; shipbuilding, 51-2, 57-8; Silk Road trade, 241; successors, 80, 81, 455; treasure ships, 60, 69-70, 78, 81-2; tribute system, 60–2, 101, 449 Zhu Gaozhi, 56, 76, 80, 81-3, 233 Zhu Yuanzhang, see Hong Wu Zhu Yunwen, 48, 50, 52 Zhu Zhanji, 83 Zink, David, 310-11, 314, 316

About the author

2 Meet Gavin Menzies

About the book

4 A Conversation with the Author

Read on

9 Excerpt: 1434: The Year a Magnificent Chinese Fleet Sailed to Italy and Ignited the Renaissance

30

Insights, Interviews & More ...

*

About the author

6 In the course of researching *1421*, [Menzies] has visited 120 countries, over 900 museums and libraries and every major seaport of the late Middle Ages.

2

Meet Gavin Menzies

GAVIN MENZIES (Royal Navy Submarine Commanding Officer, retired) first went to China in 1937, where he spent the first two years of his life. He joined the Royal Navy in 1953 and served in submarines from 1959 to 1970. As a junior officer he sailed the world in the wake of Columbus, Dias, Cabral and Vasco da Gama. When in command of HMS Rorqual (1968-1970), he sailed the routes pioneered by Magellan and Captain Cook. Since leaving the Royal Navy, he has returned to China and the Far East many times, and in the course of researching 1421, he has visited 120 countries, over 900 museums and

libraries and every major seaport of the late Middle Ages.

In his new book, 1434: The Year a Magnificent Chinese Fleet Sailed to Italy and Ignited the Renaissance (HarperCollins, 2008), Menzies makes the startling argument that a sophisticated Chinese delegation visited Italy in 1434, sparked the Renaissance and forever changed the course of Western civilization.

About the book

A Conversation with the Author

What inspired you to write 1421: The Year China Discovered America?

I had spent years researching and writing 1421, based on the events taking place all over the world in this defining year. However, my discoveries about China came by accident. When completing 1421, I came across the Zuane Pizzigano chart for the first time. The chart, drawn up by a Venetian cartographer in 1424, showed, to my disbelief, several of the Caribbean islands some seventy years before Christopher Columbus arrived there.

Why has such an engrossing concept only come into the limelight so recently?

Despite the subject matter of the book appearing so innovative, there has been talk of pre-European world exploration for many years. It is only now, however, that anyone has made an attempt to filter this wealth of information down into such a cogent and accessible package. I have spent years traveling the world in search of evidence that had often been kept away from the general public. Therefore with the publication of this book, I have unearthed and made readily available a huge quantity of evidence that was previously confined to the dusty vaults and archives of the past.

Why was 1421 such an important year all over the world?

The year 1421 was a decisive year in world history. In Europe, as the Hundred Years' War raged on, King Henry V took the bold step of marrying the French heiress Catherine of Valois, in an attempt to reconcile the countries' differences. Simultaneously, Venice, the oldest and most powerful naval power in Europe, was in a state of disarray. The old Doge, who was ill, his powers waning and his successor waiting in the wings, determined that Venice should abandon its maritime tradition and concentrate on becoming a land power. Egypt had been plunged into a state of civil war and social unrest there were no fewer than five sultans in 1421 alone. The Islamic world was also disintegrating, what with the Portuguese invasion of the North African heartlands. In December 1421 the overland route to China and the Spice Islands—the great Silk Road running from China right across Central Asia to the Middle Easthad been blocked when the Ottomans surrounded Byzantium. In that same climactic month, the Mamluk Sultan Barsbey seized power in Egypt and nationalized the spice route. The effect of the two events was to ruin the merchants who had controlled the spice trade, seal Egypt's borders to international trade, and sever the sea route through the Bosphorus to the western end of the Silk Road. ►

66 The key speech I made to thirtysix different countries, with a population of some two billion people, via television at the Royal Geographical Society in March 2002, provoked a great deal of interest from all over the world.

A Conversation with the Author (continued)

How has China reacted to the book?

The key speech I made to thirty-six different countries, with a population of some two billion people, via television at the Royal Geographical Society in March 2002, provoked a great deal of interest from all over the world. The main protagonist in our story, China, was obviously overwhelmed that their claim to have circumnavigated and charted the world before the Europeans had been substantiated by a neutral participant. Despite many of the records of the voyages being destroyed at the hands of the Mandarins in the sixteenth century, there still remain several Chinese accounts of their achievements, although skeptics have often doubted their veracity. China has already hosted several conferences on Zheng He studies, which I attended to give keynote speeches, and I was honored by being awarded a visiting professorship at Yunnan University, to which I return several times a year to lecture. Other projects include television documentaries, various museums, exhibitions and amusement parks, an epic movie, and a historical replica of one of the huge treasure ships.

Why should we believe anything the book says?

In total, some thirty-four different lines of evidence have been found to support the theory that the Chinese circumnavigated and charted the globe a century before the Europeans staked claim to having done so. The evidence is overwhelming, and encompasses both physical entities (such as shipwrecks of Chinese junks in America, Australasia and Indonesia) and examples such as the carved stones of Africa, the remains of Chinese peoples in South America and artifacts scattered all over the world, inscribed with Chinese characters, in Chinese styles, and some successfully dated back to before the arrival of the Europeans. There also exists more circumstantial evidence, such as the linguistic, ceremonial and spiritual similarities between the Chinese culture and those of other parts of the world in the fifteenth century. The linguistic similarities found between place names in Peru and Chile are heavily supportive of the notion that the Chinese exerted a huge influence there in pre-Columbian times.

What is being done to further the research in the book?

There are several projects that are currently under way, the results of which will further support claims made in 1421: The Year China Discovered America. Archaeological teams all over the world are excavating sites believed to contain relics of Chinese shipwrecks. Furthermore, the projects launched ► **6** The linguistic similarities found between place names in Peru and Chile are heavily supportive of the notion that the Chinese exerted a huge influence there in pre-Columbian times.

A Conversation with the Author (continued)

for the television series will play a very significant role in unveiling the truth about the Chinese voyages of 1421– 1423. Since the launch of the Web site (http://www.1421.tv/), countless researchers have come forward offering invaluable help and assistance, for which we are most grateful.

Why did China fail to keep her grasp on the world after wielding such incredible power at the beginning of the fifteenth century?

The difficulty in writing the book was further increased by the fact that the majority of Chinese records, documents and maps recounting the dramatic events of the 1421-1423 voyages were deliberately destroyed or hidden by the officials of the Chinese court, following an abrupt change in the country's foreign policy. The thunder and lightning storm that reduced the Emperor's palaces to a heap of smoldering rubble and killed off many of his loyal subjects was seen as a very bad omen, and it was to cause an ever-descending spiral of misfortune. With the succession of Zhu Di's son to the throne came the rejection of the outside world, with China turning in on herself. Anything commemorating previous expansionist policies was expunged from the record. \sim

Excerpt: 1434: The Year a Magnificent Chinese Fleet Sailed to Italy and Ignited the Renaissance

The Renaissance formed the basis of our modern world. Until now. scholars have considered that it came about as a result of reexamining the ideas and ideals of classical Greece and Rome. But now Gavin Menzies makes the startling argument that a sophisticated Chinese delegation visited Italy in 1434, sparked the Renaissance and forever changed the course of Western civilization. After that date the authority of Aristotle and Ptolemy was overturned and artistic conventions were challenged, as were Arabic astronomy and cartography. Following is an excerpt from the introduction to 1434 (HarperCollins, 2008), a stunning new reappraisal of history.

ONE THING that greatly puzzled me when writing 1421 was the lack of curiosity among many professional historians.

After all, Christopher Columbus supposedly discovered America in 1492. Yet eighteen years before he set sail, Columbus had a map of the Americas, which he later acknowledged in his logs. Indeed, even before his first voyage, Columbus signed a contract with the King and Queen of Spain that appointed him Viceroy of the ►

Read on

Excerpt: 1434 (continued)

Americas. His fellow ship's captain, Pinzon, who sailed with him in 1492, had too seen a map of the Americas in the Pope's library.

How do you *discover* a place for which you already have a map?

The same question could be asked of Magellan. The straits that connect the Atlantic to the Pacific bear the great Portuguese explorer's name. When Magellan reached those straits, he had run out of food and his sailors were reduced to eating rats. Worse, they were convinced they were lost.

Esteban Gomez led a mutiny, seizing the *San Antonio* with the intent to lead part of the expedition back to Spain. Magellan quashed the mutiny by claiming he was not at all lost. A member of the crew wrote,¹ "We all believed that [the Strait] was a cul-desac; but the Captain knew that he had to navigate through a very well concealed strait, having seen it in a chart preserved in the treasury of the King of Portugal, and made by Martin of Bohemia, a man of great arts."

Why were the straits named after Magellan when Magellan had seen them on a chart before he set sail? Once again, it doesn't make sense.

The paradox might be explained had there been no maps of the straits or of the Pacific—if, as some believe, Magellan was bluffing about having seen a chart. But there *were* maps. Waldseemueller published his map of

66 How do you *discover* a place for which you already have a map?

Read on

the Americas and the Pacific in 1507, thirteen years before Magellan set sail. In 1515, four years before Magellan sailed, Schoener published a map showing the straits Magellan is said to have "discovered."

The mystery only deepens when we consider the two cartographers, Waldseemueller and Schoener. Were these two hoary old sea captains who had made heroic voyages across the Pacific before Magellan? Should we rename the straits after Schoener? Hardly.

Schoener never went to sea. He flunked his exams at the University of Erfurt, leaving without a degree. He became an apprentice priest in 1515, but for failing to celebrate mass he was relegated to a small village, where his punishment was officiating at early morning mass. So how did a young man from a rural region of Germany with no maritime tradition produce a map of the Pacific well before Magellan discovered that ocean?

Like Schoener, Waldseemueller had never seen the sea. Born in Wolfenweiler near Fribourg in 1475, he spent his working life as a canon at St. Die in eastern France—a region famed for its plums but completely devoid of maritime tradition. Waldseemueller, too, left university without a degree. Yet his map of the Americas showed the Sierra Madre of Mexico and the Sierra Nevada of North America ► **66** So how did a young man from a rural region of Germany with no maritime tradition produce a map of the Pacific well before Magellan discovered that ocean?

Excerpt: 1434 (continued)

before Magellan reached the Pacific or Balboa reached its coast.

These two rustic map makers were not the only Europeans with an uncanny prescience about unseen lands. In 1419, before European voyages of exploration even began, Albertin di Virga published a world map of the Eastern Hemisphere that shows northern Australia. It was another 350 years before Captain Cook "discovered" that continent. Similarly, Brazil appeared on Portuguese maps before the first Portuguese, Cabral and Dias, set sail for Brazil. The South Shetland Islands were shown on the Piri Reis map four hundred years before Europeans reached the Antarctic.

The great European explorers were brave and determined men. But they discovered nothing. Magellan was not the first to circumnavigate the globe, nor was Columbus the first to discover the Americas. So why, we may ask, do historians persist in propagating this fantasy? Why is the *Times Atlas of World Exploration*, which details the discoveries of European explorers, still taught in schools? Why are the young so insistently misled?

After 1421 was published, we set up our Web site, www.1421.tv, which has since received millions of visitors. Additionally, we have received hundreds of thousands of e-mails from readers of 1421, many bringing new evidence to our attention. Of the criticism we've also received, the most frequent complaint has concerned my failure to describe the Chinese fleets' visits to Europe when the Renaissance was just getting underway.

Two years ago, a Chinese Canadian scholar, Tai Peng Wang, discovered Chinese and Italian records showing beyond a doubt that Chinese delegations had reached Italy during the reigns of Zhu Di (1403–1425) and the Xuande Emperor (1426–1435). Naturally, this was of the greatest interest to me and the 1421 team.

Shortly after Tai Peng Wang's 2005 discovery, Marcella and I set off with friends for Spain. For a decade, we've enjoyed holidays with this same group of friends, traveling to seemingly inaccessible places—crossing the Andes, Himalayas and Hindu Kush, voyaging down the Amazon, journeying to the glaciers of Patagonia and to the high Altiplano of Bolivia. In 2005 we walked the Via de la Plata from Seville, from which the conquistadores sailed to the New World, north to their homeland of Extremadura. Along the way, we visited the towns in which the conquistadores were born and grew up. One of these was Toledo, painted with such bravura by El Greco. Of particular interest to me were the medieval pumps by which this fortified mountain town drew its water from the river far below.

On a lovely autumn day, we walked uphill to the great cathedral that dominates Toledo and the surrounding countryside. We dumped our bags in ►

6 Two years ago, a Chinese Canadian scholar, Tai Peng Wang, discovered Chinese and Italian records showing beyond a doubt that Chinese delegations had reached Italy during the reigns of Zhu Di (1403-1425) and the **Xuande Emperor** (1426–1435).

Excerpt: 1434 (continued)

a small hotel built into the cathedral walls and set off to explore. In a neighboring Moorish palace there was an exhibition dedicated to Leonardo da Vinci and his Madrid codices, focusing on Leonardo's pumps, aqueducts, locks and canals—all highly relevant to Toledo.

The exhibit contained this note: "Leonardo embarked upon a thorough analysis of waterways. The encounter with Francesco di Giorgio in Pavia in 1490 was a decisive moment in Leonardo's training, a turning point. Leonardo planned to write a treatise on water."

This note puzzled me. I had been taught that Leonardo had designed the first European canals and locks, that he was the first to illustrate pumps and fountains. So what relevant training had he received from di Giorgio, a name completely unknown to me?

My research revealed that Leonardo had owned a copy of di Giorgio's treatise on civil and military machines. In the treatise, di Giorgio had illustrated and described a range of astonishing machines, many of which Leonardo subsequently reproduced in threedimensional drawings. The illustrations were not limited to canals, locks and pumps; they included parachutes, submersibles, tanks and machine guns, as well as hundreds of other machines with civil and military applications.

This was quite a shock. It seemed

Read or

Leonardo was more illustrator than inventor and that the greater genius may have resided in di Giorgio. Was di Giorgio the original inventor of these fantastic machines? Or did he, in turn, copy them from another?

I learned that di Giorgio had inherited notebooks and treatises from another Italian, Mariano di Jacopo detto il Taccola (called Taccola "the jackdaw"). Taccola was a clerk of public works living in Siena. Having never seen the sea or fought a battle, he nevertheless managed to draw a wide variety of nautical machines-paddle-wheeled boats, frogmen and machines for lifting wrecks, together with a range of gunpowder weapons and an advanced method of making gunpowder. It seems Taccola was responsible for nearly every technical illustration that di Giorgio and Leonardo had later improved upon.

So, once again, we confront our familiar puzzle: How did a clerk in a remote Italian hill town, a man who had neither traveled abroad nor obtained a university education, come to produce technical illustrations of such amazing machines?

This book attempts to answer that and a few related riddles. In doing so, we stumble upon the map of the Americas that Taccola's contemporary, Paolo Toscanelli, sent to both Christopher Columbus and the King of Portugal, in whose library Magellan encountered it.

Like 1421, this book is a collective \blacktriangleright

66 This was quite a shock. It seemed Leonardo was more illustrator than inventor and that the greater genius may have resided in di Giorgio. 9 endeavor that never would have been written without the help of thousands of people across the world. I do not claim definitive answers to every riddle. This is a work in progress. Indeed, I hope the reader will join us in the search for answers and share them with us—as so many did in response to 1421.

Notes

¹ Antonio Pigafetta, *Magellan's Voyage*, trans. R. A. Skelton (London: Folio Society, 1975), 49.

Don't miss the next book by your favorite author. Sign up now for AuthorTracker by visiting www.AuthorTracker.com.

Read on